OTHER MONASTICISMS

Other Monasticisms

Studies in the History and Architecture of Religious Communities Outside the Canon, 11th–15th Centuries

EDITED BY

SHEILA BONDE AND CLARK MAINES

BREPOLS

© 2022, Brepols Publishers n.v., Turnhout, Belgium

All rights reserved. No part of this publication may be reproduced stored in a retrieval system, or transmitted, in any form or by any means, electronic, mechanical, photocopying, recording, or otherwise, without the prior permission of the publisher.

D/2022/0095/33
ISBN 978-2-503-58784-4

Printed in the EU on acid-free paper

Table of Contents

SHEILA BONDE AND CLARK MAINES .. 5

Introduction:
Ordo, Religio, and the Enduring Problem of Other Monasticisms

ROBERT L. J. SHAW ... 33

The French Celestine "Network" (c. 1350–1450):
Cross-Order and Lay Collaboration in Late Medieval Monastic Reform

ARTHUR PANIER .. 65

Sainte-Croix-sous-Offémont:
An Archaeological and Architectural Perspective on the Celestine Order

SUSAN WADE .. 99

The Illumination of the Eye, and the Rhetoric of Sanctity and Contemplative Prayer
in the Early to Central Middle Ages

KYLE KILLIAN ... 127

Traditional Benedictine Monasteries in the Archdiocese of Reims:
A Spatial Analytic Approach

ERIK GUSTAFSON ... 161

Camaldolese and Vallombrosan:
Architecture and Identity in Two Italian Reform Orders

ERICA KINIAS ... 211

Reconstructing an Order:
The Architecture of Isabelle of France's Abbey at Longchamp

TABLE OF CONTENTS

LAURA CHILSON-PARKS ... 247
Overlapping Space and Temporal Access in the Chartreuse de Champmol

SHEILA BONDE AND CLARK MAINES .. 271
Hermits in the Forest:
Western France and the Architecture of Monastic Reform

KATHLEEN THOMPSON ... 343
The Abbey of Tiron in the Late Middle Ages:
The Development of a New Monastic Order

FIGURE CREDITS .. 370

SHEILA BONDE AND CLARK MAINES

Introduction: Ordo, Religio, *and the Enduring Problem of Other Monasticisms*

Introduction

On Wednesday 11 November 1215 in the Basilica of Saint John Lateran, Pope Innocent III opened the Fourth Lateran Council.[1] The assembled included the five patriarchs or their representatives, together with more than 400 bishops, 800 abbots and priors (heads of established religious orders), and other ecclesiastical and secular dignitaries. At each of the three plenary sessions held in November, delegates debated issues related to reform of the church and recovery of the Holy Land. Especially relevant for the purposes of the present volume are the strictures contained in canon 13, usually translated as:

> Lest too great a diversity of religious orders lead to grave confusion in the Church of God, we strictly forbid anyone in the future to found a new order[2]

Canon 13's apparent prohibition of the creation of new orders is often cited. Scholars have, however, debated the intent and significance of this canon and its context within Innocent's program of church reform, often casting it as a proscription doomed to failure.[3] As early as 1935, Herbert Grundmann regarded the canon instead as a direct rebuke of Innocent's ongoing approvals of new religious orders, one that must have been promoted by bishops wishing to protect their own diocesan interests as well as heads of existing orders wishing to limit competition.[4] Giles Constable and Elizabeth Freeman note that the Latin word used in the canon is *religio* rather than *ordo*.[5] Indeed, the terms for medieval religious communities were far from standardized. *Ordo* was employed to indicate a variety of notions, including the rule, or more generally the observance of a monastic house, the order of service of religious rites,

the Mass, etc.[6] Up to the eleventh century, the *ordo monasticus* indicated the entire category of monastic communities (and the *ordo canonicus* chapters of canons), but by the mid-twelfth century the notion of the Cistercians as an individual *ordo*—the *ordo cisterciensis*—was being used.[7] *Religio* is similarly multivalent, indicating a religious commitment or lifestyle, but also a religious community.[8] Jacques de Vitry (c. 1160/70–1240) used both terms in his descriptions of religious communities in his *Historia occidentalis*, composed between c. 1219 and 1225.[9] The terms used in canon 13 were complicated in their wider usage, and it may be that their meaning in the canon was intentionally ambiguous.[10]

Constable provides a gloss on the normative translation for canon 13 that takes account of the terminology, and distinguishes between the prohibition of religious "orders" and the attempt to control new forms of "religious life":

> Lest the excessive diversity of forms of religious life (*religiones*) should introduce serious confusion into the Church of God, no one in the future should establish (*inveniat*) a new form of religious life (*religionem*), but anyone who wants to convert to religious life should adopt one of those [forms] that has been approved. Similarly, anyone who wants newly to found a religious house should adopt a rule and institution from the approved forms of religious life. We also prohibit that anyone should presume to have the place of a monk in several monasteries or that one abbot should preside in many monasteries.[11]

The century before Lateran IV, of course, saw the proliferation of *religiones* and *ordines*, not only the relatively well-known Cistercians, but also the Savignacs, Tironensians, Vallombrosans, Camaldulians, and Fontevrists explored in the present volume, and a host of others including the Caulites, Trinitarians, Grandmontains, and Carmelites. Regular canons also saw new forms develop including independent Augustinian congregations, the Arrouaisians, Praemonstratensians, and Victorines. There were also hybrid foundations: Gilbertine double houses held male regular canons following the Augustinian rule and women following the Benedictine monastic rule. In fact the larger female communities requiring a support staff often had an associated male house of regular canons to serve Mass and provide sacraments, as was the case at Fontevraud.[12]

In the years immediately preceding the council, Innocent III had expressed support for a number of religious groups who walked the line between orthodoxy and heresy, embracing voluntary poverty and itinerant preaching (both suspect activities, to be newly examined and controlled by Lateran IV). Religious groups derived from the Waldensians led by Durandus of Huesca and Bernard Prim found support.[13] In 1201, Innocent approved the Humiliati, a northern Italian group of lay men and women living in voluntary poverty who had been denounced by Pope Lucius III, and four years later, in 1205, he approved the less controversial Caulites.[14] The Franciscans and Dominicans coalesced over the early years of the thirteenth century from groups embracing poverty and preaching to become established orders. The formalization as an order was, however, not the only option. The eremitic groups in the west of France, traced by Bonde and Maines in this volume, left the forest and itinerant preaching only gradually

across the late eleventh and early twelfth centuries to establish monastic communities. In the early years of the thirteenth century, Jacques de Vitry sought permission for "holy women" in the northern countries to form female cloistered communities without the status of a recognized order and often without the requirement to follow an existing rule. He received oral permission for this solution in 1216 from Pope Honorius.[15] Such groups of "holy women" including the Beguines often resisted institutionalization as an order, likely to avoid male clerical control.[16]

The taste for reform, experimentation, and grassroots initiatives within religious life continued to grow through the thirteenth century and beyond. In this volume, Robert Shaw and Arthur Panier examine the Celestine order, rooted in the mid-thirteenth century. The Celestines received papal approval under the Rule of St Benedict in 1263 (formally implemented in 1264) and further recognition as a self-governing congregation in 1275. Erica Kinias explores the *Sorores minores inclusae*, whose rule was co-authored by Isabelle of France, her Franciscan confessors and Bonaventure in 1259 and revised in 1263, receiving papal approval at both of those moments.

Despite the number and the importance of many of these religious groups, however, our understanding of monasticism has been skewed by a continuing scholarly imbalance in study and publication. Scholarship has privileged certain congregations that (anachronistically) we call "international," in particular the Cluniac and Cistercian orders, over the diversity of monastic congregations that once existed during the European Middle Ages.[17] "Great monuments" like Mont-Saint-Michel, Cluny, and Fontenay continue to form the canon of monastic architecture, and continue to dominate publication.

Monasticisms

In this introduction, as in this volume, we embrace a broad definition of monasticism that we first formulated more than twenty years ago.[18] We include under its capacious umbrella not only those enclosed communities following a monastic rule, but those canons and friars who embraced an apostolic mission to serve the laity.[19] Within this expansive definition of monasticism, therefore, we see all forms of *religio* and not only those cloistered communities that would have self-defined as *monachi*. This definition obligates us as historians, architectural historians, and archaeologists to consider the entire monastic *oeuvre* as expressive of monastic thought, and to engage with the full monastic complex as the physical expression of social, economic, spiritual, and political motives, rather than as a site occupied by a group of men or women for solely religious purposes. According to this inclusive perspective, the study of monasticism should involve all forms of material evidence from books, bodies, and buildings to charters and churches to possessions, privileges, pipes, and pottery in the effort to understand how religious men and women lived and understood themselves and their world, as well as to understand how the rest of their contemporary world understood them.

The number of monastic orders in medieval Europe is difficult to assess but surely must be in the many hundreds, even if many of them followed Benedictine and Augustinian rules and customs. Despite measures to suppress the religious orders in eighteenth-century France, there remained at least 2,645 male houses and an estimated 1,500 female ones, and these numbers

were certainly larger several centuries earlier.[20] Medieval authors group the orders into types, with Jacques de Vitry listing some nineteen and the author of the *Libellus de diversis ordinibus* dividing monastic orders by their proximity to the laity.[21] In fact, the term "congregation" or "community" may be better terms than "order" especially when discussing the variety of groups formed in the energy of the Gregorian reform and its aftermath.

By the "other" in our title, we intend to further the plural notion of monasticism. We wish to direct attention to the under-studied and to the lesser-known forms of religious life, and to point to the need to open the canon to the non-monumental and lesser buildings—smaller churches as well as the claustral and functional buildings of the monastic precinct that help us to engage with quotidian activities beyond prayer and religious observance. In part, our title is inspired by Roberta Gilchrist's 1995 volume entitled *Contemplation and Action: The Other Monasticism*.[22] Chapters in that seminal volume addressed the archaeology of medieval hospitals, the military orders, and hermits as well as religious women.[23] The aim of this volume is to extend Gilchrist's work by considering monastic congregations—male and female—whose history, sites, and practices were important during the Middle Ages, but have been excluded from the canon of medieval monasticism.

Taking the pulse of current scholarship

In order to characterize the scholarly imbalance of the current "canon" of medieval monasticism, we turn to two strategies. We will first examine the general overview texts on the history and architectural history of monasticism, and then turn to a survey of recent publication data from three major medieval journals.

Recent historical surveys of monasticism are relatively numerous. C. H. Lawrence's 2001 *Medieval Monasticism* (thrice revised) is perhaps the best known, but also useful are Peter King's 1999 *Western Monasticism: A History of the Monastic Movement in the Latin Church* and Gert Melville's 2016 *The World of Medieval Monasticism*.[24] All three begin in the early Christian "desert" and move forward rather quickly in time in order to place emphasis on the great international orders. All of these historical surveys discuss the regular canons—not just the Praemonstratensians, but the Arrouaisians and the Victorines as well—and the eremitic movements that led to coenobitic monasticism: the Camaldolese and Vallombrosans in Italy, and the Carthusians and the Grandmontains in France. Melville briefly discusses the Caulites and devotes a paragraph to the career of Bernard of Tiron, but mentions the monastery he founded in just two sentences.[25] Lawrence provides a concise history of the Franciscan and Dominican orders emphasizing their early stages.[26] Religious women figure in the survey texts by Melville, Lawrence, and King, but only Lawrence and King devote a chapter to them, and in none of the three are they integrated into the discussion.[27] There are helpful nationally organized survey texts as well. Notable is Marcel Pacaut's 1993 (revised) *Les ordres monastiques et religieux au moyen âge*, for France, which covers monastic communities from the earliest emergence in the West to the later Middle Ages, and with an appendix that traces the survival of orders in the twentieth century.[28] The two-volume *Medieval Monasticism in the West*, edited by Alison Beach and Isabelle Cochelin (2020), also takes issue with the historiographic tradition, emphasizing what the editors call "order-history," decentering coenobitic monasticism, and re-

centering female forms of religious observance, integrating them into their chapters rather than relegating them to separate or peripheral treatment.[29] Their volumes treat regular canons as well as monks, and include hermits, house ascetics, beguines, and recluses, though the military orders and those communities dedicated to preaching and service to the laity are omitted.

General surveys of monasticism's architecture are relatively fewer in number.[30] Wolfgang Braunfels' 1972 *Monasteries of Western Europe* was for more than thirty years the standard survey of monastic architecture covering monasticism's beginning in the Near East and Africa, and extending selectively through to the contemporary period.[31] For the Middle Ages, Braunfels discusses the plan of Saint Gall, Cluny, the Cistercians, Carthusians, the mendicant orders, and English cathedral monasteries.[32] Female houses are noticeable by their absence. Ernst Badstübner's 1980 *Kirchen der Mönche* provides a survey stretching from earliest monastic implantations in the East to the mendicant orders in the late Middle Ages.[33] Badstübner, as the title of his book announces, pays almost exclusive attention to churches. Kristina Krüger's 2008 *Monasteries and Monastic Orders* can be said to replace (though hardly at a comparable cost) Braunfels' book with a wonderfully illustrated survey.[34] Like Braunfels, Krüger includes Byzantine, reformation, and contemporary monasticism. Coverage is significantly broader than Braunfels' slender volume, and expands even on Badstübner's survey, though Krüger's text also focuses primarily on churches rather than other buildings of the larger monastic precinct.[35] The two-volume study *Les ordres religieux*, published in 1979–1980, and organized by Gabriel Le Bras, covers an ambitious survey of monastic houses from the earliest moments of desert monasticism to the twentieth century.[36] The first volume engages with Benedictine tradition, including the Cistercians, Carthusians, and military orders, while the second volume treats the canonial orders of secular and regular canons, including the congregations of Saint-Ruf and Sainte-Geneviève, the Carmelites, Franciscans, Dominicans, and the Society of Jesus.

Scholarship on the architecture of monasteries (including archaeological approaches to standing structures) is often divided regionally and sometimes by order. Such "national" surveys include Günther Binding and Matthias Untermann's 2001 *Kleine Kunstgeschichte des Mittelalerlichen Ordensbaukunst in Deutschland*, for Germany, and J. Patrick Greene's 1992 *Medieval Monasteries*, for Britain.[37] Binding and Untermann provide a general survey of types of monastic architecture for German monastic buildings, beginning with early monastic architecture, and covering Benedictine structures of the High Middle Ages, before turning to Cistercian and then Augustinian architecture. They conclude with architecture of the mendicant orders and Carthusians. Greene instead organizes his survey by themes, harnessing the results of several decades of distinguished monastic archaeology in Britain. He begins with the definition of a monastery and the history of archaeological engagement with monastic sites before looking at monastic foundation, growth and rebuilding, water management, food, drink and health issues, and the later histories of dissolution in Britain and the reawakening of interest in the heritage issues related to monastic buildings.

Cluny and Cluniac monasticism have consistently been a major focus of study across disciplines, partly because of Cluny's position in the history of monasticism and partly because of the place its art and architecture have held in monastic studies.[38] The early twenty-first century witnessed increased interest surrounding the celebration in 2010 of the eleven-hundredth anniversary of Cluny's foundation. New excavations, as well as conservation of the

buildings on the site, were undertaken.[39] Important conferences combining both historical and archaeological approaches were held and their acts subsequently published.[40] Other scholars focused on the reception of Cluniac monasticism from historical and literary perspectives.[41] The same years also saw an important volume on Cluniac art and architectural history.[42]

Studies of Cistercian architecture by far outweigh those of any other order, a condition that stems from the relatively good preservation afforded by the rural sites chosen by the monks, from the wealth of medieval texts written by Cistercians themselves, and from the fact that the Cistercians remain a living order.[43] Cistercian monks and nuns contribute significantly to the study of the order, which publishes several journals and book series.[44] Beginning with Hahn in 1957, and surrounding the 900th anniversary of the foundation of Cîteaux, there are fine Europe-wide surveys of Cistercian architecture.[45] There are also excellent Cistercian architectural studies devoted to individual countries.[46] A number of important Cistercian sites have received monographic treatment, among them Cîteaux, Rievaulx, and Morimond.[47] Exceptionally, Mohn's 2006 study provides a volume on the architecture of Cistercian nuns, albeit for Germany alone.[48]

If monastic architectural history for the eleventh and twelfth centuries emphasizes the congregations of Cluny and Cîteaux, for the thirteenth and fourteenth it focuses on the architecture of the Franciscans and Dominicans.[49] Surveys of the architecture of the mendicant orders tend to group the two principal congregations together.[50] Architecture for Franciscan and Dominican women has received treatment by Carla Jâggi.[51]

The independent status of the vast majority of Benedictine houses has made study of Benedictine architecture as a whole all but impossible, particularly since many Benedictine houses were themselves heads of regional congregations, as were, for example, La Sauve Majeure in the forest near Bordeaux and Montmajour in Provence.[52] Surveys such as Braunfels' and Krüger's, among others, inevitably discuss Benedictine architecture, but only Eschapasse focuses exclusively on the Benedictines.[53] His discussion, which emphasizes the formal evolution of churches, begins with the Carolingian period and extends through the early modern era, including a brief but useful section on the Maurists (the scholarly congregation of French Benedictines established in 1621).[54]

Among the less studied orders, Fontevraud and Grandmont in France have received recent attention. Over the last thirty-five years, and in connection with the 900th anniversary of the abbey's foundation, the site of Fontevraud has undergone significant restoration, historical and art historical study, and archaeological excavation. A new journal and several monographs have brought recent work to a wider audience.[55] In 1989, Carole Hutchison published a history of the order of Grandmont that includes a long chapter on its architecture and a list of Grandmontain houses.[56] In 1994 Geneviève Durand and Jean Nougaret published the acts of a two-day conference on the history, spirituality, art, and archaeology of the order of Grandmont.[57]

Compared with the enormous body of scholarship on Cistercian and Cluniac architecture, as well as on the two mendicant orders, study on the architecture of other orders pales in contrast. In this volume alone, the architecture of various orders—including the Celestines (examined by Panier), the Tironensians and other houses established by forest hermits in the west of France (explored by Bonde and Maines), and the *Sorores minores inclusae* (analyzed by Kinias)—have been essentially unstudied. The architectures of the Camaldolese and Vallombrosans are also

little studied, receiving brief treatments by Brooke and Krüger, but both are treated more fully by Gustafson in the present volume.⁵⁸

A survey of journal research on monasticism can best reflect the current state of the field, and complements our brief overview of the general literature. The editors are no strangers to such surveys. In 1988, we reviewed more than twenty journals published over a seventeen-year period from 1970 to 1987 to trace the development of the subfield of monastic archaeology in France.⁵⁹ Twelve years later, we extended that earlier survey to chart developments and changes to 1999.⁶⁰

In our 1988 survey, we examined more than fifty journals as well as conference proceedings and exhibition catalogues. Of the approximately 2500 articles, slightly more than half (1280) were strictly archaeological, as opposed to documentary. Significantly, excavation of monastic sites totaled 288, about 22.5% of the archaeological studies. These results might suggest that our material understanding of monastic life is well represented in the current state of research, but a closer look was revealing. Houses in the Benedictine tradition far outweighed canonical and mendicant ones. The distribution by orders provides an even clearer picture. Cistercian, Cluniac, and major independent Benedictine houses far outnumbered houses of all other orders combined. Moreover, work on Benedictine congregations had focused upon the Cluniacs and Cistercians with much less attention to the many independent houses that adopted the Benedictine rule.

In the survey that follows, we present the results of a review of publications appearing over the last twenty years in three journals, each with a different disciplinary focus on the Middle Ages, in order to chart the shape of publication as it concerns monasteries and monastic life across orders and in all its phases. The three journals are *Gesta*, *Archéologie Médiévale*, and *Speculum*.⁶¹ *Gesta* and *Speculum* are international in terms of their publications; *Archéologie Médiévale* covers only French material. We have counted all articles in which some aspect of monastic life played an important role in the study, rather than only those that focused exclusively on one particular aspect of monasticism.

Gesta, the biannual journal of the International Center for Medieval Art in New York, aims to publish work on medieval art in all media including architecture. From 2000 to 2019, *Gesta* published 209 articles of which 49 were articles focused on monastic issues. Of these studies, 39 concerned male houses, while only 10 concerned female ones. More interesting still from the perspective of "other monasticisms" the 49 articles represented no fewer than 13 different monastic orders, among which were single studies on each of five different orders and 8 on Orthodox (Byzantine) communities (Fig. 1). Independent Benedictine houses were the focus of 22 of the 49 studies, perhaps not so surprising given the longer history of that type of monastic life. Only 5 concerned the well-known Cistercian and Cluniac congregations. 10 articles focused on mendicant houses (Franciscan: 6, Dominican: 2, Clarissan: 2), while only 3 concerned houses of Augustinian canons, which can be said to be significantly under-represented in the sample. The most frequent focus of the 49 articles was iconography, often on issues of lay patronage and iconographic program, whether in wall painting or manuscripts. Of the 12 studies that focus on architecture, in whole or in significant part, two-thirds of them appeared in the first decade from 2000–2009. All of those papers concern themselves with the architecture of monastic churches. None considers the architecture or decoration of the claustral ranges, the cloister, or

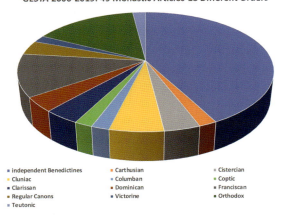

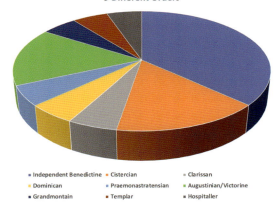

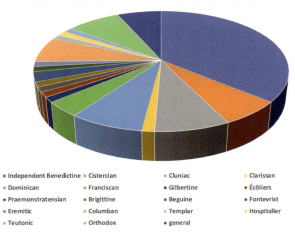

1–3
Pie charts of the number of monastic articles published in *Gesta* (top), *Archéologie Médiévale* (middle) and *Speculum* (bottom) from 2000 to 2019.

the functional/utilitarian buildings that make up an important part of monastic architecture as a whole. Clearly, there is room for more research in these areas.

Archéologie Médiévale, published by CRAHM at the University of Caen (Normandy), is a national medieval archaeology journal that publishes articles on all aspects of medieval life, secular and religious. Its contents are divided into two types: peer reviewed articles and editorially reviewed "year's work" summaries of excavations, called the *chronique des fouilles*.[62] For this survey, we have focused on the peer reviewed articles—which are fully developed research statements—rather than the *chronique summaries*, which reflect current fieldwork.

For the period 2000–2019, Archéologie Médiévale published 120 articles of which only 16 were studies that focused on monastic issues, representing slightly more than 13% of the total. Of these articles, 13 concerned male houses and 2, female ones. The 16 articles represented eight different orders, of which six were independent Benedictine houses and two were Cistercian (Fig. 2). 2 were devoted to military orders, 1 to a Templar's house and 1 to a Hospitaller's. Another 2 were devoted to mendicant orders: one Dominican and one Clarissan. Finally, 3 articles focused on regular canons, 2 on a single Victorine community, and the other on a Praemonstratensian house.

Considered in comparison to the percentages from the survey of Gesta, the number of monastic articles in *Archéologie Médiévale* seems surprisingly low and needs to be contextualized. During the last quarter of the twentieth century, France and many other countries of Europe struggled with the issue of heritage preservation. In 1973, the French government created an *Association Française d'Archéologie Nationale* (AFAN), which was intended to address the problem of salvage (or rescue) archaeology (*archéologie préventive*) in France and its territories.[63] Problems with the organizational structure of AFAN led to its dissolution in 2001 and the creation of the Institute Nationale de Recherches Archéologiques Préventives (INRAP).[64] While committed to salvage archaeology, INRAP also has a formal obligation to publication of its research, and the law that created the organization also provides time for its archaeologists to write and publish the results of their fieldwork.[65]

These circumstances have had an effect on the archaeological study of monasteries in France, and to a greater or lesser extent on other European countries as well.[66] A significant number of the 120 articles surveyed were written by INRAP archaeologists. Most are co-authored and demonstrate clearly the strength of collaborative research. The presence of INRAP in French medieval archaeology also helps explain the low number of monastic studies published in *AM* during the last twenty years. It is not simply a question of the length of time necessary for a fully developed monastic research project. Monasteries are a regular feature of the French landscape today, even when that presence survives only in a street name. Many of the better-preserved monastic sites are historic ones with a significant touristic component. Others are today public or private institutions. Some of the *archéologie préventive* published in *AM* during the last twenty years has been driven by the Commission des Monuments Historiques conservation projects (at Maubuisson, Mont-Saint-Michel, Vézelay, and Fontevraud). Other projects have been motivated by institutional expansion (Château-Landon).

One consequence of the structure of archaeological funding is that comparatively few studies based on long-term monastic research projects are likely to appear in *Archéologie Médiévale*, at least for the foreseeable future. Nevertheless, looking at the *Gesta* survey, where research looked

at 13 different orders among the 49 monastic studies, the *AM* figures are actually better, with eight different orders among 16 studies of monastic issues (see Figs. 1 and 2). The attendant qualification of this comparison lies in the fact that the studies in *Gesta* represent scholarly choices, whereas the studies in *AM* largely represent the fortuitous circumstances of rescue archaeology.

Speculum, the journal of the Medieval Academy of America, is an international review that publishes articles on all subfields of medieval studies, although works on history and literature appear more frequently than do other subfields. Contributing scholars come from a number of countries in Europe and North America. During the period from 2000 to 2019, *Speculum* published 372 articles of which 74 were devoted in whole or in important part to monastic life, effectively 20% of the total. Of the studies, 56 focused on monks and/or male houses while 18 concerned nuns and/or convents, approximately a three-to-one ratio, more even than *Gesta*'s four-to-one ratio and far more balanced than *AM*'s more than six-to-one. In spite of the high number of articles devoted to monastic issues, however, only thirteen different orders were represented (Fig. 3).[67] 13 studies focused on the Benedictine tradition: 8 on independent Benedictine houses, 3 on Cistercian ones, and 1 on Cluniacs. 4 articles focused on the Dominican order, while only 1 focused on Franciscans. 3 centered on the military orders (Templars, Hospitallers, and Teutonic Knights) and 3 others on Orthodox houses. 2 articles focused on the same beguine, Margareta of Hainaut, called Porete. The Brigittine and Praemonstratensian orders were each represented by a single study.

Perhaps the most surprising result of the *Speculum* survey is the remarkable under-representation of studies on houses of regular canons. This is particularly notable since the last twenty years have seen advances in the study of this form of monasticism, especially in France.[68] Even so, independent Augustinian houses, those of the Val des Écôliers, and even Victorine and Praemonstratensian ones have not received the attention that their standing during the Middle Ages merits them. The study of women's houses and women monastics also remains under-represented.

This selective survey of recent scholarship (accomplished during the pandemic with limited access to print journals) provides a pulse-taking of the larger field of monastic studies. Whether reflecting scholarly research choices (*Gesta* and *Speculum*) or the vagaries of archaeological funding priorities (*AM*), the results demonstrate a thriving interest in things medieval and monastic, but also reveal the ongoing dominance of "great" Benedictine congregations, and the predominance of studies of male over female subjects.

Chapters in this volume

Partly as a response to the editors' "pulse-taking" efforts in surveying the literature on monastic studies, the chapters in this volume explore congregations that have tended to be omitted from the discussions on medieval monasticism, and its philosophy, history, and architecture. The current volume began as a set of sessions organized by the editors for the 53rd International Medieval Congress at Kalamazoo in 2018. Its aim was to encourage new work by young scholars on a broad array of monastic topics and in a wide range of fields and approaches. Several of the presenters are not included in this volume, and others were invited to join after the conference,

INTRODUCTION

but the Kalamazoo sessions—with their active participation and debate on the part of speakers and audience members alike—were generative for our collective thinking about "other" forms of monasticism.

The first two chapters in our volume, one by Robert Shaw and the other by Arthur Panier, direct our attention to the little-studied Celestine order in France. The Celestines derived their name from their founder, Pietro da Morrone (1215–1297), who became (reluctantly and briefly) pope (Celestine) in 1294. Earlier, Pietro gathered together a monastic congregation from his followers at their hermitages around Sulmona in Italy, who emphasized rigorous observance of the Benedictine rule. The order spread, with over a hundred houses by 1400: the majority in Italy, thirteen in France, where growth would continue in the early fifteenth century, and one in Bohemia.[69] Gaining effective independence from the Italian branch of the order in 1380, during the Great Western Schism (1378–1417), the French province received patronage from the highest levels of French nobility, including the kings and queens.

Through documentary research and mapping, Shaw builds out from his recently published history of the order to redefine what "success" entailed for monasteries in the later Middle Ages.[70] He observes that many pre-Reformation congregations were comparatively small, since monasteries were more expensive to build in the later medieval world, and the formulation of new religious communities more challenging after Lateran IV. Late medieval reformed houses might draw strength from networks of associations with similar monastic groups, as well as from their own congregations. The French Celestines maintained their separation even from their Italian brothers in the vigor of their reform observances, instead forming ties with other religious. Shaw traces the networks of connections that bound the Celestines to other contemporary reform orders such as the Collettines and the Carthusians. He also looks closely at ties with educated bourgeoisie as a recruiting base for the order. Shaw examines the spatial distribution of these networks relative to the territorial associations of their foundations.

Arthur Panier presents the first English-language study devoted to the architecture of the Celestines in France.[71] He traces the establishment of Celestine houses from the earliest foundation of the rural establishment at Notre-Dame d'Ambert (Loiret) in 1300–1304 and Saint-Pierre-en-Chastres (Oise) in 1308–1309 to the later foundation of the Celestine priory in Paris. Panier focuses on the well-preserved house of Sainte-Croix-sous-Offémont (Oise). Using his new surveyed site plan of Offémont, and surviving evidence for the houses of the French congregation, Panier explores the question of monastic architectural features adopted by the Celestines. While he eschews the notion of a "Celestine" architectural style, he points to the frequent presence of images, burials, and armorial representations of important donors, such as are found in the burial chapel at the Celestine priory of Paris, filled with the hearts and entrails of French kings and dignitaries, or the priory at Marcoussis with its lost sculpted representations of King Charles VI and his queen Isabeau of Bavaria. Panier identifies eremitic tendencies within the monastic practice and architectural plan of Celestine houses, including the predominant use of a single-vessel church plan and the preference for individual cells within a common dormitory.

Two chapters by Susan Wade and Kyle Killian turn to the experience of traditional Benedictine communities. Such communities were found across Europe in the medieval period. Wade explores the evidence of hagiography, in which accounts written between the fifth and

the eleventh centuries celebrate the miraculous restoration of sight to blind pilgrims. Wade reads these stories through the lens of visuality and disability studies. She demonstrates that medieval miracle tales employing a vocabulary of illumination have strong parallels with the language of monastic contemplation. Both the Benedictine Rule and the Rule of the Master enjoin monks to monitor the corporeal eyes so that the soul can be protected from unwonted desires. Regulations to "cloister" the eyes redirected the monastic gaze toward the inner spiritual sense of sight. In this context, Wade explores medieval theories of vision and links the language of the miracles to rhetorical devices important to the practice of contemplative prayer. Among the examples of miraculous illumination that she explores is the tenth-century miracle by Saint Ursmer of Lobbes (Belgium) recorded by Abbot Folcuin. This miracle traces the path a blind woman takes up the hill to the shrine of Saint-Ursmer where her sight is restored, paralleling the monastic path toward spiritual illumination through meditation.

Kyle Killian examines critically the literature surrounding a group of traditional Benedictine houses in the archdiocese of Reims, which met in response to issues of monastic reform during the 1130s and after. Killian argues that houses of traditional Benedictines should be included within the discourse on monastic reform. He employs a spatial analytic approach to explore the place of these houses in the religious and architectural landscape. He also compares their distribution to that of new houses of the reform orders within the archdiocese. While Killian argues against a single "reform style" for this group of Rémois monasteries, he observes a shared set of architectural characteristics including a "centralizing" space framed by enveloping chapels. Many of the buildings, however, predate the formation of the confraternity so that the notions of "otherness" or collective identity must be sought in different ways.

The next chapter, by Erik Gustafson, presents a survey of the architecture of two Italian reform communities: the Camaldolese and the Vallombrosans, both founded in the eleventh century and centered in Tuscan Italy. Gustafson's study provides the first overview of the architecture of these two orders in English. Founded in 1025–1027, the Camaldoli were an eremitical order. The contemplative life of the hermit was an ideal, and found its expression in individual cells within their coenobitic Benedictine monasteries. The Vallombrosans, founded in c. 1040, were an austere order dedicated to monastic reform and religious activism. The monastic architecture of these two orders has been under-studied. Few medieval claustral buildings survive, and most of the surviving churches are heavily plastered, obscuring evidence of masonry breaks and early decoration. Gustafson therefore turns to a broad survey of the plan-types of these churches. He adopts the concept of "trope" from Bede's typological interpretation of buildings in an attempt to elicit meaning and to apply the notion of apostolicity to both the single-vessel churches and basilican buildings of both orders. He argues that the explanation for the predominant use of what he calls a single-nave plan by both orders should be sought in the monastic ideals practiced by the communities, and sees the single nave as a revived funerary type that invoked for both communities an adherence to the ideals of the *vita apostolica*.

Two chapters by Erica Kinias and Laura Chilson-Parks explore aspects of women's engagement with monasticism. Kinias looks at a community of female Franciscans, a group that began in France in the thirteenth century, and spread to England and Italy. Chilson-Parks engages with the Carthusians, an order founded in the eleventh century in France for both men and women, which spread to England, Italy, Spain, Germany, and Austria.

Kinias traces the relatively little-known order of the Sorores minores inclusae, a female Franciscan order co-founded by Isabelle of France (1225–1270), and her brother, Louis IX. The order's rule, co-written in 1259 and revised in 1263, was one of the new rules approved after Lateran IV. Isabelle's rule rejected Clare's "privilege of poverty," insisting that her order be permitted to accept endowments and to hold property in common. Kinias takes on the important but lost royal abbey of Longchamp. She marshals surviving plans, descriptions, and views of Longchamp to offer a reconstruction of the abbey and its church across the centuries of its existence. Kinias identifies the presence of Isabelle's private residence within the monastic enclosure, as well as her tomb in the church, and explores the conventual spaces that provided access not only for the nuns, but the lay elite who were its sponsors.

Chilson-Parks reexamines critically the model of Carthusian monasticism that emphasizes the reclusive nature of the order. She takes up the example of Champmol to investigate how the architecture of the monastery both served the needs of its (male) community as well as its lay patrons and pilgrims, many of them women. She demonstrates the subtle dimensions of permeability of the monastic enclosure, intended to isolate the monks, by showing that lay pilgrims were granted periodic access to the heart of the great cloister. Similarly, she also shows that the oratory built for Philip the Bold (1342–1404) and Margaret of Flanders (1350–1405) provided these lay patrons visual access to the main altar of the monastic church.

The final two studies, the first by the editors and the second by Kathleen Thompson, examine the monastery of Tiron (Eure-et-Loir), mother house to a congregation of more than 150 dependent houses. Established in the early twelfth century by Bernard of Tiron, the mother house at Tiron and its dependent abbeys, priories, and parishes—spread across France, England, Scotland, and Wales—are seldom mentioned in scholarship.

Sheila Bonde and Clark Maines consider eremitic groups led by charismatic itinerant preachers, including Bernard of Tiron, Robert of Arbrissel, Raoul de la Futaie, Alleaume, and Salomon. These charismats led men and women into the forests as fellow hermits, forming communities that stood, in a sense, outside the organized church. Bonde and Maines trace the processes of transformation of these "other" groups into institutionalized monastic communities. Their chapter focuses on five houses in the west of France at the end of the eleventh and beginning of the twelfth centuries: Tiron, Fontevraud (I and II), Notre-Dame du Nid-au-Merle in Saint-Sulpice-la-Forêt, and Notre-Dame d'Étival, the last two of which are little studied (Notre-Dame du Nid-au-Merle) or not studied at all (Étival).[72] They see as significant not only the choice of building plan, but also the complicated negotiations within the process of establishment, the selection of site, and the use of (largely local) building materials and techniques.[73] Their conclusion focuses on the aisleless cruciform building used by all of these nascent groups as a form suitable for eremitic monasticism: monumental in form, austere in decoration, humble in materials and method of construction, and supple in form—all qualities sought by the "new apostolicity" of the western French hermit preachers.

Kathleen Thompson can be said to have transformed historical study of the Tironensian order with her 2014 volume on the congregation from its foundation to the end of the twelfth century.[74] In *Other Monasticisms*, she extends her historical analysis of Tiron through the abbey's flourishing during the thirteenth and fourteenth centuries to its difficulties and recovery in the fifteenth and its decline in the sixteenth. Thompson's research reveals that Tiron never regained

the luster it enjoyed in the twelfth century. In the thirteenth century, however, she finds it to have been a well-funded and ably administered community, similar to other Benedictine houses. Increasingly, the community depended upon money rents for its expenses. The Hundred Years War (1337–1453) exerted a heavy impact upon the house, and especially to its "alien" priories in England, which were ultimately divested in 1391. The continuing conflict caused disruption and damage, especially in the early years of the fifteenth century. The monks exploited agricultural as well as commercial properties. They owned land in Chartres and from 1138, a plot in Paris, where they later built the Hôtel de Tiron, used by the abbots who, Thompson argues, became increasingly distant from their community.

Conclusion: common themes and future work

Other Monasticisms takes a step toward a more capacious and more representative history of European monasticism in the Middle Ages. The volume considers lesser-studied congregations, including the Camaldolese, Vallombrosans, Fontevrists, Tironensians, *Sorores minores inclusae*, and Celestines, as well as ones that remain outside scholarship such as the communities at Notre-Dame du Nid-au-Merle or Étival. It also offers reassessments of orders that are more well known such as the independent Benedictine and Carthusian orders. The volume contributes, as well, to the growing literature on the place of women in the history of European monasticism.

Despite its range, however, our volume has a number of limitations. It is admittedly Franco-centric, including only one contribution on monasteries in Italy, where Benedictine monasticism began and flourished, and none on houses from Germany, Portugal, or Spain, although important work is certainly being done on these subjects. Byzantium is not represented, and more work can usefully be undertaken on relationships between monastic forms in the East and West. A global frame would necessitate the inclusion of monastic orders and buildings in eastern Europe as well as in the Middle East and Africa.[75] More work needs to be done, and we look forward to further studies advancing this call.

The method of approach varies in all of the chapters in the present volume. Three chapters (Shaw, Thompson, and Wade) exploit historical analysis. Shaw works skillfully with obituary texts, biographies, and records of election to trace the interconnected aspects of late medieval reform orders. Thompson exploits records of sale and trade, military accounts, and charter evidence to trace the late medieval developments and decline of Tiron. Susan Wade turns instead to monastic rules, instruction books, and miracle texts, mining a vein of poetic and philosophical monastic writing, to explore the meanings of illumination. Three papers (Shaw, Killian, and Chilson-Parks) use spatial analysis in order to chart and interpret the place of monastic foundations within both the physical and spiritual landscape, and to trace the spatial configurations of the architecture. Seven authors (Panier, Kinias, Chilson-Parks, Killian, Gustafson, and Bonde and Maines) turn to architecture as their primary form of evidence.

One common theme is the importance of the hermit—and of the eremitic strain within coenobitic monasticism and canonical life. Several of the communities explored in this volume—the Camaldolese, Celestines, Tironensians, Fontevrists, and those of Notre-Dame du Nid-au-Merle and Étival—all began as eremitic groups. Even the Benedictine reformer, John Gualberto spent time at Camaldoli before establishing Vallombrosa. Recent historical scholarship has

increased our understanding of eremitism and its relationship to monasticism as a whole.[76] Gilchrist devoted a chapter in *Contemplation and Action* to the archaeological study of hermitages in England.[77] This century has seen an increased interest in eremitism. Vauchez's publication of the proceedings of a conference on eremitism in France and Italy marks a shift in research.[78] Twenty-two studies (mostly devoted to France and Italy, but also including one on Hungary and one on Switzerland), consider the nature of eremitic life during the Middle Ages, as well as the shifting relationships between eremitism and coenobitic communities. Only Italo Moretti's study of Tuscany, however, confronts the architecture of eremitism.[79] Following Vauchez, Bertocci and Parrinello have published five volumes of conference proceedings devoted to eremitism and eremitic monasticism in Europe and the New World that bring study of the phenomenon into sharper focus.[80] Eighty percent of these studies are, however, devoted to Italy. There are none for Ireland, Germany and the Lowlands, and only three for France and one for England where more work clearly needs to be undertaken. In our 1999 survey (published in 2004), we were only able to cite one study of a hermitage site in France.[81] The architecture of eremitic monasticism is notably absent from virtually all publications on Romanesque architecture or ecclesiastical reform. In this volume, Gustafson's chapter traces the eremitic origins of the Camaldolese. Chilson-Parks focuses upon Champmol with its organization into eremitic individual cells. Bonde and Maines explore the importance of the early eremitic phase in the foundation of the monastic orders of Tiron, Fontevraud, Notre-Dame du Nid-au-Merle, and Étival, and Panier demonstrates the influence of eremitic forms on the design of Celestine dormitories.

Four chapters focus on the role of female patrons and participants within monasticism. Kinias explores Longchamp, a house established by a woman for female Benedictines, and Chilson-Parks examines female interactions with the male house of Champmol. Shaw's chapter considers the role of female patrons and reformers in collaboration with the Celestines in late medieval France. Three of the four communities examined by Bonde and Maines were the mother houses of female congregations, and the authors explore the important roles women (monastics and patrons) played in the early years of those establishments. As we have seen, eighteenth-century France preserved 2,645 houses for religious men and an estimated 1,500 for religious women.[82] One might then, with reason, expect that studies of women religious should occupy at least 36% of scholarship. If we combine the numbers for the three journals we surveyed for this volume, there are 136 articles on monastic topics of which 28, or only 21% of the total, concern women religious.[83] Despite the progress made in studying women religious over the last thirty years, there remains a significant imbalance that must be overcome to attain a more representative history of medieval European monasticism. Even within the scholarship on female monasticism, there are important figures treated as canonical while others have been excluded. Until recently, Isabelle of France has been relegated to the shadow of Clare of Assisi who has been viewed as the model for Franciscan women. Kinias' study continues the recovery of this important figure by focusing on her impact upon the architecture of her order.

Lay access to monastic ideas and ideals is a theme raised by several papers in this volume. Chilson-Parks explores the permeability of the enclosure at Champmol, with lay visual access conferred by the oratory and physical access to the Great Cloister granted to pilgrims. By exploring Isabelle's residence, Kinias also traces the access given to lay patrons within the very

monastic enclosure of Longchamp. Wade explores the ways in which blind laity could access monastic prayer through "illumination." Panier shows how important lay representations were within the monastic churches of the Celestines, and Shaw demonstrates the ways in which lay supporters were important to Celestine recruitment. Contact with the laity was one of the desired aims of the *vita apostolica*, explored by Gustafson as well as Bonde and Maines. Itinerant preachers gathered groups of lay followers in mixed communities of men and women in the wildernesses of Italy and western France.

Another theme uniting the studies in this volume is the notion of monastic identity.[84] Almost all monastic orders and congregations, of course, advanced *agendae* of reform and withdrawal from the secular world in ways that are often quite similar. (How) did they distinguish themselves one from another? One important signifier, of course, was clothing. Jacques de Vitry opens his discussion of the orders in his *Historia occidentalis* with a description of their monastic habits.[85] Religious communities also mobilized architectural forms that have long been recognized as meaning-laden, even if our ability to decipher those meanings has been fraught.[86] Krautheimer helped us to see the ways in which important buildings might be "copied," procedures that demonstrated what he called "indifference to precise imitation."[87] Those copies contained forms that medieval viewers were trained to "read," although Krautheimer was careful to note that such forms held multiple "connotations, fleeting, only dimly visible, and therefore interchangeable."[88] The power of a particular building configuration like the aisleless cruciform building, then, might resonate powerfully, as Bandmann observes, as a venerable and suitable form for the church of a reforming community.[89] These forms might recall an influential model, the primitive church as a temporal referent, and/or might point toward contemporary local parish churches as a way to signal humility and voluntary poverty.

The dominance of Cistercian studies within the scholarship on monastic architecture has led to a two-fold conundrum. First, the "Bernardine plan" (a square-east ended cruciform church plan used in a number of Cistercian churches) has been incorrectly identified as a form approved by Saint Bernard and adopted unilaterally as a signifier of Cistercian simplicity. Fontenay is the touchstone monument in this discussion.[90] One of the subsequent narratives of monastic art history has been the attempt to identify an architecture for other monastic orders. When we fail to identify these, we are disappointed with ourselves—and with the order—for not creating a legible architectural style. This is, of course, wrong-headed.

The chapters in this volume make clear that many congregations turned to similar plan types, such as the "single nave" of Panier's Celestines, Kinias' *Sorores*, and Gustafson's Camaldolese and Vallombrosans, or the "aisleless cruciform buildings" of the hermit communities traced by Bonde and Maines. Most authors in this volume resist the temptation to identify an order-specific architectural style, despite noting the choice of certain forms like a single-vessel plan. Bonde and Maines look to the broader eremitic tendencies of early orders in the west of France to prefer austere materials and decorative restraint. The fact that all of the churches of new eremitic communities—not only those of the Tironensians, but also of the Fontevrists and the nuns of Notre-Dame du Nid-au-Merle and Notre-Dame d'Étival—adopted an aisleless cruciform plan, indicates to the authors that this plan type signified as a suitable one for several reforming groups. We should not expect that monastic design committees were looking for unique identifiers exclusive to their order. Rather, they sought combinations of formal signifiers

that expressed their values of restraint, humility, and austerity, and their monastic or apostolic missions. These might be found in a spare plan lacking aisles or vaulting, in restrained decoration, or in a particular focus upon a functional zone like the altar or an individual cell for devotion and prayer. We should also expect that these forms would have fallen in and out of legibility over time, both for their monastic and lay audiences.

We began this essay with an examination of the Fourth Lateran council. While we hope to have complicated the reading of the thirteenth canon and its restriction on the creation of new *religiones*, it is clear that monastic reform and supervision for the creation and administration of the growing number of religious communities lay at the heart of the discussions in November 1215. Monastic reform is an important theme uniting a number of the chapters in this volume. Shaw shows how the French Celestines embraced a strict observance of their rule and constitutions. He demonstrates that Observant reformers like the French Celestines in the late Middle Ages did not always isolate themselves in this endeavor, but rather profited from networks of association with other like-minded groups. While Benedictine practice is often viewed as the counterpoint to reform, Killian underscores the ways in which traditional Benedictine communities might themselves participate in reform discourse. Wade traces the individual monastic response to reform ideals in her discussion of monastic rules and miracle stories of illumination. Reform was expressed in the words of church councils and monastic rules, but also took architectural form. Bonde and Maines, Panier, and Gustafson all explore the ways in which a reform identity was expressed through the deliberate embrace of particular, often ascetic, architectural forms.

As we introduce the studies collected here, it is our hope that *Other Monasticisms*, with its emphasis on little-studied congregations, the role of women in monastic history, and lesser-known monastic sites and buildings will further scholarly interest in the range of medieval religious expression, and will contribute to a broader and more nuanced understanding of medieval monastic culture.

Printed Primary Works

COGD 2013. II.1, Lat. IV, c. 13: *The General Councils of Latin Christendom: From Constantinople IV to Pavia-Siena (869–1424)*, ed. Antonio García y García et al., Corpus Christianorum, Conciliorum Oecumenicorum Generaliumque Decreta II.1, Lateran IV, canon 13 (Turnhout: Brepols, 2013), p. 175.

Jacques de Vitry 1972: Jacques de Vitry, *The Historia occidentalis of Jacques de Vitry*, a critical edition by John Henry Hinnebusch (Fribourg: The University Press, 1972).

Libellus 2003: *Libellus de Diversis Ordinibus et Professionibus qui sunt in Aecclesia*, ed. and trans. Giles Constable and Bernard S. Smith (Oxford: Clarendon Press, rev. ed., 2003).

Secondary Works

Adamo 2014: Philip C. Adamo, *New Monks in Old Habits: The Formation of the Caulite Monastic Order, 1193–1267*. Studies and Texts, 189 (Toronto: Pontifical Institute of Mediaeval Studies, 2014).

Andrews 1999: Frances Andrews, *The Early Humiliati*, Cambridge Studies in Medieval Life and Thought, 4th ser. (Cambridge: Cambridge University Press, 1999).

Andrews 2006: Frances Andrews, *The Other Friars, the Carmelite, Augustinian, Sack and Pied Friars in the Middle Ages* (Woodbridge: Boydell Press, 2006).

Anon. 2000: Anonymous, *303 Arts, Recherches et Créations* (*La revue des Pays de la Loire*, 67, [2000]), 86–93.

Arnoux 2000: Matthieu Arnoux, ed., *Des clercs au service de la réforme: Études et documents sur les chanoines réguliers de la province de Rouen*. Bibliotheca Victorina, XI (Turnhout: Brepols, 2000).

Aubert 1947: Marcel Aubert, in collaboration with the Marquise de Maillé, *L'architecture cistercienne en France*, 2 vols., 2nd ed. (Paris: Vanoest Éditions d'Art et d'Histoire, 1947).

Badstübner 1980: Ernst Badstübner, *Kirchen des Mönche: Die Baukunst der Reformorden im Mittelalter* (Berlin: Union Verlag, 1980).

Baldwin 1970: Marshall W. Baldwin, "The Fourth Lateran Council," in M. W. Baldwin, ed., *Christianity through the Thirteenth Century* (New York: Walker, 1970), 292–344.

Bandmann (1951) 2005: Günter Bandmann, *Early Medieval Architecture as Bearer of Meaning*, trans. Kendall Walker (New York: Columbia University Press, 2005) [first published as *Mittelalterliche Architektur als Bedeutungsträger* (Berlin: Gebr. Mann, 1951)].

Baud 2003: Anne Baud, *Cluny, un grand chantier médiéval au cœur de l'Europe* (Paris: Picard, 2003).

Baud and Sapin 2019: Anne Baud and Christian Sapin, in collaboration with Walter Berry, Anne Flammin, and Fabrice Henrion, *Cluny: Les origines du monastère et de ses églises*. Archéologie et histoire de l'art, 35 (Aubervilliers: École nationale des chartes, 2019).

Beach and Cochelin 2020: Alison Beach and Isabelle Cochelin, eds., *Medieval Monasticism in the West*, 2 vols. (Cambridge: Cambridge University Press, 2020).

Becquet 1991: Jean Becquet, "Les Ordres secondaires," in *Naissance et fonctionnement des réseaux monastiques et canoniaux*, Actes du 1er Colloque International du C.E.R.C.O.R. (Centre Européen de Recherches sur les Congrégations et Ordres Religieux), 16–18 septembre 1985. Travaux et recherches, 1 (Saint-Etienne:

Publications de l'Université Jean Monnet, 1991), 113–115.

Bertocci and Parrinello, eds. 2010, 2011, 2012, 2013 and 2021. Stefano Bertocci and Sandro Parrinello, *Architettura eremitica: Sistemi progettuali e paesaggi culturali*, 5 vols. (Florence: Edifir, 2010–2013, 2021).

Biller 1985: Peter Biller, "Words and the Medieval Notion of Religion," *Journal of Ecclesiastical History*, 36 (1985): 351–369.

Binding and Untermann 2001: Günther Binding and Matthais Untermann, *Kleine Kunstgeschichte des Mittelalterlichen Ordensbaukunst in Deutschland* (Stuttgart: Theiss, 2001).

Blanke 2019: Louise Blanke, *An Archaeology of Egyptian Monasticism, Settlement, Economy and Daily Life at the White Monastery Federation*. Yale Egyptology Publications, 2 (New Haven: Yale Egyptology, 2019).

Bolman 2016: Elizabeth S. Bolman, ed., *The Red Monastery Church, Beauty and Asceticism in Upper Egypt* (New Haven and London: American Research Center in Egypt, Inc. and Yale University Press, 2016).

Bonde and Maines 1988: Sheila Bonde and Clark Maines, "The Archaeology of Monasticism: Recent Work in France, 1970–87," *Speculum*, 63 (1988): 794–825.

Bonde and Maines 2004: Sheila Bonde and Clark Maines, "The Archaeology of Monasticism in France: The State of the Question," in *Bilan et perspectives des études médiévales (1993–1999), Actes du IIe Congrés européen d'Études Médiévales, Barcelona, 8–12 juin 1999*, ed. J. Hamesse. Textes et Études du Moyen Âge, 22 (Turnhout: Brepols, 2004), 171–193 and 715–718.

Bonde and Maines 2020: Sheila Bonde and Clark Maines, "Architecture of Monasteries," in *Oxford Bibliographies in Architecture, Planning, and Preservation*, ed. Kevin Murphy (New York: Oxford University Press, 2020; available at http://www.oxfordbibliographies.com).

Bonde and Maines 2021 (in press): Sheila Bonde and Clark Maines, with John Sheffer, "Tiron on the Edge: Cultural Geography, Regionalism and Liminality," in *The Regional and Transregional in Romanesque Art and Architecture*, ed. Richard Plant and John McNeil (British Association for Archaeology, 2021 [in press]).

Bonis, Dechavanne, and Wabont 2008: Armelle Bonis, Sylvie Dechavanne, and Monique Wabont, *La France cistercienne* (Paris: Éditions Salvator, 2008).

Braunfels 1972: Wolfgang Braunfels, *Monasteries of Western Europe: The Architecture of the Orders* (Princeton: Princeton University Press, 1972).

Bresson (2000) 2013: Gilles Bresson, *Monastères de Grandmont, Guide d'histoire et de visite* (Saint-Sébastien-sur-Loire: Orbestier, [2000] 2013).

Brooke 1974: Christopher Brooke, *Monasteries of the World: The Rise and Development of the Monastic Tradition* (London: Paul Elek, 1974).

Brookfield 1914: Paul Brookfield, "Celestine Order," in *The Catholic Encyclopedia* (New York: The Encyclopedia Press, 1914) [retrieved May 22, 2021, from New Advent: https://www.newadvent.org/cathen/16019a.htm].

Bruzelius 2012: Caroline Bruzelius, "The Architecture of the Mendicant Orders in the Middle Ages: An Overview of Recent Literature," *Perspective, actualité en histoire de l'art*, 2 (2012): 365–386 [https://journals.openedition.org/perspective/195?lang=en].

Bruzelius 2014: Caroline Bruzelius, *Preaching, Building and Burying: Friars and the Medieval City* (New Haven: Yale University Press, 2014).

Carver McCurrach 2011: Catherine Carver McCurrach, "'Renovatio' Reconsidered: Richard Krautheimer and the Iconography of Architecture," *Gesta*, 50 (2011): 41–69.

Clarke and Crossley 2000: Georgia Clarke and Paul Crossley, eds., *Architecture and Language: Constructing Identity in European Architecture, c. 1000–c. 1650* (Cambridge: Cambridge University Press, 2000).

Constable 2010: Giles Constable, *The Abbey of Cluny, a Collection of Essays to Mark the Eleven-Hundredth Anniversary of its Foundation*. Vita Regularis: Ordnungen und Deutungen religiosen Lebens im Mittelalter, 43 (Berlin: Verlag Dr. W. Hopf, 2010).

Constable 2018: Giles Constable, "The Fourth Lateran Council's Constitutions on Monasticism," in *The Fourth Lateran Council and the Development of Canon Law and the ius commune*, ed. Atria A. Larson and Andrea Massironi. Ecclesia Militans: Histoire des hommes et des institutions de l'église au moyen âge, 7 (Turnhout: Brepols, 2018), 145–157.

Crossley 1988: Paul Crossley, "Medieval Architecture and Meaning: The Limits of Iconography," *Burlington Magazine* (Special Issue on Gothic Art), 130 (1988): 116–121.

Dalarun 2004: Jacques Dalarun, ed., *Robert d'Arbrissel et la vie religieuse dans l'ouest de la France*, Actes du colloque de Fontevraud, 13–16 décembre 2001. Disciplina Monastica I (Turnhout: Brepols, 2004).

Dor et al. 1999: Juliette Dor, Lesley Johnson, and Jocelyn Wogan-Browne, eds., *New Trends in Feminine Spirituality: The Holy Women of Liège and their Impact* (Turnhout: Brepols, 1999).

Durand and Nougaret 1992: Geneviève Durand and Jean Nougaret, eds., *L'Ordre de Grandmont, art et histoire*, Actes des journées d'études de Montpellier, 7–8 octobre 1989 (Gap: Louis-Jean, 1992).

Eschapasse 1963: Maurice Eschapasse, *L'architecture bénédictine en Europe* (Paris: Éditions des Deux Mondes, 1963).

Eydoux 1952: Henri-Paul Eydoux, *L'architecture des églises cisterciennes d'Allemagne*. Travaux et Mémoires des Instituts français en Allemagne, I (Paris: Presses universitaires, 1952).

Faravel 1996: Sylvie Faravel, "Un prieuré de la Sauve Majeure en Entre-deux-Mers bazadais: Saint-Pey-de-Castets, de sa fondation à 1525," in *L'Entre-deux-Mers et son identité. L'abbaye de la Sauve Majeure*, Actes du cinquième Colloque tenu à La Sauve Majeure, 9–17 septembre 1996, 2 vols. (Camiac-et-Saint-Denis: Comité de Liaison des associations historiques et archéologiques de l'Entre-deux-Mers [CLEM], 1996), I:139–166.

Fergusson 1984: Peter Fergusson, *Architecture of Solitude: Cistercian Abbeys in Twelfth-Century England* (Princeton: Princeton University Press, 1984).

Fergusson and Harrison 1999: Peter Fergusson and Stuart Harrison, with contributions from Glyn Coppack, *Rievaulx Abbey* (New Haven and London: Yale University Press, 1999).

France romane 2005: *La France romane au temps des premiers Capétiens (987–1152)*, Catalogue d'exposition 6 mars-6 juin 2005 (Paris: Éditions Musée du Louvre and Éditions Hazan, 2005).

Freeman 2018: Elizabeth Freeman, "The Fourth Lateran Council of 1215, the Prohibition against New Religious Orders, and Religious Women," *Journal of Medieval Religious Cultures*, 4 (2018): 1–23.

Gilchrist 1989: Roberta Gilchrist, "The Archaeology of medieval English Nunneries: a research design," in *The Archaeology of Rural Monasteries*, ed. Roberta Gilchrist and Harold Mytum. BAR British Series, 203 (Oxford: British Archaeological Reports, 1989), 251–260.

Gilchrist 1995: Roberta Gilchrist, *Contemplation and Action: The Other Monasticism* (London and New York: Leicester University Press, 1995).

Greene 1992: Patrick Greene, *Medieval Monasteries* (London and New York: Leicester University Press, 1992).

Grundmann (1935) 1995: Herbert Grundmann, *Religious Movements in the Middle Ages*, trans. Steven Rowan (Notre Dame: Notre Dame University Press, 1995) [first published as *Religiöse Bewegungen im Mittelalter*. Historische Studien, 267 (Berlin: E. Ebering, 1935)].

Guyon 1998: Catherine Guyon, *Les Écôliers du Christ: l'ordre canonial du Val des Écôliers, 1201–1539*. CERCOR, Travaux et Recherches (Saint-Étienne: Université de Saint-Étienne, 1998).

Hahn 1957: Hanno Hahn, *Die Frühe Kirchenbaukunst der Zisterzienser: Untersuchungen zur Baugeschichte von Kloster Eberbach im Rheingau und ihren europäischen Analogien im 12. Jahrhundert* (Berlin: Verlag Gebr. Mann, 1957).

Hutchinson 1989: Carole A. Hutchinson, *The Hermit Monks of Grandmont*. Cistercian Studies Series, 118 (Kalamazoo, MI: Cistercian Publications, 1989).

Iogna-Prat 2011: Dominique Iogna-Prat, "Cluny, le monachisme et la société au premier âge féodal (880–1050)," *Bulletin du centre d'études médiévales d'Auxerre | BUCEMA* [online], 15 (2011) [uploaded 14 December 2011; consulted 25 May 2020: http://journals.openedition.org/cem/11954; DOI: https://doi.org/10.4000/cem.11954].

Iogna-Prat et al. 2013: Dominique Iogna-Prat, Michel Lauwers, Florian Mazel, and Isabelle Rosé, dirs., *Cluny, les moines et la société au premier âge féodal* (Rennes: Presses universitaires de Rennes, 2013).

Jäggi 2006: Carola Jäggi, *Frauenklöster im Spätmittelalter: die Kirchen der Klarissen une Dominikanerinnen im 13. und 14. Jahrhundert*. Studien zur internationalen Architektur- und Kunstgeschichte, 34 (Petersburg: Michael Imhof, 2006).

Jestice 1997: Phyllis G. Jestice, *Wayward Monks and the Religious Revolution of the Eleventh Century* (Leiden: Brill, 1997).

Kinder (1998) 2002: Terryl N. Kinder, *Cistercian Europe: Architecture of Contemplation* (Grand Rapids, MI: W. B. Eerdmans, and Kalamazoo; MI: Cistercian Publications, 2002) [first published as *L'Europe cistercienne* (Saint-Léger-Vauban: Zodiaque, 1998)].

King 1999: Peter King, *Western Monasticism: A History of the Monastic Movement in the Latin Church* (Kalamazoo, MI: Cistercian Publications, 1999).

Krautheimer (1925) 2000: Richard Krautheimer, *Die Kirchen der Bettelorden in Deutschland* (Berlin: Gebr. Mann, [1925] 2000).

Krautheimer (1942) 1969: Richard Krautheimer, "Introduction to an 'Iconography of Medieval Architecture,'" *Journal of the Warburg and Courtauld Institutes*, 5 (1942): 1–33 [reprinted in *Studies in Early Christian, Medieval and Renaissance Art* (London and New York: New York University Press, 1969), 115–150; NB: citations are to the 1969 edition].

Krüger 2008: Kristina Krüger, *Monasteries and Monastic Orders: 2000 Years of Christian Art and Culture*, trans. Katherine Taylor (n.p.: H. F. Ullman, 2008).

Larson and Massironi 2018: Atria A. Larson and Andrea Massironi, eds., *The Fourth Lateran Council and*

the Development of Canon Law and the ius communue. Ecclesia Militans: Histoire des hommes et des institutions de l'église au moyen âge, 7 (Turnhout: Brepols, 2018).

Lawrence 1994: C. H. Lawrence, *The Friars: The Impact of the Early Mendicant Movement on Western Society*. The Medieval World (London and New York: Longman, 1994).

Lawrence (2001) 2015: C. H. Lawrence, *Medieval Monasticism*, 4th ed. (London and New York: Routledge, [2001] 2015).

Le Bras 1979–1980: Gabriel Le Bras, *Les Ordres religieux: la vie et l'art*, 2 vols. (Paris: Flammarion, 1979–1980).

Little 2004: Lester Little, "Cypress Beams, Kufic Script, and Cut Stone: Rebuilding the Master Narrative of European History," *Speculum*, 79 (2004): 909–928.

Mandonnet (1938) 1948: Pierre-Félix Mandonnet, O. P., *Saint Dominic and his Work*, trans. Sister Mary Benedicta Larkin, O. P. (London and Saint Louis: B. Herder, 1948) [first published as *Saint Dominique, l'idée, l'homme et l'œuvre* (Paris: Desclée de Brouwer, 1938)].

McDonnell 1955: Ernest W. McDonnell, "The 'Vita Apostolica': Diversity or Dissent," *Church History*, 24.1 (1955): 15–31.

McGuire 2013: Brian Patrick McGuire, "Constitutions and the General Chapter," in *The Cambridge Companion to the Cistercian Order*, ed. Mette Birkedal Bruun (Cambridge: Cambridge University Press, 2013), 87–99.

Méhu 2013: Didier Méhu, dir., *Cluny après Cluny* (Rennes: Presses Universitaires de Rennes, 2013).

Melville 2016: Gert Melville, *The World of Medieval Monasticism: Its History and Forms of Life*, trans. from the German by James D. Mixon (Collegeville: Liturgical Press, 2016).

Milis 1992: Ludo J. R. Milis, *Angelic Monks and Earthly Men: Monasticism and its Meaning to Medieval Society* (Woodbridge: Boydell Press, 1992).

Mohn 2006: Claudia Mohn, *Mittelalterliche Klösteranlagen der Zisterzienserinnen, Architektur der Frauenklöster im Mitteldeutschen Raum*. Berliner Beiträge sir Bauforschung und Denkmalpflege, 4 (Petersberg: Michael Imhof Verlag, 2006).

Moretti 2003. Italo Moretti, "Architectura degli insediamenti eremitici in Toscana," in Vauchez 2003, 277–298.

Negri 1981: Daniele Negri, *Abbazie Cistercensi in Italia* (Pistoia: Tellini, 1981).

Niermeyer 1984: J. F. Niermeyer, *Mediae Latinitatis Lexicon Minus* (Leiden: Brill, 1984).

Pacaut 1993: Marcel Pacaut, *Les ordres monastiques et religieux au moyen âge*, new aug. ed., (Paris: Nathan, 1993).

Panier 2019: Arthur Panier, "L'individu et la communauté: la réforme chez les Célestins," *Bulletin de la Société historique de Compiègne*, 42 (2019): 157–171.

Panier 2021: Arthur Panier, "Approche archéologique et architecturale des monastères de l'ordre des Célestins, L'exemple de Sainte-Croix-sous-Offémont (Oise, France)," unpublished PhD dissertation, Université Libre de Bruxelles et Université de Paris I Panthéon-Sorbonne, 2021.

Plouvier and Saint-Denis 1998: Martine Plouvier and Alain Saint-Denis, eds., *Pour une histoire monumentale de l'abbaye de Cîteaux, 1098–1998*. Studia et Documenta de la Revue Cîteaux commentarii cistercienses, 8 (Viteux and Dijon: Revue Cîteaux commentarii cistercienses, 1998).

Poirel 2010: Dominique Poirel, ed., *L'école de Saint-Victor de Paris. Influence et rayonnement du moyen âge à l'époque moderne*. Bibliotheca Victorina, 22 (Turnhout: Brepols, 2010).

Robinson 1998: David Robinson, ed., *The Cistercian Abbeys of Britain: Far from the Concourse of Men* (London: Batsford, 1998).

Robson 2006: Michael Robson, *The Franciscans in the Middle Ages*. Monastic Orders, 1 (Woodbridge: Boydell Press, 2006).

Rouquette n.d. (2015?): Jean-Maurice Rouquette, *L'abbaye de Montmajour*. Itinéraires (Paris: Éditions du Patrimoine, n.d. [2015?]).

Rouzeau 2019: Benoît Rouzeau, dir., *Morimond, archéologie d'une abbaye cistercienne XIIe-XVIIIe siècles* (Nancy: Éditions Universitaires de Lorraine, 2019).

Rudolph 2019: Conrad Rudolph, "Medieval Architectural Theory, the Sacred Economy, and the Public Presentation of Monastic Architecture: The Classic Cistercian Plan," Journal of the Society of Architectural Historians, 78.3 (2019): 259–275.

Schroeder 1937: H. J. Schroeder, O. P., *Disciplinary Decrees of the General Councils: Text, Translation and Commentary* (London and Saint Louis: B. Herder, 1937).

Shaw 2018: Robert L. J. Shaw, *The Celestine Monks of France, c. 1350–1450: Observant Reform in an Age of Schism, Council and War* (Amsterdam: Amsterdam University Press, 2018).

Stalley 1987: Roger Stalley, *The Cistercian Monasteries of Ireland* (London and New Haven: Yale University Press, 1987).

Stratford 2010: Neil Stratford, dir., *Cluny. Onze siècles de rayonnement* (Paris: Éditions du Patrimoine, 2010).

Thompson A. 2011: Augustine Thompson, "The Origins of Religious Mendicancy," in Donald Prudlo, ed., *The Origin, Development and Refinement of Medieval Religious Mendicancies* (Leiden: Brill, 2011), 3–30.

Thompson K. 2009: Kathleen Thompson, "The First Hundred Years of the Abbey of Tiron: Institutionalising the Reform of the Forest Hermits," *Anglo-Norman Studies*, 31 (2009): 104–117.

Thompson K. 2014: Kathleen Thompson, *The Monks of Tiron: A Monastic Community and Religious Reform in the Twelfth Century* (Cambridge: Cambridge University Press, 2014).

Todenhöfer 2010: Achim Todenhöfer, *Kirchen der Bettelorden: Die Baukunst der Dominikaner und Franziskaner in Sachsen-Anhalt* (Berlin: Dietrich Reimer, 2010).

Trébaol 2017a: Céline Trébaol, "L'abbaye de Saint-Sulpice et ses dépendences: l'expérience monastique au féminin dans le diocèse de Rennes, XIIe-XVIIIe siècles," unpublished PhD dissertation, Université de Rennes, 2017.

Trébaol 2017b: Céline Trébaol, "L'abbaye de Saint-Sulpice-la-Forêt et ses dépendances à l'époque moderne: la 'mère' et ses 'filles'," *Chrétiens et sociétés, XVIe-XXIe siècles*, 24 (2017): 73–96.

Trébaol 2018: Céline Trébaol, "L'abbaye de Saint-Sulpice-la-Forêt, architecture et décor (XIIe-XVIIIe siècles)," *Bulletin et Mémoires de la Société archéologique et historique d'Ille-et-Vilaine*, CXXII (2018): 51–82.

Untermann 2001: Matthias Untermann, *Forma Ordinis. Die mittelalterliche Baukunst der Zisterzienser* (Berlin: Deutscher Kunstverlag, 2001).

Valdez del Álamo 2016: Elizabeth Valdez del Álamo, "The Iconography of Architecture," in *The Routledge Companion to Medieval Iconography*, ed. Colum Hourihane (Oxford and New York: Routledge), 377–389.

Vauchez 2003: André Vauchez, dir., *Ermites de France et d'Italie (XIe-XVe siècle), Actes du colloque organisé par l'École française de Rome à la Certosa di Pontignano (5–7 mai 2000) avec le patronage de l'Université de Sienne* (Rome: École française de Rome, 2003).

Veyrenche 2018: Yannick Veyrenche, *Chanoines réguliers et sociétés méridionales. L'abbaye de Saint-Ruf et ses prieurés dans le Sud-Est de la France (XIe-XIVe siècle)*. Bibliotheca Victorina, XXV (Turnhout: Brépols, 2018).

Vicaire (1957) 1964: Marie-Humbert Vicaire, *Saint Dominic and his Times*, trans. Kathleen Pond (New York, Toronto, and London: McGraw-Hill, 1964) [first published as *Histoire de Saint Dominique* (Paris: Éditions du Cerf, 1957)].

NOTES TO THE TEXT

1. On Lateran IV, see esp. Schroeder 1937, 236–296; Baldwin 1970; and Larson and Massironi 2018.

2. This translation of canon 13 is taken from Schroeder 1937, 254–255. The translation continues: ". . ., but whoever should wish to enter an order, let him choose one already approved. Similarly, he who would wish to found a new monastery, must accept a rule already proved. We forbid also anyone to presume to be a monk in different monasteries (that is, belong to different monasteries), or that one abbot presides over several monasteries." (*Ne nimia religionum diversitas gravem in eccelsia Dei confusionem inducat, firmiter prohibemus ne quis de cetero novam religionem inveniat, set quicumque voluerit ad religionem converti, unam de approbatis assumat. Similiter qui voluerit religiosam domum de novo fundare, regulam et institutionem accipiat de religionibus approbatis. Illud etiam prohibemus ne quis in diversis monsteriis locum monachi habere presumat, nec unus abbas pluribus monasteriis presidere.*) Lat. IV c. 13, COGD 2013 II.1, Lat. IV, c. 13, p. 175.

3. On canon 13, see esp. Grundmann (1935) 1995, 60–67; Constable 2018, 149–152; Freeman 2018.

4. Grundmann (1935) 1995, 65; see also Mandonnet (1938) 1948, 33–34, for a similar reading.

5. Constable 2018 and Freeman 2018.

6. On the term *ordo*, see Niermeyer 1984, 745–747; Constable 2018, esp. 149–152; and Freeman 2018, esp. 7–10.

7. On the use of *ordo* to indicate the Cistercian order, see the discussion in Freeman 2018, 8, and n. 35; and McGuire 2013, 7.

8. On the term *religio*, see Biller 1985, esp. 358–359; Niermeyer 1984, 906.

9. Jacques de Vitry 1972 calls the Cistercians both a *religio* (chap. 14: p. 113, lines 8–9) and an *ordo* (chap. 14: p. 114, line 14); the Carthusians a *congregatio* and a *religio* (chap. 18: p. 122, line 3; and chap. 18: p. 123, line 13); the Grandmontains a *religio* and an *ordo* (chap. 19: p. 124, lines 16 and 18); and the Caulites (Valiscaulians) a *religionem cystercienses ordinis* (chap. 17: p. 121, lines 2–3).

10. The use of *ordo* to indicate a religious order, in the sense of a community of religious following a common rule and subject to a single administrative and religious organization, does not become standard until well into the thirteenth century. Some have argued that it is in fact the product of the process of formation of the mendicant orders. See Thompson A. 2011, 20–21.

11. Constable 2018, 149, n. 7.

12. Freeman 2018.

13. On Durandus and Bernard of Prim, see Vicaire (1957) 1964, 187–216; and Grundmann (1935) 1955, 44–55.

14. On the Humiliati, see Andrews 1999. On the Caulites (Valliscaulians), see Freeman 2018, 12; and Adamo 2014.

15. Grundmann (1935) 1995, 66.

16. See, for example, Dor et al. 1999.

17. Becquet 1991.

18. Bonde and Maines 1988, 795–797.

19. Grundmann (1935) 1995, 34–35; McDonnell 1955.

20. Braunfels 1972, 224.

21. Jacques de Vitry 1972; Libellus 2003.

22. Gilchrist 1995. With a similar aim, Andrews 2006 has looked historically and comparatively at the little studied, 'other' friars, the Carmelites and Augustinians, as well as the Friars of the Sack and Pied Friars.

23. Gilchrist 1989 called for an archaeology of women's houses, which she pursued for women's houses in England, Scotland, and Wales in 1994.

24. King 1999; Lawrence (2001) 2015; and Melville 2016. King, who extends his study into the twentieth century, spends the most time on the early phases of monasticism. For a different approach, see Milis 1992 who looks at monasticism as a whole and critiques its importance to medieval society.

25. Melville 2016, 270 on the Caulties (Valliscaulians); 111 and 145 on Bernard of Tiron. Lawrence (2001) 2015, 142, briefly mentions Bernard in conjunction with Vitalis of Savigny.

26. Lawrence 1994. Robson 2006 has written on Franciscan history exclusively.

27. Lawrence (2001) 2015, 199–218.

28. Pacaut 1993.

29. Beach and Cochelin 2020, 5–10.

30. For bibliography on monastic architecture, see Bonde and Maines 2020.

31. Braunfels 1972.

32. The merits of the volume notwithstanding, no coverage is given to monastic architecture of the Ottonian or Anglo-Saxon periods. Fontevraud exists only to illustrate its monastic kitchen. Of the twelfth-century orders, the Cistercians and Carthusians are covered, but not the Praemonstratensians or any of the others. Brooke 1974 provides coverage of regular canons and nuns as well as the eremitic movements of the eleventh century, though the longest discussion is still reserved for the Cistercians.

33. Badstübner 1980.

34. Krüger 2008.

35. The Cistercians receive the most extensive treatment, 65 pages in all (164–229), compared to Cluny (12 pages), to Canons Regular (3 pages), to Camaldolese, Vallombrosans, and Carthusians together (14 pages). Forty-three pages are given to the various mendicant orders and twenty-five pages are

36 given to nuns. The great advantage of Krüger's volume is the emphasis given to houses in eastern Europe.

36 Le Bras 1979–1980.

37 Binding and Untermann 2001; Greene 1992.

38 Bonde and Maines 2004, 716, fig. 4, showed Cluniac houses as the subject of 27 studies, the third highest total after Cistercians (86) and the much more numerous independent Benedictines (64).

39 See Baud 2003; Baud and Sapin 2019.

40 Iogna-Prat 2011; Iogna-Prat et al. 2013.

41 Constable 2010; Méhu 2013.

42 Stratford 2010.

43 Bonde and Maines 2004, 716, fig. 4. The bar graph shows 86 journal articles on Cistercian sites, compared to 64 on independent Benedictine houses. Of the fifteen orders shown on the graph, ten were represented by 5 or fewer articles.

44 Journals and series published by the Cistercian order include *Cîteaux:commentarii cistercienses, Cistercian Studies Quarterly, Analecta cisterciana*, and *Cistercian Publication Series*.

45 Hahn 1957; Kinder (1998) 2002; Untermann 2001.

46 See, for France, Aubert 1947; for England, Robinson 1998 and Fergusson 1984; for Ireland, Stalley 1987; for Germany, Eydoux 1952; and for Italy, Negri 1981.

47 On Cîteaux, see Plouvier and Saint-Denis 1998; on Rievaulx, see Fergusson and Harrison 1999; for Morimond, see Rouzeau 2019.

48 Mohn 2006. Considerable information on Cistercian nuns in France can be found in Bonis, Dechavanne, and Wabont 2008.

49 For a review of recent scholarship on the architecture of the mendicant order, see Bruzelius 2012.

50 Schenkluhn 2000; Bruzelius 2014. Beginning at least with Krautheimer (1925) 2000 and continuing with, e.g., Todenhöfer 2010, surveys consistently group Franciscans and Dominicans together.

51 Jäggi 2006.

52 Faravel 1996; Rouquette n.d. (2015?), 7–11.

53 Eschapasse 1963.

54 Eschapasse includes Cluny within the Benedictine tradition, but not the Cistercians.

55 The journal is *Fontevraud Histoire-Archéologie*, published by the Comité d'Histoire Fontevriste. Five volumes have appeared to date in c. 1994, 1995–1996, and 1997–1998, respectively. The monographs are Dalarun 2004 and Anon. 2000, which is the entire volume of *La revue des Pays de la Loire*, 67.

56 Hutchison 1989.

57 Durand and Nougaret 1992; Bresson (2000) 2013.

58 Brooke 1974, 75–78; Krüger 2008, 144–147.

59 Bonde and Maines 1988.

60 Bonde and Maines 2004.

61 Several articles treat more than one monastic order. In these cases, both orders are counted.

62 A subsection of the *chronique* is titled *Constructions et habitats ecclésiastiques*, which always contains at least some entries on monastic sites.

63 Salvage archaeology, or *archéologie préventive* in its French form, refers to excavation carried out in advance of the destruction of archaeological sites to allow for new construction, businesses, autoroutes, trainlines, etc. It is often carried out over limited time periods and sometimes under difficult climatic conditions.

64 https://fr.wikipedia.org/wiki/Institut_national_de_recherches_arch%C3%A9ologiques_pr%C3%A9ventives, for an overview of the history of both AFAN and INRAP. Part of the impulse to create INRAP was the *Convention européenne pour la protection du patrimoine archéologique*, passed by the European Union, 7 January 2001.

65 INRAP regularly holds conferences, colloquia, and seminars. It also has a significant internet presence.

66 First of all, nearly 85% of the funds designated for archaeological research and given to regional archaeological services to assign, were redirected to salvage archaeology projects, leaving far less support available for long-term research projects, such as monastic ones. Second, while in certain cases INRAP has the authority to delay site destruction/new construction, there are always temporal limits and often spatial ones as well.

67 2 articles focused on three different congregations. All 6 were counted. 2 other articles focused on monastic issues in a general fashion, making any association with one or more orders irrelevant to our purpose here.

68 Guyon 1998; Arnoux 2000; Poirel 2010; Veyrenche 2018.

69 Brookfield 1914.

70 Shaw 2018.

71 Panier 2019 and 2021.

72 On Notre-Dame du Nid-au-Merle in Saint-Sulpice-la-Forêt, see now Trébaol 2017a, 2017b, and 2018.

73 See also Bonde and Maines 2021 (in press) for a second study on the church of Tiron, considered through the lens of "regionalism" in Romanesque architecture.

74 Thompson K. 2014; and her earlier study of 2009.

75 On monasticism in Egypt, see recently Bolman 2016 and Blanke 2019.

76 Vauchez 2003; Jestice 1997.

77 Gilchrist 1995, 157–208, which also includes anchorite

sites as well as discussion of monasteries of eremitic origin, notably Grandmontain and Carthusian houses.

78 Vauchez 2003.

79 Moretti 2003.

80 Bertocci and Parinello, eds. 2010, 2011, 2012, 2013 and 2021. Our thanks to Erik Gustafson for calling our attention to this series.

81 Bonde and Maines 2004, 187.

82 Braunfels 1972, 224.

83 One might suggest that 13 male religious to 2 female religious from *Archéologie Médiévale* skews the total in favor of males. In fact, the numbers from *AM* are so small that the difference is less than one percent.

84 On monastic identity, see Clarke and Crossley 2000.

85 Jacques de Vitry 1972.

86 On architectural iconography, see especially Krautheimer (1942) 1969; Bandmann (1951) 2005; Crossley 1988; Valdez del Álamo 2016.

87 Krautheimer 1942 (1969), 120. See also Carver McCurrach 2011.

88 Krautheimer 1942 (1969), 149 (in the postscript); cited in Crossley 1988, 121, n. 75.

89 Bandmann (1951) 2005, 177–184.

90 This idea of the "Bernardine plan" is owed to Aubert 1947, 1:122–124, 157, and 182–183. For a critique of the "Bernardine plan," see Rudolph 2019.

ROBERT L. J. SHAW

The French Celestine "Network" (c. 1350–1450): Cross-Order and Lay Collaboration in Late Medieval Monastic Reform

To today's reader, the late medieval French Celestines are certainly an "other monasticism." There are few modern studies of the Celestines, let alone the French Celestines specifically, a relatively small, self-governing (from 1380) offshoot of this Italian Benedictine reform. With neither any longer in existence, the Celestines remain obscure even to monastic specialists.[1] Like their mother congregation, moreover, they were a later medieval creation. By this period, we are (or at least were) so often told, the high-tide of monasticism—and especially its Benedictine forms—had passed:[2] given this context, it is not surprising that few have investigated the impact of this modestly-sized, separatist congregation. And yet, the French Celestines also force us to recalibrate our notions of monastic "success," "failure," and indeed "otherness," by virtue of the range and depth of their social connections in the Late Middle Ages.[3] Focusing on the mid-fourteenth to mid-fifteenth centuries, this article will show how, when seen both as part of a nexus of other congregations with similar reformist outlooks and from the perspective of the overlapping support networks that these possessed, their importance to religious society was greater than the sum of their institutional parts.

The "other" Celestines

The historiographical obscurity of the French Celestines, and the mother Italian congregation from which they sprang, means that they require a brief introduction. The name of the congregation—by which they first came to be known in the early fourteenth century[4]—derived from their illustrious founder, the celebrated Abruzzo hermit Saint Peter Celestine (Pietro da Morrone, d. 1297) who reluctantly became pope as Celestine V (consecrated 29 August 1294)

House	Founder	Year
Paris	Garnier Marcel and the confraternity of royal notaries and secretaries	1352
Gentilly (near Sorgues)	Cardinal Annibaldo Ceccano and Cardinal Francesco degli Atti	1356
Colombier-le-Cardinal	Cardinal Pierre Bertrand	1361
Sens	Isabelle Bilouard, widow of Jean de Mézières, *maître des comptes*	1366
Metz	Bertrand Le Hongre, a notable citizen of Metz	1371
Limay-lès-Mantes	Charles V, king of France	1377
Villeneuve-lès-Soissons	Enguerrand de Coucy, marshal of France	1390
Amiens	Charles VI, king of France	1392
Avignon	"Clement VII", pope of the Avignonese line	1393
Marcoussis	Jean de Montaigu, *grand maître de France*	1404–8
Vichy	Louis II, duke of Bourbon	1403–10
Lyon	Amadeus VIII, duke of Savoy	1421
Rouen	John, duke of Bedford, completed by Charles VII, King of France	1430/1449

Based on Shaw 2018, 270.

Table 1
French Celestine expansion, 1350–1450

and resigned the office less than six months later (13 December 1294).[5] His humility contrasted with his successor Boniface VIII's claims of plenitude of power in temporal as well as spiritual affairs. Celestine's humility and his death in captivity made his memory a rallying point for the enemies of his controversial replacement. Philip IV of France ("the Fair") and the Colonna family were the architects of his canonization.[6] Before this, however, he had consolidated a monastic congregation around him, which grew from the followers he attracted at his hermitages in the mountains above Sulmona. While the desire to seek solitude stayed with him throughout his life, he proved a capable monastic reformer. Having previously been a Benedictine monk, when the time came to seek papal approbation for his band of followers (in 1263, formally implemented in 1264, reconfirmed in 1275), he requested that they be placed under the Rule of Saint Benedict.[7] The distinctiveness of Peter's religion was not lost, however, and the congregation became a Benedictine reform framed by a set of quite distinctive constitutions with a marked ascetic and penitential dimension: a strict ban on meat, expanded fasts, and a rigorous interpretation of Benedictine poverty were hallmarks, while penances (including scourging) were multiplied and the daily office expanded.[8] It spread across much of Italy, encompassing c. 100 houses by 1400, both through new foundations and the reform of existing Benedictine houses.[9]

The French province, the focal point of this article, was planted in the region in 1300 by Philip IV at the height of his conflict with Boniface VIII.[10] Its expansion took a different path to that of the Italian Celestines: the French Celestines spread solely through new foundations and were a very much smaller congregation (see Table 1). Between their arrival in France in 1300 and dissolution, which began just prior to the French Revolution, they founded twenty-two lasting monasteries, thirteen of them erected between 1350 and 1450.[11] They gained self-government in 1380, following the advent of the Great Western Schism (1378–1417), a status they managed to maintain permanently. At around the same time, they made *observantia regularis* ("regular observance") their maxim, thus aligning themselves with the rigorist "Observant" reform trend that was just beginning to make an impact across both coenobitic and mendicant orders at the time.[12] In practice, they re-affirmed and sharpened their attention to ascetic detail and monastic legislation, in their case the Rule of Saint Benedict, but above all their own voluminous constitutions. Theirs was a daunting regime that demanded accuracy in every matter: sin, and indeed often mortal sin (through breach of vow and monastic proposition), could seem to lurk behind minor slips in practice.[13] If the Italian Celestines had already laid much of the groundwork for this culture,[14] a tight-knit French Celestine province boldly attempted to reform their brothers over the Alps according to their own interpretation of "regular observance." It was for this purpose that Eugenius IV granted them control of the houses of Collemaggio in Aquila—where Saint Peter Celestine was buried—and Sant'Eusebio in Rome in 1444, and that in 1453 the former prior of Limay-lès-Mantes, Jean Bertauld (1413–1473), was elected abbot-general of the entire congregation with the backing of Nicolas V.[15]

If the Italian Celestines appear "other" in the sense that few remember them today, the French Celestines thus seem "other" in two more senses, fitting with common characterizations of late medieval monastic reform. Firstly, they were clearly not large: one cannot even begin to compare their spread in the region with the Cistercians in the High Middle Ages. Their scale might even draw the eye back to the now well-worn image of pre-Reformation monasticism as lacking the vitality and inventiveness to adapt in a changing culture, where lay religious

House	Founder	Year
Besançon	Reformed by Saint Colette, with the backing of "Benedict XIII", Blanche of Geneva, Margaret of Bavaria, duchess of Burgundy, and John the Fearless, duke of Burgundy	1410
Auxonne	John the Fearless, duke of Burgundy and Margaret of Bavaria, duchess of Burgundy	1412
Poligny	John the Fearless, duke of Burgundy and Margaret of Bavaria, duchess of Burgundy	1415
Decize	Bonne of Artois, countess of Nevers	1419–24
Seurre	Margaret of Bavaria, duchess of Burgundy, with the assistance of Guillaume de Vienne, governor of Franche-Comté	1421–3
Moulins	Marie of Berry, duchess of Bourbon and Auvergne	1421–3
Aigueperse	Marie of Berry, duchess of Bourbon and Auvergne	1423–5
Vevey	Amadeus VIII, count of Savoy	1424–5
Le Puy-en-Velay	Claudine of Roussillon, vicountess of Polignac	1425–32
Orbe	Jeanne de Montfaucon-Montbéliard, wife of Louis II of Chalon-Arley, prince of Orange	1426–8
Castres	James II, count of La Marche	1426–33
Lézignan	James II, count of La Marche, with his son-in-law Bernard, count of Armagnac	1430–6
Béziers	Reformed with the support of James II, count of La Marche	1434
Heidelberg	Louis III, count Palatine of the Rhine, with his wife, Matilda of Savoy	1437–43
Hesdin	Philip the Good, duke of Burgundy	1437–41
Ghent	The civic authorities and citizens of Ghent, with Philip the Good, duke of Burgundy	1440–2
Amiens	Philippe de Saveuse, governor of Amiens, with the assistance of Philip the Good, duke of Burgundy, and Charles VII, king of France	1442–5
Pont-à-Mousson	René of Anjou, duke of Lorraine, building on the bequest of Margaret, duchess of Lorraine (d. 1434)	1444–7

Based on Lopez 2011, 554–60, with additional information and clarifications from Warren 2016, 11–22, Sommé 2016, 31–55.

Table 2
Early Colettine houses, 1410–1450

expression became increasingly ambitious. Secondly, they appear to have set themselves apart from others, even their Italian brothers, with particular vigour. This form of "otherness" indeed might often seem to describe late medieval monastic reforms even in the more positive reappraisals that have emerged recently: bitter conflict with the *conventuales*, the unreformed who would not accept Observant rigors, is seen as particularly critical for the experience of such reformers.[16]

Ties between religious

At the same time, however, the French Celestines were seeking friendships, including with other religious. The *vita* of Jean Bassand presents some of the most illuminating examples of this kind.[17] Its subject, Jean Bassand (d. 26 August 1445), was the most important figure in the French Celestine congregation in the first half of the fifteenth century: he was elected provincial prior on five separate occasions, became the architect of their province's reform efforts in Italy, and was promoted as a saint among the French Celestines, albeit that no papal process survives. His *vita* dates from the mid-fifteenth century (the earliest surviving copy was possessed by the Celestines of Avignon and is of this period).[18] While the work is anonymous, the most likely author is the same Jean Bertauld who came to briefly lead the Italian congregation.[19] This attribution tallies with the author's statement that he eventually came to lead reform in Italy after Bassand's death,[20] the similarity of the writing style with Bertauld's surviving letters (especially the frequency of classical citations),[21] and the author's detailed geographical knowledge of northern France (Bertauld was born in Amiens and was prior of Limay-lès-Mantes for nine years).[22]

The work is notable for its extended description of how Bassand triumphed over the Italian Celestine *fratres conventuales* at Aquila, who apparently did everything they could to stymie his efforts to reform them.[23] There are, however, other contemporary reformers whom the author clearly respected. The one to whom the author devoted the most attention was Saint Colette (d. 1447), a Picardian virgin who became an Observant-influenced reformer of the Poor Clares. Born Nicole Boylet to Robert Boylet, a carpenter and servant of the local Benedictine abbey, and his wife in Corbie, Picardy (a small town about ten miles from Amiens), she was orphaned as a teenager. Having been influenced by a local beguine mistress and taken direction as a lay sister at nearby Benedictine convent for a spell, she joined the Franciscan third order and then became a recluse. Finally, she became a rigorous reformer of the Poor Clares, having professed following a meeting with the schism-era Avignonese pope "Benedict XIII" in 1406, sparking a wave of new Poor Clare foundations (see Table 2) supported (from 1427) by four male "Coletan" Franciscan communities in Burgundy that had been reformed for the purpose (Dôle, Chariez, Sellières, and Beuvray).[24] Like the French Celestines, the congregation she forged emphasized a highly detailed asceticism and obedience to extensive supplementary legislation: she added her own long list of constitutions to the Rule of Saint Clare, which she sought to have rigorously enforced.[25]

Colette was doubtless influenced by contemporary monastic reform currents. Henri de Baume, a friar who hailed from Franche-Comté and a former member of the Observant Franciscan community of Mirebeau (the Observant Franciscan movement in France was

still in its infancy at this point, but would gain significant ground from the mid-fifteenth century onward), is seen as decisive in her sudden transformation into a reformer of the Poor Clares.[26] He was perhaps not the only reformer she knew in her youth, however. According to the *vita* of Jean Bassand, Colette met the French Celestine prelate, then prior of the Celestine monks of Amiens, while she was still a member of the laity and preceding her becoming a recluse:

> [There was] a certain most devout religious woman by the name of Colette, of the most outstanding virtue, by whose industry, or rather, by the merits of whose *conversatio*, many monasteries of the Poor Clares—whose habit she had received from the hand of Pope Martin V when she was a young woman—were built. By the authority of the Apostolic See, she also led these [houses] and sustained those living there in continual poverty, in accordance with the regular observance of their legislator, Saint Francis. When she was a young girl and a most pure virgin, she glowed with such a zeal of devotion that all the inhabitants of the city of Amiens stood in awe. This girl frequently visited blessed Jean, then prior of the Celestine monastery of Amiens; gaining healthy counsel from him, she grew daily in the grace of sanctity. And he did not cease from encouraging her to persist in her salutary commitment to virginity, advising her through his words when he could and little books when he could not. This woman reached such a perfection that she entered a *reclusorium* in Corbie, from which she hailed. And finally, having received a revelation from God or from heaven, she went to Rome, explained her revelation to the supreme pontiff, and received the habit of sanctity from him, just as previously described, so that she might show the right form of living and behaving to consecrated virgins across France.[27]

Is this story true? There is at least one inaccuracy. Colette had received the habit during the Great Western Schism (1378–1417) from the Avignonese papal claimant "Benedict XIII" in 1406, not Martin V, whose election at the Council of Constance in 1417 brought the division to a close. Switching Colette's first papal patron to a figure whose claim to the office had never been doubted was surely tempting some forty years after the schism had ended. The presence of this sort of embellishment also raises a concern over the story as a whole: if it was appealing to enhance Colette's reputation through a false association, might the author not have done something similar with Bassand, by way of Colette, at a point when the latter's cult was already flourishing?[28] We must also be wary of tendencies that have been witnessed elsewhere among Observant writers: melding the complex roots of different reform groups in order to aggrandize their work, and reframing the role of female religious initiative within broader reformist narratives.[29]

There is no other contemporary source detailing the interaction of Jean Bassand and Colette of Corbie. The influence of Bassand has often been mentioned in passing but without criticism by recent historians working on Colette, since it appears in a number of the earlier antiquarian works: their meeting has been placed in Colette's time-line around 1400. In both modern and

older works, however, this detail lacks a clear source citation.[30]

The only antiquary to mention any source is also the first biographer of Colette to mention the meeting: Silvère d'Abbeville, a Capuchin who wrote in the first half of the seventeenth century. He states:

> I have discovered through an extract drawn from an old manuscript, sent by the Reverend Celestine Fathers of Paris, that Colette voluntarily visited Jean Bassand, who was the first prior of the Celestine Fathers of Amiens. A figure of saintly reputation, he taught her of the spiritual life and served as her guide and counsellor on matters of conscience.

He goes on to paraphrase the story of Bassand recommending a vow of virginity to Colette.[31] The "old manuscript" thus seems almost certainly to have been a copy of the *vita* of Jean Bassand. Colette's principle *vitae* (those of Pierre de Vaux, written soon after her death, and her follower Sister Perrine, c. 1471), meanwhile, are silent about any interaction with the Celestine prelate.[32]

Nevertheless, such a meeting is certainly not implausible. Colette's hagiographers offer a fairly vague narrative of this early period in her life. Pierre de Vaux, the writer of her first *vita*, was also at pains not to discuss influences of an extra-Franciscan origin.[33] Sister Perrine, a follower of Colette who dictated her recollections of her mentor, offers clues that Colette's path to conversion involved a wider range of influences, including the guidance of the Benedictine abbot of Corbie.[34] Overall, the limited detail offered by both these sources leaves the question very much open. The author of the *vita* of Jean Bassand, moreover, appears to have had a knowledge of Saint Colette that was independent from the only *vita* of Colette that would have been available at the time of writing (c. 1450s), that of Pierre de Vaux. While later historians can track that she was present in the region surrounding Amiens for most of the period of Bassand's priorate (1401–1408)—she left for Nice in 1406—no dates for her movements are given by Pierre de Vaux.[35] The author also somehow had correct knowledge of her location in 1445, the year of Bassand's death. The recounting of his interaction with Colette comes as part of a miracle story in which the latter received a revelation of his death (at the monastery of Collemaggio in Aquila) while living at "her monastery of Amiens": Colette had indeed returned there in the same year to complete a foundation in the city.[36]

However true or embellished the actual story presented in the *vita* of Jean Bassand was, it thus seems clear that there must have been interpersonal connections that allowed its author deeper knowledge of Colette and her life. The *vita* itself suggests that such contacts were ongoing. Bassand's death was apparently confirmed to Colette's sisters at Amiens by Celestine "brothers returning from Aquila, having assisted in his funeral."[37]

Colette was not the only reformer of Franciscan heritage in whom the Celestine author of the *vita* of Jean Bassand was interested. Like Colette herself,[38] the author also knew of Giovanni da Capestrano (d. 1456), the famed Italian Observant Franciscan reformer. The latter is said to have come to respect Bassand for his reform work at Aquila—Giovanni was a native of the region—and visited him on his deathbed:

And that religious father Giovanni da Capestrano, a distinguished preacher, was present. He had seen him [Jean Bassand] before and come to know what sort of man he was. When he had observed the saintly father draw his last breath, he said to him: "Do you recognize me, father"; and he [responded] "May the holy angels of God recognize you."[39]

Later, he is said to have delivered Bassand's funeral oration before a large audience of Aquilans, founded on the words of John 1:6: "There was a man sent from God, whose name was John."[40] As with the *vita*'s discussion of Saint Colette, we cannot verify the exact claims, although Giovanni's attendance at the death and funeral is far from unlikely: he was present in Aquila for a good portion of 1444 and 1445, having arrived for the funeral of his fellow Observant Franciscan Bernardino of Siena (d. 20 May 1444) in the same city.[41] It should also be noted that in 1446, joint festivities were celebrated in the city for the consecutive feast days of Saint Peter Celestine (19 May) and Bernardino of Siena (20 May), perhaps suggesting a growing closeness there between the Observant Franciscans and the newly arrived French Celestine reformers.[42] Whatever the exact connection between Jean Bassand and Giovanni da Capestrano, the author's awareness of this Italian Franciscan reformer thus appears suggestive of the growing range of reformist connections that the French Celestines came to possess: their Italian reform work also brought them into contact with other reformers there, such as Cypriano, an abbot of the Observant Benedictine congregation of Santa Giustina de Padua and a papal chamberlain, who assisted Bassand's efforts at Aquila.[43]

Taken together with the *vita*'s discussion of Colette, the mention of Giovanni da Capestrano also provides perspective on the nature of late medieval reformist solidarities. In Franciscan institutional terms, the Colettines and Observants are in fact considered related but distinct movements, sometimes difficult to distinguish, sometimes sparring for influence. Ultimately the Observants set themselves up outside the government of the minister-general, under their own vicars, while the Colettines recognized the authority of the minister-general, despite having their own structures and norms that separated them from the *conventuales*.[44] The distinction was not without tensions: Giovanni da Capestrano himself met Colette in 1442 in the hope of bringing her movement under greater Observant guidance, albeit that he ultimately reconfirmed Colette's ability to appoint her own visitor friars.[45] The Celestine author's positive appraisal of these key representatives of both groups reminds us that while such reformers could be divisive within their own orders—the same *vita* also treats the Italian Celestines very harshly,[46]—allegiance with the like-minded could be felt beyond such institutional boxes. Despite a diversity of origins, all these groups stressed a rigorous and detailed asceticism supported by an exacting attitude to legislation, both inherited and supplementary. The *vita*'s author was clearly more sensitive to this rigorist mindset than to the complexities of Franciscan politics: as seen above, he respected Colette since she had "led these [houses] and sustained those living there in continual poverty, in accordance with the regular observance of their legislator, Saint Francis."[47]

In the case of the Celestines, it is clear that they had further inter-order ties. The masterwork of Celestine spirituality in this period, the *Orationarium in vita Domini nostri Jesu Christi et de*

suffragiis sanctorum—written in the 1380s by Pierre Pocquet (d. 1408), a four-time provincial prior and Bassand's mentor—was popular among the Celestines,[48] but also found enthusiastic monastic audiences elsewhere. It most likely spread first to monasteries in the vicinity of Paris (where Pocquet was located during the 1380s). It was copied at Saint-Denis in 1391,[49] only shortly after it was written, while Saint-Victor came to possess it by 1444 at the very latest.[50] By the mid-fifteenth century, the *Orationarium* had travelled far. By 1456, it had reached Subiaco, a centre of Italian Observant Benedictine reform, where the fact that it was copied twice suggests that it was popular reading material.[51] Two other Italian houses of Augustinian canons regular—at Brixen and Rome (San Lorenzo fuori le Mura)—also came to possess the work in the late fifteenth century.[52] It also spread to Bohemia, Saxony, and Poland, likely by the vector of the Celestine monastery of Oybin, which abortively joined the jurisdiction of the French province in 1426.[53] Between its spread in the Île-de-France and the rest of Europe, however, it appears to have been disseminated to the north (the Benedictine abbey of Saint-Sépulcre in Cambrai) and east (to the Charterhouse of Rettel in Lorraine to the northeast, and another copy of unknown provenance now at Le Puy-en-Velay to the southeast).[54]

The presence of a copy of the *Orationarium* among the Carthusians is unsurprising given what is known of connections between the two congregations in France. There are signs of mutual respect: if the Carthusians had no formal "Observant" movement, the quality and precision of their discipline and asceticism meant that they were natural bedfellows for the French Celestines. For the aforementioned Jean Bertauld, a vociferous promotor of "regular observance" in his letters, the Carthusians sat at the cutting edge of monastic purity. Writing to a Benedictine abbot who sought to prevent one of his monks joining the Celestines, he reminded his correspondent of how the practice of monks moving to stricter orders was an integral part of monastic reform and careers: the first monks of Cîteaux had left Molesme, and it was no different in their own day that "again and again the more fervent monks likewise demand the stricter orders of the Celestines and Carthusians."[55] Meanwhile it is recorded in the mid- to-late fifteenth-century chronicle of the Metz Celestines that, in 1423, the Celestine prelate Simon Bonhomme and his companions were captured by armed men at Chémery-sur-Bar, near the charterhouse of Mont-Dieu, while on the way to the Celestine provincial chapter in Paris. Despite the regional chaos engendered by this phase of the Hundred Years' War and the resultant risks, the Carthusian prior of Mont-Dieu took the place of the imprisoned Celestines to secure their release and helped them settle with their captors at little cost.[56]

The Carthusians and the French Celestines were also drawn together by their involvement with Jean Gerson, chancellor of the University of Paris between 1395 and his death in 1429. Gerson, one of late medieval Europe's most popular authors, had forged very close ties with both congregations, corresponding with their monks (including Bassand and his mentor Pierre Pocquet),[57] and dedicating works to both (e.g., *De sollicitudine ecclesiasticorum* to the Celestines, and *De non esu carnium apud Carthusienses* and *De laude scriptorum* to the Carthusians).[58] His two youngest brothers even joined the Celestines: Nicolas and Jean the Celestine.[59] In return, the two congregations became both receptive audiences for and "publishers" of Gerson's works. Daniel Hobbins has shown the extent of their work in this regard, and it is worth noting that it was not simply simultaneous, but to some extent co-operative.[60] Gerson's youngest brother, Jean the Celestine, who was prior of the Celestine house of Lyon from 1423, was in communication

House	Founder	Year
Villeneuve-lès-Avignon	Innocent VI	1356
Liège	Prince Engelbert III of the Mark and the citizens of Liège	1357
Saix (near Castres)	Raymond Saissac, merchant of Castres and his wife, Centulia de Bretis	1359–61
Chercq-lez-Tournai	Jean de Werchin, knight errant	1375
Roermond	Werner van Swalmen, his wife, and brother Robin, canon of Maastrict	1376
Dijon (Champmol)	Philip the Bold, duke of Burgundy	1383
Rouen	Guillaume de Lestrange, archbishop of Rouen	1384
Pierre-Châtel (near Virignin)	Amadeus VI, duke of Savoy	1384
Nieuwlicht (Utrecht)	Zweder van Gaasbeek, lord of Putten and Strijen (knight in service of counts of Holland, Brabant, and prince-bishop of Utrecht)	1391
Amsterdam	Citizens of Amsterdam with co-operation of Albert I, duke of Bavaria	1392–3
Oyron (Deux-Sèvres)	Péronnelle, viscountess of Thouars	1393 (collapses due to insufficient funds in 1446)
Rettel, transferred from Marienfloss (both near Sierck, on the Moselle)	Charles II, duke of Lorraine, and Margaret, duchess of Lorraine	1415 (transferred in 1431)
Noordgouwe (rural house in Schouwen-Duiveland)	Jan Lievensz van Zierikzee	1433–4
Nantes	Francis I, duke of Brittany, and Arthur de Richemont	1445
Villefranche-de-Rouergue	Vézian (or Vésian) Valette, merchant of the town	1450
Scheut (outside the walls of Brussels)	Citizens of Brussels, with the backing of Philip the Good, duke of Burgundy	1454

Table 3
Carthusian expansion in the Francophone West and Low Countries, 1350–1454

with Anselm, a monk of La Grande Chartreuse, regarding what manuscripts he had received both from his brother and from other sources. The opening line of Jean the Celestine's letter of May 1423 speaks to an ongoing, independent correspondence with the Carthusian, at a time when the elder Gerson himself was still alive: "You have asked quite frequently, most beloved brother in Christ, that I share with you those little works which we know were compiled by my brother, the Lord Chancellor of Paris, allowing you, with a most fervent desire of love, to press on with their study."[61]

The underlying external network

The recognition of such inter-order reformist ties provides a new perspective on the scale of regional monastic activism in this period. Colette's reform was the most rapidly expanding monastic reform in Francophone regions in the early fifteenth century. Building sixteen female houses and reforming two others in just forty years between 1410 by 1450 was no small feat (see Table 2), and Colettine reform would reach forty-three monasteries by 1520.[62] The Carthusians, meanwhile, had a second growth spurt in France and the Low Countries in the Late Middle Ages, just as they did elsewhere in Europe:[63] the late fourteenth and early fifteenth centuries (see Table 3) were particularly fruitful for them in this region, with sixteen new priories founded between 1350 and 1454. Taken together, the numbers may still not be quite comparable with earlier waves of monastic expansion, but given the spectacular cost of even modest religious establishments in this period, they are far from insignificant. French Celestine evidence suggests that capital costs ran into the tens of thousands of *livres* for a house of just twelve monks and a prior, and rose through the period amid the economic instabilities of the fourteenth and fifteenth centuries.[64]

The geographies of the Celestine and Colettine expansion up to 1450 (see Maps 1–2) show a certain alignment. For the Celestines there is a concentration in Paris and northern France; another group in the Midi; and some further penetration in the east, to Lyon in the southeast, and as far as Metz in the duchy of Lorraine. For the Colettines, the early foundations concentrate along similar arcs, albeit with a different weighting: in the north from Colette's homeland in Picardy, running eastwards as far as Lorraine and the Palatinate, then south through eastern France, Burgundy, and Savoy and down into Languedoc. The Carthusian foundations of this period map fairly well over both distributions (see Map 3). They, too, gained a northern concentration, but penetrated far further into the Low Countries; they also enjoyed new foundations in Burgundy, the Midi, and Languedoc (in addition to two outlying convents in the west, one of which, Oyron, was only short-lived).

As always, where monasteries were founded depended on the territorial associations of their founders. An analysis of this goes some way towards explaining both the overlap and divergence in how the houses of these congregations were distributed.

The support the Celestines received from the Valois monarchy (see Table 1) was critical to the prominence of their houses in the Île-de-France and nearby Picardy. The houses of Paris (greatly expanded by Charles V), Limay-lès-Mantes (founded by Charles V), and Amiens (founded by Charles VI) were the cornerstones of their presence in these regions. Meanwhile, their success in the Midi was closely related to the backing of the Avignonese papal court

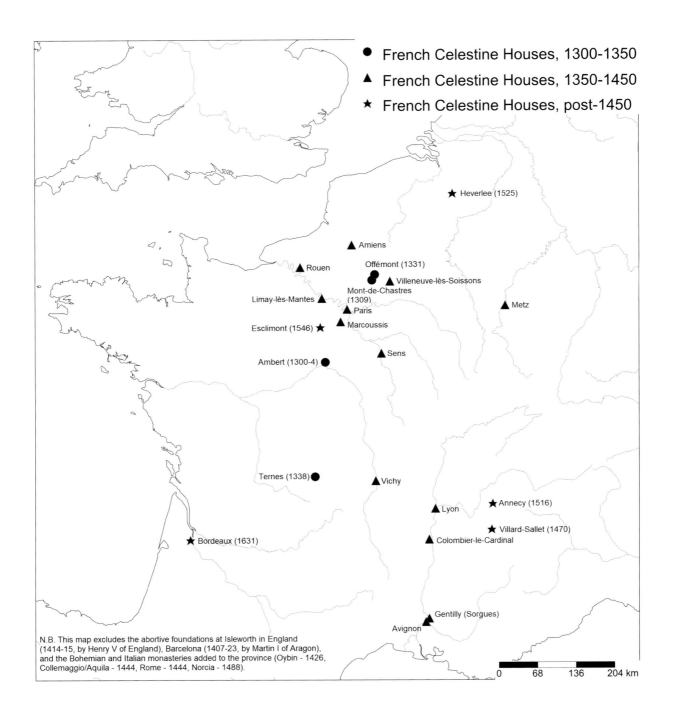

Map 1
French Celestine expansion, 1350–1450

THE FRENCH CELESTINE "NETWORK" (C. 1350–1450)

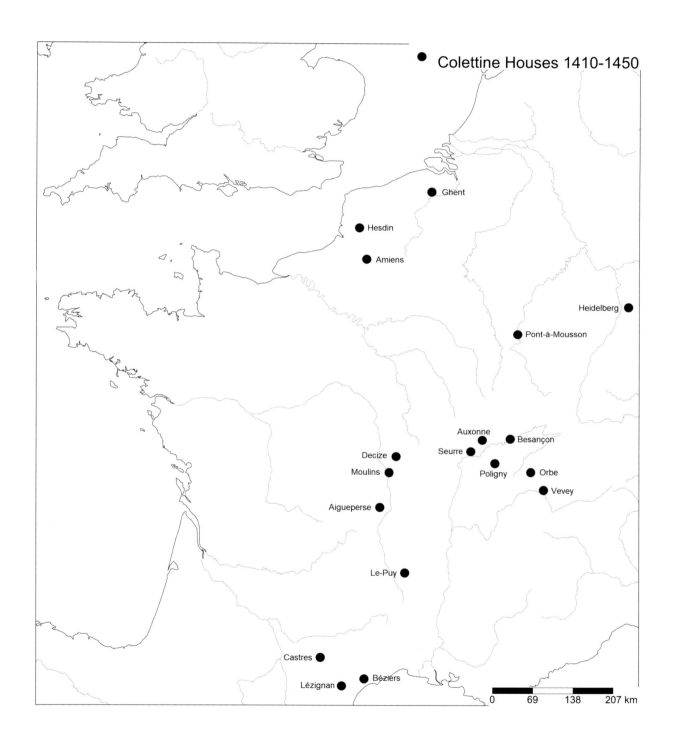

Map 2
Early Colettine houses, 1410–1450

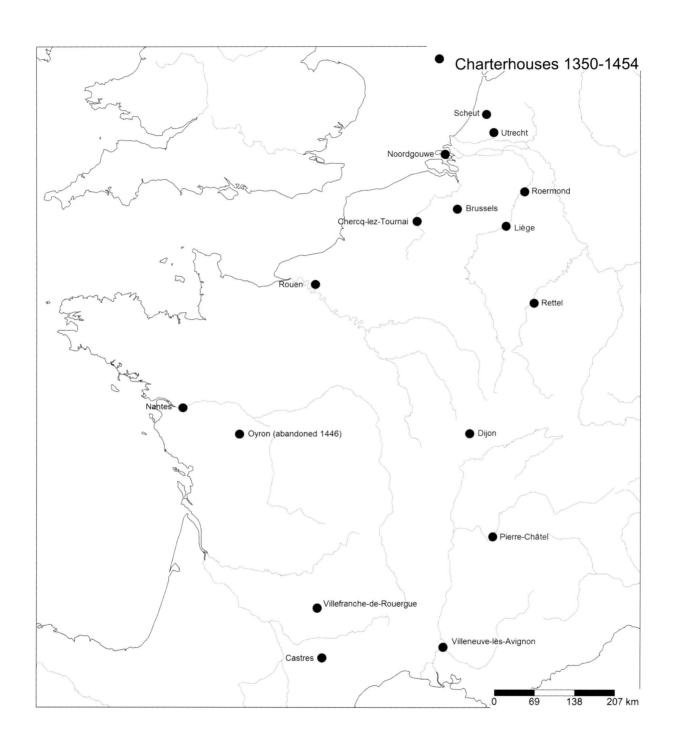

Map 3
Carthusian expansion in the Francophone West and Low Countries, 1350–1454

(Gentilly, Avignon), which had already shown support for the Carthusians (see Table 3) in this same period (Villeneuve-lès-Avignon). The house of Savoy also founded a Celestine priory (Lyon, by Amadeus VIII) after having founded a Carthusian monastery in the preceding generation (Pierre-Châtel, by Amadeus VI).

For the Colettines (see Table 2), the real impetus was provided by the houses of Burgundy and Bourbon, which helps to account for their success in Burgundy, eastern France, and Languedoc (where the Bourbonnais James II, count of La Marche, was made governor by Charles VII).[65] Both the Celestines and the Carthusians provide some obvious precursors. Prior to the Bourbon family's support for the Colettines, Louis II, duke of Bourbon, founded a Celestine house in Vichy.[66] Amadeus VIII, duke of Savoy, founded a Colettine house (Vevey, 1424–1426) in his own duchy, only a few years after completing his Celestine house at Lyon. The Carthusians, meanwhile, preceded the Colettines as objects of affection for the Burgundian court and its satellites. Philip the Bold, duke of Burgundy, was responsible for the most spectacular Carthusian foundation in the region in the period under study, the house of Champmol.[67] Associates and allies followed close behind: Amadeus VI, count of Savoy, was close to Philip and turned over his castle of Pierre-Châtel, near Virignin, to the Carthusians shortly after the construction of Champmol began (1383).[68] Charles II, duke of Lorraine (who had been a close companion of Philip's in his youth) and his wife Margaret (who later provided funding for the Colettine convent of Pont-à-Mousson in her will) orchestrated the successive transfer of two existing monastic complexes to the same community of Carthusians: Marienfloss (1415, from the Cistercians), and Rettel (1431, from the Benedictines), where these monks relocated. While the nearest settlement to this community, Sierck, was just a small town, the close proximity of the château of the dukes of Lorraine and the Moselle river made it a highly visible religious establishment.[69] Burgundian support also helped to further the expansion of the Carthusians in the Low Countries: Philip the Good, duke of Burgundy, and his son Charles provided critical funding to the house at Scheut (1454).[70]

The divergences in the distributions of these congregations are in part related to the rivalries of founding dynasties—exacerbated by the endemic conflict of the Hundred Years' War —even if each found support across political divides. The Burgundian dukes showed comparatively little interest in the Celestines (albeit that some of their supporters did), which helps to explain the absence of their houses from the duchy, Franche-Comté, and the Low Countries in this period, despite their strength in adjacent regions.[71] The Celestines had been strongly associated with Louis, duke of Orléans (d. 1407), who was a major benefactor of many of their houses, but who also became a mortal enemy of John the Fearless, duke of Burgundy.[72] It has also been argued that John preferred the Colettines to the emerging Franciscan Observant movement in part due to his suspicion that the latter was overly associated with the opposing Orléans-Armagnac party.[73] The dukes of Burgundy, who aspired to demarcate their own polity as much as wield power in France, could also be seen as steering away from religious congregations that were too strongly associated with the French crown (like the Celestines) when founding monasteries in their own territories. On the other hand, the Lancastrians (who between 1419 and 1435 were allied with Philip the Good, duke of Burgundy) showed some interest in the Celestines, perhaps seeking to take hold of the religious associations of the French crown they claimed. Following Henry V's failed attempt in 1414–1415 to found a Celestine house in England

(Isleworth) near his new Carthusian and Brigittine establishments, his brother John, duke of Bedford (d. 1435) laid the groundwork for a Celestine priory in Rouen in the early 1430s, with Henry VI providing its charter in 1445. The importance of the Celestines as a royal symbol is made clear by the fact that the Valois Charles VII issued a new charter claiming this foundation as his own in late November 1449, just weeks after seizing the city.[74]

As is clear from both these details and the tables, monastic foundations in this period were for the most part the preserve of the princes, the grandest aristocrats, and ecclesiastical magnates. Partly this was a function of rising costs. Nevertheless, where lower-status founders occur, the ties of these founders to higher ranks are also often manifest. Royal servants like Jean de Montaigu—who placed statues of Charles VI and his queen at the door of the Celestine church at Marcoussis—and Jean de Mézières, *maître des comptes*, and his widow, Isabelle Bilouard, could be seen as following the leads of their masters.[75] Meanwhile the Carthusian expansion in the Low Countries, while often involving civic leaders and authorities, followed in the wake of the support of William II, count of Flanders, who founded the first charterhouse in the region at Hérinnes, just outside Enghien (Hainaut) in 1314: this sparked the founding of five further houses within the space of fourteen years.[76] When other forms of benefaction are considered, functionaries and bureaucrats are particularly prominent, and indeed it is this class that provides some of the clearest indirect links between these rigorist congregations. Philip of Moulins, bishop of Noyon (r. 1388–d. 1409) and royal counsellor under the kings John II, Charles V, and Charles VI, supported both the Carthusian and Celestine houses in Paris, as did both Jean de Dormans, a chancellor of France under John II and Charles V who become bishop of Beauvais, and Guillaume Rose, an advocate in the Paris Parlement.[77] The royal secretaries Pierre Cramette and Guillaume de Neauville likewise split their religious bequests between the Celestines and Carthusians.[78] Gérard d'Athies (d. 1402), a Picardian noble who became a leading ecclesiastical functionary, supported both the Celestines of Amiens and the Carthusians of Mont-Renaud outside Noyon, but was also associated with Burgundy. He hailed from the Amiens region but became archbishop of Besançon in Franche-Comté in 1391: he died in 1402 while still in post, just eight years before Saint Colette reformed her first house in the same city.[79]

It would be tempting to believe from this information that support for these congregations simply sprang from princely and ecclesiastical elites and flowed downwards to their followers. Sherry Lindquist goes as far as to contrast the growth of the Carthusians with the explosion of the Franciscan and Dominican orders in the thirteenth century (founded in part on popular support in towns and cities), stating that "the Carthusians distinctly appealed to the highest nobility by their elitism and exclusivity," with the broader aristocracy and those among the upper middle classes who could truly aspire to noble status following in their wake.[80]

Considering again the broadly comparable, overlapping shape of the core geographies of new foundations among the Celestines, Carthusians, and Colettines in and around France during this period (c. 1350–1450), however, one might wonder how much the support of the most elevated individuals and dynasties was really the life-blood of these congregations. Northern and eastern France, the Low Countries, Burgundy, Savoy, and the Midi represented an arc of comparatively well-developed urban culture, and—especially in the north—regions noted for well-developed piety, particularly among the bourgeois laity. Most of these houses were indeed in or on the outskirts of towns and cities.

Early Colettine establishments (between the beginning of this reform in 1406 and 1450) were in fact founded exclusively within such environments. They enjoyed the most success in small and mid-sized towns: Auxonne, Poligny, Decize, Seurre, Vevey, Orbe, Lézignan, Hesdin, and Pont-à-Mousson fall into this category. Colette herself apparently preferred this type of settlement: for instance, she resisted the wish of Margaret of Bavaria, duchess of Burgundy, for a convent in Dijon, instead persuading her and her husband, John the Fearless, in favour of one in smaller Auxonne, which she saw as less worldly than the Burgundian capital.[81] Nevertheless, her reform also saw significant expansion in cities: Le Puy-en-Velay, Castres, Béziers, and Amiens in France, Besançon in Franche-Comté, Heidelberg in Germany, and Ghent in the Low Countries.

For the Colettines, this fit well with a mendicant heritage that had long been entwined with urban society (albeit that, as Poor Clares, they were strictly enclosed, unlike their Franciscan brothers). But the expansion of the Celestines and Carthusians followed a similar pattern, despite these being orders with eremitic origins (and, in the Carthusian case, an ongoing semi-eremitic way of life) that had previously been committed to founding houses in relatively isolated locations. Prior to 1350, foundations within the French Celestine congregation—Ambert (in the forest of Orléans), Mont-de-Chastres (in the forest of Compiègne), Ternes (near a small hamlet of the same name, about 5 km from the Creuse river), and Offémont (in the forest of Laigue)—were all rural (see Map 1).[82] In the following century, however, only the houses at Gentilly (near Sorgues, about 10 km from Avignon), Colombier-le-Cardinal (about 8 km from the small town of Annonay), and Marcoussis (near the village of the same name, about 30 km south of Paris) could claim much seclusion, and even these took over portions of the major residences of their founders. Of the rest, some, like Limay-lès-Mantes (on a hill overlooking the modest but important Seine town of Mantes) and Villeneuve-lès-Soissons (today Villeneuve-Saint-Germain, about 1 km from Soissons itself), occupied a liminal status at the boundaries of urban centres. The remainder were either in small towns (Vichy) or firmly within the walls of major cities (Paris, Sens, Metz, Avignon, Amiens, Lyon, Rouen).[83]

Similarly, between 1356 and 1454, the majority of Carthusian monasteries built in the region were situated on the outskirts of towns and cities, as in the cases of Villeneuve-lès-Avignon (on the other side of the rivers Rhône and Gard from Avignon), Liège (on a hill, Mont Cornillon, overlooking the town), Saix ("half a league" from Castres), Chercq-lez-Tournai (about 1 km from the walls of Tournai), Champmol (about 1 km from the walls of Dijon), Rouen (about 1 km east of the Saint-Hilaire gate), Nieuwlicht (about 2 km from Utrecht at the banks of the busy river Vecht), Amsterdam (about 1 km from the entrance to the city at Haarlemmerpoort), Nantes (just outside the city walls), Rettel (about 2 km from Sierck and at the banks of the Moselle), Villefranche-de-Rouergue (less than 1 km from the town, just over the river Aveyron), and Scheut (3 km west of Brussels, outside the second wall). In the case of Roermond, the foundation found room within the town itself.[84] New Carthusian houses built on the model of the Grande Chartreuse (founded in 1084), high up in the mountains and nearly 30 km from the nearest large settlement (Grenoble), were now a comparative rarity: only the monasteries of Pierre-Châtel (high up on a wooded hill, overlooking the Rhône near the village of Virignin), Oyron (10 km from the nearest small town of Thouars), and Noordgauwe (over 5 km from Zierikzee) came close to this more traditional style.

The increasing proximity of late medieval monastic expansion and activism to the life of towns and cities has not gone without comment. In regard to the Carthusians, historians have spoken of a "Copernican shift" in this period, as the relatively isolated model of earlier monasteries gave way to houses in or near towns and cities with the foundations of the fourteenth and fifteenth centuries.[85] In the case of that order, it has been suggested that the drive to found monasteries in or in close proximity to urban centres was a function of these houses holding more than just personal and dynastic spiritual value for their high-status patrons (even if that element was often strong and genuine):[86] these founders desired their work to be visible.[87] This is entirely correct, and often just the tip of the iceberg. Especially in the cases of some of the major Carthusian (Champmol) and Celestine (Paris, Amiens, Limay-lès-Mantes, Avignon) houses, it is clear that they played an important role as symbols of power and religious leadership.[88]

Nevertheless, if the public aspect of such foundations helps to explain the urban locations of such late medieval religious establishments, it follows that the largely princely and aristocratic caste who built them must have assumed a receptive audience in these locations. It is clear enough that they found one, an audience that indeed responded with more than just respect for authority and tepid mimicry. Members of the urban intelligentsia showed significant spiritual and intellectual interest in the Celestines and Carthusians: we have already seen the example of Jean Gerson, but his close associates, the theologians and reformers Pierre d'Ailly (Gerson's predecessor as chancellor of the University of Paris) and Nicolas de Clamanges, also fostered ties with both of these congregations.[89] It should also be noted that the same caste of urbane courtier and upper bourgeois figures who might be seen as followers of aristocratic fashion could in fact go to staggering lengths, both individually and collaboratively, to support such monasteries, at times risking entire legacies on projects that were far from certain to succeed. Isabelle Bilouard, the widow of Jean de Mézières, a *maître des comptes* under Charles V, staked all of the couple's property on founding a very modest Celestine house in Sens, and even this proved barely sufficient in its early years.[90] The Carthusian monastery of Saix, just outside Castres, likewise drew in the entire legacy of its childless founder Raymond Saysse, a rich merchant of Castres, and half of that of his wife.[91] Bertrand le Hongre, a notable citizen of Metz, was only able to give his Celestine house of Metz a fragile financial grounding at foundation, enough for just four monks. Continual support from his family and the bourgeoisie of the town was essential in allowing it to become a reasonably successful Celestine monastery of fifteen monks by the middle of the fifteenth century.[92]

Benefaction from the urban classes was clearly important for the continuing success of princely foundations too, at least to judge by Celestine monastic obituaries.[93] Support from bureaucrats and other bourgeois figures sometimes even led those at higher ranks to support new foundations. In some cases, where aristocratic interest in an order was already well known, one might see this as currying favour. It has been argued, for instance, that the civic council of Brussels petitioned the assistance of Philip the Good, duke of Burgundy, in founding the Carthusian monastery of Scheut in part to endear their city to him.[94] In the case of the Celestines, however, support from lower ranks appears critical in engaging Charles V around the congregation at a point when he had shown no pre-existing interest in it and royal support had seemingly diminished since the reigns of Philip IV and his sons. The confraternity of the

Notaries and Secretaries of the King, working with Garnier Marcel, a notable Paris bourgeois, were the original founders of the Paris Celestine house, even if Charles would later radically overhaul and enlarge the house as one of the centrepieces of his royal presentation, catapulting the congregation to a new level of prominence in the process. The initial impetus for the foundation in fact came from Robert de Jussy, a royal secretary, but most importantly a former Celestine novice at the house of Mont-de-Chastres, who had seemingly never lost his affection for the monks despite ultimately pursuing a different career.[95]

In the case of the Colettines, Pierre de Vaux's letter to the citizens of Amiens, a document in which he pleads with the townspeople to support the foundation of a house backed by the Burgundian court, might seem to suggest a measure of opposition within the town to that particular foundation. The underlying issue, however, appears to have been a conflict over pre-existing rights owned by the bishop, cathedral chapter, and the juridical council of the city, the latter digging in its heels over the level of amortization indemnity required.[96] Colette herself had encountered a similar issue over pre-existing rights when trying to found a house at Corbie, her place of origin, where the direct opposition of the powerful Benedictine abbey prevented the project's success in 1407 and again in 1445–1448.[97] At Ghent, however, the situation was reversed: the urban authorities petitioned the Burgundian court to help them effect a Colettine foundation there.[98] On a more general level, the successful expansion of Colettine reform in towns ultimately required a positive urban reception. If she failed to establish her first house in the small town of Corbie, Colette's monastic reform career subsequently took flight with the reform of a decrepit Urbanist house in Besançon. The act was authorized by "Benedict XIII" in 1408 at the request of Blanche, countess of Geneva, who had met the reformer through her relative, Colette's adviser Henri de Baume. The reform gained further backing from Margaret of Bavaria, duchess of Burgundy, who secured protections and exemptions from her husband, John the Fearless, after Blanche (who held Chalon-sur-Saône in vassalage from Burgundy) had introduced her to Colette.[99] The acceptance and protection of the townspeople was, however, critical to the successful implantation of reform. Colette's first recruit was indeed Marie Chevalier, the daughter of a notable bourgeois of Besançon.[100]

While foundations often required urban co-operation as well as elite support, it is at the level just mentioned—that of recruitment—where the support of bourgeois society appears most critical to late medieval monastic activism in the region. The prominence of bourgeois recruits has been noted in other studies of Observant monasticism in this period: it has even been suggested that Observant houses perhaps provided a place for prominent urban families to house their younger sons and daughters.[101] This latter characterization, however, does not quite fit with the Celestine evidence; rather, it appears that men with career options were very prominent.[102] According to his *vita*, Jean Bassand was the son of a well-to-do bourgeois family of Besançon, and had been an Augustinian canon regular before choosing to join the Celestines.[103] At Metz, one finds a good number of artisans and sons of artisans, as well as university graduates.[104] Men often joined having had access to a strong education: as mentioned, two younger brothers of Jean Gerson professed, while the aforementioned Jean Bertauld is thought to have had a university education at Paris, among many other examples.[105] Pierre Pocquet, Bassand's mentor, had reached a relatively advanced level in his academic career (it is not known whether he studied at Paris or elsewhere): he is described in the *vita* of Bassand as a

"distinguished doctor of civil law in the world . . . whose doctrine was very often selected by many judges, especially by the royal Parlement of Paris."[106]

For the Colettines, Élisabeth Lopez suggests a greater degree of aristocratic recruitment than among the Celestines: Bonne and Catherine (daughters of Bernard d'Armagnac), Marie and Isabeau (daughters of James II, count of La Marche), and Odette (the illegitimate daughter of Philip the Good), all became Colettines, the latter two reaching the rank of abbess (of Amiens and Ghent, respectively).[107] But there were also a good number of bourgeois profiles: it was not uncommon for prominent Colettines to emerge from important civic families, such as the aforementioned Marie Chevalier and Étiennette Hannequin, described by Sister Perrine as the daughter of a rich merchant. For the vast majority of early recruits, no background was recorded. We might wonder how many of them were more like the founder herself, a woman from an ordinary family who grew up in the same kind of small town in which the Colettines were able to found so many convents.[108]

With women, one might doubt the level of independent agency in profession, and perhaps especially for the daughters of the nobility: Lopez has suggested, for instance, that Bonne and Catherine d'Armagnac were perhaps less than fully willing. But were all of those set aside for monastic life required to join one of the harshest, most rigorous congregations available to them? Colette herself provides an interesting example. While her turn from a semi-religious life—seemingly in step with the well-developed lay piety frequently ascribed to the towns of late medieval Picardy—to monastic reform is presented by her hagiographers as the result of a vision, it appears she might also have been constrained through the action of male churchmen. On the other hand, her seemingly independent urge to dictate a voluminous and distinctive set of constitutions seems to lean the other way, suggesting that her religious values were more naturally aligned with rigorist religious reform. Her turn also seems less dramatic when placed alongside the example of the Celestine prelate Jean Bertauld, who in fact grew up in nearby Amiens. Remarkably, in what was clearly a pious bourgeois family, each of his four brothers also joined the Celestines.[109]

The surviving register of professions at the Paris Celestines suggests that the centres of flourishing lay piety to the north were fertile recruiting grounds for monastic rigorists in this period, tallying well with the geographical spread of houses of their own congregation as well as of the Colettines and Carthusians. The dioceses of Cambrai—neighboring that of Amiens—and Utrecht, both strongly associated with the Modern Devout, provided eleven professions between 1380 and 1430, about a seventh of their intake in this period.[110] Despite the absence of Celestine houses in Burgundy, Franche-Comté provided strong recruiting grounds for the Paris house. Between 1388 and 1408, eight men from Besançon and its environs were professed at Paris out of a total of forty-four professions in those same years. These included Jean Bassand and another important Celestine prelate, Besonce Devaux (*Bisuntius de vallibus*): both their names appear related to the city (*Bisuntium* in Latin).[111] The fact that the leading Celestine Pierre Pocquet hailed from Arbois in the same diocese, together with the elevation of the aforementioned Picard benefactor Gerard d'Athies to the archbishopric of Besançon in 1391, may well have been influential. But for such recruitment to have occurred over a twenty-year period, supportive networks based on personal, familial, professional, and/or religious ties that extended beyond these individuals must have existed in this region.

The latter connection—between the Celestines and Besançon—is particularly interesting in the context of Colettine reform. That Besançon became the city in which Colette's congregation was first successfully implanted was in part a result of the immediate welcome she received from the Burgundian court in their territories. But the decision to start exactly there and the positive reception the nuns received perhaps makes even more sense when one considers that for the previous twenty years, another rigorous, reformed form of monastic life had been a religious choice with a certain cachet for young men in the city, including one whom Colette is alleged to have met in Amiens, Jean Bassand.

Conclusion

At this point, we have moved some distance beyond a study of the French Celestines. While they have provided a good starting point due to the contrast of the ties they forged with their apparent "otherness," one might just as easily talk of a Carthusian network, of a Colettine network, or of wider European "Observant" networks, and stretch the horizons further by shifting perspective in terms of period. In the late fifteenth and early sixteenth centuries, for instance, the French Celestines and Carthusians, if no longer growing rapidly, were involved in the reform of other congregations, while the Colettines continued to grow alongside a surge of Observant activity that affected most orders.[112] Such congregations were clearly not all part of a single "family tree," even if some activists sought to provide a post-positive coherence to reformist efforts,[113] as may well be the case in the story of Jean Bassand tutoring Colette of Corbie. But it is also quite clear that beneath an increasingly well-shared reformist rhetoric lay an emerging web of real contacts and exchanges that were of profound influence and need to be carefully traced. Ultimately, no one constituent possessed this complex and constantly evolving network.

That is precisely why the exercise is so revealing. By sketching points of contact between monastic reformers across orders and the significant overlaps in their support networks in and around the late fourteenth- to early fifteenth-century Francophone West, a new window can be opened onto the broader religious tastes of this place and time. Despite quite diverse origins across multiple orders, congregations that promoted a rigorous, detailed ascetic life that was tightly bound by legislation gained particular energy in this period, and were able to recognize each other by these marks and gain confidence through association. The French Celestines and like-minded rigorists among the Colettine Poor Clares and the Carthusians (the three groups that enjoyed significant expansions through new houses in the region in the period under study) also held other things in common at this time. They were willing to live out their finely detailed and highly regimented lives of purity in close proximity to society, especially in or near towns and cities. In the process, they found real cachet not only with aristocrats and ecclesiastical magnates, but also with intellectuals like Jean Gerson, urban professionals, and other townspeople: notably, the areas of society most impacted by the rising social influence of law and professionalism, and by deepening lay pious interests, seem to have welcomed them readily. The fact that they were all very strictly enclosed groups is also striking in this context. Although one of these congregations technically belonged to a "mendicant" order (the Colettines were Poor Clares, but necessarily enclosed due to their female status), the vogue in

vowed religious life in the region appears to have shifted from the simple, open, and accessible asceticism and preaching that lay at the root of the thirteenth-century Franciscan and Dominican expansions towards well-connected but rigorously separated models of sanctity. While the Observant friars were hardly unrelated to these circles, as witnessed in the interactions of Giovanni da Capestrano, and would also expand at an increasing pace in the region from the second half of the fifteenth century, the cultural reasons for the rise of monastic congregations that remained both stringently separated from and within reach of the public in the preceding period—the mid-fourteenth to mid-fifteenth centuries—deserve to be explored more fully.[114] Overall, the monastic men and women studied here guarded their *status religiosorum* very closely at a time when the growing ambition found within lay piety is often thought to have laid down a serious challenge to the necessity of such an estate.[115] If their way of life was perhaps a response, it also appears to have been deemed essential within the same parts of society where this challenge took place.

Understanding the French Celestine congregation as part of a complex "network" also helps to rescale the achievement and the meaning of the reform of religious orders in a "pre-Reformation" era in which congregations appear individually very small next to earlier monastic successes. The impact of a late medieval monastic reform only appears modest when it is rated in institutional units—by the number of new houses (much more expensive to build in the Late Middle Ages) and by the formation of new orders (much more difficult after the Fourth Lateran Council [1215], from which point all new congregations were supposed to take an existing rule). Despite such constraints, the energy behind the work of monastic activists extended beyond these inherited boundaries—to other orders certainly, but also to an interested non-monastic audience that found new breadth both in elite and, perhaps most intensely, in bourgeois society. The varied origins and the more divisive aspects of these rigorist reformers cannot be ignored, but they clearly formed extensive and deep networks that challenge our basic perceptions of both monastic and wider religious society in this period.

Primary Works

Cambrai, Bibliothèque municipale:
 MS 238 – Pierre Pocquet, *Orationarium in vita domini nostri Jesu Christi et de suffragiis sanctorum*; 15th century, St. Sepulcre Abbey.

Leipzig, Universitätsbibliothek:
 MS 802 – Pierre Pocquet, *Orationarium in vita domini nostri Jesu Christi et de suffragiis sanctorum*; 15th century, Cistercians of Altzelle.

Le Puy, Grand Séminaire:
 MS 7 AV 018 – Pierre Pocquet, *Orationarium in vita domini nostri Jesu Christi et de suffragiis sanctorum*; possibly late 14th century.

Metz, Bibliothèque municipale:
 MS 631 – Pierre Pocquet, *Orationarium in vita domini nostri Jesu Christi et de suffragiis sanctorum*; 15th century, Carthusians of Rettel.
 MS 833 – Celestine Chronicle of Metz; late 15th century, Celestines of Metz.

Paris, Bibliothèque de l'Arsenal:
 MS 754 – Collection of monastic writings, includes Pierre Pocquet's *Orationarium in vita domini nostri Jesu Christi et de suffragiis sanctorum* late 14th/early 15th century, St. Victor, Paris.
 MS 1071 – Letters of Jean Bertauld; late 15th century, Celestines of Paris.

Paris, Bibliothèque nationale de France (BnF):
 Lat. 1200 – Collection of works, including Pierre Pocquet, *Orationarium in vita domini nostri Jesu Christi et de suffragiis sanctorum*; 1391, Abbey of St. Denis.
 Lat. 5620 – *Vita* of Jean Bassand; mid 15th century, Celestines of Avignon.
 Lat. 14502 – Pierre Pocquet, *Orationarium in vita domini nostri Jesu Christi et de suffragiis sanctorum*; 15th century, St. Victor, Paris.
 Lat. 14584 – Collection of works, including Pierre Pocquet, *Orationarium in vita domini nostri Jesu Christi et de suffragiis sanctorum*; before 1502, St. Victor, Paris.
 Lat. 17744 – Register of professions; 17th century, with further additions for the 18th, Celestines of Paris.

Prague, National Library:
 MS XIV.F.7 – Pierre Pocquet, *Orationarium in vita domini nostri Jesu Christi et de suffragiis sanctorum*; first half of 15th century, Canons Regular of Trebon.
 MS I.E.44 – Pierre Pocquet, *Orationarium in vita domini nostri Jesu Christi et de suffragiis sanctorum*; 1436, Celestines of Oybin.

Rome, Biblioteca Vallicelliana:
 MS F 50 – Pierre Pocquet, *Orationarium in vita domini nostri Jesu Christi et de suffragiis sanctorum*; 1463, St. Laurence outside-the-walls.

Subiaco, Biblioteca dell'Abbazia:
 MS cod. 286 – Pierre Pocquet, *Orationarium in vita domini nostri Jesu Christi et de suffragiis sanctorum*; 1485, Subiaco.
 MS cod. 299 – Pierre Pocquet, *Orationarium in vita domini nostri Jesu Christi et de suffragiis sanctorum*; 1456, Subiaco.

Vienna, Österreichische Nationalbibliothek:
MS Cod. 1303 – Pierre Pocquet, *Orationarium in vita Christi et de suffragiis sanctorum*; c. 1450, Augustinians of Brixen.

Wroclaw, Biblioteka Uniwersytecka:
MS I F 287 – Pierre Pocquet, *Orationarium in vita domini nostri Jesu Christi et de suffragiis sanctorum*; first half of 15th century, Canons Regular of Wroclaw.

Printed Primary Works

"Cahier de Soeur Perrine" 1911: "Le Cahier de Soeur Perrine," in D'Alençon 1911, 202–291.

"Célestins de Paris" 1902–1923: "Célestins de Paris, obituaires," in Molinier et al. 1902–1923, I:706–729.

"Chartreuse de Vauvert" 1902–1923: "Chartreuse de Vauvert, obituaires," in Molinier et al. 1902–1923, I:696–705.

"Constitutiones S. Coletae" 1897: "Constitutiones S. Coletae," in *Seraphicae Legislationis: Textus Originales* (Florence: Ad Claras Aquas, 1897), 99–171.

D'Abbeville 1628: Silvère d'Abbeville, *Histoire chronologique de la bienheureuse Colette* (n.p.: n.p., 1628).

D'Alençon 1911: Ubald d'Alençon, ed., *Les vies de Ste Colette Boylet de Corbie* (Paris: A. Picard et fils, 1911).

De Ritiis 1941: Alessandro de Ritiis, "Chronica civitatis Aquilae," in Leopoldo Cassese, ed., *Archivio Storico per le Province Napoletane*, 27 (1941): 151–216; 29 (1943): 185–268.

De Vaux 1994: Pierre de Vaux, *Vie de soeur Colette*, ed. Elisabeth Lopez (Saint-Etienne: Publications de l'Université de Saint-Etienne, 1994).

Gerson 1960–1973: Jean Gerson, *Oeuvres complètes*, ed. Palémon Glorieux, 10 vols. (Paris: Desclée, 1960–1973).

Molinier et al. 1902–1923: Auguste Molinier, Auguste Longnon, et al., eds., *Recueil des historiens de la France, obituaires*, 4 vols. (Paris: Imprimerie Nationale, 1902–1923).

"Obituaire du couvent" 1860: "Obituaire du couvent des Célestins d'Amiens," in *Recueil des documents inédits concernant la Picardie*, ed. V. de Beauvillé, 5 vols. (Paris: Imprimerie Nationale, 1860), 1:158–165.

Villeneuve necrology 1997: *The Villeneuve necrology: MS. Grande Chartreuse 1 Cart. 22*, ed. John Clark, 4 vols. (Salzburg: Universität Salzburg, 1997).

Vita Joannis Bassandi n.d.: *Vita Joannis Bassandi*, in *AASS*, 38 (5 Aug., n.d.), 870–890.

Secondary Works

Auriol 1897–1898: Achille Auriol, "La destruction de la Chartreuse de Castres par les Huguenots en 1567," *Bulletin de la Société Archéologique du Midi de la France* (1897–1898): 132–141.

Baudry 1878: Paul Baudry, *Entrée de Saint-Ouen chartreuse de Saint-Julien et église de Saint-Sauveur de Rouen* (Rouen: C. Métérie, 1878).

BIBLIOGRAPHY

Beach and Cochelin 2020: Alison Beach and Isabelle Cochelin, eds., *The Cambridge History of Medieval Monasticism in the Latin West*, 2 vols. (Cambridge: Cambridge University Press, 2020).

Becquet 1719: Antoine Becquet, *Gallicae Coelestinorum Congregationis, Ordinis S. Benedicti, monasteriorum fundationes virorumque vita aut scriptis illustrium elogia historica* (Paris: n.p., 1719).

Bellitto 2001: Christopher M. Bellitto, *Nicholas de Clamanges: Spirituality, Personal Reform, and Pastoral Renewal on the Eve of the Reformations* (Washington, DC: Catholic University of America Press, 2001).

Borchardt 2006: Karl Borchardt, *Die Cölestiner: eine Mönchsgemeinschaft des späteren Mittelalters* (Husum: Matthiesen, 2006).

Campbell 2014: Anna Campbell, "St Colette and the friars 'of the Bull'," in *Rules and Observance: Devising Forms of Communal Life*, ed. Mirko Breitenstein, Julia Burkhardt, Stefan Burkhardt, and Jens Röhrkasten (Münster: LIT, 2014), 43–66.

Campbell 2016: Anna Campbell, "Colette of Corbie: Cult and Canonization," in Muller and Warren 2016, 173–206.

Catto 2008: Jeremy Catto, "Statesman and Contemplatives in the Early Fifteenth Century," in *Studies in Carthusian Monasticism in the Later Middle Ages*, ed. Julian M. Luxford (Turnhout: Brepols, 2008), 107–114.

Chazan 2013: Mirielle Chazan, "Le couvent des célestins de Metz: jalons pour l'analyse d'un succès", in *Les Gens d'Église et la ville au Moyen Âge dans les pays d'entre-deux*, Centre de Recherche Universitaire Lorrain d'Histoire, 2013 [http://crulh.univ-lorraine.fr/sites/crulh.univ-lorraine.fr/fijiles/documents/mireillechazan.pdf; accessed 19 May 2018].

Coulton 1950: G. G. Coulton, *Five Centuries of Religion*, 4 vols. (Cambridge: Cambridge University Press, 1950).

Damen and Stein 2012: Mario Damen and Robert Stein, "Collective memory and personal *memoria*. The Carthusian monastery of Scheut as a crossroads of urban and princely patronage in fifteenth-century Brabant," *Publications du Centre Européen d'Etudes Bourguignonnes*, 52 (2012): 29–48.

Dukers 2014: Brigit Dukers, "The building history of the charterhouse of Roermond," in *The Carthusians in the Low Countries: Studies in Monastic History and Heritage*, ed. Krijn Pansters (Leuven: Peeters, 2014), 319–337.

Elm 1980: Kaspar Elm, "Verfall und Erneuerung des Spatmittelalterlichen Ordenswesens: Forschungen und Forschungsaufgaben," in *Untersuchungen zu Kloster und Stift*, ed. Josef Fleckenstein (Gottingen: Max-Planck-Institut für Geschichte, 1980), 189–238.

Favier 2006: Jean Favier, *Les Papes d'Avignon* (Paris: Fayard, 2006).

Gadby 2005: Françoise Gadby, "Les Célestins en France: les lettres de Jean Bertauld," in *Da Celestino V all'Ordo Coelestinorum*, ed. Maria Grazia Del Fuoco (L'Aquila: Libreria Colacchi, 2005), 267–286.

Gaude-Ferragu 2005: Murielle Gaude-Ferragu, *D'Or et des cendres: La mort et les funérailles des princes dans le royaume de France au bas Moyen Âge* (Villeneuve d'Ascq: Presses Universitaires du Septentrion, 2005).

Gillet 1889: Joseph Gillet, *La Chartreuse du Mont-Dieu au diocèse de Reims* (Reims: H. Lepargneur, 1889).

Glorieux 1961: Palémon Glorieux, "Gerson et les Chartreux," *Recherches de théologie ancienne et médiévale*, 28 (1961): 115–153.

Goffin 1991: Benoît Goffin, *Les six premières chartreuses de Belgique au XIV^{ème} siècle* (Salzburg: Universität Salzburg, 1991).

Gumbert 1974: J. P. Gumbert, *Die Utrechter Kartäuser und ihre Bücher im frühen fünfzehnten Jahrhundert* (Leiden: Brill, 1974).

Herde 1981: Peter Herde, *Cölestin V* (Stuttgart: Anton Hiersemann, 1981).

Hobbins 2009: Daniel Hobbins, *Authorship and Publicity Before Print: Jean Gerson and the Transformation of Late Medieval Learning* (Philadelphia: University of Pennsylvania Press, 2009).

Hoffman 1908: Karl Hoffman, *Das Kloster von Rettel* (Metz: Paul Even, 1908).

Hogg 1980: James Hogg, "Everyday life in the charterhouse in the fourteenth and fifteenth centuries," in *Klösterliche Sachkultur des Spätmittelalters. Internationaler Kongress Krems an der Donau 18. bis 21. September 1978* (Vienna: Verlag der österreichischen Akademie der Wissenschaften, 1980).

Knowles 1969: David Knowles, *Christian Monasticism* (London: McGraw-Hill, 1969).

Langer 2015: Pavla Langer, "One Saint and two Cities – Bernardino da Siena at L'Aquila," in *Saints and the City: Beiträge zum Verständnis urbaner Sakralität in christlichen Gemeinschaften (5.-17. Jh.)*, ed. Michele C. Ferrari (Erlangen: Friedrich-Alexander Universität; F-A University Press, 2015).

Lawrence 1984: C. H. Lawrence, *Medieval Monasticism* (New York: Longman, 1984).

Le Blévec 1993: Daniel Le Blévec, "Les chartreux de Villeneuve-lès-Avignon et leurs bienfaiteurs, XIV^e-XV^e siècles," *Analecta Cartusiana*, 62.1 (1993): 160–170.

Le Gall 2001: Jean-Marie Le Gall, *Les moines au temps des réformes: France 1480–1560* (Seyssel: Champ Vallon, 2001).

Leroy-Morel 1867: M. Leroy-Morel, *Recherches généalogiques sur les familles nobles de plusieurs villages des environs de Nesle, Noyon, Ham et Roye, et recherches historiques sur les mêmes localités* (Amiens: Imprimerie de Lenoël-Hérouart, 1867).

Lindquist 2008: Sherry C. M. Lindquist, *Agency, Visuality and Society at the Chartreuse de Champmol* (Aldershot: Ashgate, 2008).

Lopez 2011: Élisabeth Lopez, *Colette of Corbie: Learning and Holiness*, trans. Joanna Waller, (St. Bonaventure, NY: Franciscan Publications, 2011).

Lusset and Roest 2020: Elisabeth Lusset and Bert Roest, "Late Medieval Monasticism: Historiography and Prospects," in Beach and Cochelin 2020, II:923–940.

Martin 1992: Dennis D. Martin, *Fifteenth Century Carthusian Reform: The World of Nicholas Kempf* (Leiden: Brill, 1992).

Mixson 2009: James D. Mixson, *Poverty's Proprietors: Ownership and Mortal Sin at the Origins of the Observant Movement* (Leiden: Brill, 2009).

Mixson 2015a: James D. Mixson, "Introduction," in Mixson and Roest 2015, 1–20.

Mixson 2015b: James D. Mixson, "Observant Reform's Conceptual Frameworks between Principle and Practice," in Mixson and Roest 2015, 60–84.

Mixson 2016: James D. Mixson, "The Poor Monk and the Proprietors: Observant reform of community

as conflict," *Saeculum*, 66 (2016): 93–110.

Mixson and Roest 2015: James D. Mixson and Bert Roest, eds., *A Companion to Observant Reform in the Late Middle Ages and Beyond* (Leiden: Brill, 2015).

Monget 1898–1905: Cyprien Monget, *La chartreuse de Dijon*, 3 vols. (Montreuil-sur-Mer and Tournai: n.p., 1898–1905).

More 2015: Alison More, "Dynamics of Regulation, Innovation, and Invention," in Mixson and Roest 2015, 85–110.

Muller and Warren 2016: Joan Muller and Nancy Bradley Warren, eds., *A Companion to Colette of Corbie* (Leiden: Brill, 2016).

Nebbai-Dalla Guarda 1999: Donatella Nebbai-Dalla Guarda, "Des rois et des moines: livres et lecteurs à l'Abbaye de Saint-Denis (XIIIe-XVe siècles)," in *Saint-Denis et la royauté: mélanges offferts à B. Guenée; Actes du Colloque international en l'honneur de B. Guenée*, ed. Claude Gauvard and Françoise Autrand (Paris: Publications de la Sorbonne, 1999), 355–374.

Oldewelt 1953: W. F. H. Oldewelt, "Een ets waarop een tweetal cellen van het klooster der Kartuizers van St. Andries bij Amsterdam is afgebeeld," *Oud Holland*, 68.2 (1953): 96–106.

Ouy 2000: Gilbert Ouy, "Gerson and the Celestines," in *Reform and Renewal in the Middle Ages*, ed. Thomas M. Izbicki and Christopher M. Bellitto (Leiden: Brill, 2000), 113–140.

Ouy 2003: Gilbert Ouy, "Le Célestin Jean Gerson, copiste et éditeur de son frère," in *La collaboration dans la production de l'écrit médiéval*, ed. Herrad Spilling (Paris: Ecole Nationale des Chartes, 2003), 281–313.

Pellegrini 2004: Luigi Pellegrini, "Dall'Ordo Morronensium all'Ordo Celestinorum," in *Il monachesimo italiano nel secolo della grande crisi: atti del V Convegno di studi storici sull'Italia benedettina*, ed. Giorgio Picasso and Mauro Tagliabue (Cesena: Badia di Santa Maria del Monte, 2004), 327–349.

Picard 1986: Jean Picard, "Chartreuse de Pierre-Châtel," *Analecta Cartusiana*, 61 (1986): 146–197.

Pidoux de La Maduère 1907: André Pidoux de La Maduère, *Sainte Colette (1381–1447)* (Paris: A. Cabalda, 1907).

Roest 2013: Bert Roest, *Order and Disorder: The Poor Clares between Foundation and Reform* (Leiden: Brill, 2013).

Roest 2020: Bert Roest, "A Crisis of Late Medieval Monasticism?" in Beach and Cochelin 2020, II: 1171–1190.

Schmitz 1942–1956: Philibert Schmitz, *Histoire de l'ordre de Saint-Benoît*, 7 vols. (Paris: Éditions de Maredsous, 1942–1956).

Shaw 2018: Robert L. J. Shaw, *The Celestine Monks of France, c. 1350–1450: Observant Reform in an Age of Schism, Council, and War* (Amsterdam: Amsterdam University Press, 2018).

Sommé 2016: Monique Sommé, "The Dukes and Duchesses of Burgundy as Benefactors of Colette de Corbie and the Colettine Poor Clares," in Muller and Warren 2016, 32–55.

Timmermans 2013: Francis Timmermans, "Les fondateurs et bienfaiteurs des premières chartreuses belges," *Analecta Cartusiana*, 298 (2013): 123–138.

Vauchez 1999: André Vauchez, "The Religious Orders c. 1198–c. 1300," in *The New Cambridge Medieval History*, ed. David Abulafia, 7 vols. (Cambridge: Cambridge University Press, 1999), V:220–255.

Viallet 2016: Ludovic Viallet, "Colette of Corbie and the Franciscan Reforms," in Muller and Warren 2016, 76–101.

Warren 2016: Nancy Bradley Warren, "The Life and Afterlives of St Colette of Corbie: Religion, Politics, and Networks of Power," in Muller and Warren 2016, 6–31.

Zarri 2015: Gabriella Zarri, "Ecclesiastical Institutions and Religious Life in the Observant Century," in Mixson and Roest 2015, 23–59.

NOTES TO THE TEXT

* I would like to acknowledge the support of the Pontifical Institute of Mediaeval Studies, where I began my research on late medieval monastic "networks" as an Andrew W. Mellon Fellow. A debt of gratitude is also due to Kristin Bourassa and Erika Graham-Goering for confirming my reading of the incident concerning Simon Bonhomme recorded in the chronicle of the Metz Celestines (see n. 56).

1. There are only two modern monographs focused on the congregation. Borchardt 2006 offers the only complete history of the congregation in all geographies from foundation to Revolutionary-era suppression. More recently, on the late medieval French Celestines, see Shaw 2018. For a list of other recent works, see Shaw 2018, 13, n. 4.

2. See, for instance: Coulton 1950; Knowles 1969; Schmitz 1942–1956, vol. 3; Lawrence 1984, 224; Vauchez 1999. For a more recent overview that challenges this view, see Roest 2020.

3. See also Shaw 2018, 267.

4. Pellegrini 2004, 338.

5. Herde 1981, 31–142.

6. Favier 2006, 57.

7. Borchardt 2006, 13–14, 20, 22–23.

8. Borchardt 2006, 219–249; Shaw 2018, 65–115.

9. Borchardt 2016, 355.

10. Shaw 2018, 16, 213–214.

11. See the discussion and Table 1 below; Shaw 2018, 166–180, 213–236.

12. On Observant reform, see Elm 1980; Mixson 2009; and Mixson and Roest 2015.

13. Shaw 2018, 88–100.

14. Shaw 2018, 70–88, 99–100.

15. Shaw 2018, 17–18; Borchardt 2006, 132–138, 140–141.

16. See Mixson 2009; Mixson 2016.

17. Shaw 2018, 35–63. The text has been published by the Bollandists: *Vita Joannis Bassandi* n.d. Bassand was elected in 1411, 1417, 1426, 1432, and 1438, each time for a three-year term; see Shaw 2018, 269.

18. Paris BnF, lat. 5620, fols. 2r-16r. There is an *ex libris* on fol. 2 (*fratrum Celestinorum de Avinone*) in a fifteenth-century hand. On its dating, see Shaw 2018, 35–36.

19. Shaw 2018, 36–38.

20. *Vita Joannis Bassandi* n.d., 876. The author states that he was "third successor in the regimen of regular observance in Italy." While there are no complete lists for the French Celestine vicars and priors in Italy, Bertauld's elevation to prior of Collemaggio in 1453, where Bassand had taken charge nine years earlier, puts him in exactly the right timeframe.

21. Gadby 2005, 267; Shaw 2018, 38.

22. Alongside his knowledge of the cult of Picardian Saint Colette (discussed in this article), he is able to correctly cite the distance by river between Paris and Mantes as almost thirty miles: *Vita Joannis Bassandi* n.d., 882.

23. *Vita Joannis Bassandi* n.d., 883–884.

24. Lopez 2011, 1–148, 261, 554–560. Roest 2013, 169–171.

25. Lopez 2011, 235–266; Roest 2013, 174–175; for a published edition of the constitutions, see "Constitutiones S. Coletae" 1897.

26. Lopez 2011, 55, 58; Campbell 2014; Viallet 2016, 77–90.

27. Vita Joannis Bassandi n.d., 886–887 [with corrections from Paris BnF, lat. 5620, fol. 13r]: *Religiosa quædam devotissima, præstantissimæque virtutis, nomine Coletta; cujus industria, sive conversationis merito, monasteria plurima Religiosarum pauperum sanctæ Claræ, cujus habitum ipsa, dum virgo foret, de manu Pape Martini quinti receperat, ædificata fuere: quibus etiam auctoritate Sedis Apostolicæ præfuit, et manutenuit in continua paupertate juxta beati Francisci legislatoris earum [regularem] observantiam conversan[tes]. Quæ, dum esset juvencula, virgoque purissima, tanto zelo devotionis incanduit, ut omnes Ambianensis civitatis incolæ mirarentur. Hæc enim beatum Johannem, tunc Priorem monasterii Ambianensis, ordinis Cælestinorum frequenter adibat: a quo salutis monita percipiens, dietim proficiebat in gratia sanctitatis. Adhortari quippe non desinebat illam, ut in salutari virginitatis proposito remaneret, verbis, dum poterat, libellis, dum non poterat, ipsam erudiens. Hæc igitur ad tantam perfectionem devenit, ut reclusorium apud castrum Corbeiacum, unde traxerat originem, subintraret: ac demum, revelatione sibi facta divinitus seu cælitus, Romam adiret, summo Pontifici revelationem exponeret, et ab eo reciperet habitum, veluti protulimus, sanctitatis, ut virginibus sacris diffusis per Galliam, formam bene vivendi et conversandi præberet.*

28. Campbell 2016, 173–178.

29. Mixson 2015a, 14; More 2015.

30. Lopez 2011, 543; Campbell 2014, 45. For older works that speak of the connection, see the introduction to D'Alençon 1911, viii, and Pidoux de La Maduère 1907, 151.

31. D'Abbeville 1628, 35–36: "I'ay descouvert par l'extraict tiré d'un vieil manuscrit envoié par des Reverends Pères Celestins de Paris, que Colette visitoit volontiers Dom Jean Bassan, qui fust le permier Prieur des Pères Celestins d'Amiens, personage de saincte reputation, lequel luy apprist la vie spirituelle, et servit de guide, et Conseiller au faict de sa conscience. Mais i'ay soigneusement remarqué comme particulierement ce sainct Religieux persuadoit sa bonne fille spirituelle, de garder soigneusement, et à tousiours la fleur de sa virginité, et la consacrer au Roy des vierges, le Vierge Jesus."

32. De Vaux 1994; "Cahier de Soeur Perrine" 1911.

33 Lopez 2011, 35–38.

34 "Cahier de Soeur Perrine" 1911, 205–206; Lopez 2011, 27, 36.

35 Lopez 2011, 553.

36 *Vita Joannis Bassandi* n.d., 887: *Dum ergo beatus Johannes Aquilæ spiritum Deo reddidisset, illa trans Alpes Ambianis in suo monasterio residens, in spiritu cognovit recessum beati Patris a seculo, suis cum lætitia dicens et pluribus aliis: Hodie reverendus Pater meus spiritualis transivit de mundo: cui cives Aquilani devotas et solemnes exequias exhibent, vestigia ejus devotissime osculantes. Notaverunt autem diem, quo beata virgo Coletta revelaverat, obitum sancti Patris, et a fratribus ex Aquila redeuntibus, qui funeri ejus astiterant, hæc ita esse, velut beata virgo retulit, cognoverunt.*

37 *Vita Joannis Bassandi* n.d., 887 (see note 36 above).

38 Viallet 2016, 88.

39 *Vita Joannis Bassandi* n.d., 886: *Affuit et ille religiosus pater Johannes de Capestrano prædicator egregius; qui prius viderat illum, et noverat qualis erat. Qui dum sanctum Patrem trahere ultimum spiritum inspexisset, dixit illi: Cognoscis me Pater, At ille: Cognoscant te angeli sancti Dei.*

40 *Vita Joannis Bassandi* n.d., 886: *Reverendus autem ille pater Johannes de Capistrano sermonem egregium de conversatione ejus, de sanctitate, de modestia, de virtute, coram plurimis ducentis hominum milibus fecit, accipiens pro themate suo: Fuit homo missus a Deo, cui nomen erat Johannes,* [John 1.6] *actus ejus sanctissimos, et obitum illius gloriosum, particulariter et distincte, prout fuerat edoctus, et ipsum jam dudum agnoverat, patenter edisserens, et extollens illum summis laudibus justum, ut sanctum, utque Deo placentem coram multitudine populorum.*

41 Langer 2015, 288.

42 De Ritiis 1941, 200, cited in Langer 2015, 288.

43 For Cypriano's involvement at Aquila, see the letter of Eugenius IV (6 March 1444, *Iniunctum nobis*) in Borchardt 2006, 419–421; and Shaw 2018, 61.

44 Campbell 2014; Viallet 2016.

45 Warren 2016, 23–24, Viallet 2016, 88.

46 *Vita Joannis Bassandi* n.d., 883–884; Shaw 2018, 61.

47 *Vita Joannis Bassandi* n.d., 886 [with corrections from Paris BnF, lat. 5620, fol. 13r] (see note 27 above).

48 For a much wider discussion of the *Orationarium*, its doctrine, and its readership, see Shaw 2018, 96–99, 142–154, 247–250.

49 Paris BnF, lat. 1200; on this copy, see Nebbai-Dalla Guarda 1999, 367.

50 Paris, BnF, MSs lat. 14584, 14502; Paris, Bibliothèque de l'Arsenal, MS 754.

51 Subiaco, Biblioteca dell'Abbazia, MSs cod. 286, cod. 299 (1456).

52 Vienna, Österreichische Nationalbibliothek, cod. 1303; Rome, Biblioteca Vallicelliana, MS F 50.

53 The earliest known copy in this region belonged to Oybin itself: Prague, NL, MS I. E. 44, dated 1435. The other surviving manuscripts are: Prague, NL, MS XIV.F.7 (Canons Regular of Trebon, first half of the fifteenth century); Leipzig, UB, MS 802 (Cistercians of Altzelle, mid-fifteenth century); Wroclaw, Biblioteka Uniwersytecka, MS I F 287 (Canons Regular of Wroclaw, first half of the fifteenth century).

54 Cambrai, Bibliothèque municipale MS 238; Metz, BM, MS 631; Le Puy-en-Velay, Grand Séminaire MS 7 AV 018.

55 Paris, Bibliothèque de l'Arsenal, MS 1071, fol. 36r: *Sic et monachi molismenses cum abbate suo causa voti perfectius adimplendi cistercii monasterium construxerunt Ex monachis identidem ferventiores quoque celestinorum seu cartusiensium ordines districtiores expostulant ut iuxta sibi colatam a deo gratiam perfectioris institutionis apicem toti iam facti spiritus comprehendant.*

56 Metz, Bibliothèque municipale, MS 833, pp. 114–115: "A quel chapitre frere Simon Bonhomet priour de seans ne fut pas pourtant que, quant il se fut mis en chemin, il fut pris et desrobey de la magnie le prevost de Chimerey apres le Mondieu le vendredi apres pasques convivial, li et frere Pierre de la Haigue, et frere Blanchet le Duc et Jehan Gremay, oblat, et furent despoliez, tous fu[rent] mis en mes le champs et furent menez en prison a Chimerey. Et ce ne fut estey la grace de dieu par le moyen de damp Fremis, priour du Mondieu pour le temps, il lez eust convenus mettre a ransom ou morir en prison; le quel damp Fremis fit ung grant service a monastere de seans et a tout la religion, car il demorait pour leur corp. Et il lez fit acquiter pour poc de chose. Et convient le dit priour et freres retourner seans pour la multitude des gens d'arme qui estoient a chemi[n]s de Paris." The Carthusian prior "Fremis" mentioned here can be identified from Carthusian records as Fremin Werric, who is remembered as having been prior of the house in c. 1421–1422 (Gillet 1889, 231); this text suggests he was still in place at Easter 1423.

57 Glorieux 1961; Gerson 1960–1973, II:259–263, 263–267. Gerson collaborated with Pocquet in a *quodlibeta* held at the Paris Celestine house: Ouy 2000.

58 Gerson 1960–1973, III:77–95, IX:423–434, 434–458.

59 Shaw 2018, 17–18.

60 Hobbins 2009, 197–203; for the particular contribution of Gerson's youngest brother (Jean the Celestine), see Ouy 2003.

61 Gerson 1960–1973, X:554–561, at 554: *Postulasti saepius, amantissime mi frater in Christo, ut ea tibi communicarem opuscula, quae a germano meo Domino Parisiensi Cancellario compilata cognoscimus, afferens te ferventissimo amoris desiderio illorum studio incumbere.*

62 Lopez 2011, 554–560.

NOTES TO THE TEXT

63 Roest 2020, 1181.

64 Shaw 2018, 175–180.

65 Lopez 2011, 303–315; Warren 2016, 11–22; Sommé 2016

66 Shaw 2018, 226, 242–243.

67 Monget 1898–1905. The first two volumes cover the late medieval history of the house. On Champmol, see the study by Laura Chilson-Parks in this volume.

68 Picard 1986.

69 Hoffman 1908; Warren 2016, 19.

70 Damen and Stein 2012.

71 Shaw 2018, 225–226.

72 Shaw 2018, 223–225.

73 Warren 2016, 12–13.

74 Shaw 2018, 230–235, 261.

75 Shaw 2018, 167.

76 See Goffin 1991.

77 "Célestins de Paris" 1902–1923, I:706–729, at 709; 710, 714; "Chartreuse de Vauvert" 1902–1923, I:696–705, at 697, 702, 705.

78 "Célestins de Paris" 1902–1923, I:712; Guillaume de Neauville supported the Paris Charterhouse. See "Chartreuse de Vauvert" 1902–1923, I:704–705. Pierre Cramette is also recorded as a benefactor of the order: *Villeneuve necrology* 1997, I:72.

79 "Obituaire du couvent" 1860, I:160, 164; Leroy-Morel 1867, 43–44.

80 Lindquist 2008, 190–191.

81 Warren 2016, 12. Élisabeth Lopez states that Colette deliberately chose mid-sized towns for her foundations: Lopez 2011, 312.

82 On Mont de Chastres and Offémont, see the article by Arthur Panier in this volume.

83 Shaw 2018, 89–90.

84 Le Blévec 1993; Timmermans 2013, 135–136; Auriol 1897–1898, 133; Baudry 1878, 15; Gumbert 1974, 24; Oldewelt 1953, 99; Gaude-Ferragu 2005, 40; Hoffman 1908; Damen and Stein 2012, 30–32; Dukers 2014; and Chilson-Parks in this volume.

85 Martin 1992, 74.

86 Catto 2008.

87 Hogg 1980, 127.

88 Lindquist 2008, 213–235; Shaw 2018, 211–236.

89 Shaw 2018, 236–239, 251–252; Bellitto 2001, 26.

90 Shaw 2018, 178.

91 Auriol 1897–1898, 133–134.

92 Shaw 2018, 169–170; Chazan 2013, 4–5.

93 This was not solely restricted to urban foundations like Paris, Amiens, and Avignon: the secluded monastery of Ambert drew significant support from the townspeople of nearby Orléans. See Shaw 2018, 180–184.

94 Damen and Stein 2012, 32–33.

95 Shaw 2018, 183; Becquet 1719, 8.

96 Lopez 2011, 315–316; Sommé 2016, 45–47.

97 Warren 2016, 11; Sommé 2016, 47–48, Lopez 2011, 169.

98 Sommé 2016, 44–45.

99 Warren 2016, 11–12.

100 Lopez 2011, 451.

101 Zarri 2015, 58–59.

102 See Shaw 2018, 239–240, for a longer treatment of this issue.

103 *Vita Joannis Bassandi* n.d., 877.

104 Chazan 2013, 13–24.

105 Gadby 2005, 267–269.

106 *Vita Joannis Bassandi* n.d., 878: . . . *qui doctor egregius juris civilis erat in seculo, cujusque doctrina sæpius a multis judicibus, et a parlamento regio Parisiensi frequentius allegatur*.

107 Lopez 2011, 453–459; Sommé 2016, 44, 47.

108 Lopez 2011, 466, 489.

109 Gadby 2005, 267–269.

110 Paris, BnF, MS lat. 17744, fols. 35v-36r: Utrecht – Johannes de Brandenburg (1388), Johannes de Noerd (1389 or 1391), Theodoric Thasiech (1411), and Jodocus Rollant (1413); Cambrai – Alardus (1379), Jean Tassard (1388), Jean Farmard (1403), Guillaume Bonnell (1404), Nicolas de Montibus (1408), Michel de Hoesue (1421), and Jacques de Mosteriolo (1428); see also Shaw 2018, 241.

111 Paris, BnF, MS lat. 17744, fols. 35v-36r: Besonce Devaux (1388), Jean Birardini (1394), Jean Bassand (1395), Étienne Prevot (1395), Étienne le Moyne (1399), Pierre Leclerc (1399), Jean d'Orgelet (1401), Eudes de Palino (1408); see also Shaw 2018, 113, 240.

112 See Le Gall 2001 for a discussion of this later period.

113 Mixson 2015a, 14.

114 See Le Gall 2001, 34, on late fifteenth-century mendicant expansion. Lusset and Roest 2020, 930, also note the late medieval development of enclosed religious communities in close proximity to or within urban centres.

115 On the "challenge" of lay piety and its relationship to late medieval monastic activism, see Mixson 2015b.

ARTHUR PANIER

Sainte-Croix-sous-Offémont: An Archaeological and Architectural Perspective on the Celestine Order

During the First World War, French artillerymen used the site of Sainte-Croix-sous-Offémont to stable their horses away from the fighting (Figs. 1a and 1b). Few of them may have realized that their shelter was located on the site of a former Celestine monastery, an order little recognized, especially in France. The monastery, cloistered from its foundation in 1331 until its closure in 1778, has been sequestered in private ownership from 1811 to the present. The Celestine order has remained similarly obscured from view in the study of monastic architecture and is thus a perfect example of the "other" monastic experience. The order held an important place in late medieval and early modern society, especially in the territories that form France and Italy today. The toponymy of the places they settled is still marked by their passage. This is the case, for example, in the city of Lyon where the *Théâtre des Célestins* replaced the priory

1a Artillery horse stable in the church and chapel ruins (37th D.I.), Cl. Perraudin, April 1915, VAL255/017, Nanterre, coll. La Contemporaine.

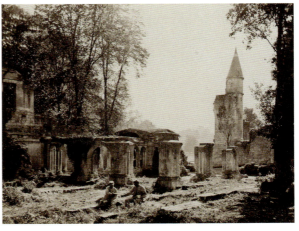

1b Two French soldiers sharing a meal next to the cloister's vestiges, Anonymous, 24 September 1915, VAL 255/013, Nanterre, coll. La Contemporaine.

that once stood in its place, or in Paris where the dock located near the place they possessed is still referred to as the *Quai des Célestins*. In Vichy, a famous brand of mineral water is even now taken from a spring once belonging to the Celestines and carries the name of the order. This article aims to refocus attention on the Celestine order from an architectural and archaeological perspective, through the case study of the relatively well-preserved house of Sainte-Croix at Offémont.

Between 1774 and 1780 the French Celestine experience came to an end. Many priories, especially those that were located in cities, were dismantled. Others were only partially destroyed or were adapted by monks or nuns from other congregations. Sainte-Croix-sous-Offémont is one of the few examples of a Celestine priory for which there are important parts of buildings still standing with no major post-Revolutionary modifications. The remains of the church and its chapels, part of the chapter room, an agricultural complex, as well as the foundations of almost all of the other buildings of the monastery allow us to record an accurate and complete plan of the site, to understand the phases of construction, and to identify the function of various parts of the priory. Through an archaeological approach to the architecture of this monastery, we can see how the Celestines built their priories, as well as the ways in which the brothers lived within them and negotiated contact with the external world.

The evolution of the Celestine plan through the end of the Middle Ages

I begin with a brief historical framework in order to contextualize the archaeological and architectural understanding of Offémont's monastic spaces. As we will see, there was great diversity in Celestine foundations, and it is important to explore this diversity before examining the specific example of Sainte-Croix.

The Celestines' story started in central Italy before they spread to France and attempted to settle in the kingdom of England. Their Italian origins are the first step in the creation of this "other" monastic order. In the second part of the thirteenth century, a charismatic hermit, Pietro da Morrone (1215–1296) and the community that had gathered around him lived in the mountainous region of Abruzzo in Italy. Pietro was famous in the region for his piety which allowed him to expand his community rapidly and increase the number of settlements. Luigi Pellegrini has explored the establishment system of the order from its earliest possessions.[1] As he notes, the sites the Celestines chose were primarily located between the regions of Abruzzo and Molise in central Italy and were mostly isolated sites difficult of access and suitable for eremitic life. Because of their remote locations, one of their only economic activities was linked with transhumance paths.[2]

We know that Pietro and his companions founded more than a dozen eremitical communities between 1244 and 1264.[3] Among these, one of the most famous hermitages is that of Santo Spirito a Maiella. This community was located on a mountainside and possessed an oratory within which the hermit brothers prayed together. The building, still standing, consists of a modest single-vessel structure that reflects the ideals of humility and simplicity. This hermitage was one of the most important, and served as the headquarters of the order before this responsibility was transferred to the abbey of Santo Spirito al Morrone near the city of Sulmona in 1293.[4] The latter remained the only abbey of the order, since the other houses were priories or smaller cells.

In 1263, Pietro da Morrone and his community initiated a process to adopt the Benedictine Rule.[5] In order to confirm this process, Pietro met with the pope at the second council of Lyon in 1275, to secure support for his community.[6] Since the council of Lateran IV in 1215 placed limitations on the creation of new monastic orders, Pietro's request was a charged one. Pietro had been a Benedictine monk at the monastery of Santa Maria in Fayfolis until his 21st year when he decided to become a hermit.[7] He chose the Benedictine rule for his community, perhaps because he was already familiar with this congregation and not necessarily because they most closely resembled the principles of his community. Although they followed the Benedictine Rule, many of the eremitic dimensions of this new order were determined by their Constitutions. Pietro's order, originally called the Murronensians, expanded not only through the creation of new houses, but also through the transformation of pre-existing Benedictine monasteries into Murronensian ones. This process of adapting pre-existing Benedictine houses to their reformed way of life also had an impact on the Murronensians themselves, who slowly adopted some elements of the Benedictine version of monasticism. This change also came to be reflected in their architecture, as we will see below.

Between the end of the thirteenth century and the beginning of the fourteenth century, two important changes in Celestine history occurred. First, Pietro da Morrone became Pope Celestine V in 1294, a post he resigned barely four months later.[8] Second, many congregations, including those with eremitical tendencies, were attracted to rapidly developing urban centers. For example, in the final years of the thirteenth century, the eremitical monks of Camaldoli established a house in the city of Florence at the site of Santa Maria degli Angeli. The *inurbamento* phenomenon is also encountered in the context of the Carthusian order, from the fourteenth century.[9] It is around this time that Charles II of Anjou (who helped to convince Pietro da Morrone to become pope) founded a community of Murronensians in Naples, the capital of his kingdom.[10] This took place following the death of Celestine V in 1296. As the founder of the Murronensians, Pietro had forbidden the settlement of monasteries in urban centers and refused to allow the monks to serve powerful laypeople such as Charles II and his entourage.[11] Little by little, however, the Murronensians began to adopt the monastic tendencies of their era and to merge their eremitical origins with those of the more communal Benedictine tradition.

The French Celestines largely owe their existence to Philip IV, the Fair, king of France (r. 1285–d. 1314). The French "arm" of the order founded twenty-two monasteries, primarily between the years 1350–1450. Philip invited brothers of the Murronensian congregation to immigrate to his kingdom in 1300 during a conflict between the king and Pope Boniface VIII, who had succeeded Celestine V. The decision to bring to France the community that the former pope had founded was a clear message of political discord between the king and the current pope. Indeed, while the king of France sought increased power and tried to raise new taxes on the Church in his kingdom, the pope was following the opposite policy. Bringing the Murronensian brothers into France was a way for the king to demonstrate his power within his kingdom and to let the pope know that he should only concern himself with spiritual matters as Celestine V had done. After the death of Boniface VIII in 1303, the Murronensians remained important to the king of France. On 5 May 1313, the canonization of Celestine V took place, seven years after Philip the Fair had demanded it of Pope Clement V. From this moment, the order became known as the Celestines.

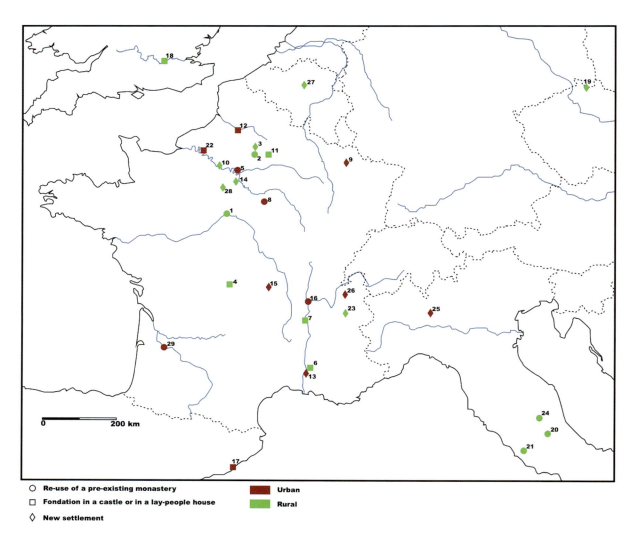

2 Locations and types of Celestine houses of the French province.

While the Celestines had already started to settle in suburban areas in Italy, we must wait until the year 1352 to see the foundation of a priory near a town in France, when the priory in Paris was established.[12] In France it was thus only after the 1340s, once the order removed the prohibition of urban settlements from their constitutions, that we begin to see new suburban foundations.[13] This phenomenon in France was also a product of the expansion of fortifications enclosing many cities during the Hundred Years' War. For example, the Celestine priory in Paris was first located outside the town walls. A few years later, the priory was incorporated inside the new city walls during the major construction work in the eastern neighborhoods of Paris (between 1356 and 1383) that was undertaken by Charles V.[14] In Avignon, the priory founded in 1393 on the south side of the city was also enveloped within the newly-built town walls.[15]

The first two French Celestine houses, Notre-Dame d'Ambert founded in 1304 near Orléans, and Saint-Pierre-en-Chastres founded in 1309 near Compiègne, more closely upheld the ideal of isolation from the early days of the order (Figs. 2, 3).[16] Both are located in forested areas around the Île-de-France. The priory of Saint-Pierre-en-Chastres is even located on a presumed Iron Age oppidum that forms a hill, reminiscent of where the first hermitages in the

SAINTE-CROIX-SOUS-OFFÉMONT

Map n°	Name of House	Year of foundation or of attachment to the French province
1	Notre-Dame d'Ambert	1304
2	Saint-Pierre-en-Chastres	1309
3	Sainte-Croix-sous-Offémont	1331
4	Notre-Dame de Ternes	1338
5	Notre-Dame de l'Annonciation de Paris	1352
6	Saint-Martial de Gentilly	1356
7	Notre-Dame de Colombier	1361
8	Notre-Dame de Sens	1366
9	Notre-Dame de Metz	1370
10	Sainte-Trinité de Limay-lez-Mantes	1377
11	Sainte-Trinité de Villeneuve-les-Soissons	1390
12	Saint-Antoine d'Amiens	1392
13	Saint-Pierre-Célestin d'Avignon	1393-5
14	Sainte-Trinité de Marcoussis	1404-8
15	Sainte-Trinité de Vichy	1403-10
16	Notre-Dame des Bonnes Nouvelles de Lyon	1407
17	Chapelle des Saintes-Reliques du palais royal de Barcelone (Spain)	1407
18	Isleworth (Sheen-England)	1414
19	Saint-Michel d'Oybin (Germany)	1426
20	Sancta-Maria di Collemaggio (Aquila-Italy)	1444–attached to the french province
21	Sancto Eusebio (Rome-Italy)	1444–attached to the french province
22	Notre-Dame de Rouen	1449
23	Sainte-Catherine de Villard-Sallet	1470
24	Saint-Benoit de Nursie (Italy)	1488–attached to the french province
25	Notre Dame de la Victoire (Milan-Italy)	1515
26	Sainte-Croix d'Annecy	1518
27	Notre-Dame d'Heverlee	1521
28	Notre-Dame d'Esclimont	1546
29	Notre-Dame de Verdelais	1627

Celestine priories of the French province.

Abruzzo mountains were located.[17] Likely due to the necessity for swift settlement, the sites where Ambert and Saint-Pierre-en-Chastres were founded belonged to pre-existing priories that the king acquired for the Murronensian monks.[18] From this point onward, and unlike their Italian brothers, the expansion of the French community proceeded relatively slowly.

In fact, it was not until about twenty years after the creation of Saint-Pierre-en-Chastres that a third foundation was established. At this point, however, the Celestine monks of France were probably not numerous enough to settle an entirely new priory on their own. Thus in 1331, when Sainte-Croix-sous-Offémont was founded, it was at first a simple cell, a dependency of the priory of Saint-Pierre-en-Chastres, located a mere eight kilometers away.

The royal family faced problems of succession following Philip the Fair's death in 1316, and the Celestine order was no longer part of the royal policy regarding religious foundations, although members of the royal family and the court continued to bestow privileges and donations on the order. After the death of Charles IV the Fair in 1328, the Capetian dynasty came to its end and was replaced by the house of Valois when Philip VI took the crown that same year.

For later Celestine foundations in France, lay patrons became more and more essential to the expansion of the order. The important relationships that the Celestines shared with powerful ecclesiastical and lay patrons were also reflected in their choices of location. For example, in 1338 the priory Notre-Dame de Ternes was established inside the family castle of Roger Lefort, bishop of Limoges.[19] This is not an isolated case, as many other examples followed, as at Colombier in 1361 where the priory's location was also inside the walls of the founder's castle.[20]

A number of major changes occurred for the Celestines located in the kingdom of France between the end of the fourteenth and the beginning of the fifteenth century. After facing problems during the fourteenth century, especially the successive military defeats of the French army during the Hundred Years' War, the power of the king of France seemed increasingly fragile. In order to restore the image of strength that royal power had at the beginning of the century, Charles V decided to take over the foundation of the Celestine priory in Paris. In 1367, he founded a new church for the priory where he and the queen were represented as donor figures on each side of the main portal, flanking the figure of the order's founder, Saint Peter Celestine (Pietro da Morrone), on the trumeau. The founder of the Celestine order was shown placing his left hand on top of his papal tiara held at his left hip, a representation of his resignation of the office and of his humility (Fig. 4).[21] In this portal composition, the king used the Celestine priory and order as a reflection of his own piety and as a political tool to reinforce his legitimacy, linking himself to Philip the Fair, Charles' great ancestor and supporter of the Celestines, as well as to the sainted founder of the order. From this point onward, and until the end of Charles VI's reign, favoring the Celestine order became an act of reverence toward the royal family among members of the French court. This support brought the French Celestines wealth and political influence, so that during the Western Schism (1378–1417) they were able to form an essentially independent province inside their own larger congregation.[22]

Since the thirteenth century, all Celestine houses had been subordinated to the central abbey of Santo Spirito del Morrone near Sulmona. Following the separation, the Celestines of the French province adopted the same model as their Italian brothers, but with the Paris priory at their head. The province was still officially under the titular authority of the central abbey but with much more independence.[23]

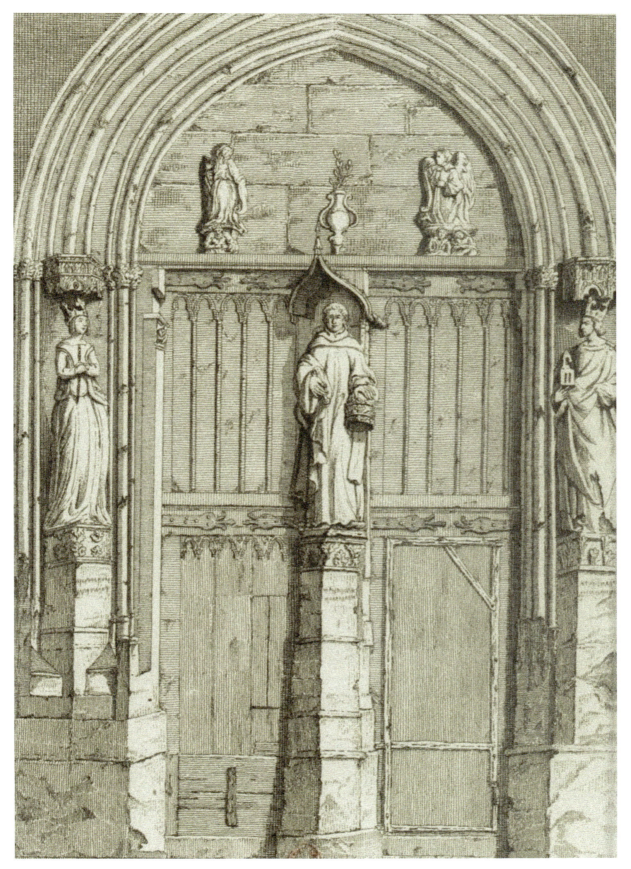

4
Church portal of the Celestines of Paris, in Millin 1790–98, T.1: pl.2.

The very strong links that tied the Celestines to the high dignitaries of the French court in this particular period lasted until the end of the seventeenth century. These ties have implications for certain features of their architecture, as we will see later, and for the choice of sites the later Celestine foundations occupied. We can see on the map (see Fig. 2) that the houses of the French Celestines were almost all founded around two regions. In the south of France, the Celestine priories that were built in and around the Comtat Venaissin testified to the interest of members of the Papal Curia and ecclesiastical patrons in the order founded by the sainted hermit pope.[24] The Comtat Venaissin was in fact part of the Papal States between the thirteenth and eighteenth centuries, located in the region around the cities of Avignon and Carpentras. The other group of priories were all established in the greater Ile-de-France region and were the result of the interest in the order among members of the royal court.

Sainte-Croix-sous-Offémont: circumstances of foundation

Sainte-Croix-sous-Offémont is situated in the forest of Laigue (Oise), near the village of Saint-Crépin-aux-Bois and close to the castle of Offémont, which belonged to the family of Nesle (Fig. 5). This territory was part of the diocese of Soissons when the priory was founded in the year 1331 by Jean I de Nesle (d. 1352) and Marguerite de Mello (d. 1342). The lord of Nesle was an important member of the royal administration of Philip VI of Valois. His father, Guy I de Nesle (d. 1302), was marshal of France before Jean became part of the secret council of Philip VI and president of the Court of Accounts with other powerful lords.[25] Marguerite de Mello was also powerful. Her family was at the head of an important lordship in the region of Senlis (Oise). When Marguerite and Jean married, her lordship became part of the Nesle family heritage. Together, Jean and Marguerite granted the Celestines the land in the vale below their castle of Offémont, providing them with a site near a natural spring, access to the castle fish ponds, and the right to cut wood from the forest of Laigue in proximity to the new foundation.[26] At a distance of 1.1 kilometers, the Celestine house was far enough away from the castle to enjoy a comfortably isolated and independent location. As already mentioned, Sainte-Croix was at first a simple dependency of the priory of Saint-Pierre-en-Chastres. It was only in 1405, after donations from Louis I of Orléans and the archbishop of Besancon, Gérard d'Athiès, increased the number of monks in the house, that the site was recognized as a priory by the French provincial chapter.[27] The valley where Offémont was located was originally called *Froideval*, or "cold valley," which implies the inhospitality of the place. Moreover, as is stipulated in the foundation charter, the brothers were to settle a house surrounded by ditches and hedges to mark clearly the boundaries of the monastic precinct. This is the only information we have concerning the nature of the initial building as well as the original monastic enclosure.[28]

In 1334–1339, a new stone church was begun and likely finished quickly, because in 1340 a chapel was founded by Marguerite de Mello next to the choir.[29] Through the fourteenth century, the monks of Offémont received many donations from the house of Nesle, the kings of France, and minor nobility from the immediate region and villages around the priory. After the donations of Louis I of Orléans and the archbishop of Besancon in 1405, the monks enlarged their church and renovated some of their buildings. Today, most of the vestiges we can see—the church and its chapels, the two agricultural buildings of the outer courtyard—were built between the end

SAINTE-CROIX-SOUS-OFFÉMONT

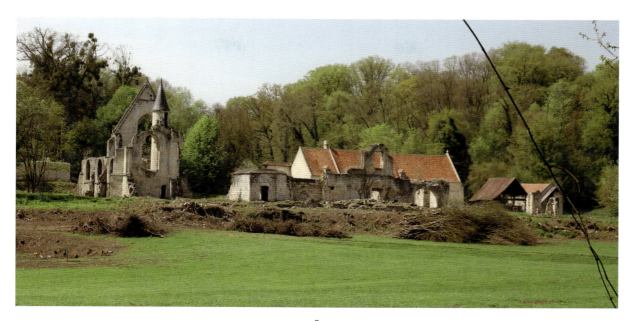

5
Sainte-Croix-sous-Offémont from the east, 2018.

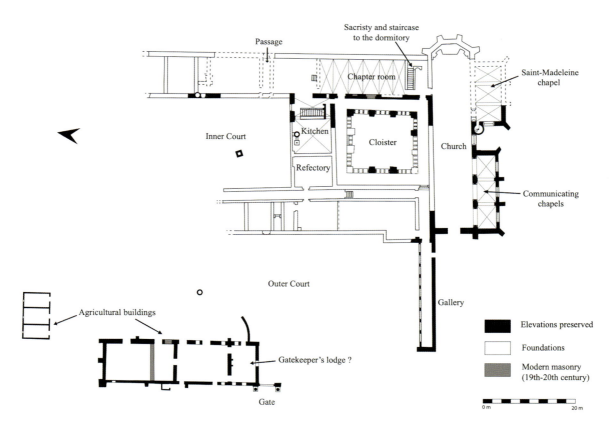

6
Plan of the vestiges of Sainte-Croix-sous-Offémont.

of the fifteenth and the beginning of the sixteenth century. From the end of the Hundred Years' War in the middle of the fifteenth century, the archives show that the monks acquired many possessions, through donations or purchase. These possessions consisted principally of land and vineyards as well as buildings located in or near the surrounding villages from which the brothers received rent.[30] The income from these possessions yielded a period of prosperity for the monks. At the same time, the region around the towns of Soissons and Compiègne was also slowly rebuilding its churches, as well as its civil and military buildings, many of which had seen destruction or damage during the conflict of the preceding century. Two examples are the parish church of Saint-Antoine in Compiègne and the town hall of that city, both rebuilt in the beginning of the sixteenth century.[31] This activity attracted masons, carpenters, and other workers related to the construction trade, who were also available for the monks of Sainte-Croix-sous-Offémont to hire. The priory cloister was rebuilt in the 1570s, after the Montmorency family inherited the castle of Offémont in 1530, when the last member of the Nesle family, Louise de Nesle, passed away. The Montmorency architect, Jean Bullant, worked on the renovation of the castle through his master mason Pierre Desilles during the 1570s, and the style used in the cloister is strongly linked to other construction sites where that architect worked, especially the castle of Fère-en-Tardenois (Aisne).[32] In the sixteenth century, Sainte-Croix-sous-Offémont attracted a number of pilgrims, due to its reputation for possessing important relics. These relics included fragments of the Holy Cross, a goblet and a tooth belonging to Saint Peter Celestine, as well as a bone fragment of blessed Pierre of Luxembourg, a cardinal buried in the Celestine priory of Avignon.[33] Extant vestiges of standing structures survive on the site. The gate of the priory and a wooden roofed gallery in the northern court date from the seventeenth and eighteenth centuries. The rest of what can be seen on site are foundations of the walls of dismantled monastic buildings, walls that are represented on my new, surveyed plan of the monastery (Fig. 6).

After the last monk left the priory of Sainte-Croix in 1778, the buildings were used as a stone quarry for the surrounding villages. During the First World War, as mentioned above, the priory was used to stable horses of the French army. Finally, some minor restorations of the architectural remains were undertaken in the 1960s. Since that time, the monastic site has not been modified and the remaining vestiges are still sufficiently extensive to provide a clear picture of the different spaces that existed within the priory.

Offémont: sources

The study of Sainte-Croix relies upon a range of sources of information: including the standing structures, accounts of the excavations led by Paul Guynemer in 1912, archival sources, and several pictorial representations of the site (Fig. 7).[34] Taken together, these sources contribute to an improved understanding of how the brothers, oblates, and servants lived within the monastic precinct. The most important written sources for an understanding of the history of the priory are provided by Simon Plarion, a Celestine monk of Sainte-Croix-sous-Offémont in the sixteenth century, and Dom Placide Bertheau, a Maurist monk who lived in the seventeenth century.[35] They both saw the priory when Celestine monks were living in it and thus provide us with valuable descriptions of the church, burials, and several other aspects of the monastery.

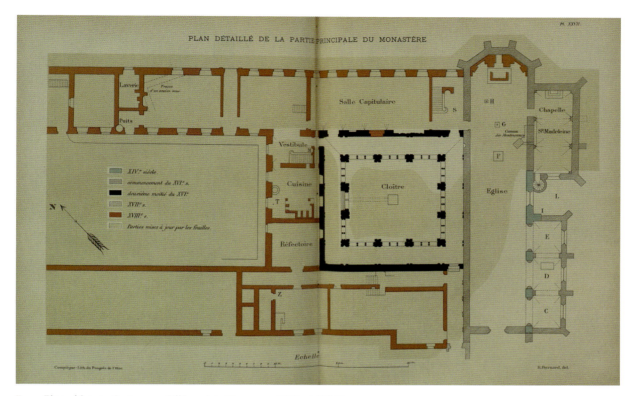

7 Plan of Sainte-Croix-sous-Offémont, in Guynemer 1912, pl. XXVII.

Regarding the iconography, there are few representations of the priory, and few of those are useful for an architectural approach to the site. Between 1733 and 1734, N. Matis surveyed the park of Offémont for the services of the king. The watercolor he created is a very accurate topographic map on which we can see Offémont's castle and priory with their gardens and the surrounding villages (Fig. 8). While this map is a useful record of the landscape of the site in the eighteenth century, the plan of the priory is, at best, schematic. The most accurate plan when it comes to the priory's buildings is an anonymous watercolor, also from the eighteenth century (Fig. 9). Providing a plan of the entire site, this watercolor is particularly interesting for what it tells us about the priory and its precinct, especially since it is a testimony to the state of the site when the monastery was still functioning, probably just before the departure of the monks.

Offémont: description of the site

In the anonymous watercolor we can see the extent of the house, the limits of the monastic enclosure represented by a continuous line (Fig. 9).[36] Visitors could enter the monastery from three directions, one on the west side facing the forest of Laigue (1), another on the southeast side next to the castle lands (2), and the third on the south side leading to a path coming from the villages of Offémont and Saint-Crépin-aux-Bois (3). The watercolor suggests the variety of the landscape around the monastic complex. The painter represented the wooded alleys that the monks roamed, the woods, the fishponds (4) from which they took the fish they ate, and the small vegetable gardens that are indicated by small rectangles next to the priory (5). Several small buildings are also represented around the priory (6). Even though these buildings

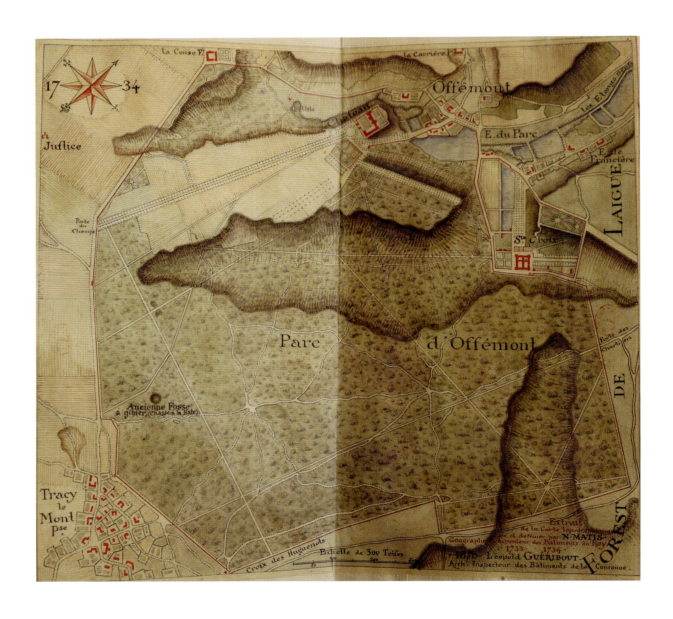

Paris, Bibliothèque nationale de France, topographic map of Offémont's park and its surroundings, watercolor, N. Matis, 1733–34, NAF6675.

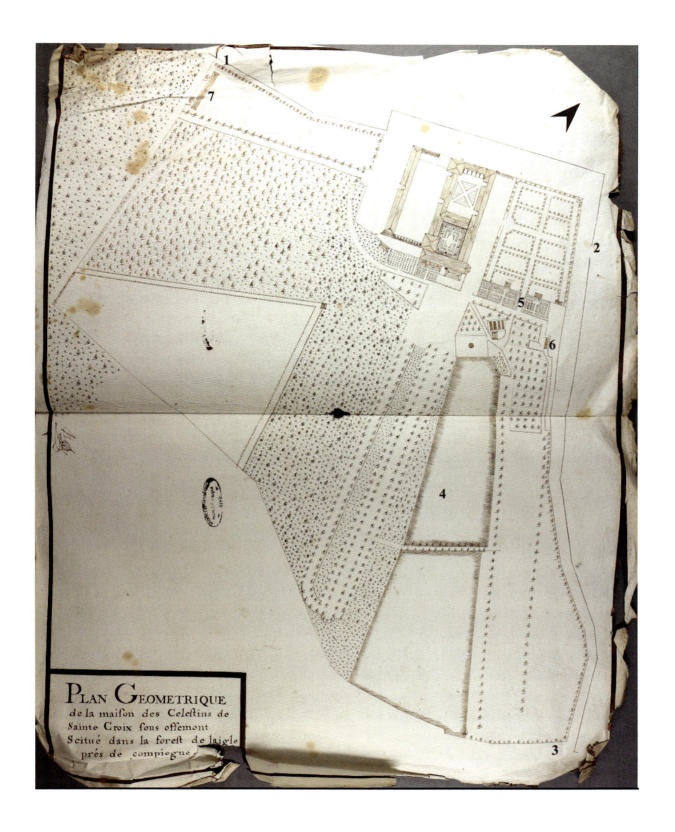

Beauvais, Archives départementales de l'Oise, Plan of Sainte-Croix-sous-Offémont, watercolor, Anonymous, 18th century, 11983.

have now disappeared, we can attempt to identify their purpose based on their location and in connection with what can be identified in other Benedictine monasteries. Most of these buildings were probably intended to store agricultural tools and produce. The Benedictine Rule, which the Celestines followed, required that every brother of the monastery practice manual as well as intellectual work during the day.[37] Little is said about the manual work in the Celestine constitutions, but certain offices were foreseen for the administration of the temporal affairs of the monastery. For example, the procurer was in charge of temporal matters both inside the priory and in relation to the outside world. Part of the long building next to the west entrance could have served as a gatehouse (7). In the Rule of Saint Benedict, the gate keeper was supposed to be an older brother who had his cell next to the gate of the monastery in order to welcome visitors at any time.[38]

Concerning the priory itself, the watercolor gives many details we lack today. The monastic buildings are built around three courtyards that are closed off from the outside world. Excepting the cloister, each courtyard has one gallery represented in the painting by arcades. The cloister is the smaller courtyard closest to the church, which is the most fully decorated and is surrounded by four galleries used by the monks to move within their monastery. Another decorated courtyard is located on the north side of the monastic complex. This one is depicted as being entirely closed off from the outside world and only one gallery can be seen on its north end. The last courtyard is the largest and is located on the west side of the complex. Once again, only one gallery can be seen but it has no decoration and its north end is not entirely closed off from the rest of the monastic enclosure. Several transitions between spaces in the priory are represented by large doors. Furthermore, people visiting the priory could directly access the church through a path on the south side of the monastery that led to the church's main portal.

The church still stands, adjacent to the cloister's south gallery. It is a modest, single vessel building, measuring 39.75 m long by 8.20 m wide, terminating in a three-sided apse. Vestiges of four chapels remain in elevation on the south side of the church. The largest one, attached to the choir, is the chapel of Sainte-Marie-Madeleine founded in 1340 by Marguerite de Mello. A simple chaplaincy at first, the building was erected at the beginning of the sixteenth century. It is a large chapel, measuring 11.90 m long by 5.5 m wide. Three chapels that communicated directly with the nave are located closer to the west façade of the church and are thought to have been founded by Louise de Nesle (d. 1530) and Jean VI de Bruges (d. before 1509) who held the castle at the beginning of the sixteenth century. The total surface area of these chapels measures 15.60m long by 4.10m wide, and was divided into three equal spaces. All of the chapels housed altars to celebrate private masses for their founding donors, whose sculpted coats of arms can still be seen on the corbels supporting the vaults.[39] The nave of the church was covered by a wooden roof, while the chapels, and probably the sanctuary, were vaulted, as they were at the Celestine priory in Paris.[40] The church was thus large enough to host the entire community during the liturgical hours, as well as visiting pilgrims during other services. At its largest, at least as far as we know, the community of Sainte-Croix counted thirteen monks and two oblate brothers in 1770.[41]

Stained glass and glazed tile fragments were found, described, and photographed during the excavations led by Guynemer. Unfortunately, most of these artefacts were not found *in situ*, no measured drawings of them were made, and they have all disappeared since, although

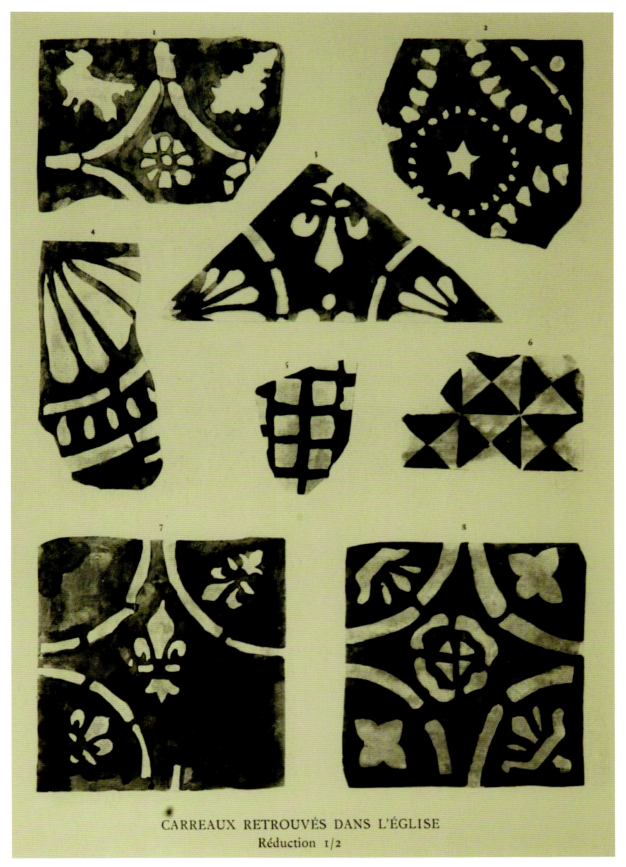

10a
Glazed tiles from the church of Sainte-Croix-sous-Offémont and its chapels, in Guynemer 1912, pl. XXXIV and XXXV.

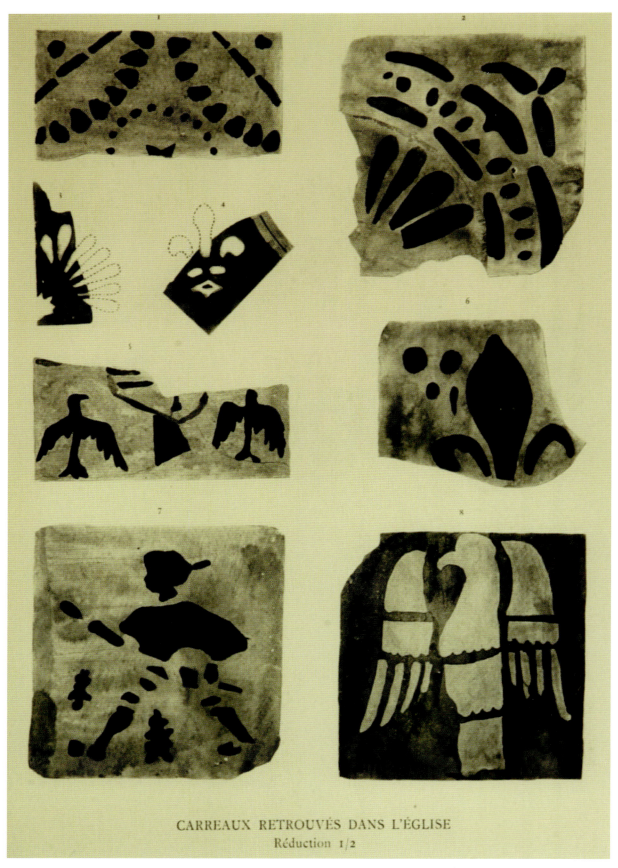

10b
Glazed tiles from the church of Sainte-Croix-sous-Offémont and its chapels, in Guynemer 1912, pl. XXXIV and XXXV.

some photographs survive. From the evidence of this excavated material we learn that the communicating chapels were paved with bicolor glazed tiles with yellow, white, or red geometric patterns. In the choir of the church and in the Madeleine chapel tile fragments were found that were not only decorated with geometric patterns but with animals, vegetal motifs, and heraldic figures as well (Fig. 10a–b).[42] No stained glass remains in the windows of the church or its chapels. We know from written sources, however, that important lay and ecclesiastical donors were represented in some of the windows.[43] We also know from Guynemer's excavations that the glazing program included grisaille glass bearing floral decoration (Fig. 11).[44]

11 Stained glass fragments from Sainte-Croix-sous-Offémont with no mention of their original position, Guynemer 1912, pl. XL.

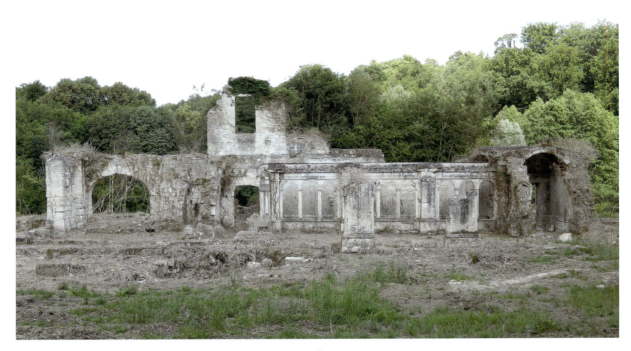

12
Vestiges of Sainte-Croix-sous-Offémont's cloister from the northwest, 2018.

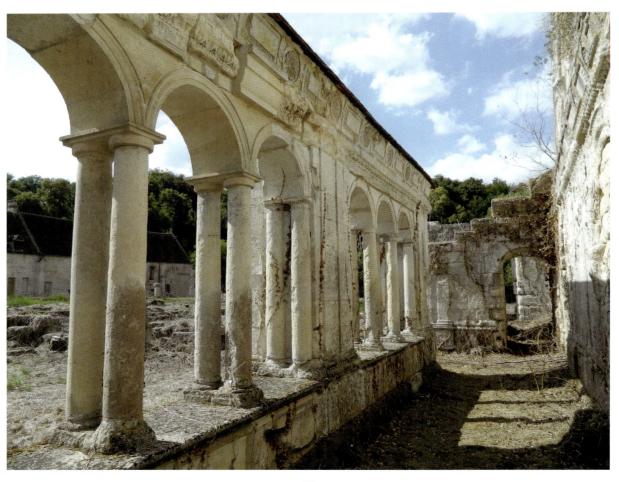

13
Vestiges of Sainte-Croix-sous-Offémont's east cloister gallery from the southeast, 2018.

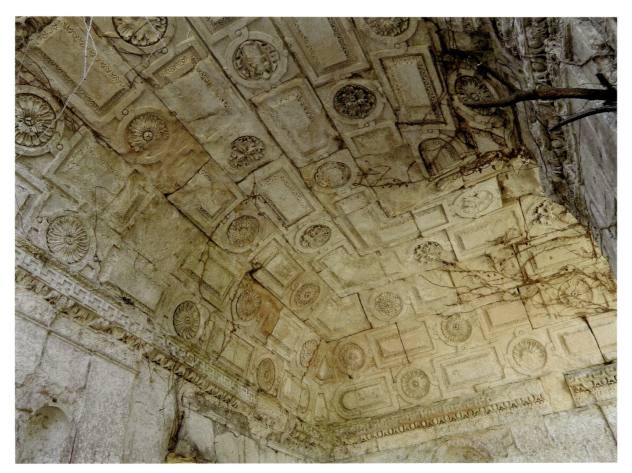

14 Sainte-Croix-sous-Offémont's cloister vault in the southeast corner, 2018.

Nothing is known about the medieval cloister, but Simon Plarion mentions that it was rebuilt in the 1570s.[45] This Renaissance cloister, which is attached to the church on the latter's north side, is in fact misaligned.[46] Indeed, unlike what we can see on Guynemer's plan, the cloister is a quadrilateral without any right angles (see Figs. 6, 7). Each gallery measures approximately 20 m long and 2 m wide.

A lavabo built into one of the pilasters of the north gallery (next to the access to the cloister garden) was probably used by the monks as their laver (see Fig. 6). The lavabo has since been destroyed, but it was described by Guynemer in 1912 along with the sump in the central part of the cloister garth into which the water of the lavabo was then discharged.[47]

The parts of the east and north cloister galleries that remain standing today allow us to describe how the cloister was decorated. The round-arched arcades are carried on twin Doric columns separated by piers (Figs. 12, 13). Above the arcades runs a complicated frieze consisting of a narrow band of foliation separated from an egg and dart band by a thin bead and reel motif. Above this is a narrow meander in low relief. Finally, the larger upper band alternates between rosettes and rectangular panels. This same complicated frieze also decorates the cloister's outer walls. The most astonishing and remarkable aspect of the Renaissance cloister is its flattened barrel vault with richly sculpted coffering. In addition to the mouldings, individual blocks of the coffering include an alternation of roses, figures of saints, and heraldic devices (Fig. 14).

The vault survives only in the southeast corner of the cloister. The motifs are thus too limited to decide if the saints and heraldic emblems held a primarily decorative function or if they belonged to a larger iconographic program. In the latter case, one might imagine that their function could also extend to teaching about the saints and biblical figures and to pointing out the arms of important donors to new members of the community, who would pass beneath them on a daily basis.

Along the eastern, or dormitory, range of the cloister, the sacristy was located next to the staircase by which the brothers descended directly from their second-floor dormitory to enter the choir for the celebration of the hours of Matins and Lauds.[48] Next to it, the large, vaulted space, identified by Guynemer as the chapter room, was more likely a modern refectory as it had direct access to a modern underground cellar and to the kitchen. All that remains of the dormitory on the second floor of the range is one surviving window.

The kitchen was located on the north range of the cloister, with an attendant sewage system and a well providing fresh water. For Guynemer, the small room next to the kitchen is likely the refectory (see Fig. 7). Clearly, the size (8 m x 6.40 m) and the square shape of this room, compared to that of what we think is the refectory (14.7 m x 7.60 m), instead suggests its use as an early modern chapter room (see Fig. 6).[49] The only known door of this room gives onto the west building of the cloister range. Nonetheless, we think another door existed on the south side, allowing direct access from the cloister.[50]

Less is known about the west range of the cloister. Its vestiges, which are mostly wall foundations, indicate that there were several rooms accessible from a long corridor. Similar to a *conversi* alley, this corridor was walled off from the western gallery of the cloister. It allowed people in the buildings of the west range to circulate without disturbing the activities of the cloister. This architectural arrangement could mean that this side of the priory was reserved for people whose access to the cloister was restricted. The corridor also provided access to another cellar linked to the one on the east range, as well as to a subterranean spring house. Considering the access to storage rooms and water, as well as the pile of dishes found by Guynemer at point "Z" on his plan, the two large rooms of this range could have served as a guests' dining hall (see Figs. 6, 7).

The remains of a second floor that is still visible on the wall attached to the church shows traces of two chimneys. The evidence of heated and comfortable spaces, as well as a place to store food and draw fresh water, all indicate that these buildings were probably reserved for guests or oblates who could enjoy more comfortable quarters than the professed. In the Celestine order, oblates performed the same functions as the Cistercian *conversi*, who were principally in charge of manual labor.[51] The upper floor could also have been a likely location for the library, but at this point we can only speculate on its location.

Though our evidence for the buildings surrounding the inner courtyard, north of the cloister, is limited, we can assume that the latrines and possibly the infirmary were located there (see Fig. 6). These functional structures were usually separated from the ritual spaces but close enough to be easily accessible by the brothers. The east range of the inner courtyard was continuous with the east claustral range. In fact, the dormitory may have extended along the east side of the inner courtyard and may have occupied most of the space on the second floor of this range, as it does at the priory of Saint-Pierre-en-Chastres (Fig. 17). The brothers had to

have easy access to the latrines from where they slept, so we can suggest that the latrines would have been on the north end of the east range. Buildings on the east side of the inner courtyard also had access to water on the first floor through a well (see Fig. 6).

The remaining two sides of the inner courtyard are more difficult to interpret. The remains of the buildings on the north side, including the gallery that is represented in the eighteenth-century watercolor (see Fig. 9), have disappeared. If we look at other Celestine monasteries, we can see that there is no consistent pattern in the type, size, and arrangement of rooms that we find around this courtyard. For example, in the Celestine priory of Metz, the latrines and spaces used to store furniture and food were all arranged around the inner courtyard, but the refectory and the kitchen were also on this side of the monastery.[52]

The outer courtyard likely served an agricultural purpose and some of its buildings are still partially standing today. In the eighteenth-century watercolor, this courtyard is the largest and the only one with no decoration (see Fig. 9). Connected to the cloister through a corridor, the gallery of the outer courtyard gave access to a building that we can see in the watercolor, but which has since been completely destroyed. The missing building was originally attached to the seventeenth-century gate of the monastery. Next to it, the so-called "tithe barn" is a long building divided today into four interior spaces. Originally it was divided into only three spaces as one of the walls is an early modern addition. The first room on the gate side has a fireplace, which indicates another possible space for the gatekeeper's lodge.[53] As mentioned above, the gatekeeper's lodge was integral to the control of life within the walls. As it is the only room with a fireplace, we can exclude the possibility that the rest of the building may have been the guest house. The two other rooms are large enough to have served agricultural purposes. We know that in 1336 Jean of Nesle gave to the monks the right to graze twenty cows and sixty pigs in the forest of Laigue.[54] Moreover, in the accounts of the priory of the eighteenth century it is stipulated that the monks should pay a "M. Brignant" for the repairs that he had accomplished on the farm buildings of Sainte-Croix.[55] Finally, on the north side of the outer courtyard, another farm building divided into three small rooms remains standing.

The clear separation between agricultural and quotidian spaces, and between quotidian and ritual/liturgical spaces, underscores the enclosed, contemplative nature of life within the priory. For the monks, that life was centered around ritual and repetition, prayer and isolation. The location of the priory next to the forest of Laigues as well as its enclosure guaranteed the isolation that the monks were seeking. Furthermore, they had access to food and water resources through their fishponds, their herds, and their agricultural exploitations inside the monastic precinct. Even with the small size of its community, the priory was built in order to lodge its brothers, oblates, and also visitors. This entire infrastructure allowed the brothers to focus on their liturgical duties without having to leave their enclosure often or, perhaps for some, at all.

Celestine monastic features

We will first consider the question of patronage and architectural symbolism, before turning to the coexistence of eremitical and Benedictine architectural features in the Celestine priories. Description and analysis of the organization of the spaces within the priory at Offémont allows

us to ask whether there are specific features, arrangements of structures, and spaces that are shared by houses of the Celestine order, which we will then consider.

In the fourteenth century, it was already common for powerful lay and ecclesiastic patrons to give large donations to monasteries. Donations could take several forms: money, goods, resources, or land. A donation could also imply an architectural creation through the construction of a funerary monument, a chapel, the gift of an artwork or altar furnishings, or even an entirely new monastery. There were many reasons to donate to a monastic community: as a demonstration of the piety of the donor; as an act intended to oblige a community's prayers on his/her behalf, with the aim of reducing the time the donor's soul might spend in purgatory; or as a celebration of a military victory.[56] From Charles V's reign it became increasingly important, and expected, for high dignitaries of the kingdom to demonstrate their social rank and power through expensive patronage and donations.[57] Therefore, it was important to identify the donor with their heraldic devices and sometimes their sculpted or painted representation. This is the case, for example, at the Carthusian monastery of Champmol outside Dijon, founded in 1383 by the duke and duchess of Burgundy, Philip the Bold and Marguerite III.[58] In order to assert their status as founders, as well as their piety, both Philip and his wife were represented in the church portal.

During this period, the Celestine order became an integral part of Charles V's pursuit of legitimacy and authority. Through the Paris priory and the figural decoration of its western portal, but also through the foundation of the priory of Limay-les-Mantes, the Celestine order became closely linked to the French monarchy. Honoring the Celestines had again become a political act of reverence toward the crown.[59] Thus, Celestine monasteries of the French province are marked by images of powerful ecclesiastical and lay patrons. As an example of the latter, the Celestine priory of Marcoussis, founded by Jean of Montaigu (d. 1409) in 1403, was a monument celebrating the glory of its founder and of the king. The lord of Montaigu was an important member of the royal court as he served Charles VI as grand treasurer of France. The sculpture representing Jean of Montaigu was seen on the church portal next to the king, Charles VI. On the opposite side the effigy of his wife, Jacqueline de la Grange (d. 1422) could be seen next to the queen Isabeau of Bavaria (d. 1435).[60]

Another example is found at the Celestine priory in Paris. In addition to the representation of the royal couple on the portal, the church had three chapels on its south side. These chapels were filled with burials of the heart and entrails of many French kings, as well as tombs of princes, high dignitaries, and ecclesiastical lords. From Jean II (d. 1364) to Charles IX (d. 1574) almost every king of France had their heart or their entrails buried in the Paris priory, which thus assumed the role of a secondary Saint-Denis.[61] Louis I, duke of Orleans, the brother of Charles VI, chose the Celestines as his preferred monastic order. In addition to his generosity toward almost all the houses of the Celestine French province, he founded chapels in the priories of Paris, Saint-Pierre-en-Chastres, Avignon, and Amiens, among others. After his assassination in 1407 by the men of his rival, John the Fearless (d. 1419), he was buried in the chapel he had founded in the Celestine priory of Paris. His wife, Valentine Visconti, was buried next to him after her death in 1408.[62]

The powerful patrons of Sainte-Croix-sous-Offémont also left their mark on the architecture of the site (Fig. 15). The three empty niches on the church façade were probably once filled with

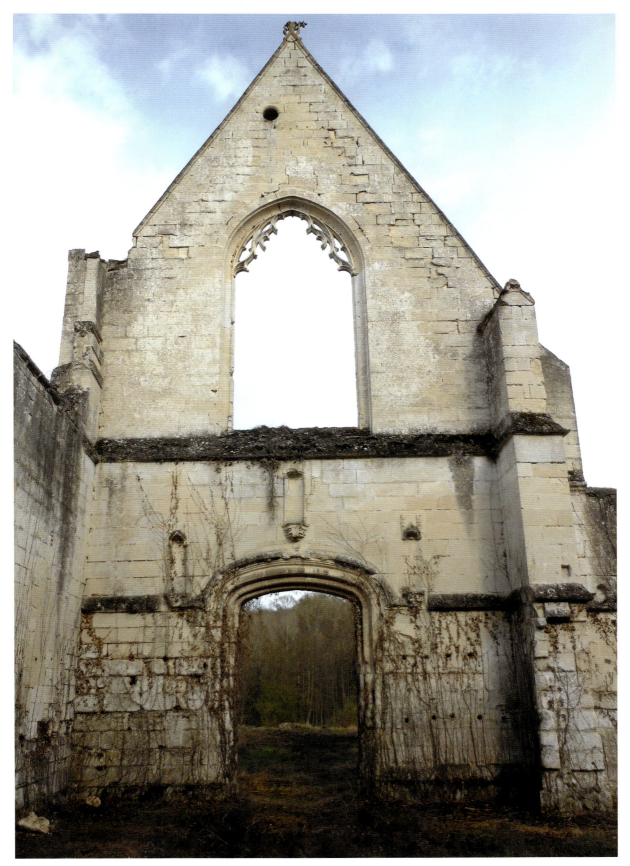

15
View of the west façade of the church of Sainte-Croix-sous-Offémont, 2018

Coat of arms of the Dauphin of France

Arms of Sainte-Croix-sous-Offémont mixing the cross of the Celestine order with the arms of the House of Nesle

Coat of arms of the House of Orléans

16 Three heraldic representations on the ceiling of the cloister of Sainte-Croix-sous-Offémont, 2018.

statues of the founders, Jean I de Nesle and Marguerite de Mello, or of Jean VI de Bruges and Louise de Nesle, who helped restore the church in the early sixteenth century, flanking Saint Peter Celestine in the central niche above the portal, and thus reproducing the model of the Paris priory. Each of the four chapels on the south side of the church had sculpted heraldries of the donors as well as burial monuments and commemorative plaques.[63] Sculpted heraldic devices of the royal family were to be seen on the cloister's ceiling and walls. Moreover, symbols of patrons were also painted on walls and on stained glass (Fig. 16).[64] In the church and its chapels, the sources describe seventeen windows representing portraits of the donors, sometimes with their families, or their coats of arms. Indeed, there were probably more representations since the sources only described the "most noticeable" ones. All of these representations were seen by the brothers of Sainte-Croix-sous-Offémont every day, reminding them of the perpetual debt that required them to pray for their patrons' souls.

The organization of spaces within an architectural complex is profoundly connected to the ways in which people use it or live within it. Our observations of the architectural remains at Offémont thus lend insight into the routines of the Celestine monks, how they moved between spaces, where they ate and where they slept. Around the cloister of Offémont, the layout of chapter room and sacristy beneath the dormitory on the east range, as well as the kitchen and refectory located on the cloister range opposite the church, are similar to what one encounters in many Benedictine monasteries. This organization is already the layout visible in the ninth-century plan of Saint-Gall and is consistent with Benedictine architectural organization in the ensuing centuries.[65]

Nevertheless, we see at Offémont and other Celestine priories elements characteristic of orders with eremitical tendencies, such as the Camaldolese, Vallombrosians, and even Carthusians.[66] Here, the main similarity is the church. Many of the churches of these orders are simple, single-vessel buildings of modest dimensions, very much like the church at Saint-Croix-sous-Offémont. Partly this reflects the small size of communities in the eremitic tradition, but it is also an architectural expression of the ideal of simplicity and modesty common to those orders.

Except for a few examples, the churches of the Celestine order have the same characteristics as Sainte-Croix-sous-Offémont. The Paris priory's church was a single nave structure, with a five-sided apse, and chapels added to its south side. The priories at Saint-Pierre-en-Chastres and Sens present single naves with a semi-circular chevet, and a door giving access to another room behind the choir. We do not possess a great deal of information about the function of this room, but given its location and the comparisons we can make, it could have functioned as the sacristy or as a retro-choir. We know Carthusians built retro-choirs in some of their churches, as has been recently shown for Bourgfontaine.[67] The construction phases of Sainte-Croix-sous-Offémont and Saint-Pierre-en-Chastres show that the churches originally had a single nave and that the side chapels were added afterward, which seems to be the case for most Celestine churches.

The modest dimensions and forms of these churches bring the space back to its primary function. It is the place where the brothers gather to celebrate divine liturgy as it is stipulated in the Benedictine Rule. The simplicity of these buildings seems reminiscent of the oratories of eremitical communities, like Pietro da Morrone's in Italy, where hermits gathered daily before going back to their isolated and individual spiritual work.[68]

Concerning the other spaces in the priory, the dormitory seems to be an emblematic place for the Celestine order, where the Benedictine Rule and the eremitical ideal meet. Indeed, Saint Benedict's Rule stipulates that the monks are all to sleep together in the same place.[69] In traditional Benedictine monasteries, the dormitory is a large and open room, where the monks slept next to one another.[70] In contrast, coenobitic orders with eremitical tendencies often chose to sleep in individual cells. Some of these cells resemble small houses, sometimes with a small garden attached to it. This is the case in the monastery of Camaldoli in Tuscany, for example.[71] The Carthusians are also well known for their custom of grouping individual cells around a large cloister.[72] In the constitutions of the Celestine order, it is stipulated that each brother had to sleep in an individual cell. This requirement appears in the first known legislative text of the Celestine order from the end of the thirteenth century.[73] The cell was a strictly personal space, and no brother could enter the cell of another. The prior was the only person allowed to enter another's cell, and that was solely for purposes of inspection.[74] In the first decades of the community that Pietro da Morrone gathered around him, each member slept in a separate cave, and the idea of dividing the dormitory into individual cells may, ultimately, be reminiscent of this time.

At Sainte-Croix-sous-Offémont, the vestiges of the dormitory are too limited to allow us to understand its plan. We must therefore look to the iconographic and textual evidence. The dormitory plan of Saint-Pierre-en-Chastres, drawn after the monks left the priory, allows us to see the interior arrangement of the dormitory (Fig. 17). On the second story of the eastern claustral range fifteen cells can be counted. A central corridor provides access to all of the cells. At its north end, the larger cell bears an inscription that identifies it as the cell of the prior (*chambre du prieur*). On its south end, a large staircase provided a means for the monks to access the church for matins. While the plan alone is not enough to affirm that the dormitory of Saint-Pierre-en-Chastres was separated into cells in the fourteenth century, the plan, together with the stipulation in the Celestine customs regarding individual cells strongly suggests that it was. Moreover, the obituary of Saint-Pierre-en-Chastres written in the fourteenth century confirms that the Celestine brothers had already adopted this architectural feature. In 1376,

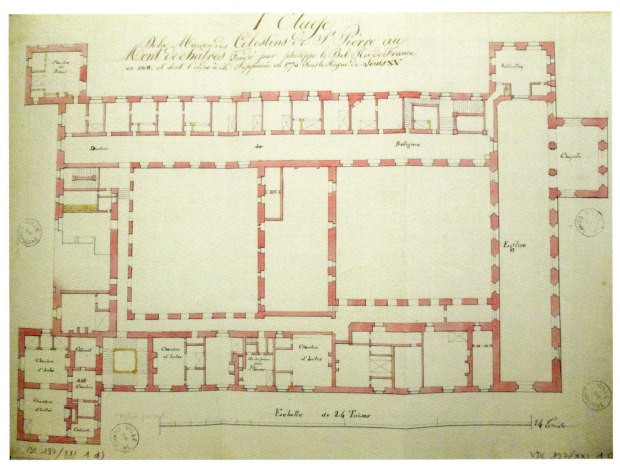

17 Compiègne, Bibliothèque municipale de Compiègne, Plan of the second floor of the eastern claustral range at Saint-Pierre-en-Chastres, Anonymous, 18th-19th century, VCD 197–XXI.

a priest from Crépy-en-Valois donated money to support the creation of an opening for a new brother. The donation mentions that the brother will have to sleep in "the third cell of the dormitory, overlooking the vineyard."[75]

Even though the Celestines provide an early example of a dormitory divided into individual cells, they were not the only congregation to follow the model of the eremitical orders of the eleventh and twelfth centuries. The Franciscans, who first slept in a common dormitory, started to divide their dormitories into separate cells during the thirteenth century, as the case of the house at Châlons-en-Champagne reveals.[76] In the following centuries, many Benedictine monasteries divided their dormitories into individual cells, but this tendency was progressively applied, and it only became common around the sixteenth century. In Celestine priories, the dormitory cells were probably built at first with wooden partitions before using stone in the ensuing centuries. The interior of each cell had to be visible from the common corridor, so we can image openings in the doors. Only a few items of furniture were allowed. The prior could inspect the cell at least every month and confiscate valuables at his discretion, in order to prevent any abuse.[77]

Thus, from the hermit caves of the primitive order founded by Pietro da Morrone, to the dormitory cells seen in late medieval monasteries, it is evident that Celestine brothers maintained

an eremitical spirit. The use of dormitories, a communal space, divided into individual cells, reflects a duality of experience and a tension between a desire to follow the Benedictine Rule and a need for isolation rooted in an eremitical heritage.

From the mountainous region of the Abruzzo to more distant realms, Pietro da Morrone's order evolved, investing in new spaces and relationships with powerful persons. From their eremitic roots, through their establishment within the Benedictine order, to the creation of a quasi-separate French Celestine movement, their ways of building monasteries changed. We cannot define a Celestine architecture entirely distinct from other eremitic orders. As we have seen, however, their methods of planning relate to the specific monastic and historical experience of their order. Always quick to adapt to the current trends, their demise was also in line with changing times, as it occurred during the *siècle des Lumières* when their monastic ideal had lost its relevance. In 1778 the last monk of Sainte-Croix left the priory, thereby leaving the buildings as sole witnesses to their passage.

Primary Works

Beauvais, Archives Départementales de l'Oise (ADO):
 H6795–7009, Domaine de Sainte-Croix-sous-Offémont, 14th-18th centuries.

Chantilly, Archives du Château de Chantilly (ACC):
 1–GE-001, Biens de la Maison de Montmorency, 1481–1607.

Paris, Archives nationales de France (AN):
 K185, n°16, Célestins d'Offémont, 1331–1370.
 Q^1 857, Titres de l'arrondissement de Compiègne, 13^e-18^e siècles.
 G^9 73, États des biens et pièces relatives à la suppression des Célestins de Sainte-Croix-sous-Offémont, 18th century.

Paris, Bibliothèque Nationale de France (BnF):
 MS 790, Constitutions des Célestins, 15th century.
 MS 928, f°109–44, Recueil concernant les Célestins, *Instituta Beati Petri*, 16th century.
 MS lat. 13891, dom Placide Bertheau, Mémoires sur Compiègne.
 MS NAF 6675, Simon Plarion, "Généalogie historique des seigneurs d'Offémont et maison de Nesle, et fondation des Célestins de Sainte-Croix en Froideval sous Offémont," 16th century. Genealogy available through the 18th century copy by dom Brice.

Secondary Works

Aniel 1983: Jean-Pierre Aniel, *Les Maisons de Chartreux des origines à la chartreuse de Pavie* (Geneva: Droz, 1983).

Becquet 1719: Antoine Becquet, *Gallicae Coelestinorum Congregationis Ordinis S. Benedicti monasterium fundationes virorumque vita aut scriptis illustrium elogia historica* (Paris: n.p., 1719).

Benedict 1982: *The Rule of Saint Benedict in English*, trans. from the Latin by Timothy Fry (Collegeville: Liturgical Press, 1982).

Berdeaux-le Brazibec 2007: Marie-Laure Berdeaux-le Brazibec, "Viollet-le-Duc, les fouilles de Champlieu et du camp de Saint-Pierre et le dessein archéologique de Napoléon III," in Seridji 2007, 84–95.

Beurrier 1634: Louis Beurrier, *Histoire du monastère et couvent des pères célestins de Paris, contenant les antiquités et privilèges ensemble les tombeaux et épitaphes des rois des ducs d'Orléans et autres illustres personnes* (Paris: Pierre Chevalier, 1634).

Bonde and Maines 2013: Sheila Bonde and Clark Maines, "The Heart of the Matter: Valois Patronage of the Charterhouse at Bourgfontaine," in Hourihane 2013, 76–98.

Bonde and Maines 2014: Sheila Bonde and Clark Maines, "Bourgfontaine: une Chartreuse royale du XIV^e siècle, sondages et prospection," unpublished field report available at the Service régional de l'archéologie des Hauts de France, Amiens, 2014.

Borchardt 2006: Karl Borchardt, *Die Cölestiner: eine Mönchsgemeinschaft des späteren Mittelalters* (Husum, Germany: Matthiesen, 2006).

Bouchet d'Argis 1742: Antoine-Gaspard Bouchet d'Argis, "Mémoire historique concernant la seigneurie de Marcoussis et le prieuré des Célestins qui est dans le même lieu," *Mercure de France*, n°1 (1742): 1279–1293.

Bouteiller 1862: E. Bouteiller, "Notice sur le couvent des Célestins de Metz," *Extrait des Mémoires de l'Académie impériale de Metz*, 43 (1862): 467–517.

Braunfels 1975: Wolfgang Braunfels, *Monasteries of Western Europe: The Architecture of the Orders* (London: Thames and Hudson, 1975).

Caby 1995: Cécile Caby, "Érémitisme et 'inurbamento' dans l'ordre camaldule à la fin du Moyen Âge," *Médiévales*, 28 (1995): 79–92.

Caby 1999: Cécile Caby, ed., *De l'érémitisme rural au monachisme urbain. Les Camaldules en Italie à la fin du Moyen Âge* (Rome: École française de Rome, 1999).

Caby 2014: Cécile Caby, ed., *Camaldoli e l'ordine camaldolese dalle origini alla fine del XV secolo* (Cesena: Centro Storico Benedettino Italiano, 2014).

Cazelles 1958: Raymond Cazelles, *La société politique et la crise de la royauté sous Philippe de Valois* (Paris: Librairie d'Argences, 1958).

Comte 1996: Sonia Comte, "Les Célestins, le roi et le pape: Les monastères d'Avignon et de Gentilly et le pouvoir," *Provence Historique*, 184 (1996): 229–251.

Coppack 1990: Glyn Coppack, *Abbeys and Priories* (London: Batford, 1990).

De Roucy 1869: Albert de Roucy, "L'obituaire des célestins de Saint-Pierre-en-Chastres," *Bulletin de la Société historique de Compiègne*, 1 (1869): 185–193.

Di Carlo 2003: Stefania di Carlo, *I celestini di Parigi* (Aquila: SpazioArte, 2003).

Éwig 1860: Léon Éwig, *Compiègne et ses environs, nouvelle édition, revue, corrigeé et augmentée* (Compiègne: J. Dubois et fils, 1860).

Faucherre 2001: Nicolas Faucherre, "L'enceinte de Paris," in Pleybert 2001, 76–85.

Fruit 1988: Élie Fruit, ed., *Histoire de Compiègne* (Dunkerque: Édition des Beffrois, 1988).

Gaude-Ferragu 2005: Murielle Gaude-Ferragu, *D'or et de cendres, la mort et les funérailles des princes dans le royaume de France au bas moyen-âge* (Villeneuve d'Ascq: Presses Universitaires du Septentrion, 2005), 42–59.

Guenée 2004: Bernard Guenée, "Introduction," in Taburet-Delahaye 2004, 19–20.

Guynemer 1912: Paul Guynemer, *La seigneurie d'Offémont* (Compiègne: Société historique de Compiègne, 1912).

Herde 1994: Peter Herde, "Célestin V," in Levillain 1994, 319–322.

Horn and Born 1979: Walter Horn and Ernest Born, *Plan of St. Gall*, 3 vols. (Berkeley: University of California Press, 1979).

Hourihane 2013: Colum Hourihane, ed., *Patronage, Power and Agency in Medieval Art*. Princeton, Index of Christian Art, Occasional Papers, XV (University Park, PA: Pennsylvania State University Press, 2013).

Jansen 1998: Virginia Jansen, "Architecture and Community in Medieval Monastic Dormitories," in Lillich 1998, 59–94.

Jouve 1976: Michel Jouve, "Sondages sur l'oppidum de Saint-Pierre-en-Chastres à Vieux-Moulin," *Revue archéologique de l'Oise*, 8 (1976): 39–44.

Labande 1903: Léon Honoré Labande, "La dernière fondation des Papes d'Avignon. Le couvent des Célestins," *L'Art*, 52 (1903): 586–599.

Lambin 1905: Paul Lambin, *Histoire de Saint-Pierre-en-Chastres et de ses dépendances*, (Compiègne: Impr. du Progrès de l'Oise,1905).

Lassus 1849: Jean-Baptiste-Antoine Lassus, "Monastère des Célestins du mont de Chastres, en la forêt de Cuise," *Bulletin du Comité historique des arts et monuments: archéologie, beaux-arts* (1849): 47–64 and 80–92.

Lawrence 2001: C. H. Lawrence, *Medieval Monasticism: Forms of Religious Life in Western Europe in the Middle Ages*, 3rd ed. (London: Longman, 2001).

Le Maire 1648: François le Maire, *Histoire de l'église et diocèse d'Orléans, augmentées en cette seconde édition de plusieurs choses mémorables* (Orléans: Maria Paris, 1648).

Lenoir 1867: Albert Lenoir, *Statistique monumentale de Paris* (Paris: Imprimerie impériale, 1867).

Le Roy de Pierrefitte 1862: Jean-Baptiste le Roy de Pierrefitte, "Prieuré de Ternes," *Mémoires de la Société des sciences naturelles et archéologiques de la Creuse*, 4 (1862): 66–91.

Levillain 1994: Philippe Levillain, dir., *Dictionnaire historique de la papauté* (Paris: Fayard, 1994).

Lillich 1998: Meredith Lillich, ed., *Studies in Cistercian Art and Architecture*, vol. 5. Cistercian Studies Series, 167 (Kalamazoo, MI: Cistercian Publications, 1998).

Lindquist 2008: Sherry C. M. Lindquist, *Agency, Visuality and Society at the Chartreuse de Champmol* (Abingdon-on-Thames: Routledge, 2008).

Mazon 1889: Albin Mazon, *Essai historique sur le Vivarais pendant la Guerre de Cent Ans (1337–1453)* (Tournon: Parnin, 1889).

Mesqui 1988: Jean Mesqui, Île-de-France 2, les demeures seigneuriales (Paris: Picard, 1988).

Millin 1790–1798: Aubin-Louis Millin, *Antiquités nationales ou Recueil de monumens pour servir à l'histoire générale et particulière de l'empire françois, tels que tombeaux, inscriptions, statues ... tirés des abbayes, monastères, châteaux et autres lieux devenus domaines nationaux*, 5 vols. (Paris: Chez Marie François Drouhin, 1790–1798).

Nicod 1897: E. Nicod, "Le cardinal Pierre de Colombier," *Revue du Vivarais*, 5 (1897): 343–355.

Paoli 2004: Ugo Paoli, *Fonti per la storia della Condregazione Celestina nell'archico segreto Vaticano* (Cesena: Centro Storico Benedettino Italiano, 2004).

Pellegrini 2004: Luigi Pellegrini, "Dall 'Ordo morronensium' all 'Ordo celestinorum," in Giorgio Picasso and Mauro Tagliabue, eds., *Il monachesimo italiano nel secolo della grande crisi: Atti del V Convegno di studi storici sull'Italia benedettina* (Cesena: Centro Storico Benedettino Italiano, 2004), 327–349.

Perkinson 2013: Stephen Perkinson, "Portraits and their Patrons: Reconsidering Agency in Late Medieval Likenesses," in Hourihane 2013, 236–254.

Piganiol de la Force 1765: Jean-Aimar Piganiol de la Force, *Description historique de la ville de Paris et de ses environs*, 10 vols. (Paris: Libraires associés, 1765).

Plagnieux 2006: Philippe Plagnieux, "Jean de Montaigu ou la résistible ascension d'un parvenu à la lumière des arts," in Taburet-Delahaye 2006, 103–118.

Pleybert 2001: Frédéric Pleybert, dir., *Paris et Charles V, Arts et Architecure* (Paris: Action artistique de la Ville de Paris, 2001).

Pommier 1915: Alexandre Pommier, *Essai sur le Monastère d'Ambert ès forest d'Orléans, son origine et sa suppression* (Orléans: Paul Pigelet et fils, 1915).

Rodière 1925: Roger Rodière, Épitaphier *de Picardie* (Paris: Picard, 1925).

Seridji 2007: Dominique Seridji, ed., *Viollet-le-Duc à Pierrefonds et dans l'Oise* (Pierrefonds: Centre des Monuments Nationaux, 2007).

Shaw 2018: Robert Shaw, *The Celestine Monks of France, c. 1350–1450: Observant Reform in an Age of Schism, Council and War* (Amsterdam: Amsterdam University Press, 2018).

Sustrac 1899: Charles Sustrac, "Les Célestins de France, essai sur leur histoire et leurs constitutions (1300–1789)," PhD dissertation (Paris: École Nationale des Chartes, 1899).

Taburet-Delahaye 2004: Élisabeth Taburet-Delahaye, ed., *Paris 1400 les arts sous Charles VI* (Paris: Fayard, 2004).

Taburet-Delahaye 2006: Élisabeth Taburet-Delahaye, *La création artistique en France autour de 1400* (Paris: École du Louvre, 2006).

Viollet-le-Duc 1862: Eugène Viollet-le-Duc, "Fouilles du camp de Saint-Pierre, forêt de Compiègne," *Revue archéologique*, 5 (1862): 282–283.

Volti 2003: Panayota Volti, *Les couvents des ordres mendiants et leur environnement à la fin du Moyen Âge* (Paris: CNRS, 2003).

NOTES TO THE TEXT

1. Pellegrini 2004.
2. Borchardt 2006, 311–318.
3. Paoli 2004, 8.
4. Borchardt 2006, 32; Paoli 2004, 12.
5. On 1 June 1263, Pope Urban IV issued the bull *Cum Sicut*, asking Nicolas da Fossa, bishop of Chieti, to incorporate the eremitical community within the Benedictine order. Paoli 2004, 5; Borchardt 2006, 19; Shaw 2018, 8.
6. Pope Gregory X issued the bull *Religiosam vitam eligentibus* on 22 March 1275 during the Council of Lyon. See Becquet 1719, XII-XIII; Paoli 2004, 5; Borchardt 2006, 19 and 23; Shaw 2018, 8.
7. Paoli 2004, 4; Borchardt 2006, 18–19.
8. Paoli 2004, 12–13; Borchardt 2006, 34; Herde 1994, 320.
9. "*Inurbamento*" is used by Caby 1995, to describe this phenomenon. On the first urban Carthusian and Camaldolian settlements, see Aniel 1983, 48, and Caby 1999. See also Gustafson in this volume.
10. Borchardt 2006, 54.
11. This interdiction is found in the *Instituta Beati Petri* that were probably written by Pietro da Morrone and/or his close companions between 1275 and 1294. See the sixteenth-century copy of this text in Paris, BnF, MS 928, fols. 109–144, Recueil concernant les Célestins, *Instituta Beati Petri*.
12. On this priory, see Beurrier 1634; Becquet 1719, 8–18; Piganiol de la Force 1765, IV:180–278; Millin 1790–1798, I:1–172; Lenoir 1867, 171–189; Di Carlo 2003.
13. We do not know exactly when these constitutions were written. See the fifteenth-century copy of the constitutions, Paris BnF, MS 790, Constitutions des Célestins; See also Sustrac 1899, 150–151; Borchardt 2006, 333–501; Shaw 2018, 73.
14. Piganiol de la Force 1765, IV:17; Millin 1790–1798, I:2; Faucherre 2001, 76–85.
15. The new fortifications of Avignon were undertaken by Pope Clement VI in 1349 and pursued by Innocent VI. Becquet 1719, 28–39; Labande 1903; Comte 1996.
16. On the priory of Ambert, see: Le Maire 1648, 128; Becquet 1719, 3–5; Pommier 1915. On the priory of Saint-Pierre-en-Chastres, see: Becquet 1719, 5–6; Lassus 1849; Éwig 1860, 141; Lambin 1905; Borchardt 2006, 74–75.
17. Between 1861 and 1865, Napoléon III asked Viollet-le-Duc to supervise an archeological operation at Mont Saint-Pierre in order to seek vestiges of a supposed oppidum. Viollet-le-Duc 1862; Jouve 1976; Berdeaux-le Brazibec 2007.
18. At Ambert, the priory had belonged to the order of Saint-Victor in Paris, while the priory at Saint-Pierre was a possession of the Benedictine abbey of Saint-Crépin-le-Grand in Soissons.
19. Becquet 1719, 6–7; Le Roy de Pierrefitte 1862; Borchardt 2006, 70–71.
20. Becquet 1719, 20–22; Mazon 1889, 108–123; Nicod 1897; Borchardt 2006, 72.
21. Beurrier 1634, 58–61; Piganiol de la Force 1765, IV:183; Borchardt 2006, 77.
22. In the bull *Sacræ vestræ religionis* of 25 January 1380, the antipope Clement VII gave the French Celestines the right to create their own province. Beurrier 1634, 177–180; Becquet 1719, 12–14; Paoli 2004, 24.
23. See Robert Shaw's study in this volume, where he observes that several French Celestines became heads of the order and that two houses in Italy came under French control.
24. The "hermit pope" was one of the names given to Célestine V after his resignation. Borchardt 2006, 64–72.
25. Cazelles 1958, 124 and 170.
26. Paris, AN, K185, n°16, Célestins d'Offémont, April 1331, Jean de Nesle, Charte de fondation de Sainte-Croix-sous-Offémont.
27. Becquet 1719, 46–47; Guynemer 1912, 84.
28. Paris, AN, K185, n°16, Célestins d'Offémont, Jean de Nesle, Charte de Fondation de Sainte-Croix-sous-Offémont, April 1331: ". . . une maison avec l'entreclos des fossez et des haies ainsy comme elle se comporte au lieu-dit Froideval, dessous nostre chastel d'Ouffémont, laquel maison est appelé le Val Sainte Croix dès ores en avant à tousjours."
29. The manuscript of Dom Bertheau is difficult to understand and the date the author wrote is unclear: Paris, BnF, MS lat. 13891, dom Placide Bertheau, Mémoires sur Compiègne, fol. 136. On the chapel, see Paris, AN, Q^1 857, Marguerite de Mello, Charte de fondation de la chapelle Sainte-Madeleine, 15 August 1340.
30. Beauvais, ADO, H6795–7009, Domaine de Sainte-Croix-sous-Offémont, 14th-18th centuries. For Fère-en-Tardenois, see Mesqui 1988, 197–203.
31. Fruit 1988, 94.
32. Chantilly, ACC, 1–GE-001, Biens de la Maison de Montmorency, 1481–1607.
33. Paris, BnF, MS lat. 13891, Bertheau, Mémoires, fol. 138; Guynemer 1912, 89.
34. Guynemer 1912, 81–118.
35. Paris, BnF, MS NAF 6675, Plarion, Généalogie historique . . .; Paris, BnF, MS lat. 13891, Bertheau, Mémoires.
36. Today the domain of the priory is attached to the castle and its limits are different.

37 *Benedict* 1982, chapter 48, 69–71.

38 *Benedict* 1982, chapter 66, 90–91.

39 One of the communicating chapels still had its altar in 1912. See Guynemer 1912, 96–97 and 107–108.

40 Lenoir 1867, vol. 3, pl. III.

41 Beauvais, ADO, H6989, fols. 1–8, État des revenus de Sainte-Croix tant en grain qu'argent affermé à différents particuliers.

42 Guynemer 1912, 99–100.

43 Paris, BnF, MS NAF6675, Plarion, Généalogie historique . . ., fols. 17–20; Guynemer 1912, 95–98.

44 Guynemer 1912, pl. XI. Guynemer makes no mention of the provenance of these fragments.

45 Paris, BnF, MS NAF6675, Plarion, Généalogie historique . . ., fols. 34–35; Guynemer 1912, 110.

46 Representations of the cloister of Offémont all show the cloister regularized in contrast to the surveyed reality.

47 Guynemer 1912, 110–113.

48 Paris, BnF, MS NAF6675, Plarion, Généalogie historique . . ., fol. 20; Guynemer 1912, 113.

49 Guynemer 1912, 98–99 and 116–117.

50 The vestiges of the south wall of this room are insufficient to affirm or deny the existence of a door at this location.

51 Paris, BnF, MS 928, Recueil concernant les Célestins, *Instituta Beati Petri*, fol. 109; Sustrac 1899, 187 and 209–210; Shaw 2018, 92.

52 Bouteiller 1862, 498–499.

53 Coppack 1990, 100.

54 Paris, AN, K185, n°16, Célestins d'Offémont, Jean de Nesle, Don de vingt vaches et soixante porcs aux Célestins de Sainte-Croix-sous-Offémont, 1331–1352.

55 Paris, AN, G⁹73, États des biens et pièces relatives à la suppression des Célestins de Sainte-Croix-sous-Offémont: "Plus la somme de quatre cent onze livres deux sols pour réparations faites à la ferme de Ste Croix suivant les huits quittances enliassées icy rapportées cy: 411 livres 2 sols."

56 Becquet 1719, 74–76.

57 Guenée 2004, 19.

58 Aniel 1983, 65. On Champmol, see Lindquist 2008. On the patronage of Philip and Marguerite of Burgundy, see Chilson-Parks in this volume.

59 Plagnieux 2006, 114.

60 Bouchet d'Argis 1742; Plagnieux 2006.

61 Beurrier 1634, 346–363.

62 Beurrier 1634, 277–420; Gaude-Ferragu 2005.

63 Paris, BnF, MS lat. 13891, Bertheau, Mémoires, fols. 136–143; Rodière 1925, 577–588.

64 Paris, BnF, MS NAF6675, Plarion, Généalogie historique . . ., fols. 17–20; Guynemer 1912, 95–99. On modes of the representation of individuals, portraiture, and heraldic devices, see Perkinson 2013.

65 Horn and Born 1979.

66 See, in this volume, Gustafson on the Vallombrosians and Camaldolese, as well as Bonde and Maines on the Tironensians and other monastic houses with an eremitic history. Both studies discuss churches with aisleless naves.

67 Bonde and Maines 2013. See also Bonde and Maines 2014, 22–58.

68 Vestiges of several hermitages still exist in the Abruzzo, such as Santo Spirito a Maiella and Sant'Onofrio al Morrone.

69 *Benedict* 1982, chapter 22, 49.

70 Jansen 1998.

71 Lawrence 2001, 149–152; Caby 1995, 67–88; Caby 1999, 177–178; Caby 2014.

72 Braunfels 1975, 111–124.

73 Paris, BnF, MS 928, Recueil concernant les Célestins, *Instituta Beati Petri*, fols. 107–144; Borchardt 2006, 245–246; Shaw 2018, 67.

74 Paris, BnF, MS 928, Recueil concernant les Célestins, *Instituta Beati Petri*, fol. 110; Shaw 2018, 73.

75 De Roucy 1869, 187.

76 Volti 2003, 169. The town changed its name from Châlons-sur-Marne in 1997.

77 Paris, BnF, MS 928, Recueil concernant les Célestins, *Instituta Beati Petri*, fol. 110; Shaw 2018, 73.

SUSAN WADE

The Illumination of the Eye, and the Rhetoric of Sanctity and Contemplative Prayer in the Early to Central Middle Ages

Tales of miraculous illumination of the blind were ubiquitous in medieval hagiography. These stories often followed a pattern: blind pilgrims proved their devotion through sustained prayer at a saint's shrine and were rewarded by an infusion of divine light that also restored their physical vision. Because miracles of restored sight are prevalent in medieval hagiography, these stories are sometimes considered to be a conventional type, a healing miracle based on the miracles of Christ, universal and somewhat generic.[1] In this paper, however, I will demonstrate that sight and its loss were linked in fuller ways to notions of sanctity and spiritual illumination. Providing re-readings of miracle texts through the lens of visuality, I will explore the specifically monastic attitudes toward sight and light in rules, devotional practices, and meditative devices between the sixth and twelfth centuries. Moreover, I will trace the stories of lay visitors to monastic sites who were also "illuminated" by their experiences. In this way, lay "illumination" created a textual construct for an "other" type of monasticism in which lay penitents were incorporated into the monastic practice of contemplative prayer.

Unlike Gospel stories of healing the blind, in which the blind typically are "made to see," medieval miracles of sight restoration tend to use a vocabulary of illumination in which beams of shining light are infused into blind eyes through saintly intervention.[2] Radiant light was also a compelling and pervasive manifestation of sanctity and divine visitation, and stories of miraculous illumination echo the language used to define the virtues of the saints. Paulinus of Nola wrote about light as a symbol of sanctity, describing saints as the glowing gold on Christ's head, shining "like glowing eyes in the head of the body," and "as gold fire tried by God."[3] Paulinus' description of the glowing light of the saints is mirrored in the *vita* of Gertrude of Nivelles: "[o]nce as Gertrude stood near the altar of S. Sixtus for prayer a sphere of bright flame descended above her," illuminating the entire basilica and the sisters of Gertrude's monastery.

The anonymous author of Gertrude's *vita* connected the light with her sanctity by asking "[w]hat could this manifestation of light have meant, unless it were a visitation of the true light that never ceases to illuminate the saints praying for themselves and others?"[4] The decoration of saintly relics with light-reflecting jewels and precious metals was, as Cynthia Hahn has recently noted, predicated on the understanding that illumination of these objects symbolized the reflected light of sanctity. Miracles of illumination of the blind could thus be understood as contributing to the "halo of light" that Hahn has identified as the ornamentation of saints.[5]

The term "visuality" refers to more than the act of corporeal seeing. Visuality, as Robert S. Nelson writes, "belongs to the humanities or social sciences because its effects, contexts, values, and intentions are socially constructed."[6] In late antiquity and the Middle Ages the meanings and values associated with the visual were often a fundamental aspect of the experience of sacred spaces. As Georgia Frank argues in *The Memory of the Eyes*, pilgrims' experience of viewing holy sites was interpreted as more than corporeal seeing, also involving use of the "eye of faith," with which pilgrims perceived and, through the rays of light emitted from their eyes, also visually touched past biblical events.[7] Thus, Franks asserts that for late antique pilgrims the visual was haptic, combining the senses of sight and touch.[8] Additionally, as Martin Jay notes, the "neo-Platonic search for the colorless white ecstasy of divine illumination" was essential to medieval religious and particularly mystical texts and thought.[9]

The significance of illumination to early medieval concepts of sanctity suggests that hagiographic accounts of the illumination of the blind symbolized a spiritual enlightenment that held a significance beyond physical healing.[10] Miraculous illumination of the blind represented an interior infusion of brilliant rays of light entering into the eyes and souls of people who were visually impaired, thus restoring sight by filling the eyes with a light that was then emitted from the eye to produce physical vision. A sixth-century miracle from Gregory of Tours' *de Virtutibus S. Martini* epitomizes many of the cultural and religious values earlier medieval authors associated with the restoration of visual perception. After being blinded while working in his master's field, a man named Ursulf journeyed to Saint Martin's shrine and spent two months praying for Martin's intercession. On Easter day, during celebration of the Eucharist, Saint Martin restored "the light of his (Ursulf's) eyes" which then reflected light like the stars.

> Then, as we have said, having come to the blessed tomb, and weeping and lamenting, he asked for the return of the sight which he had lost. On the day of his recovery, while the grace of the Lord's body was given to the people, the blessed bishop also deigned to give him back the light of his eyes, so that while the sun shone, the stars of his eyes reflected its light.[11]

Just as the light had descended over Saint Gertrude of Nivelles as she was praying, Ursulf's devoted and sustained prayers to Saint Martin were rewarded with divine illumination. Ursulf's illumination was, however, achieved through the intervention of Saint Martin, and thus, the light of Ursulf's eyes is a manifestation and reflection of Saint Martin's saintly luminescence. The last line of the miracle suggests that Ursulf dedicated himself to God, joining the monastic community at Tours:

... in the one whose corporal eyes the blessed Martin first opened to contemplate earthly things, he now illumined the eye of his heart so that he would not desire them; and he saw fit to dedicate to his service the one whom, so to speak, he caused to be reborn again in the world.[12]

The narrative ends with a pointed reference to monastic contemplative prayer and the monastic gaze, which directed the eye away from gazing at earthly things toward the meditative inward gaze directed at the divine. In this miracle, illumination of a lay penitent suggests a replication of the radiant visions that were one of the stated goals of monastic contemplative prayer. Ursulf is composed as a monastic model, an illuminated lay person who turns the gaze of his eyes inward; thus, a monastic "other" manifests the spiritual enlightenment that was the objective of monastic meditative prayer, and of monasticism itself.

Like this story from the *de Virtutibus S. Martini*, narratives describing miraculous illumination of the blind are meant to demonstrate the power of the saints, revealing the radiance that was believed to be both the essence, and the proof, of sanctity. Miraculous illumination infused the blind with light, making them receptacles for the brilliance of the saints. Much like the lustrous decoration of relics, stories of the illumination of the blind found in *vitae* and miracle books functioned as radiant hagiographic ornaments demonstrating the divine incandescence of the saints. Because miracles of restored sight recalled the illumination of sanctity, these types of miracles appear to have held a particular significance to their monastic and ecclesiastical authors who sometimes have incorporated rhetoric reminiscent of practices associated with monastic prayer in miracles of illumination. This inclusion metaphorically connected miraculous illumination with the radiant visions that were the objective of contemplative and sustained prayer. With a focus on miracles of illumination of the blind from the sixth, tenth, and eleventh centuries, this paper proposes that these types of miracles represented not only restoration of physical sight but also interrelated associations about contemplative prayer, spiritual illumination, radiant decoration of relics, and the possible use of lustrous reliquaries in practices of contemplative monastic prayer.

Medieval hagiographic texts typically did not describe the process of restored vision with common verbs of healing such as *sanare* or *curare*, but this does not mean that the miraculous restoration of physical sight only held metaphoric associations with spiritual illumination.[13] Even miracles that describe the actual restoration of sight as illumination do sometimes portray the blind as seeking a "cure."[14] As Irina Metzler has shown in her examination of miracles of sight restoration in *Disability in Medieval Europe*, medieval people understood that corporeal blindness could be caused by physical disorders and diseases.[15] Miracles of restored sight sometimes describe the anatomical reasons for blindness. More recently in *Stumbling Blocks Before the Blind*, Edward Wheatley has suggested that while the miraculous cure of blindness was meant to manifest the power of the saints, "medieval Christianity often constructed disability as a spiritually pathological site of absence of the divine."[16] For this reason, as in the story of the miraculous restoration of Ursulf's sight by Saint Martin, medieval miracles of sight restoration often appear to highlight the possibility of cure through, as Wheatley writes, "freedom from sin and increased personal faith."[17] Whether pre-modern European societies

viewed conditions such as blindness as a physical disability as opposed to a "norm," or—as Lennard J. Davis has argued—as a continuum that runs from the physical perfection represented by the saints to physical imperfection of those with bodily impairments, the pervasiveness of these types of miracle is evidence that blindness was considered to be a physical affliction that, like other types of bodily disease or impairment, merited miraculous intercession.[18] Without denying the physical aspects of blindness, this essay seeks to understand how monastic and ecclesiastical authors of the early to central Middle Ages connected illumination of the blind with the spiritual illumination that was the goal of monastic contemplative prayer and meditation.

Light and sight in late antique and medieval optical theories

The description of restored sight as an infusion of light is attributable to late antique and early medieval optical theories that associated the sensory perception of physical sight with illumination of the physical eye. As Suzanne Conklin Akbari writes, theories of extramission were promoted through the works of Neoplatonist authors such as Plotinus, Porphyry, Proclus, and particularly a ninth-century translation of the Pseudo-Dionysius.[19] Translations of Plato's *Timeaus* were particularly influential on the prevalence of belief in optical extramission, and Calcidius' Latin translation and detailed commentary on the *Timaeus*, composed around the beginning of the fifth century, held great importance to the understanding of the mechanics of physical vision in late antiquity and the early to central Middle Ages.[20] Although Calcidius' commentary only addressed the aspects of the *Timaeus* that he thought needed further explanation, the text of the commentary contains an analysis of Plato's writings about vision that specifically examines the connection between the eye and the soul.

Calcidius' construct of the process of seeing proposes three aspects of light that induce sight: light coming from the body of the viewer, rays of light from the sun, and light reflected from the object that is seen. Before beginning his examination of Plato's optical theories, Calcidius cites the works of Heraclitus that highlight the tangible nature of the connection between subject and object that was central to the understanding of the gaze of extramission. Calcidius states that "it is the aim of the soul (*animi*), he [Plato] said, being stretched out through movement of the eye in this way to touch and handle things worth notice."[21] Calcidius then moves to a consideration of optical theories of the Stoics, the geometers, and the peripatetics. As David Lindberg writes, "[b]y reporting that the geometers and the peripatetics classified vision according to three modes of radiation—direct, indirect, and refracted," Calcidius supplies the "standard organizing principle" of medieval optics.[22]

Calcidius begins a comprehensive examination of Plato's optical theory by discussing how the light of the eye is derived from the fire inside of the body, and identifies the rays of light that emanate from the eye as the "instrument of the soul" (*instrumentum animae*).[23] Calcidius finally delivers an explanation of physical sight by defining the process of coalescence of the three distinct aspects of light that is crucial to the process of seeing. In Calcidius' explanation of Plato's theory, the "principle cause" of vision is the ray of light that develops within the fire of the body and flows out from the eye. While sight cannot happen without the light of the sun, which is "closely related" to the light that is developed in the body and the flame that flows

from the visible bodies, it is the light of the soul that initiates sight. Calcidius creates a hierarchy of light that preferences the ray of light that develops within the fire of the body and is the instrument of the soul.

Miracles describing illumination of the blind were influenced by late antique and early medieval optical theories; thus, an initial examination of theological and philosophical theories of optics and sight is essential to understanding how the infusion of rays of miraculous light were considered to restore the function of the physical eye.[24] Early medieval scientific and medical texts outlining the workings of the physical eye depended upon the maintenance of encyclopedic knowledge through the reiteration of the traditions of Roman authors. Thus, an understanding of vision as a process of the extramission of light from the eye predominated in the early to central Middle Ages.[25]

While the understanding that sight was the highest of all the senses had a long tradition in the ancient world, optical theory that interpreted the soul as the origin of the light that flowed from the physical eye accentuated late antique and early medieval Christian theological writings about the primacy of sight. Like other late antique authors, Augustine of Hippo considered the sight of the physical eye as an important metaphor for knowing God.[26] Augustine's *De Trinitate* and *De Genesi ad litteram* both discuss the importance of sight and vision. In *De Trinitate*, which compares the workings of sight to the Trinity, Augustine declared the eyes to be "the most excellent of the body's senses" (*senus corporis maxime excellit*) because the use of the physical eye came closest to the experience of intellectual vision, used in contemplating and achieving visions of God.[27] In *De Genesi ad litteram* Augustine also identifies ocular vision as the most excellent of the senses. However, in this text Augustine uses physical sight as the foundation of a hierarchy of perception that begins with corporeal vision, moves to spiritual vision, and finally ends with intellectual vison, which cannot be deceived because—with God's help—the intellect seeks out meaning.[28]

Augustine's prodigious corpus of theological texts formed the basis of much of the scholarly theological and philosophical discussion of the Middle Ages, and although Augustine's primary concern was not an examination of the workings of the physical eye and the mechanisms that created vision, his writings on sight and vision were foundational to the medieval understanding of physical sight and spiritual vision well into the twelfth century.[29] Augustine also believed that corporeal vision was the result of a visual flow of light from the eyes, which created a single visual stream that produced the sensation of sight in the soul: "It is light, the finest element in bodies and hence more akin to soul than the others, that is first diffused in a pure state through the eyes and shines forth in rays from the eyes to behold visible objects."[30]

In *De Trinitate*, Augustine examines the processes of physical sight as a metaphor for the Trinity. As in Calcidius' commentary, Augustine held that sight involved the unified actions of three components: the object, which exists before being seen; the process of actual sight or vision that allows the object to be known to the viewer; and conscious intention, which actualizes the gaze. Augustine's understanding of the possible effects the physical gaze might have on the subject of the gaze is especially distinctive in book 11 of *De Trinitate*; here Augustine outlines the extramission of rays of light from the eye to discuss the operation of the physical eye as it sees an object. The haptic nature of the rays of light that shine from the physical eye is then explained with an example of how the gaze of extramission joins viewer to object:

The will possesses such power in uniting these two that it moves the sense to be formed to that thing which is seen, and keeps it fixed on it when it has been formed. And if it is so violent that it can be called love, or cupidity, or lust, it also exerts a vehement influence on the rest of the body of this living being. And where a duller and harder matter does not offer resistance, it changes it into a similar form and color. One may see how easily the little body of the chameleon changes into the colors that it sees.[31]

In the metaphor of the chameleon, each of the three aspects of physical sight works in unison to imprint the seen object on the soul. The will, which "belongs only to the soul," exerts a force that enables it to join itself with the object. However, this example also suggests the dangers inherent in the gaze; if the gaze is made too forceful through violent desire, the object that is viewed can mutate the physical nature of the viewer. Like the body of the chameleon, which changes its color because the color it sees is imprinted onto its "little body," the body of the viewer may be affected by violent use of the gaze.[32]

Light, sight, and blindness

The perceived tangibility of the physical gaze meant that the misuse of the gaze of the physical eye could be dangerous for the health of the soul, particularly for the soul of the monastic. Thus, blindness might have been viewed as a sort of natural claustration. However, when Paulinus of Nola wrote that he desired the "blindness of Samson," he was referring to the need to blind the "bodily eye by turning away from the things of the world."[33] Although it is possible to find references in which physical blindness blocked the temptations of the world, these instances are highly unusual in hagiographic miracle texts.[34] Rather, many early miracles of sight restoration reflect Augustine's assertation that miracles were meant as "witnesses to faith;" these miracles portray illumination of blindness as related to the correction of either an inability to see the truth of Christianity or heretical error.[35] In the *Ecclesiastical History of the English People*, Bede uses several miracles of eyesight to symbolize the reformation of early British Christianity; in one story, for example, the holy man Germanus simultaneously fills both the eyes of a blind girl and the minds of the Britons with the "light of truth" (*lumen veritatis implevit*), thereby turning the Britons away from the Pelagian heresy.[36] As Georgia Frank has noted, Christian authors of late antiquity privileged vision as the most significant sense through which to gain knowledge of God. Blindness thus represented a physical state of being but also presented a complicated theological problem when it came to explaining why God would create blindness.[37] As Frank summarizes, many late antique theologians maintained that "humans were born to see God," pointing to the eyes' position—the highest on the body—as indicative of an especially close proximity to God.[38] Thus, as Frank writes, these theologians "divinized" the eye and "reduced the horror of blindness."[39]

While the authors of early medieval miracles did not always associate blindness with paganism or sin, stories of miraculous restoration of sight always depicted blindness as a condition that impaired the body. If, as Lennard Davis has argued, the "regnant paradigm" concerning impairment was not based in a scale of normalcy but one of "ideal," then all humans

would fall below the perfection of the saints.[40] Perhaps because miracle texts were intended to demonstrate the idealized perfection and efficacy of sanctity, descriptions of miraculous restoration of sight often emphasized the limits of the blind penitent's physical condition as a contrast to the exemplary ideal represented by the saint. Like the illumination of Ursulf, described at the beginning of this essay, miracles of restored sight can include an explanation of the cause of blindness, the length of time a person had endured the condition, information about how the blind were led to the saint's shrine, and the amount of time the blind penitent spent in prayer and veneration at the saint's tomb.

Miracles of illumination sometimes discuss the condition of blind eyes, before they are restored, by describing a blockage that restricts the emission of light. This is in keeping with the understanding of Augustine who, in his discussion of how the blind see images in dreams but not while awake, suggested that blindness is caused by an inability to emit the rays of vision: "[W]hen blind people are awake the attention of vision is led along its customary way until it arrives at the eyes; and then it is not sent forth but remains there."[41] Indeed, the importance of the emission of light to physical vision is evident in how miracles of illumination use the Latin vocabulary of light interchangeably with words for vision and sight. This is the case in one of Saint Martin's miracles in which Gregory of Tours describes a deacon named Theodomer who was blinded by cataracts that "gravely obstructed" his eyes.[42] After Theodomer spent the night in penitential prayer and weeping at Martin's bed at Candes, ". . . the cataracts closing his eyes were opened, and he deserved to see the light."[43] With a graphic description of the pain caused by the medical intervention of physicians treating cataracts with iron lancets, Gregory ended the miracle by suggesting that these painful cures were unnecessary because through Saint Martin's power Theodormer's sight was restored.[44]

Miracles that did not describe a physical blockage preventing the emission of light from the eye also attributed blindness to a lack of light. In the seventh-century text of the *Vita Austreberta*, the abbess of Pavilly, one of the women religious of the monastery, "lost the light of her eyes" for twelve years before she was illuminated by the saint.[45] And in the life of the recluse Saint Monegund, found in Gregory of Tours' *Vita Patrum*, a woman, who "rudely watched" (*inportunae prospexit*) Monegund walking in a cloistered garden, was blinded and "lost her light" (*lumine caruit*).[46] The use of nouns and verbs of light and illumination to describe both blindness and restoration of sight continued into the central Middle Ages. For instance, the eleventh century *Vita S. Odilonis* by Jotsold (Iotsold) of Cluny contains several miracles that describe the blind men and women whose eyes are either "deprived of light" (*oculorum privatus lumine*) or "totally deprived of light" (*toto privatus lumine*) before they are rewarded with illumination at Odilo's sepulcher.[47]

While late antique and early medieval ocular theories certainly contributed to the interchangeable uses of light to describe restoration of sight, the illuminations described in hagiography also represented a powerful symbol of the light of the saints. Although miracles of illumination could be understood as metaphors for belief, stories of restored sight are also testaments of a literal infusion of light from the saints. All miracles are manifestations of the virtues of the saints; however, the language of illumination found in miracles of restored sight suggests that this type of miracle might particularly exemplify the nature of the light that symbolized the saints' special position as intercessors between God and humans. As Paulinus

of Nola claimed, the divine grace and reflected light from Christ could be seen in the glow of Saint Felix's bones: "There and then a light shone forth from the bones laid to rest, and from that time to the present day it has never grudged giving proofs of the saint's efficacious merit with its resources of healing."[48] Here, Paulinus equated the reflected light of Christ with the potential for miraculous healing from Saint Felix's bodily relics; the relics shine forth with miraculous healing light.

Gregory the Great's commentary on the *Song of Songs* furthers Paulinus' understanding that saints are illuminated by the reflected light of God, by suggesting that after they have left their bodies saints are deeply bathed in the flame of the "true light."[49] Light was proof of sanctity because the luminous reflection of the intense light of God was evidence of the saints' proximity to God. Gregory of Tours stated in his prologue to the *Virtutes* that ". . . the same Lord who now illuminates his (Martin's) tomb with powerful deeds worked in him when he was in the world." [50] When blind penitents sought restoration of their sight at Martin's tomb they were enlightened (*caecos illuminari*). According to Jotsold (Iotsold) of Cluny, when blind penitents prayed at the tomb of Saint Odilo they asked to receive their "lost light" (*lumen amissum recepit*).[51] By requesting to receive lost light, the blind were asking the saint to infuse their eyes, and thus souls, with light that symbolized the saint's proximity to the light of Christ. In this way, hagiographic texts of the miraculous illumination of the blind could be viewed as stories in which the reflected light of Christ is directly infused into the eyes of the petitioners.

Monastic prayer and illumination

Just as miracles of the illumination of the blind use a vocabulary in which light and sight are interchangeable, these miracles also sometimes incorporate rhetoric that suggests the processes that monastic authors advocated for meditative prayer. As with miracles of illumination, the ultimate goal of meditative prayer was a vision of the burning intensity of divine light. In order to achieve illuminating visions, monastic authors warned that the eye of the soul must remain pure by guarding the corporeal eye from misuse. Early monastic rules restricting the physical gaze of monks and women religious illustrate how the physical gaze of extramission was believed to affect the purity of the soul, and these rules often draw compelling connections between the gaze of the corporeal eye and that of the eye of the soul. Chapter Four of Augustine's *Praeceptum* specifically deals with lust and the possibility of carnality through the use of the eye, with the injunction that "[w]hen you see a woman do not cast (*iaciuntur*) your eyes on her or any women. You are forbidden to see women when you are out of the house."[52] Augustine's use of the verb *iacere* in the first part of this proscription about looking suggests a particularly potent and intent use of the gaze. By also forbidding monks to see (*videre*) women, however, Augustine directed his monks not just to censor their viewing but to control their eyes completely when out of the monastery.

Like Augustine's *Praeceptum*, many early rules regulate the gaze of monks and women religious. Unlike Augustine's rules for urban monks, Caesarius of Arles' regulation for the strict enclosure of women religious might suggest that women need not control their eyes since their ability to gaze at men would be limited by claustration.[53] However, chapter 23 of Caesarius' *Rule for Virgins* admonishes women religious "let not concupiscence of the eye (*concupiscentia*

oculorum) of any man spring up in you at the devil's instigation, nor should you say you have chaste souls if you have unchaste eyes (*oculos inpudicos*)."[54] Caesarius' directive to guard the eye furthers the close association between the eye, the soul, and the heart by stating that impure eyes are messengers for impure hearts.

The concept that the gaze was directed by the intent of the soul is best illustrated by the instructions for maintaining purity found in chapter 8 of the sixth-century *Rule of the Master*. The chapter begins by discussing the fragility of the human body as the "lodging place" of the soul.[55] The Master situates the heart as the locus of the soul and warns monks that the soul seeks to escape the walls of the body (*corporali muro*) through the "windows" (*fenestras*) of the eyes and through the mouth and ears.[56] These openings of the body are highly susceptible to sin because the soul activates each of the senses, "the seeing of the eyes, the speaking of the mouth, the hearing of the ears."[57] To protect the soul from impure desires the Master advises that first monks must ". . . close the windows of the eyes to its desires and lower the gaze, fixing it on the ground." When the eyes are cast down ". . . the soul will not long for whatever it sees."[58] While the Master asserts that the mouth and ears represent other openings through which the soul could seek sin, it is the eyes that are the windows through which the soul may seek "the object of its desires."[59]

Although the *Benedictine Rule* contains no specific regulation to guard the eye, like the Master, Benedict instructed that to maintain humility monks should keep their eyes focused on the ground, effectively cloistering the gaze.[60] Like the *Rule of the Master*, Benedict's rule restricts the uses of orifices like the mouth and the ear.[61] The *Benedictine Rule*, however, contains no direct injunction against using corporeal sight to gaze at women. Nevertheless, Benedict begins his rule with an instruction suggesting the spiritual use of the inner eye. In verse 9 of the "Prologue" Benedict exhorts monks to rise each day with their "eyes open to divine light."[62] Use of the inner eye is also discussed in verse 47 of chapter 4, "The Tools of Good Works," which warns that monks should ". . . keep the prospect of death before your eyes every day."[63] Benedict then states that the first step on the ladder of humility is ". . . placing the fear of God before his eyes at all times."[64] The twelfth and final step of humility is to show humility at all times by keeping the eye focused on the ground.[65] Eyes that are focused on the ground are effectively cloistered, maintaining the outer aspect of humility while protecting the monk's corporeal sight from dangerous viewing.

Although all of these regulations are meant to guard against bodily sin, the close connection between the eye and the soul meant that maintaining the purity of the eye was essential for monastic meditative prayer. Regulations to "guard the eye" turned the monastic gaze from its focus on the world to concentrate instead on holding images and words, including the face of Christ, within the inner spiritual eye. As in the case of blind penitents, the reward for sustained visualization of Christ's face was illumination. As Cassian wrote in his Tenth Conference on Prayer:

> But they alone see his Godhead with purest eyes who mounting from humble and earthly tasks and thoughts go off with him to the lofty mountain of the desert which, free from the uproar of earthly thought and disturbance, removed from every taint of

vice, and exalted with the purest faith and with soaring virtue reveals the glory of his face and the image of his brightness to those who deserve to look upon him with the clean gaze of the soul.[66]

While *all* those who pray might see the face of Jesus, only those who have purified eyes are rewarded with the "image of Christ's brightness," in the "clean gaze of the soul."[67] As Karl Leyser has written, for Cassian "it was not the retreat into the desert, but the gaze into one's own soul which marked the beginning of the struggle against temptation."[68]

Consideration of Cassian's Tenth Conference returns us to the last lines of the miraculous illumination of Ursulf, in which Gregory of Tours uses language echoing Cassian's understanding of the reward for the claustration of the inward monastic gaze. Just as the practice of contemplative prayer will (in Cassian's estimation) be rewarded with the image of Christ's "brightness," Ursulf's devoted and sustained prayers to Saint Martin are rewarded with miraculous illumination, which consequently restores corporeal sight.

> . . . in the one whose corporeal eyes the blessed Martin first opened to contemplate earthly things, he now illumined the eye of his heart so that he would not desire them; and he saw fit to dedicate to his service the one whom, so to speak he caused to be reborn to the world.[69]

Illumination of the corporeal eye leads to illumination of the eyes of the heart, a monastic gaze directed from looking at earthly things toward meditations on the divine. Thus, Ursulf's ultimate reward is claustration of the physical eye as he joins the monastery and directs his gaze and his desires away from earthly things to achieve the greater reward of spiritual illumination. In this way, Gregory of Tours uses Ursulf as a kind of monastic facsimile, a man who discovers spiritual illumination and rebirth through illumination of the physical eye.

Spiritual and physical illumination and monastic spaces

Contemplative prayer was also portrayed as a path or "way," and as Mary Carruthers has discussed in *The Craft of Thought*, certain rhetorical techniques of holding in the mind images of a *ductus*, or an imaged path, were used to achieve visions of illumination.[70] Monks and women religious were taught to construct imaginary buildings in their minds as a framework to facilitate meditation. One quality of these imagined spaces was the ability they afforded the viewer to mentally move within them.[71] As Carruthers writes, the early ninth-century monastic Plan of Saint Gall has been identified as both a building schema and an outline for meditation on monastic life—"the earliest surviving example of an architectural *pictura*."[72] Carruthers, who refers to the Plan of Saint Gall as a "meditation machine," connects the *Plan*'s use of the word *templum* (for the church) to the late antique and early medieval penitential act of measuring the Tabernacle of Ezekiel.[73]

The use of buildings in meditative and penitential prayers was thus connected to architecture that could be real as well as imagined. Indeed, the connection between the spiritual directives

of monasticism and the monastery are apparent in the prologue to the Benedictine Rule, which describes the monastery as the "road to the Lord's tabernacle" (*viam ipsius tabernaculi*) and a "school for the Lord's service" (*dominici scola servitii*).[74] A chapter from Gregory the Great's *Dialogues*, in which Saint Benedict appears to the abbot and prior of a newly organized satellite monastery in a vision and tells them exactly how the monastery buildings should be organized, reinforces the understanding that the design and organization of monastery buildings were inspired by the divine.[75] The intertwining of monastic spiritual practice with the construction of monastery buildings is beautifully illustrated in the twelfth-century text by Peter of Celle in his *Liber de panibus*, which creates a *ductus* for meditation by equating monastery buildings to the physical attributes of Jesus:

> The chest of Jesus is there, the refectory; the bosom of Jesus is there, the dormitory; the face of Jesus is there, the oratory; the breadth the length the height and the depth of Jesus is there, the cloister; the community of Jesus and all the saints are there, the chapter-house; the stories about Jesus and the unity of the Father, Son and Holy Spirit are there, the auditorium.[76]

Mary Carruthers suggests that Peter internalized the meditative context of the *Plan of Saint Gall* and used it to build an image of Jesus that corresponds to the use of each specific area within the monastery. Peter prefaces these comparisons with another reflection on monastic architectural spaces by using the Psalms, which further emphasizes that although monastic buildings fulfilled the needs of the physical body the importance of these spaces was in their daily use for prayer and meditation. As Peter states "all places illustrate the tabernacle" (*omnium stationes et tabernacula illlustrat*):[77]

> The soul is led to the refectory, where without hunger it may be remade, without thirst it may be intoxicated and it may say: "He maketh me lie down in pastures" (Ps 23:2); in the dormitory where it may sleep without lethargy and it may say: "I will both lay me down in peace and sleep" (Ps 4:8); in the oratory where without weariness it may pray and it may say: "At dawn you will hear my voice" (Ps 5:3); in the cloister where without disdain it may sit and it may say: "in the shadow of your wings you have protected me" (Ps 17:8).[78]

When considered together, these passages build on each other to create twin rhetorical paths comprising a guided meditative tour of the monastery, building both an image of Jesus and presenting appropriate prayers for each space.

Miracles of illumination of the blind sometimes also portray the blind as they tread a path that leads to an infusion of radiant light. This is the case in a tenth-century miracle of Saint Ursmer of Lobbes recorded by Abbot Folcuin. This miracle takes place within the larger monastic precinct of Saint-Pierre de Lobbes, specifically in the crypt of Saint-Ursmer.[79] The miracle recounts the story of one of the monastery's own paupers, a blind woman who

was supported by the abbot's charity:

> One day the blind woman came to pray at Saint Ursmer's shrine and when she climbed the hill on which his reliquary church is placed, in a spot marked by an old oak tree, she perceived light vibrate around her as though it came through the tiniest cracks of the sanctuary; she was illuminated by the body of Saint Ursmer.[80]

Saint-Ursmer sits on a steep hill overlooking the river Sambre and the abbey church of Saint-Pierre (Fig. 1). Its complex history begins as a church of Notre-Dame de Lobbes, established in the seventh century by Saint Ursmer as a funerary parish within the larger precinct of the abbey of Saint-Pierre de Lobbes.[81] Notre-Dame received the burials, not only of Saint Ursmer himself, but also those of five of his sainted successors. By the mid-ninth century, the church had come to be known as Saint-Ursmer, largely because of the reputation of the sainted abbot and his holy successors.[82] From its foundation, the church was served by monks from Saint-Pierre. In the late tenth century, however, a community of twelve secular canons was installed at Saint-Ursmer, under the direction of a provost who was always to be a monk of the abbey.[83] For their prebends and other revenues, the canons were dependent on the abbot of Saint-Pierre.[84]

The church of Saint-Ursmer is an impressive, basilican structure, nearly 80 metres long and comprised of a nave flanked by aisles, a low western transept, a taller eastern one, and a short architectural choir terminating in a flat chevet (Figs. 1, 2). Entered from the west through a porch and tower, the crypt with the tomb of Saint Ursmer lies beneath the raised choir at the opposite end of the building (Fig. 3). While there has been some controversy about the construction dates for the church, it seems probable that the nave and western transept were built during the mid-ninth century, vestiges of the Carolingian phase of the building.[85] The porch and tower at the west end and the expanded choir were added in the late eleventh century under the aegis of the provost and monk, Olbaud.[86]

In the passage from Folcuin's account of the miracle of the blind woman, she climbed the hill towards the sarcophagus of the saint and her sight was fully restored by light coming from the sanctuary (Fig. 3). This narrative is evocative of the steps for prayer outlined in *De doctrina Christiana*, in which Augustine associated each step on the ascent towards God with spiritual illumination from an increasingly intense light and a correlating emotion ranging from fear to joy: "On fixing your gaze, to the extent that you are able, on this light as it sheds its rays from afar, and on perceiving that with your weak sight you cannot bear its brightness, you come to the fifth stage, that is to the stage of counsel which goes with mercy."[87] The blind woman becomes a surrogate for the monk or woman religious on the path of ascent toward God. The body of the saint, like the light of God, gradually illuminated the blind woman in a process that brought about the restoration of her physical vision. In this story, however, the particular attributes of an actual physical space are used to describe the blind woman's ascent to Ursmer's tomb. Illumination began to occur at a particular spot, an oak tree, which was halfway up the hill on which Ursmer's church sat. The description of this geographic marker suggests a specific spot at which other supplicants climbing the hill towards Ursmer's tomb might stop and contemplate the scope of the saint's power for spiritual illumination.

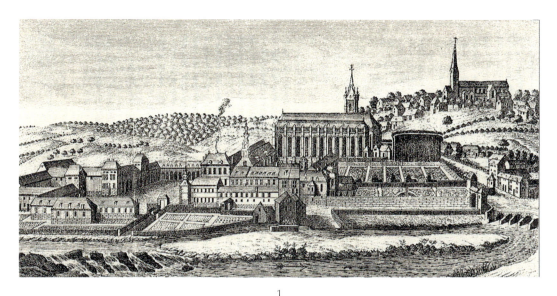

1
Anonymous, eighteenth engraving of Lobbes from the south showing the abbey of Saint-Pierre in the town and the collegiate church of Saint-Ursmer on the hill.

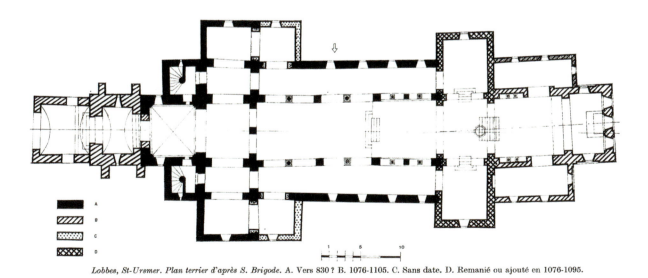

Lobbes, St-Ursmer. Plan terrier d'après S. Brigode. A. Vers 830 ? B. 1076-1105. C. Sans date. D. Remanié ou ajouté en 1076-1095.

2
Plan of the Collegiate Church of Saint-Ursmer.

3
Crypt of the Church of Saint-Ursmer, showing the sarcophagus of Saint Ursmer, 7th/8th century.

4
Church of Saint-Ursmer at Lobbes, view of the nave looking east.

For the monks of Lobbes who also climbed the hill—whether in procession on special feast days, or individually for private devotions—to the church that housed Saint Ursmer's sarcophagus, the narrative of this miracle transposes an ascent in actual geographic space onto the spiritual space of daily meditational practice. While some of the monastic buildings of Saint-Pierre were burned during a raid by the Hungarians in the spring of 954, the martyrial church at Lobbes survived essentially intact.[88] When monks climbed towards Saint Ursmer's church, the oak tree would have marked a spot at which they could stop and prepare themselves for the further ascent towards the saint, just as it would for pilgrims. However, monks could also hold the image of the hill and the oak tree in their minds as a *ductus*, mentally walking around the space to facilitate meditation.[89] The narrative of the ascent up the hill, with its specific description of the oak tree, could function as a mnemonic for the monks who lived and worked at the monastery. The monks could also incorporate entry into the monastery church and progression through the nave as they approached the crypt and Saint Ursmer's tomb physically or in their devotional meditations (Fig. 4). Like many important monastic churches in the region, Saint-Ursmer seems to have had an outer crypt from the mid-ninth century to the late eleventh.[90] Transformation of the eastern part of the church at that time brought access to the tomb—both visual and physical—inside the church.[91] By imagining each step, the monks, like the blind woman, could gradually become illuminated until they were granted a gift of inner vision.

While the illumination at Ursmer's shrine created a *ductus*, using the physical space of the ascent to his reliquary coffin, the first miracle describing the illumination of the blind Guibert in Bernard of Angers' early eleventh-century *Liber miraculorum sancta fidis* appears to construct a *ductus* that uses Sainte Foy's reliquary statue as its guide (Fig. 5). Guibert's eyes were ripped out while he was on pilgrimage to Foy's shrine at Conques. On the anniversary of his blinding, Sainte Foy appeared to Guibert in a vision promising to restore his eyesight if he made another pilgrimage to her shrine. In describing Guibert's vision of Sainte Foy, Bernard wrote a detailed description of Foy's face and clothing that constructed a *ductus* associating the colors of Foy's clothing with a hierarchy of virtue, beginning with the golden color of Foy's glowing clothing representing spiritual illumination.

Recalling Paulinus of Nola's assertions that the light from saints is a sign of their faith and closeness to God, Bernard begins with a commentary on the spiritual attributes of Sainte Foy's luminous clothing:

> [T]he character of her face and her marvelous style of dress—insofar as it was possible for Guibert to discern them—were, I think, not without a reason, for these things carry in themselves a very clear portent. If we are able to accept her clothes exceeding the measure of her person as the armor or protection of abounding faith, then the golden radiance of her clothing figures overtly the illumination of spiritual grace. Why the delicacy of the embroidery or the pleating of the sleeves if they do not reveal that she was clothed in divine wisdom?[92]

Bernard moves from an examination of the meanings associated with Sainte Foy's clothing to the decoration of her crown and the color of her face, correlating each of these parts of the

saint's body with a virtue:

> And, rightly, on the principal part of the body, that is, on the head, four gems were seen, through which we are able to observe clearly the quadrivium of the cardinal virtues: prudence, justice, fortitude, and temperance.... As to her face, I mentioned it first in my description because I learned of it first from my informant. Nevertheless I place it last in my exposition, because in her face I see a figure of the aim and pinnacle of her whole life, for I perceive that the whiteness of her face signifies charity. As a matter of fact, it is appropriate that through whiteness, which conquers other colors by its own radiance, charity, the most perfect of virtues is understood. I mentioned the whiteness of her face before describing her blush (which implies martyrdom), as did my informant, not inappropriately, because there is no way to attain the grace of martyrdom without the preeminence of charity.[93]

Thus, Bernard uses the associations of color and the physical features of Sainte Foy's body as plotting points that might guide the reader through a meditational map of Sainte Foy's virtuous qualities.

Bernard's description of Sainte Foy also bears a striking resemblance to her reliquary statue. The adjectives used to illustrate her flowing golden clothing, delicately pleated sleeves, and the glowing stones set in the crown on her head could be used to write a description of Sainte Foy's luminous reliquary. Focusing intently on a visual image, or *pictura*, was also a monastic meditative practice.[94] As Mary Carruthers writes, the image could be "either actualized in a visual medium or described in words for the eye of the mind." As we have seen, Cassian advocated that monks construct an image of Christ's face within the mind and hold it in front of the inner eye to facilitate withdrawal. In advising the monastic individual to think upon the image (*imago*) of Christ, Cassian considered that, while beginners would see a physical face, for monks more advanced in this practice the face of Christ would become ever more illuminated.[95] The resemblance between Bernard's description of Guibert's vision of Sainte Foy and her reliquary statue creates a *pictura* for meditation that is both actualized and described in words. Starting with an exposition on the meanings associated with the color of her clothing, Bernard moves to a consideration of how the jewels on Sainte Foy's head represent the cardinal virtues. Finally, reminiscent of Cassian, Bernard ends by focusing on how the brilliant white of Sainte Foy's face represents charity, identified by the author as a requirement for the "grace" of martyrdom. In ways similar to Peter of Celle's later architectural *ductus* comparing Jesus' body to monastic spaces, in this first miracle in the *Liber miraculorum sancta fidis* Bernard of Angers conducts the reader through an escalating consideration of how Sainte Foy's physical attributes signify her spiritual virtues. For readers (and listeners) familiar with Foy's reliquary, Bernard's *ductus* recalls the actual physical object and suggests a method for its use in monastic meditative practice.

The similarities between the description of Guibert's vision of Sainte Foy and her reliquary statue also suggest the importance of light and illumination to the cult of the saints. Hahn has suggested that the glowing nature of reliquaries was meant to "ennoble relics by encasing them

5 Conques, Reliquary Statue of Sainte-Foy, ninth century with accretions, photo ZiYouXunLu, Wikicommons.

to create enhanced light."[96] For Paulinus of Nola, the reliquary was meant to symbolize the risen body of the saint. As he writes: "Among those who rise, precedence will be given to the group whose flesh is covered with a shining garment."[97] If the process of illuminating the material of the relic is symbolic of the enhanced light of saints, the use of Sainte Foy's relic as a *ductus* furthers the idea that using the relic in this way could be a method of achieving illuminating visions through meditative prayer.

In their study of the *Liber miraculorum sancta fidis*, Kathleen Ashley and Pamela Sheingorn state that Bernard was writing for a sophisticated audience. He sent a copy to his former teacher Fulbert of Chartres. Ashely and Sheingorn suggest that because of his audience, Bernard "manipulated convention" by adding comic effects or additional, sometimes unexpected, information. This particular miracle, concerning Guibert's vision of Sainte Foy, makes numerous references to the imposition of blindness as punishment for lust.[98] Bernard, however, was also composing the text as a narration of his growing belief in the efficacy of Sainte Foy's wonder-working miracles; thus, in creating a *ductus* with the use of the reliquary, Bernard progresses from initially mocking the reliquary to deeming it an object worthy of veneration, including use in contemplative prayer.[99] Certainly, the monks of Conques and Bernard's audience at Chartres would have understood that the description of Foy's reliquary created a rhetorical path to be followed in order to move the mind to illumination. In this way, the first miracle in Bernard's *Liber miraculorum sancta fidis* describes the illumination of the physical eyes of the blind Guibert

while building a *ductus* for the spiritual illumination of the monks at Conques. Like Ursulf, Guibert also joined the monastery at Conques after his illumination but was unable to control himself from lustfully gazing at women and was finally punished by Sainte Foy and expelled from the monastery.

Conclusion

Based in late antique optical theories, miracles of sight restoration written from the fifth to eleventh centuries employed luminescent language that connected the restoration of blindness with a physical infusion of the light of Christ as it was reflected from the saints. For the monastic and episcopal authors of the miracle texts examined in this essay, this language of light also appears to have symbolized spiritual illumination, and perhaps for this reason miracles of sight restoration sometimes recall the rhetoric prescribed for meditative prayer.

Folcuin's miracle of the illumination of the blind woman at Lobbes features details that monks might have incorporated into a meditative tour of their own monastery. While monastic devotion at Lobbes had apparently lapsed in the ninth century, by the time of Folcuin and his successors, Heriger and Hugo, the monastery was experiencing a renewal of spiritual and educational practice.[100] Additionally, a later copy of the polyptyque of Lobbes, recorded from the ninth to the eleventh centuries, gives a list of books in the monastery's collection that included Augustine's *De doctrina* and Gregory the Great's *Dialogues*. As we have seen, each work either describes a path for illumination or attributes spiritual meaning to monastic buildings.[101] Bernard of Angers' description of Sainte Foy, in the miracle recounting the illumination of Guibert, is much more detailed in creating a word picture that mimics Sainte Foy's actual reliquary. Bernard's carefully ordered construction of color and virtue builds a more intentional *ductus* that might lead monks to meditative prayer and illumination. Bernard's educated audience at the School of Chartres would certainly have understood that the description of Sainte Foy's reliquary also represented a meditation on a hierarchy of virtue. Although the path to illumination in Folcuin's miracle story is not as elaborately constructed as the one found in Bernard of Angers' text, the difference between these two miracles may be telling. Whether or not Folcuin intended to build a *ductus*, as an author immersed in monastic culture and spiritual practice he recorded a miraculous sight restoration that occurred on a path from blindness to illumination.

Although those who experienced sight restoration are sometimes depicted as joining the monastery after their illumination, even in miracles in which the formerly blind do not join the monastery, lay supplicants become a monastic "other" through incorporation of rhetorical devices for contemplative prayer. In miracles of sight restoration, the illumination of non-monastic people could be seen as representing a kind of textual construct of an "other" type of monasticism in which stories of lay penitents were composed to inform and implant rhetorical devices central to the practice of contemplative prayer.

Patricia Cox Miller has identified hagiographic accounts that describe the light reflected from the saints as "verbal dazzle."[102] Adorning reliquaries and the spaces in which they existed with incandescent materials also created an atmosphere in which visitors would visually experience the light that was associated with the saints. The language that late antique and early medieval

authors used to discuss the decoration of reliquaries is evocative of the language describing the miraculous illumination of the blind. In ways similar to the shimmering incandescent light associated with the decoration of reliquaries, hagiographic accounts of illumination of the blind offer direct evidence that the saints were enrobed in light and could also be considered a type of verbal dazzle within miracle collections. In this way, hagiographic texts describing the miraculous illumination of the blind appear to have held profound symbolism connecting sight, radiance, and the "enhanced light" of luminous reliquaries. Additionally, these types of miracle stories created a parallel to the illuminating experience that pilgrims encountered as they venerated the luminous and shimmering reliquaries at saintly shrines. Considering that the monastic and clerical custodians of shrines recalled these stories for the pilgrims who came to venerate the saint, miracles of the illumination of the blind offered visitors a narrative that exemplified their own experience of illumination from the saints as they viewed incandescent reliquaries.[103] Thus, miracles of the illumination of the blind appear to have held significations that were associated with the transformative power of spiritual illumination for both monastic communities and lay pilgrims.

Abbreviations

AASS	Acta Sanctorum
CCSL	Corpus Christianorum, Series Latina
MGH SS	Monumenta Germaniae Historia Scriptores
PL	Patrologia Latina Cursus Completa

Primary Works

Mons, Archives de l'Etat:
 Mons MS 34 *Polyptyque of Lobbes*, 9th-11th centuries.

Printed Primary Works

Anon. 1864: Anonymous, *De S. Austreberta virgine in Belgio et Normannia*, in *AASS* (10 Feb.), 1864, cols. 417–424.

Anon. 1888: Anonymous, *Vitae sanctae Geretrudis*, ed. Bruno Krusch, *MGH SS rerum Merovingicarum*, 2 (Hannover: n.p., 1888), 447–474.

Anon. 1991: Anonymous, "Vita IV S. Brigidae," in *Medieval Irish Saints' Lives: An Introduction to the Vitae sanctorum hiberniae*, ed. Richard Sharpe (Oxford: Clarendon Press, 1991).

Augustine (1950) 1993: Augustine of Hippo, *City of God*, trans. Marcus Dodds (New York: Modern Library, [1950] 1993).

Augustine 1962: Augustine of Hippo, *De Doctrina Christiana*, ed. Joseph Martin, *CCSL*, 32 (Turnhout: Brepols, 1962).

Augustine 1968: Augustine of Hippo, *De Trinitate*, ed. W. J. Mountain, *CCSL*, 50 (Turnhout: Brepols, 1968).

Augustine 1982: Augustine of Hippo, *The Literal Meaning of Genesis*, trans. J. H. Taylor, 2 vols. Ancient Christian Writers, 41–42 (New York: Newman Press, 1982).

Augustine 1987: Augustine of Hippo, *Praeceptum*, in *Augustine of Hippo and His Monastic Rule*, ed. and trans. George Lawless (Oxford: Oxford University Press, 1987).

Augustine 1996: Augustine of Hippo, *Teaching Christianity*, trans. and notes Edmond Hill, O. P. (Hyde Park, New York: Augustinian Heritage Institute and New City Press, 1996).

Augustine 2002: Augustine of Hippo, *On the Trinity*, trans. Stephen McKenna (Cambridge: Cambridge University Press, 2002).

Augustine 2010: Augustine of Hippo, *De Genesi ad litteram, libri duodecim* [Library of Latin Texts Online] (Turnhout: Brepols, 2010).

Bede 1896: The Venerable Bede, *Venerabilis Baedae, Historiam ecclesiasticam gentis Anglorum*, ed. Charles Plummer (Oxford: Clarendon Press, 1896).

Bibliography

Bede 1930: The Venerable Bede, *Ecclesiastical History, Volume I: Books 1–3*, trans. J. E. King. Loeb Classical Library, 246 (Cambridge, MA: Harvard University Press, 1930).

Benedict of Nursia 2011: Benedict of Nursia, *The Rule of Saint-Benedict*, ed. and trans. Bruce L. Venarde. Dumbarton Oaks Medieval Library, 6 (Cambridge, MA: Harvard University Press, 2011).

Bernard of Angers 1994: Bernard of Angers, *Liber Miraculorum Sancta Fides*, ed. Luca Robertini (Spoleto: n.p., 1994).

Biblia Sacra 1977: *Biblia Sacra Latina: ex Biblia Sacra Vulatae Editionis* (Ilkley, Yorkshire: Scolar Press, 1977).

Calcidius 1962: Calcidius, *Timaeus: A Calcidio translatus commentarioque instructus*, ed. J. H. Waszink (London: Warburg Institute, 1962).

Caesarius of Arles 1988: Caesarius of Arles, *César d'Arles, Oeuvres Monastiques*, ed. and trans. Adalbert de Vogüé and Joël Courreau. Sources Chrétiennes, 345 (Paris: Les Éditions du Cerf, 1988).

Folcuin 1866: Folcuin of Lobbes, *Historia miraculorum sancti Ursmari*, in *AASS* (19 Apr.), 1866, cols. 561–570.

Gregory the Great 1979: Gregory the Great, *Dialogues*, ed. Paul Antin (Paris: Les Éditions du Cerf, 1979).

Gregory the Great 2012: Gregory the Great, *On Song of Songs*, ed. and trans. Mark DelCogliano (Collegeville, MN: Cistercian Publications and Liturgical Press, 2012).

Gregory of Tours (1885) 1969: Gregory of Tours, *de Virtutibus Sancti Martini*, in *MGH SS rerum Merovingicarum*, I, part 2, *Gregorii Episcopi Turonensis, Miracula et opera minora*, ed. Bruno Krusch (Hannover: Hahn, [1885] 1969).

Gregory of Tours 2015: Gregory of Tours, *Lives and Miracles*, ed. and trans. Giselle de Nie. Dumbarton Oaks Medieval Library, 39 (Cambridge MA: Harvard University Press, 2015).

Iotsold 1999: Iotsold (Jotsold) of Cluny, *Iotsald Von Saint-Claude, Vita Des Abtes Odilo Von Cluny*, in *MGH SS Rerum Germanicarum in Usum Scholarum Separa*, LXVIII, ed. Johannes Staub (Hannover: Hahn, 1999).

Cassian 1846: John Cassian (Joannis Cassiani), *Collationes*, in *PL*, 49 (Paris: Migne, 1846).

Cassian 1997: John Cassian (Joannis Cassiani), *The Conferences*, trans. Boniface Ramsey. Ancient Christian Writers, 57 (New York: Newman Press, 1997).

The Master 1964–1965: *La régle du Maître*, ed. and trans. Adalbert de Vogüé, 3 vols. Sources Chrétiennes, 105–107 (Paris: Éditions du Cerf, 1964–1965).

Paulinus of Nola 1847: Paulinus of Nola (S. Paulini Nolani), "*Epistolae*," in *PL*, 61 (Paris: Migne, 1847).

Paulinus of Nola 1967: Paulinus of Nola (S. Paulini Nolani), *Letters of Paulinus of Nola*, trans. P. G. Walsh, 2 vols. (New York: Newman Press, 1967).

Paulinus of Nola 1975: Paulinus of Nola (S. Paulini Nolani), *The Poems of Paulinus of Nola*. trans. P. G. Walsh (New York: Newman Press, 1975).

Peter of Celle 1855: Peter of Celle, *Liber de panibus*, in *PL*, 202 (Paris: Migne, 1855), cols. 929–1046.

Secondary Works

Barasch 2001: Moshe Barasch, *Blindness: A History of An Image in Western Thought* (New York: Routledge, 2001).

Brigode 1949: Simon Brigode, "L'architecture religieuse dans le Sud-Ouest de la Belgique. 1. Des origines à la fin du XVe siècle," *Bulletin de la Commission Royale des Monuments et des Sites* (1949): 85–345.

Carruthers 1998: Mary Carruthers, *The Craft of Thought: Meditation, Rhetoric, and the Making of Images, 400–1200* (Cambridge: Cambridge University Press, 1998).

Conklin-Akbari 2004: Suzanne Conklin-Akbari, *Seeing Through the Veil: Optical Theory and Medieval Allegory* (Toronto: University of Toronto Press, 2004).

Cox Miller 2000: Patricia Cox Miller, "'The Little Blue Flower is Red:' Relics and the Poetizing of the Body," *Journal of Early Christian Studies*, 8 (2000): 213–236.

Davis 2002: Lennard J. Davis, *Bending Over Backwards: Disability, Dismodernism and Other Difficult Positions* (New York: New York University Press, 2002).

Diem 2005: Albrecht Diem, *Das monastische Experiment, die Rolle der Keuscheit bei der Entsthehung des westlichen Klosterwesens. Vita regularis*: Ordnungen und Deutungen religiosen Leben sim Mittelalter, vol. 24 (Munster: LIT, 2005).

Dierkins 1985: Alain Dierkins, *Abbayes et Chapitres entre Sanbre et Meuse (VIIe-XIe siècles), Contribution à l'histoire religieuse des campagnes du Haut Moyen Age*. Beihefte der Francia, 14 (Sigmaringen: Jan Thorbecke Verlag, 1985).

Frank 2000a: Georgia Frank, *The Memory of the Eyes* (Berkeley: University of California Press, 2000).

Frank 2000b: Georgia Frank, "The Pilgrim's Gaze in the Age before Icons," in Nelson 2000a, 98–115.

Genicot 1972: Luc Genicot, *Les églises mosanes du XIe siècle. Livre I: Architecture et société* (Louvain: Université de Louvain, 1972).

Genicot 1979: Luc Genicot, "Les cryptes extérieures du pays mosan au XIe siècle: reflet typologique du passé carolingien?" *Cahiers de Civilisation médiévale*, 88 (1979): 337–347.

Grodecki 1958: Louis Grodecki, *L'architecture ottonienne, Au seuil de l'art roman* (Paris: Armand Colin, 1958).

Hahn 1997: Cynthia Hahn, "Seeing and Believing: The Construction of Sanctity in Early-Medieval Saints' Shrines," *Speculum*, 72 (1997): 1079–1106.

Hahn 2010: Cynthia Hahn, "What do Reliquaries do for Relics?" *Numen*, 57 (2010): 284–316.

Jay 1994: Martin Jay, *Downcast Eyes: The Denigration of Vision in Twentieth-Century French Thought* (Berkeley: University of California Press, 1994).

Kleinberg 1992: Ariad Kleinberg, *Prophets in Their Own Country: Living Saints and the Making of Sainthood in the Later Middle Ages* (Chicago: University of Chicago Press, 1992).

Leyser 2000: Karl Leyser, *Authority and Asceticism from Augustine to Gregory the Great* (Oxford: Clarendon Press, 2000).

Lindberg 1976: David C. Lindberg, *Theories of Vision from Al-Kindi to Kepler* (Chicago: University of Chicago Press, 1976).

Lindberg 2007: David C. Lindberg, *The Beginnings of Western Science* (Chicago: University of Chicago Press, 2007).

Metzler 2006: Irina Metzler, *Disability in Medieval Europe: Thinking about Physical Impairment during the High Middle Ages, c. 1100–1400* (New York: Routledge, 2006).

Nelson 2000a: Robert S. Nelson, ed., *Visuality Before and Beyond the Renaissance* (Cambridge: Cambridge University Press, 2000).

Nelson 2000b: Robert S. Nelson, "Introduction—Descartes's Cow and Other Domestications of the Visual," in Nelson 2000a, 1–21.

Sanderson 1971: Warren Sanderson, "Monastic Reform in Lorraine and the Architecture of the Outer Crypt, 950–1100," *Transactions of the American Philosophical Society*, new ser., 61, Pt. 6 (1971): 3–36.

Schulenburg 1998: Jane Schulenburg, *Forgetful of Their Sex: Female Sanctity and Society, ca 500–1100* (Chicago: University of Chicago Press, 1998).

Sheingorn 1995: Pamela Sheingorn, *The Book of Sainte-Foy*, (Philadelphia: University of Pennsylvania Press, 1995).

Sheingorn and Ashley 1999: Pamela Sheingorn and Kathleen Ashley, *Writing Faith: Text, Sign, and History in the Miracles of St. Foy* (Chicago: University of Chicago Press, 1999).

Sigal 1985: André Sigal, *L'Homme et le miracle dans la France médiévale XI-XII siècle* (Paris: Les Éditions du Cerf, 1985).

Somfai 2002: Anna Somfai, "The Eleventh-Century Shift in the Reception of Plato's *Timaeus* and Calcidius' Commentary," *Journal of the Warburg and Courtland Institutes*, 65 (2002): 1–21.

Ward 1987: Benedicta Ward, *Miracles and the Medieval Mind* (Philadelphia: University of Philadelphia Press, 1987).

Warichez 1909: Joseph Warichez, *L'Abbaye de Lobbes depuis les origins jusq'en 1200* (Paris: Casterman, 1909).

Wells 2010: Scott Wells, "The Exemplary blindness of Francis of Assisi," in *Disability in the Middle Ages: Reconsiderations and Reverberations*, ed. Joshua R. Eyler (Burlington, VT: Ashgate, 2010), 67–80.

Wheatly 2010: Edward Wheatly, *Stumbling Blocks Before the Blind: Medieval Constructions of Disability* (Ann Arbor: University of Michigan Press, 2010).

NOTES TO THE TEXT

1. Pierre-André Sigal includes miracles of restored sight with other miracles of healing, noting that "the process of healing eye lesions is not fundamentally different from those of other illnesses and infirmities." By using the reference to lesions, however, Sigal appears to assume that miracles of restored sight convey meaning mainly as thaumaturgical and highlights his emphasis on using quantitative analysis of miracles to uncover statistical data on medieval social attitudes. Sigal himself cites the need to contextualize miracles within their own time and geographical place but, as Ariad Kleinberg writes, "quantification treats all cases as equal" because it lacks focus on analysis of the language and narrative structures of particular types of miracles. This approach tends to distort and flatten individual meaning. Sigal 1985, 117–118 and 230–232; Kleinberg 1992, 11.

2. For instance, in Mark 8:25, a blind man's vision is "... restored so that he could see everything clearly." *Biblia Sacra* 1977, *... et restitutus est ita ut clare vidaret omnia*.

3. *Hoc enim aurum forma sanctorum est, qui in capite corporis, ut lumina micant, et sun aurum ignitum Deo*. Paulinus of Nola 1847, 274; Paulinus of Nola 1967, 2:29.

4. Anon. 1888, 458: *Quid istius lucis manifestatio indicabat nisi vere luminis visitatio qui omnem sanctum pro se et omnibus orantem inluminat?*

5. Hahn 2010, 292.

6. Nelson 2000b, 2.

7. Frank 2000a, 107. See also Frank 2000b.

8. Frank 2000a, 124.

9. Jay 1994, 39.

10. Hahn 1997, 1084.

11. Gregory of Tours 2015, Miracles of Saint Martin, Bk II, 13.4:556–557: *Dum eum claudere conatur, excaecatus est. Tunc, ut diximus, ad beatum sepulcrum veniens, flens et eiulans, visum quem perdiderat flagitabat. Die auem illa, dum populo gratia diminici corporis traderetur, et ei beatus antistes reddere lumen dignatus est ac, elucente sole, luminum suorum refulserunt stellae*.

12. Gregory of Tours 2015, Miracles of Saint Martin, Bk II, 13.5:558–559: *... cui corporales oculos ad contemplanda terrena prius aperuit, nunc cordis oculos, ne ea concupiscat, illuminavit; et ad suum dignatus est dicare servitium quem, ut ita dicam, renasci denuo fecit in mundum*.

13. In a boolean search of the online database for the *Patrologia Latina*, the key words *caeco illuminato* retrieved seventy-seven hits and forty matches. *Caeco sanato*, however, received only six hits and five matches, and the database found no hits or matches for *caeco curato*. See http://pld.chadwyck.com. This is also reflected in Gregory of Tours's *de Virtutibus S. Martini*, Bk III, wherein nine titles identify stories of sight restoration and eight specifically use the verb *inluminatus*. Gregory of Tours (1885) 1969, 180–181.

14. Anon. 1888, 466.

15. As Metzler found in the miracles of Saint Elisabeth of Marburg, "[m]any different symptoms are described" in the twenty-one miracles of restored sight, and many of the miracles include "dramatic healing descriptions." Metzler 2006, 237.

16. Wheatly 2010, 11.

17. Wheatly 2010, 11.

18. Davis 2002, 105. The idea of a continuum of perfection is supported by Scott Wells, who has argued that the thirteenth-century biographers of Saint Francis had difficulty reconciling the "abnormality" of Francis' blindness with the exemplarity of sanctity. Wells 2010, 69.

19. Conklin-Akbari 2004, 26.

20. Lindberg 1976, 89. Although Cicero's translation of the *Timeaus* was also known to medieval scholars, Calcidius' commentaries on the text were particularly important to medieval concepts of optics, as is evident from the 140 extant manuscript copies of the translation and commentary. Anna Somfai notes that from the ninth through the fifteenth century, 140 copies were made of Calcidius' texts while only 16 copies were made of Cicero's translation in the same period. There appears to have been a diminished interest in Cicero's translation after the tenth century when production of this volume dropped markedly. Somfai 2002, 4.

21. Calcidius 1962, 249: *At vero, Heraclitus, intimum motum, qui est intentio animi sive animadversio, porrigi dicit per oculorum meatus atque ita tangere tractareque visenda*.

22. Lindberg 1976, 89–90.

23. Calcidius 1962, 255.

24. Ward 1987, 3–4.

25. Lindberg 2007, 146–147.

26. For an examination of the importance of sight to early Christian writers of the East, see Frank 2000a, 115–118.

27. Augustine 1968, 334; Augustine 2002, 61.

28. Augustine 2010, 395–399, 12.25–14.30; and Augustine 1982, II:193–198.

29. Lindberg 1976, 89–90.

30. Augustine 2010, 401, 16.32: *Id est lux, primum per oculos sola diffunditur, emicat que in radiis oculorum ad visibilia contuenda*; and Augustine 1982, II:199.

31. Augustine 1968, 339; Augustine 2002, 66.

32. Augustine 1968, 339; Augustine 2002, 66.

33. Paulinus of Nola 1967, 2:25.

34. A rare case in which blindness is seen as claustration is found in the story of Daria from the *vita* of Saint Brigit of Ireland. Although she had been blind since birth, Daria begged Saint Brigit to restore her eyesight. Upon seeing the beauty of the world, Daria asked Brigit to

return her blindness because lack of sight made it easier to find God. Anon. 1991, 204.

35 Augustine (1950) 1993, 831. In later medieval art, characters such as Synagoga and the Anti-Christ are depicted as either blindfolded or blind in one eye, and many early medieval miracles of restored sight involving blind pagans are metaphors for conversion. Barasch 2001, 77–92.

36 In a second miracle, the orthodox missionary to the Britons, Augustine of Canterbury, and several Pelagian bishops all try to illuminate a blind man. Predictably, Augustine restores the man's sight and by doing so is declared the "herald of heavenly light." Bede 1930, 206–207.

37 Frank 2000a, 115.

38 Frank 2000a, 115.

39 Frank 2000a, 115.

40 Davis 2002, 105.

41 Augustine 2010, 20.42: . . . *cum autem vigilant caeci, ducitur per illa itinera intentio cernendi, quae cum ad loca venerit oculurum non exeritur foras*, 409; Augustine 1982, II:207.

42 Gregory of Tours 2015, Bk II, 19.3 (570–571): *graviter obseratos*.

43 Gregory of Tours 2015, Bk II, 19.3 (572–573): *Lucescente autem die, reseratis cataractis luminum, lumen videre promeruit*. In Giselle de Nie's excellent new translation of Gregory's *de Virtutibus* this is translated as "When the skies began to lighten at break of day, however, the cataracts closing his eyes were opened, and he deserved to see the light." However, as the clause reads "*reseratis cataractis luminum*," I would suggest that the light played a role in opening the cataracts.

44 Gregory of Tours 2015, Bk II, 19.4 (572–573).

45 Anon. 1864, 425.

46 Gregory of Tours 2015, de Monegunde, XIX.10 (272–273).

47 Iotsold 1999, Bk III. 8 (248) and Bk III. 6 (247), respectively: . . . *importunae prospexit, mox que, oculis clausis, lumine caruit*.

48 Paulinus of Nola 1975, 119.

49 Gregory the Great 2012, 171.

50 Gregory of Tours 2015, *Prologus*, Bk I, 1.1 (422–423): *Ille nunc exornans virtutibus eius tumulum, qui in eo operatus est cum esset in mundo*

51 Iotsold 1999, Bk III:6, 247.

52 Augustine 1987, 88.

53 Caesarius of Arles 1988, 198. During the turbulent era in which Caesarius established his monastery, enclosure created a safe space within the city of Arles to protect women religious from the problems associated with invasion and the upheavals of regime change. See Schulenburg 1998, 140. Leyser 2000, 89, has suggested that the rule of strict enclosure was probably also meant to signal that the women religious of Saint John's were chaste virgins who "fully deserved church support."

54 Caesarius of Arles 1988, 198.

55 The Master warns that the mouth is another avenue of escape for the soul and thus monks must guard their speech as well as their eyes and ears. The Master 1964–1965, 398–401. For an examination of the role of the eyes, ears, and most particularly the mouth in maintaining chastity in the Rule of the Master, see Diem 2005, 235–237.

56 The Master 1964–1965, I, 8:9–10 (400): . . . *in quo corporali muro quasi per quasdam fenestras oculorum*.

57 The Master 1964–1965, I, 8:17 (402): *Ergo si haec anima in nobis oculorum visum, oris eloquium, aurium agit auditum,*

58 The Master 1964–1965, I, 8:19–20 (402): . . . *claudat concupiscentiis suis oculorum fenestras et humiliatos declinet in terra aspectos,...nec quaecumque viderit anima concupiscit*.

59 The Master 1964–1965, vol. I, 8:9 (400): . . . *unum, in quo corporali muro quasi per quasdam fenestras oculorum foraminibus deintus animam credimus respicere et de intrinsecus concupiscentias suas ipsam semper intellegimus invitare;*

60 Benedict of Nursia 2011, VII: 63 (52–53)

61 Benedict of Nursia 2011, VII: 56 (52–53) and VI:1–8 (42–43) for the mouth; Prologue: 1 and 8–11 (2–3).

62 In his rule, Benedict encourages an understanding of the divine by simultaneously seeing and hearing God in the heart. *Regula Benedicti, prologus*: . . . *apertis oculis nostris ad deificum lumen* Benedict of Nursia 2011, Prologue: 9 (2–3).

63 Benedict of Nursia 2011, IV:47 (34–35): . . . *mortem cottidiae ante oculos suspectam habere*.

64 Benedict of Nursia 2011, VII:10 (46–47): *Primus itaque humilitatis gradus est, si timorem Dei sibi ante oculos semper ponens* In this way, the regulations for use of the eye in Benedict's rule reinforce the understanding that the monk has responsibility for his own salvation. Diem 2005, 237.

65 Benedict of Nursia 2011, VII:62–66 (52–53).

66 Cassian 1846, 847; Cassian 1997, 375.

67 Cassian 1846, 847; Cassian 1997, 375.

68 Leyser 2000, 49.

69 Gregory of Tours (1885) 1969, 163; Gregory of Tours 2015, 558.

70 Carruthers 1998, 116–117.

71 Carruthers 1998, 259; for the concept and use of the *ductus*, see also 116–170.

72 Carruthers 1998, 230.

73 Carruthers 1998, 238.

74 Benedict of Nursia 2011 Prologue: 45 (8–9) and Prologue: 23 (4–5).

75 Gregory the Great 1979, 203: *Nocte vero eadem, qua promissus unlucescebat dies eidem servo Dei, quem illic patrem constituerat, atque eius praeposito vir Domini in somnis apparuit, et loca singula, ubi quid aedificari debuisset, subtiliter designauit.* See also Carruthers 1998.

76 Peter of Celle 1855, 965: *In auditorio, ut ibi sine praevaricatione vivat. Pectus Jesu, ibi est refectorium; sinus Jesu ibi est dormitorium; vultus Jesu, ibi est oratorium; latitudo, longitudo, sublimitas et profundum Jesu, ibi est claustrum; consortium Jesu et ominium beatorum, ibi est capitulum; narrationes Jesu de Patris et Filii et Spiritus Sancti unitate, et de apertione mysterii incarnationis suae, ibi est auditorium.* See also Carruthers 1998, 238–239.

77 Peter of Celle 1855, 965.

78 Peter of Celle 1855, 965: *Ducitur anima in refectorio, ubi sine fame reficiatur, sine siti inebrietur et dicat: "In loco pascuae ibi; me collocavit"* (Ps XXIII:2) *In dormitorio, ut ibi sine torpore dormiat et dicat: "In pace in idipsum dormiam et requiescam"* (Ps IV:8) *In oratorio, ut ibi sine taedio oret et dicat: "Ad te orabo, Domine, mane exaudies vocem meam"* (Ps V:3) *In claustro, ut ibi sine fastidio sedeat et dicat: "In umbra alarum tuarum protexisti me"* (Ps XVII:8). NB: I have corrected Migne's psalm numbering to contemporary usage.

79 Lobbes was typical of many larger early medieval monasteries, like Centula and Saint-Médard in Soissons, in that there were several churches within the monastic precinct, each of which had a different function. See Dierkens 1985, 127, n. 321.

80 Folcuin 1864, *AASS*, April 19, col. 566: *Caeca tunc quaedam, [elemosynis Abbatis sustentata] eleemosyna Tredesendis, illius quae Stephano nupserat, alebatur. Haec quodam die orandi causa ad memoriam S. Ursmari venit: & dum montem, cui supra est ecclesia posita requiei ejus, scanderet; in intercapedine, quam quercus antiqua disterminat, ex adytis templi, [ad corpus S. Ursmari illuminatur:] quasi per tenuissimas rimulas, aliquantulum luminis se versus vibrare persensit. Progressa demum ad sancti Patris nostri tumulum, visui plene restituta est.*

81 For a recent summary of the history of Saint-Ursmer, see Dierkens 1985, 127–128 and 315–317 for earlier bibliography on the church. See also Genicot 1972, 48–53, and Brigode 1949, 115–117. For a larger study of the history of the church, see Warichez 1909.

82 Dierkens 1985, 127.

83 Dierkens 1985, 127–128. At least one canon of Saint-Ursmer is known to have become a monk of Saint-Pierre, further testimony of the close relationship between the two houses. See Dierkens 1985, 128 and n. 332.

84 Dierkens 1985, 128.

85 On the dating of the western transept and nave to the Carolingian period, see Brigode 1949, 118–132, whose excavations in the 1940s provided the material evidence for the early dating. Dierkens 1985, 134, accepts Brigode's dating of most of the building to the ninth century. For the contrary view, see Grodecki 1958, 55–59, whose interpretation and later dating is based on formal analysis.

86 For the additions to the west and east ends of the church, see Brigode 1949, 157–169; and Dierkens 1985, 135.

87 For instance, on the fifth step towards illumination, "[q]uam ubi aspexerit, quantum potest, in longinqua radiantem, suique aspectus infirmitate sustinere se illam lucem non posse persenserit; in quinto gradu." Augustine 1962, 37–38, and Augustine 1996, II:11 (137).

88 Saint-Ursmer's position above the valley gave the monks advanced warning because the brothers could see the dust rising from the hooves of the advancing army's horses. See Warichez 1909, 53.

89 Carruthers 1998, 259.

90 See Genicot 1979, 343–344, who makes an argument that the Carolingian church had an outer crypt, likely meaning that physical access, though not necessarily visual access, to the tomb of Saint-Ursmer was from the east.

91 Sanderson 1971, 14. It is unclear whether the outer crypt of Saint-Ursmer had one or two stories.

92 *Oris autem qualitas, quantum fas fuit huic, cui hec visio apparuit, discernere, sive mirabilis habitus non, ut reor, sine causa extiterunt; nam preclarum in se hec eadem gerunt portentum, siquidem vestes mensuram persone excedentes, armaturam sive protectionem exuberantis fidei possumus accipere quarum aureus fulgor spiritalis gratie illuminationem aperete figurat. Quid subtilitas picture manicarumve rugositas, nisi divine sapientie indaginem prefert?* Bernard of Angers 1994, 81. Translation Sheingorn 1995, 46–47.

93 Bernard of Angers 1994, 81: *Et merito in principali corporis parte, idest capite, sunt vise quatuor gemme, per quas liquido principalium virtutum, prudentie, iustitie, fortitudinis ac temperantie possumus advertere quaduvium. . . . Restat faciei qualitas, quam licet primam, ut a relatore didicimus, premisissemus, ultimam tamen in expositione nostra ponemus, quia in eadem, que est totius vite summa finisque, karitatem significari sentimus, per candorem videlicet faciei. Bene etenim per candorem, qui nitore sui alios colores vincit, karitas intelligitur, virtutum perfectissima, quem nos ante ruborem, qui martyrium insinuat, non absurde, ut a nostro relatore accepimus, premisimus, quia ad martyrii gratiam absque karitatis eminentia nequaquam pervenitur.* Translation Sheingorn 1995, 46–47.

94 Carruthers 1998, 203.

95 Cassian 1846, 827. In Cassian's words "the glory of his face" (*vultus eius*) and the "image of his brightness" (*claritatis imaginem*) are revealed to those who purify

and remove themselves from every earthly thought and disturbance.

96 Hahn 2010, 292.
97 Paulinus of Nola 1975, 302.
98 Sheingorn and Ashley 1999, 40–41.
99 Bernard of Angers 1994, 84–85.
100 See Warichez 1909, chap. 5.
101 Mons MS 34, fol. 40v.
102 Cox Miller 2000, 233.
103 Hahn 1997, 1084.

KYLE KILLIAN

Traditional Benedictine Monasteries in the Archdiocese of Reims: A Spatial Analytic Approach

Introduction

In his 1986 discussion of the "crisis of coenobitism," John Van Engen makes a compelling case to reclaim established Benedictine houses for our discussion of twelfth-century monastic reform.[1] He points to the success of these houses well into the middle part of that century and argues for the longstanding concern for reform in monastic culture throughout the Middle Ages. In his formulation, twelfth-century monastic reform took place in a specific socio-historical context—a social landscape—in which monasteries operated. A decade later, Giles Constable asserted that the polemical literature on the subject of twelfth-century reform was as much a Cluniac production as a Cistercian one. He pointed out that fault lines in the debate fell between individual visions of reform and not between monastic orders or cultures.[2] It follows that the question is not which monasteries or orders were reformed and which were not, but rather how each house or group of houses responded to the cultural environment of the twelfth century. Even those scholars, however, accepted the category of "traditional" Benedictine houses as a coherent group juxtaposed to newly articulated modes of reformed monastic life.[3]

Some recent scholarship has re-emphasized the complexity and variety of twelfth-century monastic life.[4] Ellen Arnold, for example, has illustrated how the monastic culture of the abbey of Stavelot-Malmedy was formed in part by the complex imaginary the monks developed with respect to the forests of the Ardennes. Kathryn Salzer presents the interlocking geopolitical borders that shaped the existence of Vaucelles as a Cistercian house. Stephen Vanderputten has observed that not all monastic houses responded in the same way to the idea of monastic reform at an institutional level. Rather than a simple conflict between reformed and non-reformed communities, he demonstrates that responses to reform are imbedded in a particular historical landscape.[5] In all three cases, the negotiated experience of a specific historical situation shaped how monastic communities related to changes in monastic culture. Building on studies of these

FIGURE 1 – Table listing abbots who were recorded at a meeting of black monks in Reims in 1131.

The first eighteen in order as listed in B. N. MS Latin 2677, folios 83v–84r. The last three in alphabetical order likely fill the erasures in that manuscript which gives twenty-one as the total number of signatories.

PLACE NAME	FOUNDATION	RE-FOUNDATION	ICONOGRAPHIC SOURCE
Erasure			
SAINT-NICOLAS-AUX-BOIS	1080		Monasticon Gallicanum, pl. 87
SAINT-QUENTIN-LE-MONT	644	943	Monasticon Gallicanum, pl. 89
NOYON, Saint-Eloi	640	986	Monasticon Gallicanum, pl. 90
SAINT-THIERRY	500	972, 993	Monasticon Gallicanum, pl. 95
CHEZY, Saint-Pierre	736		Monasticon Gallicanum, pl. 96
REBAIS, Saint-Pierre	635		Monasticon Gallicanum, pl. 60
LAGNY, Saint-Pierre	644	993, 1017/1018	Monasticon Gallicanum, pl. 67
LIESSIES, Saint-Lambert	741	1095	de Croÿ, 624-625
LAON, Saint-Vincent	580	961	Monasticon Gallicanum, pl. 88
ORBAIS, Saint-Pierre	670		Monasticon Gallicanum, pl. 98
SAINT-MICHEL-EN THIÈRACHE	670	940	—
HOMBLIÈRES, Sainte-Hunegonde	650	948	—
BEAUVAIS, Saint-Lucien	560		—
HAUTMONT, Saint-Pierre & Saint-Paul	649		de Croÿ, 263-263
Erasure			
CAMBRAI, Saint-Sépulchre	1064		—
SAINT-AMAND-EN TOURNAISIS	639		—
HASNON, Saint-Pierre	670	1065	de Croÿ, 260-261
LAON, Saint-Jean-Baptiste	641	1128	Monasticon Gallicanum, pl. 85
ANCHIN, Saint-Sauveur	1079		de Croÿ, 244-245
LOBBES, Saint-Pierre	691		—
SOISSONS, Saint-Médard	575		Monasticon Gallicanum, pl. 101

institutional and cultural landscapes, my essay brings together evidence for the physical and spatial dimensions of a small group of Benedictine houses within the archdiocese of Reims, which met several times during the 1130s to discuss relationships among their houses as they responded to monastic reform in the twelfth century (Fig. 1).

Two surviving documents and extracts from a now lost third record the decisions taken by those abbots in the early years of the 1130s. Recently, Vanderputten has brought together all three versions of this document into a critical edition of the texts.[6] In that article, he makes the compelling case that the statutes we use as evidence for a general chapter are not a singular artifact, but fragmentary pieces of evidence for a process that unfolded over several years. Neither of the extant versions of the text are preserved in the archives of abbeys whose abbots were listed as present. Instead, one survives in a customary for the abbey of Sainte-Rictrude-Saint-Pierre in Marchiennes and another in a collection of commentaries and letters in the archives of the abbey of Saint-Martin in Tournai.[7] Only one of the documents, that from Tournai, includes a list of abbots who were present in 1131. Moreover, the list comes in the middle of the text and two of the names have been erased at an uncertain date. In Figure 1, the first eighteen houses are listed in the order in which the names appear in the Tournai document, and includes the erasures. The last three houses listed on Figure 1 are houses for which there are compelling reasons to suppose that they were involved in this particular association. Berlière pointed out that the chronicle of Saint-Pierre de Lobbes discussed the support of Pope Innocent II for the work of reform in monasteries in the archdiocese of Reims, making it clear that the abbot of Lobbes was part of this initiative.[8] Both the abbots of Lobbes and Saint-Sauveur d'Anchin were among those addressed in a letter from Pope Innocent II praising their reform efforts.[9] The other ten abbots named in that letter are also listed in the Tournai document as attending the meeting of 1131. The third name, that of the abbot of Saint Médard in Soissons, hosted a meeting of the association's abbots in the following year, and so should be included on this list as well (Fig. 1).[10] Therefore, the list of abbots of the twenty-one abbeys on which this paper is based cannot be seen as definitive. It is possible that abbots of other houses were present and that the relationship among the twenty-one abbeys represented at the conference fluctuated over time. While these uncertainties make it difficult to perceive a single authoritative text, they foster the sense of communities actively involved with each other in an ongoing process of refining monastic life. The two documents are fragments that provide part of a picture of how one group of abbots saw the practice of monastic life within their communities.

Another part of that picture can be found in the physical spaces in which those communities practiced monastic life. Of these houses, substantial portions of the monastic churches survive for only three of them: Orbais, Saint-Michel-en-Thierache, and Lagny. Plans are known from archeological evidence and pictorial representations of four more churches (Saint-Thierry, Saint-Lucien in Beauvais, Saint-Médard in Soissons, and Saint-Vincent in Laon). Architectural remains of other structures within the monastic precincts survive only fragmentarily, but these have not been the subject of systematic study. While a full material study belongs to my much larger book project, in this article I want to focus on the spatial aspects of these houses—considering how they existed in the landscape and on the built environment in which their monks acted.[11] As we will see, the spatial center of these houses and their relationships complicates notions of institutional centers of gravity. The spatial center and the relationships among the houses

also indicate ways in which the existing monastic landscape both shaped and was altered by changing monastic cultures and new institutional forms within the archdiocese of Reims during the twelfth century. Institutional boundaries and distinctions between orders have governed our conception of monastic identity. Yet the spatial characteristics of these houses make clear that neither of these categories is sufficient to explain how and why these particular houses sought to form a community.

In the introduction to her important book on the subject of the "other monasticism" in Britain, Roberta Gilchrist argued that we should pay attention to those monastic institutions that were fundamental to the everyday religious life of the Middle Ages, even if those institutions were hard to see and only of regional, or even local, importance when viewed from the perspective of supra-regional monastic orders such as the Cistercians.[12] I base this essay on her notion that everyday monastic practice is essential to our understanding of houses that she might justifiably categorize as "mainstream." In other words, the "other monasticism" that I explore here is the situated context of monasteries that are involved in larger processes such as monastic reform and the development of centralized mechanisms of governance.

Community

In 1131, the abbots of twenty-one communities of black monks met in Reims to discuss the practice of religious life at their respective houses.[13] In the first half of the twelfth century the archdiocese of Reims consisted of eleven dioceses in the areas of what is today northeastern France and southwestern Belgium.[14] Succeeding meetings were held in Soissons (1132) and probably on three other occasions between 1154 and 1170.[15] As I will discuss later, the only abbey in the diocese of Reims that appears to be part of this group was Saint-Thierry, over fifteen kilometers northwest of the city of Reims. This raises several questions to which we do not currently have answers. One question is the location of the meeting itself. Did it take place at the abbey of Saint-Thierry rather than in the city itself? The meeting in Soissons was hosted by the abbey of Saint-Médard, located across the river Aisne from the episcopal town, and one part of the agreement reached by the abbots deals with the financial hardships both of travel to and the hosting of such a meeting. Therefore, the meeting may have been held just outside Reims in 1131. Yet the record seems specific about the location. Moreover, we know that the pope was in Reims that year for a council. Matthew Albino, papal legate at that time, wrote a letter in response to the Reims group's decisions that suggests a connection between the two meetings. The very important abbeys of Saint-Rémi and Saint-Nicaise in Reims do not seem to have been part of the group, but we might wonder whether one of them hosted the meeting. If so, how are we to understand their relationship to the monastic houses under discussion here? As Vanderputten and others have pointed out, the relationship between Cluniac affiliation and power structure in this region was complex. Patronage and political optics may have played an important role in how various Benedictine abbots presented themselves. It is my belief that a "thicker description" of monastic life as practice in these twenty-one locations will help provide part of what are undoubtedly multivalent answers to these questions.

The record of the 1131 meeting begins with the creation of a prayer association requiring that monks and lay brothers of each monastery participate in a complex set of prayers for the

deceased brothers of the other member monasteries.[16] In addition to the association, the abbots also called upon themselves to reinforce certain practices in the daily life of their respective monasteries. Familiar psalms were shortened or eliminated so that the monastic offices might be said more deliberately and with more gravity. The monks were abjured to refrain from eating meat unless sick, to keep silent at the table, and to be provided with readings during the meal. The abbots were enjoined to eat with their monks unless a pressing need prevented it. All of these provisions, of course, form part of the Benedictine rule. The need to reiterate them in 1131 implies, however, that they had fallen out of practice and that there was a desire to reinstate them, thereby reinforcing a more literal adherence to Benedict's rule.[17] Perhaps more controversial in the context of debates about monastic reform was the desire for absolute silence in the cloister. This seems a small detail and only merits a single sentence in the record of the abbots' decisions. A letter from the papal legate and former Cluniac monk, Matthew Albano, however, chastised the abbots who subscribed to the decisions of 1131 for departing from traditional Cluniac customs.[18] The legate made a point of citing silence in the cloister as damaging to a sense of community. The abbots responded to Albano by rejecting his characterization and asserting that they acted in the interest of preserving monastic ideals in their communities. The decisions taken by this group of twenty-one abbots, tied as those decisions were to the regulation of the internal life of their monasteries, would seem intended to bind a dispersed group of monasteries together into a single, larger community that was, in turn, intended to be seen as distinct from other groups of monasteries, as it evidently was by the papal legate.

The way that these abbeys were invested in the reform currents of the twelfth century may be suggested by their foundation histories considered as a group. Most of the twenty-one are early foundations, dating to the sixth and seventh century (Fig. 1). As such, they represent a group of houses that had been present in the monastic landscape of France almost from the beginning of Christianity in the West. Yet three of the houses—Anchin, Saint-Nicholas-aux-Bois, and Saint-Sépulcre in Cambrai—are later, eleventh-century foundations.[19] According to Elder, the abbots of Anchin and Saint-Nicholas-aux-Bois were particularly active in the years leading up to 1131 and appear in that sense to have been leaders among the group at Reims.[20] Furthermore, another three—Hasnon, Lagny, and Liessies—were re-founded more recently during the eleventh century and might reasonably be considered among this reform-minded group.[21] We might add to this the fact that Saint-Jean-Baptiste in Laon had been re-founded in 1128 just before the meeting. Thus, seven of twenty-one of these houses might be considered as part of a wave of eleventh-century foundations focused on issues of reform.[22] The group of twenty-one therefore embodies both the deep history of monasticism that undergirds the rhetoric of reform as a return to the primitive monastic life as well as the vitality of houses adapting to thrive in new social and religious circumstances.

Since Usmer Berlière at the turn of the last century, this meeting has been characterized as a general chapter.[23] In part, the term "general chapter" is a useful rubric focusing attention on the significant question of what made these particular houses come together as a body and what characterized their association. One approach to the study of these twenty-one monasteries has been to see in the decisions their abbots reached in 1131 the formation of an incipient order that relates in some way to the rise of the centralized Cistercian or Praemonstratensian models of monastic and canonical governance. In particular, the descriptions of life within these twenty-

one monasteries have resonated with the language of reform orders—especially that of the Cistercians. Stanislaus Ceglar worked to inscribe their activity within the development of Cistercian polemics. He highlighted associations between the abbots who led these houses, especially William of Saint-Thierry, and well-known figures in Cistercian circles.[24] Rozanne Elder accepted the idea that these abbots were reacting to new reform orders, especially the Cistercians. In order to understand that reaction, she charts the interpersonal relationships between the abbots who represented their house in the 1131 meeting. She presents these interactions in terms of density, or number of abbots at each event. She also presents each of the abbots by the length of their abbatial tenure at the house they represented when they met in 1131. Taken together, Elder's data concerning these abbots provides a spatialized dimension for this discussion.[25] Conspicuous in her assessment is how often many of the abbots, but especially William of Saint-Thierry and Simon of Saint-Nicholas-aux-Bois, interacted with Cistercians—particularly Bernard of Clairvaux. Thus, these abbeys can be mapped onto a reform landscape dominated by the rise of Bernard and the Cistercians.

In contrast, Vanderputten argues that the general chapter in Reims represents a response to several historical circumstances, only one of which was the social context of reformed monasticism.[26] The result of the meeting in 1131 was not the institutional centralization that the Cistercians would eventually adopt.[27] Their response was different and, as Vanderputten reiterated, historically situated. He articulates the numerous valances of power at play in the interactions of abbots, bishops, the papacy, and patrons.[28] He documents the complex set of political forces that might have been driving the abbots to represent themselves as belonging to a reform movement in northern France. In his view, the institution created in Reims in 1131 was not pursued after the immediate causes of this specific response lost their urgency. His arguments allow us to see that reform monasticism is not so much a category as it is a way of living religious life in a specific context and at a particular time. Coupled with the rich tapestry of relationships presented by Ceglar and Elder, the multivalence of political contexts these scholars delineate reveals crucial facets of the history of the twelfth-century monastic reform in northern France.

If an essentialized model of the Cistercian response is not appropriate to these houses, then what is? The response to such a question has focused primarily on institutional identity: How cohesive a constitutional body was this group of monasteries? What was the group's relationship to specifically constituted reform orders? These are important questions. Yet lost in these discussions are the monasteries themselves and the monks who inhabited the places and spaces of monastic life. From this perspective, the prescriptions and proscriptions that accompanied the prayer association can be read as an attempt to create a shared experience among the brothers of the individual monasteries. On the one hand, this could facilitate visits between the monks and abbots of associated houses. One section of the statutes, probably datable to 1132, discusses the proper way to host a guest and to be one.[29] If the basic routines and expectations of the house visited by a monk were to be familiar to him, it would greatly reduce any disruption of the regularity on which monastic life depends. On the other hand, regulations themselves help establish a shared imaginary, in which monks from one house could construct a shared experience with monks at other houses across time and space.

The close relationships suggest a larger community whose ties go beyond constituting a

monastic order, or even the annual round of prayers for the dead brothers of the other houses. The normalization of monastic life and the prayer associations within the cloister can be read as a type of spatial enclosure and as a desire to circumscribe the lived spaces of a group of communities. That this does not seem to have resulted in the kind of centralized formation that characterized the Cistercians and the Praemonstratensians is not solely a question of institutional structure or the relative commitments of communities to an idealized notion of reform. It is also a function of the disparate spaces in which these communities were constructing their social relationships and institutional identities.

In this respect, the houses of older, "traditional" Benedictine monks, like those whose abbots gathered together at Reims beginning in 1131, have been drawn as "other" even by those who seek to reposition their place in twelfth-century monastic history. First, these houses are "other" in terms of progress and the domination of new "reform orders," focused as scholarship has been on canonical figures and debates. Second, they may be seen as "other" with respect to the development of formally articulated institutional regimes. The fundamentally spatial construction of this otherness is striking. For scholarship, institutional histories and centers of gravity organized this otherness. Yet the geographic (i.e., spatial) construct of center and periphery governs these approaches.[30] To return to what I take to be a significant implication of the observations of both Van Engen and Constable, in order to understand specific polemical and institutional forms of identity, we must place them contextually within an encompassing monastic culture. This begs the question of how these abbeys looked "on the ground" in explicitly spatial terms in relation to landscape, both to one another and within each monastic site itself. After all, the socio-historical context of twelfth-century monastic reform had a concrete material dimension.

Landscapes

In their book *The Social Logic of Space*, Hillier and Hanson argue that the ordering of space and buildings is really about the ordering of relations between people.[31] This approach differs from structuralist approaches in that it breaks the dichotomy between social subject and spatial object by asserting that the delineation of space is itself a social activity and architecture therefore constitutes, rather than merely represents, the social ordering of meaning. From this perspective we can expect an understanding of the spatial characteristics of these abbeys to have informed important aspects of how the communities that made up this group related to monastic reform in the twelfth century.

Although the abbots who met in Reims during 1131 describe themselves as belonging to the archdiocese of Reims, they do not represent all of the Benedictine houses in the archdiocese not already affiliated with one of the reform orders.[32] Houses following the Benedictine rule, even excluding the Benedictines belonging to the Cistercian order, constitute a dense monastic presence in the landscape. Certainly, the group of twenty-one monasteries does not include any of the important female Benedictine houses in the archdiocese of Reims, like Notre-Dame in Soissons or Notre-Dame in Morienval, near Crépy-en-Valois.[33] In addition, two of the signatory abbots, those from Saint-Pierre in Lagny and Saint-Pierre in Rebais, represented monasteries that were located in the diocese of Meaux, a diocese suffragan not to Reims, but to the archdiocese

of Sens (Fig. 2). Nor were all of the dioceses within the archdiocese of Reims represented at the meeting of 1131. There were no Benedictine houses from the dioceses of Therouanne, Tournai, Amiens, or Senlis and only one from the diocese of Beauvais.[34] There were also none from the diocese of Châlons-sur-Marne (today Châlons-en-Champagne), which shares a long border with the diocese of Reims. These discrepancies indicate that when these abbots wrote that they belonged to the archdiocese of Reims, they were not making a claim about ecclesiastical geography, but rather a claim about social and political affiliation. This distribution and the limited participation in the group beg the question of just what characterizes these monasteries spatially.

If the archdiocese of Reims is not a sufficient or even operative geographical boundary, then we need to be more precise about the spatial patterning of these abbeys. There was a clear concentration of monasteries in the group of twenty-one that were located in and around the geographic center of the archdiocese of Reims. The abbeys of the Reims group are closer together in the northern part of the archdiocese and more dispersed in the south. Notably, there is only one monastery, Saint-Thierry, in the diocese of Reims itself and none in the diocese of Châlons-sur-Marne. These sites, along with the two abbeys located in the diocese of Meaux, shift the center of the group's geographic distribution westward. The absence of any abbey from four of the northern and western dioceses within the archdiocese concentrates the geographical distribution of participating houses toward the center, to an area between Noyon, Laon, and Soissons. Figure 3 represents the twenty-one participating abbeys distributed around the mean coordinate—the averaged location of the abbeys in question. While we might rightfully talk about power centered in Reims as the archdiocesan center with the suffragan bishoprics arranged around it, the center of monastic space for the twenty-one "remois" monasteries was neither in the city of Reims nor in its diocese, but rather within the diocese of Laon.

The abbeys were also distributed within a demographic landscape. Most of these abbeys (fifteen out of twenty-one) were located in either a rural setting or in small towns. However, six of them were located in or at the edge of episcopal cities: Laon, Soissons, Noyon, Beauvais, and Cambrai (Fig. 4).[35] Two of these six abbeys, Saint-Vincent and Saint-Jean, were located in close proximity to Laon, the only episcopal center with more than one representative house. Laon is the closest episcopal center to the notional geographic center of all twenty-one abbeys. Therefore, the support of Bishop Barthelemy de Jur for the Praemonstratensians and the inclusion by the consortium of an association of prayers with the order of Prémontré in a later version of their commitments may have particular significance for the way in which this group of twenty-one houses formulated their relationship to monastic reform.

Yet none of these episcopal centers and their six attendant monasteries lies at the notional center of all twenty-one abbeys. Their spatial distribution suggests several foci of identity and power. Whatever the supra-regional administrative identity of the new orders, the monastic landscape into which they fit was dominated by communities who owed obedience first to their bishop. Furthermore, bishops in the archdiocese of Reims were intimately involved with the establishment and maintenance of monastic practices.[36] The six abbeys located in episcopal cities represent, spatially, points of liaison with the authority of the bishop. Whether an individual bishop helped marshal resources in favor of the twenty-one abbots' vision of monastic life, mitigated resistance to that vision, or entirely supported other monastic enterprises may have

TRADITIONAL BENEDICTINE MONASTERIES IN THE ARCHDIOCESE OF REIMS

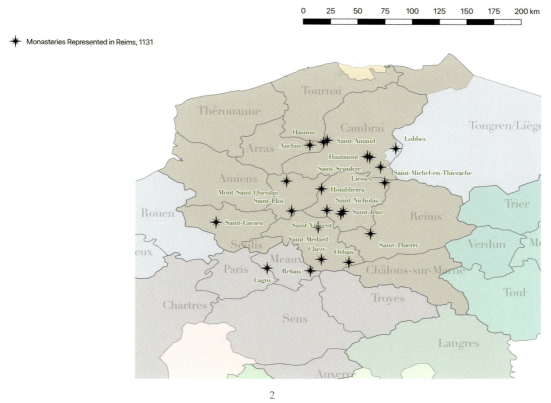

2
Distribution of the abbeys listed as present or likely present at the 1131 meeting with respect to the Archdiocese of Reims.

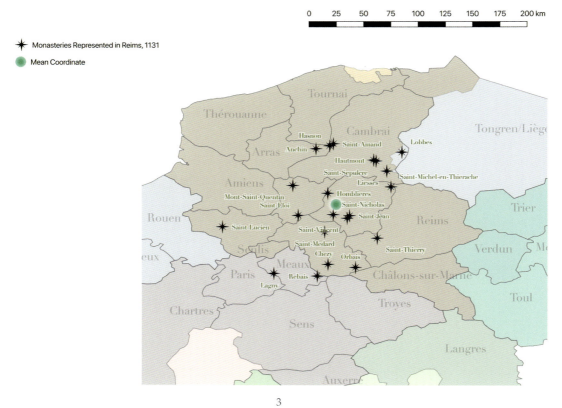

3
Mean coordinate of the abbeys listed as present at the 1131 meeting.

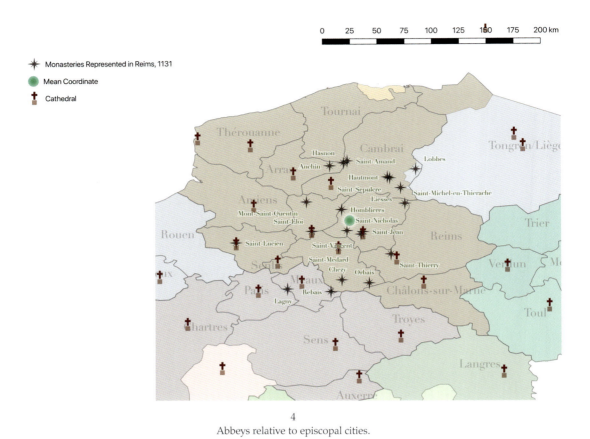

4
Abbeys relative to episcopal cities.

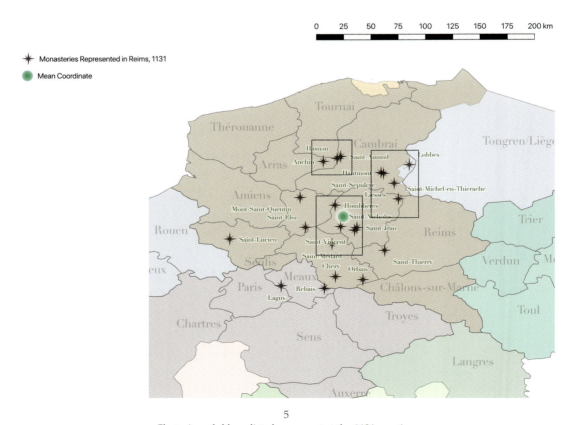

5
Clustering of abbeys listed as present at the 1131 meeting.

varied according to time and place. Yet the presence of abbeys closely tied to episcopal centers among the twenty-one suggests a systematic approach to the role of local bishops in a shared monastic culture.

Proximity to episcopal centers is not the only spatial characteristic evident in the distribution of these houses. Three groups of monasteries form clear clusters based on marked proximity (Fig. 5). Saint-Jean and Saint-Vincent in Laon, Sainte-Hunegonde de Homblières, Saint-Nicholas-aux-Bois and Saint Médard cluster around the average geographical center of the group. Elder asserts that the abbots of all of these houses (except the abbot of Homblières) were those in most frequent contact during the years leading up to 1131—at least according to surviving documentary records.[37] This notion reinforces the idea that Laon was the central locus of monastic practice for these twenty-one houses.

Toward the east, Hautmont, Saint-Sépulchre in Cambrai, Lobbes, Liesses, and Saint-Michel-en-Thiérache form a second concentration. Elder asserts that Gilbert of Saint-Michel-en-Thiérache was also a central player in the years before 1131 and his abbey may have formed a center for this eastern cluster. These five houses were also abbeys that seem to have had direct contact with Pope Innocent II when he was in the region in March of 1131.[38]

To the north, Anchin, Hasnon, and Saint-Amand also cluster together. The abbot of Anchin, Alvisius, became bishop of Arras in 1131. His leadership may have been central to creating this group whose concerns were more focused to the north and east. Vanderputten, however, argues that Alvisius became disillusioned with the 1131 group and moved on to work at reform on his own terms. During the twelfth century, the Cistercian and Praemonstratensian presence was negligible in the areas around this cluster. It may thus be that their negligible presence reflects important aspects of the monastic landscape that shaped the relationships among these three monastic communities within the larger group of twenty-one.

Saint-Thierry, Orbais, Rebais, Chézy, and Lagny form a line across the southern end of the distribution—a line that corresponds in part to the northern limits of the county of Champagne. Mont-Saint-Quentin and Saint-Eloi define a western boundary, with Saint-Lucien in Beauvais a distant outlier even further west. The relative isolation of these houses from the rest in the group raises several interesting questions. Certainly, these three houses form points of contact between several ecclesiastical and comital power structures. Because these three western houses occupy a dense monastic landscape comprised of multivalent modes of monastic life, it is unlikely that we should view them as marking any sort of frontier. It is more likely that their location offers insight into what specific characteristics were active in supporting a sense of shared identity among the twenty-one monasteries of the Reims group. Evidence for these characteristics can be found in a more thorough understanding of their social and physical landscapes.

Although a clear picture of what these distributions reflect must be the result of a more detailed study of monastic landscapes in the regions, it is clear that the position of these abbeys in the landscape is neither random nor evenly distributed. Instead, their distribution forms a set of clusters. Compare, for example, the Cistercian and Praemonstratensian foundations in these dioceses (Figs. 6–11). Cistercian houses were evenly distributed in the diocesan landscapes from the beginning of their presence in the archdiocese of Reims. The Praemonstratensians, founded in the diocese of Laon, became evenly distributed in the landscape as they expanded into a supra-regional order. The difference between the even distribution of the new orders

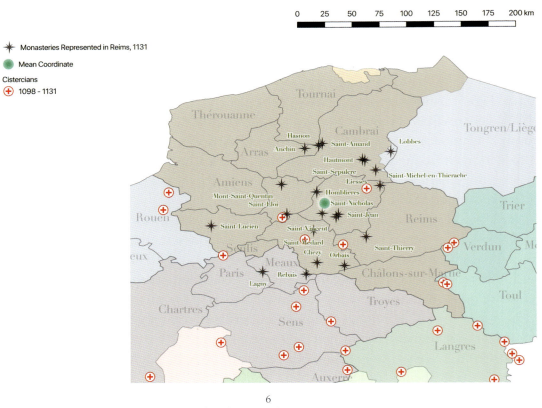

6
Cistercian foundations in the region prior to 1131.

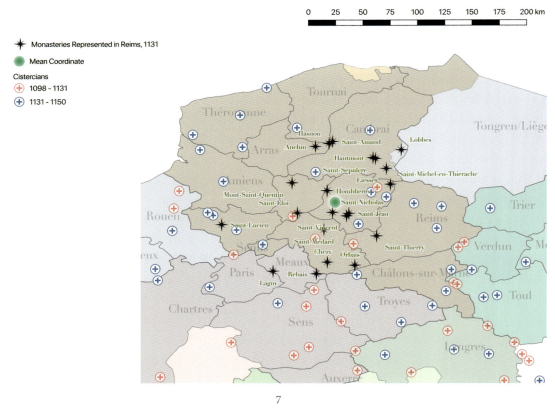

7
Cistercian foundations in the region between 1132 and 1150.

TRADITIONAL BENEDICTINE MONASTERIES IN THE ARCHDIOCESE OF REIMS

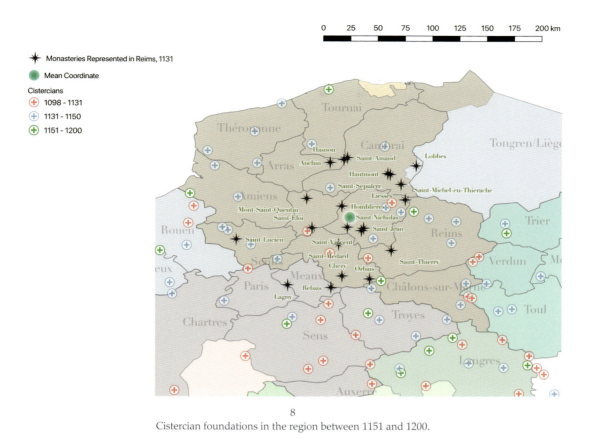

8
Cistercian foundations in the region between 1151 and 1200.

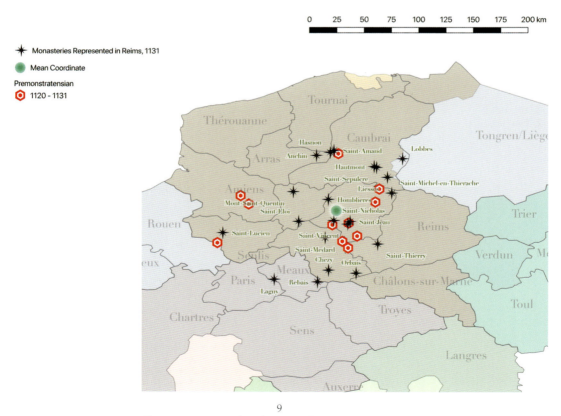

9
Praemonstratensian foundations in the region prior to 1131.

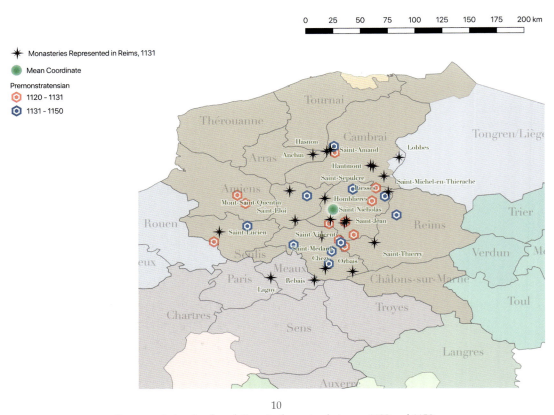

10
Praemonstratensian foundations in the region between 1132 and 1150.

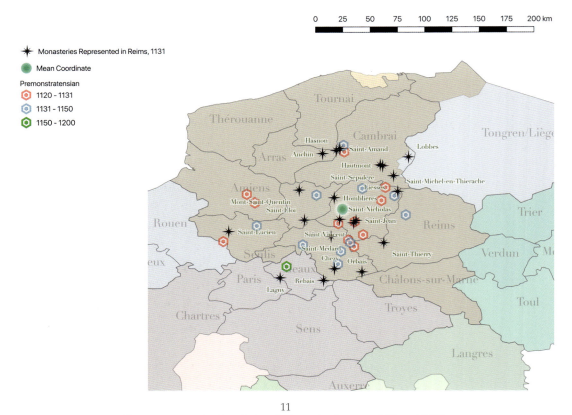

11
Praemonstratensian foundations in the region between 1151 and 1200.

and those of the Reims group is not accidental, but is a direct product of both history and geography. The clusterings of the Reims group in the landscape correlate to the long history that tied them to the places they occupied. They had all interreacted with each other and the surrounding monastic landscape for many decades (and even centuries in some cases). When the abbeys of the Reims group came together to express a shared vision, they did so with a long and disparate set of historical experiences.[39] Theirs was a relationship that had to make room for fully developed senses of place. By contrast, the evenly dispersed patterns of the Cistercians and, ultimately, the Praemonstratensians reflect the newness of their presence in this area, and as a correlative to that, the presence of available land. They are not constrained (or supported) by deep implication in the history of this region and therefore reflect a spatial pattern spread across the surface of the landscape.

Yi-Fu Tuan described landscapes as works of imagination characterized by the intersection of objective and subjective views of an environment. In his formulation, objective views use abstraction to model the complexities of landscape, while subjective views engage with a situated experiential view of an environment.[40] Both views operate together to create a spatialized social experience. Gerald Guest formulated a similar distinction between abstract and concrete in the context of medieval artistic production.[41] He maps abstraction onto the pictorial background and the concrete onto the pictorial foreground. Bill Hillier and Julienne Hanson formulate this distinction more clearly in spatial terms when they use the term "trans-spatial" to describe constraints of spatial relationships that are determined from the outside rather than from the logic of physical proximity.[42] The clustered distribution of the Reims abbeys reflects social relations imbedded in the history of their locations. The more evenly dispersed pattern of the Cistercian and eventually Praemonstratensian houses references institutional structures overlying localized landscapes.

In spite of the close relationship between the existing abbeys and the new orders, their spatial difference, and the social logic that difference implies, necessitates that their manifestation of reform be fundamentally different. The looseness of the organization formed by the twenty-one Benedictine abbeys does not so much result from a failure to centralize as it reflects a group for which that kind of centralization was deemed inappropriate, not least because extricating themselves from a well-established spatial context in order to align themselves with a trans-spatial institutional framework would have presented insurmountable difficulties.

While the spatial distribution of the new orders may have been governed by trans-spatial rules imposed from outside, they nevertheless altered the spatial dynamics of the areas they entered. In the years leading up to 1131, the Cistercians were certainly a developing presence in the region. Whatever their political and intellectual impact on regular life in the years before 1131, they did not yet dominate the region with their presence (Fig. 6). In the twenty years between 1130 and 1150, that situation changed, and what looks like a Cistercian wave from the south overtook the region and flowed well beyond it to the north, east, and west (Fig. 7). The Cistercian expansion in this region practically collapses after 1150 as the already densely occupied monastic landscape had reached a limit in absorbing the new order of Benedictines (Fig. 8).

Perhaps of greater significance for the abbots present at the Reims meeting was the growth of the Praemonstratensian canons. They, of course, expanded outward from their organizational

center—their mother house of Prémontré located in the forest of Saint-Gobain, north of Soissons and west of Laon within the latter diocese, where Bishop Bartholomew was instrumental in establishing the order. The initial regional character of the order (which soon became an important international one) explains their early clustering in the diocese of Laon in the decade leading to 1131.[43] The more uniform distribution of new foundations in the two decades that followed resembles the pattern of Cistercian development. I would argue that this reflects a spatial characteristic of the new centralized orders whose spatial logic is transregional and trans-spatial. Like the Cistercians, new Praemonstratensian foundations in the region almost cease between 1150 and 1200.

In fact, two of the abbots from the Reims conference, those of Saint-Nicolas-aux-Bois and Saint-Vincent in Laon, witnessed the transformation of Saint-Martin in Laon from a collegiate church of secular canons founded in the Carolingian period into a Praemonstratensian house of regular canons.[44] Vanderputten argues that the role of Praemonstratensians in the lives of these abbots from Reims was more significant than has been appreciated.[45] While his institutional arguments are compelling, the central position of Prémontré and its early houses within the archdiocese of Reims must also have played a role in the formulation of monastic reform for the abbots who met in 1131. The abbots of Saint-Nicolas-aux-Bois and Saint-Vincent in Laon represent two of the monasteries in the cluster around that geographic center. It may be that those abbots were instrumental in facilitating the integration of the new order of reform canons into the existing monastic landscapes. Similarly, one might argue that the "otherness" of the Reims group diminished as the new reform orders settled into the monastic landscape.

If Vanderputten is correct in arguing that the political urgency bringing these abbots together in 1131 dissipated soon afterward, I would also add that the spatial urgency diminished as well. As the Cistercians and Praemonstratensians settled into the landscape, the reform abbots encountered like-minded neighbors, and relations with these new neighbors provided support for the so-called reform mode of traditional monastic life. There was no longer a need to look across the diocese or even outside the region for a shared experience to validate those modes of life.

Architecture

In 1990, Amos Rapoport argued that architecture is not simply a collection of isolated spaces arranged according to formal criteria.[46] Instead, he invited us to see architectural spaces as parts of interdependent systems. According to him, the criteria we use to characterize the buildings and the spaces within them must consider the reality of the somatic experience of space as a user moves from one space to the next. Our experience and memory of adjacent spaces frames how we experience the space in which we stand and, what is more, fundamentally changes the nature of that space. If Rapoport is correct in asserting the systemic and somatic nature of architectural perception, then reconstruction of these ever-expanding physical landscapes becomes a critical part of understanding individual elements of that built environment, such as the church, chapter room, or refectory.

Most of the buildings associated with these twenty-one monasteries have been destroyed. Monastic precincts and cloisters have become so fragmented that only systematic programs

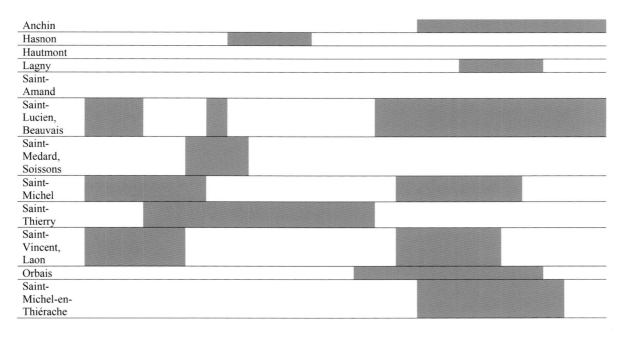

12 Approximate dates for important church building campaigns.

of archaeology and recording might bring at least a few of them into focus. More is currently known about the churches of these abbeys. By combining documentary evidence and physical remains, we can suggest approximate dates for major campaigns of church construction for some of them. Figure 12 tabulates in a schematic form the construction histories of twelve abbeys about which some information can be recovered.

Of the twenty-one abbeys connected to the prayer association of 1131, only three churches survive. By chance, Saint-Pierre in Lagny-sur-Marne, Saint-Michel-en-Thiérache, and Saint-Pierre in Orbais are all of similar design and exhibit a similar plan (Fig. 13 [a, b, d]).[47] Long, projecting axial chapels characterize all three early Gothic choirs. Contiguous radial chapels open off an ambulatory at Orbais and Lagny, whereas, at Saint-Michel, the ambulatory is omitted and chapels are inserted between the transept arms and the choir, a solution that nevertheless provides a similar experience of expanding space around the choir that occurs at Orbais and Lagny. In all three cases the naves have a separate construction history from the choirs. Saint-Thierry had a strikingly similar design to Saint-Pierre Orbais and should be considered with these three survivals (Fig. 13 [c]).[48] Ground plans are, of course, a peculiarly modern and analytic way of "seeing" buildings. Their uniform presentation of the buildings' features (arcades, walls, and windows) can easily mask the differences in the three-dimensional experience of what, in plan, appear as similar spatial arrangements.

Human interactions with monastic churches such as these were carefully controlled. Approach to a monastic site was regulated with respect to an individual's status. People of a given status would have consistently approached a monastery in the same way. From the perspective

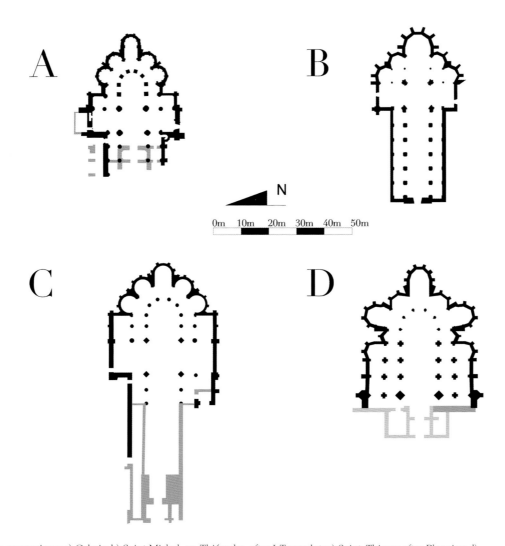

13 Plan comparison: a) Orbais; b) Saint Michel-en-Thiérache, after J. Trouvelot; c) Saint-Thierry, after Plouvier; d) Lagny-Sur-Marne, after Sardon, each with modifications by the author.

of a cloistered monk, approach to the church was not only consistent, it was persistent, being experienced several times a day, every day of the year, every year of a monk's religious life. A monk entered his church to pass directly into the liturgical choir, either by descending the night stairs from the dormitory into a transept arm for matins or from the cloister through a door in the easternmost bay of the nave aisle, or, occasionally, through a door in a transept arm, as at Cistercian Ourscamp. The liturgical choir was not always identical to the architectural one. Both included the apse, and the rectilinear parts of the central vessel east of the crossing; but the liturgical choir typically also included the crossing bay and sometimes extended a bay or two into the nave, especially before Gothic churches frequently built longer choirs. Further, the liturgical choir was an enclosed space, with walls varying in height from building to building. Doors to the liturgical choir enclosure were typically on the long side, near to the monk's point of entry into the church. The monk's view of his church, both on entering the building and from within the liturgical choir, was thus always fragmentary and never "entire," as when the modern visitor enters from a door in the west façade to gaze down the longitudinal axis

14
Saint-Pierre in Orbais, interior looking toward choir apse.

of the building, free of screens and furniture, all the way to the apse. Choir screens removed the monks visually and physically from the nave of the church (that is, from the nave bays not included in the liturgical choir) while the enveloping spaces of the ambulatory and chapels provided a light-filled series of expanding, but partial, vistas that monks could see from their stalls in the choir (Fig. 14).

The effect of the liturgical choir was to anchor the monk's visual experience within the space of the sanctuary, effectively monumentalizing the choir and the chapels and integrating the high vaults of the choir and the radiating chapels off the ambulatory, or those inserted into the angle between the choir and transept as at Thiérache. This notion of a central pivot must have been experienced as a centrally-organized space revolving around the high central crossing vault. As Richard Krautheimer has argued, centrally-organized religious structures have a rich history of associations in the medieval West that included the Holy Sepulcher, martyria, and baptisteries.[49] These associations call to mind the early Church and the apostolic life that monasticism in all of its forms sought to recall and reproduce. The choirs of these surviving churches are, of course, not centrally-planned spaces in structural terms. Those spaces had, however, profoundly centralizing effects, particularly from the point of view of the monks performing liturgical services. As Paul Crossley points out, the medieval world was suffused with symbolism and all of these connotations,

> . . . [that] should not be neatly categorized as starting points for the design or *post festum* interpretations. The significances would have "vibrated" simultaneously in the mind of the educated observer. For twelfth-century symbols were to the inner, spiritual, world what pilgrimages and the knightly quest were to the outer: invitations to a journey of discovery.[50]

Here I argue for the application of these ideas directly to the monk's experience of his church. The desire to reinforce a monk's sense that he is not living in the world but in a kind of perpetual liminality, a desert, is reinforced by the architecture both of the monastic church and the convent as a whole.

The experiential link between the choir and its enveloping chapels also speaks to another aspect of monastic life for these monks in the twelfth century, namely to monastic reform. Whether or not consciously understood in symbolic or metaphorical terms, the recurring presence of community in the liturgical choir, together with the more individualized performance of ceremonies in the surrounding chapels, must have shaped the monk's understanding of his monastic vocation. In light of the significant presence of the Praemonstratensian order within the landscape that the twenty-one Benedictine abbeys inhabited, the monastic churches of Notre-Dame in rural Lieu-Restauré and Saint-Martin in urban Laon form an interesting comparison.[51] Their choirs are not enveloped by ambulatories and radial chapels, but terminate in a simple semi-circular apse or a flat chevet (Fig. 15).[52] Moreover, the chapels of these churches open off the transept arms and are thus separated from the visual experience of the monk in the choir. The resulting visual experience of these two Praemonstratensian churches is thus more constrained and simpler than that of the surviving Benedictine houses of the Reims group.

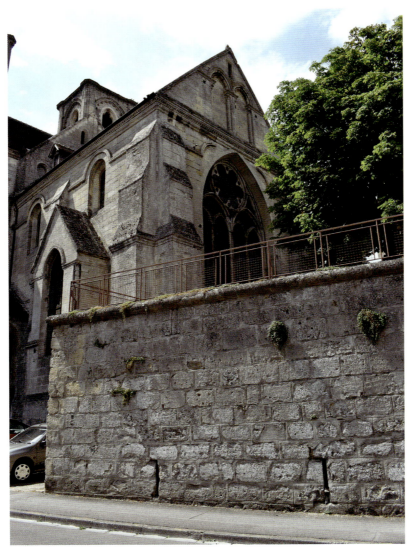

Praemonstratensian churches. Top: Notre-Dame in Lieu-Restauré, remains of the semi-circular apse.
Bottom: Saint-Martin, Laon, flat eastern termination.

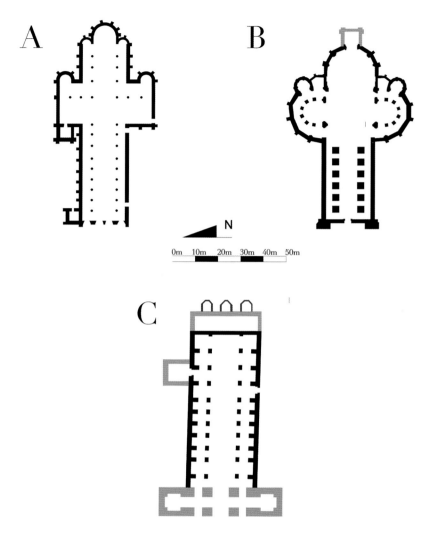

16 Plan comparison: a) Saint-Vincent, Laon, after P. Glotain; b) Saint-Lucien, Beauvais, after Leman; c) Saint-Medard, Soissons, after Defente, each with modifications by the author.

The three surviving churches of the Benedictine group, and the fourth discussed with them, do not, of course, represent all of the other churches within the Reims community. Three plans record the interior organization of the medieval churches of Saint-Vincent in Laon, Saint-Médard in Soissons, and Saint-Lucien in Beauvais. Together these plans indicate a very different arrangement of spaces and a very different monastic spatial experience (Fig. 16). Two of these plans—one for Saint-Vincent in Laon and the other for Saint-Médard in Soissons— clearly record the late medieval state of these abbeys, and, in the case of Saint-Médard, do not reveal the array of chapels present in the crypt beneath the choir. Reconstruction at Saint-Vincent in Laon appears to have begun in the late twelfth century and continued sporadically into the sixteenth century.[53] The abbey of Saint-Médard had a new church consecrated in 1131 by Innocent II.[54] A plan from 1568, before the church was damaged during the Wars of Religion and heavily restored in the seventeenth century, may well reflect some or all of the construction from that early period.[55] The third, Saint-Lucien in Beauvais, is known to us primarily from archaeological excavation and pre-destruction drawings and prints.[56] The monks of Saint-

Lucien in Beauvais constructed a new church for their abbey in the second half of the twelfth century. All three of these abbeys were located in the "suburbs," immediately outside episcopal centers. As such, they contrast with the four abbey churches discussed earlier that were located in monastic towns. Yet all three of these other churches constitute singular architectural spaces and reflect their location within the dense architectural environment of an episcopal city. While they may have expressed similar ideas about the nature of monastic vocations, they did so in different ways. Indeed, monastic architecture may have had a different role to play in these episcopal centers.

Although the evidence is fragmentary, two trends seem apparent from this timeline of construction histories and from the surviving examples. The first is that new or renewed building was a common occurrence in the first decades of the twelfth century, when the abbots of these houses were preparing to meet in Reims to discuss how to regulate the internal lives of their monasteries. Architecture, then, was part of that vision. In fact, the monks of Saint-Médard in Soissons consecrated a new church and may have completed reconstruction of the abbey in the very year that the abbots met in Reims.[57] This was the building the rest of the abbots would see the following year when they all convened at Saint-Médard for the next meeting. There is no evidence for Saint-Médard's stylistic influence on other buildings. Nevertheless, the fact of new construction was clearly a part of the experience of monastic renewal for these abbots and by extension for their abbeys.

The second trend is that many of the twenty-one abbeys were building or rebuilding in the decades just before and just after 1200. These building programs were in the new Gothic style. While Gothic can be understood as innovation and a break with the past, in this monastic context I think we should interpret this stylistic choice instead as a way to engage with a past. In particular, renewal had a double meaning that evoked both the past and present, and Gothic architectural forms in this context activated both meanings. Marvin Trachtenberg articulated the fundamental role that "the modern" should play in our understanding of Gothic architecture.[58] His observation that newness had a significant value during the Middle Ages remains a crucial if underexploited contribution to medieval building history. In Trachtenberg's formulation, modernity is explicitly the corollary of a developed sense of the past. There is no new without an old to which it can be compared. Turning in the other direction, the new makes the past present and makes it useable.

This valence of Gothic architecture in a landscape of reform might be illustrated by a document written by an abbot of Orbais in the year 1180 to commemorate the translation of the relics of Réole, the abbey's founder and patron saint.[59] In that record, he describes the consecration of an altar dedicated to the Virgin and Saint Thomas. The altar had already been built during previous renovations to the church; renovations that correlate to the late twelfth-century adoption of Gothic forms. The disruption caused by the construction process may have ended, but until the consecration took place the altar could not be fully reintegrated into the religious life of the monks. Like their adoption of practices associated with a more ascetic monastic life, the public consecration of this altar was a statement about how the abbey saw itself with respect to the world in which its occupants lived. This is particularly so because the consecration was accompanied by the transfer to a new reliquary of the remains of Saint Réole. For several generations his relics had been buried below the main altar in the church, and their

exhumation and placement in a new reliquary were therefore a prime opportunity for ceremonial display. The brothers were moving relics from the darkness and invisibility of a subsurface sarcophagus to the bright visibility of a jeweled reliquary that had been specially commissioned to hold them. The display of the monastery's founder and his figurative renovation in new containers (church and reliquary) must have resonated with the lives of the monks as they put themselves and their monastery on display.

Conclusion

My objective in this essay has been narrowly focused. I wished to show how space has been relegated to the background of discussions about twelfth century monastic reform. To do this, I have focused on two specific aspects of the landscape: one, the distribution of an associated group of Benedictine monasteries as compared to the distribution of newly founded houses affiliated with reform orders and, two, the distribution of church construction histories.

The chance survival of a record of decisions taken by the abbots from communities of black monks who met in Reims in 1131 illuminates an attempt on the part of those abbots to regulate monastic life. They did so by integrating the brothers of the several monasteries through an association of prayers for the dead and by normalizing the practice of monastic life within the several houses. The particular forms that normalization took and the image of a group of houses working together across a region has suggested to scholars a close relationship between these actions and a growing reform movement in the late eleventh and early twelfth centuries, especially those exemplified by Cistercians and Praemonstratensians. As Ceglar and Elder document, those abbots who met in Reims were intimately involved with key figures in those orders and so were involved in events that would come to dominate institutional ideas about monastic reform. There is no denying the impact that the rapid spread of the Praemonstratensian and Cistercian orders, or the impact that the monks from those orders, both as individuals and as communities, had on the religious life of the twelfth century.

Yet as Vanderputten points out, there was more at stake than just the abstract idea of monastic reform. Although he does not argue the point explicitly, a focus on Bernard and the Cistercians as the archetype for twelfth-century monastic reform requires that we regard as a failure the absence of a new order for the Reims abbeys. By focusing on the complex interplay of power structures, Vanderputten is able to reframe the Benedictine group of twenty-one houses as a response to a specific set of historical circumstances. The lack of fully-formed and continual general chapters after the first initial meetings was thus not a failure, but a successful response to ephemeral political demands.

Both approaches provide insights into fundamental aspects of this complex historical phenomenon. Yet neither approach makes room for the monasteries themselves and the monks who inhabited them. In part, the nature of the written evidence privileges this focus on ideological debates and power structures. Very little written evidence survives from inside any one of these twenty-one older Benedictine monasteries. While the desire on the part of the abbots to control corporate experience may determine the initial configuration of monastic life, that configuration only persists through its continued use as social practice in evolving spatial and historical circumstances. If we break the dichotomy between social subject and

spatial object then the delineation of space is itself a social activity. Landscapes and architecture constitute, rather than merely represent, part of the social ordering of meaning. The ordering of spaces occupied by these abbeys constituted the shared experience of monastic life and the desire to project a corporate unity.

The clustering of the houses of black monks contrasted markedly with the relatively even distribution of both Praemonstratensian and Cistercian houses. I have argued that this pattern was a direct correlate of the difference between these two groups in the temporal dimension of the landscape. The black monks were already deeply imbedded in dense social and physical landscapes. Their physical response to a reformed mode of monastic life had to be different than that of newly-established orders whose primary challenge was to make a place for themselves in an existing landscape. The distribution of new orders also points to a particular historical moment. For both new orders, initial presence beginning about 1120 was followed by a rapid increase in new houses between 1130 and 1150. After that, however, new Praemonstratensian and Cistercian foundations in this region all but cease. We thus see about a generation of intense change. One explanation for this spatial and temporal reality might be that the abbots' meeting in Reims was successful in transforming their collective monastic landscapes from the inside.

The architectural spaces of this process document specific elements of this emplacement. Three surviving churches and the record of a fourth clearly indicate a shared sense among some of these houses about what a monastic church should look like and how it should function. By contrast, the three monastic churches of this community located in episcopal centers expressed a different sense of architectural form and one that relates directly to their urban environment. While there are clear patterns within subsets of this group of Remois monasteries, we cannot see a single "reform style" of architecture in the monuments that survive. Such a framing presupposes that the architecture of these abbeys is an expression of identity and reduces the question to one of architecture as background or symbol. If on the other hand we view architecture as part of the spatial fabric from which social action is formed, then we can begin to pursue questions about how cultures of reform were produced and reproduced through the spaces they inhabited.

Primary Works

Douai, Bibliothèque Municipale (BM):
 MS 540, fol. 69r-69v (from Marchiennes)

Paris, Bibliothèque nationale de France (BnF):
 MS lat., 2677, fol. 83v-84r (presumably from Tournai)

Secondary Works

Arnold 2013: Ellen Fenzel Arnold, *Negotiating the Landscape: Environment and Monastic Identity in the Medieval Ardennes* (Philadelphia: University of Pennsylvania Press, 2013).

Atsma 1976: Hartmut Atsma, "Les monastères urbains du nord de la Gaule," *Revue d'Histoire de l'Église de France*, 62.168 (1976): 163–187.

Barthélemy 1985: Dominique Barthélemy, "Rénovation d'une seigneurie: les chartes de Crécy-sur-Serre en Laonnois (1190)," *Bibliothèque de l'École des Chartes*, 143.2 (1985): 237–274.

Berlière 1891: Ursmer Berlière, "Les Chapitres généraux de l'ordre de S. Benoît avant le IVe concile de Latran (1215)," *Revue Bénédictine*, 8 (1891): 255–264.

Berlière 1894: Ursmer Berlière, *Documents inédits pour servir à l'histoire ecclésiastique de la Belgique* (Maredsous: Abbaye de St-Benoît, 1894).

Berlière 1901: Ursmer Berlière, "Les Chapitres généraux de l'ordre de S. Benoît avant le IVe concile de Latran," *Revue Bénédictine*, 18 (1901): 364–398.

Berman 2000: Constance Berman, *The Cistercian Evolution: The Invention of a Religious Order in Twelfth-century Europe* (Philadelphia: University of Pennsylvania Press, 2000).

Boutémy 1954–1955: André Boutémy, "Les relations artistiques entre les abbayes d'Anchin et de Saint-Amand au milieu du XIIe siècle," *Bulletin de la Société Nationale des Antiquaires de France* (1954–1955): 75–78.

Bussière 1999: Roselyne Bussière, "Le choeur gothique de Saint-Pierre de Lagny," in *Pierre, lumière, couleur: études d'histoire de l'art du Moyen Age en l'honneur d'Anne Prache*, ed. Fabienne Joubert and Dany Sandron (Paris: Presses de l'Université de Paris-Sorbonne, 1999), 185–198.

Cassidy-Welch 2001: Megan Cassidy-Welch, *Monastic Spaces and their Meanings: Thirteenth-Century English Cistercian Monasteries*. Medieval Church Studies, 1 (Turnhout: Brepols, 2001).

Ceglar 1976: Stanislaus Ceglar, "The chapter of Soissons (autumn 1131) and the authorship of the reply of the Benedictine abbots to Cardinal Matthew," in *Studies in Medieval Cistercian History*, vol. II, ed. John R. Sommerfeldt (Kalamazoo, MI: Cistercian Publications, 1976), 92–105.

Ceglar 1988: Stanislaus Ceglar, "William of Saint-Thierry and his leading role at the first chapters of the Benedictine abbots (Reims 1131, Soissons 1132)," in *William, Abbot of St. Thierry: A Colloquium at the Abbey of St. Thierry*, ed. Jerry Carfantan (Kalamazoo, MI: Cistercian Publications, 1988), 34–112.

Champion 1989: Timothy C. Champion, "Introduction," in *Centre and Periphery, Comparative Studies in Archaeology*, ed. T. C. Champion. One World Archaeology, 11 (London: Routledge and CRC Press, 1989), 1–21.

Clark 1984: William W. Clark, "Cistercian influences on Praemonstratensian church planning: Saint-Martin at Laon," in *Studies in Cistercian Art and Architecture, vol. 2*, ed. Meredith Lillich (Kalamazoo, MI: Cistercian Publications, 1984), *161–188*.

Constable 1996: Giles Constable, *The Reformation of the Twelfth Century* (Cambridge: Cambridge University Press, 1996).

Cottineau 1939: dom Laurent Henri Cottineau, *Répertoire Topo-bibliographique des Abbayes et Prieurés* (Mâcon: Protat frères, 1939).

Crossley 1988: Paul Crossley, "Medieval Architecture and Meaning, the Limits of Iconography," *Burlington Magazine*, 130 (1988): 116–121.

Crozet 1946: René Crozet, "Étude sur les consécrations pontificales," *Bulletin monumental*, 104 (1946): 5–46.

Darney 1994: Georges Darney, *Histoire de Lagny* (Paris: Office de l'Édition & de Diffusion du Livre d'Histoire, 1994).

De Certeau 1984: Michel de Certeau, *The Practice of Everyday Life*, trans. Steven Rendell (Berkeley: University of California Press, 1984).

Defente 1994: Denis Defente, "Saint-Médard de Soissons et son église principale," *Congrès archéologique de France, tenu en Aisne méridionale*, 2 vols. (Paris: n.p., 1994), II:651–672.

Defente 1996a: *Saint-Médard, Trésors d'une abbaye royale*, ed. Denis Defente (Paris: Somogy-Éditions d'art), 1996.

Defente 1996b: Denis Defente, "Etude topographique et architecturale," in Defente 1996a, 273–362.

Deshoulières 1920: François Deshoulières, "Lagny," *Congrès archéologique de France tenue à Paris en 1919* (Paris, 1920): 127–137.

Dewez 1890: Jules Dewez, *Histoire de l'abbaye de St. Pierre d'Hasnon* (Lille: Imprîmerie de l'Orphelinat de Don Bosco, 1890).

Droguet 1994: Vincent Droguet, "L'abbaye Saint-Vincent de Laon," *Congrès archéologique de France, tenu en Aisne méridionale*, 2 vols. (Paris, 1994), II:413–430.

Du Bout 1890: dom Nicolas du Bout, *Histoire de l'abbaye d'Orbais (Marne), par dom Du Bout, publiée d'après le manuscrit original de l'auteur, avec additions et notes, par Etienne Héron de Villefosse, . . . Préface de Louis Courajod (24 avril 1889)*, ed. Étienne Héron de Villefosse (Paris: A. Picard, 1890).

Elder 2005: Ellen Rozanne Elder, "Communities of reform in the province of Reims: the Benedictine 'chapter general' of 1131," in *The Making of Christian Communities in Late Antiquity and the Middle Ages*, ed. Mark F. Williams (London: Wimbledon, 2005), 117–129; 182–188.

François 1997: Jean-Luc François, "Étude de l'évolution du bâtiment principal de l'abbaye Notre-Dame de Lieu-Restauré (Oise) du XIIe au XVIIIe siècle," *Revue archéologique de Picardie*, 1.2 (1997): 141–172.

François and Perrin 1976: Jean-Luc François, in collaboration with G. Perrin, "Essai archéologique de datation des bâtiments de l'abbaye de Lieu-Restauré," *Cahiers archéologiques de Picardie*, 3 (1976): 163–189.

Gall 1926: Ernst Gall, "Die Abteikirche Saint-Lucien bei Beauvais," *Wiener Jahrbuch für Kunstgeschichte*, 4 (1926): 59–71.

Gardner 1980: Stephen Gardner, "Notes on a View of Saint-Lucien at Beauvais," *Gazette des Beaux Arts* (Nov. 1980): 149–156.

Gigot 1983: Alain Gigot, "L'église abbatiale de Saint-Michel en Thiérache," *Abbayes et Prieurés de l'Aisne. Mémoires de la Fédération des Sociétés d'histoire et d'archéologie de l'Aisne*, 28 (1983): 35–47.

Gigot 1986: Alain Gigot, "Ancienne abbaye bénédictine de Saint-Michel en Thiérache, Découverte de vestiges de l'abbaye du XIIème siècle dans la galerie du cloître," *Mémoires de la Fédération des Sociétés d'histoire et d'archéologie de l'Aisne*, 31 (1986): 162–166.

Gilchrist 1995: Roberta Gilchrist, *Contemplation and Action: The Other Monasticism* (London: Leicester University Press, 1995).

Gerzaguet 1997: Jean-Pierre Gerzaguet, *L'Abbaye d'Anchin de sa foundation . . . au XIVe siècle: essor, vie et rayonnement d'une grande communauté bénédictine* (Villeneuve-d'Ascq: Presses universitaires du Septentrion, 1997).

Guest 2012: Gerald B. Guest, "Space," *Studies in Iconography*, 33 (2012): 219–230.

Héliot 1965: Pierre Héliot, "Deux église champenoises méconnues: les abbatiales d'Orbais et d'Essomes," *Mémoires de la Société d'agriculture, commerce, sciences, et arts de la Marne*, 80 (1965): 86–112.

Héliot 1970: Pierre Héliot, "L'abbaye de Saint-Thierry et les débuts de l'architecture gothique en Champagne," *Bulletin de la Société nationale des antiquaires de France* (1970): 337–358.

Héliot and Prache 1979: Pierre Héliot and Anne Prache, "L'architecture à Reims et dans ses environs entre 1150 et 1300," in *Saint-Thierry: une abbaye du VIe au XXe siècle*, ed. Michel Bur (Saint-Thierry: Association des Amis de l'Abbaye de Saint-Thierry, 1979), 457–477.

Henriet 1983: Jacques Henriet, "Saint-Lucien de Beauvais, mythe ou réalité?" *Bulletin Monumental*, 141.3 (1983): 273–294.

Henriet 2005: Jacques Henriet, *À l'aube de l'architecture gothique: Saint-Lucien de Beauvais, mythe ou réalité?* (Besançon: Presses Universitaires de Franche-Comté, 2005).

Hillier and Hanson 1984: Bill Hillier and Julienne Hanson, *The Social Logic of Space* (Cambridge: Cambridge University Press, 1984).

Jacquin 1903: Mannès Jacquin, *Etude sur l'abbaye de Liessies: 1095–1147* (Brussels: Kiessling, 1903).

Killian 2008: Kyle Killian, "The Landscapes of Saint-Pierre d'Orbais: An Anthropology of Monastic Architecture," unpublished PhD dissertation, Columbia University, 2008.

Krautheimer 1942: Richard Krautheimer, "Introduction to an 'Iconography of medieval architecture'," *Journal of the Warburg and Courtauld Institutes* (1942): 1–33.

Lefebvre 1991: Henri Lefebvre, *The Production of Space*, trans. Donald Nicholson-Smith (Oxford: Blackwell, 1991).

Leman 1977: Pierre Leman, "Les fouilles de l'Abbaye. Saint-Lucien de Beauvais," *Cahiers archéologiques de Picardie*, 4 (1977): 277–288.

McCurrach 2011: Catherine Carver McCurrach, "'Renovatio' Reconsidered: Richard Krautheimer and the Iconography of Architecture," *Gesta*, 50.1 (2011): 41–69.

McGuire 2000: Brian Patrick McGuire, "Charity and Unanimity: The Invention of the Cistercian Order: A Review article," *Cîteaux: Commentarii Cistercienses*, 51 (2000): 285–97.

Molinier 1890: Auguste Molinier, ed., *Les Obituaires français au moyen âge*, 4 vols. (Paris: Imprimerie Nationale, 1890).

Nora 1997: Pierre Nora, *Les Lieux de Mémoire* (Paris: Editions Gallimard, 1997).

Ott 2015: John S. Ott, *Bishops, Authority and Community in Northwestern Europe, c. 1050–1150* (Cambridge: Cambridge University Press, 2015).

Polonovski 1982: Max Polonovski, "La nef de l'église Saint-Pierre de Lagny d'après trois rapports d'experts du XVIIIe siècle," *Revue de l'Art*, 56 (1982): 41–58.

Polonovski 2000: Max Polonovski, "Le portail disparu de l'église abbatiale Saint-Pierre de Lagny," in *Utilis est lapis in structura: mélanges offerts à Léon Pressouyre*, ed. Martine François and Pierre-Yves Le Pogam (Paris: Comité des travaux historiques et scientifiques, 2000), 35–49.

Rapoport 1990: Amos Rapoport, *The Meaning of the Built Environment: A Nonverbal Communication Approach* (Tucson: The University of Arizona Press, 1990).

Rowlands 1987: Michael Rowlands, "Center and Periphery: a Review of a Concept," in *Center and Periphery in the Ancient World*, ed. M. Rowlands, M. Larsen, and K. Kristiansen (Cambridge: Cambridge University Press, 1987), 1–11.

Salzer 2017: Kathryn Salzer, *Vaucelles Abbey: Social, Political, and Ecclesiastical Relationships in the Borderland Region of Cambrensis, 1131–1300* (Turnhout: Brepols, 2017).

Schuermans 1984: Michel Schuermans, *Etude du site de l'Abbaye de Liessies* (Fourmies: Ecomusée de la région de Fourmies-Trélon, 1984).

Smadja 2014: Philippe Smadja, *L'abbaye de Lieu-Restauré. Un demi-siècle de sauvegarde et de restauration.* Histoire médiévale et archéologie, 27 (Compiègne: CAHMER, 2014).

Trachtenberg 2001: Marvin Trachtenberg, "Desedimenting Time: Gothic Column/Paradigm Shifter," *RES: Anthropology and Aesthetics*, 40 (2001): 5–28.

Tuan 1977: Yi-Fu Tuan, *Space and Place: The Perspective of Experience* (Minneapolis: University of Minnesota Press, 1977).

Vanderputten 2007: Steven Vanderputten, "A Time of Great Confusion, Second-Generation Cluniac Reformers and the Resistance to Centralization in the County of Flanders (c. 1125–45)," *Revue d'Histoire Ecclésiastique*, 102 (2007): 47–75.

Vanderputten 2013: Steven Vanderputten, *Monastic Reform as Process: Realities and Representations in Medieval Flanders, 900–1100* (Ithaca and London: Cornell University Press, 2013).

Vanderputten 2015: Steven Vanderputten, "The First 'General Chapter' of Benedictine Abbots (1131) Reconsidered," *The Journal of Ecclesiastical History*, 66.4 (2015): 715–734.

Vanderputten 2016: Steven Vanderputten, "The Statutes of the Earliest General Chapters of Benedictine Abbots (1131–Early 1140s)," *The Journal of Medieval Monastic Studies*, 5 (2016): 61–91.

Van Engen 1986: John Van Engen, "The 'Crisis of Ceonobitism' Reconsidered: Benedictine Monasticism in the Years 1050–1150," *Speculum*, 61 (1986): 269–304.

Venarde 1997: Bruce L. Venarde, *Women's Monasticism and Medieval Society: Nunneries in France and England, 890–1215* (Ithaca and London: Cornell University Press, 1997).

Villes 1977: Alain Villes, "L'ancienne abbatiale Saint-Pierre d'Orbais," *Congrès Archéologique de France*, 135 (1977): 549–589.

Waddell 2000: Chrysogonus Waddell, "The myth of Cistercian origins: C.H. Berman and the manuscript sources," *Cîteaux: Commentarii Cistercienses*, 51 (2000): 299–386.

Waldman 1985: Thomas G. Waldman, "Abbot Suger and the Nuns of Argenteuil," *Traditio*, 61 (1985): 239–272.

Wigny 1972: Baron Wigny, "L'abbatiale de Saint-Michel en Thiérache, modèle de Saint-Yved à Braine et l'architecture gothique des XIIe et XIIIe siècles," *Bulletin de la Commission royale des monuments et des sites*, n. s. 2 (1972): 13–43.

* First and foremost, I would like to thank the editors for their thoughtful and generous contributions to my research over the years, including that presented in this article, which have been invaluable. I would also like to thank the anonymous reviewer whose suggestions and observations significantly clarified my argument.

1. Van Engen 1986.
2. Constable 1996, 133–134.
3. As recently as 2013, Ellen Arnold, in her compelling treatment of the monastic landscapes of Stavelot-Malmedy in the Ardennes, could still paint a picture of a decaying Benedictine monasticism giving way to the vitality of the Cistercians (Arnold 2013, 21–22). I am not singling out Arnold here, but rather pointing to the currency of this formulation.
4. Arnold 2013 and Salzer 2017.
5. Vanderputten 2013.
6. Vanderputten 2016.
7. The copy that was preserved with the customary from Marchiennes is Douai, Bibl. Mun., MS 540, fol. 69r-69v, and is edited and discussed by Vanderputten 2016. The manuscript, apparently from Tournai, is Paris, BnF MS lat., 2677, fols. 83v-84r, and has been discussed at length by Ceglar 1988.
8. Berlière 1894, 391.
9. Berlière 1891, 257–60.
10. Ceglar 1988, 58, and Elder 2005, 122.
11. This paper represents portions of my current book project, which explores the physical and social landscapes of these twenty-one monasteries in order to better understand the architectural landscapes within which they operated. In some ways, my approach parallels that of Venarde 1997 for women's houses.
12. Gilchrist 1995. Though succinct, the first page of the introduction makes her point clearly and without equivocation. On the study of everyday life, see also de Certeau 1984. Ott 2015, 15, also makes the point that focus on reform in non-monastic church contexts limits the regional and the historically situated nature of ecclesiastical activity.
13. Vanderputten 2015, and Vanderputten 2016. In fact, Van Engen 1986, 284, already mentions the 1131 meeting as evidence for established Benedictine responses to reform environments. Constable 1996, 181, cites it as an example of a twelfth-century monastic practice that included general chapters and visitations. Ceglar 1988 and Elder 2005 also provide specific treatments of the 1131 general chapter in Reims. In his 2015 essay, Vanderputten places "general chapter" in quotation marks, signaling his intent to re-frame the idea of a general chapter as a response, in this case ephemeral to specific historical circumstances, rather than a narrowly defined institutional construct. Elder (2005, 117) had already used quotation marks to signal the difference between what took place in 1131 and the annual meetings of the Cistercian order.
14. Reims, Soissons, Chalons-sur-Marne, Senlis, Beauvais, Noyon-Tournai, Laon, Amiens, Arras, Cambrai, and Thérouanne. The shape of the archdiocese was a complex reality in itself. Arras only became part of the archdiocese in 1093, while in 1146 Noyon-Tournai was divided into two separate dioceses. This complexity is certainly relevant to my discussion here, however pursuing it falls outside the scope of the immediate discussion. See Ott 2015 for a discussion of the archdiocese during the centuries that fall on either side of 1200.
15. Vanderputten 2015, 731–732, who discusses the paucity of evidence for an annual meeting of these abbots after 1132.
16. The opening of the document reads: *Hoc est societas inter abbates Remis ordinata, ut pro fratribus defunctis qui sunt de illa societatequater in anno, id est in IIIIor temporibus, unum officium fiat in conventu* This association of prayers was constituted among abbots at Reims so that a divine office for the deceased brothers who were in that association be performed four times a year, that is during the four seasons See Vanderputten 2016, 79.
17. It is worth remembering that the Cistercians also followed the Benedictine rule and claimed to be following it literally. It may thus be that the reinstatement of original Benedictine practices by the Reims group was not only directed at reforming themselves, but was also a response to Cistercian polemic.
18. Ceglar 1976, 65–86, provides a discussion and edition of the letter. Further discussion can be found in Ceglar 1988, where he argues that William, abbot of Saint-Thierry, was essentially responsible for the composition of the Reims group's response to Mathew's letter. Vanderputten (2015), however, makes important observations in regard to how much of the document speaks directly to Cluniac liturgical practice, and argues that this as much as Cistercian polemic was the operative context of this document.
19. The abbeys of Anchin, Lobbes, and Saint-Nicolas-aux-Bois were all eremitic foundations, Lobbes in the seventh century and the other two in the eleventh. On Lobbes, see Ward in this volume. On eremitic foundations and the reform movement in the west of France, see Bonde and Maines in this volume.
20. For the history of Anchin, see Gerzaguet 1997.
21. For the history of Hasnon, see Dewez 1890. For Liessies, see Jacquin 1903 and Schuermans 1984. For the history of Lagny, see Darney 1994; for its architecture, see Bussière 1999, Polonofski 1982 and Polonofski 2000.
22. "Refoundation" obviously transforms life at any given monastery. Refoundation does not necessarily deny or reject the history of the site. New, reformed monks

would presumably have been entirely comfortable appealing to the history of the place and the predecessor community when engaged in matters such as dispute settlements.

23 See primarily Berlière 1894, and Berlière 1901. Both Elder 2005 and Vanderputten 2015, however, place quotation marks around the words "general chapter" in their titles, indicating their skepticism about whether the 1131 meeting should be understood as a general chapter for the houses involved. Before Berlière, a partial transcript of this record was published by Molinier 1890, 288–289, under the rubric of obituary records, presumably because the first part of the text deals with arrangements for prayers for the dead at each monastery and for the deceased brethren from the other monasteries in the larger group of Benedictine houses.

24 Ceglar 1976, and Ceglar 1988. For a critique of this presentation, see Vanderputten 2016, esp. 73–74.

25 Elder 2005. Her discussion of tenure provides insight into one aspect of how these abbots might have been able to institute their vision for monastic life in their individual monasteries. The longer an abbot successfully governed his brethren, the more authority he is likely to have had to make changes or regulate certain aspects of life more strictly. She does not, however, consider how many years an abbot may have held office, at this house or elsewhere, before taking up the abbacy of his current house. Given how well she documents the interactions of abbots within and outside of this prayer association, an abbot may well have come to a new office with well-established authority.

26 Vanderputten 2015, 716–721 where he discusses previous scholarship and its focus on singular explanatory frameworks in the context of making compelling arguments for the complex historical situatedness of these abbots' actions.

27 Vanderputten 2016, esp. 70–72, where he compares how this community documented their efforts with how Cistercians, Praemonstratensians, and Cluniacs documented theirs. There has been vigorous debate regarding when the Cistercians adopted centralized rule. See Berman 2000 for a later date and opposing views by McGuire 2000 and Waddell 2000.

28 On the role of bishops within the push for monastic reform in the archdiocese of Reims, see Ott 2015.

29 Vanderputten 2016, 85, on the passage he designates as section 13. Vanderputten focuses on the important issue of abbots being required to attend meetings (Vanderputten 2016, 75–76). The first sentences deal more generally, however, with the facilitating of monastic guests: *Si in civitate vel castello ubi sit abbatia, synodus aut conventus aliquis advenerit, ut secundum apostolum ecclesia non gravetur, abbates et monachi si voluerint competentius intrabunt monasterium, famulis vero et egalis suis de suo foris providebunt.* (If a synod or convocation should come to a city or castle where there is a monastery, so that, following the apostolic church, that monastery not be burdened, the abbots and monks, if they should judge it appropriate, having entered into the monastery, should provide for servants and similar people outside their community.)

30 On the concept of center and periphery and its use in archaeological study, see Rowlands 1987 and Champion 1989.

31 Hillier and Hanson 1984. Other important discussions of space include Lefebvre 1991 and Nora 1997.

32 The 1131 document begins: *Hoc est societas inter abates Remis Constituta*. Important houses in the region, such as Saint-Crepin-le-Grand outside of Soissons and Saint-Faron in Meaux, are examples of houses whose relationship to those of the 1131 community might shed light on the complexities of monastic identity. As another example, neither Saint-Remi nor Saint-Nicaise in Reims were part of the community either. A full understanding of "who" the monks of the Remois abbeys were will require understanding why such abbeys were not part of it.

33 It is worth observing, with respect to the absence of women's houses in the Reims group, that two of those houses—Homblières, evidently during the tenth century, and Saint-Jean-Baptiste de Laon in 1128—were originally convents and that their nuns were forcibly removed. See Venarde 1997, 43, and Barthélemy 1985, 240–241. Waldman 1985 mentions Saint-Jean-Baptiste in Laon specifically in the context of Suger's attitude toward reform and the forcible replacement of female monastics by male ones at Argenteuil.

34 Although Tournai was administered from Noyon in 1131, I include it here for the geographical significance of the designation.

35 For urban monasteries in northern France, see Atsma 1976.

36 Ott 2015, 15. Later in his book (183–185), Ott details the involvement of Gervais, archbishop of Reims, in the second half of the eleventh century, and his direct involvement in managing monastic life specifically in his city and diocese.

37 Elder 2005, 127.

38 Elder 2005, 127.

39 Three monasteries (Anchin, Saint-Nicholas-aux-Bois, and Saint-Sépulcre) were not founded until the second half of the eleventh century, while Saint-Jean in Laon seems to have been re-founded in some form in 1128. Yet all four of these houses are located in close proximity to others in the group, which implicates them in a monastic landscape that extends back into the sixth and seventh centuries.

40 Tuan 1977. Arnold 2013 elaborates on the subjective view, as Tuan might formulate it, when she describes how the monks of Stavelot-Malmedy expressed their sense of the forest of the Ardennes.

41 Guest 2012.

42 Hillier and Hanson 1984, 40.

43 Six new Praemonstratensian houses were founded in the adjacent diocese of Soissons, most of them established around 1130, essentially contemporary with the 1131 meeting in Reims.

44 Vanderputten 2015, 726. For discussion of Saint-Martin before and after its transformation into a Praemonstratensian house in about 1124, see Clark 1984.

45 Vanderputten 2015, 729. In his discussion, Vanderputten documents the many points of interaction between the associated abbots of the Reims group and the rise of the Praemonstratensian order.

46 Rapoport 1990.

47 For the architecture of Lagny, see Deshoulières 1920, Polonovski 1982, Bussiere 1999, and Polonovski 2000. For Orbais, see Héliot 1965, Villes 1977, and Killian 2008. For Saint-Michel-en-Thiérache, see Gigot 1983, Gigot 1986, and Wigny 1972.

48 For the architecture of Saint-Thierry, see Héliot 1970 and Héliot and Prache 1979.

49 Krautheimer 1942. Literature on the meanings of medieval architecture is voluminous and it is not our purpose here to review it. For a recent critique of Krautheimer, see McCurrach 2011. For a recent approach to the meaning of monastic architecture, with particular reference to Cistercian buildings in thirteenth-century England, see Cassidy-Welch 2001.

50 Crossley 1988, 121.

51 For Lieu-Restauré, see Smadja 2014, François 1997, and François and Perrin 1976. For Saint-Martin, see Clark 1984.

52 As newly established monastic communities, they are unlikely to have yet acquired the relics and/or burials that would have made the chapel spaces necessary.

53 Droguet 1994.

54 Defente 1996, 106. Defente publishes for the first time the abbé Delanchy's history of Saint-Médard, which documents several aspects of the relationship between Saint-Médard and the papacy. On pages 150–152, Delanchy discusses the late eleventh- and early twelfth-century history of monastic reform at Saint-Médard. See also Defente 1994. Beginning in spring of 2019, Defente assembled a new team of archaeologists to reconsider the architectural history of the abbey church. Preliminary results are such that much of what has been thought to be the case will need to be revised.

55 Defente 1996.

56 For the results of excavation, see Leman 1977. Although I am not concerned here with the stylistic history of Gothic architecture, Saint-Lucien has been a significant focus of discussion and debate regarding key moments in the development of the Gothic. See Henriet 1983 (reprinted as Henriet 2005) for a discussion of those debates. See Gall 1926 for an early study. Gardner 1980 publishes the discovery of a print that aids in a reconstruction of the interior space.

57 Cottineau 1939, 3052. Building chronology is not sufficiently precise to be able to say definitively whether the pope consecrated a newly finished church. Alternatively, the church may have been under construction and consecrated because the pope was available to do so. On consecrations, see Crozet 1946.

58 Trachtenberg 2001.

59 Du Bout 1890, 60–62. His first phrase after an opening chronological frame reads: *Mihi Willermo dei gratia Orbacensi abbati placuit altare quaddam quod constitutum erat in reaedificatione templi, in honorem Beatae Mariae Virginis et sancti Thomae martyris consecrari.* (It was pleasing to me, William, by the grace of God abbot of Orbais, to consecrate a certain altar in honor of the Blessed Virgin Mary and the holy martyr Thomas that had been set up during the rebuilding of the church.) Concerning the reliquary, Abbot William writes: *Placuit de caetero mihi cum fratrem meorum consilio, nec non metropolitani et Suessionnensis praecepto corpus Beati Reoli longaeva vetustate in quodam veteri vase repositum transferri in novum quod aedificatum constabat opere sumptuoso, lapidibus pretiosis, gemmis, auro et argento.* (For the rest, it pleased me in consultation with my brothers and not less with the direction of the metropolitan and Soissons, to transfer the ancient body of the blessed Réole placed long ago in a certain antique vase, into a new one that was made with sumptuous craftsmanship, with precious stones, gems, gold, and silver.)

ERIK GUSTAFSON

Camaldolese and Vallombrosan: Architecture and Identity in Two Italian Reform Orders

In the traditional narrative of monastic history, Italy was one of the cradles for monasticism in the western Mediterranean, home to Benedict and his rule as the wellspring from which most European monasticism would grow. From the Carolingian period onwards, however, the standard story of monasticism leaves Italy for the North, reshaped by the Aachen reforms and then Cluny. Much of the complexity added to this narrative by more recent scholarship has focused on the North, considering the influence of Irish monasticism on the continent, the rise of orders of regular canons following the Rule of Saint Augustine, the military and other new orders such as the Cistercians, Carthusians, and Grandmontains. Italy only returns to relevance in the later Middle Ages with the mendicant orders, particularly the Franciscans. This narrative generally omits two robust but regional Italian monastic congregations, the Camaldolese and the Vallombrosans.[1] While other reform orders have been marginalized by scholarly emphasis on the Cistercians and Cluniacs, the Camaldolese and Vallombrosans have been doubly marginalized, first by being neither Cistercian nor Cluniac, and second by being located in Italy. The Camaldolese were an eremitical order living predominantly in cenobitic monasteries, and the Vallombrosans were an austere Benedictine order actively promoting the reform of the Church. Both founded during the eleventh century in the Apennine mountains between Tuscany and Umbria, the orders grew rapidly side by side in central and northern Italy.[2] Contemporaries if not predecessors of the Cistercians and the other, better-known French reform orders, the presence of these Italian orders delayed the arrival of their Burgundian cousins in central Italy for at least a century. Deeply informed by, and participatory in, the religious reforms of the eleventh and twelfth century often referred to as the Gregorian Reform, the Camaldolese and Vallombrosans were at the vanguard of contemporary monastic thinking. The "other" Camaldolese and Vallombrosan orders mark central Italy as a vibrant and active center of medieval monasticism.

While many monastic histories at least acknowledge the Camaldolese and Vallombrosans, monastic architectural history tends to omit these orders almost entirely.[3] A handful of articles

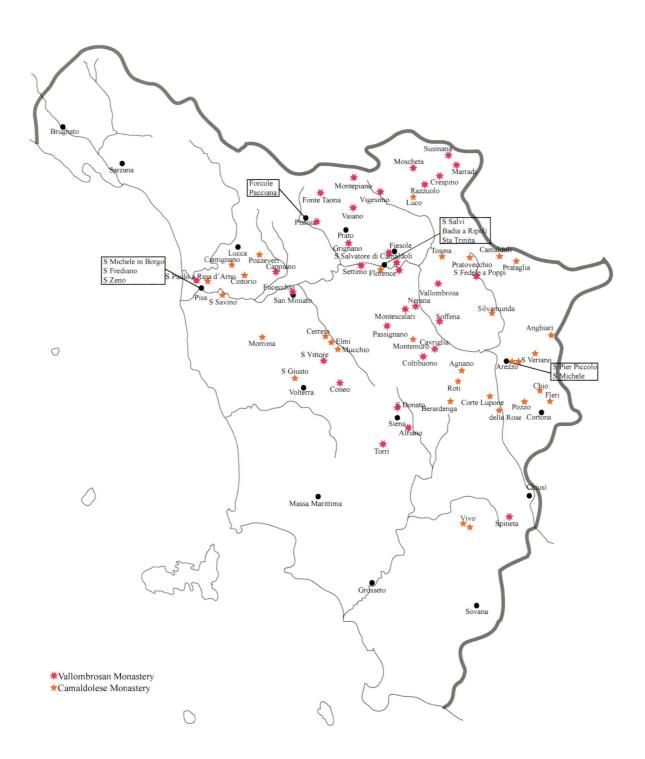

1
Map of Vallombrosan and Camaldolese monasteries in Tuscany.

has been published on Vallombrosan architecture, although Camaldolese architecture has never been studied collectively.[4] This essay seeks to introduce these central Italian orders and their architecture, using the roughly forty extant Camaldolese and Vallombrosan churches in Tuscany as a study sample (Fig. 1). I will argue that through the course of the eleventh and twelfth centuries both the Camaldolese and Vallombrosans were deliberately systematic in the construction of their monastic churches, using architecture to convey visually the spiritual charisma of each order as a renewal of the apostolic origins of monastic life. The Camaldolese and Vallombrosans nearly always built single-nave churches, although both often included architectural elaborations specific to their order. Various terms have been used to describe this church type.[5] In this paper, I intend "single nave" as a unifying term that refers to the principal spatial vessel, irrespective of function; it thus includes the architectural nave, the crossing (where present), the architectural choir, and the sanctuary. Two related questions arise regarding single nave churches: Why did these distinctly different orders build such consistently similar churches, and how do these orders help us consider wider patterns in medieval monastic architecture?

The broad focus on Camaldolese and Vallombrosan church typology is framed by the kinds of evidence available. While constitutions, or customs, for each order survive (and will be discussed below), these texts provided generalized instructions for each order on liturgical and functional issues of daily monastic life. Isabelle Cochelin has characterized two aims underpinning the writing of monastic customaries: their role as inspirational works or as normative texts.[6] The Camaldolese and Vallombrosan customaries blend both categories, similar to Cochelin's description of the Carthusian customaries, in that each set of constitutions synthesized the traditions of ideal practice in each mother house as a model for other monasteries within the order.[7] How such general instructions might have been enacted in individual houses can be hypothesized, but we lack both documents tailored to specific houses (if these existed) and the corresponding intact claustral complexes that would allow for material analyses.

Camaldoli and Vallombrosa themselves are still today the active mother houses for each order. Both have claustral complexes largely rebuilt in the early modern period. Neither site, however, has been the subject of monographic architectural study.[8] Nearly all of the other monasteries considered were reduced to parish churches from the sixteenth century onwards, further resulting in the general loss of claustral evidence. Surveys of Tuscan Romanesque architecture have predominantly focused on churches, so even in cases where claustral ranges partially survive there are few published plans.[9] Indeed, publication of the material aspects of extant monasteries of all orders in Tuscany is meager. Unlike northern Europe where exposing masonry has long been preferred, plaster covering both rubble and ashlar masonry has remained largely normative to the present day in Italy, further impeding architectural study. Italian churches also generally remain surrounded by adjoining structures, inhibiting exterior fabric analysis. These flanking buildings include residences, later parochial buildings, and agricultural structures, any of which might reuse walls from claustral structures still obscured by plaster. Pending extensive monographic and archaeological investigation of each Camaldolese and Vallombrosan monastic site, a broad-ranging analysis that takes a macroscopic view of each order's history and the architecture of their churches is the most effective use of the evidence currently available.

In examining Camaldolese and Vallombrosan churches as a means to study those orders as "other monasticisms," this article will consider how architecture can frame and focus monastic identities, which are in turn expressed through the rituals of the resident monks. It is unclear to what extent the laity were allowed into these monastic churches, making the question of lay participants for these performances of identity difficult to address.[10] The focus will therefore be on the monastic form of life for each order—specifically, on how Camaldolese and Vallombrosan church architecture informed monastic identity. I will start by considering the mechanisms through which architecture can signify, analyzing how the medieval exegetical method of tropology could interpret the single-nave church type as a moral instruction for the resident monks to follow the apostolic ideal in their every action. Such a conceptual frame then provides the setting for closer investigations of monastic history, spirituality, and architecture, first for the Camaldolese and then the Vallombrosans. I will argue that the Camaldolese and Vallombrosan orders drew from a shared apostolic inheritance that both informed their architecture and ideals and inspired their different monastic practices. The result was overlapping but distinct identities, realized above all in the specific ways in which the monks of each order conducted their form of life.

Monastic architecture and the apostolic ideal

To begin, I will consider the broader architectural and religious questions informing why these distinctly different orders consistently built such similar churches. Starting from the premise that architecture could produce complex layers of meaning for historical audiences, I ask what mental habits and patterns of interpretations might have been brought to bear by medieval reform monks on their own churches.[11] This initial inquiry addresses how monastic churches might have signified for those who were committed to their spiritual form of life. Without discounting the importance of claustral spaces in the daily life of monks, I argue that the church was the conceptual heart of every monastery. Churches were too important for their architectural design to be casual, which raises the question of how simple churches could signify. Monastic architectural history has generally tended to associate architectural form with monastic identity, treating churches as literal manifestations of the spiritual identities of resident religious men and women. The logical ramification of this approach is that the identity of each religious order should be differentiated by its architecture. In repeatedly employing the single-nave type, the Camaldolese and Vallombrosans participated in an understudied Europe-wide pattern of reform as new orders consistently built single-nave churches (a corpus I will discuss further below). Rather than arguing that each of these orders sought to individualize themselves by making minute formal changes to a shared architectural type, I suggest that these groups chose to build single-nave churches in order to signal participation in a shared religious ideal, the *vita apostolica*. This approach inverts the idea of monastic architecture as manifesting a specific identity, instead considering the church type as an intentional choice connoting a broad religious value that frames the more specific liturgical and functional practices of the resident order.

The methodological problem comes in assessing the mechanisms through which a connection between spiritual ideals and architectural form and decoration might be established.

The standard scholarly interpretation mentioned above has long read monastic architecture mimetically. Through this lens, the shape of a church and/or the style of its decoration are understood as a representation of the resident monks' spiritual ideals. That is, either a limited, austere style of decoration and/or the simplicity of plan and elevation are considered to represent spiritual austerity and humility, an analysis most often associated with the Cistercians and the mendicant orders.[12] In this paper, I suggest considering a tropological interpretation, which in the medieval exegetical tradition connects a figure (a trope, a type, or a scheme as Bede terms it) with a moral principle that guides mental habits.[13] Tropes as figurative, or metaphorical, modes of speech were a fundamental element of medieval rhetoric and exegesis, defined and explained by both Isidore (c. 560–636 CE) and Bede (c. 672–735 CE), who wrote the treatise "On Schemes and Tropes" to instruct monastic readers on the language of the Scriptures.[14] For Bede, tropes were allegories that reveal deeper layers of meaning.[15] When discussing the allegorical meanings of the Temple of Solomon, Bede describes the tropological sense of the temple as, "it is each of the faithful, to whom the Apostle said, 'Know you not, that your bodies are the temple of the Holy Spirit, who is in you?' (1 Cor 3:16, 6:15)."[16] Bede's linkage between an architectural trope and the active, moral practice of life as signified tropologically is clear. More broadly, Caroline Walker Bynum has emphasized the fundamental importance of socio-cultural models in medieval thought drawing from the tropological tradition, particularly with regard to religious models whose imitation, "shaped both 'outer man' (behavior) and 'inner man' (soul)."[17] Such a habit of thought aligns specific types of inner and outer behavior with broader conceptual frames. In the tropological sense, the activation of an architectural trope is realized through the form of life practiced by those using the architectural space. That is, the active moral guidance provided through the tropological sense was an interpretation of the historical socio-cultural traditions associated with an architectural type, mediated by the specific interests of the monks resident at that church. In this way, monastic architecture is read through the habits of monastic biblical exegesis. The representational interpretation of simplicity as humility can be layered with the tropological interpretation informing the moral ideals framing that practice of humility, multiplying the ways in which the resident monks both affirmed and were affirmed by their spiritual identity.

The first step in this tropological analysis entails identifying the architectural trope or type. The figurative connections I am suggesting hinge on the viewer recognizing a typological pattern. Such an interpretive approach does not identify a prototypical model to which later buildings refer, the first mode of signification Richard Krautheimer demonstrated with medieval architectural copies of the Holy Sepulchre.[18] Rather, I draw from the second mode of signification discussed by Krautheimer, that an architectural type is defined by a formal pattern of repeated construction at multiple locations that share an identity created by corresponding socio-religious practices, such as baptisteries.[19] Crossley's trenchant criticisms of medieval architectural iconography have focused on the subjectivity of linking form with historical ideas, arguing that such analyses are logically correlative rather than causal. In my view, this criticism mistakes causal objectivity as normative, and reflects modern standards rather than medieval ones. Typology had been one of the fundamental methods of biblical exegesis since Paul who, in Romans 5:14, calls Adam "a figure of him who was to come."[20] For this mode of architectural signification, pattern recognition must be combined with historical context for

the architectural trope to signify. For Krautheimer's baptisteries, the context was provided by a baptismal font and related practices of baptism, while the medieval church of the monastic reform was grounded in the identity of the resident monks and their form of life.

The medieval single-nave reform church presents such a formal pattern. The single-nave church type was used consistently by reform groups from the eleventh century onwards, often but not always with the transepts or lateral extensions that make a church cruciform in plan. The type seems to have been used already in Carolingian southern France at monasteries associated with the reformer Benedict of Aniane (c. 747–821 CE), such as the first church of Sainte-Marie at Aniane itself, the first church at Marmoutier (before side aisles were added in a second campaign), and Psalmodi, as noted by Jenny Shaffer.[21] Jill Franklin has linked the eleventh-century aisleless cruciform church with the idea of religious reform, and in particular with the architecture of canons regular in England.[22] Eleventh- and twelfth-century reform orders in France and England such as the Tironensians, Celestines, Grandmontains, Carthusians, and some Augustinian canons, as well as the later mendicant orders, all predominantly built single-nave churches.[23] Some Cistercian houses also built aisleless cruciform "first" churches.[24] The Camaldolese and Vallombrosans were the chief participants in this tradition for central Italy. When taken together, the churches of these monks and canons represent an explosion of single-nave church construction across Europe, broadly tied to the reform ideals of their builders.

The second step in this tropological analysis entails identifying the historical associations of the architectural trope. The aisleless cruciform church was a funerary church type that spread across Europe starting in the fourth and fifth centuries.[25] The two best-known surviving late antique examples are in Milan. The Basilica Apostolorum (better known as San Nazaro; see Fig. 2) was originally built by Ambrose (c. 340–397 CE) as an aisleless cruciform structure, its transepts screened from the crossing bay by columns.[26] Possibly built slightly later, San Simpliciano is larger than the Basilica Apostolorum and was also originally an aisleless cruciform church.[27] Both were vaulted in the late eleventh century, when the latter was also converted into a basilica. The church type had a notable diffusion in the fifth and sixth centuries around Europe. From at least the sixth century, transepts started to be omitted, resulting in funerary churches in which the main spatial vessel, the "single nave," focused attention and movement towards the primary holy burial area. The type maintained its significance through the Carolingian and Ottonian eras at major monasteries at Farfa and Saint Pantaleon in Cologne.[28] Like baptisteries, the type was defined by both formal elements and socio-religious practices: not all single-nave churches were necessarily understood as funerary churches, and not all funerary churches had single naves. When both aspects were combined, the funerary church typology remained a potent force in architectural signification until the eleventh and twelfth centuries when it was appropriated by reform monks and canons.

The third step in this tropological interpretation identifies the interests and ideals that framed the identity of the resident monks. The eleventh and twelfth centuries witnessed a wide variety of religious forms of life for the particularly devout to adopt and follow. All of these options were also equally informed, however, by a yet more fundamental model, that of the lives of Jesus and the apostles, generally referred to as the *vita apostolica*.[29] Indeed, the patristic fathers themselves had portrayed ascetic monastic life as apostolic, starting with the *Vita Antonii* of Athanasius (c. 296–373 CE), one of the textual traditions that guided the eleventh-

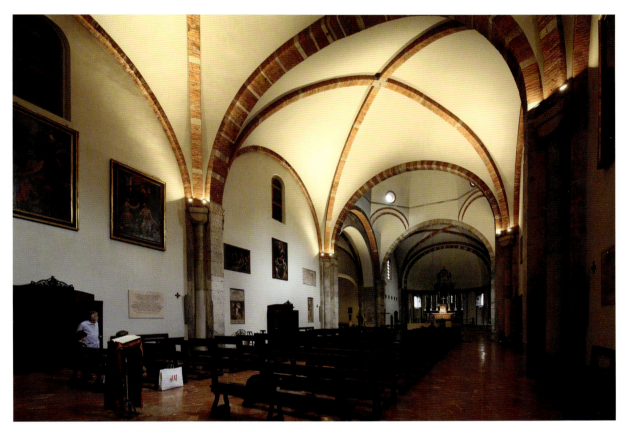

2 San Nazaro in Brolo (Basilica Apostolorum), Milan, view of the nave looking toward the apse.

century monastic reformers.[30] This idealization of the primitive church was a significant point of reference for the canonical legislation of reform in the eleventh century as well.[31] The sparing description of the apostolic life in the Book of Acts, combined with various comments on abjuring wealth and the value of humility elsewhere in the New Testament, provided a powerful and powerfully elastic apostolic ideal that was used to ground the various models for religious life competing in the eleventh and twelfth centuries.[32] Apostolicity was not the preserve of reform monks alone, but was the ideal model for all Christians, with the common life and idealized poverty as its most perfect forms.[33]

The fourth and final step in this tropological analysis interprets the architectural type/trope through those ideals, informing the moral habits that defined the monks' form of life. Again, as one of the most influential medieval monastic authors, Bede provides the connective logic. In his treatise *De Templo*, Bede describes the Temple of Solomon as a figure of the holy universal Church, which in turn was a figure of Christ's body.[34] For Bede, the material church is figuratively founded on Christ, while the stones in the walls are the apostles and saints.[35] The tropological lesson provided by linking the funerary church type with the allegorical idea of the walls as the apostles was the *vita apostolica*. The apostolic ideal was the moral model for shaping one's mental habits to be most like Christ and attain spiritual perfection, and therefore was the tropological ramification of the apostolic allegory of the church structure. The church was allegorically apostolic, but the *vita apostolica* was realized through the choices and actions of the monks themselves. The church serves as the trope interpreted by the informed monastic

mind as a moral lesson, grounding the resident order's specific practices in the fundamental ideals of Christianity.

If this allegory was generalized to all churches, then what would make the single-nave church type a more potent tropological signifier? Franklin has suggested that the Basilica Apostolorum served as an architectural model for medieval reform churches, particularly the Romanesque cathedral of York.[36] While the Basilica Apostolorum is an example of this broader typology, it seems unlikely that it was the model for a series of copies around Europe.[37] The funerary church type throughout Europe had long been associated with holy burials, from the original apostles to the panoply of early Christian saints. Moreover, as Samantha Kahn Herrick has argued, many of these late antique western saints were increasingly viewed as apostolic in the eleventh and twelfth centuries.[38] Further, the funerary church type resonated with the ascetic monastic idea of being dead to the world,[39] while also appealing to monastic patrons wishing to be buried close to the tombs of holy monks or founder saints. In addition, the single-nave spatial type also corresponds with the proportions of Solomon's Temple as given by Bede: 60 cubits long, 20 cubits wide, and 30 cubits high, resulting in a long space higher than it was wide, as found in so many medieval reform churches.[40] Taking all these factors into account, the single-nave reform church was not made apostolic by replicating an architectural model representing apostolicity such as the Basilica Apostolorum, but rather by applying the tropological message of the funerary church type as part of the apostolic form of life practiced by the monks inside the church. As demonstrated by the contemporary debate between canons and monks over who best fulfilled the *vita apostolica*, apostolicity was not the autonomous domain of monastic reform orders. While the single-nave architectural form, as a metaphor or figure, invoked broad religious ideals such as apostolicity, that apostolicity truly manifested itself through the practice of the monastic form of life specific to orders such as the Camaldolese and Vallombrosans, as will now be examined in depth.

The Camaldolese

The development of the Camaldolese order was not based on the charisma of a founder, or a mother house seeding the region with daughter houses. Camaldoli itself was founded in passing between 1025 and 1027 by Saint Romuald (c. 951–1025), a monastic idealist completely dedicated to perfecting the eremitic calling.[41] The congregation of Camaldoli was officially sanctioned by Pope Paschal II (1099–1118) in two bulls dated 1105 and 1113.[42] Growing from thirteen houses in 1105 to ninety-five houses in 1198, the order developed a significant presence in central and northern Italy. By 1200, the Camaldolese had thirty-three monasteries in Tuscany.[43] The majority of these houses were rural monasteries, but urban houses were also founded from an early date. The contemplative life of a hermit was the ideal of Camaldolese practice, conducted in a cell within a cenobitic monastery. This interpretation of the *vita apostolica* focused on the ascetic tradition of Anthony and the Desert Fathers as the ideal form of life. In *The Institutes*, a requisite book for every medieval monastic library, John Cassian describes the apostolic derivation of the Desert Fathers, who received the form of life from Mark who instructed the first monks to retain "those magnificent qualities that we read in the Acts of the Apostles were originally cultivated by the Church."[44] Cassian then defines those qualities by quoting Acts 4:32, the epitome of the

apostolic ideal.[45] The emphasis in the mid-twelfth century Camaldolese *Liber Eremitice Regule* was on the solitary life rather than withdrawal from the world, suggesting that rural or urban distinctions were unimportant once inside the monastery.[46]

Originally from Ravenna, Romuald founded scores of monasteries in central Italy, one of which happened to be Camaldoli.[47] A nobleman born in the mid-tenth century, Romuald became the abbot of the Cluniac Sant'Apollinare in Classe in 998. Just over a year later, Romuald retired from the monastery and began wandering as a hermit, from Italy to Cuxa, Istria, and back to Italy. He began founding monasteries, most importantly that at Camaldoli, where his new hermitage was joined with a nearby cenobitic site. Although he left no rule or specific structure for an order, one nevertheless arose based on the combination of eremitic and cenobitic monasticism.[48] That an order arose at the house continuing the traditions of Romuald was due not to the founder, but to later generations of leaders who codified and exported his ideals. The Camaldolese were not the only monastic congregation to grow out of Romuald's foundations: the monks of Fonte Avellana, on the border between the Marche and Umbria, also developed a sizeable order in the eleventh and twelfth centuries, although they had few houses in Tuscany.[49]

Romuald merged anchoritic eremitism with cenobitic monasticism, insisting that hermits living like the Desert Fathers in cells in the wild near a monastery should submit themselves in obedience to the abbot of the monastery under the rule of Saint Benedict. The eventual result was a fluid balance between life in a monastery and life in hermitages, with monks moving back and forth between the two. Romuald himself was, however, a wanderer, roaming repeatedly around Italy and abroad, bringing with him his message of a religious life. Indeed, in his *Vita* written by Peter Damian (c. 1007–1072), Romuald is characterized as balancing his internal ascetic devotion towards God with his duty to bear witness to others through his own life.[50] Echoing the Sermon on the Mount, Damian tells us that "wherever he went, [Romuald] lit the torches of others through his holy preaching,"[51] striving to "convert the whole world into a monastic hermitage,"[52] lighting the torches of faith in those listening to his preaching.[53]

The growth of the Camaldolese order itself was much more organic, with monasteries and hermitages given to Camaldoli by laity or bishops in order that the houses might be reformed or founded using the Camaldolese observance.[54] It is therefore the Constitutions, the document regulating Camaldolese religious life, that defined what it meant to be a Camaldolese monk or hermit. The first Constitutions of the Order were written by Prior Rodolfo I (in office 1074–1088), shortly before the congregation received official approval during the papacy of Paschal II.[55] The second guiding document for the Camaldolese was written by Prior Rodolfo II (in office 1158–1165) somewhere between 1158 and 1176, and is known as the *Liber Eremitice Regule*, the Book of Eremitical Rule.[56] These two documents reflect the development of the Camaldolese from an exclusive focus on the hermitage to a fluid balance between monasteries and hermitages.[57] In the Constitutions, the hermitage at Camaldoli is supreme; the lower hostel (later to become the monastery at Camaldoli) serves above all to support the hermits and keep outsiders away. Rodolfo I noted that some who had joined the hermitage were not in fact prepared for the lifestyle, and so established the monastery as a place where new monks could learn the lifestyle and train to join the hermitage. In the first Constitutions, the emphasis is above all on the hermit's practice, on the details of fasting throughout the liturgical year, mortifications, and attending masses said by monks ordained as priests. The few monasteries of the order were expected to

follow the rule of Saint Benedict strictly, and the Camadolese observance encouraged more fasting even for the monks.

The *Liber Eremitice Regule*, written nearly a century after the Constitutions,[58] established a more nuanced standard for the Camaldolese order. While still maintaining the hermitage at Camaldoli as the highest calling, the *Liber* encourages a balance between the active and contemplative lives for all the monks of the order. By the mid-twelfth century, the order had acquired many other monasteries and a few more hermitages, and the new constitutions reflected a balance of power and spirituality between the various members of the order. The solitary life was praised in the Prologue as the preeminent form of religious life, although no distinction is made here between hermits or monks. The following ten chapters of the *Liber* present a series of examples, charting the history of this highest religious way. The first example is Moses, who retired to the desert and then to Mount Sinai where, after fasting and directing his thoughts inwards, he received the divine fire. The Desert Fathers followed John the Baptist and Christ, understood through Cassian as the ideal ascetic exemplars of the *vita apostolica*.[59] From the start, the *Liber* emphasizes the intimacy of interior devotion, but also leaves implicit space for a balance between the solitary and communal ways. Unlike the Cluniac emphasis on liturgy as the core monastic practice, Mass and the hours were a secondary component of the Camaldolese life whose predominant concern was an inner focus. Whether a hermit or monk, a Camaldolese brother was taught in the *Liber* to practice the virtues of hermits: humility, obedience, abstemiousness, compassion, patience, silence, and meditation.[60] These virtues can lead to the perfection of love, a state of grace that the charity of God can bestow upon the worthy (Chapter 47). Such an emphasis on charity is both Augustinian in origin and symptomatic of the broad emphasis on the apostolic life current in the twelfth century.[61] Yet within the monastery, the rhetoric of love and charity predominated, restricted to the inner experience of those properly trained for this religious life.

How do these spiritual ideals encapsulating Camaldolese identity relate to the architecture of the order? Individual houses have received some monographic attention, but Camaldolese architecture has never been studied synthetically.[62] Of the thirty-three Camaldolese houses in Tuscany, five monasteries are lost and five have been completely rebuilt.[63] Of the remaining twenty-three churches (including three in ruins and seven only partially extant), twelve are single-nave buildings; seven are single-nave churches with transepts or transept-like chapels; and four are basilicas. While the dates of foundation or donation to the Camaldolese are known for most of these houses, it is unclear whether the monasteries were built under Camaldolese control.[64] Generally built of rubble core walls faced with ashlar or *moyen appareil*, and lacking features such as capitals or moldings, which might suggest stylistic comparisons, the churches are impossible to date with any precision. Without archaeological investigation to determine the presence of building phases, such questions cannot currently be answered. Independent Benedictine monasteries across Tuscany in the eleventh and twelfth centuries were predominantly built as basilicas but also occasionally as single-nave churches, so some of the churches that became Camaldolese may have predated the order's acquisition of them. Moreover, it is possible that some of the earlier houses acquired by the Camaldolese may have been reformed first and then affiliated with the order. Given the uncertainty in dating construction precisely, the corpus of Camaldolese architecture nonetheless presents a highly consistent pattern of architectural

form: the single-nave church. This architectural type perfectly suited the Camaldolese apostolic eremitical identity, blending the funerary dead-to-the-world monastic ideal with the Desert Fathers-based apostolic asceticism of the monk-hermits. That nearly all Camadolese churches were aisleless, similar to the single-nave churches of so many other reform orders, suggests an intentionality in using the building type.[65] Regardless of whether the Camaldolese built the church themselves or the church was brought into the congregation when a monastery adopted the Camaldolese observance, the practice of that order's form of life was precisely what activated the apostolic trope of the single-nave church type.

With the exception of the four basilicas mentioned above, the single-nave is the dominant unifying element in Camaldolese architecture. Camaldolese churches tend to have length to width proportions of 3:1 or 4:1, and have steep, narrow vertical proportions, all aspects that emphasize spatially the single nave (and that recall Bede's reported dimensions of Solomon's Temple). At the few transepted churches, the transept-like spaces vary from being more like extended flanking chapels to true cross-axial expansions from the nave. Berardenga and Ruoti had crossing cupolas, and San Veriano is unique for terminating a single-nave church with three semi-circular apses.[66] In practice, this variety suggests that the single nave was the necessary component of a Camaldolese church. There were, evidently, no set expectations for the eastern terminal end. Whether specific monasteries wished to incorporate other spatial elements into the culmination of the church around the altar area seems to have been left to each house.

Of the twelve simple single-nave Camadolese churches,[67] we will now look at the hermitage church of Camaldoli. Camaldoli was a double-sited community, in that it comprised two architectural complexes set a few kilometers apart on the side of a steep mountain: the lower monastery and the upper hermitage (Fig. 4).[68] The monastery has been rebuilt heavily through the centuries. It has two cloisters: the one on the south dates from the trecento and later, while the northern one dates from the cinquecento.[69] The monastic church was reconstructed in the cinquecento, and is now a fairly standard sixteenth-century monastic church with a retro-choir.[70] While the monastery has been completely rebuilt, the hermitage up the mountain is largely intact.[71] It was founded by Romuald in the early eleventh century and consecrated in 1027, with a church and five cells built as individual houses. Additional cells were added through the eighteenth century. A "cell of Romuald" is preserved, which seemingly served as the model for the other cells. Each house-cell has its own garden, bedroom, and chapel, so that each monk could live in complete isolation.

The church of the hermitage, San Salvatore, seems to have been rebuilt after a fire, leading to a consecration of the church on 23 August 1220 by Cardinal Ugolino (Figs. 3, 4, 7a).[72] How much of the earlier church might have been reused is hidden by the heavy seventeenth-century decoration covering the walls. A single-nave church terminating in a semi-circular apse, San Salvatore combines the expected simplicity of a hermitage church with a larger, more monumental scale. The church stands towards the front of the walled hermitage precinct, between the hermit cells and the entrance facing the lower monastery. It seems that the hermitage support-buildings, including conversi lodgings, cellars, kitchen, etc., were located on this lower side of the complex, although the current structures are later in date. I have speculatively reconstructed the interior layout in Figure 7a to suggest choir stalls for the monks in the central third of the church, with space for the conversi at the back near the western

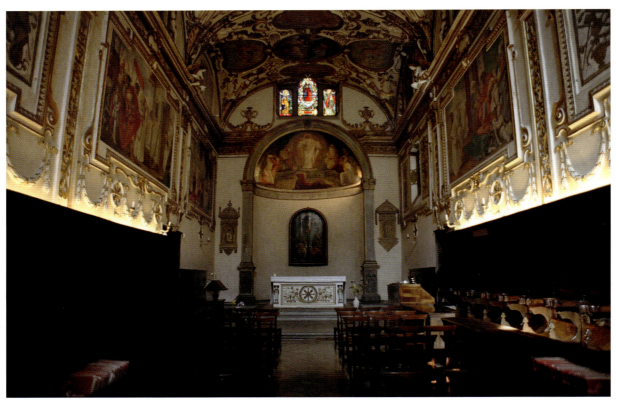

3 San Salvatore, Eremo di Camaldoli, view of the nave looking toward the apse.

portal, roughly based on the current fifteenth-century stalls.[73] Lateral portals likely allowed the hermits to enter the choir on either side of the church, taking the most direct path from their cells, while the western portal allowed the conversi to enter.[74] In the Constitutions of Prior Rodolfo I, of the 1080s, all hermits except for full recluses were required to attend Mass on all Sundays except for those of the two Lents, as well as on the feasts of Christmas, Easter, and Pentecost, and daily for Matins and the Hours.[75] Liturgical processions were few, if any—the internal spiritual encounter of the monk singing quietly was the ritual focus of the church. The single-nave church space mirrors and amplifies these liturgical emphases, enclosing everyone during worship within one spatial volume soaring overhead from the western portal to the main altar. The church of Camaldoli was dedicated to Christ as Savior, the ultimate model of the ascetic, eremitic life in early Camaldolese texts. As close imitators of the Desert Fathers in observing the ideal ascetic form of the apostolic life passed down from Christ, the monks fulfilled the tropological imperative of their church. Drawing from Bede's allegorical framework, the church dedicated to and founded on Jesus was built with figurative walls of the Desert Fathers as apostolic successors whose ethical lessons were embodied tropologically by the practice of the Camaldolese monks, pouring themselves inward to find God through the solitary way of the ascetic hermit.

From among the seven single-nave monastic churches with transept-like additions,[76] we will consider the Badia di Santa Maria di Agnano, possibly the most intact medieval Tuscan Camaldolese church (Figs. 5, 6, 7b).[77] Agnano joined the Camaldolese around 1113, having been founded in the late tenth century. Again, the date of the architecture is difficult to determine.

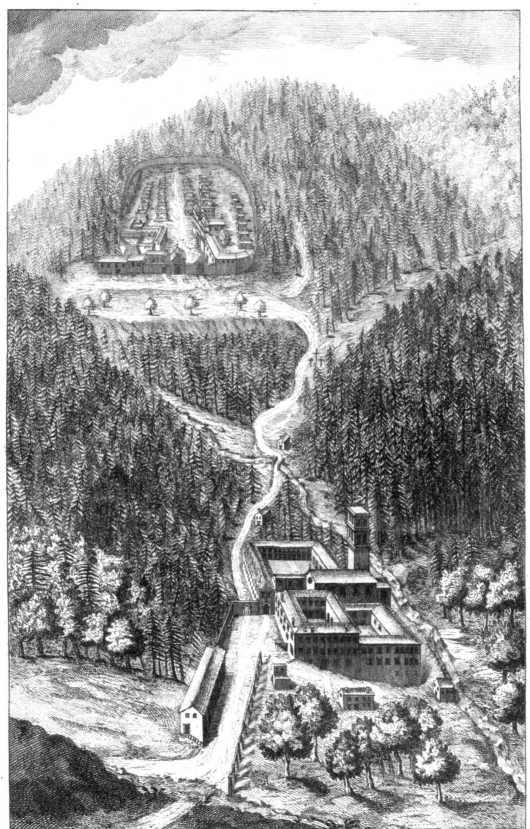

Hermitage and Monastery of Camaldoli, frontispiece engraving from *Annales Camaldulenses: Tomus Primus* (Venice, 1755).

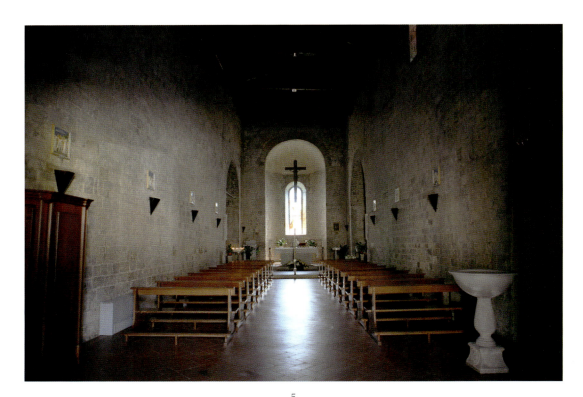

5
Santa Maria di Agnano, view of the nave looking toward the apse.

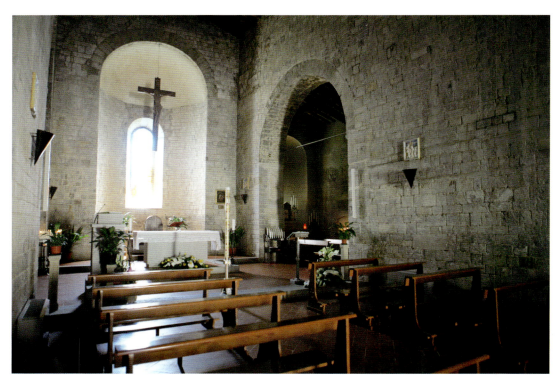

6
Santa Maria di Agnano, view from the nave showing the opening to the southern transept arm and the apse.

The church could predate the arrival of the order, although the regularity of the *moyen appareil* masonry suggests a mid-twelfth century date after the monastery became Camaldolese. While slightly longer than San Salvatore at the hermitage of Camaldoli, the church at Agnano better preserves the long and narrow spatial dimensions that would have also characterized the former. Applying the same hypothetical interior divisions used for the Camaldoli hermitage, we can suppose that the church was likely divided into choir and conversi areas (Fig. 7b), both connected to the altar by the continuous space of the single nave. The claustral structures of the monastery are unknown.[78] Separated from the main spatial vessel by diaphragm arches that carry the lateral walls part way across the transept opening, these side spaces are treated more like flanking chapels than a transverse spatial axis. By providing room for extra altars, these transepts-cum-flanking chapels served as spaces for festival masses for saints important to the monastery, as well as devotional spaces for individual, eremitic meditation and prayer. Obedience to Camaldolese observance was a recurring problem at Agnano, raising the further possibility that the chapel/transepts maintained traditions from the earlier history of the monastery.[79] All of these options are likely, and open the possibility of additional layers of liturgical practice in the transept/chapels. The main spatial vessel remains the primary physical and conceptual focus of the church, housing communal monastic practices and embodying the identity of the Camaldolese order.

The final category of Camaldolese church is the basilican church, of which four survive, all found in urban contexts: three in Pisa and one outside Volterra.[80] The order also had houses in Florence and Arezzo.[81] Cécile Caby has noted that, like all Camaldolese houses, these urban foundations were the result of reformer bishops or laity who summoned monks to found or reform urban monasteries.[82] Caby interprets these urban houses as useful to the order, in that they allowed the Camaldolese to maintain the various political and economic ties between rural monasteries and communal governments or bishoprics. Having an urban base to conduct such business was deemed useful from an early date.[83] Further, as Camaldolese monasticism merged eremitic asceticism and cenobitic eremiticism, not every Camaldolese monk had to live in rural hermitages. Whether in these urban monasteries or more rural houses, Camaldolese cenobitic monks were expected to foster the interior life and behavioral rigors of hermits, although on a reduced scale. The Pisan Camaldolese houses of San Michele in Borgo[84] and San Frediano[85] are both in the center of the city, while San Zeno[86] is in the northeastern corner just inside the Porta San Zeno. San Frediano became Camaldolese around 1076, San Michele before 1111, and San Zeno before 1136.[87] At all three sites, the order began rebuilding their churches soon after arriving. Whether the monks or their patrons dictated the choice of basilica over single-nave church is unknown, although the explosion of churches around the city replicating the new architectural style established by the Pisa Duomo might suggest that civic identity outweighed any hypothetical Camaldolese architectural agenda.[88] Regardless of architectural form, the ideal practice of Camaldolese spirituality in the church would have been the same as at other monasteries of the order. The tropological understanding of the church as a moral reminder of the *vita apostolica* would still apply, as it was ultimately built on an ideal allegory of the church universal. Even without the heightened figurative emphasis of the single-nave funerary church type, the Camaldolese hermit-monk form of life was what defined the brothers. Church architecture could be understood in ways that amplified aspects of that identity, but such

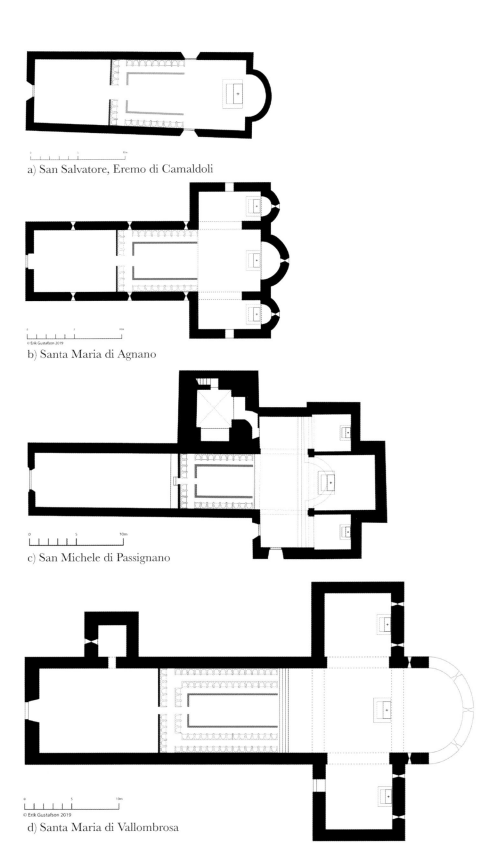

a) San Salvatore, Eremo di Camaldoli

b) Santa Maria di Agnano

c) San Michele di Passignano

d) Santa Maria di Vallombrosa

7a–d
Camaldolese and Vallombrosan church plans with hypothetical reconstructions of the liturgical choirs and altar placements.

figuration required the presence of the Camaldolese to signify. Camaldolese churches were not apostolic because of their form. Rather the Camadolese form of life, based on the Desert Fathers as the ideal apostolic successors to Christ, was what activated the apostolic trope of their churches.

The Vallombrosans

While the Camaldolese were driven by an apostolic eremitic ideal, the early Vallombrosans were instead motivated by an aggressive apostolic reformist agenda. The Vallombrosans were unusual in that their monks regularly left the cloister to preach. Their aim in this was to engage the laity in the monks' stand for reform and against simony. As Kathleen Cushing has noted, the Vallombrosans "publicly used their asceticism and their reputations of sanctity as instruments for reform."[89] The Vallombrosans actively preached outside their monasteries against any clergy tainted by simony. Disagreement over the extent of appropriate active engagement dominated eleventh- and twelfth-century debates in regard to the definition of both monks and regular canons as heirs to the apostolic ideal, categories that Caroline Bynum has shown to be more rigid for modern scholars than medieval reformers.[90] The Vallombrosan extreme of active practice was met with both praise and condemnation within the church. Similar to the *pataria* in Milan, the early Vallombrosans preached that the sacraments of clerics touched even indirectly by simony were invalid, leading to Peter Damian labelling them in 1067 as locusts who devoured everything good in the Church by betraying their pure withdrawal.[91] Despite the criticisms of Damian, Pope Leo IX (in office 1049–1054) demonstrated his approval by consecrating the new church at Vallombrosa, while the Vallombrosan views on simony were closely aligned with those of Cardinal Humbert of Silva Candida (c. 1000–1061) in his *Libri III adversus simoniacos*.[92] The new Vallombrosan order was confirmed in 1056 by Pope Victor II (in office 1055–1057) and spread extremely rapidly through central and northern Italy, with around seventy houses by 1200, thirty-three of these in Tuscany.[93]

In around 1040, the monastery of Vallombrosa was established in the hills just outside Florence. The founder of this new monastery was Saint Giovanni Gualberto (c. 985–1073), a Florentine monk from San Miniato al Monte who had rejected the contemporary simoniacal religious establishment of the city.[94] Upon leaving the monastery, Gualberto consulted the urban hermit Teuzo (fl. c. 1030–1050), formerly a monk at the Badia di Santa Maria but who had also abandoned the cenobitic life in protest of simony to live in a cell in the center of Florence.[95] Like the Vallombrosans, Teuzo was involved in a dispute with Peter Damian, who wrote a highly critical letter around 1055 on the undisciplined life of the urban hermit.[96] Damian condemned Teuzo's street corner preaching and public activism—precisely what appealed so strongly to Gualberto.[97] Teuzo urged Gualberto to condemn both the simonist abbot as well as the bishop of Florence. Giovanni did so in a public market, and then fled the city to become a hermit for several years, spending some time at Camaldoli before founding Vallombrosa.

As noted in the *Vita sancti Iohannis Gualberti*, the saint's religious lifestyle was centered on ascetic exercises of extreme rigor, on the renunciation of food and superfluous clothing, and on an alternation between retreat in the monastery and periodic descents into the city to intervene in the public squares.[98] The Gualbertian vision for his new monastery was thus

rooted in an extremely rigorous observance of the Benedictine Rule, marked most significantly by the austerity of daily life and absolute rule of *clausura*. To enable this complete claustration, the Vallombrosans instituted an organization of *conversi*, as did many other orders.[99] Austerity was achieved through harsh asceticism and the practice of poverty. Life at Vallombrosa was also informed by the rule of Saint Basil and that of the apostles, as testified by the Anonymous Life of Gualberto (written around 1115).[100] As Phyllis Jestice has noted, the early Vallombrosans owed much to the Basilian emphasis on providing charitable help to both brother monks and the laity.[101] This expression of brotherly love was combined with the ideal apostolic life based on Acts 2:44–47 and 4:32–37, where everything was shared in common for the good of all. Kaspar Elm has pointed out that Gualberto was modelling his new monastic customs on the *vita apostolica*, following the examples of the apostles and Desert Fathers in poverty, asceticism, and the act of wandering from the city to the desert and back.[102] Early Vallombrosan monasticism was thus perched on a balance between a strict, ascetic, cenobitic Benedictinism and an apostolic call to preach in the streets against the evils of society to help save the souls of others.

Gualberto and his brothers lived at Vallombrosa in their strict observance from the founding of the monastery until 1049, when Pope Leo IX issued a call to all monks, and especially those in Tuscany, to preach against married clergy and other abuses.[103] The Vallombrosans, as well as others, seem to have heeded the call. The zealous crusade conducted by Gualberto and the early Vallombrosan monks gained a specific focus upon the election of Bishop Pietro Mezzabarba of Florence in 1062 (in office 1062–1068), a protest that seems to have had significant public support.[104] Such active participation in secular matters was seen by many contemporaries as violating the fundamental tenets of monasticism, and they condemned Gualberto and the Vallombrosans for their perceived lapses. The Vallombrosan accusation of simony was condemned by the papacy, but the monks kept up their campaign. Peter Damian was sent in 1066 to adjudicate, and in 1067 Bishop Mezzabarba burned the Vallombrosan monastery of San Salvi just outside Florence, killing many of the monks and turning public opinion against himself. Representatives of the congregation were sent to Rome later in 1067 to denounce the bishop and to offer an ordeal by fire to prove their accusations. The Vallombrosans were rebuffed and sent home.[105] An ordeal by fire was nevertheless successfully undertaken without papal approval on 13 February 1068 by the Vallombrosan monk Pietro Igneo (fl. 1060–1089) outside Florence at the monastery of Settimo, forcing Pope Alexander II to dismiss the bishop.[106] The Vallombrosans were vindicated by the ordeal, broadly interpreted by contemporaries as evidence for the sanctity of their cause and their apostolic life.

Although the early Vallombrosans are most commonly characterized as anti-simoniacal crusaders, it is difficult to ascertain whether this tradition continued past the first few generations of brothers.[107] After Giovanni Gualberto died in 1073, Pope Gregory VII (r. 1073–1085) sent a letter to all the members of the Vallombrosan congregation exhorting them to be faithful to the life and model of their founder.[108] Pope Urban II (r. 1088–1099), however, ordered the monks back into their cloisters in 1091 following a protest action by the Vallombrosans against the new bishop of Pisa.[109] This came only a year after official papal recognition of the order, issued on 6 April 1090.

The last decade of the eleventh century seems to have marked a turning point in the congregation. Twenty years after the death of Gualberto and following official papal recognition,

the process of institutionalization began.[110] The first General Chapter of the Abbots seems to have been held in the 1070s, although the first record is from 1095.[111] The *Vita* of Gualberto by Andrea da Strumi (fl. 1080–1107) was written in 1092.[112] The first constitutions seem to have been written sometime between 1096 and 1112.[113] The constitutions are concerned almost entirely with the liturgical and fasting duties of the monks. Bernardo degli Uberti (c. 1060–1133), who became Abbot General of the order in 1098, seems to have helped institutionalize the stability of the monks within the monasteries. In the General Chapter of 1101, monks were expressly forbidden from leaving the cloister except for unavoidable need (*excepta inevitabili necessitate*).[114] As Bernardo had been made a cardinal in 1099, such a stipulation carried the weight of a papal decree. Bernardo had joined the congregation around 1085, a decade after the death of Gualberto, and so represents a generational shift in how the order defined itself. As Abbot General and a cardinal, he was able to dictate the return to strict enclosure over the older generation who objected to the change.[115]

While the ability of the monks to go out in the world themselves seems to have radically diminished at the close of the eleventh century, the apostolic ideal of charity remained central to Vallombrosan spirituality. Vallombrosan monasticism has been described as "benedictine obedience open to the lay world" by Francesco Salvestrini, in that nearly all Vallombrosan monasteries were located on major roads and had hostels (*spedali*) nearby for both their *conversi* as well as passing travellers.[116] Before dying, Giovanni Gualberto left an exhortation to his followers, encouraging them to treasure the *vinculum caritatis*, the chain of charity that bound them together and made possible the salvation of their souls.[117] The phrase is Augustinian in origin, and rooted for Gualberto in New Testament ideals of love for all mankind.[118] Such a motivation was at the root of the early Vallombrosan efforts towards reforming the church. Within the order, the *vinculum caritatis* led the congregation to see itself as a unity, in which each individual monastery was thought of as equivalent to Vallombrosa itself (predating the Cistercian *Carta Caritatis* by at least twenty-five years).[119] Moreover, in a departure from traditional Benedictine practice, monks of one monastery could transfer to a different house with the approval of their Abbot General.[120] As monks were increasingly confined within the cloisters from the 1090s, the *vinculum caritatis* took on more legislative and monastic emphases than the earlier apostolic intention. While choir monks were expected to remain enclosed with their monasteries, other means were devised to carry the bonds of charity to the outside world. Hostels (*spedali*) run by the Vallombrosans fulfilled a key role in this larger charitable mission.[121] Further, as the order was increasingly clericalized, monk-priests in the church were able to offer spiritual guidance to members of the laity who sought it out, and *conversi*-priests were appointed to oversee chapels and parish churches controlled by the monasteries.[122] Francesco Salvestrini has argued that the acceptance of secular clerics as *conversi* was relatively common from the early twelfth century onward, both for pastoral care in dependent parish churches as well as to conduct spiritual guidance in suffragan parish churches with the approval of parish rectors, key components in Vallombrosan outreach to the laity.[123]

Of the thirty-three Vallombrosan monasteries founded in Tuscany before 1200, seventeen are still extant in their medieval state, four are partially extant, seven were rebuilt in the early modern period destroying the earlier structure, two are in ruins, and three are lost. Vallombrosan architecture was first studied by Jean-René Gaborit in a two-part publication of 1964–1965,

a work that remains the basic reference on the subject.[124] Italo Moretti published four further articles on Tuscan Vallombrosan architecture.[125] For nearly all of the churches whose physical structure has been lost, Gaborit was able to find enough evidence to suggest the original plan. Only three of the thirty-three pre-1200 Vallombrosan monasteries cannot be discussed at all.[126] Through his survey, Gaborit demonstrated that the Vallombrosans nearly always built single-nave churches with transepts. Of the thirty churches that can be discussed, twenty-six are single-nave with transepts[127] and four are basilican (two with transepts).[128] Few of these buildings can actually be dated accurately, and so it is generally safer to consider them as having been erected during the twelfth century, rather than to speculate about more precise dating. About half of these monasteries were reformed by the Vallombrosans; that is, the order was called or sent to a monastery whose observance of the Benedictine Rule had lapsed. Italo Moretti has hypothesized that many Vallombrosan churches were first built as single-nave structures and were only subsequently given transepts.[129] While it is true that many Vallombrosan churches seem to have multiple building phases, not enough evidence exists at any one site to be sure whether a second campaign finished earlier work or changed the design of the church. This is not to discount the possibility of a wave of reconstruction in the twelfth century, during which time the Vallombrosan churches would have been uniformly given transepts. There is, however, currently no evidence for such a sweeping claim.

For the purposes of this essay, it is enough to note that by the beginning of the thirteenth century, nearly all Vallombrosan houses had single-nave churches with transepts forming a tau cross in plan, sometimes articulated with a crossing surmounted by a cupola on a drum.[130] Vallombrosan churches consistently have long, narrow naves, generally higher than they are wide (again sharing the proportions Bede gave of Solomon's Temple), with slightly varying solutions at the east end to emphasize the altar area. In nearly all these cases, the remarkably consistent repetition of a single iconic spatial type clearly suggests architectural form was important to the order as a marker of their identity and presence. Like the Camaldolese, the single-nave church type connoting withdrawal from the world and reform monasticism matched well with Vallombrosan ideals. What differentiated a Vallombrosan church from a Camaldolese church was the monks inside and their form of life, both apostolic in inspiration but distinct in their spiritual practices.

The *Vita sancti Iohannis Gualberti* records that the first church at Vallombrosa was built in 1038 in wood.[131] A stone church was immediately begun thereafter, completed by 1058 when Cardinal Humbert of Silva Candida consecrated two altars in addition to the original, indicating that the wooden oratory had been replaced.[132] Nothing is known of the first stone church, which was replaced from 1224–1230 following complaints—made while the order hosted the 1223 general chapter—that the older church was uncomfortably small.[133] Given the presence of three altars and the number of other Vallombrosan churches built in the twelfth century that followed the model of a single-nave with transepts, it seems likely that the first stone church at Vallombrosa shared the type. Without archaeological work in the nave, such a conclusion must remain hypothetical.

The thirteenth-century Santa Maria di Vallombrosa is a single-nave church with transepts forming a tau cross, originally with a raised dome or vault above the crossing (Figs. 7d, 8, 9).[134] The interior has undergone many renovations from the fifteenth through the eighteenth centuries,

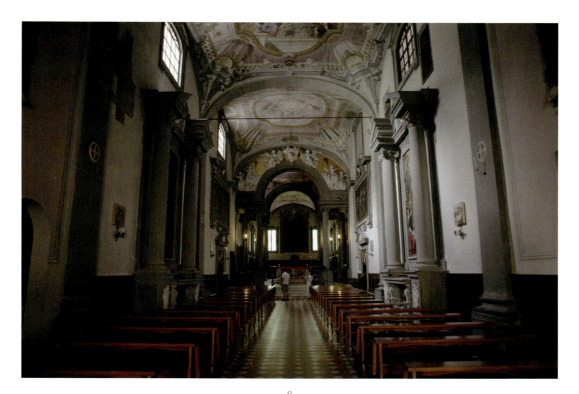

8
Santa Maria di Vallombrosa, view of the nave looking toward the apse.

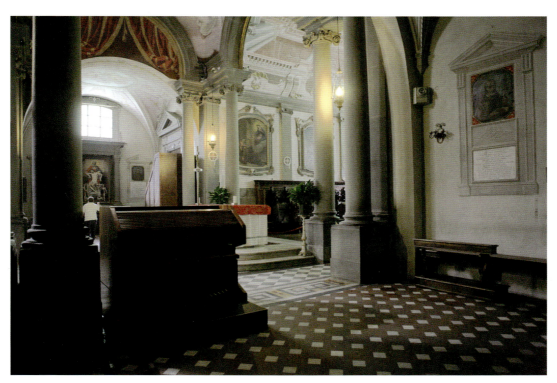

9
Santa Maria di Vallombrosa, view from the crossing showing the northern transept arm and part of the apse.

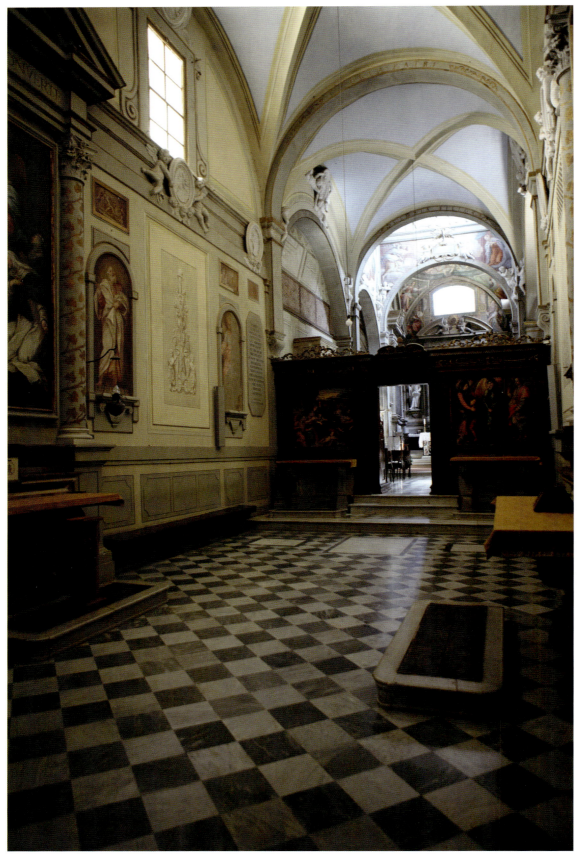

10
San Michele di Passignano, view of the nave looking toward the apse.

most notably the movement of the choir into a rebuilt, extended main chapel and the vaulting of the interior.[135] Vallombrosa has relatively greater length than the other Vallombrosan churches, unsurprising in the mother house of the order. The transepts are also relatively larger, and are squares nearly equal to the nave width. All the vaulting is a later addition; the original church would have had an open-truss roof. The nave was redecorated in the seventeenth century, when the earlier main chapel was also replaced with a deep retro-choir.[136] Chapels and a sacristy were also added on the east side of the transepts, not shown in Figure 7d. In spite of all these modifications, the early thirteenth-century structure is still clear. In the current church, four steps lead from the main spatial vessel up to the crossing. That the transepts and crossing were originally at this level is suggested by the door in the south transept leading into the cloister. I have hypothetically reconstructed the monks' choir at the foot of these stairs, leaving space at the western end of the church for conversi.

The Vallombrosans were more focused on a developed, sung liturgy than were the Camaldolese, drawing from the Cluniac tradition in their early twelfth-century constitutions, which are almost entirely dedicated to the minutiae of the Hours, masses, and feasts.[137] Beginning their day at Matins, the monks processed into the church and genuflected at the high altar before taking their seats in the choir.[138] At Vallombrosa, the path from the cloister entrance in the south transept to the choir passes the altar, where the monks would have genuflected. I have suggested the main altar may have been in the crossing under some sort of small tower, leaving space for the presbyters to circumambulate the altar with incense and prayers, but also making the altar the spatial and visual focus of the church.[139] In addition to the canonical Hours, allowance was made for private prayer in the church. Brothers not leaving the cloister for manual labor in the afternoon were required to recite Psalms silently.[140] Such worship could have taken place in the choir or at altars in the transepts. The single-nave church with transepts is focused on the crossing, framed at the east by a more complex sanctuary. The monks' movement into and out of the church and their mental attention during worship was always oriented towards the altar. The domed, or vaulted, crossing thus became exemplary of the Vallombrosan experience of sacred space. In *The Institutes*, John Cassian describes the apostolic basis for the nighttime and daytime prayers, as passed from the apostolic fathers to the monks of Egypt and Palestine.[141] The Vallombrosan constitutions likewise founded themselves on the institutions of the Fathers, aligning themselves with the apostolic tradition through Cassian.[142] The Vallombrosan focal experience on liturgical prayer was framed spatially by the single-nave church. That church was made apostolic through the Hours and prayer rooted in the practice of the apostles. The brothers at Vallombrosa performed on a daily basis their interpretation of ideal Christian monastic life. With each Hour performed in devotion to God, the monks actively performed the moral lessons of the *vita apostolica*, constantly reaffirming the tropological lesson of the church in which they gathered to pray.

The Vallombrosans acquired Passignano in 1049, a house that would become significant within the order as the monastery where Gualberto passed his last years and would be buried (Figs. 7c, 10, 11).[143] Gualberto's body was probably buried in the crypt, which consists of three aisles ending in an apse (the relics are now kept in the northern chapel of the church). Stylistically the crypt seems to date to the mid-eleventh century, possibly relating it to monastic structures built before the arrival of the Vallombrosans.[144] The nave is likely the original eleventh-century

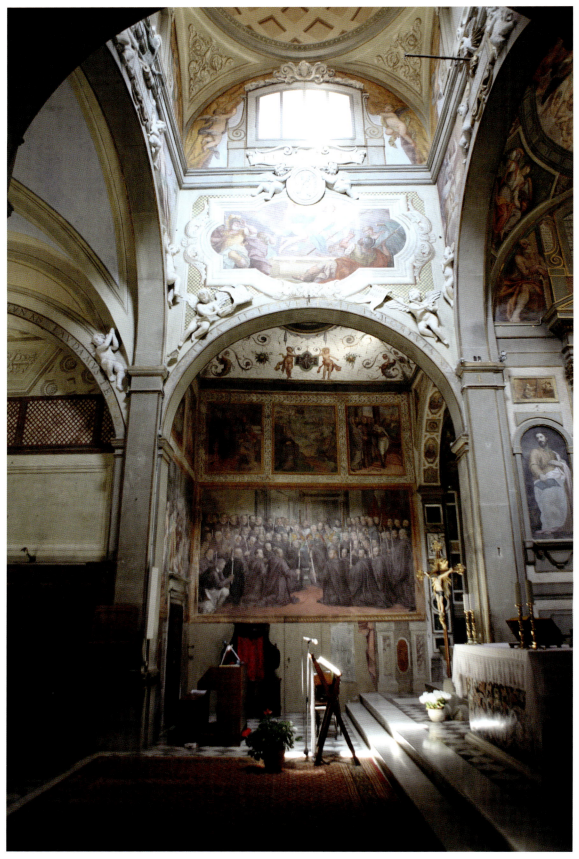

11
San Michele di Passignano, view from the crossing into the northern transept arm.

structure, but a heavy redecoration campaign of the sixteenth century has completely obscured its walls. The fifteenth-century claustral complex abuts the church on the south and a canonry was built along the north side of the church in 1875 after the monastery had been suppressed. These structures obscure the exterior nave masonry, while the east end masonry is exposed but heavily obscured by trees.

Long and narrow, the nave proportions are consistent with Vallombrosa and other churches of the order. Like Vallombrosa, monks would have entered through the south transept, genuflected towards the altar, and then processed into the choir. The choir screen and stalls date from the sixteenth century, likely replacing the previous medieval ones. The east end of Passignano was rebuilt in the 1280s after a 1255 fire, replacing the earlier transepts and single apse (suggested with grey lines in Figure 7c, based on the crypt below) with transepts forming a tau cross, a square apse, and two square chapels.[145] How much of the medieval fabric remains in the current eighteenth-century reworking of the crossing cupola is unclear. The pointed arches of the transept chapels are still intact, suggesting that the eastern end of the church would have been higher and brighter than the east end of Vallombrosa built some seventy years before. Despite the difference in style, the eastern end of Passignano, with its two additional projecting chapels, is an elaboration of the Vallombrosan type, focused on the centrality of the altar to balance the spatial emphasis on the choir of the single-nave church.

Like the Camaldolese, four basilican churches provide the exceptions to the single-nave norm. The four are Settimo, Vaiano, San Paolo a Ripa d'Arno in Pisa, and Santa Trinitá in Florence. In each case, basilican churches were already on site when the Vallombrosans arrived, as was also the case when in 1198 the order was given Santa Prassede in Rome by Pope Innocent III (r. 1198–1216 CE). The rural monastic churches at Settimo and Vaiano were left as they were. The Vallombrosans were only resident at Settimo from c. 1040–1090, when control reverted to the Cluniacs.[146] During that time, however, Settimo was very important within the order, having been the site of Pietro Igneo's famous 1068 victory through an ordeal by fire over the Florentine bishop Pietro Mezzabarba, which legitimated the order in the eyes of Pope Alexander II. By holding general chapters of the Vallombrosan abbots at Settimo in 1073 and 1076, the order emphasized the memory of both the ordeal by fire and their papal approval. It is probable that the church of Settimo became something of a *loca sancta* following the ordeal by fire, so tearing it down to build a single-nave church might have risked damaging the holy history of the site. Founded in the ninth century, Vaiano had been a powerful regional monastery in the foothills of the Apennines on the road between Florence and Bologna before joining the Vallombrosans around 1075, raising the possibility that long-standing patrons' funerary rights and the corresponding liturgical traditions might have played a role in church design.[147] The basilicas in Pisa and Florence were rebuilt by the order into larger and more elaborate churches. San Paolo a Ripa d'Arno in Pisa[148] and Santa Trinitá[149] in Florence were both basilicas with transepts, a relatively unusual combination in Tuscan architecture.[150] The transepts at both these churches form a tau cross in plan, the same arrangement used across the order as demonstrated by single-nave Vallombrosa and Passignano.[151] Like the Camaldolese basilican churches in Pisa, San Paolo a Ripa d'Arno and Santa Trinitá were important churches for their respective cities as well as being Vallombrosan monasteries. Their architecture drew on the civic style of the respective cathedrals, although the addition of tau-cross transepts linked them with

the architectural and liturgical traditions of the Vallombrosans. At all four of these basilican churches, it was again the monks' form of life that asserted their Vallombrosan identity. While the single-nave church tropologically heightened the apostolic inspiration of Vallombrosan practice, that identity was realized in the monks' actions and thoughts rather than in their architecture. The predominance of single-nave churches with tau-cross transepts suggests that the aisleless cruciform type was the preferred church of the order, but monastic observance was more important than architectural conformity. Ultimately it was the Vallombrosan form of life, based on the apostolic traditions of constant prayer and charitable love, that activated the apostolic trope of their churches.

Conclusion

Monastic architecture could carry many associations: for powerful patrons it could reflect their own power and status; for its dependents a monastic complex could represent its own extensive land holdings spanning its full domain; for visiting monks many monasteries might be associated primarily with their great scriptoria producing elaborate illuminated manuscripts or with the kinds of lodgings provided for guests; for political leaders monasteries might connote either a rival power to subdue or a strong supporter; and for many others monastic architecture might simply have represented a sacred world of prayer and sanctity accessible only to the powerful elite. For these and many other reasons, the choice of architectural form and style mattered. For the Camaldolese and Vallombrosans, their architecture served to reinforce their own monastic identities. Across Europe during the eleventh and twelfth centuries the old funerary church type was renewed into the reform church type, an architectural trope of early Christian holy burials that resonated with the ideal of monastic withdrawal as death to the world. Monks trained in the biblical exegetical tradition would have understood the church as an allegory of Christ and the apostles, and further as a tropology invoking the *vita apostolica* as the moral basis for how each monk lived their life. For all reform monks and canons, including the Camaldolese and Vallombrosans, church architecture could figuratively encourage reform ideals, but the funerary church type would only become a reform church type through the widespread and repeated practice of reformed apostolic forms of life in similar church spaces.

Camaldolese and Vallombrosan church architecture served as a frame for the performance of each order's identity. The simple, single-nave church type repeated at 45 of 53 surviving houses tropologically signified the apostolic basis for both Camaldolese and Vallombrosan forms of life. The programmatic, repeated use of the architectural trope provides evidence of an intentional use of architecture to articulate the identity of each order, itself performed through their daily practices. The Camaldolese and Vallombrosans shared an intent to reform monasticism as the most holy mode of Christian practice, living as closely as possible to the religious life of Christ and the apostles. The similarities of their architecture reflect this shared aim. The single-nave church framed, in turn, the solitary eremitic ideal within a coenobitic house for the Camaldolese, and the austere cycle of prayer and moral action of the Vallombrosans. It was the monks who established and performed the apostolic identities of their orders, which were given solemnity and focus by their architectural settings. The Camaldolese and Vallombrosans should no longer find their orders among the seldom considered "other

monasticisms." The two orders deserve a more visible place in monastic architectural history, emphasizing their importance among the twelfth-century apostolic movements in Europe as well as for the later rise of the mendicant orders from the central Italian cradle of reform monasticism.

Primary and Secondary Works

Andrault-Schmitt 2016: Claude Andrault-Schmitt, "Un mémorial aristocratique: le monastère de Grandmont au comet de la Marche (1177–1307)," *Cahiers de civilisation médiévale*, 59.2 (2016): 113–141.

Andrault-Schmitt 2018: Claude Andrault-Schmitt, "Grandmont and the Example of the English Kings: An Example of Patronage in the Context of an Ascetic Architectural Trend," in *Romanesque Patrons and Processes*, ed. Jordi Camps, Manuel Castiñeiras, John McNeill, and Richard Plant (London: Routledge, 2018), 93–108.

Aniel 1983: Jean-Pierre Aniel, *Les maisons de Chartreux: des origins a la Chartreuse de Pavie* (Paris: Arts et Métiers Graphiques, 1983).

Aston 2009: Mick Aston, *Monasteries in the Landscape* (Stroud: Amberly Publishing, 2009).

Aubert 1947: Marcel Aubert, in collaboration with the Marquise de Maillé, *L'architecture cistercienne en France*, 2 vols., 2nd ed. (Paris: Les Éditions d'Art et d'Histoire, 1947).

Bacci and Stopani 2007: Antonio Bacci and Renato Stopani, *Badia Agnano* (Florence: Centro Studi Romei, 2007).

Badstübner 1980. Ernst Badstübner, *Kirchen der Mönche: Die Baukunst der Reformorden im Mittelalter* (Berlin: Union Verlag, 1980).

Baethgen 1934: Friedrich Baethgen, "Vitae Sancti Iohannis Gualberti," *Monumenta Germaniae Historica: Scriptores*, 30.2 (1934): 1076–1110.

Baggiani 2016: Franco Baggiani, *San Michele in Borgo: Cenni di storia della chiesa (1076–2016)* (Pisa: Edizioni ETS, 2016).

Bandmann 1951: Günter Bandmann, "Ikonologie der Architektur," *Jahrbuch für Ästhetik und Allgemeine Kunstwissenschaft*, 1 (1951): 65–109.

Bandmann (1951) 2005: Günter Bandmann, *Early Medieval Architecture as Bearer of Meaning*, trans. Kendall Wallis (New York: Columbia University Press, [1951] 2005).

Barney et al. 2006: Stephen Barney, W. J. Lewis, J. A. Beach, and Oliver Berghof, eds., *The Etymologies of Isidore of Seville* (Cambridge: Cambridge University Press, 2006).

Barone 2017: Zaira Barone, "La chiesa di Santa Maria di Campogrosso ad Altavilla Milicia (Palermo)," *Restauro archeologico*, 2 (2017): 106–121.

Bartelink 2004: G. J. M. Bartelink, "Monks: The Ascetic Movement as a Return to the Aetas Apostolica," in *The Apostolic Age in Patristic Thought*, ed. A. Hilhorst (Leiden: Brill, 2004), 204–218.

Beccaria 1998: Sara Beccaria, "I conversi nel Medioevo: un problema storico e storiografico," *Quaderni medievali*, 46 (1998): 120–156.

Belisle 2007: Peter-Damian Belisle, *Camaldolese Spirituality: Essential Sources* (Bloomingdale, IN: Ercam Editions, 2007).

Benvenuti and Borghi 1964: L. Benvenuti and P. Borghi, "Risultati di uno studio sulla chiesa di San Zeno in Pisa," *Bollettino dell'Accademia degli Euteleti della città di San Miniato*, 27 (1964): 147–160.

Berman 2000: Constance Berman, *The Cistercian Evolution: The Invention of a Religious Order in Twelfth-Century Europe* (Philadelphia: University of Pennsylvania Press, 2000).

Bernacchioni 1999: Annamaria Bernacchioni, "Badia di San Michele e Chiesa di San Biagio," in *Il Chianti e la Valdelsa senese*, ed. Valentino Baldacci (Milan: Mondadori, 1999), 176–178.

Bertocci 2012: Stefano Bertocci, "Le chiese del Sacro Eremo e del Monastero di Camaldoli: rilievo e documentazione per la costruzione di una 'sistema' delle conoscenze," in *Architettura eremitica: Sistemi progettuali e paesaggi culturali. Atti del Terzo Convegno Internazionale*, ed. Stefano Bertocci and Sandro Parrinello (Florence: Edifir, 2012), 54–63.

Bettarini, Frati, and Stopani 1996: Ilaria Bettarini, Marco Frati, and Renato Stopani, eds., *Chiese medievali della Valdelsa: Tra Firenze, Lucca e Volterra* (Empoli: Editori dell'Acero, 1996).

Binski 2004: Paul Binski, *Becket's Crown: Art and Imagination in Gothic England 1170–1300* (New Haven: Yale University Press, 2004).

Blum 1990: Owen Blum, ed., *The Letters of Peter Damian, 31–60* (Washington, DC: Catholic University of America Press, 1990).

Blum 1998: Owen Blum, ed., *The Letters of Peter Damian, 91–120* (Washington, DC: Catholic University of America Press, 1998).

Boesch Gajani 1964: Sofia Boesch Gajani, "Storia e tradizioni vallombrosana," *Bullettino dell'istituto storico italiano per il medio evo e archivio muratoriano*, 76 (1964): 99–215.

Bonde, Killian, and Maines 2011: Shela Bonde, Kyle Killian, and Clark Maines, "The Earliest Church at Ourscamp and the Long History of Cistercian 'First Churches' in France," *Commentarii cistercienses*, 62 (2011): 5–35.

Bossi and Ceratti 1993: Paolo Bossi and Alessandro Ceratti, *Eremi camaldolesi in Italia: Luoghi, architettura, spiritualità* (Milan: Vita e Pensiero, 1993).

Braunfels 1972: Wolfgang Braunfels, *Monasteries of Western Europe* (London: Thames and Hudson, 1972).

Brucher 1988: Günter Brucher, *Die sakrale Baukunst Italiens im 11. und 12. Jahrhundert* (Cologne: Dumont Verlag, 1988).

Bruzelius 2014: Caroline Bruzelius, *Preaching, Building and Burying: Friars in the Medieval City* (New Haven: Yale University Press, 2014).

Bynum 1982: Caroline Walker Bynum, *Jesus as Mother: Studies in the Spirituality of the High Middle Ages* (Berkeley: University of California Press, 1982).

Caby 1999: Cécile Caby, *De l'érémitisme rural au monachisme urbain: Les Camaldules en Italie à la fin du Moyen Âge* (Rome: École Française de Rome, 1999).

Caby 2003: Cécile Caby, "De l'abbaye à l'ordre: Écriture des origines et institutionnalisation des expériences monastiques, XIe-XIIe siècle," *Mélanges de l'École française de Rome: Moyen Âge*, 115.1 (2003): 235–267.

Caby 2005: Cécile Caby, "Règle, coutumes et statuts dans l'ordre camaldule (XIe-XIVe siècle)," in *Regulae-Consuetudines-Statuta*, ed. Cristina Andenna and Gert Melville (Münster: Lit Verlag, 2005), 195–222.

Caby and Licciardello 2014: Cécile Caby and Pierluigi Licciardello, eds., *Camaldoli e l'ordine Camaldolese dalle origini alla fine del XV secolo* (Cesena: Badia di Santa Maria del Monte, 2014).

Calati 1952–1954: Benedetto Calati, "Vita attiva e vita contemplative: La tradizione patristica nella primitiva legislazione camaldolese," *Vita Monastica*, 6 (1952): 10–28, 83–90; 7 (1953): 48–57; 8 (1954): 66–88.

Calati 1983: Benedetto Calati, "Una permanente tensione monastica: Cenobio - Eremo," *Vita monastica*, 162 (1983): 84–96.

Caneva 1999: Caterina Caneva, "Abbazia di Santa Maria," in *I dintorni di Firenze*, ed. Cristina Acidini (Milan: Mondadori, 1999), 197–199.

Caneva 2007: Caterina Caneva, *Museo d'arte sacra dell'Abbazia di Vallombrosa: guida alla visita del museo e alla scoperta del territorio* (Florence: Edizioni Polistampa, 2007).

Cantelli 1995: Giuseppe Cantelli, ed., *L'architettura religiosa in Toscana: Il Medioevo* (Florence: Banca Toscana, 1995).

Carruthers 1998: Mary Carruthers, *The Craft of Thought: Meditation, Rhetoric, and the Making of Images, 400–1200* (Cambridge: Cambridge University Press, 1998).

Carruthers 2008: Mary Carruthers, *The Book of Memory: A Study of Memory in Medieval Culture*, 2nd ed. (Cambridge: Cambridge University Press, 2008).

Carver McCurrach 2011: Catherine Carver McCurrach, "'Renovatio' Reconsidered: Richard Krautheimer and the Iconography of Architecture," *Gesta*, 50 (2011): 41–69.

Cassanelli 1986: Roberto Cassanelli, "La basilica di S. Nazaro Maggiore a Milano tra XI e XII sec.: dall'edificio Ambrosiano al cantiere romanico," in *Ambrogio e le cruciforme 'romana' basilica degli Apostoli nei milleseicento anni della sua storia* (Milan: NED, 1986), 131–141.

Cassanelli and Piva 2011: Roberto Cassanelli and Paolo Piva, *Lombardia Romanica: II, paesaggi monumentali* (Milan: Jaca Book, 2011).

Cassian 2000: John Cassian, *The Institutes*, trans. Boniface Ramsey (New York: Newman Press, 2000).

Cassidy-Welch 2001: Megan Cassidy-Welch, *Monastic Spaces and their Meanings: Thirteenth-Century English Cistercian Monasteries* (Turnhout: Brepols, 2001).

Ceccarreli Lemut and Garzella 2016: Maria Luisa Ceccarreli Lemut and Gabriella Garzella, eds., *San Michele in Borgo: mille anni di storia* (Pisa: Pacini, 2016).

Chellini 2007: Riccardo Chellini, "Note sulla viabilità medievale e le infrastrutture (ponti e spedali) nel territorio fiorentino," in *Archeologia del paesaggio medievale: Studi in memoria di Riccardo Francovich*, ed. Stella Patitucci Uggeri (Florence: Edizioni all'Insegna del Giglio, 2007), 79–103.

Chenu (1957) 1997: Marie-Dominique Chenu, *Nature, Man and Society in the Twelfth Century*, trans. Jerome Taylor and Lester Little (Toronto: University of Toronto Press, [1957] 1997).

Choisselet and Vernet 1989: Danièle Choisselet and Placide Vernet, *Les* Ecclesiastica Officia *cisterciens du XIIeme siècle* (Reiningue: Abbaye d'Oelenberg, 1989).

Ciardi 1999: Roberto Paolo Ciardi, *Vallombrosa: santo e meraviglioso luogo* (Ospedaletto: Pacini, 1999).

Ciliberti and Salvestrini 2014: Riccardo Ciliberti and Francesco Salvestrini, eds., *I vallombrosani nel Piemonte medievale e moderno: Ospizi e monasteri intorno alla strada di Francia* (Rome: Viella, 2014).

Ciotta 1992: Gianluigi Ciotta, s.v. "Basiliani," *Enciclopedia dell'Arte Medievale* (Rome: Treccani, 1992), 3:154–162.

Cochelin 2014: Isabelle Cochelin, "Customaries as Inspirational Sources," in *Consuetudines et Regulae: Sources for Monastic Life*, ed. Carolyn Marino Malone and Clark Maines (Turnhout: Brepols, 2014), 27–72.

Connolly 1995: Seán Connolly, ed., *Bede: On the Temple* (Liverpool: Liverpool University Press, 1995).

Constable 1987: Giles Constable, "The Ceremonies and Symbolism of Entering Religious Life and Taking the Monastic Habit, from the Fourth to the Twelfth Century," in *Segni e riti nella chiesa altomedievale occidentale* (Spoleto: Centro Italiano di Studi sull'Alto Medioevo, 1987), 2:771–834.

Coomans 2018: Thomas Coomans, *Life Inside the Cloister: Understanding Monastic Architecture* (Leuven: Leuven University Press, 2018).

Cowdrey 1968: H. E. J. Cowdrey, "The Papacy, the Patarenes and the Church of Milan," *Transactions of the Royal Historical Society*, 18 (1968): 25–48.

Cowdrey 1972: H. E. J. Cowdrey, ed., *The* Epistolae Vagantes *of Pope Gregory VII* (Oxford: Clarendon Press, 1972).

Crosara 1970: Fulvio Crosara, *Le Constitutiones e le Regulae di vita eremitica del b. Rodolfo: Prima legislazione camaldolese nella riforma gregoriana* (Rome: n.p., 1970).

Crossley 1988: Paul Crossley, "Medieval Architecture and Meaning: the Limits of Iconography," *The Burlington Magazine*, 130 (1988): 116–121.

Crossley 2010: Paul Crossley, "*Ductus* and *Memoria*: Chartres Cathedral and the Workings of Rhetoric," in *Rhetoric Beyond Words: Delight and Persuasion in the Arts of the Middle Ages*, ed. Mary Carruthers (Cambridge: Cambridge University Press, 2010), 214–249.

Crostini and Angeli Murzaku 2018: Barbara Crostini and Ines Angeli Murzaku, eds., *Greek Monasticism in Southern Italy: The Life of Saint Neilos in Context* (Abingdon: Routledge, 2018).

Curuni 1969: Alessandro Curuni, "Le chiese romaniche in Pisa e dintorni," *Comune di Pisa*, 5.3–4 (1969): 24–32.

Curuni 1970a: Alessandro Curuni, "Le chiese romaniche in Pisa e dintorni," *Comune di Pisa*, 6.5–6 (1970): 19–32.

Curuni 1970b: Alessandro Curuni, "Le chiese romaniche in Pisa e dintorni," *Comune di Pisa*, 6.11–12 (1970): 14–26.

Cushing 2005a: Kathleen Cushing, "Of *Locustae* and Dangerous Men: Peter Damian, the Vallombrosans and Eleventh-Century Reform," *Church History*, 74 (2005): 740–757.

Cushing 2005b: Kathleen Cushing, *Reform and the Papacy in the Eleventh Century: Spirituality and Social Change* (Manchester: Manchester University Press, 2005).

D'Acunto 1993: Nicolangelo d'Acunto, "Lotte religiose a Firenze nel secolo XI: aspetti della rivolta contro il vescovo Pietro Mezzabarba," *Aevum*, 67 (1993): 279–312.

D'Acunto 2002: Nicolangelo d'Acunto, "Un eremita in movimento: Il Romualdo di Pier Damiani," in *San Romualdo: Storia, agiografia e spiritualità* (Negarine: Il Segno di Gabrielli editori, 97–130.

D'Acunto 2005: Nicolangelo d'Acunto, "Vallombrosani," in *Regulae – Consuetudines – Statuta*, ed. Cristina Andenna and Gert Melville (Münster: LIT Verlag, 2005), 157–167.

Dahan 1999: Gilbert Dahan, *L'exégèse chrétienne de la Bible en Occident medieval, XIIe-XIVe siècle* (Paris: Cerf, 1999).

Dalla Negra 2005: Riccardo dalla Negra, *Le Badia di San Salvatore di Vaiano: storia e restauro* (Livorno: Sillabe, 2005).

Dameron 1991: George Dameron, *Episcopal Power and Florentine Society 1000–1320* (Cambridge, MA: Harvard Historical Studies, 1991).

David 1984: Massimiliano David, *La basilica di San Nazaro* (Milan: Edizioni ET, 1984).

De Lubac (1959) 2000: Henri de Lubac, *Medieval Exegesis, II: The Four Senses of Scripture*, trans. E. M. Macierowski (Grand Rapids: Eerdmans, [1959] 2000).

Dezzi Bardeschi and Masetti 1981: Marco Dezzi Bardeschi and Maria Luisa Masetti, "La chiesa di S. Trinità a Firenze," *L'architettura*, 27 (1981): 720–725.

Doquang 2018: Mailan Doquang, *The Lithic Garden: Nature and Transformation of the Medieval Church* (Oxford: Oxford University Press, 2018).

Doria, Zuccheri, and Galluzzi 1957: B. Doria, T. Zuccheri, and S. Galluzzi, "San Paolo a Ripa d'Arno in Pisa," *L'architettura*, 19 (1957): 50–55.

Duvernay 1952. Roger Duvernay, "Citeaux, Vallombrosa, et Étienne Harding," *Analecta sacri Ordinis Cisterciensis*, 8 (1952): 379–494.

Dvornik 1958: Francis Dvornik, *The Idea of Apostolicity in Byzantium and the Legend of the Apostle Andrew* (Cambridge, MA: Harvard University Press, 1958).

Elm 1995: Kaspar Elm, "La congregazione di Vallombrosa nello sviluppo della vita religiosa altomedievale," in *I Vallombrosani nella società italiana dei secoli XI e XII*, ed. Giordano Monzio Compagnoni (Vallombrosa: Edizioni Vallombrosa, 1995), 13–33.

Emerick 2011: Judson Emerick, "Building *more romano* in Francia during the Third Quarter of the Eighth Century: The Abbey Church of Saint-Denis and its Model," in *Rome Across Time and Space: Cultural Transmission and the Exchange of Ideas, c. 500–1400*, ed. Claudia Bolgia, Rosamond McKitterick, and John Osborne (Cambridge: Cambridge University Press, 2011), 127–150.

Fergusson 1984: Peter Fergusson, *Architecture of Solitude: Cistercian Abbeys in Twelfth-Century England* (Princeton: Princeton University Press, 1984).

Fernie 1983: Eric Fernie, *The Architecture of the Anglo-Saxons* (New York: Holmes & Meier, 1983).

Fernie 2014: Eric Fernie, *Romanesque Architecture: The First Style of the European Age* (New Haven: Yale University Press, 2014).

Fossa 2014: Ugo Fossa, "L'espansione Camaldolese in Toscana (XI-XIII secolo)," in *Camaldoli e l'ordine Camaldolese dalle origini alla fine del XV secolo*, ed. Cécile Caby and Pierluigi Licciardello (Cesena: Badia di Santa Maria del Monte, 2014), 135–152.

Franklin 2012: Jill Franklin, "Augustinian and other Canons' Churches in Romanesque Europe: The Significance of the Aisleless Cruciform Plan," in *Architecture and Interpretation: Essays for Eric Fernie*, ed. Jill Franklin, T. A. Heslop, and Christine Stevenson (London: Boydell Press, 2012), 78–98.

Franklin 2013: Jill Franklin, "Iconic Architecture and the Medieval Reformation: Ambrose of Milan,

Peter Damian, Stephen Harding and the Aisleless Cruciform Church," in *Romanesque and the Past*, ed. John McNeil and Richard Plant (Leeds: British Archaeological Association, 2013), 77–94.

Frati 1997: Marco Frati, *Chiese romaniche della campagna Fiorentina* (Empoli: Editori dell'Acero, 1997).

Frati et al. 1996: Marco Frati, Antonello Mennucci, Mauro Ristori, and Claudia Spagnuolo, *Chiese medievale della Valdelsa: Tra Siena e San Gimignano* (Empoli: Editori dell'Acero, 1996).

Frigerio 1991: Salvatore Frigerio, *Camaldoli: note storiche spirituali artistiche* (Verucchio: Pazzini Editore, 1991).

Gabbrielli 1990: Fabio Gabbrielli, *Romanico aretino* (Florence: Salimbeni, 1990).

Gaborit 1964: Jean-René Gaborit, "Les plus anciens monastères de l'Ordre de Vallombreuse (1037–1115): Étude archéologique," *Mélanges d'Archéologie et d'Histoire*, 76 (1964): 451–490.

Gaborit 1965: Jean-René Gaborit, "Les plus anciens monastères de l'Ordre de Vallombreuse (1037–1115): Étude archeologique," *Mélanges d'Archéologie et d'Histoire*, 77 (1965): 179–208.

Gandt and Bertrand 2018: Lois Gandt and Pascal Bertrand, eds., *Vitae Antonii Versiones latinae*. Corpus Christianorum Series Latina, 170 (Turnhout: Brepols, 2018).

Gibson, Gilkes, and Mitchell 2017: Sheila Gibson, Oliver Gilkes, and John Mitchell, "Farfa Revisited: The Early Medieval Monastery Church," in *Encounters, Excavations and Argosies: Essays for Richard Hodges*, ed. John Mitchell, John Moreland, and Bea Leal (Oxford: Archaeopress, 2017), 137–161.

Giostra 2007: Caterina Giostra, "La basilica di S. Simpliciano fra età paleocristiana e altomedioevo: alcuni spunti," *Studia ambrosiana*, 1 (2007): 77–98.

Grundmann 1995: Herbert Grundmann, *Religious Movements in the Middle Ages*, trans. Steven Rowan (Notre Dame: University of Notre Dame Press, [1935, in German] 1995).

Guidobaldi 1998: Federico Guidobaldi, "Per una cronologia preambrosiana del S. Simpliciano di Milano," in *Domum tuam dilexi: Miscellanea in onore di Aldo Nestori* (Vatican City: Pontificio istituto di archeologia cristiana, 1998), 423–450.

Guiges 2001: Guiges Ier le Chartreux, *Coutumes de Chartreuse* (Paris: Cerf, 2001).

Gustafson 2012: Erik Gustafson, "Tradition and Renewal in the Thirteenth-Century Franciscan Architecture of Tuscany," PhD dissertation, New York University, 2012.

Gustafson 2018: Erik Gustafson, "Medieval Franciscan Architecture as Charismatic Space," in *Faces of Charisma*, ed. Brigitte Bedos-Rezak and Martha Rust (Leiden: Brill, 2018), 323–347.

Hallinger 1956: Kassius Hallinger, "Woher kommen die Laienbrüder?" *Analecta sacri ordinis Cistercianses*, 12 (1956): 1–104.

Herrick 2010: Samantha Kahn Herrick, "Studying Apostolic Hagiography: The Case of Fronto of Périgueux, Disciple of Christ," *Speculum*, 85.2 (2010): 235–270.

Herrick 2012a: Samantha Kahn Herrick, "The Interdependent 'Vitae' of Apostolic Saints," *Hagiographic*, 19 (2012): 31–56.

Herrick 2012b: Samantha Kahn Herrick, "Le pouvoir du passé apostolique," in *Hagiographie, idéologie et politique au Moyen Âge en Occident*, ed. Edina Bozóky (Turnhout: Brepols, 2012), 129–138.

Herrick 2015: Samantha Kahn Herrick, "Apostolic Founding Bishops and Their Rivals: The Examples of Limoges, Rouen, and Périgueux," in *Espace sacré, mémoire sacrée: Le culte des évêques dans leurs villes (IVe-XXᵉ siècle)*, ed. Christine Bousquet-Labouérie and Yossi Maurey (Turnhout: Brepols, 2015), 15–36.

Herrick 2020: Samantha Kahn Herrick, "Saints Lives on the Move: The Circulation of Apostolic Legends," in *Hagiography and the History of Latin Christendom, 500–1500*, ed. Samantha Kahn Herrick (Leiden: Brill, 2020), 78–97.

Hutchison 1989: Carole Hutchison, *The Hermit Monks of Grandmont* (Kalamazoo, MI: Cistercian Publications, 1989).

Hutterer 2019: Maile Hutterer, *Framing the Church: The Social and Artistic Power of Buttresses in French Gothic Architecture* (University Park, PA: Pennsylvania State University Press, 2019).

Jasper 2012: Kathryn L. Jasper, "Reforming the Monastic Landscape: Peter Damian's Design for Personal and Communal Devotion," in *Rural Space in the Middle Ages and Early Modern Age*, ed. Albrecht Classen (Berlin: de Gruyter, 2012), 193–207.

Jasper and Howe 2020: Kathryn Jasper and John Howe, "Hermitism in the Eleventh and Twelfth Centuries," in *The Cambridge History of Medieval Monasticism in the Latin West*, ed. Alison Beach and Isabelle Cochelin, 2 vols. (Cambridge: Cambridge University Press, 2020), 2:684–696.

Jestice 1993: Phyllis Jestice, "The Gorzian Reform and the Light Under the Bushel," *Viator*, 24 (1993): 51–78.

Jestice 1997: Phyllis Jestice, *Wayward Monks and the Religious Revolution of the Eleventh Century* (Leiden: Brill, 1997).

Kendall 1991: Calvin Kendall, ed., *Bede: Libri II De Arte Metrica et De Schematibus et Tropis* (Saarbrücken: AQ-Verlag, 1991).

Kinder 2002: Teryl Kinder, *Cistercian Europe: Architecture of Contemplation* (Kalamazoo, MI: Cistercian Publications, 2002).

Kinney A. 2013: Angela Kinney, ed., *The Vulgate Bible: Volume VI: The New Testament* (Cambridge, MA: Harvard University Press, 2013).

Kinney D. 2006: Dale Kinney, "Rome in the Twelfth Century: *Urbs fracta* and *renovatio*," *Gesta*, 45.2 (2006): 199–220.

Kovacevich 1951: Carlo Angelo Kovacevich, *L'Abbazia di Vallombrosa* (Rome: La Libreria dello Stato, 1951).

Krautheimer 1942: Richard Krautheimer, "Introduction to an 'Iconography of Medieval Architecture,'" *Journal of the Warburg and Courtauld Institutes*, 5 (1942): 1–33.

Krüger 2008: Kristina Krüger, *Monasteries and Monastic Orders: 2000 Years of Christian Art and Culture*, trans. Katherine Taylor (n.p: h. f. Ullmann, 2008).

Kunst 1981: Hans-Joachim Kunst, "Freiheit und Zitat in der Architektur des 13. Jahrhundert: Die Kathedrale von Reims," in *Bauwerk und Bildwerk im Hochmittelalter: Anschauliche Beiträge zur Kultur- und Sozialgeschichte*, ed. Karl Clausberg (Giessen: Anabas, 1981), 87–102.

Kurze 1964: Wilhelm Kurze, "Campus Malduli, Die Frühgeschichte Camaldolis," *Quellen und Forschungen aus italienischen Archiven und Bibliotheken*, 44 (1964): 1–34.

Kurze 1971: Wilhelm Kurze, "Zur Geschichite Camaldolis in Zeitalter der Reform," in *Il monachesimo e la riforma ecclesiastica* (Milan: Vita e Pensiero, 1971), 399–412.

Lawrence 2015: C. H. Lawrence, *Medieval Monasticism: Forms of Religious Life in Western Europe in the Middle Ages*, 4th ed. (London: Routledge, 2015).

Levy 2018: Ian Christopher Levy, *Introducing Medieval Biblical Interpretation: The Senses of Scripture in Premodern Exegesis* (Grand Rapids: Baker Academic, 2018).

Licciardello 2004: Pierluigi Licciardello, ed., *Consuetudo Camaldulensis: Rudolphi Constitutiones, Liber Eremitice Regule* (Florence: Edizioni del Galluzzo, 2004).

Licciardello 2007: Pierluigi Licciardello, "I camaldolesi tra unità e pluralità (XI-XII sec.): Istituzioni, modelli, rappresentazioni," in *Dinamiche istituzionali delle reti monastiche e canonicali nell'Italia dei secoli X-XII*, ed. Nicolangelo d'Acunto (Negarine: Il Segno di Gabrielli editori, 2007), 175–238.

Licciardello 2013: Pierluigi Licciardello, ed., *Libri tres de moribus* (Florence: Edizioni del Galluzzo, 2013).

Lomartire 2003. Saverio Lomartire, "Riflessioni sulla diffusione del tipo 'dreiapsiden-Saalkirche' nell'architettura lombarda dell'altomedioevo," *Hortus Artium Medievalium*, 9 (2003): 417–432.

Longo 2003: Umberto Longo, "La conversione di Romualdo di Ravenna come manifesto programmatico della riforma eremitica," in *Ottone III e Romualdo di Ravenna* (Negarine: Il Segno di Gabrielli editori, 2003), 216–236.

Lumini 1972: Ubaldo Lumini, *Abbazia di San Zeno in Pisa* (Pisa: Litografia Tacchi, 1972).

Lumini 1974: Ubaldo Lumini, "Precisazione sui sette edifici del S. Zeno Pisano," *Antichità viva*, 13 (1974): 62–67.

Lusuardi Siena, Neri, and Greppi 2015: Maria Silvia Lusuardi Siena, Elisabetta Neri, and Paola Greppi, "Le chiese di Ambrogio a Milano," in *La memoria di Ambrogio di Milano*, ed. Patrick Boucheron and Stéphane Gioanni (Rome: École Française de Rome, 2015), 31–86.

Marchini and Micheletti 1986: Giuseppe Marchini and Emma Micheletti, *La chiesa di S. Trinità a Firenze* (Florence: Cassa di Risparmio di Firenze, 1986).

Marrucchi 1998: Giulia Marrucchi, *Chiese medievali della Maremma grossetana* (Empoli: Editori dell'Acero, 1998).

McClendon 1987: Charles McClendon, *The Imperial Abbey of Farfa: Architectural Currents of the Early Middle Ages* (New Haven: Yale University Press, 1987).

McCready 2011: William McCready, *Odiosa sanctitas: St Peter Damian, Simony, and Reform* (Toronto: Pontifical Institute of Mediaeval Studies, 2011).

McDermott 2016: Ryan McDermott, *Tropologies: Ethics and Invention in England, c. 1350–1600* (Notre Dame: University of Notre Dame Press, 2016).

McDonnell 1955: Ernest McDonnell, "The 'Vita Apostolica:' Diversity or Dissent," *Church History*, 24 (1955): 15–31.

Meade 1968: Denis Meade, "From Turmoil to Solidarity: The Emergence of the Vallumbrosan Monastic Congregation," *American Benedictine Review*, 19 (1968): 323–357.

Meade 1985: Denis Meade, "General Preface," in *Acta Capitulorum Generalium Congregationis Vallis Umbrosae*, ed. Nicola R. Vasaturo (Rome: Edizioni di Storia e Letteratura, 1985), VII-XXVI.

Melville 2016: Gert Melville, *The World of Medieval Monasticism* (Kalamazoo, MI: Cistercian Publications, 2016).

Mersch 2009: Margit Mersch, "Programme, Pragmatism, and Symbolism in Mendicant Architecture," in *Self-Representation of Medieval Religious Communities*, ed. Anne Müller and Karen Stöber (Münster: LIT Verlag, 2009), 143–166.

Merlo 1993: Giovanni Grado Merlo, "Le riforme monastiche e la *vita apostolica*," in *Storia dell'Italia religiosa: L'antichità e il medioevo*, ed. André Vauchez (Bari: Laterza, 1993), 271–292.

Miccoli 1966: Giovanni Miccoli, *Chiesa gregoriana: Ricerche sulla Riforma del secolo XI* (Florence: La Nuova Italia, 1966).

Miccoli 1960: Giovanni Miccoli, *Pietro Igneo: studi sull'età gregoriana* (Rome: Istituto storico italiano per il Medio Evo, 1960).

Monzio Compagnoni 1995: Giordano Monzio Compagnoni, ed., *I Vallombrosani nella società italiana dei secoli XI e XII* (Vallombrosa: Edizioni Vallombrosa, 1995).

Monzio Compagnoni 1998: Giordano Monzio Compagnoni, "'Vinculum caritatis et consuetudinis:' Le strutture di governo della congregazione Vallombrosana e il loro sviluppo dal 1073 al 1258," in *Il monachesimo italiano nell'età comunale*, ed. Francesco G. B. Trolese (Cesena: Badia di S. Maria del Monte, 1998), 563–594.

Monzio Compagnoni 1999a: Giordano Monzio Compagnoni, ed., *L'Ordo Vallisumbrosae tra XII e XIII secolo* (Vallombrosa: Edizioni Vallombrosa, 1999).

Monzio Compagnoni 1999b: Giordano Monzio Compagnoni, "Lo sviluppo delle strutture costituzionali vallombrosane dalle origini alla fine del '200," in *L'Ordo Vallisumbrosae tra XII e XIII secolo*, ed. Giordano Monzio Compagnoni (Vallombrosa: Edizioni Vallombrosa, 1999), 35–208.

Moretti 1987: Italo Moretti, "Qualche considerazioni sui resti medievali della chiesa abbaziale di San Salvatore a Fucecchio," in *L'abbazia di San Salvatore di Fucecchio e la 'Salmaranza' nel basso Medioevo* (Fucecchio: n.p., 1987), 97–105.

Moretti 1990a: Italo Moretti, ed., *Romanico nell'Amiata* (Florence: Salimbeni, 1990).

Moretti 1990b: Italo Moretti, "Architettura romanica vallombrosana nella diocesi medievale di Pistoia," *Bullettino storico Pistoiese*, 102 (1990): 3–30.

Moretti 1994: Italo Moretti, "L'architettura vallombrosana in Toscana (secoli XI-XIII)," *Arte Cristiana*, 82 (1994): 341–350.

Moretti 1995: Italo Moretti, "L'architettura vallombrosana delle origini," in *I Vallombrosani nella società italiana dei secoli XI e XII*, ed. Giordano Monzio Compagnoni (Vallombrosa: Edizioni Vallombrosa, 1995), 239–257.

Moretti 1999: Italo Moretti, "L'architettura vallombrosana tra romanico e gotico," in *L'Ordo Vallisumbrosae tra XII e XIII secolo*, ed. Giordano Monzio Compagnoni (Vallombrosa: Edizioni Vallombrosa, 1999), 483–504.

Moretti 2004: Italo Moretti, *Passignano e i Vallombrosani nel Chianti* (Florence: Edizioni Polistampa, 2004).

Moretti 2009: Italo Moretti, "La Badia a Passignano: Le origini e l'architettura medievale," in *Passignano in Val di Pesa: un monastero e la sua storia I*, ed. Paolo Pirillo (Florence: Olschki, 2009), 255–274.

Moretti 2014: Italo Moretti, ed., *Passignano in Val di Pesa: un monastero e la sua storia II* (Florence: Olschki, 2014).

Moretti and Stopani 1966: Italo Moretti and Renato Stopani, *Chiese romaniche nel Chianti* (Florence: Salimbeni, 1966).

Moretti and Stopani 1968: Italo Moretti and Renato Stopani, *Chiese romaniche in Valdelsa* (Florence: Salimbeni, 1968).

Moretti and Stopani 1970: Italo Moretti and Renato Stopani, *Chiese romaniche in Val di Cecina* (Florence: Salimbeni, 1970).

Moretti and Stopani 1972a: Italo Moretti and Renato Stopani, *Chiese romaniche in Val di Pesa a Val di Greve* (Florence: Salimbeni, 1972).

Moretti and Stopani 1972b: Italo Moretti and Renato Stopani, *Chiese romaniche dell'Isola d'Elba* (Florence: Salimbeni, 1972).

Moretti and Stopani 1974: Italo Moretti and Renato Stopani, *Architettura romanica religiosa nel contado fiorentino* (Florence: Libreria Editrice Salimbeni, 1974).

Moretti and Stopani 1981: Italo Moretti and Renato Stopani, *Romanico senense* (Florence: Salimbeni, 1981).

Moretti and Stopani 1982: Italo Moretti and Renato Stopani, *La Toscana* (St. Léger Vauban: Zodiaque, 1982).

Morozzi 1973: Guido Morozzi, "Il restauro dell'abbazia," in *Vallombrosa nel IX centenario della morte del fondatore Giovanni Gualberto* (Florence: Giorgi & Gambi, 1973), 161–166.

Negri 1978: Daniele Negri, *Chiese romaniche in Toscana* (Pistoia: Tellini, 1978).

Nuti 1953: Giancarlo Nuti, "La chiesa di S. Paolo a Ripa d'Arno in Pisa ed i suoi recenti ritrovamenti," *Palladio*, 3 (1953): 177–184.

Olsen 1969: Glenn Olsen, "The Idea of the 'Ecclesia Primitiva' in the Writings of the Twelfth-Century Canonists," *Traditio*, 25 (1969): 61–86.

Olsen 1979: Glenn Olsen, "Reference to the *Ecclesia Primitiva* in Eighth Century Irish Gospel Exegesis," *Thought*, 54 (1979): 303–312.

Olsen 1980: Glenn Olsen, "St. Boniface and the *Vita Apostolica*," *American Benedictine Review*, 31.1 (1980): 6–19.

Olsen 1982a: Glenn Olsen, "Bede as Historian: The Evidence from his Observations on the Life of the First Christian Community at Jerusalem," *Journal of Ecclesiastical History*, 33.4 (1982): 519–530.

Olsen 1982b: Glenn Olsen, "Reform after the Pattern of the Primitive Church in the Thought of Salvian of Marseilles," *The Catholic Historical Review*, 68 (1982): 1–12.

Olsen 1984: Glenn Olsen, "The Image of the First Community of Christians at Jerusalem in the Time of Lanfranc and Anselm," in *Les mutations socio-culturelles au tournant des XIe-XIIe siècles*, ed. Raymonde Foreville (Paris: Éditions du Centre National de la Recherche Scientifique, 1984), 341–353.

Olsen 1992: Glenn Olsen, "One Heart and One Soul (Acts 4:32 and 34) in Dhuoda's 'Manual'," *Church History*, 61 (1992): 23–33.

Olsen 2005: Glenn Olsen, "The *Ecclesia Primitiva* in John Cassian, the Ps. Jerome Commentary on Mark and Bede," in *Biblical Studies in the Early Middle Ages*, ed. Claudio Leonardi and Giovanni Orlandi (Florence: Sismel, 2005), 5–27.

Pagano 2012: Andrea Pagano, "La realtà virtuale per la fruizione remota delle architetture religiose del complesso di Camaldoli," in *Architettura eremitica: Sistemi progettuali e paesaggi culturali: Atti del Terzo Convegno Internazionale*, ed. Stefano Bertocci and Sandro Parrinello (Florence: Edifir, 2012), 64–71.

Pagano 2013: Andrea Pagano, "Metodologie di rilievo per l'analisi dell'architettura storica a Camaldoli," PhD dissertation, Università degli Studi di Firenze, 2013.

Parrinello, Bua, and Ceccarelli 2012: Sandro Parrinello, Sara Bua, and Riccardo Ceccarelli, "Il rilievo per l'indagine storico-evolutiva della Chiesa dei SS. Martiri Donato e Ilarino a Camaldoli," in *Architettura eremitica: Sistemi progettuali e paesaggi culturali: Atti del Terzo Convegno Internazionale*, ed. Stefano Bertocci and Sandro Parrinello (Florence: Edifir, 2012), 354–357.

Penco 1961: Gregorio Penco, *Storia del monachesimo in Italia* (Rome: Edizioni Paoline, 1961).

Pèra 1954: Luigi Pèra, *L'architettura minore del periodo romanico in Pisa: le chiese di S. Frediano e di S. Michele degli Scalzi* (Rome: Istituto Polografico dello Stato, 1954).

Pincelli 2000: Anna Pincelli, *Monasteri e conventi del territorio Aretino* (Florence: Alinea Editrice, 2000).

Pinelli 1994: Marco Pinelli, *Romanico in Mugello e in Val di Sieve* (Empoli: Editori dell'Acero, 1994).

Pinelli 2008: Marco Pinelli, *Chiese romaniche del Mugello* (Empoli: Editori dell'Acero, 2008).

Pirillo 2009: Paolo Pirillo, ed., *Passignano in Val di Pesa: un monastero e la sua storia I* (Florence: Olschki, 2009).

Piva 2010: Paolo Piva, "Edilizia di culto cristiano a Milano, Aquileia e nell'Italia settentrionale fra IV e VI secolo," in *Storia dell'architettura italiana: Da Costantino a Carlo Magno*, ed. Sible de Blaauw (Milan: Electa, 2010), 98–145.

Quilici 1941–1942: Brunetto Quilici, "Giovanni Gualberto e la sua riforma monastica," *Archivio Storico Italiano*, 99.2 (1941): 113–132; 99.3–4 (1942): 27–62; 100.1 (1942): 145–199.

Ranft 2006: Patricia Ranft, *The Theology of Work: Peter Damian and the Medieval Religious Renewal Movement* (New York: Palgrave Macmillan, 2006).

Recht 2008: Roland Recht, *Believing and Seeing: The Art of Gothic Cathedrals*, trans. Mary Whittall (Chicago: University of Chicago Press, 2008).

Redi 1987: Fabio Redi, "San Michele in Borgo (Pisa): Rapporto preliminare, 1986," *Archeologia medievale*, 14 (1987): 339–368.

Redi 1991: Fabio Redi, *Chiese medievali del Pistoiese* (Cinisella Balsamo: Silvana, 1991).

Reindel 1988: Kurt Reindel, ed., *Die Briefe des Petrus Damiani: Teil 2, Nr. 41–90* (Munich: Monumenta Germaniae Historica, 1988).

Reindel 1989: Kurt Reindel, ed., *Die Briefe des Petrus Damiani: Teil 3, Nr. 91–150* (Munich: Monumenta Germaniae Historica, 1989).

Rigoli 2005: Adriano Rigoli, "Il monastero di San Salvatore di Vaiano," in *Monasteri d'Appennino* (Porretta Terme: Gruppo di Studi Alta Valle del Reno, 2005), 55–81.

Rinaldi, Favini, and Naldi 2005: Sara Rinaldi, Aldo Favini, and Alessandro Naldi, *Firenze romanica* (Empoli: Editori dell'Acero, 2005).

Ristow 2009: Sebastian Ristow, *Die Ausgrabungen von St. Pantaleon in Köln: Archäologie und Geschichte von römischer bis in karolingisch-ottonische Zeit* (Bonn: Habelt, 2009).

Ristow 2011: Sebastian Ristow, "St. Pantaleon in Köln: Ausgrabungen, Bau- und Forschungsgeschichte der Lieblingskirche von Kaiserin Theophanu," in *Byzanz und Europa: Europas östliches Erbe*, ed. Michael Altripp (Turnhout: Brepols, 2011), 50–64.

Romeo 1980: Francesco Giuseppe Romeo, *La Badia di Settimo: origini, splendore e decadenza* (Prato: Ed. del Palazzaccio, 1980).

Ronzani 1980: Mauro Ronzani, "L'organizzazione della cura d'anima nella città di Pisa (secoli XII-XIII)," in *Istituzioni ecclesiastiche della Toscana medieval* (Galatina: Congedo Editore, 1980), 35–85.

Ronzani 2014: Mauro Ronzani, "Una presenza in città precoce e diffusa: I monasteri camaldolesi pisani dalle origini all'inizio del secolo XIV," in *Camaldoli e l'ordine camaldolese dalle origini alla fine del XV secolo*, ed. Cécile Caby and Pierluigi Licciardello (Cesena: Badia di Santa Maria del Monte, 2014), 153–179.

Rossi 1991: Giustino Rossi, "Discepolo Anonimo: Vita di San Giovanni Gualberto," in *Alle origini di Vallombrosa*, ed. Giovanni Spinelli and Giustino Rossi (Novara: Europià, 1991), 131–146.

Saalman 1962: Howard Saalman, "Santa Trinita I and II and the 'Crypts' under Santa Reparata and San Pier Scheraggio," *Journal of the Society of Architectural Historians*, 21.4 (1962): 179–187.

Saalman 1966: Howard Saalman, *The Church of Santa Trinita in Florence* (New York: College Art Association, 1966).

Salmi 1926: Mario Salmi, *L'architettura romanica in Toscana* (Milan: Bestetti e Tumminelli, 1926).

Salmi 1958: Mario Salmi, *Chiese romaniche della campagna Toscana* (Milan: Electa, 1958).

Salvestrini 2001: Francesco Salvestrini, "Natura e ruolo dei conversi nel monachesimo vallombrosano (secoli XI-XV): Da alcuni esempi d'area toscana," *Archivio storico italiano*, 159.1 (2001): 49–105.

Salvestrini 2002: Francesco Salvestrini, "La storiografia sul movimento e sull'Ordine monastico di Vallombrosa," *Quaderni medievali*, 103 (2002): 294–323.

Salvestrini 2007: Francesco Salvestrini, "*Ut in vera unitate cum vinculo perfectionis*: La definizione della rete monastica vallombrosana dalle origini al *Capitulum domni Benigni Abbatis* del 1216," in *Dinamiche istituzionali delle reti monastiche e canonicali*, ed. Nicolangelo d'Acunto (Negarine: Il Segno dei Gabrielli, 2007), 239–312.

Salvestrini 2008: Francesco Salvestrini, *Disciplina Caritatis: Il monachesimo vallombrosano tra medioevo e prima età moderna* (Rome: Viella, 2008).

Salvestrini 2010: Francesco Salvestrini, *I vallombrosani in Liguria: Storia di una presenza monastica fra XII e XVII secolo* (Rome: Viella, 2010).

Salvestrini 2011: Francesco Salvestrini, ed., *I vallombrosani in Lombardia* (Milan: ERSAF, 2011).

Salvestrini 2013: Francesco Salvestrini, "La prova del fuoco: Vita religiosa e identità cittadina nella tradizione del monachesimo fiorentino (seconda metà del secolo XI)," *Annali di Storia di Firenze*, 8 (2013): 51–79.

Sannazaro 2008: Marco Sannazaro, "Ad modum crucis: La basilica paleocristiana dei SS Apostoli e Nazaro," *Studia Ambrosiana*, 2 (2008): 131–153.

Sanpaolesi 1975: Piero Sanpaolesi, *Il Duomo di Pisa: e l'architettura romanica Toscana delle origini* (Pisa: Nardini, 1975).

Sauerländer 1995: Willibald Sauerländer, "Integration: A Closed or Open Proposal?" in *Artistic Integration in Gothic Buildings*, ed. Virginia Chieffo Raguin, Kathryn Brush, and Peter Draper (Toronto: University of Toronto Press, 1995), 3–18.

Schenkluhn 2000: Wolfgang Schenkluhn, *Architektur der Bettelorden: Die Baukunst der Dominikaner und Franziskaner in Europa* (Darmstadt: Wissenschaftliche Buchgesellschaft, 2000).

Schenkluhn 2006: Wolfgang Schenkluhn, "Iconografia e iconologia dell'architettura medievale," in *L'arte medievale nel contesto*, ed. Paolo Piva (Milan: Jaca Book, 2006), 59–78.

Schenkluhn and Van Stipelen 1983: Wolfgang Schenkluhn and Peter Van Stipelen, "Architektur als Zitat: Die Trierer Liebfrauenkirche in Marburg," in *700 Jahre Elisabethkirche in Marburg, 1: Die Elisabethkirche - Architektur in der Geschichte*, ed. Hans-Joachim Kunst (Marburg: N. G. Elwert, 1983), 15–30.

Schneider 2016: Laurent Schneider, "Une fondation multiple, un monastère pluriel: les contexts topographiques de la genèse du monastère d'Aniane d'après l'archéologie et la *Vie de saint Benoît* (fin VIIIe-IXe siècle)," *Bulletin du Centre d'études médiévales d'Auxerre*, hors ser. 10, 2016 [https://journals.openedition.org/cem/14481; last accessed 29 August 2020].

Shaffer 2005: Jenny Shaffer, "Psalmodi and the Architecture of Carolingian Septimania," *Gesta*, 44 (2005): 1–11.

Speer 2006: Andreas Speer, "Is There a Theology of the Gothic Cathedral? A Re-reading of Abbot Suger's Writings on the Abbey Church of St.-Denis," in *The Mind's Eye: Art and Theological Argument in the Middle Ages*, ed. Jeffrey Hamburger and Anne-Marie Bouché (Princeton: Princeton University Press, 2006), 65–83.

Spinelli and Rossi 1998: Giovanni Spinelli and Giustino Rossi, eds., *Alle origini di Vallombrosa* (Novara: Europía, 1998).

Sternberg 2013: Maximilian Sternberg, *Cistercian Architecture and Medieval Society* (Leiden: Brill, 2013).

Stiaffini 1983–1984: Daniela Stiaffini, "La chiesa e il monastero di S. Paolo a Ripa d'Arno di Pisa," *Rivista dell'Istituto Nazionale d'Archeologia e Storia dell'Arte*, 6.7 (1983–1984): 237–284.

Stopani 2001: Renato Stopani, ed., *La Badia a Passignano* (Florence: Editoriale gli Arcipressi, 2001).

Tabacco 1954: Giovanni Tabacco, "'Privilegium amoris:' aspetti della spiritualità romualdina," *Il Saggiatore*, 4.2–3 (1954): 1–20.

Tabacco 1957: Giovanni Tabacco, ed., *Petri Damiani Vita beati Romualdi* (Rome: Istituto Storico Italiano per il Medio Evo, 1957).

Tabacco 1960: Giovanni Tabacco, "Eremo e cenobio," in *Spiritualità cluniacense* (Todi: Accademia Tudertina, 1960), 326–335.

Tabacco 1965: Giovanni Tabacco, "Romualdo di Ravenna e gli inizi dell'eremitismo camaldolese," in *L'eremitismo in Occidente nei secoli XI e XII* (Milan: Vita e Pensiero, 1965), 73–121.

Tellenbach 1993: Gerd Tellenbach, *The Church in Western Europe from the Tenth to the Early Twelfth Century* (Cambridge: Cambridge University Press, 1993).

Tigler 2006: Guido Tigler, *Toscana Romanica* (Milan: Jaca Book, 2006).

Timmermann 2017: Achim Timmermann, *Memory and Redemption: Public Monuments and the Making of Late Medieval Landscape* (Turnhout: Brepols, 2017).

Toker 1975: Franklin Toker, "Excavations Below the Cathedral of Florence, 1965–1974," *Gesta*, 14.2 (1975): 17–36.

Turtulici 1994: Fulvio Turtulici, "Il monastero di Santa Maria di Agnano," *I quaderni dell'arte*, 4.6 (1994): 74.

Untermann 2001: Matthias Untermann, *Forma Ordinis: die mittelalterliche Baukunst der Zisterzienser* (Munich: Deutscher Kunstverlag, 2001).

Valdez del Alamo 2017: Elizabeth Valdez del Alamo, "The Iconography of Architecture," in *The Routledge Companion to Medieval Iconography*, ed. Colum Hourihane (London: Routledge, 2017), 373–385.

Vasaturo 1962: Nicola R. Vasaturo, "L'espansione della congregazione vallombrosana fino alla meta del secolo XII," *Rivista di storia della chiesa in Italia*, 16.3 (1962): 456–485.

Vasaturo 1973: Nicola R. Vasaturo, "Vallombrosa: ricerche d'archivio sulla costruzione dell'abbazia," in *Vallombrosa nel IX centenario della morte del fondatore Giovanni Gualberto* (Florence: Giorgi & Gambi, 1973), 1–22.

Vasaturo 1983: Nicola R. Vasaturo, ed., "Redactio Vallumbrosana: saec. XII," in *Consuetudines Cluniacensium Antiquiores cum Redactionibus Derivatis*, ed. Kassius Hallinger (Siegburg: Verlag Schmitt, 1983), 309–381.

Vasaturo 1985: Nicola R. Vasaturo, *Acta Capitulorum Generalium Congregationis Vallis Umbrosae: I Institutiones Abbatum (1095–1310)* (Rome: Edizioni di Storia e Letteratura, 1985).

Vasaturo 1994: Nicola R. Vasaturo, *Vallombrosa: L'abbazia e la congregazione* (Vallombrosa: Edizioni Vallombrosa, 1994).

Vedovato 1994: Giuseppe Vedovato, *Camaldoli e la sua congregazione dalle origini al 1184* (Cesena: Badia di S. Maria del Monte, 1994).

Vedovato 1998: Giuseppe Vedovato, "Camaldoli nell'età comunale," in *Il monachesimo italiano nell'età comunale*, ed. Francesco G. B. Trolese (Cesena: Badia di S. Maria del Monte, 1998), 529–562.

Venditti 1967: Arnaldo Venditti, *Architettura bizantina nell'Italia meridionale*, 2 vols. (Naples: Edizioni Scientifiche Italiane, 1967).

Vicaire 1963: Marie-Humbert Vicaire, *L'imitation des apôtres* (Paris: Éditions du Cerf, 1963).

Viti 1995: Goffredo Viti, *Storia e arte della abbazia cistercense di San Salvatore a Settimo a Scandicci* (Florence: Certosa di Firenze, 1995).

Vivarelli 2000: Maurizio Vivarelli, *Camaldoli: sacro eremo e monastero* (Florence: Ottavo, 2000).

Vones-Liebenstein 2020: Ursula Vones-Liebenstein, "Similarities and Differences between Monks and Regular Canons in the Twelfth Century," in *The Cambridge History of Medieval Monasticism in the Latin*

West, ed. Alison Beach and Isabelle Cochelin, 2 vols. (Cambridge: Cambridge University Press, 2020), 2:766–782.

White 1938: Lynn White, *Latin Monasticism in Norman Sicily* (Cambridge: Medieval Academy of America, 1938).

NOTES TO THE TEXT

1. Lawrence 2015 gives Camaldoli and Vallombrosa four pages (138–141), mostly on the related but separate figure of Peter Damian; likewise Melville 2016, 92–93, for the Camaldolese, with a smattering of other comparative references mostly to the Camaldolese elsewhere, and (94) the Vallombrosans. Unsurprisingly Penco 1961 spent more time on both orders: 211–219 for the Camaldolese and 230–237 for the Vallombrosans.

2. I use the term "order" here in a general sense for extended multi-house religious communities sharing a centralized administration and legislation; the Camaldolese and Vallombrosans were both founded as congregations, before the term "order" began to be used for such religious groups. In a bull of 1113, Paschal II defined the Camaldolese congregation as an *ordo*. For the history of the Camaldolese, see Vedovato 1994; Vedovato 1998; Caby 1999; Caby and Licciardello 2014. For the history of the Vallombrosans, see Boesch Gajani 1964; Meade 1968; Vasaturo 1962; Monzio Compagnoni 1995; Monzio Compagnoni 1999a; Spinelli and Rossi 1998; Salvestrini 2008.

3. Braunfels 1972, 111, nominally mentions Camaldoli and Vallombrosa as sites without considering them in any detail; Badstübner 1980 moves from Cluny and Hirsau to the Cistercians; Krüger 2008, 144–148, includes short entries on both the Camaldolese and Vallombrosans; Aston 2009, 79–80, makes only passing mention of the creation of the congregations; Coomans 2018 does not mention either.

4. On Vallombrosan architecture, see Gaborit 1964; Gaborit 1965; Moretti 1990b; Moretti 1994; Moretti 1995; Moretti 1999; Gustafson 2012. The first survey of Tuscan Camaldolese architecture can be found in Gustafson 2012.

5. The terms include aisleless, single vessel, and in various European usages, *nef unique, navata unica, sola nave*, and *einschiffige*.

6. Cochelin 2014. See also Caby 2003.

7. Cochelin 2014, 42. For the Camaldolese constitutions, see Licciardello 2004 and Licciardello 2013. For the Vallombrosan constitutions, see Vasaturo 1983.

8. A PhD dissertation at the University of Florence has been written on both the hermitage and monastery at Camaldoli, but has unfortunately not yet been published; Pagano 2013. For further citations on both Camaldoli and Vallombrosa, see below.

9. Such as the Vallombrosan monastery at Passignano, whose claustral plan has not been published (to my knowledge) despite two recent edited volumes dedicated to the complex: Pirillo 2009; Moretti 2014. The historiographic focus in scholarship on Tuscan Romanesque architecture has produced formal catalogues and gazetteers summarizing essential documentation. For general surveys of Tuscan Romanesque architecture, see Salmi 1926; Salmi 1958; Negri 1978; Moretti and Stopani 1982; Brucher 1988, 118–202; Cantelli 1995; and Tigler 2006. There have been two waves of Romanesque study focusing on Tuscan sub-regions, the first by Moretti and Stopani (1966, 1968, 1970, 1972a, 1972b, 1974, 1981), and the second in the 1990s and into the early 2000s (Gabbrielli 1990; Moretti 1990a; Redi 1991; Pinelli 1994; Frati et al. 1996; Bettarini, Frati, and Stopani 1996; Frati 1997; Marrucchi 1998; Rinaldi, Favini, and Naldi 2005; Pinelli 2008).

10. The constitutions of both orders are silent on the question of lay access although, given the outreach impulse of both orders, at least some laity probably experienced the church interiors. In contrast, treatment of guests concerned both the Cistercians and the Carthusians. For the former, see the *Ecclesiastica Officia*, Choisselet and Vernet 1989, 246–249, on guests at the monastery; 292–295, on sick guests, including burial if they die; and 334–337, which lays out the porter's responsibilities toward guests. Clauses concerning guests in the church are sprinkled throughout no fewer than eighteen (other) chapters of the *Ecclesiastica Officia*: for the Carthusians, see the Constitutions of Guigo, Guiges 2001, 184–185, according to which guests are admitted in the choir; 204–207, on the horses of guests; 210–211, on women; 238–239, on the reception of guests.

11. The scholarly literature dealing with the idea of architectural meaning for historical audiences is substantial; see for example Hutterer 2019; Doquang 2018; Gustafson 2018; Timmermann 2017; Crossley 2010; Recht 2008; Speer 2006; Bandmann (1951) 2005; Binski 2004; Cassidy-Welch 2001; and Sauerländer 1995.

12. For the Cistercians, see Sternberg 2013; Kinder 2002; Cassidy-Welch 2001; Untermann 2001; Aubert 1947. For the mendicants, see Schenkluhn 2000; Bruzelius 2014; and Mersch 2009.

13. Levy 2018, 33–34, 44–45, 148–150; McDermott 2016, 11–86; De Lubac (1959) 2000, 127–177; Dahan 1999. It is worth observing that Cistercian Fontenay is often held up as an example of the simplicity and austerity of Cistercian architecture. This is certainly true as far as its non-figural sculpted decoration and glazing—capitals with abstract water leaves and grisaille glass—are concerned. Fontenay is, however, hardly a simple building. Originally entered through a porch at the west, its nave, flanked by side aisles, give onto a transept, the arms of which open on the east into chapels. A two-bay choir opens from the crossing and terminates in a flat apse lighted by three lancet windows.

14. Barney et al. 2006, Bk I, chap. XXXVII, "De Tropis," 60–64; Kendall 1991, "De Schematibus et Tropis," 168–209.

15. As opposed to schemes whose purpose is purely to beautify the text: Kendall 1991, 168–169.

16. . . . *per tropologiam quisque fidelium, quibus dicitur: 'An nescitis quia corpora vestra templum est Spiritus sancti qui in vobis est'* Kendall 1991, 198–200, 207.

17. Bynum 1982, 90; see 82–109 for Bynum's full

discussion of models. See also the important work of Mary Carruthers on medieval habits of thought and memory: Carruthers 1998 and Carruthers 2008.

18 Krautheimer 1942, 1–20, which serves as the basis for what has become a school of architectural iconography as the replication of models, such as Fernie 2014, 215–227; Schenkluhn 2006; Schenkluhn and Van Stipelen 1983; Kunst 1981. For responses to Krautheimer, see Carver McCurrach 2011; Valdez del Alamo 2017; and Crossley 1988. Particularly for German readers, Bandmann (1951) 2005 and Bandmann 1951 have also been important.

19 The less-often cited last third of his classic article, Krautheimer 1942, 20–33.

20 The Latin is, . . . *qui est forma futura* . . ., the English translation from the 1750s Challoner Douay-Rheims edition, both as published in Kinney A. 2013, 810–811.

21 Shaffer 2005; see also Schneider 2016 for the most recent excavations and site history of Aniane.

22 Franklin 2012; Franklin 2013.

23 On Tironensian architecture, see Bonde and Maines in this volume. See also Panier's discussion of Celestine architecture. On the Grandmontains, see Hutchison 1989, 281–349; Andrault-Schmitt 2016; and Andrault-Schmitt 2018. For the Carthusians, see Aniel 1983. Also worth noting are the Italo-Greek, Basilian monastic churches in Calabria and Sicily, particularly those built by the Normans in the late eleventh and early twelfth century such as the single-nave church with transept at San Giovanni Theristis outside Bivongi and the ruined Santa Maria di Campogrosso east of Palermo. Not all Norman (or earlier) Basilian churches had a single-nave form, but the trend does seem significant despite the fragmentary survival of southern Italian Norman architecture. On Italo-Greek monasticism, see Crostini and Angeli Murzaku 2018, and White 1938; for Basilian architecture, see Barone 2017; Ciotta 1992; and Venditti 1967, 2:892–948.

24 For example, Fergusson 1984, 23–29, writing on early Cistercian houses in England, noted that single-vessel "first churches" were too small and out of date by the mid-twelfth century. Bonde, Killian, and Maines 2011 discuss the long life (and changed purposes) of four Cistercian "first churches" in France, all of which were replaced by larger, more complicated buildings as the communities grew.

25 See for example the comments in Bandmann (1951) 2005, 179–184 (although his formal derivation from Cappadocian prototypes may be questioned) and Valdez del Alamo 2017, 380–381.

26 Lusuardi Siena, Neri, and Greppi 2015, 56–61; Cassanelli and Piva 2011, 33–35; Sannazaro 2008; Cassanelli 1986; David 1984.

27 San Simpliciano may have been the Basilica Virginum founded by Ambrose, but there is no conclusive evidence to sustain the attribution. Lusuardi Siena, Neri, and Greppi 2015, 52–56; Cassanelli and Piva 2011, 35–36; Piva 2010, 106–109; Giostra 2007; Guidobaldi 1998.

28 On Farfa, see Gibson, Gilkes, and Mitchell 2017, and McClendon 1987. On Saint Pantaleon, see Ristow 2009 and Ristow 2011.

29 Ranft 2006, 84–90; Olsen 2005; Chenu (1957) 1997, 202–238, 239–269; Grundmann 1995, 7–30, 219–226; Merlo 1993; Olsen 1992, 1984, 1982a, 1982b, 1980, 1979, and 1969; Bynum 1982, 9–21, 30–32, 82–109; Miccoli 1966, 225–299; Vicaire 1963; Dvornik 1958; McDonnell 1955.

30 For the Latin text of Athanasius used by medieval monks, see Gandt and Bertrand 2018. See also Bartelink 2004.

31 For example, in a letter of 1063 to Pope Alexander II, Peter Damian framed his argument for the pope to legislate the common life of all canons by writing, "But since we have the holy apostles and other apostolic men as our teachers, we must not follow our own opinions in choosing, nor obstinately and willfully defend what once we have chosen to do, but place irrevocable faith only in those teachings that have been settled by approved doctors of the Church," in Blum 1998, letter 98.3:88 (for the Latin, see Reindel 1989, letter 98:85).

32 Vones-Liebenstein 2020; Bynum 1982, 82–109.

33 According to Urban II in canons 2–3 of the Third Council of Nimes (1096), "Priests, both monks and canons, who announce the precepts of God are called angels. For such an angelic hierarchy, the more it contemplates God, the more sublimely it is confirmed in dignity. . . . It is proper that those who have left the world have the major care to pray for the sins of the people and more power to absolve them than secular priests. Because these live according to the apostolic rule and following in the footsteps [of the apostles] live the common life. . . . Thus it seems to us that they who renounce their own things for God are permitted to baptize, to distribute communion, to give penance and absolve from sins. . . . That is why we decide that those who hold to the pattern of the apostles can preach, baptize, give communion, receive penitents and give absolution," in Bynum 1982, 30–31.

34 Connolly 1995, *De Templo* 1.1:5.

35 Connolly 1995, *De Templo* 1.1:5–6.

36 Franklin 2013 and Franklin 2012. Franklin also argued that the Basilica Apostolorum was a center of reform in the eleventh century. Careful examination of the historical evidence argues that the center was located elsewhere. See McCready 2011; Cowdrey 1968.

37 Most prestigious apostolic burial churches in medieval Europe were aisled cruciform churches: Old Saint Peter's and San Paolo fuori le Mura in Rome, San Marco in Venice, and Santiago de Compostela, as well as the Holy Apostles in Constantinople and the church of John at Ephesus in the eastern Mediterranean. Even

the churches of major early Christian confessor saints along the pilgrimage roads, such as Saint-Martin in Tours, Saint-Martial in Limoges, Saint-Front in Périgueux, or San Isidoro in Leon, were cruciform basilicas. While the Basilica Apostolorum in Milan had the antiquity of an Ambrosian association for the name, its relics were apostolic *brandea* rather than burials of apostolic saints, with the exception of the local apostle San Nazaro, after whom the church is usually called today.

38 Herrick 2020, 2015, 2012a, 2012b, and 2010.
39 Constable 1987, 794–795.
40 Connolly 1995, 22–23, *De Templo 6.1*.
41 Longo 2003; D'Acunto 2002; Tabacco 1965, 1957, and 1954.
42 Vedovato 1994, 65–72, 180–183.
43 Fossa 2014.
44 Cassian 2000, Bk 2, V:39–41.
45 Cassian 2000, Bk 2, V:39.
46 See Caby 1999 for an extensive discussion of the urban/rural dichotomy for the Camaldolese.
47 For the early history of Camaldoli, see Kurze 1971 and 1964.
48 Tabacco 1965.
49 For the congregation of Fonte Avellana, see Jasper 2012; Jasper and Howe 2020.
50 Tabacco 1957; English translation in Belisle 2007, 105–175.
51 *Erat enim vir beatissimus quasi unus de seraphim, quia et ipse flamma divini amoris incomparabiliter estuabat, et alios, quocumque pergeret, sancte predicationis facibus incendebat*, Vita beati Romualdi, chap. 35: Belisle 2007, 145; Tabacco 1957, 74.
52 *Adeo ut putaretur totum mundum in heremum velle convertere et monachico ordini omnem populi multitudinem sotiare*, Vita beati Romualdi, chap. 37: Belisle 2007, 147; Tabacco 1957, 78.
53 See also Jestice 1993.
54 Licciardello 2007, and Caby 1999, 74–77.
55 Licciardello 2004, 2–21; Belisle 2007; Caby 2005; Crosara 1970.
56 Licciardello 2004, *Consuetudo Camaldulensis*, 22–81. A third legislative text was written by Martin III, Prior of Camaldoli, in 1253; Licciardello 2013, 108–289.
57 Licciardello 2004, *Consuetudo Camaldulensis*, XLVII-LXXI; Calati 1983; Calati 1952–1954; Tabacco 1960.
58 Licciardello 2004, *Consuetudo Camaldulensis*, XLI-XLVI.
59 Chapters IV-VI of the *Liber Eremitice Regule* cover "The Example of John the Baptist (*Exemplum Iohannis Baptiste*)," "The Example of the Savior (*Exemplum Salvatoris*)," and "The Example of the Ancient Fathers (*Exemplum Patrum Antiquorum*);" Licciardello 2004, *Consuetudo Camaldulensis*, 28–31. Cf. Cassian 2000, Bk 2, V:39.
60 Chapters 39–44 present and discuss these virtues of the hermit: *humilitas, obedientia, sobrietas, pietas, patientia, silentium,* and *meditatio;* Licciardello 2004, *Consuetudo Camaldulensis*, 58–69.
61 Jestice 1997, 160–169.
62 The first survey of Tuscan Camaldolese architecture can be found in Gustafson 2012. Bossi and Ceratti 1993 focuses on several Camaldolese hermitages, but is not an overall survey of the order.
63 The monasteries of San Savino in Chio, San Quirico delle Rose, Sant'Angelo a Cortelupone, the remote Casentino monastery of Selvamonda, and the monastery of Santo Stefano a Cintorio have all been destroyed leaving no traces. See Gustafson 2012, 180–181. The Eremo di Fleri, San Bartolomeo in Anghiari, the monastery of San Pier Piccolo in the center of Arezzo, the monastery of Santa Margherita in Tosina, and San Giovanni Evangelista in Pratovecchio have all been replaced by later buildings, leaving no discernable trace of their earlier churches. See Gustafson 2012, 181–182.
64 At least 22 of the 33 Tuscan Camaldolese houses were given to the order to be reformed. Fossa 2014; Gustafson 2012, 179–195; Licciardello 2007. How many of the churches for those donated monasteries were already standing when the gift was made is unclear. While it would be interesting to chart the correlation between churches built specifically under Camaldolese control and churches built independently but with a similar form, such an inquiry is not currently possible. Future research will be directed to this question.
65 Without extensive excavations at these monasteries to determine dating and possible building phases, it will not be possible to demonstrate concretely a Camaldolese building campaign of single-nave churches at all their houses. Until such excavations can be undertaken, we must rely on the evidence of the extant churches that demonstrate uniformity.
66 The design of San Veriano with a single nave ending in three apses is unusual in Tuscany, but is consistent with a group of churches in northern Italy that Saverio Lomartire has linked with elite patronage; Lomartire 2003. Nothing is currently known about the founding of San Veriano, so the comparison remains suggestive but inconclusive.
67 San Pietro a Fontiano (known as Mucchio), Sant'Andrea al Pozzo, San Pietro di Luco, San Salvatore di Camaldoli in Florence, San Michele in central Arezzo, San Pietro di Cerreto, the Badia di Santa Maria a Elmi, the Badia di Morrona, the church of San Benedetto at the Eremo del Vivo, the hermitage church of Camaldoli, the Badia di Santa Maria a Prataglia, and the Badia of San Veriano. See Gustafson 2012, 182–189.

68 Despite its historical significance, there is no published monographic study of Camaldoli. The first full architectural survey of both complexes was the dissertation of Andrea Pagano (Pagano 2013), which unfortunately has not yet been published. Vivarelli 2000 and Frigerio 1991 are guides and popular publications. There are brief discussions of the church of San Salvatore in Pincelli 2000, 109–117, and Gabbrielli 1990, 176–177.

69 Pagano 2012.

70 Bertocci 2012; Parrinello, Bua, and Ceccarelli 2012.

71 Pagano 2012 has drafted surveyed plans of the hermitage, and suggests dates for some of the cells.

72 Pagano 2013, 275–276, 312.

73 All four plans are drawn to scale, but are not exact surveyed plans. The reconstructions of choir and altar locations are speculative, meant to suggest the historicity of the medieval spaces even though precise data is lacking at this time for historically based plans.

74 Any evidence for a conversi portal that might have opened in the southwestern corner of the church from the adjacent building was destroyed in the eighteenth century when the lower 2/3 of the wall was removed to create a transept along the western end of the church.

75 Rudolphi Constitutiones V.19, in Licciardello 2004, *Consuetudo Camaldulensis*, 12–13. Brothers are specifically forbidden from singing beautifully: "We are more suited to mourning than to singing (*Magis enim expedit nobis lugere quam canere*)," RC V.23, Licciardello 2004, *Consuetudo Camaldulensis*, 12–13.

76 The Badia di Montemuro, the Badia di San Salvatore della Berardenga, the Badia di San Bartolomeo a Cantignano, San Savino in Cerasolo, the Badia di San Pietro a Pozzeveri, the Badia di San Pietro a Ruoti, and the Badia di Santa Maria di Agnano. See Gustafson 2012, 189–192.

77 Bacci and Stopani 2007; Turtulici 1994; Gabbrielli 1990, 172–173.

78 It is possible that Agnano had cloisters on both sides of the church, as at the lower monastery of Camaldoli, although further research will be required to clarify this. The remains of doors in the north and south transept spaces might suggest this was the case. The phenomenon of double cloisters at Camaldolese monastic houses requires further attention. The fourteenth-century urban Camaldolese monastery of Santa Maria degli Angeli was arranged the same way. The system may reflect the eremitic/cenobitic balance of the order, but this remains hypothetical.

79 Caby 1999, 85–87, 141–142.

80 Along with the three Pisan churches of San Michele in Borgo, San Frediano, and San Zeno, the fourth Camaldolese basilican church was the Badia dei Santi Giusto e Clemente outside Volterra. See Gustafson 2012, 192–195.

81 San Salvatore di Camaldoli in Florence was a single-nave church, while no trace of the Camaldolese-era church of San Pier Piccolo in Arezzo remains as it was replaced by a later church.

82 Caby 1999, 205–216.

83 Caby 1999, 216–218.

84 Ceccarreli Lemut and Garzella 2016; Baggiani 2016; Tigler 2006, 210–212; Redi 1987; Curuni 1970a.

85 Curuni 1969; Pèra 1954.

86 Sanpaolesi 1975; Lumini 1974; Lumini 1972; Curuni 1970b; Benvenuti and Borghi 1964.

87 Ronzani 2014.

88 For the Romanesque architecture of Pisa, see Sanpaolesi 1975.

89 Cushing 2005a, 754.

90 Bynum 1982, 22–58.

91 McCready 2011, 65–111; Cushing 2005a, 753–757.

92 Cushing 2005a, 743–748. The consecration by Leo IX is reported in the *Vita* of Gualberto by Andrea Strumi as occurring in 1058, four years after Leo's death when Humbertus of Silva Candida consecrated two altars in the church. If Leo IX did perform a consecration, it would more likely have occurred in 1049 or 1050 while Leo was travelling through Italy.

93 This number of houses is derived from Vasaturo 1962, as well as Vasaturo 1994. See also Ciliberti and Salvestrini 2014; Salvestrini 2011; Salvestrini 2010. The Tuscan houses will be listed below in the discussion of Vallombrosan architecture.

94 Vasaturo 1994; Meade 1968; Boesch Gajani 1964; Quilici 1941–1942.

95 The Badia di Santa Maria was a Carolingian foundation, built just inside the eastern Carolingian walls of Florence corresponding to the current Via del Proconsolo. New city walls expanding the city center were built in the 1170s, leaving the Badia as a block surrounded by city streets. Where Teuzo's cell might have been located in the eleventh century is unclear, but seems to have been somewhere inside the city.

96 Letter 44, Reindel 1988, 7–33; Blum 1990, 221–243.

97 See McCready 2011, 119–123; D'Acunto 1993.

98 Baethgen 1934, 1082; Elm 1995, esp. 26.

99 The possible influence of the Vallombrosans on the Cistercians in the use of lay brothers and the ideal of charity has received occasional notice but rarely sustained analysis. See Salvestrini 2008, 245–302; D'Acunto 2005, esp. 161–162; Salvestrini 2001; Beccaria 1998; Hallinger 1956, 32–37, for the mid-eleventh century mention by Peter Damian; and Duvernay 1952.

100 Baethgen 1934, 1106: *Cum quibus non tantum secundum cenobialem monasteriorum consuetudinem, quantum iuxta*

sanctorum patrum, scilicet apostolorum sanctique Basilii maximque sancti Benedicti, tam vestimentorum vilitate quam mentis humilitate morumque honestate contituit vivere normam, chap. III, lines 9–12. (With their choice to live not so much according to the cenobitic customs of monasteries of the time but rather according to the rule of the holy fathers, that is the apostles, Saint Basil and above all Saint Benedict, both for the poverty of vestments and humility of soul as for the honesty of life.)

101 Jestice 1997, 246.

102 Elm 1995, 29.

103 Cushing 2005a, 746; Jestice 1997, 217–219.

104 For Mezzabarba and Gualberto, see Dameron 1991, 51–55.

105 Peter Damian led their critics at the synod on theological grounds; see Cushing 2005a.

106 Salvestrini 2013; McCready 2011, 196–251; D'Acunto 1993, 303–308; Miccoli 1960.

107 Salvestrini 2007; Salvestrini 2002.

108 The letter is transcribed and translated in Cowdrey 1972, 4–7.

109 The letter is transcribed in Vedovato 1994, 178–180; for a summary of the scandal, see Vasaturo 1994, 26–28.

110 Monzio Compagnoni 1999b, and D'Acunto 2005.

111 Vasaturo 1985.

112 Baethgen 1934.

113 Vasaturo 1983 published the customs in the *Corpus Consuetudinum Monasticarum*. For a discussion and dating, see Monzio Compagnoni 1999b.

114 Vasaturo 1985, 6–8.

115 Salvestrini 2007, 270.

116 To put the Salvestrini quotation in its full context: *Un altro dato a mio avviso significativo che contribuì a connotare il monachesimo vallombrosano – obbedienza benedettina aperta al mondo laico –, fu la connessione fra chiostri rurali ed ospedali*, Salvestrini 2007, 306.

117 Baethgen 1934, 1100–1101, chap. 80 of the Life; for the Italian translation, Rossi 1991, 117–119.

118 Augustine, *Homilies on the Gospel of John*, in treatise 26.13 (on John 6:41–59) uses the phrase *vinculum caritatis* in his famous synthesis of Eucharist theology: *O sacramentum pietatis! O signum unitatis! O vinculum caritatis!*

119 Monzio Compagnoni 1998, 570. Concerning the *Carta Caritatis*, 25 years assumes a date of 1119. Should the document date to the mid-twelfth century as argued by Constance Berman, the gap would be considerably larger: Berman 2000, 46–92.

120 Meade 1985, XII-XVII.

121 See Chellini 2007.

122 Ronzani 1980, 46, giving examples from the monastery of San Paolo a Ripa d'Arno in Pisa.

123 Salvestrini 2007, 258–261.

124 Gaborit 1964; Gaborit 1965.

125 Moretti 1990b; Moretti 1994; Moretti 1995; Moretti 1999.

126 Santa Maria di Vigesimo, Santa Mustiola in Torri, and San Salvatore in Fucecchio were all completely rebuilt. See Gustafson 2012, 156–157.

127 San Salvatore di Fontana Taona, Santa Maria di Nerana, Santa Maria di Grignano, San Michele di Forcole, San Fedele di Strumi, Santa Maria di Pacciana, San Bartolomeo di Cappiano, San Pietro di Moscheta, San Paolo di Razzuolo, San Salvi at the outskirts of Florence, Santa Reparata di Marradi, San Salvatore di Soffena, Santa Maria di Susinana, Santa Trinita d'Alfiano, Santa Maria in Cavriglia, San Cassiano di Montescalari, San Lorenzo di Coltibuono, Santa Maria di Crespino, Santa Maria di Montepiano, San Michele in the center of Siena, San Bartolomeo in Bagno a Ripoli, San Fedele in Poppi, the monastic church of Santa Maria di Vallombrosa, Santa Maria di Coneo, Santa Trinita di Spineta, and San Michele di Passignano. See Gustafson 2012, 158–173.

128 The Badia di San Salvatore a Settimo, San Salvatore a Vaiano, San Paolo a Ripa d'Arno in the center of Pisa (a basilica with projecting transepts), and Santa Trinita in the center of Florence (also a basilica with projecting transepts). See Gustafson 2012, 174–178.

129 Moretti 1987, 101–102, citing Vigesimo and Torri as primitive examples.

130 Most of the churches built later in the twelfth century have this motif: Coltibuono, Vallombrosa, Siena, and Coneo earlier in the century are the best examples. Poppi and Ripoli were built without articulated crossings and both date to the start of the thirteenth century. Montepiano seems to have had an articulated crossing at the start of the twelfth century, evidence that the motif existed from early on.

131 Baethgen 1934, 1083. The stone altar of the church was dedicated to Mary, the Archangel Michael, the apostles Bartholomew and Thomas, Pope Saint Stephen I, Saint Benedict, and Saint Nicholas, by Bishop Rudolph of Paderborn in 1038, who was travelling through Florence in the retinue of Emperor Conrad II. Vasaturo 1994, 3–8; Vasaturo 1973, 1, 12.

132 Vasaturo 1994, 8–14; Vasaturo 1973, 1–2, 12–13.

133 Vasaturo 1994, 59–60; Vasaturo 1973, 2–3, 13–14. A foundation stone on the façade records the work conducted under Abbot Benigno by Magister Petrus, with the support of Bishop Raimondo of Castro in Sardegna as well as Popes Gregory IX and Honorius III; Kovacevich 1951, 17.

134 Caneva 2007; Caneva 1999; Ciardi 1999; Vasaturo

135 Vasaturo 1973, 3–22.

136 The rounded apse is no longer extant, but was documented during the 1957–1959 restoration work at Vallombrosa when the current choir floor was opened and the apse foundations were revealed; Morozzi 1973, 163–164.

137 Vasaturo 1983.

138 Constitutions I.3, *De Uigilis: Omnes igitur tunc ad aecclesiae introitum ienua flectant et adorates omnibus reuerentur cum ienu flexo altaribus unusquisque ad agendan orationem trinam se praeparet in loco scilicet sibi iniuncto.* Vasaturo 1983, 316–317.

139 That the crossing originally had some sort of cupola is confirmed by the remains of the thirteenth-century *tiburio* above. The presence of a *tiburio* indicates that an arch had to have divided the nave from the crossing to support one side of the cupola. This arch is now embedded within the baroque Serlian motif. It is possible the arches separating the transepts from the crossing are original. The groin vaulting in the transepts (not original) does not follow the same line as the round arches, and the Baroque additions in the crossing are built against these arches.

140 The sixth and twentieth chapters of the constitutions address private prayer (*De oratione priuata* and *De interuallo et priuata oratione respectively*); Vasaturo 1983, 320, 330.

141 Cassian 2000, Books 2–3, 35–74.

142 *. . . consuetudinem ipsius uolumus litteris exprimere qualiter eadem a patribus, quibus est instituta, debent moraliter uiuere . . .*; Vasaturo 1983, 315.

143 Pirillo 2009; Moretti 2014; Moretti 2004; Stopani 2001; Bernacchioni 1999; Moretti and Stopani 1972a, 49–52; Gaborit 1964, 483–488.

144 Gaborit compares the crypt to eleventh-century crypts in the cathedral of Fiesole, Santa Trinita in Florence, and San Miniato al Monte, as well as "rustic" crypts at the monasteries of Badicroce and Farneta and the cathedral of Sovana.

145 Moretti 2009, 265–273.

146 Frati 1997, 229–232; Viti 1995; Romeo 1980.

147 Dalla Negra 2005; Rigoli 2005.

148 Tigler 2006, 214–219; Stiaffini 1983–1984; Doria, Zuccheri, and Galluzzi 1957; Nuti 1953.

149 Marchini and Micheletti 1986; Dezzi Bardeschi and Masetti 1981; Saalman 1966; Saalman 1962.

150 The Romanesque cathedral of Santa Reparata had pseudo-transepts in the form of flanking chapels, and the cathedral of Pisa was a full cruciform basilica. For Santa Reparata, see Toker 1975, and for the Pisa Duomo see Sanpaolesi 1975.

151 This tau cross plan also recalls Roman precedents such as Old Saint Peter's, San Paolo fuori le Mura, and many others; for the tau cross Roman churches, see Emerick 2011 and Kinney D. 2006.

ERICA KINIAS

Reconstructing an Order: The Architecture of Isabelle of France's Abbey at Longchamp

Introduction

In his 1787 *Guide des amateurs et des étrangers voyageurs à Paris*, Luc Vincent Thiéry provides an extraordinary account of the interior of the abbey church of l'Humilité de Notre Dame, also known as Longchamp, just west of Paris in the present-day Bois de Boulogne. Entering the abbey church from the south, according to Thiéry, a visitor encounters Isabelle of France's tomb "around the middle of the grille of the nuns' choir, and a part of it is found outside."[1] This remarkable arrangement of Isabelle's tomb, oriented along the east-west axis of the church and bisected by an iron grille separating the nuns' choir to the west from the high altar to the east, allowed both the nuns and the townspeople access to her saintly curative powers.[2] Isabelle (1225–1270), daughter of French queen and regent Blanche of Castile, and sister to Louis IX, France's famous royal saint, is best known as the co-author of a new rule for Franciscan women, first approved in February 1259. A revised version was approved by Pope Urban IV in July 1263, with the official name of the order given as *Sorores minores inclusae* (Order of Enclosed Sisters Minor). But what merited Isabelle's unusual burial at Longchamp? And more importantly, what role did this royal abbey have in the establishment of Isabelle's new order?

Recent scholarship has shed important light on Isabelle of France's role as founder of the order of *Sorores minores*.[3] Unfortunately, the destruction of Longchamp beginning in 1792 has largely excluded this site from scholarship on royal patronage in the thirteenth century, obscuring its long-term impact on the development of female Franciscan monastic architecture.[4] This study addresses this omission by synthesizing the fragmentary textual and pictorial evidence of Longchamp's architecture, offering a reconstruction that traces the site's expansion and modification from 1260 through to the expulsion of the nuns after 1790. This study will then contextualize Longchamp's spatial organization and architectural features with other contemporary female houses, most notably two Cistercian houses founded by Isabelle's mother—the abbeys at Maubuisson, near the royal residence at Pontpoint (Val-d'Oise), dedicated

in 1242, and Notre-Dame du Lys (Seine-et-Marne), dedicated in 1248.[5] In analyzing the corpus of pictorial and cartographic sources for Longchamp, a more complex picture of Longchamp emerges. We can also appreciate the role of architecture in the construction of a new vision of Franciscan monastic life for women.[6]

Isabelle of France and the Order of *Sorores minores inclusae*

For decades after Francis of Assisi's death in 1226, unresolved questions about how to incorporate female communities into the Franciscan movement confounded Church leaders concerned by the growing number of women across Italy joining unregulated communities in search of a penitential and mendicant life in the first decades of the thirteenth century.[7] These communities often lacked the necessary endowments to support their new communities. As Bert Roest and others have argued, the institutional Church's desire to regularize and assimilate these communities into existing orders (primarily Cistercian or Benedictine) often conflicted with the women's desire for a religious life more closely aligned with the Franciscan model of evangelical poverty.[8]

Complicating these efforts at regularization was the lack of clarity around the extent of the financial and pastoral commitment for new communities wanting Franciscan affiliation. The notion of *cura monialium*, or the spiritual care of nuns, even generated controversy during Francis's life, as his followers struggled with limiting their contact with women while simultaneously wanting to support new houses of penitent women following their ideals of poverty—and thus requiring their financial and pastoral support.[9] Unfortunately for the women of these communities, including Francis's most notable disciple Clare of Assisi and her community at San Damiano, the saint's own recorded views on the subject were ambiguous. Consequently, friars generally resisted adopting these obligations after Francis's death in 1226.[10] By 1253, this ambiguity resulted in three, often contradictory, rules aimed at regularizing early female Franciscan communities and resolving tensions around the *cura monialium*: Cardinal Ugolino (later Pope Gregory IX)'s *Forma vitae* of 1219; its later modification by Pope Innocent IV in 1247; and Clare of Assisi's *Forma vitae*, which Pope Innocent IV approved in the last year of her life in 1253.[11] Innocent's Rule of 1247 responded to the order's reluctance to commit to the *cura monialium* by requiring monastic endowments and allowing chaplains outside the Franciscan order, effectively minimizing their institutional connection with the Friars Minor. Clare's *Forma vitae*, on the other hand, resisted this model and conformed more fully to her vision of women's religious life in poverty and dependence on the friars. Correspondence among Isabelle, Innocent IV, and Bonaventure, Minister General of the Order of Friars Minor, however, shows Isabelle's insistence on her own approach to crafting a rule for Franciscan women that ensured an unprecedented degree of autonomy and privilege while establishing a lineage direct from the Franciscan movement.[12]

It is a measure of both Isabelle's political acumen and the rule's appeal to both the Franciscan order and papal interests, therefore, that Pope Alexander IV approved the first version of the rule in 1259 despite its violation of the Fourth Lateran's 1215 prohibition on the creation of new orders.[13] In the preface, Pope Alexander IV clearly identifies it as a new *religio*, a "way of life" or "order," approved under special circumstances:

> Although it has been forbidden . . . that anyone should invent a new form of religious life . . . nevertheless, wanting to look favorably on the undertakings of the abovementioned king and Isabelle in this matter, we grant the rule written below.[14]

The 1259 version of Isabelle's rule ultimately rejected what had been central to Clare's conception of Franciscan practice for women, the *privilegium paupertatis* (privilege of poverty), in favor of accepting endowment and allowing nuns to hold communal property.[15] As Sean Field has demonstrated, while the 1259 version bears some similarity to Innocent IV's 1247 revision of Ugolino's rule, like Clare's *Forma vitae* it is also explicit in requiring the appointment of Franciscan chaplains and confessors, as well as requiring direct oversight from the Minister General of the Franciscan order.[16] Additionally, the rule required that the nuns receive the Eucharist at least twice a month, a substantial increase from the seven times per year specified in both Ugolino's rule of 1219 and Clare's rule of 1253.[17]

For Isabelle of France, however, an important part of her vision for her rule had yet to be realized. In the 1263 revision of the 1259 rule, Isabelle obtained for the women of her order the title of *Sorores minores inclusae*—the Enclosed Sisters Minor, emulating the Franciscan friars' title of *Fratres minores*, a distinction never granted any other order of women.[18] One of the critical provisions in the 1263 revision also allowed the rule to be adopted by other communities.[19] As Sean Field argues, Isabelle was committed to not only an institutional affiliation with the Friars, but to asserting "a gendered equality" within the Franciscan movement.[20] Expanding on the privileges in Isabelle's rule, Pope Alexander IV issued a series of five bulls further codifying their institutional autonomy, including: *Inter alia sacra*, issued on 22 February 1259, allowing Louis IX to enter the abbey's cloister and to provide the nuns with spiritual instruction;[21] *Etsi universe orbis*, which placed Longchamp directly under the jurisdiction of the pope (rather than the bishop of Paris), similar to the Damianite foundations at this time in Italy and France;[22] and importantly, *Devotionis vestre precibus*, which allowed nuns at Longchamp the unusual privilege of inheriting or selling their property.[23] After Marie de Beaujeu took vows at Longchamp in 1300, for example, she retained her inherited right to income from tithes of the town of Préverenges near Lausanne (in present-day Switzerland), donating only a year's income to Longchamp in 1312.[24]

While never taking monastic vows, Isabelle continued to shape Longchamp as a site of Capetian sanctity and locus of pilgrimage until her death in 1270. For example, in 1266, Isabelle received papal permission for royal burials at Longchamp and, in 1267, permission for the royal family to visit her tomb at Longchamp after her death.[25] By the end of the fourteenth century, at least a dozen more houses would adopt Isabelle's rule across France, England, Italy, and even Spain.[26] A majority of the foundations adopting Isabelle's rule were custom built, welcoming nuns from royal or high noble families, including Sainte-Claire à l'Ourcine-lèz-Saint-Marcel near Paris, founded by Isabelle's sister-in-law (Louis IX's queen), Marguerite of Provence, in 1287, and the abbey at Nogent-l'Artaud (Aisne), founded in 1299 by Blanche of Artois (Isabelle's niece), Queen of Navarre.[27]

The nuns at Longchamp would continue to follow Isabelle's rule down to the house's suppression in February 1790.[28] In 1792, the abbey's lands were sold, and the church was

dismantled soon thereafter, followed by the complete progressive robbing and ruin of the abbey's buildings. A thirteenth-century grange east of the cloister range remained standing until 1856, its great size (46 by 18 meters) drawing the attention of Eugène Viollet-le-Duc, who included it in his 1857 *Dictionnaire*.[29] That same year, however, at the inauguration of Georges-Eugène Haussmann's new monumental public park at the Bois de Boulogne, all that remained was the abbey's ruined dovecote and windmill—preserved as ruins in the picturesque panorama capturing Haussmann's notion "of air and view" (*de l'aire et de la vue*) in a new Parisian urban aesthetic.[30]

A critical inventory of sources for Longchamp

The approach to reconstructing Longchamp's monastic complex requires an analysis of surviving textual, pictorial, and cartographic sources and plans that considers their varying representations over time. This study will consider the historical contexts of each pictorial and cartographic source, resulting in a new two-dimensional reconstruction.[31] We have neither surviving structural evidence nor archaeological context for the site, nor visual representations of Longchamp datable to the medieval period. In their absence, medieval and early modern textual evidence—descriptions of the structures and references to buildings or building works— and visual evidence from the seventeenth up through the mid-1900s will serve as this study's primary sources of evidence.

Textual sources used in the reconstruction of Longchamp can be considered in three general categories: prescriptive texts (monastic rules, legislation, and papal privileges); narrative descriptions (hagiographic texts and first-person accounts); and records of building works (including specific parts of the site). As such, the most important prescriptive texts for this study include the two versions of Isabelle's rule (1259 and 1263); papal bulls conferring privileges;[32] a cartulary begun in 1333 by abbess Jeanne de Gueus;[33] and a fifteenth-century manuscript containing the abbey's calendar, privileges, liturgical instructions, obits and anniversaries, vernacular histories, and necrology.[34]

Narrative texts include copies of two texts by Agnes of Harcourt, the third abbess of Longchamp (her *Letter on Louis IX and Longchamp*, dated 4 December 1282, and her *Life of Isabelle of France*, composed around 1283),[35] and a seventeenth-century chronicle.[36] Isabelle of France's saintly renown was eclipsed by the canonization of her brother Louis IX in 1297. Nonetheless, by the beginning of the seventeenth century, attention around this 'other' royal saint saw a rise in popularity.[37] Two biographies of Isabelle written at this time—Sébastien Roulliard's 1619 *La saincte mère, ou vie de M. saincte Isabel de France* and Nicolas Caussin's *La Vie de St. Isabelle*, published in 1644—provide valuable evidence of the spatial organization of the church and claustral buildings.[38] Additionally, Isabelle's entry in the 1743 *Acta Sanctorum* explicitly draws on Roulliard's 1619 description of Isabelle's tomb.[39] The epitaph installed alongside the tomb between 1445 and 1515 is mentioned briefly by Thiéry as being perpendicular to the screen situated between the space for the laity and the nuns' choir.[40] Several brief records of the initial construction of Longchamp survive, comprising records of the initial purchase of land and domain rights of the surrounding Forêt de Compiègne in 1255.[41] Selected entries in inventories compiled at the beginning of most abbesses' terms between 1287 and 1741 are also central to

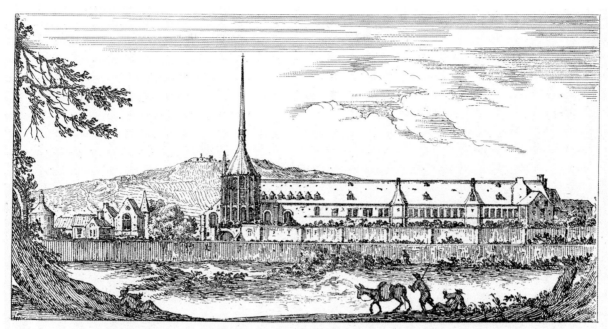

L'ABBAYE DE LONGCHAMP AU XVIIe SIÈCLE, D'APRÈS LA GRAVURE D'ISRAEL SILVESTRE *(Collection de Cambis)*.

1 Israël Silvestre (1621–1691), *Vue de l'Abbaye Royal des Religieuses de Longchamp à une lieue de Paris*, 1652, engraving, 10.3 × 18.1 cm. Musée Carnavalet, Histoire de Paris, no. G.429.

understanding the phasing of repair and expansion of Longchamp over time,[42] complemented by surviving records of building works and repairs initiated by Charles IV (1323) and Philip VI (1349).[43]

Surviving images provide evidence for both the topography of the site and Longchamp's claustral buildings in the pre-Revolutionary period. These include views of the environs around Paris and Bois de Boulogne (which include Longchamp); views of Longchamp; plans of individual parts of the site; and plans of Longchamp. (For a comprehensive list of the known depictions of Longchamp, see the Appendix.) A majority of these representations are on maps of Paris and its environs dating to the seventeenth through the nineteenth centuries, or form part of surveys associated with Haussmann's redevelopment work during the Second Empire. The earliest known images of Longchamp, which all date to the middle of the seventeenth century, include: an intaglio engraving, *Vue de l'Abbaye Royal des Religieuses de Longchamp a une lieue de Paris*, executed by Israël Silvestre in 1652 (Fig. 1);[44] the *Vue de l'abbaye de Longchamp*, an etching by Flemish engraver Albert Flamen produced around 1650;[45] Philippe de Champaigne's dedicatory painting of Isabelle of France commissioned by Longchamp in 1659;[46] an anonymous engraving titled *Le Mont Valerien, autrement dit le Calvaire, à 2 lieues de Paris*, produced around 1650 (Fig. 2); and a view of Longchamp in a painting of Saint-Cloud attributed to Étienne Allegrain from 1675 (Fig. 3).[47] Another important early image is Jean Baptiste Feret's 1712 painting *Seine Landscape at St. Cloud, which includes a view of Longchamp from the south*.[48] The most intriguing in this study is also one of the last images produced before the monastery's destruction: Hubert Robert's 1790 watercolor, which offers a problematic yet tantalizing view inside Longchamp's ruined parlor (Fig. 4).[49]

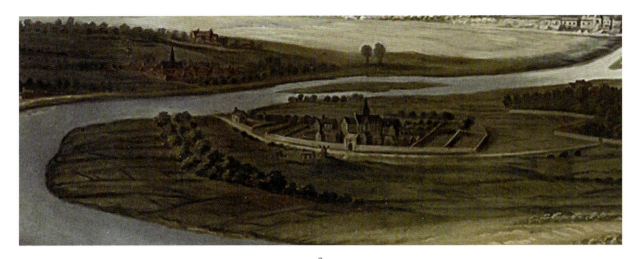

2
Longchamp (Étienne Allegrain) (attrib.), *Vue cavalière du château et du parc de Saint-Cloud vers 1675*, c. 1675–1677, oil on canvas, 314 × 386 cm (detail). Original at Château de Versailles, MV 743.

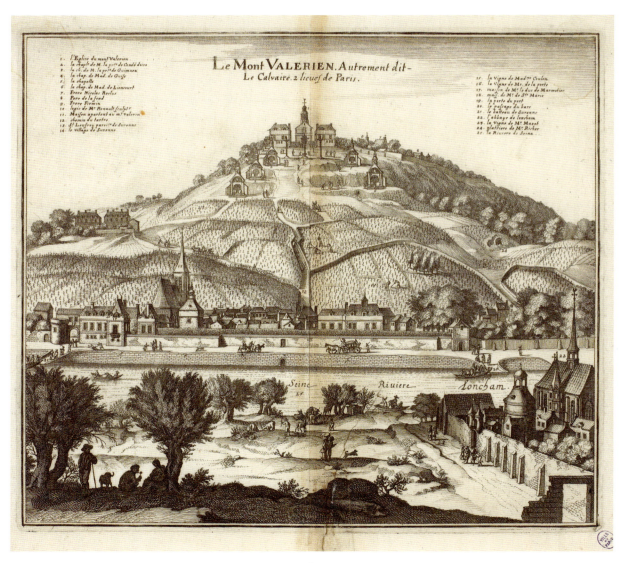

3
Anonymous, *Le Mont Valerien autrement dit le calvaire à 2 lieues de Paris*, c. 1650.
Collection du musée du domaine départemental de Sceaux.

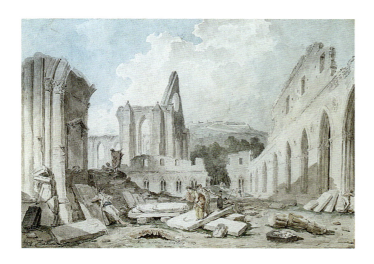

4 Hubert Robert (1733–1808), *Ruines de l'Abbaye de Longchamps*, c. 1790, Stockholm, National Museum, NMH 129/1950, public domain.

Another important early depiction of Longchamp is a plan embedded in a panoramic view of the abbey's environs prepared by George Lallemant in 1619.[50] Lallemant's view was commissioned during a lawsuit between Longchamp and the town of Suresnes over access rights to water from the fountain of Veau-d'Or.[51] Since the priority of the map seems to have been to depict the salient topographic features in the environs of the abbey and town (including the abbey's agricultural lands to the south), architectural details of the abbey itself are limited. The map does, however, provide important information about Longchamp's water management. A 1731 map of Paris, on the other hand, provides a more detailed view of the monastic complex (Fig. 5). The work of Claude Roussel, a military engineer who had just completed a significant survey project of the Pyrenees ten years earlier, this meticulously detailed map spans numerous plates, one of which includes the Bois de Boulogne.[52]

Isabelle of France's entry in the 1743 publication of *Acta Sanctorum* includes an illustration of the interior of Longchamp's church (Fig. 6).[53] Last, and most significant for this study, is Nicolas-François Regnault and François Forget's 1792 plan of Longchamp, a copy of an unknown original, and the product of a Revolutionary survey of *biens nationaux* (Fig. 7).[54] While Regnault and his wife and collaborator, Geneviève Regnault, were well-known engravers, most recognized for their 1774 publication on botanical subjects, *La Botanique mise à la portée de tout le monde*, little is known about Forget, obscuring critical context about the production of this important plan.[55] Finally, two modern studies of Longchamp's architecture will be considered: Gaston Duchesne's 1906 *Histoire de l'abbaye royale de Longchamp* and a thesis by Joël Audouy completed in 1949.[56]

Analysis of the evidence for Longchamp's architecture

Agnes of Harcourt provides the first textual description of architectural space at Longchamp in her *Letter on Louis IX and Longchamp* and her *Life of Isabelle of France*. As Field points out, the letter emphasizes Louis's role as co-benefactor of the abbey with Isabelle of France and was, therefore, likely composed for use as testimony in Louis IX's canonization inquiry held at Saint-Denis between 1282–1283.[57] In the letter's description of Longchamp's foundation ceremony, the king places the first foundation stone, followed by his queen, his two sons, and his sister

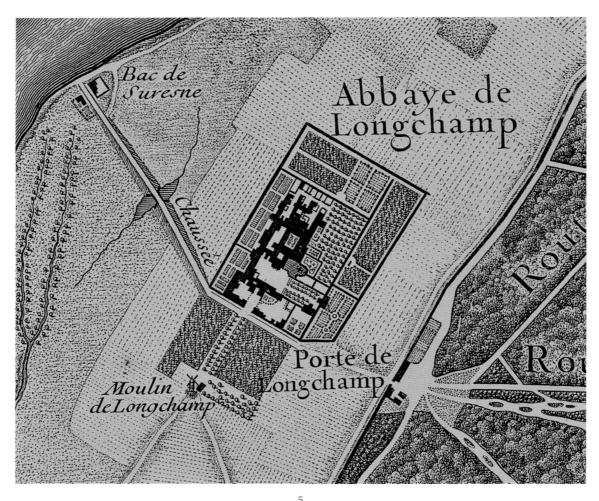

5

Claude Roussel, *Paris, ses fauxbourgs et ses environs où se trouve le détail des villages, châteaux, grands chemins pavez et autres, des hauteurs, bois, vignes, terres et prez, levez géométriquement*, plate 26 (detail). BnF, département Cartes et plans, GE DD-2987 (798, 1–7 B).

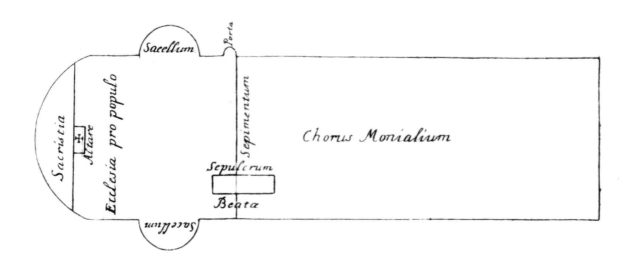

6

Illustration of Longchamp's church, with entrance for lay visitors in the southeast portal, and the nuns' choir to the west separated by a choir screen.

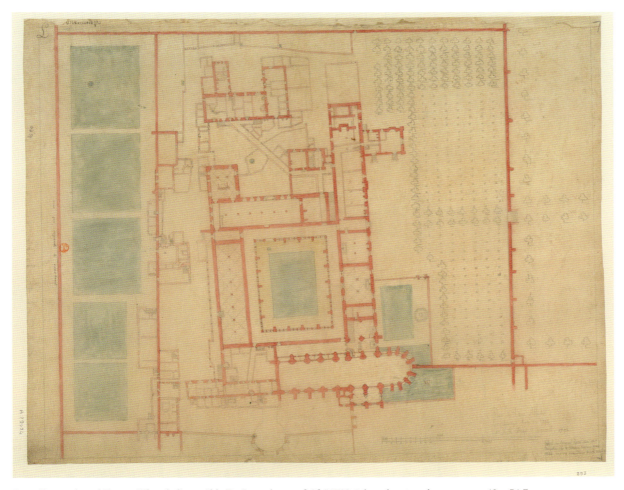

7 Regnault and Forget, "Plan de l'anc. Abb. De Longchamps [sic]," 1792, ink and watercolor on paper, 42 × 54.7 cm. BnF Reserve FOL-VE-53 (G).

Isabelle—the sequence emphasizing both Louis's support for the foundation and Isabelle's saintly humility.[58] While Agnes places Louis IX at the heart of Longchamp's foundation and endowment, donating relics—reputed fragments of the True Cross and a thorn from the Crown of Thorns—and providing building materials, the "Life" equally centers Isabelle's role, noting that Isabelle paid the considerable sum of 30,000 *livres parisis* for Longchamp's construction.[59]

The opening preface in Longchamp's necrology, begun in 1325, records that the first nuns at Longchamp took the veil on 25 June 1260. Although it is unclear how these first nuns were recruited, by the November 1261 at least five nuns were brought from the Franciscan house in Reims to help instruct the nuns on religious life.[60] At this time, the church and the two-story east and north claustral buildings were complete, the east wing (connected to the church's north transept) containing the nuns' dormitory on the upper level and the sacristy and chapter room on the ground level, with the north wing containing the refectory above the cellars (Fig. 8). Agnes describes the unprecedented events surrounding the enclosure ceremony in which Louis IX was

> ... devotedly present when we entered into religion and enclosed us. And soon after, he entered among us, as he could enter there according to our rule by permission

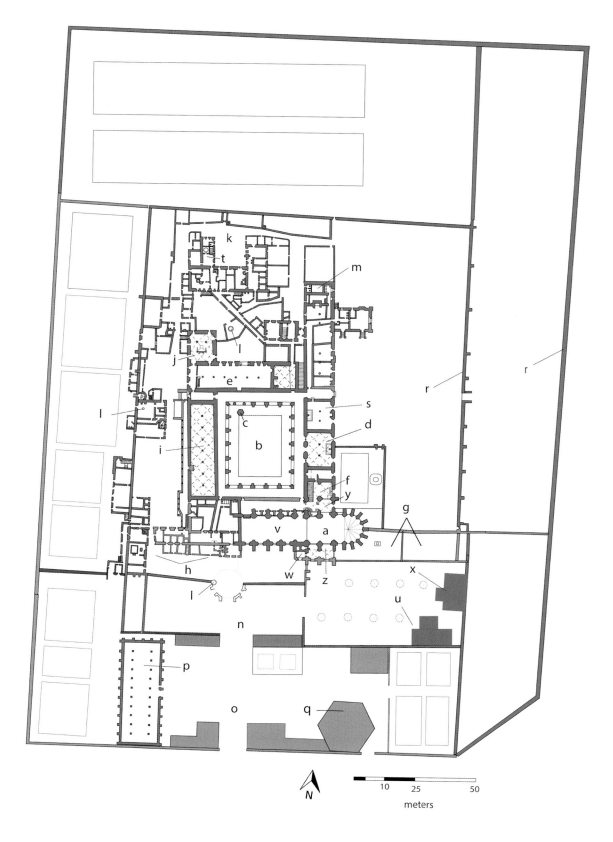

8
Reconstructed plan of Longchamp, ground floor (based on Regnault and Forget): a) church; b) cloister; c) lavabo; d) chapter house; e) cellar, with upper level refectory; f) library/scriptorium; g) cemetery; h) friar's wing; i) two-level parlor; j) refectory kitchen; k) infirmary wing; l) well; m) latrines; n) inner courtyard; o) outer courtyard/stable block; p) grange; q) dovecote; r) enclosure wall; s) novices' chapel; t) infirmary kitchen; u) Isabelle of France's residence/chapel; v) choir; w) octagonal tower/chapel; x) abbess apartment/parlor; y) sacristy; z) lay entrance to abbey church.

of Monseigneur the pope. And Madame Isabelle, his good sister, our holy mother, accompanied him. We were gathered together before him in chapter. He seated himself right down on our level, and he gave the first sermon and teaching that we had had since we had entered there, and he said that we ought to take as our example Monseigneur Saint Francis and Madame Saint Clare and other saints who lived with such sanctity and perfection.[61]

In this extraordinary scene in which normative prohibitions on enclosed nuns' interaction with men are suspended, Louis IX and Isabelle both confirm their temporal and spiritual roles as founders and, arguably more importantly, as sacral exemplars to the nuns at Longchamp.

Descriptions from Guillaume of St. Pathus's (1250–1313) *Life of Saint Louis* offer intriguing context to the description of the king's visits to Longchamp alongside Isabelle.[62] At the Cistercian monastery of Royaumont, which he co-founded in 1228 with his mother (then regent) Blanche of Castile, a young Louis is described as helping to serve the monks at meals, washing their feet, and eating alongside the abbot in the refectory. Similarly, at the Franciscan house at Orléans and the Cistercian abbey at Chaalis, Louis is also recorded eating in the refectory and sitting alongside the friars in the chapter room.[63] The significant difference between these examples and Longchamp, however, is that the latter represents the first time Louis's presence was recorded within a community of nuns.[64]

Evidence of the second phase of construction, the expansion of the refectory and kitchen, appears in the early fourteenth century, continued by a donation from Charles IV in 1324.[65] Most intriguing are those contributions around the arrival of Blanche of France (c.1311–1358), the youngest daughter of Philip V and Jeanne de Bourgogne, who entered Longchamp around the age of eight in 1319 and was therefore at Longchamp during the last years of her father's life.[66] In April 1320, just one year after taking her vows, Blanche wrote to her father requesting that a residence be built at Longchamp for her use—an extraordinary accommodation that was in clear defiance of the rule stating that all nuns, including the abbess, sleep in a common dormitory.[67] This violation notwithstanding, the residence was duly built and completed by March of 1323, for the sum of approximately 178 *livres*.[68]

As a young Blanche entered Longchamp as a novice, pope John XXII directed Nicholas de Lyra, who had just been elected provincial minister, to allow Blanche and the royal family, numerous privileges: Blanche would reside in a private residence in the novitiate wing along with two secular women (*mullieres sæculares*) until her profession. She would have the privilege of selecting two friars as confessors, would be excused from following "extraneous" parts of the rule, and would have the privilege of allowing her mother to visit.[69] Surviving receipts also reveal that Blanche retained a private chaplain, friar Nicole Gueulle, throughout her life.[70] Her servants would, therefore, have access to the novices' wing and all other claustral spaces necessary to attend to the young princess. It is likely that the novices occupied cells in the southwest corner of the western claustral range, which was connected to the church, but it is unclear from the floor plan how the space was partitioned to accommodate living spaces for the friars, the novices, and the lay sisters. As only professed nuns had access to the choir, novices and lay sisters may have accessed the church through the covered ground-level passage from the cloister. The nuns likely accessed the choir by a stairway from the south end of the

dormitory or from the second level of the cloister walk. The exceptional access Blanche and her family had at Longchamp was extended to the treatment of her body after death—contrary to the rule that required all nuns to be buried within the enclosure, Blanche received permission to have her heart removed and buried alongside her mother's heart in the Franciscan church in Paris.[71]

Spatial privileges were not reserved only for nuns with royal connections. The 1483 inventory includes a separate entry for the lavishly decorated "chambre de mademoiselle Magdelaine," described as a vaulted room with tapestries (*dociles*) and two curtains, and seven blue bedcoverings.[72] This lavishly decorated private cell in the nuns' dormitory likely belonged to Magdelaine de Bretagne, daughter of Richard, count of Étampes and Marguerite of Orléans, who professed at Longchamp in November 1461.[73] The same inventory notes Magdelaine's multiple donations to the abbey, including several gold and silver liturgical cups and plates, and a sizable assembly of plates, pots, and cups for use in the refectory—all of which displayed the Breton coat of arms.[74] It is unclear from the entry if the Breton tableware was used by the nuns on a daily basis (it is listed as items not belonging to a particular space, such as the refectory or cellar), but it demonstrates the presence of objects signifying the abbey's donors and, at the same time, the prestigious status of its nuns.

Other minor structural modifications and repairs appear in the abbey's inventory, but no major building works are noted until the later part of the fourteenth century. The Hundred Years' War forced the nuns to abandon the abbey and stay in Paris multiple times, between 1346 and 1429.[75] A list of urgent repairs initiated by abbess Marie du Gueux, and later abbess Agnès de Chevrelle, on the nuns' return to Longchamp in 1360 does, however, confirm the presence of the infirmary to the north of the refectory (Fig. 8 [t]).[76] In August 1349, Philip VI (r. 1328–d. 1350) donated a house and garden formerly belonging to a Héloïse du Port to the nuns at Longchamp at the request of Blanche of France.[77] His donation may not have been enough, however—four years later in 1353, Blanche sold numerous silver vessels and jewels for the completion of a chapel in the church dedicated to the Virgin Mary—presumably in the two bays added to the south of the church during this period.[78]

Further donations from Charles V record the addition of a fountain between the inner and outer courtyards.[79] In April 1367, Charles V also issued an order to Longchamp's abbess, Marie de Gueux, to rebuild the enclosure wall and install window grilles, two requirements of enclosure under Isabelle's rule.[80] The subsequent sale of some of the abbey's twenty-eight relics to assist with repairs also indicates the extent of the decay and damage inflicted on the buildings.[81]

A period of prosperity followed the tumultuous period of the Hundred Years' War, evident in the multiple building projects and repairs beginning in the 1460s.[82] The inventory of 1467, made by abbess Jehanne Porchère, records numerous repairs to the church's forty-two glazed windows and extensive repairs to the friars' rooms, including new fireplaces (Fig. 8 [h]).[83] Porchère notes the expansion of the larger of two infirmaries (*la grand enfermerie*) by adding a story and extending the water channel.[84] Modifications made to the *petite enfermerie* noted at the time also allow the identification of both infirmaries and kitchen spaces in Regnault and Forget's plan. The inventory notes that the *petite enfermerie*, situated in front of the main convent kitchen (distinct from a second kitchen that prepared special food for the infirmaries),

was repaired due to flooding.[85] Between 1499 and 1513, abbess Jacqueline de Mailly solicited the financial support of her parents to pay for costly repairs including a second floor to the infirmary kitchen and repairs to a small chapel situated in the inner courtyard north of the abbey church (Fig. 8 [u]).[86]

Evidence from the seventeenth-century chronicle suggests that what may be the final significant building phase at Longchamp began in 1654, under abbess Claude de Bellièvre. Bellièvre is described as demolishing the existing parlor (*locutorium*) along the west claustral range, and constructing in its place "un fort beau pavillon" consisting of two parlors—one on the ground floor and the other above on the side of the church next to the former abbess's apartment, which, as she notes, was called the "chapelle."[87] The chronicle notes that the cost of such an extensive project, 3,600 *livres*, was donated by Bellièvre's brother, Pomponne II de Bellièvre, who was at that time the first president of the Parlement de Paris.[88] Both the parlor and the abbess's apartments served as important spaces regulating the flow of physical contact between the secular and the cloistered worlds.

This discussion in the chronicle of Bellièvre's renovations is the most important source for Isabelle's residence at Longchamp. The only earlier reference to the residence surfaces in Agnes of Harcourt's account of the death of Isabelle in February 1270. She describes how, on the night of Isabelle's death, Sister Clémence of Argas "opened the window, which was next to her bed," whereby she heard "a very sweet and melodious voice about the house where she [Isabelle] was lying."[89] The chronicle further clarifies the location as being "between the dovecote, the southside of the church and the cloister wall."[90] Described as the place Isabelle had built and where she had made "continuous sacrifice and holocaust of her heart," but that had since been largely abandoned, the space was then renovated by Bellièvre—with donations from the nuns—into a chapel for their exclusive use.[91] In December 1664, an enclosure wall was built around the south side of the church to encompass the new chapel, connected through a new opening in the cemetery wall. This new southern extension to the enclosure allowed the nuns to access Isabelle's former residence and chapel without leaving the cloister.[92]

Evidence of the dormitory and its decoration in the early modern period also survives from the chronicle. In 1664, Bellièvre's successor, abbess Jacqueline de Mailly, had the dormitory floor tiled at the cost of 549 livres, noting that it was the first time the floor had been tiled in four hundred years. One year later, in 1665, Mailly installed an altar in the center of the dormitory above which was mounted a large painting of Isabelle de France, referred to in the chronicle as "nostre sainte mere." The installation of the altar, which coincided with the renovation of Isabelle's residence into a chapel for the nuns, provides important evidence about the growth of devotional practices around Isabelle of France at Longchamp after Pope Leo X, in 1521, had allowed the Franciscan order to celebrate Isabelle's offices.[93]

The organization of the extra-claustral structures receives detailed attention in the abbey's fifteenth-century inventories as well as the description of buildings south of the church in the 1786 inventory.[94] The abbey's attendant friars had a common room as well as individual cells and housing for their servants, likely situated along the west wing extending in front of the church. Gertrude Młynarczyk further clarifies this location, suggesting that the abbey's novices occupied quarters above the friars' servants' lodges, west of the church but within the inner courtyard (Fig. 8 [h]).[95] The buildings south of the claustral range included a farmhouse and

residence, stables, a dairy, and a small garden.[96] A large, two-story house, called "le Bâtiment de la Voûte," presumably because of its vaulted interior, is singled out in the 1792 sale notice—notable for its large central room with a fireplace, three upstairs bedrooms, its own garden, well, and lavatory, the total extent measuring approximately 1,500 meters2.[97] The size of this residence corresponds to the only other extra-claustral structure in Forget and Regnault's plan having substantial foundations that adjoin the enclosure wall to the northeast. Its location straddling the buildings to the northeast and connected to the cloister through a corridor running south along the ground floor north of the eastern claustral range, also suggests that the "Bâtiment de la Voûte" could be the same structure as described in the 1483 inventory as "la Sale du Roy," and referring to another residence that could access Longchamp's cloister.[98] A group of buildings to the west of the cloister also overlapping the enclosure wall, situated between the western edge of the refectory and the gardens, are referred to as the buildings of Saint Louis and "le Village" in the 1792 survey.[99]

The priest and procurator (who managed the temporal and legal affairs of the abbey) also had private quarters within the outer courtyard. An inventory completed in March 1790 notes the presence of an apothecary and library to the south of the infirmaries, most likely added in the sixteenth century and catering to both the nuns and the lay visitors.[100] That the apothecary also had its own library underscores the extent of the expansion of the abbey in the north range beyond the cloister from the fifteenth century onwards.[101] Despite its attention to detail through the cloister and inner courtyard, Forget and Regnault's plan of Longchamp does not show the location of the choir or its grille mentioned by Thiéry in 1787 and the outer courtyard is outside its coverage—features that may have been a part of the original plan. The 1790 inventory does, however, confirm the presence of these structures in the outer courtyard, including lodging for workers and the dovecote.

Assuming the general details of the cloister represent the ground level, Forget and Regnault's plan contributes additional evidence about the organization of the cloister. Longchamp's refectory is represented as a two-story structure with access, presumably, from an upper-level cloister walk connecting to the dormitory on the eastern claustral wing—suggested by the absence of an entrance from the cloister on the ground level.

The other pictorial sources provide additional evidence for Longchamp's structural features. Applying the perspectival conventions of the seventeenth century, Silvestre's 1652 etching places the viewer directly within the scene—a clear view of the skeletal buttresses of the church's east end appears in the distance as the viewer emerges from the western edge of the densely-wooded Bois de Boulogne. The viewer confronts the abbey from its most visually compelling perspective—the double elevation of Longchamp's apse that draws the viewer's gaze upward along the height of its needle-like steeple. An attempt to depict structures south of the church provides some tantalizing clues as to the organization of the inner and outer courtyards, including the chapel in the outer courtyard, the dovecote, and what may be a two-story parlor situated on the southern edge of a small garden enclosure off the inner courtyard. Pictorial evidence of the chapel also appears in an anonymous watercolor of Longchamp completed around 1795.[102] While Silvestre chooses to depict Longchamp looking west, Duval's later sketch from 1780 depicts a more modest church from that shown in Silvestre's work, perhaps made possible by its perspective from the Seine looking east onto Longchamp's west

end. In other representations of the church's west end, the façade is shown as a single elevation with a set of three graduated lancet windows above which sits a single roundel. Additionally, Robert's *ruinisme* view depicts a similar west end of the ruined church from inside the west cloister wing from around 1790—which presumably, in the context of Forget and Regnault's plan, could be from the perspective of the abbey's ground-level parlor.

Reconstruction

While Sean Field has demonstrated Isabelle's role as a "principal actor" behind the order of *Sorores minores*, the absence of structural evidence for Longchamp has obscured a fuller understanding of how Franciscan life for women as envisioned by a royal patron found spatial and architectural expression.[103] Compelling similarities in the processes of establishing religious houses do, however, exist. It is clear that Blanche of Castile and Isabelle of France used their patronage to assert political and spiritual authority in the institutional development of Cistercian and Franciscan female monasticism, respectively. Specifically, Blanche of Castile pressured the Cistercian order to acknowledge female houses within the order and, similarly, Isabelle of France established a distinct brand of female Franciscan monasticism.[104] Like that of Maubuisson and Le Lys, Longchamp's architecture is important to the expression and continued reinforcement of this royal and spiritual identity. As Alexandra Gajewski's 2012 analysis has shown, Maubuisson and Le Lys share a synthesis of simplicity and sophistication.[105] Despite the differences in the architectural scale between the Cistercian monastery for men at Royaumont and its two sister abbeys for women, Maubuisson and Le Lys, Gajewski argues that foundations for nuns should not be interpreted as more modest and reserved, but rather as sharing a vital similarity that "marries simplicity of form to sophistication of detail."[106] For Gajewski, this simplified sophistication of abbey churches for female monasteries constructed in the mid-thirteenth century is exemplified in Le Lys's squared eastern apse (as compared with Royaumont's and Maubuisson's polygonal apses), and contrasts with the innovative tracery design of its eastern windows. For Gajewski, this contrast does not express a hierarchy between male and female monasteries, but rather a "desire for *varietas*," or variety within a visual context of architectural design. The question remains, therefore, as to whether Longchamp exhibits a comparable gesture of simplified sophistication.

In comparison to the royal abbey churches of Maubuisson and Le Lys, Longchamp's church has both important similarities and distinctive differences. The plan—a simple, un-vaulted hall with seven broad bays terminating in a vaulted, seven-part polygonal apse—is reminiscent of female Cistercian churches founded without royal patronage up through the 1250s.[107] Using Silvestre's etching as a referrant for the exterior of the church, its two-story elevation with stacked rows of attenuated lancet windows creates a visual succession continuing around the chevet and uniting the lower and upper levels. The interior was separated into two distinct spaces by an iron grille covered in black cloth—the nuns' choir to the west and high altar for public worship to the east. While both Longchamp and Maubuisson had a seven-bay nave, Maubuisson's nave was flanked by two aisles and included a two-bay southern transept and integrated northern transept and sacristy, thus producing a different interior space and exterior façade from Longchamp.[108]

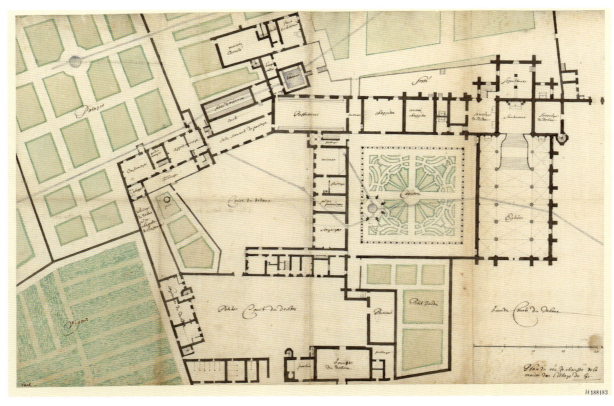

9 Robert Cote, "Plan de rez-de-chaussée de la maison de l'abbaye du Lys," 1720, pen and ink on paper, 53.7 × 83.9 cm. Paris, BnF, département Estampes et photographie, Reserve HA-18 (C, 11)-FT 6.

The position of Isabelle of France's residence at Longchamp also presents an intriguing comparison to the royal residences used by Blanche of Castile at Maubuisson and Le Lys (Fig. 9). At those two houses, the royal complexes are situated at a further distance southwest of the church. At Longchamp, perhaps because of its comparatively modest size, Isabelle's residence is closer to the monastery. Located in the inner courtyard southeast of Longchamp's church, Isabelle's residence allowed her visual access and a more direct spatial intimacy at Longchamp than Blanche of Castile enjoyed, while simultaneously allowing her to retain a politically active status as a royal penitent. The practice of building a royal residence near or adjacent to a female monastery was informed by existing models. The most notable example for this study is the royal Cistercian abbey of Santa Maria la Real de Las Huelgas, located west of Burgos, Castile, founded by Blanche of Castile's parents Alfonso VIII of Castile and Eleanor of England in 1187, in which a royal palace was situated west of the church within the outer courtyard. The royal residence at Las Huelgas was, however, much more integrated into the functions of the royal court than that at Blanche of Castile's abbeys and at Longchamp. As David Catalunya has argued, Las Huelgas should be considered "as an extension of the Royal House of Castile" and a place selected "to perform the most extravagant royal ceremonies."[109]

Longchamp's church also shares some of the architectural characteristics of Blanche of Castile's Cistercian abbeys, despite the apparent differences among them. As Terryl Kinder has convincingly argued, while Le Lys's church was smaller than Maubuisson (the vault height of Le Lys was 17 meters compared with 20 meters at Maubuisson), and it used a square apse

rather than a polygonal one, the two buildings share key stylistic similarities (notably in the cross section and base moldings of their cruciform crossing piers, as well as a shared three-story elevation resting on octagonal plinths), all of which underscore their shared patron and suggest that they were planned by the same atelier.[110] While establishing the same degree of certainty about their stylistic similarities with Longchamp in the absence of structural remains is difficult, the productive tension in the architecture at Longchamp—the wealth and status of a royal foundation expressed in the subtle, technically sophisticated form of a simplified plan—is consistent with Blanche of Castile's foundations. This design aesthetic is also reflected in the tensions inherent in Isabelle of France's rule—where Franciscan humility is paired, perhaps uneasily, with Capetian sanctity.

While it is difficult to identify a single referent for Longchamp's church, evidence suggests compelling similarities with other contemporary monastic chapels. The Augustinian abbey church of Saint-Martin-aux-Bois (Oise) is perhaps the most analogous to Longchamp's distinctive two-story exterior elevation. All that remains of Saint-Martin, which was originally founded in the eleventh century, is the choir of its church, remodeled around 1245, but it is notable for its double-elevation design with two rows of tall lancet windows and a rounded chevet.[111] Also similar to Longchamp are two mid-thirteenth-century, single vessel chapels with polygonal apses: the now destroyed Virgin Chapel at Saint-Germain-des-Prés, Paris, which lay north of the abbey church, and the Virgin Chapel at the Benedictine abbey of Saint-Germer-

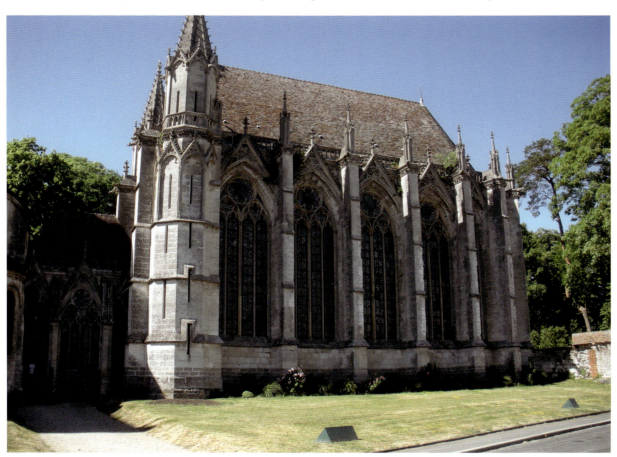

10 Lady Chapel of Saint-Germer-de-Fly, view from the south.

de-Fly (Oise), which is connected at the west by a vaulted passage leading to the axial chapel of the abbey's chevet (Fig. 10).[112] Begun around 1260, nearly a century after the completion of the abbey church, the chapel at Saint-Germer-de-Fly had a triple function: a private oratory for abbot Pierre Wessencourt (d. 1272); a chapel dedicated to the Virgin Mary; and a reliquary chapel for the remains of Saint Germer, the abbey's first abbot and founder.[113] Tall, narrow buttresses terminating in delicate sculpted pinnacles frame the fenestration at Saint-Germer and, as I suggest, at Longchamp. Each window at Saint-Germer is composed of paired lancets surmounted by a large oculus. Each lancet, in turn, is subdivided into two smaller lancets surmounted by a smaller oculus. The windows at both Saint-Germer-de-Fly and Longchamp are crowned by openwork gables that terminate in smaller pinnacles. The effect of the openwork and both types of pinnacle creates a screen visually separating the windows from the high wall behind it and obscuring the separation of the wall from the roof. The introduction of openwork gables in architectural design, combined with the use of pinnacles, links the conception of chapels serving as monumental reliquaries to the form and decoration of portable ones.

Similar to Longchamp, Saint-Martin's double-elevation windows provide an illusory effect of a unified clerestory reminiscent of the innovative design of Sainte-Chapelle, Paris (Fig. 11).[114] Constructed in the 1240s by Blanche of Castile and Louis IX, the resplendent palace chapel was designed to house the important Passion relics obtained by Louis IX on crusade in the Holy Land, including the Crown of Thorns.[115] Similar to Longchamp, a fragment of the Crown of Thorns from Sainte-Chapelle was also shared with another royal foundation, the Franciscan friary of

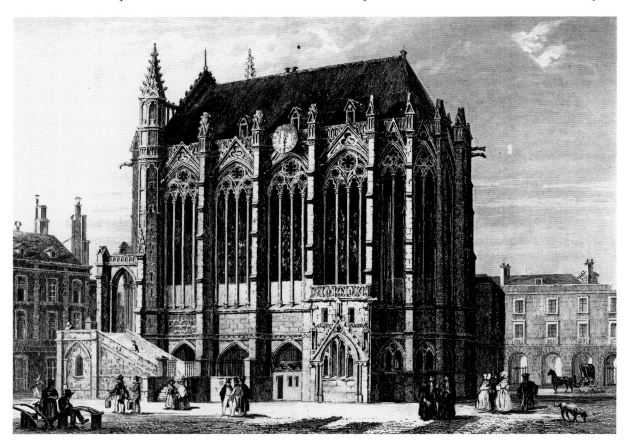

11 Monteil, View of the Sainte-Chapelle from the east-southeast.

Paris completed around 1250, just a decade before Longchamp.[116] As Laure Beaumont-Maillet argues as part of her study of the friary, Louis IX's early patronage of Sainte-Chapelle, placed it at the forefront of the construction of Capetian political and religious identity.[117] Identifying the Sainte-Chapelle as the exemplum for Longchamp as part of this broader context of royal patronage does not, however, elide their architectural differences. Sainte-Chapelle's two-story elevation, ornate, stained-glass windows make the aesthetics, and most certainly the spatial experience, distinct from that at Longchamp. In this way, Longchamp's subtle references to both the royal reliquary chapel and the restrained ornamentation find more similarity with Blanche of Castile's foundations at Maubuisson and Le Lys.

Conclusion

Preliminary conclusions and new questions emerge about Longchamp's architecture, especially in relation to both contemporary monastic patronage projects and Isabelle's unique vision for Franciscan women. Given the rich corpus of evidence about the daily life of the nuns at Longchamp, further research can expand our understanding of how the nuns, friars, and the laity used spaces in the inner and outer enclosure areas. Most significant is the organization of the conventual structures and the church, which allow for a number of avenues for pilgrims, visitors, and donors to interact with the potent, sacred spaces of the abbey, such as the chapel and the tomb of Isabelle of France. Important details about the location of the extra-claustral structures do emerge, however, tracing the expansion of the abbey and its change of priorities—such as the relocation and expansion of the infirmary in the fourteenth century and the location of the cells for the resident friars and their servants. Ultimately, though, Longchamp reflected a unique hybridity of design and expressed a productive tension between royal power and monastic austerity. Its status as a royal abbey and a reliquary chapel for privileging Isabelle's memory mirrors tensions present in Isabelle's rule and the realities of a royal Franciscan foundation. The structural and stylistic similarities with other royal projects, including Sainte-Chapelle, also suggests that Isabelle was just as much interested in her architectural legacy as she was her monastic rule.

APPENDIX

Inventory of Primary Pictorial Sources of Abbey of l'Humilité de Notre Dame (Longchamp)

Figure N°
Date Author, Title, Collection, Medium

A. Views of Paris and the Bois de Boulogne (Forêt de Rouvroy).

1619	George Lallement, Panoramic drawing of Longchamp and the village and hills of Suresnes, 10 December 1619. AM N/III Seione-et-Oise 479 (1). Ink on parchment.
c. 1630	(Anon.) *Forêt de Rouvroy ou Bois de Boulogne.* BnF Reserve FOL-VE-53(C). Ink on paper.
(Fig. 3) c.1650	(Anon.) *Le Mont Valerien autrement dit le calvaire à 2 lieues de Paris,* Collection du musée du domaine départemental de Sceaux, no. 85.50.18. Engraving.
c. 1657	(Anon.) *Plan du port de Neully, terrior de Chaliot et la Roulle.* Paris AN, CP/N/II/Seine/31. Ink on parchment.
1650	Albert Flamen, *Veüe de l'abbaye de Long champ [sic] a Surene.* (Published in Musée Carnavalet, *Histoire de Paris,* no. G.12006). Engraving.
1666	P. Barillon d'Amoncourt, "Plan de la forest de Rouvray appellée à présent Bois de Boulogne." AN CP/N/II/Seine/157. Ink and paint on paper.

B. View of Longchamp or individual parts of the site

c. 1650	(Anon.) *Plan Tant de l'Enclose de l'Abbaye Royalle de Longchamp que Des Terres qui Entoure La Ditte Abbaye qui contient au total Deux cent quarente neuf Arpents quarente neuf Perches Deux tiers.* AN Q/1/073.
(Fig. 1) 1652	Israël Silvestre, *Vue de l'Abbaye Royal des Religieuses de Longchamp a une lieue de Paris.* Musée Carnavalet, Histoire de Paris, no. G.429. Engraving.
c. 1652	Philippe de Champaigne, *La bienheureuse Isabelle, sœur de saint Louis, offrant à la Vierge le monastère des clarisses de Longchamp.* Notre-Dame de Bonne-Nouvelle, Paris. Oil on canvas.
(Fig. 2) 1675	Étienne Allegrain, *Vue cavaliere du château et du parc de Saint-Cloud.* Musée national des Châteaux de Versailles et de Trianon, no. MV 743. Oil on canvas.
1703	Nicholas de Fer, *Le Bois de Boulogne près Paris, appartenant au Roy et a dames religieuses de l'abbaye de Longchamp . . .,* 1703. Engraving.
1712	Jean Baptiste Feret, *Seine Landscape at St. Cloud.* Amalienburg Palace, Munich, no. NyAm.G0021. Oil on canvas.

APPENDIX

(Fig. 5)
1715 Claude Roussel, *Paris, ses fauxbourgs et ses environs où se trouve le détail des villages, châteaux, grands chemins pavez et autres, . . .* (plate 26). BnF, CPL GE DD-2987 (798,1–7B). Engraving.

c. 1725 Jean Baptiste Féret, *Vue de la vallée de la Seine depuis les coteaux de Meudon*, Schloss Nymphenburg, Munich. Oil on canvas.

1746 Charles-Nicolas Cochin, *Longchamp en 1746*. BnF Reserve FOL-VE-53 (G).

1746 D. P. Duval, *La Seine et l'Abbaye de Longchamp*. Musée du domaine départemental de Sceaux, no. 38.33.1. Pencil on paper.

1780 (Anon.) *Longchamp, Bac de Suresnes*. BnF Reserve VE-26 (F). Watercolor.

1788 Misbach, *Abbaye de Longchamps*. BnF Estampes et photographie, VE-26 (F). Pencil on paper.

(Fig. 4)
1790 Hubert Robert, *Ruines de l'abbaye de Longchamp*, c. 1790. Stockholm, Nationalmuseum, NMH 129/1950. Oil on canvas.

1795 (Anon.) *L'Abbaye de Longchamp*. BnF EST. Provenance: Destailleur Province, t. 1, 207 (verso). Pen drawing with watercolor.

1843 Alfred Bonnardot, "Restes de l'abbaye de Longchamp en septembre 1843." Paris, Musée Carnavalet, D.111582. Pencil on paper.

1850 Godfrey Durand (attrib.), "Longchamp sous Louis XIV." Paris, Musée Carnavalet. Engraving.

1856 J. Lobet, *Le Nouveau Bois de Boulogne et ses alentours; histoire, description et souvenires* (Paris: Hachette, 1856), 79.

1867 Adolphe Joanne, *Paris illustré: nouveau guide de l'étranger et du Parisien*, (Paris: Hachette, 1867), 232.

C. Site Plans of Individual Buildings

(Fig. 6)
1743 *Acta Sanctorum*, August 1743, vol. VI, 791.

1790 (Anon.) *Plan Tant de l'Enlos de l'Abbaye Royalle de Longchamp que Des Terres qui Entoure La Ditte Abbaye qui contient au total Deux cent quarente neuf Arpens quarante neuf Perches Deuxtiers*. Paris AN Q/1/1073. Engraving.

(Fig. 7)
1792 Regnault and Forget, *Plan de l'anc. Abb. de Longchamps*. BnF Reserve FOL-VE-53 (G). Pencil and watercolor on paper.

1857 M. Davioud, Plan and longitudinal section of Longchamp's grange. In Viollet-le-Duc, *Dictionnaire raisonné de l'architecture française du XIe au XVIe siècle*. Engraving.

Primary Works

Paris, Archives nationales (AN):
 AF//IV/1292
 K//37; K//41; K//44; K//47; K//49
 L//102; L//120; L//261; L//303; L//368; L//1021; L//1022; L//1026; L//1027; L//1028; L//1029
 LL//1600; LL//1601; LL//1604
 N//III/Seine-et-Oise 479
 Q/1/1067
 S//4418
 T//1602

Paris, Bibliothèque de l'Arsenal:
 MS 1240

Paris, Biblothèque nationale (BnF):
 MS Fr 6214l; MS Fr 11662; MS Fr 13747; MS Fr 24950
 Cartes et plans, GE DD-2987
 Destailleur, Province I: Anon. 1800. "L'Abbaye de Longchamp".
 Rouen, Bibliothèque municipale (BM):
 MS 1232

Printed Primary Works

Acta Sanctorum (AASS), 1643–1940, 68 vols. Antwerp and Brussels: Bollandists.

Bullarium Franciscanum Romanorum Pontificum constitutione: continens . . . conquistis undique monumentis (BF), 1759–1904, ed. Joannes Hyacinthus Sbaralea, et al. Rome: Congregationis de Propaganda Fide.

Secondary Works

Allirot 2005: Anne-Hélène Allirot, "Isabelle de France, Sœur de Saint Louis: La Vierge Savant: Étude de la Vie d'Isabelle de France écrite par Agnès d'Harcourt," *Médiévales*, 48 (2005): 55–98.

Allirot 2008: Anne-Hélène Allirot, "Longchamp et Lourcine: deux abbayes féminines dans la construction de la mémoire capétienne (fin XIIIe-première moitié du XVIe siècle)," *Revue d'Histoire de l'Eglise de France*, 94 (2008): 23–38.

Allirot 2011: Anne-Hélène Allirot, *Filles de roy de France: Princesses royales, mémoire de saint Louis et conscience dynastique (de 1270 à la fin du xive siècle)* (Turnhout: Brepols, 2011).

Andenna 2015: Cristina Andenna, "Lo 'Spazio Della Parola' Come Luogo Di Incontro Fra Il Chiostro e La Corte," in *Spazio e Mobilità Nella "Societas Christiana" Spaczio, Identità, Alterità (Secoli X-XIII)*, ed. Nicolangelo d'Acunto, Giancarlo Adenna, and Elisabetta Filippini (Brescia: Atti del Convegno Internazionale, 2015), 245–262.

Armstrong 2006; Regis J. Armstrong, *The Lady: Clare of Assisi, Early Documents* rev. ed. (New York: New City Press, 2006).

Aubert 1947: Marcel Aubert, in collaboration with the Marquise de Maillé, *L'architecture cistercienne en France*, 2nd ed., 2 vols. (Paris: Vanoest Éditions d'Art et d'Histoire, 1947).

Audouy 1949: Joël Audouy, *Le Temporel de l'abbaye de Longchamp des origines à la fin du XVe siècle* (Paris: École des Chartes, 1949).

Babelon 1977: Jean-Pierre Babelon, *Israël Silvestre: Vues de Paris* (Paris: Berger Levrault, 1977).

Barrière et al. 2001: Bernadette Barrière, Marie-Elisabeth Montulet-Henneau, Armelle Bonis, Sylvie Dechavanne, and Monique Wabont, eds., *Cîteaux et les femmes*. Rencontres à Royaumont, November 1998 (Paris: Créaphis, 2001).

Baxter and Martin 2010: Denise Amy Baxter and Meredith S. Martin, eds., *Architectural Space in Eighteenth-Century Europe: Constructing Identities and Interiors* (Farnham: Ashgate Publishing, 2010).

Beaumont-Maillet 1975: Laure Beaumont-Maillet, *Le grand couvent des Cordeliers de Paris: étude historique et archéologique du XIIIe siècle à nos jours* (Paris: H. Champion, 1975).

Berman 1997: Constance Berman, "Abbeys for Cistercian Nuns in the Ecclesiastical Province of Sens: Foundation, Endowment and Economic Activities of the Earlier Foundations," *Revue Mabillon, 8 (1997): 83–113*.

Berman 2000: Constance Berman, *The Cistercian Evolution: The Invention of a Religious Order in Twelfth-Century Europe* (Philadelphia: University of Pennsylvania Press, 2000).

Berman 2010: Constance Berman, "Two Medieval Women's Property and Religious Benefactions in France: Eleanor of Vermandois and Blanche of Castile," *Viator, 41.2 (2010): 151–182*.

Berman 2018: Constance Berman, *The White Nuns: Cistercian Abbeys for Women in Medieval France* (Philadelphia: University of Pennsylvania Press, 2018).

Bideault and Lautier 1987: Maryse Bideault and Claudine Lautier, *Ile-de-France gothique. I: les églises de la vallée de l'Oise et du Beauvaisis* (Paris: Picard, 1987).

Billot 1998: Claudine Billot, *Les Saintes-Chapelles royales et princières* (Paris: Éditions du Patrimoine, 1998).

Bjurström 1982: Per Bjurström, *French Drawings: Eighteenth Century* (Stockholm: Liber Fölag, 1982).

Bonde, Coir, and Maines 2017: Sheila Bonde, Alexis Coir, and Clark Maines, "Construction–Deconstruction–Reconstruction: The Digital Representation of Architectural Process at the Abbey of Notre-Dame d'Ourscamp," *Speculum, 92, Special Issue S1 (2017): 288–320*.

Bonde and Maines et al. 2009: Sheila Bonde and Clark Maines, in collaboration with Elli Mylonas, and Julia Flanders, "The Virtual Monastery: Re-Presenting Time, Human Movement, and Uncertainty at Saint-Jean-des-Vignes, Soissons," *Visual Resources, 25.4 (2009): 363–377*.

Bork 2003: Robert Bork, "Into Thin Air: France, Germany, and the Invention of the Openwork Spire," *Art Bulletin, 85 (2003): 25–53*.

Branner 1965: Robert Branner, *St. Louis and the Court Style in Gothic Architecture* (London: A. Zwemmer, 1965).

Brenk 1995: Beat Brenk, "The Sainte-Chapelle as a Capetian Political Program," in *Artistic Integration in Gothic Buildings, ed. Virginia Chieffo Raguin, Kathryn Brush and Peter Draper (Toronto: University of Toronto Press, 1995), 195–213*.

Brown 1985: Elizabeth A. R. Brown, "Burying and Unburying the Kings of France," in *Persons in Groups: Social Behavior as Identity Formation in Medieval and Renaissance Europe*, ed. Richard C. Trexler (Binghamton, NY: Medieval and Renaissance Studies, 1985), 241–266.

Brunet-Lecomtes 1997: Sylvie Brunet-Lecomtes, "Les vitraux du XIIIe siècle de la chapelle de la Vierge de Saint-Germer-de-Fly," *Bulletin du Groupe d'Étude des Monuments et Oeuvres d'Art de l'Oise et du Beauvaisis (GEMOB)*, 80–81 (1997): 49–60.

Bruzelius 1992: Caroline A. Bruzelius, "Hearing is Believing: Clarissan Architecture, ca. 1213–1340," *Gesta*, 31 (1992): 83–91.

Bruzelius 2014: Caroline A. Bruzelius, *Preaching, Building, and Burying. Friars and the Medieval City* (New Haven: Yale University Press, 2014).

Burke 2013: Linda Burke, "'She Is the Second St. Clare': The Exemplum of Jehanne de Neuville, Abbess of Longchamp, in a Fourteenth-Century Defense of Women by Jehan Le Fèvre," *Franciscan Studies*, 71 (2013): 325–360.

Catalunya 2017: David Catalunya, "The Customary of the Royal Convent of Las Huelgas of Burgos: Female Liturgy, Female Scribes," *Medievalia*, 20 (2017): 91–160.

Caussin 1644: Nicolas Caussin, *La vie de Ste Isabelle, soeur du roy saint Louis et fondatrice du monastère royal de Long-champ, Qui a donné un parfait exemple de la vie neutre des personnes non mariées ny religieuses* (Paris: Sonnius, Bechet, Bray, 1644).

Cochelin 2015: Isabelle Cochelin, "Deux cuisines pour les moines: *coquinae* dans les coutumiers du XIe siècle," in *Enfermements II. Règles et dérèglements en milieu clos (IVe-XIXe siècle)*, ed. Isabelle Heullant-Donat, Julie Claustre, Élisabeth Lusset, and Falk Bretschneider (Paris: Publications de la Sorbonne, 2015), 89–113.

Cocheris 1870: Hippolyte Cocheris, *Histoire de la ville et de tout le diocese de Paris par l'abbé Lebeuf, Nouvelle Edition, annotee et continuee jusqu'à nos jours*, 4 vols. (Paris: Durand, 1870).

Cohen 2016: Meredith Cohen, *The Sainte-Chapelle and the Construction of Sacral Monarchy: Royal Architecture in Thirteenth-Century Paris* (New York: Cambridge University Press, 2016).

Collective Work 1987: Collective Work (Ouvrage collectif), *Espace français: Vision et aménagement, XVIe-XIXe siècle* (Paris: Archives nationales, 1987).

Corbel 1931: Henri Corbel, *Petite histoire du Bois de Boulogne* (Paris: Albin Michel, 1931).

Corlieu and Léguillette 1906: Auguste Corlieu and Ch. Léguillette, *Histoire de Nogent-l'Artaud* (Chateau-Thierry: n.p., 1906).

Cubadda 1997: Valérie Cubadda, "Seigneurs et terroir de Nogent-l'Artaud aux XIIe et XIIIe siècles," *Mémoires de la Fédération des Sociétés d'histoire et d'archéologie de l'Aisne*, 42 (1997): 53–66.

Curran and Graille 1997: Andrew Curran and Patrick Graille, "Exhibiting the Monster: Nicolas-François and Genevieve Regnault's 'Les Ecarts de la Nature'," *Eighteenth-Century Life*, 21 (1997): 16–22.

Dalarun et al. 2014: Jacques Dalarun, Sean Linscott Field, Jean-Baptiste Lebigue, Anne-Françoise, Leurquin Labie, Annie Dufour, Fabien Guilloux, and Xavier Hélar, eds., *Isabelle de France soeur de Saint Louis: Une princesse mineure* (Paris: Éditions franciscaines, 2014).

Delaborde 1899: Henri-François Delaborde, *Vie de sainte Louis par Guillaume de Saint-Pathus, confesseur de la reine Marguerite* (Paris: A. Picard, 1899).

Delorme 1938: Ferdinand Delorme, *En marge du Bullaire franciscain* (Paris: Aux éditions franciscaines, 1938).

Duchesne 1906: Gaston Duchesne, *Histoire de l'abbaye royale de Longchamp (1255 à 1789),* 2nd ed. (Paris: Daragon, 1906).

Erlande-Brandenburg 1975: Alain Erlande-Brandenburg, *Le Roi est mort: Étude sur les funérailles, les sépultures et les tombeaux des rois de France jusqu'à la fin du XIIIe siècle* (Geneva: Droz, 1975).

Erlande-Brandenburg 1993: Alain Erlande-Brandenburg, "La pierre armée au XIIIe siècle dans l'architecture rayonnante," *Bulletin de la Société nationale des antiquaires de France* (1993): 271–274.

Falskau 2006: Christian-Frederik Falskau, "Hoc Est Quod Cupio: Approaching the Religious Goals of Clare of Assisi, Agnes of Harcourt, and Isabelle of France," *Magistra, 12 (2006): 3–29.*

Faucheux 1969: Louis Étienne Faucheux, *Catalogue raisonné de toutes les estampes qui forment l'œuvre d'Israël Silvestre, précédé d'une notice sur sa vie* (Paris: F. De Nobel, 1969).

Field 2002: Sean Field, "New Evidence for the Life of Isabelle of France (1225–1270)," *Revue Mabillon, 13 (2002): 117–131.*

Field 2003a: Sean Field, "The Abbeses of Longchamp up to the Black Death," *Archivum Franciscanum Historicum, 96 (2003): 237–244.*

Field 2003b: Sean Field, *The Writings of Agnes of Harcourt: The Life of Isabelle of France and the Letter on Louis IX and Longchamp (Notre Dame, IN: University of Notre Dame, 2003).*

Field 2006: Sean Field, *Isabelle of France: Capetian Sanctity and Franciscan Identity in the Thirteenth Century* (Notre Dame, IN: University of Notre Dame Press, 2006).

Field 2007a: Sean Field, "Imagining Isabelle: The Fifteenth-Century Epitaph of Isabelle of France at Longchamp," *Franciscan Studies, 65 (2007): 371–403.*

Field 2007b: Sean Field, "The Abbesses of Longchamp in the Sixteenth century," *Archivum franciscanum historicum, 96 (2007): 553–559.*

Field 2008: Sean Field, "The Missing Sister: Sébastien le Nain de Tillemont's Life of Isabelle of France," *Revue Mabillon, 19 (2008): 243–270.*

Field 2013: Sean Field, *The Rules of Isabelle of France: An English Translation with Introductory Study (St. Bonaventure, NY: Franciscan Institute Publications, 2013).*

Field 2014: Sean Field, "Paris to Rome and Back Again: The Nuns of Longchamp and Leo X's 1521 Bull Piis omnium," *Studies in Medieval & Renaissance History, 11 (2014): 155–223.*

Field 2015: Sean Field, "Pierre Perrier's 1699 *Vie de Sainte Isabelle de France*: Precious Evidence from an Unpublished Preface," *Franciscan Studies, 73 (2015): 215–247.*

Field 2019: Sean Field, *Courting Sanctity: Holy Women and the Capetians (Ithaca, NY: Cornell University Press, 2019).*

Field 2020: Sean Field, "Agnes of Harcourt as Intellectual: New Evidence for the Composition and

Circulation of the *Vie d'Isabelle de France*," in *Women Intellectuals and Leaders in the Middle Ages*, ed. Kathryn Kerby-Fulton, Katie Ann-Marie, and John Van Engen (Woodbridge, Suffolk: Boydell & Brewer, 2020), 79–96.

Frœhlich 1960: André Frœhlich, "The Manuscript Maps of the Pyrenees by Roussel and La Blottière," *Imago Mundi*, 15 (1960): 94–104.

Gaillard 1976: Jeanne Gaillard, *Paris, la ville (1852–1870)* (Paris: Honoré Champion, 1976).

Gajewski 2000: Alexandra Gajewski, "Recherches sur l'architecture cistercienne et le pouvoir royal: Blanche de Castille et la construction de l'abbaye du Lys," in *Art et Architecture à Melun Au Moyen Age: Actes du Colloque d'histoire de l'art et d'archéologie tenu à Melun les 28 et 29 novembre 1998*, ed. Yves Gallet (Paris: Picard, 2000), 223–254.

Gajewski 2012: Alexandra Gajewski, "Patronage Question Under Review: Queen Blanche of Castile (1188–1252) and the Architecture of the Cistercian Abbeys at Royaumont, Maubuisson, and Le Lys," in *Reassessing the Roles of Women as 'Makers' of Medieval Art and Architecture*, ed. Therese Martin (Leiden: Brill, 2012), 197–244.

Gaposchkin 2010: M. Cecilia Gaposchkin, "Place, Status, and Experience in the Miracles of Saint Louis," *Cahiers de recherches médiévales et humanistes*, 19 (2010): 249–266.

García y García and Lauritzen 2013: Antonio García y García and Frederick Lauritzen, eds., *The General Councils of Latin Christendom from Constantinople IV to Pavia-Siena (869–1424)* (Turnhout: Brepols, 2013).

Garreau 1955: Albert Garreau, *Bienheureuse Isabelle de France, soeur de Saint Louis* (Paris: Éditions franciscaines, 1955).

Gasser 2007: Stephan Gasser, "L'architecture de la Sainte-Chapelle: État de la question concernant sa datation, son maître d'œuvre et sa place dans l'histoire de l'architecture," in Hediger 2007, 157–180.

Gilchrist 1994: Roberta Gilchrist, *Gender and Material Culture: The Archaeology of Religious Women* (London and New York: Routledge, 1994).

Godet-Calogeras 2012: Jean F. Godet-Calogeras, "Francis and Clare and the Emergence of the Second Order," in *The Cambridge Companion to Francis of Assisi*, ed. Michael Robson (Cambridge: Cambridge University Press, 2012), 115–126.

Guilloux 2013: Fabien Guilloux, "La règle et la vie des sereurs meneurs encloses. Une traduction en langue romane de la règle d'Isabelle de France (ca. 1315–1325)," Archivum Franciscanum Historicum, 106 (2013): 5–39.

Hamburger 1992: Jeffrey H. Hamburger, "Art, Enclosure and the Cura Monialium: Prolegomena," *Gesta*, 31 (1992): 108–134.

Hediger 2007: Christine Hediger, ed., *La Sainte-Chapelle de Paris. Royaume de France Ou Jérusalem Céleste? (Actes du Colloque tenu au Collège de France, 2001)* (Turnhout: Brepols, 2007).

Henriet 1985: Jacques Henriet, "Un édifice de la première génération gothique: l'abbatiale de Saint-Germer-de-Fly," *Bulletin monumental*, 143 (1985): 93–142.

Hopkins 2015: Richard Hopkins, *Planning the Greenspaces of Nineteenth-century Paris* (Baton Rouge: Louisiana State University Press, 2015).

Jäggi 2001: Carola Jäggi, "Eastern Choir or Western Gallery? The Problem of the Place of the Nuns' Choir

in Königsfelden and Other Early Mendicant Nunneries," *Gesta, 40 (2001): 79–93.*

Jäggi 2006: Carola Jäggi, *Frauenklöster im Spätmittelalter: Die Kirchen der Klarissen und Dominikanerinnen im 13. und 14. Jahrhundert (Petersberg: Imhof, 2006).*

Jarrard 1999: Alice Grier Jarrard, "Representing Royal Spectacle in Paris, 1660–1662," *L'Esprit Créateur, 39 (1999): 26–37.*

Jordan 2003: William Chester Jordan, "Isabelle of France and Religious Devotion at the Court of Louis IX," in *Capetian Women,* ed. Kathleen Nolan (New York: Palgrave, 2003), 209–223.

Jordan 2007: William Chester Jordan, "The Representation of Monastic-Lay Relations in the Canonization Records for Louis IX," in *Religious and Laity in Western Europe, 1000–1400: Interaction, Negotiation, and Power, ed.* Emilia Jamroziak and Janet E. Burton (Turnhout: Brepols, 2007), 225–239.

Joudiou 2006: Gabrielle Joudiou, *Isabelle de France et l'Abbaye de Longchamp* (Paris: Éditions franciscaines, 2006).

Katz 2015: Melissa Katz, "A Convent for 'la Sabia': Violante de Aragón and the Foundation of Santa Clara de Allariz," in *Culture and Society in Medieval Galicia: A Cultural Crossroads at the Edge of Europe, ed. James D'Emilio (Leiden: Brill, 2015), 812–836.*

Kimpel and Suckale 1990: Dieter Kimpel and Robert Suckale, *L'architecture gothique en France, 1130–1270, trans. from the German by Françoise Neu (Paris: Flammarion, 1990).*

Kinder 1976: Terryl Kinder, "Blanche of Castile and the Cistercians: An Architectural Re-Evaluation of Maubuisson Abbey," *Cîteaux--commentarii cistercienses, 27 (1976): 161–188.*

Kinder 2002: Terryl Kinder, *Cistercian Europe: Architecture of Contemplation (Grand Rapids: W. B. Eerdmans Publishing. Co., 2002).*

Kinias 2021. Erica Kinias, "Building an Order: Architecture, Space, and Gender in Isabelle of France's Rule of *Sorores Minores* (Ph.D. diss., Brown University).

Knox 2008: Lezlie S. Knox, *Creating Clare of Assisi: Female Franciscan Identities in Later Medieval Italy (Leiden: Brill, 2008).*

Le Goff 1996: Jacques Le Goff, *Saint Louis* (Paris: Gallimard, 1996).

Lemé-Hébuterne 2015, 2018: Kristiane Lemé-Hébuterne, dir., *Saint-Martin-aux-Bois (Oise), Histoire et archéologie d'une abbaye de chanoines de saint Augustin (XII^e-XVIII^e siècles).* Sér. Histoire médiévale et archéologie, 28 and 31 (Compiègne: CAHMER, 2015, 2018).

Lester 2011: Anne Elisabeth Lester, *Creating Cistercian Nuns: The Women's Religious Movement and Its Reform in Thirteenth-Century Champagne (Ithaca, NY: Cornell University Press, 2011).*

Młynarczyk 1987: Gertrud Młynarczyk, *Ein Franziskanerkloster im 15. Jahrhundert: Edition und Analyse von Besitzinventaren aus der Abtei Longchamp* (Bonn: Ludwig Röhrscheid Verlag, 1987).

Molinier and Longnon et al. 1902–1923: Auguste Molinier and Auguste Longnon et al., eds., *Recueil des historiens de la France, obituaires*, 4 vols. (Paris: Imprimerie Nationale, 1902–1923).

Mollat and Lesquen 1904–1947: Guillaume Mollat and Guillaume de Lesquen, eds., *Jean XXII (1316–1334): Lettres communes analysées d'après les registres dits d'Avignon et du Vatican*, 16 vols. (Paris: Fontemoing, 1904–1947).

Mueller 2006: Joan Mueller, *The Privilege of Poverty: Clare of Assisi, Agnes of Prague, and the Struggle for a Franciscan Rule for Women* (University Park, PA: Pennsylvania State University Press, 2006).

Nolan 2003: Kathleen Nolan, ed., *Capetian Women: The New Middle Ages* (New York: Palgrave Macmillan, 2003).

Nolan 2009: Kathleen Nolan, *Queens in Stone and Silver: The Creation of a Visual Imagery of Queenship in Capetian France* (New York, NY: Palgrave Macmillan, 2009).

Pelletier 2007: Monique Pelletier, "Representations of Territory by Painters, Engineers, and Land Surveyors in France during the Renaissance," in *The History of Cartography*, ed. David Woodward, 6 vols. (Chicago: University of Chicago Press, 2007), III:1522–1537.

Peterson 2011: Ingrid Peterson, "Letters to Agnes of Prague," in *The Writings of Clare of Assisi: Letters, Form of Life, Testament and Blessing*, ed. Michael W. Blastic, Jay M. Hammond, and J.A. Wayne Hellmann (St. Bonaventure, NY: Franciscan Institute Publications, 2011), 19–58.

Radisich 1998: Paula Rea Radisich, *Hubert Robert. Painted Spaces of the Enlightenment* (Cambridge: Cambridge University Press, 1998).

Regnault and Regnault 1774: Nicolas-François Regnault and Genevive de Nangis Regnault, *La Botanique mise à la portée de tout le monde* (Paris: Didot, 1769).

Robert-Dumesnil 1835–1871: Alexandre-Pierre-François Robert-Dumesnil, *Le Peintre-graveur français, ou catalogue raisonné des estampes gravées par les peintres et les dessinateurs de l'école française*, 11 vols. (Paris: Bouchard-Huzard, 1835–1871).

Roest 2011: Bert Roest, "Appropriating the Rule of Clare," *Canterbury Studies in Franciscan History*, 3 (2011): 63–92.

Roest 2013: Bert Roest, *Order and Disorder: The Poor Clares between Foundation and Reform* (Leiden: Brill, 2013).

Roest 2014: Bert Roest, "Rules, Customs, and Constitutions within the Medieval Order of Poor Clares," in *Consuetudines et Regulae: Sources for Monastic Life in the Middle Ages and Early Modern Period*, ed. Carolyn Marino Malone and Clark Maines (Turnhout: Brepols, 2014), 305–330.

Roulliard 1619: Sébastien Roulliard, *La saincte mère, ou vie de M. saincte Isabel de France* (Paris: Taupinard, 1619).

Roussel 1731: Capitaine Roussel, *Ses Fauxbourgs et ses environs: où se trouve le détail des villages, châteaux, gands chemins pavez, et autres, des hauteurs, bois, vignes, terres, et prez, levez géometriquement* (Paris: Roussel, 1731).

Tardif 1866: Jules Tardif, *Monuments historiques*, vol. I (Paris: J. Clay, 1866).

Thiéry 1787: Luc Vincent Thiéry, *Guide des amateurs et des étrangers voyageurs à Paris ou description raisonnée de cette ville, de sa banlieue, & de tout ce qu'elles contiennent de remarquable*, vol. I (Paris: Hardouin & Gattey, 1787).

Trouillard 1896: Guy Trouillard, *Études sur la discipline et l'état intérieur des abbayes de l'ordre des Urbanistes et principalement de l'abbaye de Longchamp du XIIIe au XVIe siècle* (Paris: École des Chartes, 1896).

Vauchez 1993: André Vauchez, "Female Sanctity in the Franciscan Movement," in *The Laity in the Middle*

Ages: Religious Beliefs and Devotional Practices, ed. Daniel E. Bornstein, trans. Margery J. Schneider (Notre Dame, IN: University of Notre Dame Press, 1993), 171–184.

Viard 1917: Jules Marie Édouard Viard, *Les journaux du trésor de Charles IV le Bel* (Paris: Imprimerie nationale, 1917).

Vidier et al. 1900: Alexandre Vidier, Arend Van Buchell, Lambregt Abraham Van Langeraad, and Nathan Chytraeus, *Description de Paris par Arnold Van Buchel (1585–1586)* (Paris: Société de l'histoire de Paris et de l'Ile-de-France, 1900).

Ville de Paris 1905: *Ville de Paris, Procès-Verbal* (12 January 1905) (Paris: Commission municipale du Vieux Paris, 1905).

Ville de Paris 1923: *Ville de Paris, Procès-Verbal* (27 October 1923) (Paris: Commission municipale du Vieux Paris, 1923).

Viollet-le-Duc 1868: Eugène Viollet-le-Duc, *Dictionnaire raisonné de l'architecture Française du XIe au XVIe*, 10 vols. (Paris: Ernest Gründ, 1868).

Volti 2003: Panayota Volti, *Les couvents des ordres mendiants et leur environnement à la fin du moyen âge: le nord de la France et les anciens Pays-Bas méridionaux* (Paris: CNRS Éditions, 2003).

Wadding 1931–1941: Lucas Wadding, *Annales Minorum seu trium Ordinum a S. Francisco institutorum*, ed. P. J. M. Fonseca ab Ebora, 32 vols. (Florence: Ad Claras Aquas [Quaracchi], 1931–1941).

Willesme 1992: Jean-Pierre Willesme, "Les Cordelières de la rue de Lourcine: des origines à l'implantation du nouvel Hôpital Broca," *Paris et Ile-de-France*, 43 (1992): 207–249.

Worcester 1999: Thomas Worcester, "Neither Married nor Cloistered: Blessed Isabelle in Catholic Reformation France," *Sixteenth Century Journal, 30 (1999): 457–472.*

* I am indebted to Bert Roest, Sean Field, and Fabien Guilloux, as well as to the editors for their help with this chapter.

1. Thiéry 1787, 23–24, descriptions partially reprinted in *Ville de Paris* 1923, 138–41; Młynarczyk 1987, 41; and Duchesne 1906, 10–13. For a discussion of Isabelle of France's tomb and fifteenth-century epitaph, see Field 2007a. A similar description of Isabelle's tomb appears in a travel chronicle written by Arnold Van Buchel in 1585, translated into French by Vidier et al. 1900, 91.

2. Louis IX was canonized in 1297. Isabelle's canonization process received papal support when, in January 1521, pope Leo X issued a bill authorizing the celebration of Isabelle's offices. A sixteenth-century copy narrative describing the approval of her office is in Paris, BnF, MS Fr. 11662, fols. 15–20. See Field 2006, 161, n. 84. Recent research on the role the nuns at Longchamp had in the recognition of Isabelle as a saint includes: Field 2006, 2007a, and 2015. See also Roest 2011, and Roest 2013, 60–62, 65, 122–123.

3. Most recently, Field 2019, 23–53; Dalarun et al. 2014; Burke 2013; Field 2015; Jordan 2003; Allirot 2008; Field 2006; Falskau 2006; Allirot 2005; and Field 2002. This essay is part of my doctoral dissertation (Kinias 2021) which investigates the art and architecture of Isabelline houses across France, England, Spain, and Italy.

4. Exceptions include Trouillard 1896; Duchesne 1906, 10–22, and Audouy 1949. A copy of Audouy's plan is reprinted in Młynarczyk 1987, 54.

5. For recent research on Maubuisson, see Berman 2018, 100–149; Berman 2010; and Gajewski 2012. See also Allirot (2011, 294–328)'s survey of Capetian monastic foundations in the thirteenth and fourteenth centuries.

6. Berman (2010)'s study of the patronage activities of Blanche of Castile and Countess Eleanor of Vermandois elucidate how each employed a combination of cash and income-producing properties to further their respective projects.

7. An early copy of Hugolino's Rule of 1219 is in *Bullarium franciscanum* (*BF*) 1759, I:263–267, reprinted in Armstrong 2006, 73–85. Innocent IV's *Rule of 1247* can be found in *BF* 1761, II:476–480; trans. and ed. in Armstrong 2006, 89–105.

8. Roest 2013, 17–25, and 2014, 305–330. For other discussions on early communities of women inspired by Franciscan ideals, see Vauchez 1993; and Knox 2008.

9. For a general review of these legal and political debates, see Knox 2008, 1–18, 87–122; Roest 2013, 21–38. For a broader discussion of *cura monialum* in other female monastic traditions, see Hamburger 1992; and Dalarun et al. 2014, 25–39.

10. Godet-Calogeras 2012, 123–126.

11. These *Forma vitae* were considered supplemental documents to the Benedictine or Cistercian rules. Bert Roest provides a succinct summary of the complex historical and religious circumstances of early female Franciscanism in Roest 2013, chap. 1, and Roest 2014. See also Knox 2008, 18–86.

12. Field 2006, 61–94.

13. A copy of the proceedings is in Rouen, BM, MS 1232, fols. 69r-77v. The text is published in García y García and Lauritzen 2013. See also Roest 2013, 60–62; and Field 2006, 89–116.

14. *BF* 1765, III:64: *Nos autem licet inhibitum fuerit in Consilio generali, ne quis novam Religionem inveniat; sed quicunque ad Religionem converti voluerit, unam de approbatis assumat: similiter qui voluerit religiosam domum de novo fundare, Regulam, & institutionem accipiat de Religionibus approbatis: volente stamen Regis, & Isabella prædictorum votis annuere favorabiliter in hac parte indrascriptam Regulam eidem Isabellæ Trans. in Field 2013, 58.*

15. For a discussion of Clare of Assisi's relationship to the *privilegium paupertatis*, and her communications with Agnes of Bohemia, dated between 1234 and 1253, around the *privilegium*, see Mueller 2006, 33–88, and Peterson 2011. Isabelle's rule of 1259 is preserved in the 1765 printing of *BF* 1765, III:64–68, note b, and an original of the 1263 rule is held in Paris, Bibliothèque de l'Arsenal, MS 1240, *BF* 1761, II:477–486; Wadding 1931–1941, IV:507–515. A French version is held in Paris, AN, LL//1601, fols. 25r-46r, and is edited in Guilloux 2013. Both the 1259 and the 1263 rules are edited in Field 2013.

16. See also Roest 2013, 21–67. Translation of correspondence between Clare of Assisi and the papal offices leading up to 1253 can be found in Armstrong 1988, 89–105. See also Field 2013, 9–42; and Roest 2013, 60–67.

17. *BF* 1761, II:480, trans. in Field 2013, 72. For the importance of the Eucharist in female Franciscan devotion, see Bruzelius 1992; Jäggi 2001.

18. The name *Sorores Ordinis Humilium Ancillarum Beatissimae Mariae Virginis Gloriosae* was issued in 1259; *BF* 1765, III:64. Urban IV issued a revision to Isabelle's Rule on 27 July 1263, *Religionis augmentum eo*, first printed in Wadding 1931–1941, IV:573, and reprinted in *BF* 1761, II:477–486, in which the title of *Sororum Minorum inclusarum* (*Sorores minores inclusae*) was adopted. Field cites evidence that, even prior to 1263, Isabelle and the nuns at Longchamp were referring to themselves as *Sorores minores*. Field 2006, 66–73, 111.

19. *BF* 1761, II:478–479: *Regula ipsa Sororum Minorum inclusarum de cetero nominetur; & servetur perpetuo in prætacto Monasterio, & in aliis Monasteriis de cetero fundandis, seu plantandis, in quibus Sorores eamdem Regulam prositeri contigerit, sic correcta. . . . Omnes vero volentes in hoc Monasterio, & in aliis in posterum fundandis, in quibus hæc Regula professa fuerit* Trans. in Field 2006, 59, 63–64.

20. Field 2013, 34. See also Andenna 2015, 251–262.

21 The inventory of Longchamp's papal bulls in 1472 is recorded in Paris, AN, LL//1600 (fols. 1r-2r). A fourteenth-century Latin copy is in Paris, AN, LL//1600 (fols. 63r-67r), which includes a French version at 68r-67r and in Longchamp's fifteenth-century customary Paris, BnF, MS Fr 11662 (fols. 37v-39v). Discussed in Field 2002, 114; edited by Delorme 1938, 20–22.

22 A fourteenth-century summary of the bull is in Paris, AN, LL//1601, fols. 43r-43v. Field 2003b, 65.

23 Paris, BnF, MS Fr 11662 (fol. 43v). Trans. in Dalarun et al. 2014, 213–215. This summary is largely from Field 2003b, 66.

24 Paris, AN, L//1021, no. 20. Duchesne 1906, 138.

25 Paris, AN, L//261, no. 100. Field 2006, 129. Edited in Field 2002, 131.

26 Bert Roest provides a meticulous overview of the expansion of Isabelline houses in Roest 2013, 60. See Kinias 2021, 18–23. Allirot 2011, 295–306; and Field 2006, esp. 116–120. The abbey of Santa Clara de Allariz, in southern Galicia, was founded by Violante de Aragón (d. 1300/1301) in 1290. *BF 1759–1904, IV:187–188. See also Katz 2015.*

27 Saint-Marcel was originally founded in 1287 in Troyes as *la Pauvreté de Nostre-Dame*. Studies of Saint-Marcel include Willesme 1992; Allirot 2008; and Guilloux 2013. For Nogent-l'Artaud, see Corlieu and Léguillette 1906; Cubadda 1997; Roest 2013, and; Kinias 2021, 329–347.

28 Paris, AN, S//4418. The nuns at Longchamp received an expulsion order on 26 February 1790. After failing to comply, abbess Jeanne Jouy was summoned in June 1790 and ordered to leave. Their property and land (179 hectares) were sold to Guillaume d'Orcy in April 1792 for 184,600 *livres*. In July 1852, at the start of Napoleon III's land acquisition to construct new public parks and gardens, the remaining land and buildings of Longchamp were ceded to the City of Paris. See Duchesne 1906, 111–113; and Gaillard 1976.

29 Viollet-le-Duc 1868, VI: 43–47.

30 Quoted in *Ville de Paris* 1905, "Session of 12 January," 138. A recent study of the construction of greenspaces in Paris during the nineteenth century is in Hopkins 2015.

31 Drawing on scholarship in virtual reconstruction, such as the work of Sheila Bonde, Alexis Coir, and Clark Maines in their reconstruction of the Augustinian monastery of Saint-Jean-des-Vignes, Soissons, and the building processes of the Cistercian abbey church at Ourscamp—and informed by the methodological issues it highlights—this two-dimensional visualization will begin this process of digital reconstruction of Longchamp. See Bonde and Maines et al. 2009, and Bonde, Coir, and Maines 2017, S288–S320. See also Bruzelius 2014, 67–105.

32 Fifteenth-century copies of the original papal bulls survive in Paris, AN, LL//1601, fols. 1v-2r, 63r-67v, with French translation on fols. 68r-72r.

33 Paris, AN, L//1021, no. 41. Transcribed in part by Cocheris 1870, IV:272–274.

34 Paris, BnF, MS Fr 11662 includes: a calendar (fols. 1v-13v); Isabelle's beatification narrative (fols. 15r-20v); a list of nuns at Longchamp in 1521 (fols. 16v-17r); a copy of a papal bull allowing for the celebration of Isabelle's office in 1521 (fols. 17v-20r); a calendar of anniversaries (fols. 22r-44r); various liturgical instructions (fols. 30v-37v); a French copy of Alexander IV's papal bull issued 25 February 1259 (fols. 37v-39v); a preface and Agnes's *Letter (40r-41v); prescriptions for nuns entering Longchamp (fols. 41v-43r); a Latin copy of Devotionis vestre precibus*, issued by Alexander IV on 3 March 1259 (fol. 43r); and the necrology beginning c. 1446 through c. 1788 (fols. 44v-110v). Transcribed in part by Delorme 1938; Field 2002, Appendix B, 394–398, and; Dalarun et al. 2014. Summarized in Młynarczyk 1987, 180. The necrology has been edited in part by Molinier and Longnon et al. 1902–1923, I, pt. 2:669–683.

35 The earliest copy of Agnes's *Letter is held at the Bibliothèque nationale in Longchamp's customary, Paris, BnF, MS Fr 11662, fols. 40r-41v. Trans. and ed. in Field 2002, chap. 7, and (in French) in Dalarun et al. 2014, 267–313. A copy of Agnes's Life of Isabelle is found in Sébastien le Nain de Tillemont's Cahier B, copied from the now-lost original at Longchamp by Antoine Le Maistre in January 1653 (Paris, BnF MS 13747). Field 2008, 247–250. For an analysis of Agnes's life at Longchamp, see Field 2003 and Allirot 2005. A recent study of the composition of Agnes's Vie of Isabelle is explored in Field 2020.*

36 Paris, AN, LL//1604, fol. 1r.: *Comense d'escrire en aoust mil sis cents par Soeur Denise de Costeblanche pendant quelle estoit Tresoriere de laditte abbaie.* Denise Costeblanche was treasurer at Longchamp until her death in 1626. The chronicle is written in two hands, Costeblanche's (fols. 1r-12v), followed by that of the new treasurer Madeline Brice (d. 1685); Paris, BnF, MS Fr 11662, fol. 68v, fol. 76r. I thank Sean Field and Fabien Guilloux for sharing a transcription of this manuscript. Their annotated edition is forthcoming.

37 An overview of which is in Field 2015.

38 Roulliard 1619; Caussin 1644. For studies exploring the rise of Isabelle of France's cult in the seventeenth century, see Worcester 1999; Field 2007a; and Field 2007b.

39 *AASS, VI:791. For royal burial practices in thirteenth- and fourteenth-century France, see Erlande-Brandenburg 1975; Brown 1985; Nolan 2009; and Lester 2011, 27–31.*

40 Consisting of three broadsheets with text with a vernacular summary of Agnes's "Life" *mounted in a wooden frame, the epitaph hung on the west-facing side of the grill. The epitaph is held at Paris, BnF MS Fr 6214. See Field 2007a. The text is translated in Dalarun et al. 2014, 340–349.*

41 Documents related to the purchase of land for Longchamp are found in Paris, AN, L//120. Agnes of Harcourt relates land and goods Louis IX provided for Longchamp in her *Letter, transcr. and ed. in Field 2003b, 48: Il donna tout le merrien de nostre eglise et les estaus du monstier. Il donna les quins et les admortissemens de noz rentes et vj livres parisis pour faire doz despens quant nous y entrasmes nouvellement, et lx livres de bois en la forest de Compiegne.*

42 Longchamp's inventories and registries are found in Paris, AN, L//1026, nos. 2 (for the year 1281) and 5 (1289); K//37, A. 2a (1305); L//1027, no. 5 (1325), nos. 8, 9 (1339), no. 10 (1330), no. 14 (1348), no. 16 (1360), nos. 17, 18, and 19 (1375), no. 21 (1400); L//1021, no. 48 (1345); and L//1028, nos. 5 (1447), 7 (1467), and 9 (1481). Młynarczyk (1987, 57, 139–176) summarizes information concerning the abbey library; she also (1987, 282–340) transcribes in full the inventories for the years 1447, 1467, and 1481. Cocheris (1870, IV: 262–68) presents an transcriptions of the 1305 and 1327 inventories. Inventories from 1305, 1325, and 1339 are transcribed in Dalarun et al. 2014, 320–321, 331–335.

43 Paris, AN, K//41, no. 5, and K//44, no. 17. See also the inventory of 1305 in Paris, AN, K//37/A, no. 2.

44 A print is held in Paris, Musée Carnavalet, Histoire de Paris, no. G.429. It is reproduced in Babelon 1977 and Faucheux 1969. For biographical history, see Faucheux 1969, and Jarrard 1999.

45 A print is held at the Musée Carnavalet, n° G.12006. Flamen's engraving is reproduced in Robert-Dumesnil 1835–1871, I (1835):222.

46 Philippe de Champaigne (also attributed to Jean-Baptist de Champagne), c. 1659, *La bienheureuse Isabelle, soeur de saint Louis, offrant à la Vierge le monastère des clarisses de Longchamp*. Notre-Dame de Bonne-Nouvelle, Paris. An engraving of the painting by Nicolas Bazin is held at the Louvre, Paris, RF31r.

47 Held at the Musée du domaine départemental de Sceaux, no. 85.50.18. Reproduced in Garreau 1955, 80. This engraving may have been the model for Edmond Morin's 1800 engraving, *Vue panamorique de l'ancienne abbaye de Longchamp*, reproduced in Corbel 1931.

48 Jean Baptiste Feret, *Seine Landscape at St. Cloud*, is held at the Amalienburg Palace, Munich, no. NyAm.G0021. Reproduced in Baxter and Martin 2010, 41–43.

49 Hubert Robert, *Ruines de l'abbaye de Longchamp*. Nationalmuseum, Stockholm, NMH 129/1950. Reproduced in Bjurström 1982, 1158. For Hubert Robert's treatment of architectural ruins, see Radisich 1998, 97–116.

50 Paris, AN, N//III/Seine-et-Oise 479 (1). Lallemant's map was reproduced in *Espace français: Vision et aménagement, XVIe-XIXe siècle*, the catalogue for *an exhibition organized by the Direction des Archives de France, Sept. 1978–Jan. 1988*. See Pelletier 2007, 1524, n. 18.

51 Records of the lawsuit are found in Paris, AN, Q/1/1067. See also Duchesne 1906, 197.

52 Roussel 1731, no. 26. Paris, BnF, Cartes et plans, GE DD-2987 (798, 1–7 B). Reproduced in Garreau 1955, 48, and Joudiou 2006, 20. Roussel's military career and mapmaking is discussed in Frœhlich 1960.

53 *AASS*, VI:791. Reproduced in Garreau 1955, 111; Młynarczyk 1987, 52; and Field 2007a, 384. Architectural fragments purportedly stolen from Longchamp's church are believed to have been incorporated into the expanding formal gardens of the Château de Bagatelle during the 1920s. I could not find, however, any documentary evidence explicitly connecting them with Longchamp.

54 Paris, BnF, Est., Reserve FOL-VE-53 (G). A handwritten note in the bottom right-hand corner reads: *Plan de l'anc Abb. De Longchamps dressé en 1792 par M.M. Forget et Regnault. 1792.* In a later hand: *Calqué sur l'original déposé chez Mr. Barrachin (rue de Provence 24) en Mars 1844. (voir ma conveyance de cette année)* Reproduced in Garreau 1955, 109. Reference is given to the plan's commission in Paris, AN, AF/IV/1292, no. 4.

55 Regnault and Regnault 1774. Neither Regnault has been the subject of major study, except for Curran and Graille 1997.

56 Duschesne 1906.

57 On Agnes of Harcourt's life, see Field 2003b, 11–19.

58 Paris, BNF, MS Fr 11662, fols. 40r-41v: *Nous faisons savoir a tous ceulx qui ces lettres verront que nostre tres reverend et saint pere monseigneur le roy Loÿs fonda nostre eglise et mist de sa propre main la premiere pierre. Et ma dame la royne Marguerite sa femme y mist la seconde pierre, et Monseigneur Loÿs leur ainsné filz y mist la tierce pierre. Et ma dame Ysabel sa bonne seur nostre scincte mere, y mist la quarte pierre.* Edited in Field 2003b, 46.

59 Edited in Field 2003b, 47–49, 65. The amount is also noted in Paris, AN, LL//1604, fol. 3r: *Ladite abbaie fut onze ans ou environ à bastir et a couté à laditte dame trente mil livres parisy, et y a de fondassion quatre centz livres parisy pour y nourrir LX religieuse pour chanter jour et nuit le divin service.* See Allirot 2005, 85; Gajewski 2012; and Dalarun et al. 2014, 110–111. As Dalarun notes, King Louis VIII left 20,000 *livres* to his daughter Isabelle in his testament, suggesting some basis for Agnes's account of Longchamp's foundation. As a point of comparison, Louis IX paid the immense amount of 100,000 *livres* for the initial construction phase at Royaumont abbey while ten years later, in 1233, Blanche of Castile paid a total of 21,431 *livres* for six years of the construction of Maubuisson. As Gajewski's research shows, these compare with the annual budget of the French monarchy at 250,000 *livres*.

60 Paris, AN, L//1027, no. 22. Edited in Molinier and Longnon et al. 1902–1923, I:664; and Field 2006, 216, n. 3. A French copy of an original papal bull issued by Urban IV on 20 November 1261 (Paris, BnF, MS Fr

61 Paris, BnF, MS Fr 11662, fols. 40r-41v. Edited in Field 2003b, 46–47.

62 Noted in Field 2006, 97, 216, nn. 4, 6; and Delaborde 1899, 59–74, 104–111.

63 *Il mengoit ilecques en refrectoir, a la table de l'abé, et li abbes seoit delez lui*. Delaborde 1899, 85–86, 102, and 109; and Le Goff 1996. A summary of Louis's interactions with monastic life is in Jordan 2007, 231–235.

64 An exception is his involvement with the tertiaries at the Maison-Dieu in Compiègne (Oise), which he founded in 1260, where he performed the office of the dead. Delaborde 1899, *109*.

65 In 1324, Charles IV provided funds for the repair of Longchamp's fountain. Paris, AN, K//41, no. 5; cited in Tardif 1866, #1160.

66 Paris, AN, L//1026, no. 1; Paris, BnF, MS Fr 11662, fol. 45; ed. in Molinier and Longnon et al. 1902–1923, I:69–70. Paris, AN, LL//1604, fols. 10r-11v, elaborates on the notable royal guests present at her profession on 25 May 1337.

67 *Omnes Sorores sanæ tam Abbatissa, quam aliæ in communi dormitorio jaceant; & quælibet per se lectum habeat ab aliis separatum*. Translated in Wadding 1931–1941, IV:508.

68 The work at Longchamp is documented in two accounts, one in March 1322 and the other in May 1323. Viard 1917, #*273, 3104, 3105*: [March 1322] *Cepimus supra executionem Regis Philippi Magni sic . . . pro operibus carpentarie domus, seu edicicii facti pro domina Blancha filia Regis, apud Longum Campum, per litteras suas datas XVIe Aprilis CCCXX et litteras Regis de mandato, et per cedulam curie que dicit quod ponantur inter debita*, and [May 1323] *Stephanus de Bercencuria et Nicolaus Le Loquetier, solutores . . . sibi debitis pro merreno liberato per ipsum pro operibus carpentarie abbatie Longi Campi, pro domina Blancha filia dicti Regis ibi minorissa*.

69 Original in Paris, AN, L/303, no. 56. Published in Mollat and Lesquen 1904–1947, II (1905):351–352, and III (1906):52. See also Allirot 2011, 306–313.

70 Paris, AN, L//1029, no. 1. Noted in Allirot 2011, 317.

71 Field 2013, 63: [4] *Moreover, when they die, let both professed sisters and novices or serving sisters be buried within the enclosure of the monastery*. Paris, AN, L//1604, fol. 38r: *le coeur de la ditte dame sr blanche a estè enterrè au couvent des peres cordeliers de paris le 26ᵉ avril 1358 au pres le corps de la reine ieanne sa mere*.

72 Paris, AN, L//1028, no. 9: *Item, de la chamber de mademoiselle Magdalene ung ciel, docile, deux courtines et sept serges, tout de pers*. Młynardczyk 1987, 335.

73 Paris, BnF, MS Fr 11662, fol. 58r: *Madamoiselle seur magdalene de bretaigne fille de treshailt et puissant seigneur Richart de bretaigne comte de Etampes et de vertus et seigneur de clisson et de treshault et puissant dame madame Marguerite dorleans contesse et dame des dis lieu icelle magdal[ene] leur de trespuissant et reidube prince francoys duc de bretaigne fut vestue le mirquedi xxcᵐᵉ jour de novembre lan mil iiiiᵉ iiiiᵉ lxi. Et tresassa le lundi xxixᵉ jour de mars avant palques audit lan mil iiiiᵉ lxi*. Roest 2013, 67–69, notes that the adaptation of a common dormitory into cells was both associated with the increase in private devotional practice and considered an expression of social hierarchy—both of which became focal points for Observant reforms.

74 Paris, AN, L//1028, no. 9; Młynarczyk 1987, 327–35: *Item, . . . une couppe doree garnie de couvlesque, VI taces de chacune marc et demy, ung gobelet, ung petite benoistrier, une equiere de deux mars et demy, une saliere de VI onces et six cuillers de VI onces, somme de la vaisselle de latdite demoiselle XVII mars et demy*, and *. . . de la vaisselle de seue noble demoiselle seur Magdelaine de Bretaigne souse platz de trois sortes, deux douzaines d'escuelles, six saulcieres, duex quartiers, deux potz de trois chopin[s], deux pintes, deux choppiness, deuz eguieres, deux salieres, toute latdite vaisselle aux armes de ladite demoiselle*.

75 Paris, AN, LL//1604, fol. 13r: *La 14e abbesse fust soeur Agnes de la Chevrelle. De son temps a esté contrainte de faire de grande reparations . . . car les lieux estoient venus en cy grandes ruynes à cause des guerres. . . . Laditte dame a esté éleue le 21me aoust 1360, elle a gouverné le couvent 15 ans . . . de son temps, le couvent a esté deux fois à Paris*. See also Młynarczyk 1987, 59–64, and Field 2003a. The nuns fled Longchamp twice during Chevrelle's abbacy.

76 Paris, AN, LL//1604, fols. 13r-13v.

77 Paris, AN, K//44, no. 17; Tardif 1866, 385, #1297.

78 Paris, AN, L//1022. Confirmed on 8 March 1384, with its endowment of 40 *livres tournois for the maintenance of a secular priest, nominated by the abbess, who would say three masses every week. Paris, AN, L//368, no. 11*. Published in Delorme 1938, 122.

79 Paris, AN, K//47, no. 56; Duchesne 1906, 16.

80 Paris, AN, K//49, no. 17; Tardif 1866, #1452; Duchesne 1906, 20. Marie de Gueux was abbess at Longchamp from 1349 until her death in 1360. Paris, AN, L//1604, fol. 13r-v; Paris BnF MS Fr 11662, fol. 47.

81 Paris, AN, LL//1604, fol. 15r: *le couvent hors des grandes debtes au il estoit a cause des guerres, qu'il avoit fallu emprunter et aussy engager plussieurs reliques de nostre eglise*. An inventory of Longchamp's relics was made by abbess Jeanne de Geux in 1325 (Paris, AN, L//1027, no. 5). Translated in Dalarun et al. 2014, 331–334.

82 Paris, AN, LL//1604, fol. 13r, noted in Młynarczyk 1987, 59–64: *La 14e abbesse fust sœur Agnes de la Chevrelle. De son tempe a esté contrainte de faire de grande reparations: elle a faict out à noeuf la charpenterie et le plomb du clocher, elle fist faire l'escluze et fist refaire toutes les fontaines et autres grandes reparations, car les lieux estoient venus*

en cy grande ruynes à cause des guerres. A reassessed chronology of Longchamp's abbesses is in Field 2003a.

83 Paris, AN, L//1028, no. 7; transcribed in Młnarczyk 1987, 304–306. Jeanne la Porchère was abbess at Longchamp between 1467 until her death in May 1481. Paris, BnF MS Fr 11662, fol. 55r.

84 Paris, AN, L//1029, no. 9; transcribed in Młnarczyk 1987, 325.

85 Paris, AN, L//1028, no. 5; Paris, AN, L//1029, no. 9, transcribed in Młnarczyk 1987, 325. The distinction between the two kitchens can also be found in the nun's chronicle under Jeanne de la Neuville (d. 1399) who constructs new chimneys for the large kitchen (*la grande cuisine*). Paris, AN, LL//1604, fol. 15r. On monastic kitchens, see Cochelin 2015.

86 Paris, AN, LL//1604, fol. 19r. Summarized in Duchesne 1906, 17, and Młnarczyk 1987, 44–45.

87 Paris, AN, LL//1604, fol. 50v: *elle a faict abbatre le grand parloir qui mesassoit de ruine il y a avoit long temps et a faict esleur un fort beau pavillon qui contient deux parloirs l'an enbras et l'autre au desus du costé de l'eglise tout ioignant l'appartement de l'abbesse qui nous appelons la chapelle.* Claude de Bellièvre (1608–1670) was abbess at Longchamp between 1653–1659 and again in 1668–1670. Paris, BnF, MS Fr 11662, fol. 74v.

88 Paris, AN, LL//1604, fol. 50v: *laquelle reparation luy a couté trois mil six cens livres laquelle somme lui a este donné par Monseigneur le premier president son frere.*

89 Edited in Field 2003a, 72–73. Clémence de Argas (Argaz) is listed in the fifteenth-century obituary among the first nuns at Longchamp, having died before 1321. Paris, BnF, MS Fr 11662, fol. 45r.

90 Paris, AN, LL//1604, fol. 49v: *Entre ce colombier, le côté sud de l'eglise et le mur du cloître se trouvaient les restes du logis de Sainte Isabelle.* Transcribed in Młynarczyk 1987, 41.

91 Paris, AN, LL//1604, fol. 47r: *La plus grande de ces passions a esté de faire honorer sainte Ysabel nostre sainte fondatrise dans le lieu mesme ou la ditte saint avoit faicte de continuelles sacrifice et holocoste de son coeur à Dieu par des prieres, oraisons jour et nuict. La ditte sainte ayant faict bastire ce saint lieu pour y faires ces retraites ordinaire pour s'antretenir avec son cher espoux, lequelle lieu avoit esté abandonné de longtemps par les guerres...*

92 Paris, AN, LL//1604, fol. 47r: *Pour la satisfaction de la comunauté elle a faict faire les clotures necessaire pour nous mettre la ditte chapelle . . . l'on a faict une ouverture dans nostre cimmetiere. L'ouverture estant faict aussy tost toute la communauté a esté dedans offrire ces veux et prieres à Dieu.*

93 Paris, AN, LL//1604, fol. 58: *Du temps auuy de la ditte abbesse 1664 a esté carlée nostre dortoire. Il c'est trouvée en longeur et largeur soixante et quatorze thoise et un car. La ditte reparation a couté à la maison cinq cens quatre vingt quatorze livres. Depuis quatre cens ans il n'avoit point encore esté carlée.* And on fol. 61. *La ditte dame de Mailly dans l'année 1665 a faict placer un authel et un grand tableau de nostre sainte mere dans le milieu de nostre dortoire, qui a couté IIc XXV livres tournois.* Isabelle is consistently referred to as "nostre sainte mere" throughout the chronicle. Jacqueline de Mailly (c. 1450–d. 1515) was abbess between 1499–1513. Paris, BnF MS Fr 11662, fol. 56v, edited in Field 2007b, 556. On Isabelle of France's beatification, see Field 2014.

94 Paris, AN, AF/IV/1292, 2, no. 123.

95 Młynardczyk 1987, 46–47.

96 Paris, AN, AF/IV/1292, 2, no. 194: *Un corps de Ferme, composé du logement du Fermier, Ecuries, Laiteries, Granges, Angards, cour et jardin derriere al grange, contenant en total un arpent vingt perches ou environ.*

97 Paris, AN, AF/IV/1292, 2, no. 194: *Maison dite le Bâtiment de la Voûte, elle est composée au rez-de-chaussee d'une grande pièce à cheminée, et plusieurs chambres l'ambrissées dans les combles, un jardin, un Puits, un grande Court et cabinet d'aisance, le tout contenant en superficie vingt-huit perches ou environs.*

98 Paris, AN, L 1028, no. 9, transcribed in Młynardczyk 1987, 324.

99 Paris, AN, AF/IV/1292, 2, no. 197: *Entre les jardins es le refectoir est un groupe de batiments dits de St. Louis avec plusieurs petites constructions appellees le Village, lequelles constructions sous composèas de clouloir, es ausres petite pieces.* A brief entry in the 1438 inventory (Paris, AN, L//1028, no. 9) records the repair of two gutters (*goustieres*) in the "Sale au Roy." Młynardczyk 1987, 324.

100 Paris, AN, T//1602, no. 1570.

101 Paris, AN, T//1602, no. 1570.

102 Paris, BnF, Provenance: Destailleur Province, 1800. t. 1, 207v.

103 Field 2006, 85–89 and 95–120.

104 For recent examinations of Blanche of Castile's relationship with the Cistercian order, see Berman 2018 and Gajewski 2000.

105 Gajewski 2012, 234.

106 Gajewski 2012, 234. Gajewski's analysis responds to a methodological tradition of identifying stylistic hierarchies, as represented in the work of Dieter Kimpel and Robert Suckale, and Robert Branner's notion of "court style," which interprets the modesty and exuberance of thirteenth-century Capetian architecture as a reflection of a patron's gender and personality. See Kimpel and Suckale 1990; Branner 1965. See also Bruzelius 1992; Gilchrist 1994, 36–60; and Gajewski 2000.

107 Gajewski 2012, 198–220. For studies on the architecture of Cistercian foundations for nuns, see Kinder 2002, esp. 165–168; Barrière et al. 2001; Berman 1997; and Aubert 1947, 173–216. Reference to Longchamp's

vaulted choir is found in Agnes's *Life*. *La guete de nostre meson neet la moutier et estoit en haut as voutes en une corbelle tiree a cordes par engin. La corde rompi et il cheyt sur les estaus du moutier et fu mout quasse* Edited in Field 2003b, 90–91.

108 Branner 1965, esp. 30–55.

109 Catalunya 2017, 92. See also Berman 2018, 10–28, and chap. 6.

110 Kinder 1976, 184–188. A discussion of female Cistercian architecture can be found in Berman 1997, and Berman 2000.

111 This comparison is restricted to its eastern exterior elevation and the decorative simplicity of its triple-lancet windows topped with a trefoil oculus. Unlike Longchamp's plan, Saint-Martin's church has a five-bay nave with two side-aisles. On Saint-Martin-aux-Bois, see now Lemé-Hébuterne 2015, 2018.

112 Henriet 1985, 93–142; Bideault and Lautier 1987, 293–310; and Brunet-Lecomtes 1997.

113 Bideault and Lautier 1987, 303.

114 Branner 1965, 58–60. See also Bork 2003.

115 Recent scholarship on Sainte-Chapelle most applicable to this study includes: Erlande-Brandenburg 1993; Brenk 1995; Billot 1998; Gasser 2007; Cohen 2016, 65–100; and Hediger 2007. See also Branner 1965, 58–60.

116 Beaumont-Maillet 1975, 250–314.

117 Beaumont-Maillet 1975, 250–314. See also Volti 2003, 253–261.

LAURA CHILSON-PARKS

Overlapping Space and Temporal Access in the Chartreuse de Champmol

Traditional scholarship on Carthusian monasticism has explored the ways in which the architecture of charterhouses reflects the reclusive ideals of the Carthusian Rule. In this context, historians have found the Chartreuse de Champmol, a site of pilgrimage and the recurring presence of laity, a fascinating case study in its repeated contradiction of the requirements for seclusion outlined in the Carthusian Rule. Champmol is often portrayed as "other," as an exception within the historiography of the order. This chapter will use the Chartreuse de Champmol to examine the ways in which monastic architecture could adhere to the ideals of the order while also responding to the specific needs of its communities—monastic or secular—over time. I focus primarily on the charterhouse in the late fourteenth and early fifteenth century. At this time, the Carthusian order relied primarily upon the *Antiqua Statuta* of 1271 and the *Nova Statuta* of 1368, both of which originated in the *Consuetudines Cartusiae* that Guigo I assembled between 1121 and 1127 to document the practices passed down from the Carthusian's founder, Bruno of Cologne.[1] Throughout this chapter I will refer to these three documents as "the Rule" to represent prescribed actions, which will be contrasted with evidence for actual practice at Champmol. At Champmol, oratories for lay prayer fulfilled both monastic and lay functions, permitting a defense of the Rule (prescribed actions) while accommodating the spiritual needs of the charterhouse's patrons (actual practice). The oratory built for Philip the Bold (1342–1404) and Margaret of Flanders (1350–1405), the duke and duchess of Burgundy, serves as a particularly useful case study with which to explore the boundaries of monastic and secular space.[2] I will also investigate the crossing of boundaries within the charterhouse as a whole, as well as the resulting architectural and regulatory responses. Through an examination of changes within monastic space over time, I will challenge the notion that the presence of the laity undermined the seclusion of the order and suggest instead a more nuanced adherence to the Rule predicated upon temporal control of overlapping spaces.

A commitment to the isolation that preoccupies scholarship and defines the ethos of the Carthusians dates to the very beginning of their history. The order began in the late eleventh

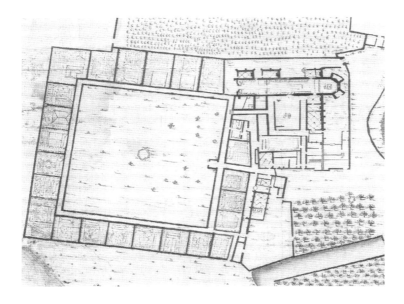

1 Unknown, plan of the Chartreuse de Champmol, 1760. Archives de la Ville de Dijon, 4 Fi 782.

century as a response to an ideological interest in the desert fathers of early Christianity. In the inaccessible mountains of the French Alps, the early Carthusians worked to incorporate the isolated life of the desert hermit into the communal life of a monastery.[3] A characteristic assemblage of two cloisters, one large and one small, developed—each representing an aspect of this dual nature of the semi-eremitic community (Fig. 1). The small cloister, together with the chapter house, refectory, and the adjoining church, formed the center of communal aspects of Carthusian practice—the chapter meetings, shared meals, and services respectively. The great cloister, conversely, simulated the reclusive life of the desert ascetics that the Carthusian Rule sought to recreate. Cells, typically in the form of two-story houses with a garden and covered walkway, serving as a private or personal cloister, were completely enclosed by walls to separate each monk from his brothers. It was in eremitic seclusion that the Carthusian monk spent the majority of his time.

2 Edoardus Bredin, Le vray portraict de la ville de Dijon, 1574. Paris, Bibliothèque nationale de France.

Seclusion was also simulated on a larger scale. Particularly in the early days, the charterhouse was isolated through geographical and topographical inaccessibility. Many houses chose rugged precipices or dense forests for their sites. The monastery further assured its communal isolation through architectural means by placing a wall around the perimeter of the charterhouse site.[4] As the defining principle of the order lay in this commitment to isolation, boundaries, both physical and metaphorical in nature, feature prominently in the Rule of the order. According to the Rule, the laity were barred from entering the monastery's walls.[5] The presence of women was considered especially injurious.[6] The aim of this isolation, and the rules that defined it, was to preserve eremitical seclusion, even where it was not created geographically. These boundaries and rules would become even more important as charterhouses emerged in more urban areas in the fourteenth and fifteenth centuries in response to both the increased involvement of lay patrons and a need for increased security.[7]

Champmol, founded in this period, was both geographically close to the laity and engaged with their concerns. At the time the duke and duchess built the Chartreuse de Champmol, it lay on the road between Paris and Dijon, "two arrow shots" (*enuiron deux trais d'arc*) to the west of the walls of medieval Dijon (Fig. 2).[8] The river Ouche, which runs from Lusigny-sur-

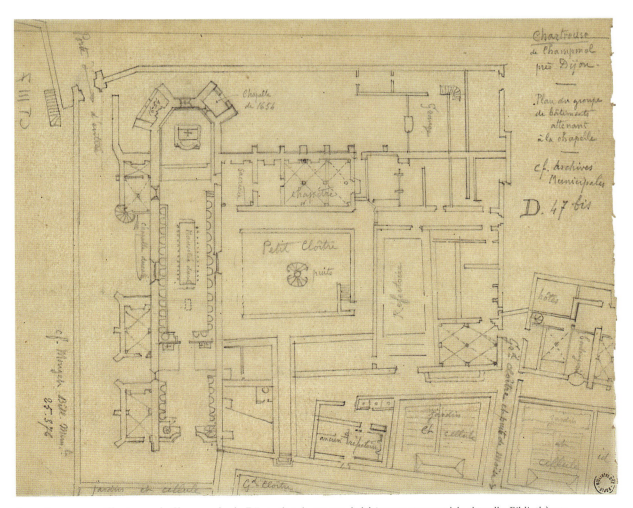

3 Anonymous, Chartreuse de Champmol près Dijon: plan du groupe de bâtiments attenant à la chapelle. Bibliothèque municipale de Dijon.

4 Jean de Merville, Claus Sluter and workshop, Well of Moses, Chartreuse de Champmol, Dijon, 1385–1404.

Ouche into the Saône in Échenon, ran along its southern border.⁹ Moreover, in addition to housing the duke's body after his death, the monastery provided a prayer space for the duke and duchess during their lives in the form of a tower oratory with visual access to the choir (Fig. 3). Additional spaces—chapels, a guesthouse, and later a loge (a gallery typically projecting from the upper part of a wall)—accommodated lay individuals within the monastic complex. Spatially, these structures were arranged peripherally around the monastery. The exception is the chamber built for the duke, which Cyprien Monget, with the aid of an account dating to 18 May 1391, places above the refectory.¹⁰

The community at Champmol further expanded its lay networks beyond the more intimate relationship with their patrons to include the transitory presence of pilgrims. In 1418, 1432, and 1445 the pope issued decrees granting indulgences to those laymen and women who made pilgrimage to the Well of Moses, known in the accounts as the Great Cross, at the Chartreuse

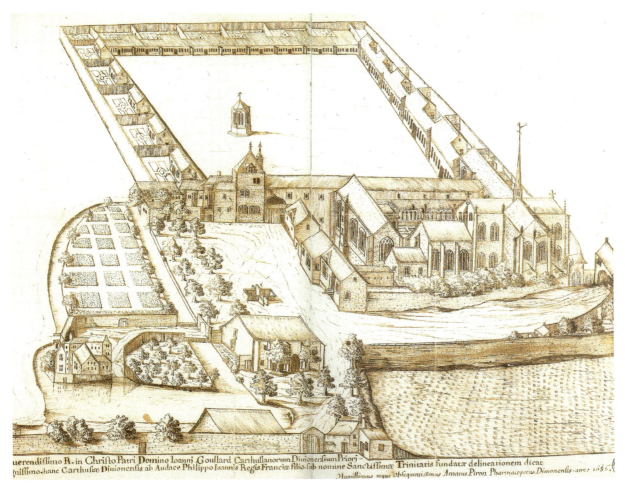

5 Aimé Piron, Chartreuse de Champmol, perspective drawing, 1686. Bibliothèque municipale de Dijon.

de Champmol.[11] Begun by Claus Sluter in 1396 and completed in 1404, this sculpture, standing about twenty-five feet high, features life-sized figures of the biblical prophets on its base and a monumental crucifix at its summit (Fig. 4).[12] The charterhouse did not have any major relics with which to attract pilgrims, so Sluter's monument offered an alternative spiritual experience.[13] Many scholars have equated the pilgrims' movement around the naturalistic imagery of the Well with the theatrical drama of contemporary liturgical plays.[14] Sherry Lindquist argues that it served as a silent "homily hewn in stone."[15] Whatever its inspiration or contemporary equivalent, the overwhelming scale, naturalistic modelling, and sumptuous paint and gilding of the Great Well would have made it a rare, three-dimensional object of contemplation at a time when affective prayer was popular.[16] This object of pilgrimage, which Laura Gelfand believes was the original intent of the sculpture, was placed at the very center of the large cloister: the symbolic heart of monastic isolation (Fig. 5).[17] To experience it, pilgrims would have had to penetrate both the interior and exterior walls of the monastery.

Both Lindquist and Gelfand have explored how individuals from outside the monastic community—patrons, pilgrims, and women more generally—interacted with Champmol. Lindquist has argued that the Carthusians included the laity but controlled them architecturally in order to preserve as well as to perform their seclusion.[18] She notes that the presence of women

in particular needed to be controlled to project "the illusion of an exclusive male preserve."[19] Gelfand has used Lindquist's description of hitching posts, guest parlors, and extra seats in the choir to argue that the monastery intended from its inception to accommodate pilgrims and guests, who ultimately form a single category in her analysis.[20] In her interpretation of the monastery, Gelfand skeptically concedes that the monastic cell may have preserved eremitic seclusion, but argues that the rest of the monastery would have yielded to continuous contact.[21] Ironically, though the involvement and proximity of the laity meant that the monastery was not as isolated as the archetype of the first foundation in the French Alps, nor as insulated as its Rule demanded, both the monks and the lay participants were drawn to the order by the same inducement: the potency of private prayer. The duke and duchess of Burgundy not only received the benefits of the heightened power of Carthusian prayer, but were also given their own sequestered spaces for prayer.

The richly-appointed oratory built for Philip the Bold and Margaret of Flanders at Champmol—known in the sources as the "the oratory of my lord" (*l'oratoire de monseigneur*)—has been discussed by previous authors.[22] Attached to the northern wall of the church, often described as a faux-transept, the oratory consisted of two stories accessible by an external staircase (Fig. 6). The interior of each story, 9.44 by 5.6 meters in plan, was oak-paneled and equipped with a fireplace and an altar.[23] On each level the walls were pierced by three windows—two on the northern wall and one on the eastern wall above the altar.[24] These windows were both glazed and shuttered.[25] The space, with its windows and fireplace, would have been airy and comfortable and, according to the descriptions in the primary sources, suitably ornate. Both levels gave visual access to the church through a narrow opening in the southern wall that looked toward the main altar.[26]

This opening would have given its occupants visual access to the space beyond, while shielding the viewer's body from the choir below. From a practical perspective, the arrangement would have allowed the elite lay viewers, banned from the church by the Rule, to witness the celebration of the eucharist. The ringing of a bell to signal the impending transubstantiation, the raising of the transformed eucharist, and the strategic lighting of the altar all contributed to the pomp around the rite while rendering Christ's body visible to the congregation.[27] Theoretically, for the Carthusians, this congregation comprised only the monks, lay brothers, and visiting religious. Room was planned for the latter—as both Gelfand and Lindquist note. Though no more than two priors and twenty-four monks ever resided at Champmol, the monks' choir had seventy-two choir stalls.[28] At Champmol, the monks and their ecclesiastic visitors sitting in these stalls would have had a clear view of the altar. The lay brothers, partitioned in the choir at the western end of the church, would not have. After as early as 1409, a wooden barrier separated their stalls from those of the monks so that the lay brothers "could not see the faces of the priests at the altar . . . when they chant the mass."[29]

As the oratory suggests, the congregation at Champmol also extended, at times, to include the ducal family and their attendants. Each group—the monks, lay brothers, and ducal family—had separate spaces in which to experience the mass. The monks and lay brothers each had their own choirs and, on the periphery of these, the ducal family had their oratory. In 1390, the accounts for Champmol give the visibility of the altar—the site of the transubstantiation—as the reason for the window in the oratory constructed for the ducal family and their attendants:

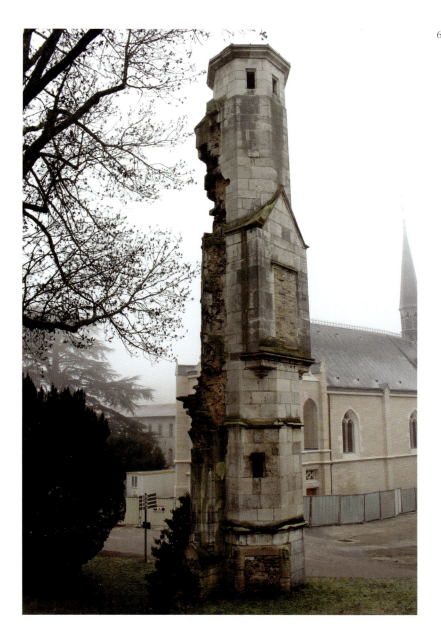

6 Druet de Dammartin, ducal oratory stair, Chartreuse de Champmol, Dijon, 14th century.

"by which my lord sees God raised on the high altar of the church."[30] Given this emphasis, we might see the oratory at Champmol as an instance of patrons wielding their influence to demand the privilege of viewing the eucharist, which Miri Rubin has noted underlay many rituals in the later Middle Ages. The inability of the lay brothers to view the altar underlines the importance of class in accessing and asserting that right.

While visual access to the altar, and *ipso facto* to the transubstantiation, was cited as central to the duke's motivation, the oratory should not be removed from its role as a sequestered space of prayer. The moment of "lay gazing" or "sacramental gazing" was intended to be one of individual contemplation in which the viewer held the layers of symbolism attendant in the eucharist in his or her mind to meditate upon its meaning and receive its benefits.[31] The oratory provided both the mechanism for viewing the altar and the space in which to retreat into interior contemplation through the decrease, albeit not the complete erasure, of

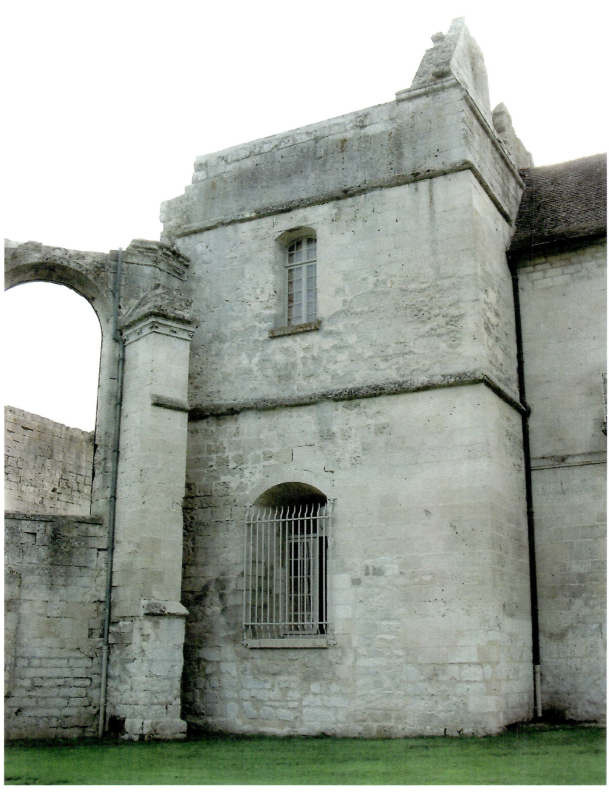

7
"Tour Valois," Bourgfontaine, Villers-Cotterêts, France, 14th century.

external stimuli. Of course, this use of partial seclusion to retreat inward mimics, though on a less individualized scale, the total seclusion that the Carthusian order sought for its monks in the construction of separate cells. Ezekiel Lotz specifically compares the duke's and duchess' oratory with the upper story of the Carthusian cell and claims that Philip took the *"oratoire haut"* as his prototype.[32] He cites the presence of the monks on the construction site as an available model for the duke to witness their manner of prayer, particularly as Philip was involved in outfitting the manor house in which the monks lived with its necessary furnishings.[33] At Champmol, each cell was equipped with a devotional image, an altar, and prayer stalls and kneelers.[34] As Lotz points out, the duke and duchess had a variety of devotional images in stone, glass, and paint upon which to gaze, as well as an altar and similar furnishings.[35] They also had the option of using the space for prayer when mass was not underway, liberating them from the rigid monastic schedule.

Though Lotz's article makes the case for the Carthusian cell as a model for the architecture of personal prayer, the oratory at Champmol may well be modeled on an earlier spatial accommodation of patrons within the charterhouse that provided a view similar to the oratory. Sheila Bonde and Clark Maines have argued for the presence of a high-status prayer space at the Chartreuse de Bourgfontaine. A square, three-story tower sharing a wall in common with the north side of the choir still stands, the first floor of which Bonde and Maines believe allowed its lay patrons to witness the mass (Fig. 7).[36] This space was not the only one to accommodate these patrons—in fact, the charterhouse included an entire residence, of which the tower was a part.[37] As Bonde and Maines have pointed out, "It is as if the monastery proper, or at least its church, served as the chapel of the residence."[38] The lay patrons for whom these spaces were constructed included Charles, count of Valois; his third wife, Mahaut de Saint-Pol; Philip VI of France; and his second wife, Blanche of Navarre—the grandparents and great-grandparents of Philip the Bold. Vincent Tabbagh has claimed that the very incentive to construct Champmol resulted from Philip's desire to emulate the foundation of these originators of the Valois dynasty, as "in his [chaplain's] opinion ancestors could be venerated through their imitation more than prayers on their behalf."[39] The oratory at Champmol may well respond to the privileges granted to the lay patrons within this archetype.

The visual experience in these spaces may have been similar to the contemporary squint, a small hole in a partition that allows a single viewer to see into the chancel, as described by Sarah Stanbury and Virginia Chieffo Raguin in their introduction to *Women's Space: Patronage, Place and Gender in the Medieval Church*.[40] As the authors describe, in this manner of viewing, "the viewer projects visually into the space beyond; squints work something like magnifying glasses, though they do not magnify they give you a sense of being an intimate participant."[41] Of course, the situation of the duke and duchess within the oratory shifts the experience and sightlines. If situated near the southern wall adjacent to the opening, we can imagine that only one to two viewers would have been able to see through the narrow window at a time. If situated further back, the ability to view would have been limited, if accessible, and the experience perhaps more auditory than visual.

The oratory at the château of Germolles, which was being built contemporaneously with the Chartreuse de Champmol by the same architect and artisans and for the same patroness, may hint at the orientation of the duke and duchess to the window in relation to the view of

the altar. At Germolles, the chapel and consecrated altar were placed within a tower jutting out from the northeastern corner of the eastern wing of this courtyard residence. A space, roughly 1.4 meters square, faces the altar directly, separated from it only by a wide doorway. The width and depth of this space, its western wall consisting of a fireplace, has room to accommodate no more than two individuals positioned side-by-side.[42] The rest of the couple's entourage would have sat within the larger, rectangular room to the south of the tower, looking in at the altar and the duke and/or duchess who faced it. The marked primacy of this position may indicate that the duke and/or duchess were situated directly in front of the window at Champmol, while their attendants looked on from further back.

Whatever the orientation, we can guess that the experience at Champmol would have differed slightly from the squint—the amplified opening likely setting the viewer further back from the window and allowing for more peripheral vision into the oratory. This distance would have diminished the sense of presence in the space beyond as well as the intimacy of that experience. These differences, however, would not necessarily have altered the sense of projection. Like the squint, this visual participation and projection would have given the ducal couple a sense of privileged access. Furthermore, in the type of restricted access practiced within the Carthusian church this viewing is simultaneously an act of "laying claim to that space."[43] At Champmol, the presence of the ducal decorations, portraits, and later the sculpture of the duke atop his tomb (Fig. 8), which would have been visible from the oratory, would have legitimated and manifested this claim.

The architecturally separate but visually connected oratory at Champmol thus occurs within a broader array of spaces that mobilize similar solutions to analogous demands and communities. Consistently, the existence of these spaces and divisions responds to the presence of lay individuals, male and female, who are understood to require both integration into the community and physical separation from it. These solutions suggest a shared understanding of the importance of including those from outside the immediate monastic community, even when their inclusion should, in a modern understanding of adherence to the Rule, technically detract from the goals of the monastery. The common location of these solutions on the periphery of the church, and often of the monastic complex itself, appears to attempt to preserve the separateness of the spaces the monks frequented.[44] Thus, the monastic walls of the Carthusian Rule used to describe the boundaries of Carthusian seclusion seem to be not those surrounding the monastic complex, but rather those delineating the core monastic space of the cloister.[45] Yet, despite the architectural separation of lay bodies, the monastery appears to have accommodated their presence deep within that emblematic space.

In contrast with the static, peripheral nature of the oratory, which contrived both a separation and the frequent, recurring inclusion of the duke and duchess, pilgrimage was characterized by a transitory presence that penetrated the center of the monastic space. We cannot definitively identify how and where the fifteenth-century pilgrim gained access to the great cloister, but several scholars have offered possibilities.[46] Other temporary excursions into monastic space also occurred.[47] While there is no concrete evidence as to when the practice began, Gelfand has suggested that pilgrims also visited the church.[48] As mentioned above, Philip the Bold also had a chamber of his own off the small cloister, which indicates that he would have been present in the area of the small cloister.[49]

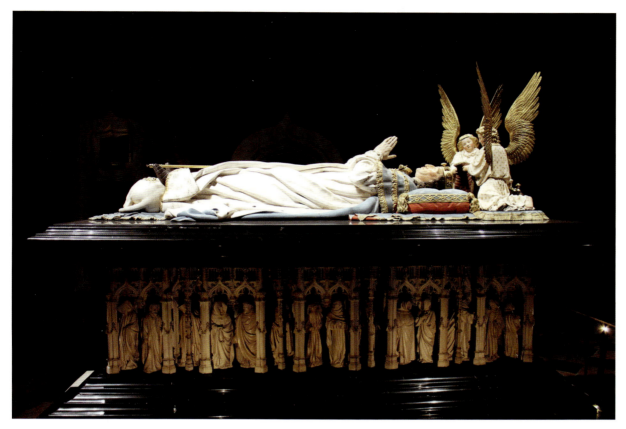

8 Jean de Merville, Claus Sluter, Claux de Werve, and workshop, restored tomb of Philip the Bold, Musée des Beaux-Arts, Dijon, France.

This last "inclusion" seems to indicate a gendered distinction between modes of accommodation. In 1417, when Vincent Ferrars came to preach at Champmol, a "loige," or *loge*, was built "on the wall"—a quintessentially peripheral position—to allow the duchess and her attendants access to the oration.[50] Notably, the account that describes this situation clarifies the arrangement that is meant to give the duchess and her ladies auditory access, and does not explicitly mention visual access, as was done in the case of the oratory. As Lindquist has noted, this placement "skillfully satisfied the women's demands while protecting the [Carthusian's] self-image by following their Rule to the letter."[51] The centrality of the duke's chamber and the peripheral location of the loge and the ducal oratory, paired with the Rule's caution against the presence of women, indicate that gender may well be the critical factor in the architectural accommodation of the laity. Like the church oratory of the duke and duchess, the loge permitted auditory access while hiding and separating the duchess, simultaneously marginalizing and distinguishing her. This architectural exclusion extended to inanimate lay bodies. The initial décor of the interior of the church included representations of Philip the Bold in the form of a tomb effigy, a painting, and a stained-glass depiction, but did not include even a single depiction of Margaret of Flanders.

Yet, contemporary with this moment of separation, women were permitted into the great cloister to make pilgrimage to the Well of Moses. Their access did not change until 1506, when the pope banned their presence. Even then, papal decree did not stop women from gaining

access to the monastery. According to the complaints of a prior in the seventeenth century, more than one woman dressed as a man in an attempt to make pilgrimage to the well.[52] The distinction between the presence of laywomen making pilgrimage and the accommodation of the duchess' spiritual needs appears to hinge upon an unwillingness to create a lasting architectural accommodation for the former.[53] The presence of pilgrims is temporary and not explicitly architecturally represented. By contrast, the duchess' presence was advertised to those in the choir both conceptually, by the window looking into the church, and explicitly, by the opening of the shutters of that window, after their installation in 1409, so that its occupants could view the mass.[54]

The exterior entrance to this architectural accommodation may indicate either a concern with Margaret's access to the church, as Lindquist has argued,[55] or, alternatively, a distinction of the ducal couple's status. Two other chapels at Champmol that Prochno argues functioned as prayer spaces for the laity were constructed for three of Philip's chamberlains (see Fig. 3). To the west of the ducal oratory lay the chapel of Saint Peter, endowed by the duke's first chamberlain and trusted friend Guy de La Trémoïlle, Sire de Sully (1343–1397). According to Prochno's reading of the accounts, the space was connected to the choir by means of a double-doored entryway and was decorated in much the same manner as the ducal oratory.[56] Guy's brothers, Guillaume (1345–1397) and Pierre (c. 1350–1426), also endowed chapels, dedicated to the Virgin and Saint Martin respectively. These two chapels together formed a two-story oratory that mirrored the ducal oratory across the choir, and are sometimes referred to in the accounts as "the oratory of my lord . . . next to the vestry."[57] Like the other ducal oratories, these chapels had narrow windows into the choir that gave visual access to the altar and were equipped with prayer stools, suggesting that they served as spaces of prayer.[58] Both Guillaume and Guy died in 1397 and were buried in their endowed chapels. As the carpenters did not equip the chapels with furniture for prayer until 1401, the chapels of Saint Peter and the Virgin may have served as funerary chapels, much like those found at the Valois charterhouses of Paris and Bourgfontaine.[59]

We do not have a record of the entombment of Pierre de La Trémoïlle, who did not die until 1426, in the second-story oratory to which he contributed. Unlike his brothers, Pierre gave the more modest sum of 500 francs toward the construction of this chapel, compared to Guillaume's 2,000 for the construction of the chapel below.[60] Significantly, 500 francs matches exactly the donations made by the two lay donors of the sacristy and the chapter house, two spaces that would not have accommodated lay use. The disparity between Pierre's donation and those of his brothers may indicate that the upper oratory was never, in fact, intended for his use or his burial. Yet the fact that this oratory, and the one below it, had windows into the choir suggests the potential of their use to attend mass. The question of who would have done so is more difficult to answer, but the designation of this space as "the oratory of my lord . . . next to the vestry" suggests that the ducal family had control of this space as well.

The actual use of all of these chapels was likely intermittent.[61] An account dating to 1389 documents Margaret's commission of alterations to the ducal oratory based on what she saw while attending the Easter service.[62] The external entrance of this oratory would permit the duke and duchess to enter without disturbing the mass, and thus allow them to come and go as they pleased. We can only speculate as to whether the use of the other chapels was restricted

or controlled. Access to the two-story oratory by the vestry might have been possible from the south of the church, but the chapel of Saint Peter seems to have been accessed through the lay brother's choir.[63] Prochno uses Charles the Bold's entrance into his oratory through the cathedral of Saint-Donatian in Bruges in 1467 to suggest a similar type of access for the duke and duchess at Champmol.[64] The planned and sanctioned nature of this 1467 entrance and the fact that Saint-Donatian was a cathedral rather than a monastic church may, however, distinguish this occurrence from more frequent use at Champmol.

The monastic community also had access to these spaces. Keys to each of the chapels were kept in an armoire in the sacristy.[65] In this way, the chapels were used as both secluded spaces of prayer by the lay community and had the potential to be used as ritual stations by the monastic community. If we think about the rest of the monastery as being similarly temporally nuanced, the entire complex manifests comparable overlapping patterns. These patterns possess several nodes of particular significance. The church, which patrons and pilgrims visited, also served as the locus of mass and procession for the monastic community. The great cloister, where pilgrims visited the well, was used daily by the monks to reach the communal areas of their complex. These spaces are neither designated for lay nor religious use, but rather respond to each community's need. Monastic movement through space occurred communally at regulated times—matins, vespers, and mass on Sunday and feast days—and along regulated paths.[66] It would therefore have been possible to regulate both the monks' access to the church and pilgrims' access to the great cloister while preventing contact between the monastic and lay communities.[67] The accounts mention both a gatehouse, a manned structure that could have regulated or directed access, and a special fund for locks, which are fundamental to our understanding of access.[68] With these devices, movement of pilgrims within the monastery could be brought to a halt on Sundays and feast days when the monks made their way from their cells to the church and small cloister.[69]

Beyond the hourly change in the use of a single space, the Chartreuse de Champmol itself went through changes in use—in terms of both activity and community—throughout its life as a charterhouse. The very introduction of sanctioned pilgrimage by several fifteenth-century papal bulls and the eventual official, though not always adhered to, termination of women's access, suggests a change in the understanding of the threat of women's presence and the success with which these communities could be kept separate. In other words, the use of the space could adapt to the needs of both lay and monastic communities without necessitating a change in architecture. At other times, small architectural changes responded to the use of space, for example the addition of railings to the duke's tomb in the church after it was erected in 1410 to prevent visitors from damaging the tomb.[70] Some adaptations to the changing needs of the community necessitated larger additions. Though it may have been a temporary addition, the erection of the loge was an architectural alteration made to the existing cloister wall.

Construction itself, of which the appended loge was a part, was a centuries-long process in which we see various individuals asking for alterations or additions.[71] Though authors often give 1410 as the date when the monastery was essentially finished, and discuss the period of construction as a rapid one, the monastic community and its patrons themselves likely did not consider the monastery to be complete. The cells in the great cloister, in particular, would have been considered a space for growth. Charterhouses, with their numerous additional cells, were

expensive undertakings, and often Carthusian cells were added over time, including through donation by lay individuals.[72] The fact that the final number of cells at Champmol appears to have resulted in a quadrilateral cloister suggests either areas left intentionally open in anticipation of eventual additions or extensive rebuilding later on. A map of Dijon dating to 1574 provides evidence for the former (Fig. 5). Drawn to scale in bird's-eye perspective, Edoardus Bredin's map contains a great deal of detail, depicting the turrets, lucarnes, rose windows, and machicolation of Dijon's cityscape. In this rendering of the charterhouse, the south side of the great cloister consists of only a fence. While the artist may have only meant to generalize the monastery for the sake of reference, or to remove buildings that would have obscured the famous Well of Moses, the details of the depiction suggest some level of familiarity.[73] The arrangement of the small cloister also changed over time. Monget notes that though work began on the refectory much earlier, it was not complete by the time the monks were residing in their cells and a room off the western side of the large cloister served as a "provisional refectory" (*réfectoire provisoire*) for some time.[74] A room labeled "old refectory" (*ancien réfectoire*) on an eighteenth-century floor plan in the Bibliothèque municipale of Dijon matches Monget's description, and may perhaps be the evidence for his assertion.[75] The recording of this earlier placement of the refectory on an eighteenth-century plan suggests that the memory of changes in the charterhouse's architecture lingered and was deemed worthy of preserving.

For the most part, examinations of the architecture at Champmol collapse time to discuss the complex as a stable entity. If we were to regard Champmol as a dynamic group of structures, we would find a more expansive and fluid practice of monasticism that, though it acknowledged the Rule, interpreted its bounds differently at different times and did not limit its responses to the strict way we interpret that Rule today. While architecture served as a fundamental guide for interactions, it did not restrict those interactions themselves or prevent the participation of individuals the Rule was intended to exclude. Yet through both the careful peripheral situation and temporal control of overlapping spaces, the Chartreuse de Champmol attempted to both preserve the solitude of its monastic inhabitants and offer similar spiritual experiences to lay individuals.

Lindquist points to the irony of lay individuals seeking the seclusion-enhanced power of Carthusian prayer and thus threatening the very power they sought to deploy—something potently represented in the cross-dressing of seventeenth-century women who undermined papal decree because they believed in the power of what pilgrimage offered, thus both subverting and reinforcing the spiritual hierarchy. The phenomenon of ironic undermining of this hierarchy belongs to the larger trend of elite lay individuals pursuing the benefits offered by the solitude of a Carthusian monastery. Beyond their own case study of Bourgfontaine, Bonde and Maines have called attention to the charterhouses of Trisulti, Florence, and Saint-Croix-en-Jarez as possessing structures adjacent to the church and intended for lay use, often giving these individuals visual access into the church.[76] The Chartreuse of Saint-Sauveur, in Villefranche-de-Rouergue, France, begun in 1452, also possessed a seemingly active patroness and a chapel, designated for visitors and women in particular, situated on the periphery of the monastic space in comparable relation to the church as the oratory at Champmol.[77] Evidently, Champmol's method of inclusion through architectural separation belongs to a wider Carthusian practice. Champmol is not an oddity so much as part of a widespread solution to rising interest by laity,

whose presence would seem to have threatened the very power of Carthusian prayer to which the laity sought access.

This interest extended beyond receiving prayers to participating in those prayers. For the pilgrims visiting the monument, who did not have access to this type of secluded prayer, the monument of the Well of Moses offered a unique access to monastic space and an evocative experience to inspire affective piety. Lindquist goes so far as to say that "The large cloister was as close as the laity could get to the 'holy ground,' the 'heaven' of the Carthusian cells."[78] The duke and duchess and their immediate circle had access to a much closer imitation of Carthusian solitude. The private prayer space of the oratory not only imitated that of the Carthusians physically, but also allowed the duke and duchess visual access to the moment of transubstantiation at the altar and to the monastic choir—one of three spaces where the monks came together as a community. In granting their lay patrons these oratories, the monastic community at the Chartreuse de Champmol, and at other Carthusian houses, included them by secluding them. In doing so, the order brought these lay elites more firmly into a monastic community that distinguished itself by the separation of its members. The architectural space of this seclusion—the oratory—linked them linguistically and idealistically in an evocative historical connection to the *oratorium* of the desert fathers.

Primary Works

Dijon, Archives départmentales de la Cote-d'Or (ADCO):
>B11671, fol. 272r and 250r-v: account book of Amiot Arnaut, entry of payment to Denys Pichon, 6 February 1389.
>B11673, fols. 194v-195r: account book of Amiot Arnaut, entry of payment to Robin Langineur, 14 May 1409.
>B4471, fols. 58r-59v: account book of Jean Moisson, entry of payments to Girart de Lomon, 24 July 1417.

Dijon, Bibliothèque Municipale (BM):
>Fonds Baudot, MS 2081: notebook of Louis-Bénigne Baudot, *"Chartreuse de Champmol: Notes Prises Pendant la Revolution,"* 1789.
>L Est. 5027 CT-III 4: "Plan géométral de la Chartreuse"
>L Est. 5027 CT-111 5: "Plan de la Chartreuse"
>L Est. 5027 CT-111 6: "Plan de la Chartreuse"
>L Est. 5027 AO-I 1: "Elévation principale du bâtiment des hôtes, marqué au plan géneral n° 17," 1786

Printed Primary Works

Guigues Ier 1984: Guigues Ier le Chartreux, *Coutumes de Chartreuse*, 2nd ed. rev. and cor. (Paris: Editions de Cerf, 1984).

Paradin de Cuyseaulx 1566: Guillaume Paradin de Cuyseaulx, *Annales de Bourgogne par Guillaume Paradin de Cuyseaulx avec une table des choses memorables conentues en ce present livre* (Lyon: Antoine Gryphius, 1566).

Secondary Works

Aniel 1983: Jean-Pierre Aniel, *Les maisons de Chartreux: des origines à la Chartreuse de Pavie* (Geneva: Droz, 1983).

Bonde and Maines 2013: Sheila Bonde and Clark Maines, "The Heart of the Matter: Early Valois Patronage at the Carthusian Bourgfontaine," in *Patronage: Power and Agency in the Middle Ages*, ed. Colum Hourihane (Princeton: Index of Christian Art, and Pennsylvania State University Press, 2013), 76–98.

Combe 1959: Jean Combe, *La chartreuse de Sainte-Croix-en-Jarez* (Saint-Etienne: Dumas, 1959).

Fliegel, Jugie, and Barthélemy 2004: Stephen N. Fliegel, Sophie Jugie, and Virginie Barthélemy, eds., *Art from the Court of Burgundy: The Patronage of Philip the Bold and John the Fearless, 1364–1419* (Dijon: Musée des Beaux-Arts, 2004).

Gelfand 2005: Laura D. Gelfand, "'Y Me Tarde': The Valois, Pilgrimage, and the Chartreuse de Champmol," in *The Art and Architecture of Late Medieval Pilgrimage in Northern Europe*, ed. Sarah Blick and Rita Tekippe (Leiden and Boston: Brill, 2005), 567–586.

Hogg 1989: James Hogg, *The Evolution of the Carthusian Statutes from the Consuetudines Guigonis to the Tertia Compilatio, Analecta Cartusiana* (Salzburg: Institut für Anglistik und Amerikanistik, Universität Salzburg, 1989).

Hogg and Sargent 2013: James Hogg and Michael Sargent, eds., *The Chartae of the Carthusian General Chapter,* vol. I (Salzburg: Universität Salzburg, 2013).

Hogg and Schlegel 2004: James Hogg and Gerhard Schlegel, "The Carthusians and their Heritage," in James Hogg and Gerhard Schlegel, eds., *Monasticon Cartusiense Francia* (Salzburg: Institut für Anglistik und Amerikanistik, 2004), I, pt. 4:V-XCVII.

Jugie, Kagan, and Huynh 2007: Sophie Jugie, Judith Kagan, and Michel Huynh, *La Chartreuse de Champmol et le Puits de Moïse* (Paris: Éditions du Patrimoine, 2007).

Laurière 1999: Raymond Laurière, "La Chartreuse Saint-Sauveur de Villefranche-de-Rouergue," unpublished PhD dissertation, Université de Toulouse II le Mirail, 1999.

Lindquist 1995: Sherry Lindquist, "Patronage, Piety, and Politics in the Art and Architectural Programs at the Chartreuse de Champmol in Dijon," unpublished PhD dissertation, Northwestern University, 1995.

Lindquist 2003: Sherry Lindquist, "Women in the Charterhouse: the Liminality of Cloistered Spaces at the Chartreuse de Champmol in Dijon," in *Architecture and the Politics of Gender in Early Modern Europe*, ed. Helen Hills (Burlington, VT: Ashgate Publishing, 2003), 177–192.

Lindquist 2008: Sherry Lindquist, *Agency, Visuality, and Society at the Chartreuse de Champmol* (Burlington, VT: Ashgate, 2008).

Lotz 2008: Ezekial Lotz, "Secret Rooms: Private Spaces for Private Prayer in Late-Medieval Burgundy and the Netherlands," in *Studies in Carthusian Monasticism in the Late Middle Ages*, ed. Julian Luxford (Turnhout: Brepols, 2008), 163–177.

Mâle 1904: Emile Mâle, "Le renouvellement de l'art par les mystères à la fin du moyen âge," *Gazette des Beaux-Arts,* 31 (1904): 89–106, 215–230, 283–301, and 379–394.

Mâle (1908) 1971: Emile Mâle, *Religious Art in France: The Late Middle Ages*, trans. Marthiel Matthews (New York: Harper and Row, [1908] 1971), 35–38.

McNamer 2010: Sarah McNamer, *Affective Meditation and the Invention of Medieval Compassion* (Philadelphia: University of Pennsylvania Press, 2010).

Monget 1898: Cyprien Monget, *La Chartreuse de Dijon: d'après les documents des archives de Bourgogne*, vol. I (Montreuil-sur-Mer: Imprimerie Notre-Dame des Prés, 1898).

Monget 1901: Cyprien Monget, *La Chartreuse de Dijon: d'après les documents des archives de Bourgogne*, vol. II (Montreuil-sur-Mer: Imprimerie Notre-Dame des Prés, 1901).

Monget 1905: Cyprien Monget, *La Chartreuse de Dijon: d'après les documents des archives de Bourgogne*, vol. III (Montreuil-sur-Mer: Imprimerie Notre-Dame des Prés, 1905).

Morand 1991: Kathleen Morand, *Claus Sluter: Artist at the Court of Burgundy* (Austin: University of Texas Press, 1991).

Pérouse de Montclos 2004: Jean-Marie Pérouse de Montclos, *Architecture: méthode et vocabulaire*, 5th ed. (Paris: Monum/Éditions du Patrimoine, 2004).

Prochno 2002: Renate Prochno, *Die Kartause von Champmol: Grablege der burgundischen Herzöge, 1364–1477* (Berlin: Akademie Verl., 2002).

Prochno 2004: Renate Prochno, "The Chapels," in Fliegel, Jugie, and Barthélemy 2004, 183–187.

Rochet 2013: Quentin Rochet, *Les filles de saint Bruno au Moyen Age: les moniales cartusiennes et l'exemple de la chartreuse de Prémol: XIIe-XVe siècle* (Rennes: Presses universitaires de Rennes, 2013).

Roy 1903–1904: Emile Roy, *Le mystère de la Passion en France du 14e au 16e siècle: étude sur les sources et le classement des mystères de la Passion* (Geneva: Slatkine Reprint, 1903–1904).

Rubin 1991: Miri Rubin, *Corpus Christi: The Eucharist in Late Medieval Culture* (Cambridge: Cambridge University Press, 1991).

Stanbury and Raguin 2005: Sarah Stanbury and Virginia Chieffo Raguin, eds., *Women's Space: Patronage, Place and Gender in the Medieval Church* (Albany: University of New York Press, 2005).

Stöber 2007: Karen Stöber, *Late Medieval Monasteries and Their Patrons: England and Wales, c. 1300–1540*. Studies in the History of Medieval Religion, 29 (Woodbridge, Suffolk, and Rochester, NY: Boydell Press, 2007).

Tabbagh 2004: Vincent Tabbagh, "Introduction: Religious Institutions Founded by the Dukes," in Fliegel, Jugie, and Barthélemy 2004, 167–168.

Taglienti 1979: Atanasio Taglienti, *La certosa di Trisulti: Ricostruzione storico-artistica* (Casamari: Tipografia Abbazia di Casamari, 1979).

Vachez 1904: Antoine Vachez, *La chartreuse de Sainte-Croix-en-Jarez* (Lyon: Louis Brun, 1904).

NOTES TO THE TEXT

1. For a description of the origin and context of these two statutes, see Hogg 1989, 99.

2. Though the accounts that document the construction of the Chartreuse de Champmol refer to this oratory as "the oratory of my lord," there is evidence for the presence of Margaret of Flanders as well. In 1389, the duchess called the carpenter at work on the château de Germolles back to Champmol to make alterations based on observations she made while attending Easter mass there. See Lindquist 2008, 100.

3. The Carthusian order also had nuns, whose legislation and architecture differed slightly from their male counterparts. The community of monks from which the Carthusian order grew settled in the Chartreuse mountains in 1084, though Hogg sets the official date of the order's foundation at 1140 or 1141, when the first General Chapter was convened. It was around this time that a community of nuns in southern France sought direction from the Carthusians, but they were not officially incorporated into the order until the middle of the thirteenth century. The 1271 *Antiqua Statuta* includes specific guidelines for Carthusian nuns. Hogg and Schlegel 2004, IX, XII-XIII. For more information on the foundations for nuns, see Rochet 2013.

4. For a description of the variety of enclosures encircling charterhouses, see Aniel 1983, 38–39.

5. All individuals who were not "a friend or benefactor of the order" were banned from "the precincts of the charterhouse." Hogg and Sargent 2013, 9 and 64. The *Antiqua Statuta* explicitly restricts women from being brought into the cloister, even by the prior. Hogg and Sargent 2013, 37.

6. Sherry Lindquist, in discussing the order's opposition to the presence of women in the charterhouse, quotes a particularly vivid line from Guigo's *Consuetudines*: "it is not possible for a man to hide the fire in his breast without his clothes burning, or to walk on hot coals with the bottoms of his feet intact, or to touch the pitch without being caught in it" (*nec posse hominem aut ignem in sinu abscondere, ut vestimenta illius non ardeant, aut ambulare super prunas plantis illesis, aut picem tengere, nec inquinari*). Lindquist 2008, 33. The explicit exclusion of women from the borders of the monastery goes back as far as the first Carthusian Rule, called the *Consuetudines*, written by Guigo I, the second prior of the Grande Chartreuse, in the first half of the twelfth century. Guigo I, 21:1. In the statutes, the monks were further reminded that, among other things, they were not to give confession to women, to speak with them, or even to visit with the women of their own families. Hogg and Sargent 2013, 65–66. Despite these limitations, elite women were granted special access in the statutes of the order. For example, according to the Ordinances of the General Chapter, Militissa of Picardy, along with her four ladies-in-waiting, was allowed to enter one Carthusian monastery a week. Hogg and Sargent 2013, 60.

7. Hogg and Schlegel 2004, XIV.

8. Sherry Lindquist takes this description of Champmol's distance from Dijon from Guillaume Paradin de Cuyseaulx's sixteenth-century *Annales de Bourgogne*. The translation is Lindquist's. Lindquist 2003, 177. Paradin de Cuyseaulx 1566, 396.

9. What remains of the monastery now lies entirely within the bounds of the city. Dissolved during the French Revolution, the monastery was sold to Emmanuel Crétet in May of 1791—thirteen days after the last of its monks were expelled. Crétet styled himself the count of Champmol and created a romantic ruin from its walls. The majority of the monastery—all save the guest house, church portal, wells, and oratory stair—were disassembled and sold as building material. In 1833 a mental institution moved onto the site, constructing for its purposes a U-shaped court around the well in the general location of the medieval cloister and a small Gothic Revival church into which the original church portal now opens. Today, the site functions as both a mental institution and as a tourist attraction for those wishing to visit the fragments of the fourteenth-century charterhouse.

10. Monget 1898, 222.

11. Monget 1901, 54–55. As Lindquist argues, the banning of women from the charterhouse in 1506 by Pope Julius II suggests that those making pilgrimage to the well originally included laywomen. Lindquist 2008, 194.

12. For a concise history of the construction of the Great Cross, see Morand 1991, 337–340.

13. Gelfand 2005, 567.

14. For a summary of the history of comparison between the cross and liturgical plays, see Lindquist 2008, 186–187, n. 175. She primarily cites Roy 1903–1904, 436; Mâle (1908) 1971; and Mâle 1904 in regard to the connection drawn between the drama of liturgical plays and the purpose and effect of the cross. However, she notes that more recent scholarship—including Prochno 2002, 236–237, and Morand 1991, 103–105—does not accept a concrete influence.

15. Lindquist 2008, 173.

16. For more on affective meditation and its relationship to the Passion, see McNamer 2010.

17. Gelfand 2005, 583–584.

18. Lindquist 2008.

19. Lindquist 2008, 198. For a general treatment of the role of gender in the liminal space of the monastery, see Lindquist 2003.

20. Gelfand 2005, 574–575, 579, 584.

21. Gelfand 2005, 575.

22. On descriptions of the spaces of the monastery, see Morand 1991, and Lindquist 1995 and 2008. Prochno 2002 has conducted a rich examination of the primary

sources to recreate the monastery as it was in the years 1364–1477, primarily the church and the sculpture in the two cloisters. She also contributed a short description of the chapels in Fliegel, Jugie, and Barthélemy 2004, 183–186. Lotz 2008, 163–167, also deals with the ducal oratory in his article on the private prayer spaces. While contemporary sources call this space the "oratory of my lord," Lindquist 2008, 100, offers evidence for the presence of Margaret of Flanders as well. See note 2 above. My description of the oratory relies primarily upon Renate Prochno's description and the primary sources she has transcribed as well as the description in Lindquist 2008.

23 Prochno 2002, 137–139.

24 Prochno 2002, 139.

25 Dijon, ADCO, B11671, fol. 272r; B11673, fols. 194v-195r.

26 These windows into the choir are sometimes referred to as "*lucarnes*" (dormers) in the scholarship on Champmol. This frankly puzzling term seems to refer to an unusual interior arrangement, as *lucarnes* traditionally occur on roofs and would only contain a slanted opening with difficulty. On the term in general, see Pérouse de Montclos 2004, col. 161. In fact, the opening that gave visual access to the altar was just a narrow, slanted window and not a dormer protruding into the choir, which would have demonstrably advertised the presence of the duke and duchess on the other side. The medieval accounts do not describe anything other than an opening. Nor indeed does Baudot use the term in his description: *Cette espece de fenetre longue et etroitte est disposée de façon que les ducs et duchesses pouvaient voire assis pres d'une cheminee, dont je vais parler et qui est dans cette chapelle le chartreux au maitre autel de l'eglise de chartreux sans etre vues eux mémes* (This type of long, narrow window is situated in such a way that the dukes and duchesses could see, seated close to the chimney of which I spoke and which is in the chapel, the Carthusian at the main altar of the church of the Carthusians without being seen in return). Dijon, BM, Fonds Baudot, MS 2081, fol. 224. Translation by author. As Prochno notes in a footnote, it was Cyprien Monget's incorrect transcription of Baudot's account that introduced the term: . . . *dans l'autre arcade est la porte d'entrée de cette chapelle par l'Eglise et le petit espèce de crenot qui est à côté, par lequel, de la cheminee, on voit le prêtre à l'autel de l'Eglise* . . . (In the other arch is the door to enter into this chapel from the church and the small type of *lucarne* that is beside it by which, from the chapel, one sees the priest at the altar of the church . . .). Translation by author. For Prochno's footnote, see Prochno 2002, 140, n. 113; for Monget's transcription of Baudot, see Monget 1905, 132.

27 Rubin 1991, 73.

28 Gelfand 2005, 579. Lindquist 2008, 33.

29 . . . *l'on n'y voye ou visaige les prestres aux aultes . . . quant ilz chanteront messe*. Dijon, ADCO, B11673, fols. 194v-195r. Transcribed in Prochno 2002, 346.

30 . . . *p(ar) lesquelles mons(eigneur) voit Dieu levé au grant autel de l'esgl(is)e*. Dijon, ADCO, B11671, fol. 272r. Transcribed in Prochno 2002, 304.

31 Rubin 1991, 63.

32 Lotz 2008, 167–169.

33 Lotz 2008, 168–169.

34 For a brief description of what such devotional images may have included, see Lindquist 2008, 53.

35 For descriptions of the imagery in the oratory, see Prochno 2002, 137–166; Prochno 2004, 183–185; and Lindquist 2008, 36–41.

36 Bonde and Maines 2013, 90.

37 Bonde and Maines 2013, 90.

38 Bonde and Maines 2013, 92.

39 Tabbagh 2004, 168.

40 Stanbury and Raguin 2005, 1–10.

41 Stanbury and Raguin 2005, 8.

42 The placement of the visual access of the duke and duchess next to the fireplace also unifies the experience at Germolles and Champmol. When visiting the lower oratory of the charterhouse in 1792, after its sale in 1791, Baudot specifically mentions that the duke and duchess would have been able to see the altar through the narrow, slanted window when sitting beside the fireplace on the southern wall. Dijon, BM, Fonds Baudot, MS 2081, fol. 224.

43 Stanbury and Raguin 2005, 8.

44 Lindquist discusses this separation as a manifestation and negotiation of the liminality of monasticism. Lindquist 2008, 198–208.

45 The banning of women from the cloister, mentioned above, suggests a conscious delineation of sacred monastic space that used the cloister as a boundary, at least at the time the *Antiqua Statuta* was written. Hogg and Sargent 2013, 37.

46 Gelfand and Morand both place the pilgrimage entrance to the well on the eastern end of the cloister. Gelfand 2005, 583. Morand 1991, 108–109. Lindquist points out that the 1760 plan shows a possible pilgrimage route (Fig. 1). Lindquist 2003, 182. Indeed, on the 1686 drawing an odd, shed-like structure appears to block a rather grand, and certainly large, entrance in front of the large cloister (Fig. 5). When we look at this feature on the 1760 abbey plan, we find no corresponding structure, but the wall has an irregular slant in an odd location that suggests renovation or alteration (Fig. 1). This large entrance and corridor may have functioned as the pilgrimage entrance to the well that Gelfand has identified in the accounts (Gelfand 2005). As these visual sources are substantially later than the construction of the monastery, however, the conclusion is far from definitive.

47 Beyond the other individuals discussed in this paragraph, tradesmen, laborers, tenants, and merchants would have been present within the monastery. Lindquist 2008, 198. The Carthusians also had many servants to support their seclusion and manage the complex. Lindquist 2003, 180. These roles were typically present in the medieval monastery, however their presence at Champmol resulted from an administrative and architectural change within the charterhouse, namely the movement of the accommodations and tasks of the lay brothers to within the main monastic complex. Originally, these members of the community lived in *correries*—monastic complexes that mirrored those of Carthusian fathers but that housed the lay brothers and the practical administration of the monastic estates. *Correries* typically sat at a distance of several kilometers from the main monastic complex. This separation facilitated the restriction of visitors to the lower complex and away from the metaphorical desert. When, however, charterhouses began to move into more urban settlements, *correries* disappeared. On correries, which are not well studied, see Hogg and Schlegel 2004, VIII-IX and XXI.

48 Though technically lay individuals were not allowed in the church itself, we have evidence of their presence within the space at a later period. Gelfand 2005 describes some of these visits, including that of Georges Lengherand who documented his visit to the church in 1486 on his way to see the Well of Moses. While we have no idea of the regularity of these visits, we can place at least one woman in the church. According to Monget 1901, 320–321, Anne of Austria and her ladies made a special visit to Champmol in 1650. The monastery complained about the resulting state of the church ornaments and the loss of figures on the tombs in the choir, among other things, after the women had departed. Lindquist provides a list of the elite women identified by Monget 1901. Lindquist 2008, 210, n. 58.

49 Though the accounts explicitly identify the chamber in the small cloister as "for my lord" (*par Monseigneur*), it is not inconceivable that Margaret might have made use of it as well. The accounts similarly name the duke as the instigator and occupant of the ducal oratory, but, as noted above, Margaret's presence at the Easter mass suggests that she too used the space. The identification of the chamber and oratory with the duke, however, certainly offers evidence for a gendered hierarchy within the designation of space.

50 . . . *sur le mur*. Dijon, ADCO, B4471, fols. 58r-59v. Reproduced in Lindquist 2008, 211, n. 86.

51 Lindquist 2008, 198.

52 Lindquist 2008, 194.

53 It is worth noting that the *loge* may have been a temporary construction for the event.

54 Dijon, ADCO, B11673, fols. 194v-195r. The installation of the shutters in 1409 meant that, though the duchess' presence would have been conveyed conceptually in the time of Margaret of Flanders, her explicit presence would begin with Margaret of Flanders' successor, Margaret of Bavaria (1385–1419).

55 Lindquist 2008, 197.

56 Prochno 2002, 169–171.

57 . . . *l'oratoire de mons(eigneur) aud(it) Champmol d'au costé le revestiaire*. Dijon, ADCO, B11671, fol. 250r-v. Transcribed in Prochno 2002, 303.

58 For a description of the windows, see Prochno 2004, 186. For the prayer stools, see Prochno 2002, 171.

59 Prochno 2004, 185.

60 Prochno 2004, 186.

61 Baudot's account notes in passing that this oratory was . . . *la chapelle dans laquelle les ducs et duchesses entendaient aux chartreux la messe l'hiver* (the chapel in which the duke and duchess attended the Carthusian winter mass), but he does not give support for this claim. His fixation on the fireplace next to which the duke and duchess would have sat may have given birth to the idea. Dijon, BM, Fonds Baudot, MS 2081, fol. 224. Transcribed in Prochno 2002, 361.

62 For a discussion of Margaret's role within Champmol's construction, see Lindquist 2008, 100–101.

63 The eighteenth-century floor plans of the church show only external access for the two, non-ducal chapels on the northern side of the church and do not indicate the interior access for which the contemporary construction accounts and later descriptions give evidence (Fig. 1). It is possible that the entrances to the chapels were reorganized when the church was paneled and redecorated in the Baroque style in 1740.

64 Prochno 2002, 139.

65 Prochno 2004, 186.

66 Guigo I 1127, 29:6. It is worth noting that even though monks were meant to stay in their cells, they may not have always done so; one ordinance warns the monks "not to enter the cell of another," which, of course, suggests that they did. Hogg and Sargent 2013, 34.

67 By the time of the foundation of Champmol, the Carthusians had produced a revision of the *Consuetudines*—the *Statuta Nova*—and had additionally circulated various statutes that acted as addenda to the Rule. These addenda were typically written as need arose in direct response to issues that had come to the attention of the provincial visitors, fathers who were assigned to tour Carthusian monasteries in a particular region as a means of administrative and qualitative control. These statutes thus indirectly suggest practices occurring within monasteries that were illicit, or at the very least unsanctioned. They are a reminder that, though the Carthusians had an official set of rules and an administrative system of inspection, the daily, actualized practices within the monastery

cannot necessarily be understood in their entirety by a strict reading of the Rule. Hogg and Sargent 2013, 34.

68 Both Lindquist and Gelfand discuss these locks as mechanisms that advertise the presence of outsiders. Gelfand argues that while they could be for monks to protect themselves from one another, it was "more likely that such security measures were taken because the presence of outsiders necessitated them." Gelfand 2005, 584. Lindquist identifies their intent as defending against "undesirable contact." Lindquist 2008, 198.

69 The papal bulls explicitly give Saturdays and Good Fridays as pilgrimage days that would earn indulgences, thus plausibly limiting the period of time in which pilgrims were present. Lindquist 2008, 177, n. 24. We should, however, not necessarily allow the papal bull to limit our vision of the scope of time in which pilgrims visited, given that women continued to visit even after they were forbidden from participating in pilgrimage to Champmol.

70 Gelfand 2005, 579.

71 Margaret of Flanders' requests for alterations, which was mentioned above to suggest punctuated use of the oratory, is one such request for architectural modification that documents a dynamic and responsive approach to changing use.

72 In 1433, two more cells were added to the large cloister by Philip the Good and Isabella of Portugal to celebrate the birth of their son, Charles the Bold. Jugie, Kagan, and Huynh 2007, 11. Patrons of a lower class than Philip and Isabella also donated cells as a more affordable way of participating in the support of a monastery and receiving the spiritual benefits that accompanied it. Stöber 2007, 13 and 26–28.

73 In his representation of the Chartreuse de Champmol, Bredin (Fig. 2) has rendered not only the church and cloister, but the Well of Moses, the arcade and buildings of the large cloister, the well to the north of the church, and the kitchens and outbuildings. Notably, however, where Dijon follows the north/south orientation indicated in the legend, Champmol has been rendered in the reverse. The choir of the church as depicted here lies to the west and the cloister extends to the north, rather than to the east and south respectively. It may be that Bredin chose this perspective in order to provide a more comprehensive view of the monastery and its outbuildings, which lay primarily on the southern side of the church. The cavalier view used for both the city and the large cloister and outbuildings of Champmol would, however, have enabled Bredin to represent the majority of these, losing only a fraction of the chapter house and sacristy behind the spire of the church.

74 Monget 1898, 57, n. 1.

75 The online records for this floor plan do not give a date or an author. The plan seems, however, almost identical to the floor plan dated to 1760 and might well have been a part of the commission of the colored floor plan and/or the initial preparations for the renovations to the charterhouse. For the colored floor plan, see Jugie, Kagan, and Huynh 2007, 14. According to plans in the Bibliothèque municipale of Dijon, Champmol had planned on completely remodeling its site in the eighteenth century. "Plan de la Chartreuse" L Est. 5027 CT-111 5 and 6, Bibliothèque municipale of Dijon (removed from MS 2081, pp. 253 and 257 respectively - Fonds Baudot, Chartreuse de Dijon). In this plan, the black lines appear to correspond to earlier plans, including Figure 1, whereas the red lines seemingly show the planned renovations. A colored plan in the Bibliothèque municipale of Dijon may be the culmination of these plans: a beautiful depiction of the vision for these renovations. "Plan géométral de la Chartreuse" L Est. 5027 CT-III 4, Bibliothèque municipale of Dijon (removed from MS 2081, pp. 129–130 - Fonds Baudot, Chartreuse de Dijon, Bibliothèque municipale of Dijon). An elevation of the library shows that the Grande Chartreuse approved the plans, or at least one particular elevation, in 1786. "Elévation principale du bâtiment des hôtes, marqué au plan général n° 17," 1786, L Est. 5027 AO-I 1, Bibliothèque municipale of Dijon. By 1791, the monastery had been closed and sold to Emmanuel Crétet.

76 On Bourgfontaine, see Bonde and Maines 2013, 88. On Trisulti, see Taglienti 1979. On Jarez, see Vachez 1904 and Combe 1959. See also Aniel 1983.

77 Laurière 1999.

78 Lindquist 2008, 197.

SHEILA BONDE AND CLARK MAINES

Hermits in the Forest: Western France and the Architecture of Monastic Reform

Introduction

Toward the end of the eleventh century, the forests of western France were occupied by numerous eremitic groups, many of them led by men who were charismatic preachers.[1] These men and their followers sought the wilderness where they could pursue an apostolic life.[2] As Grundmann pointed out in 1935, the notion of apostolicity for these men centered on preaching to the laity about actively imitating Christ and the apostles in poverty, austerity and humility.[3] He also emphasized that these reform communities were not created out of existing monasteries, as happened in the case of Cîteaux, but were created through interaction with the laity and were populated with women and men from the artisanal classes.[4]

Some of these leaders, like Robert of Arbrissel (c. 1045–d. 1116) and Vitalis of Mortain (c. 1060–1122), have long interested scholars. Others, like Bernard of Tiron (c. 1045–d. 1116), have come more recently to scholarly attention.[5] Alleaume of Étival (d. 1152), Raoul de la Futaie (d. 1129), and Saloman of Nyoiseau (d. 1140) have been less well studied. According to Bernard's biographer, the Tironensian monk Geoffrey Grossus, hermits were important and numerous in the religious landscape. He tells us that there were in the wildernesses of Brittany and the Maine, around 1100, ". . . a multitude of hermits Among them were the leaders and teachers: Robert of Arbrissel, Vitalis of Mortain and Raoul de la Futaie"[6] Toward the ends of their public careers, each of these men chose to found a monastery in an effort to make permanent in coenobitic form the values that each sought to embody in the daily practice of their eremitic groups.[7] Four of them—Robert of Arbrissel, Alleaume, Raoul de la Futaie, and Saloman—founded double monasteries (joint houses of women and men): respectively Fontevraud, Notre-Dame d'Étival, Notre-Dame du Nid-au-Merle in Saint-Sulpice-la-Forêt, and Notre-Dame de Nyoiseau (Map). All five houses were placed under the leadership of an abbess with the nuns' community being the larger and the smaller male component principally present

Map Google Earth view of Brittany, Normandy, and the west of France showing the locations of seven monasteries of eremitic origin.

to serve the female house. Robert of Arbrissel (again), Bernard of Tiron, and Vitalis of Mortain founded houses for men: Notre-Dame de La Roë, La Sainte-Trinité de Tiron, and Saint-Martin de Savigny, though women played important roles as patrons and participants, at least at Tiron. In this paper, we will focus on the monumental churches erected by four of these men and their followers, considering their sites, plans, and elevations, as well as their decoration and the spatial experience of their interiors. We will not consider Vitalis of Mortain's new monastery at Savigny, founded c. 1112 in the forest near the village of Savigny-le-Vieux (Manche). The architectural remains that survive on the site are usually dated after the affiliation of Savigny and its daughter houses to the Cistercian order and are thus outside the immediate purview of our study.[8] We also do not consider Notre-Dame de Nyoiseau, founded c. 1109, where the architectural remains above ground are insufficient for study.[9] We will explore the five other churches not simply as architectural forms, but as expressions of the idea of reform for the founders and their early successors.

The hermits

Robert of Arbrissel, Raoul de la Futaie, Alleaume, Bernard of Tiron, and Vitalis of Mortain were known to one another, sometimes appearing at councils and courts together or sharing time together in the forests and beyond. Salomon is typically identified as a disciple of Arbrissel.[10] Robert and Bernard were both present at the Council of Poitiers in November of 1100.[11] Bernard, Robert, and Vitalis also seem to have known one another during their time in the "desert."[12]

Toward the end of their lives, Bernard and Robert traveled together, going to Chartres and Blois to mediate the disputed election of Bishop Geoffrey of Lèves.[13] In his *Vita Altera* of Robert of Arbrissel, Andreas of Fontevraud includes mention of Bernard.[14] Rather less is known about Alleaume, the youngest member of this group.[15] He is probably not the same as the "Adelinus" who appears in Geoffrey's *Life of the Blessed Bernard*.[16] Nevertheless, the number of charismatic hermits active in the forests of the west of France, and the similarity in the patterns of their monastic foundations, make it likely that Alleaume was known to Robert, Raoul, and Bernard.

During the eremitic and itinerant periods of their lives, these men were both important to, and problematic for, the Church. They were important participants in ecclesiastical reform in western France and yet, at the same time, operated largely outside normative ecclesiastical experience. While they might attend church councils, their movements in and out of the wildernesses of western France allowed them to operate outside the easy reach of episcopal control. In 1096, Pope Urban II summoned Robert of Arbrissel to Angers and designated him an apostolic preacher, entitling him to preach wherever he went and, presumably, legitimizing his itinerant preaching.[17] This papal act recognized Robert as a charismatic preacher. It should, however, probably also be seen as a move to place the hermit under a degree of ecclesiastical control and, as such, illustrates the interstitial position that wandering hermit preachers occupied.

To summarize, all of these men seem to have known one another and were known to bishops and even popes. It seems clear that they held similar ideas about what reform meant in their part of the world. For them, a new, reformed "other" monasticism emphasized simplicity, austerity, and a commitment to a strict reading of the rule, whether Benedictine or Augustinian. As we turn to consider the churches of the monasteries that four of them founded (see Map)—La Roë and Fontevraud (Robert), Étival (Alleaume), Saint-Sulpice-la-Forêt (Raoul), and Tiron (Bernard)—we will see that the four founders and their immediate successors seem to have shared similar notions about a distinctive monumental form—in plan and elevation—that their churches should take to express their ideals. All elected to build aisleless, cruciform churches terminating in relatively short sanctuaries.

The Abbey of Notre-Dame de La Roë

Notre-Dame de La Roë was the earliest monastery established by Robert of Arbrissel, who acted first as one of a small group of co-equal hermit-clerics, and later as "first Father and Pastor of our congregation" during the early years after its foundation in 1096.[18] This house of Augustinian canons quickly became an important presence in the Haut-Anjou, controlling more than thirty parishes in the region barely forty years after its foundation. While the abbey has received scholarly attention, the architecture of its church is not nearly as well-studied as the history of its community.

Foundation
Robert of Arbrissel retreated from Angers into the forest of Craon, where the site of La Roë was to be, probably in the spring of 1095. Baudri, bishop of Dol, tells us in his *Historia Magistri Roberti* that many people came to the forest of Craon to hear the charismat preach and to learn

of his way of life.[19] Some of these people chose to stay with Robert and a common dwelling was built to accommodate their presence.[20] Baudri's testimony indicates that the beginnings of a residential community preceded the formal foundation of the monastery and that it included essential quotidian structures.[21]

The establishment and early development of the abbey of Notre-Dame de La Roë has been carefully examined by Jean-Marc Bienvenu. His analysis of the first fourteen acts recorded in the cartulary of the abbey allows us to see in considerable detail the process of the transformation of a group of hermits into a monastic community.[22] In February 1096, at the request of Renaud, lord of Craon, Pope Urban II confirmed the lord's gift of seven measures of forest to the six clerics in order that they build a church and live according to the Augustinian rule.[23] Bienvenu argues, on the basis of a close reading of the words chosen in the early charters, that the first charter did not establish an abbey, but rather represented the "foundation of a group of canons with an eremitic character."[24] A little more than a year later in 1097, Geoffroi de Mayenne, bishop of Angers, consecrated the altar of a first, presumably wooden, church and blessed its cemetery.[25] Bienvenu shows that Bishop Geoffroi, acting on his own, decided to erect a parish at La Roë and gave the canons the *cura animarum* (the cure of souls, i.e., the responsibilities of parish priests), requiring them to submit to episcopal authority.[26]

Bienvenu then traces the process by which the group of co-equal canon-hermits became a monastic community.[27] The first step seems to have been the bestowing of leadership on a single individual, in the person of Robert d'Arbrissel. The charismat is identified in a charter of 1100–1102/1105 as "first father and pastor of our congregation," marking a shift from the notion of a group of hermit-canons to a congregation.[28] By c. 1100, d'Arbrissel had departed La Roë to establish Fontevraud. A first prior, Gautier le Petit, is named in a charter dated 1100–1101.[29] Two other priors, neither of whom was one of the original six hermit-canons, held the office before an abbot was chosen in 1102/1105, probably, as Bienvenu suggests, to accommodate the absences of Robert d'Arbrissel.[30] The naming of other officers, e.g., sacristan, and the presence of *pueri* in this period, also attests to the growth of the community.[31] The final stage in the transformation of the group of hermits came in late December 1102/1105, when Quintin was elected as the first abbot and blessed fifteen days later.[32] Abbot Quintin was one of the original six canon-hermits whose name appeared second in the foundation charter, immediately after Robert d'Arbrissel's.

From the early charters, and from Baudri's "Life," it is clear that the act of foundation of what was to become the abbey of Notre-Dame de La Roë resulted from negotiations between Robert and his five companions, their secular patron, Renaud of Craon, Pope Urban II, and Geoffrey of Mayenne, the bishop of Angers. It also seems clear that the six priests were already formally established at the site of the future abbey as a community of hermits and that the act of foundation marks a transformational moment in the history of the site and its community. The charters also reveal that the canons were to build a church in honor of the Virgin, which church was dedicated, and a cemetery blessed, little more than a year later. Bienvenu infers from this that the building was, at least in the greater part, built of wood.[33]

There is no reason to suppose that the complicated process of transforming a formalized group of six hermit-canons into a full-blown Augustinian abbey would be exactly replicated at the three other sites we consider below. Each of those communities had their own set of

complicated circumstances. The great advantage of the evidence for La Roë is that we have the documentation that allows us to see in detail one set of circumstances that permitted hermits to become monastics.

The site

The abbey of Notre-Dame de la Roë sits in the center of a tiny village in the northernmost part of the diocese of Angers, about halfway between the town of Craon and the village of Arbrissel from which Robert took his name.[34] Today La Roë is surrounded by farmland, but Robert's initial hermitage settlement was within the forest of Craon and the brothers were obliged to clear lands that became the site of the Augustinian abbey. For about two decades after the formal act of foundation, the new house was known as S. Maria de Bosco or de Silva.[35]

The church

As noted earlier, the first church at La Roë was consecrated by the bishop of Angers little more than a year after the formal establishment of a community of hermit-canons. This building, of which nothing material is known, was likely small and built of wood. It has been reasonably assumed that a second, larger, stone church was begun around the time that the first abbot was elected and installed, though there is no documentation for this.[36]

Substantial portions of that second church remain in elevation on the site today (Figs. 1, 2). Notre-Dame de la Roë is an aisleless, cruciform church, its nave opening into a square, towered

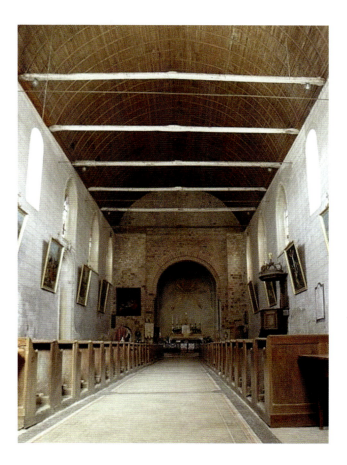

1 Notre-Dame de la Roë, view of the interior from west to east.

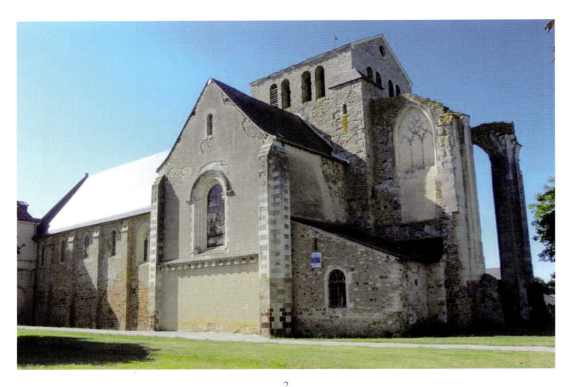

2
Notre-Dame de la Roë, view of the church from the southeast showing the nave,
transept, and ruins of the Late Gothic choir.

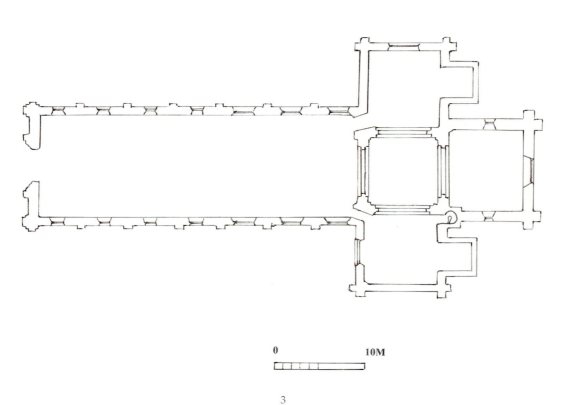

3
Notre-Dame de la Roë, reconstructed plan of the second church.

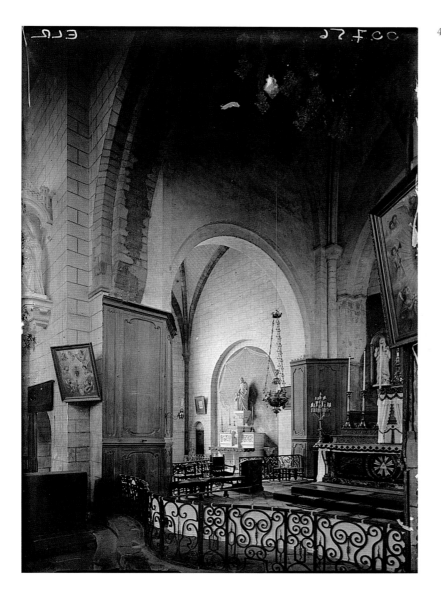

4 Notre-Dame de la Roë, view into the north transept arm showing the blocked arch that opened into a now missing absidiole.

crossing and, through unequal lateral passages, into square, single bay transept arms (Fig. 3).[37] A square stair turret, giving access to the tower, occupies the southeast corner of the crossing bay and is entered from the south transept arm. The original choir and sanctuary were replaced in the late Gothic period. Most of that structure and the spire over the crossing collapsed in 1795 and were never replaced. The nave, transept arms, and original choir are separated from the crossing by diaphragm arches intended to help support a crossing tower. In the eastern wall of each arm, a blocked arch presumably once gave into absidioles (Fig. 4). Today, a small, square structure with a sloping roof (see Fig. 2) occupies the area immediately behind the blocked arch on the south side. Presumably this structure is not original and replaced a more typical absidiole terminating in a small semi-circular apse. Nothing is known of the original apse. If, however, the absidioles terminated in apses rather than flat walls, their form would suggest that the original termination of the twelfth-century sanctuary was also semi-circular.

 The twelfth-century part of the church of La Roë is built of a combination of granite and *grès roussard*, a type of dense, iron laden sandstone, both quarried locally with the former appearing

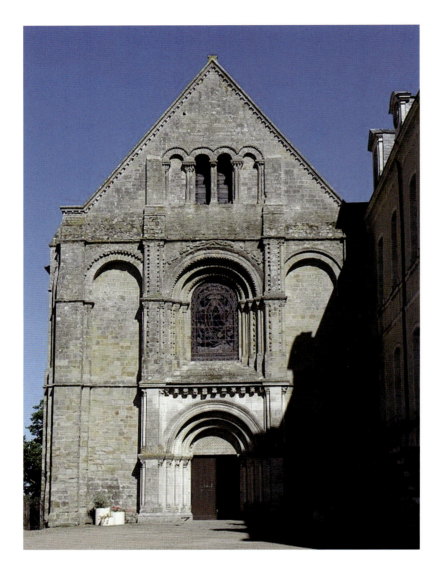

5 Notre-Dame de la Roë, view of the west façade.

primarily in the upper half of the four westernmost bays of the nave and the façade. As Jacques Mallet has observed, it is not merely the difference in stone that suggests a second campaign, but rather that the change in stone is paralleled by a change in stone cutting, from *moellons* to *moyen appareil*.[38] This also suggests the discovery of, or access to, a different quarry. Larger windows, filled with flamboyant tracery, occupy the three easternmost bays of the nave and were presumably inserted at the same time the choir and sanctuary were rebuilt. It may be that the difference in fenestration marked the difference between the liturgical choir of the canons and the parish church, at least in the late medieval period. The smaller, round-headed windows, set high in the wall and framed by a header moulding, are presumably the original, twelfth-century windows.[39]

The façade of La Roë is a carefully conceived design, its composition integrated both vertically and horizontally (Fig. 5). Decoration, as befits a reformed house of Augustinian regular canons, is kept to a minimum and is understated. A band of corbelled heads and an arc of fantastic beasts constitute the extent of the sculpture. The absence of figuration and narrative reliefs is notable.[40]

The west façade of La Roë is built with a thicker wall than the walls of the nave, a difference necessitated by the façade's layered composition. Comprised of two stories beneath the gable, the façade is subdivided by four buttresses, the two outer ones wider and simpler than the two inner ones that frame the portal in the center. The portal, which has been heavily restored, is composed of splayed embrasures that step back to carry columns that, in turn, support moulded archivolts that frame a tympanum and a thin lintel borne on the jambs.[41] The row of corbelled heads extends above the portal just below the cornice that divides the first and second stories. At ground level, the lateral bays of the façade are simple flat walls.

The second story consists of a central window framed by stepped embrasures corresponding to archivolts that replicate the composition of the façade below. The projecting moulding above the outer archivolt carries a series of griffons carved in low relief. The central buttresses are framed on both sides by four pairs of columns that correspond in height to the subdivisions of the central bay: the embrasure zone (1), the tympanum and archivolt zone (2), the embrasures of the window zone (3), and the archivolt area above the central window (4). The lateral bays culminate in semi-circular arches carried on the thin pilasters that frame the buttresses. Finally, in the gable area between the buttresses, there is an arcade of four arches borne on paired columns, the central three of which frame a pair of round-headed windows.

According to the authors of *Gallia christiana*, Abbot Robert II de Montenazé (kn. 1128–1140?) completed construction of the twelfth-century church, and had it consecrated.[42] Mallet, citing Angot's reference to post-consecration charters, believed that the church was not complete at the time of consecration and was finished only later, probably during the reign of Abbot Michel (r. 1149–1170).[43] Though he does not say so explicitly, Mallet seems to associate the upper walls of the nave and the façade (i.e., the granite parts of the church) with this later work.

We think, however, that the issue of the construction chronology is more complex and less evident. Angot's remarks are worth quoting *in extenso*:

> On travaillait depuis longtemps à la construction de l'église abbatiale. Enfin, de 1137 à 1139, l'archevêque de Tours, assisté des évêques de la province: Ulger d'Angers, Hamelin de Rennes, Hugues du Mans, Danoald de Saint-Malo; des plus hauts barons: Guérin de Craon, Guy de Laval, Guillaume de la Guerche, Hamon, son frère, etc., consacra l'édifice, probablement le 9 août, car la foire instituée à cette occasion se tint depuis à pareil jour. On continua pourtant encore de travailler au monument, et les dons se multipliaient pour qu'il fût magnifique, *ad opus ecclesiæ ædificandum tam magnum quam ædificari possit* [to the work of building the church as great as it can be built].[44]

First, as Angot makes clear, we do not have a fixed date for the consecration of La Roë, which is often given as c. 1138.[45] Second, while Angot provides a list of his sources for his remarks on the commune of La Roë, he gives no specific source for the Latin clause quoted above.[46] We thus do not know the context of the quotation and cannot judge whether the gifts were prospective or retrospective. In its entry for Abbot Robert II, *Gallia christiana* describes gifts of churches to La Roë by Bishop Hamelin of Rennes and others, before it mentions the consecration. Mallet mentions

that a bull of 1136 (Pope Innocent II, r. 1130–d. 1143) confirmed La Roë in its possession of thirty-one churches and that a bull of 1184 (Pope Lucius III, r. 1181–d. 1185) doubled that number.[47] It is possible that Angot's Latin quotation is metaphorical, meaning gifts to the *spiritual* work of the church, building it as great as it can be through the gift of lesser churches to control in the sense of the reform movement of which La Roë was so important in western France.

Further, if the dedication of the church involved a pope, or perhaps even just the archbishop of Tours, we might suspect it was a consecration of opportunity, depending upon a visit for some other purpose and having no necessary relationship to construction.[48] The list of participants in the consecration given above by Angot, and confirmed by *Gallia christiana*, suggests an elaborately planned event for the consecration of a church that had been completed, as the author of *Gallia christiana* claims.

To summarize our discussion of the first abbey of regular canons established in the archdiocese of Tours, Notre-Dame de La Roë grew out of a small community of hermit-canons into an abbey of considerable wealth and power, and did so in less than fifty years.[49] The abbey was sited in the "desert," that is, within the forest of Craon. The church built by/for the new canons took a century-old form—the aisleless cruciform plan. In the west of France, this form dates at least to the early eleventh century, as in the cathedral of Angers.[50] The choice of this older form, which also appeared in lesser churches, by a community of Augustinian canons participating in the monastic reform movement changed its meaning. Simple in plan and austere in decoration—devoid of figural narrative on its west façade—La Roë marked this older plan type as appropriate for churches of the reform movement. In the discussion that follows, we make the case that the canons of La Roë constituted the first of the western French eremitic groups to become regular. These groups chose wilderness sites that were located in the Mayenne, in Brittany, and in the western reaches of the Île-de-France. As we will see, all of these communities adopted the aisleless cruciform plan and chose to decorate their buildings austerely, using local stone and simple masonry techniques.

The monastic complex of Fontevraud

Soon after the formal foundation of his group of hermit-canons at La Roë, Robert of Arbrissel moved on to Fontevraud to establish a double monastery. Fontevraud is the best known of any of the monasteries of eremitic origin in the west of France founded by hermit preachers around the beginning of the twelfth century (see Map). Its second church (Fontevraud II), and indeed the monastery as a whole, is also the best preserved of any of the new communities established by those men. As a result, it is the most frequently studied and the most fully restored.

Foundation

Robert of Arbrissel had a long and varied career, in the early part of which he served as archpriest of the diocese of Rennes. By 1095, he had chosen to become a hermit and retreated into the forest of Craon, where, as we have seen, he established the house of regular canons at La Roë.[51] As Robert traveled around western France attending councils and preaching, his charismatic nature and zeal for reform again attracted followers, many of whom were women. Around 1100, Robert and his followers settled at Fontevraud.[52] By 1106, both the bishop of Angers and

Pope Pascal II had recognized Fontevraud as a community of religious. Robert wrote a rule for his new community, leaving the convent and the entire complex under the charge of an abbess. A church for the priests serving the altars of the nuns' church, a chapel in the house for former prostitutes and one in the Lazare house (for lepers) completed the community. Not long after, Robert returned to itinerant preaching, leaving his new community under the leadership of Hersende of Champagne, who was followed by Petronille of Chemillé in 1115, regarded as Fontevraud's first abbess. It was Petronille who commissioned the "Life" of Robert of Arbrissel that provides us with so much information about his career.

Bienvenu has traced Robert's negotiations with secular nobility to establish the abbey.[53] The success of these negotiations is reflected in the gifts of lands and resources that made Fontevraud possible. Bienvenu relates the gifts made to Robert and his nuns that positioned the new community strategically in the county of Anjou, but within the diocese of Poitiers. Ecclesiastical support is reflected not only in the recognition of the new monastery by Pope Pascal II and the bishop of Angers, but also in the choice of four bishops of Poitiers to be buried there: the contemporary reformer, Pierre II (d. 1115); Guillaume I Gilbert, Pierre's successor who died at Fontevraud (d. 1124); and two others.[54]

The abbey site

Fontevraud is located in the forested hills east of Tours and south of the river Loire. The medieval notion of founding a new monastery, especially one growing from the eremitic tradition, consistently refers to the isolated and uninhabitable nature of a new community's site. This trope is repeated in the early lives of Robert of Arbrissel.[55] Although still isolated today, however, the area around Fontevraud was, and is, rich in timber and building stone, with quarries yielding ample amounts of *tuffeau*, a soft limestone, making the materials for constructing the new monastery an immediately local matter. The site was neither arid nor completely unsettled at the time the first monastic community arrived, as claimed by Baudri, bishop of Dol, in his life of Robert d'Arbrissel.[56] Three streams supply water to the communities of Fontevraud and there were at least two mills along one of them at the time of foundation.[57]

The churches of Notre-Dame de Fontevraud (I and II)

The church of Notre-Dame de Fontevraud II is an archetypal monument of the Romanesque in twelfth-century western France (Fig. 6a). An aisleless, cruciform structure, it terminates in an apse, ambulatory, and three radial chapels.[58] A single absidiole opens off each arm of its north and south transepts. The three large bays of its nave are surmounted by domical vaults borne on pendentives and the crossing by a massive tower. The interior impresses with its richly articulated mural surfaces: projecting piers that support the vaults; dado zone blind arcading; wall passages beneath the windows that are, in turn, framed by colonnettes; and richly carved capitals.[59] The sculptural richness of Fontevraud's interior, its vaulting, and the complexity of its chevet arrangement combine to make it a classic example of Romanesque architecture. The present church of Notre-Dame de Fontevraud is, however, the second conventual church on the site.[60] As such, it gives what may be a misleading impression of the founder's original intentions.

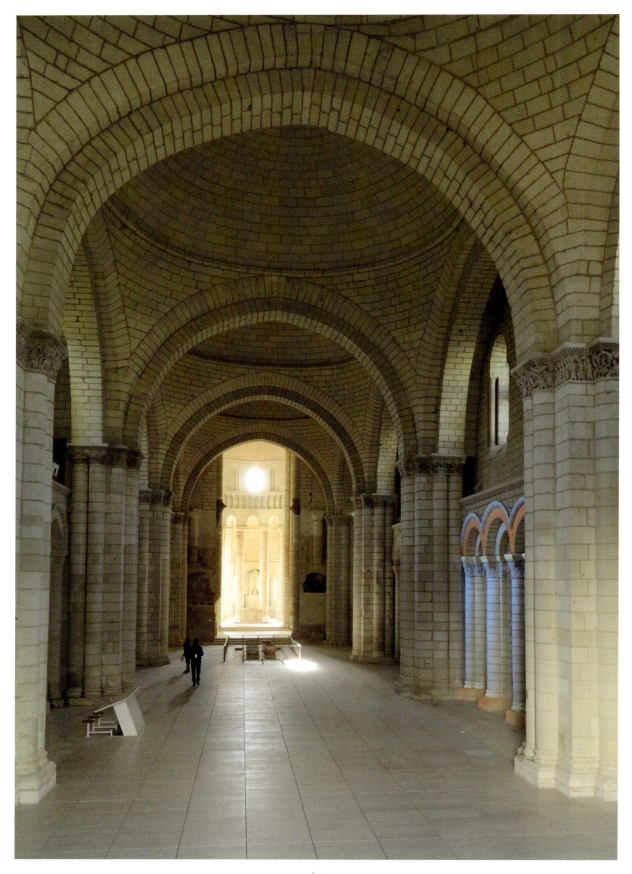

6a
Interior of Fontevraud II, view toward the east.

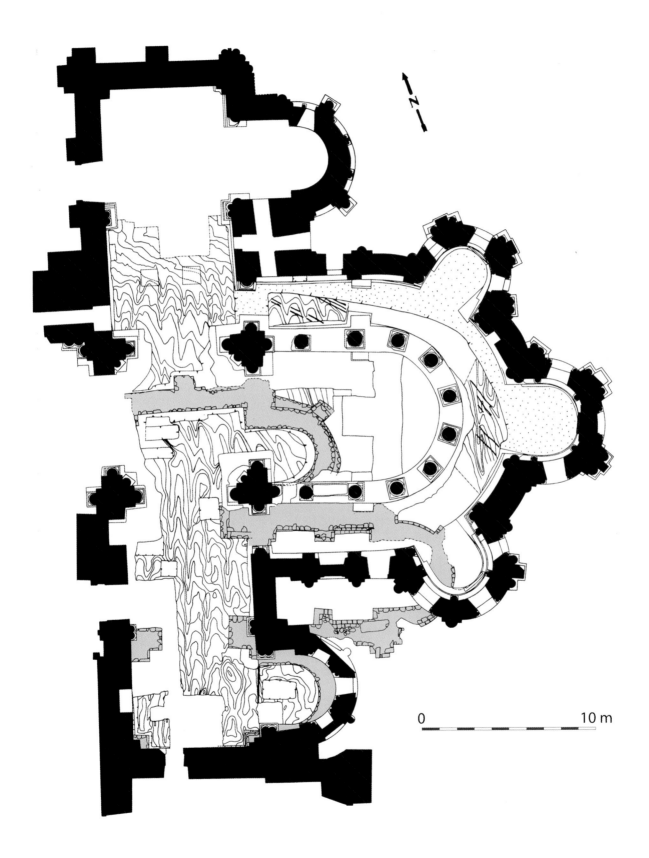

6b
Excavated plan of Fontevraud I, courtesy of Daniel Prigent.

Excavations carried out between 1986 and 1990 at the crossing and the south transept arm of the existing church have revealed parts of an earlier stone church on the site (Fig. 6b).[61] The archaeological evidence is not, however, decisive for an understanding of the complete plan of Fontevraud I. The excavations revealed the foundations of a two-bay choir terminating in a semi-circular apse as well as portions of what are presumed to be relatively short transept arms.[62] They also revealed the single absidioles that opened off each arm, absidioles that were set very close to the exterior walls of the choir. The only part of the nave brought to light was a portion of the southeast crossing pier, and the archaeologists suggest that the nave may never have been completed. Daniel Prigent and his team believed that the revealed remains of Fontevraud I were those of an aisleless, cruciform building.[63] One might add that the plan of Fontevraud II supports this interpretation, as does the plan of the church Robert built at La Roë, since both adhere to this form.[64] One might also add that the revealed parts of Fontevraud I are almost identical to the original plan of the near-contemporary parish church of Notre-Dame de Chemillé, whence came the first abbess of Fontevraud.[65] Nevertheless, the proximity of the absidioles to the choir suggests the possibility of an apse-*en-echelon* composition, which would not preclude a nave flanked by side-aisles and a basilican cross-section.[66]

We can say nothing about the decoration of Notre-Dame de Fontevraud I, which did not survive the twelfth century. We can, however, assert that its most likely plan resembles much more closely the plans of Étival and Saint-Sulpice–Notre-Dame du Nid-au-Merle (as we will see below) than it does the plan of Fontevraud II.

The brothers' church at Fontevraud
The priory of the canons regular, Saint-Jean-de-l'Habit, was located about two hundred and fifty meters east-northeast of the church of Notre-Dame de Fontevraud.[67] Abandoned during the French Revolution, Saint-Jean-de-l'Habit was dismantled, serving as a stone quarry. A painted view of the church in the process of dismantlement, dating to 1815 and signed by Vauzelle, shows the remains of a Gothic building with a single-vessel nave seen from behind what appears to be the eastern crossing arch.[68] The view also shows part of one bay of the choir articulated with a dado-zone blind arcade beneath a tall window. Whether the building had a transept is unclear from this foreshortened image alone, but several eighteenth-century plans of Fontevraud provide a plan of the church that shows that Saint-Jean-de-l'Habit had a transept with no projecting absidioles.[69] Thus, the church for men at Fontevraud seems also to have adhered to the aisleless cruciform plan.

The double monastery of Notre-Dame d'Étival-en-Charnie

Like Robert's monastery at Fontevraud, Alleaume's foundation at Étival was a double house. This important but little-studied monastery was located in the forest of Charnie (Sarthe) (see Map). Notre-Dame was the head of its own congregation whose nuns followed the Benedictine rule.

Foundation
The formal act of foundation of Notre-Dame d'Étival took place in 1109 and is recorded in a

charter of Raoul II, viscount of Beaumont-sur-Sarthe.[70] It is clear from the charter that the church was already built when the formal act was promulgated and that the church was consecrated on the same occasion.[71] The circumstances of foundation are nevertheless complex.[72] Several years earlier, Alleaume, whom the charter identifies as being "born of distinguished lineage," had evidently established a hermitage in a place bristling with brambles (*horridum vepribus locum*) called Saint-Nicolas-en-Charnie where a much-rebuilt chapel still survives.[73] Alleaume, by his life and preaching, attracted people to the hermitage, some of whom may (or may not) have been women. At this point, Alleaume entered into negotiations with Raoul II of Beaumont who gave land to establish a house for women at Étival-en-Charnie in the year 1109. Raoul's sister, Godehildis of Beaumont, then a nun at Ronceray, became the first abbess.[74] The male community at Saint-Nicolas is not thought to have long survived the foundation of the convent.

A double community may have been intended from the outset near the chapel of Saint-Nicolas, but resources and/or land may not have supported that goal. A happy congruence of circumstances seems to have led to the foundation of Notre-Dame d'Étival in a more propitious location. Godehildis appears to have wanted to transform her religious life, perhaps through contact with Alleaume, who was already in the area, or earlier through the intermediary of Robert of Arbrissel. She may then have prevailed upon her brother to provide land and support for a new community and, with the blessing of Alleaume, have become head of the community, much as Pétronille of Chemillé became abbess of Fontevraud. It may also be that the male community first established at Saint-Nicolas-en-Charnie soon abandoned that site to become the resident priests for the larger female house. Were that to have been the case, they would presumably have had a new chapel built near the convent church, but we have found no record of it and no trace of its existence has been found on the site.

The abbey site
The abbey of Notre-Dame d'Étival-en-Charnie was, and is, located in the forest of Charnie, near the small town of Chemillé-en-Charnie (Fig. 7). The site has, since the French Revolution, become a farm. Nothing remains of the conventual and other buildings, save for a large gatehouse/guesthouse structure on the north side of the church. That building is today roofless and in ruinous condition. Of the church, only the north transept arm survives (Fig. 8). The transept arm, and presumably the rest of the church, were constructed of *moellons* and *petit appareil* of *grès roussard*, laid in relatively regular courses set in thick beds of yellowish mortar. Buttresses, wall angles, and window embrasures are built of dressed blocks of the same stone, which is known throughout the region and used, for example, in the nave of the cathedral of Le Mans and, as we have seen, at La Roë and (as we will see) in the abbey church at Tiron. Ample sources of water are available in the immediate area, as surviving ponds east of the church make clear. Wood remains easily accessible, even today, in the forest of Charnie where the site is located.

The nuns' church of Notre-Dame d'Étival: description and analysis
A late seventeenth-century watercolor view by Louis Bourdan, together with the remains of the north transept arm and a schematic plan of the site dating to 1790, permit us to describe the plan and elevation of the church as well as to discuss aspects of its construction technique, decoration, and dating (Fig. 7).[75] Bourdan's view allows us to state that the remains of the north

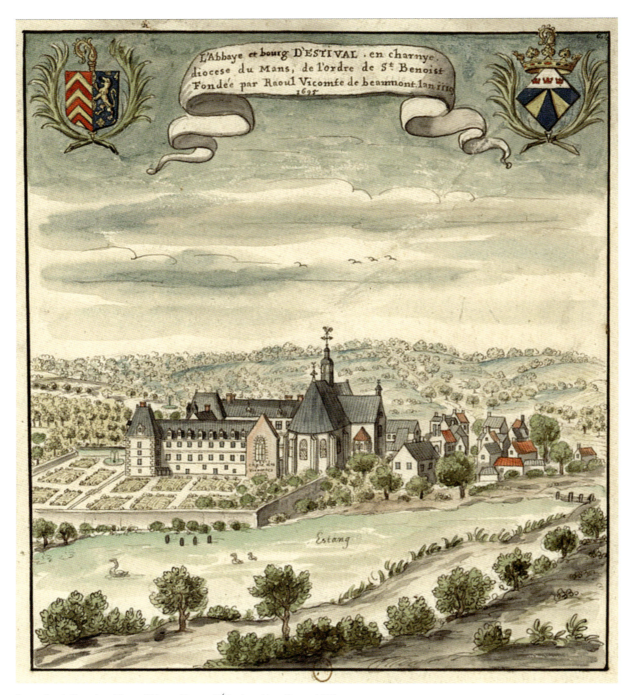

7 Louis Bourdan, View of Notre-Dame d'Étival and its village, 1695.

transept, and its single absidiole, constitute the entirety of that part of the building, since the arm in his image is relatively short. On the south side of the church, Bourdan has represented no transept arm, choosing instead to show an awkwardly placed, evidently Gothic chapel, labelled "Chapelle des viscounts." The chapel once contained a series of dynastic tomb sculptures for the Beaumont family, a number of which survive in the Musée d'archéologie et d'histoire in Le Mans.[76] The Gothic chapel, although larger than the north side absidiole, occupies the same position as the presumed original south transept arm and absidiole. As it is shown, this chapel

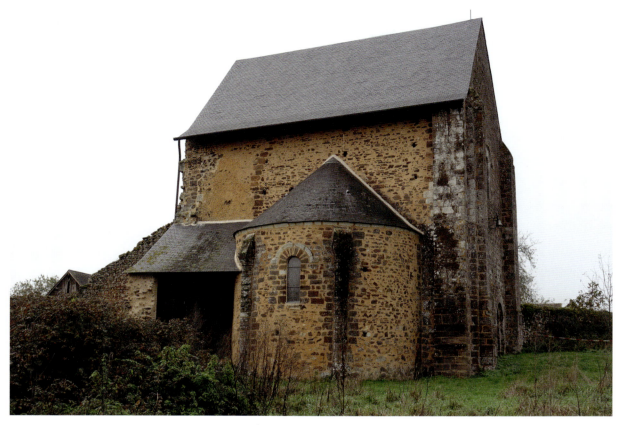

8 View of the north transept arm and apsidiole of Étival from the east-northeast.

appears to be free-standing, but a much more likely circumstance is that it replaced an earlier absidiole and was attached to a south transept arm that Bourdan did not represent, perhaps for compositional reasons. In the tiny space between the chapel and the church is a partial view of the west claustral range.

The west side of the surviving transept arm shows no trace of a side aisle (Fig. 9a), confirming the early modern plan's representation of an aisleless nave (see Fig. 7). Moreover, twelve courses of the northwest crossing pier and vestiges of an adjacent, narrow, lateral passage between the nave and transept remain in elevation (Fig. 9b). Lateral passages of this type are widespread in single nave churches in western France beginning with the cathedral of Angers around 1025.[77]

In most large churches with short architectural choirs, the enclosed area of the liturgical choir extended into the nave. The lateral passages permitted access to the transept arms and to their chapels directly from the nave without having to pass through the liturgical choir. While Bourdan's view of the apse shows it as semi-circular, the 1790 plan clearly indicates its three angled walls. These observations allow us to assert that the church at Étival was an aisleless, cruciform building with a short choir most probably terminating in a polygonal apse (see Fig. 7).

Surviving decorative elements are confined to two capitals and bases of columns articulating the buttresses of the north transept absidiole, and two others found inside the north transept arm. Carved from recalcitrant *grès roussard*, the capitals consist of a slightly curved bell decorated with interlaced, tubular forms arranged in abstract patterns. The windows in the

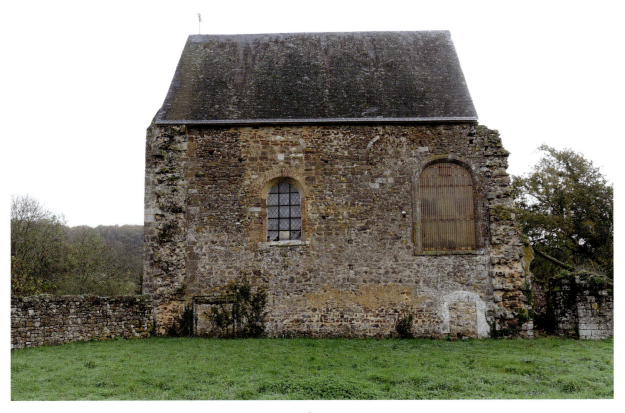

9a
View of the north transept arm of Étival from the west.

9b
Étival, remains of the northwest crossing pier and the adjacent lateral passage.

surviving absidiole and the terminal wall of the transept arm are narrow and round-headed.

While the surviving evidence is limited, the construction technique and the decorative forms are commensurate with a church built in the first part of the twelfth century. The rest of the monastery, at least as Bourdan represents it, included claustral ranges of the early modern period as well as the Gothic funerary chapel that presumably replaced the original absidiole on the south transept arm. The pictorial and material evidence suggest a successful house of Benedictine nuns, which responded to increased wealth and changing patronage conditions but maintained its original church for reasons of tradition and piety.

The brothers' church of Saint-Nicolas-en-Charnie (known as the Chapel of Saint-Alleaume)
The chapel of Saint-Alleaume, located along the road between Torcé-Viviers-en-Charnie and Blandoet, is a small rectangular building entered from the west (Fig. 10). Its walls are built of rubble with roughly dressed blocks of *grès roussard* at the quoins and within the round arch that frames the western portal. Portions of this much reworked building may date to the twelfth century.[78] How long this small church remained in service for brothers serving the altars of the nuns of Étival is unclear. While it is often thought that the chapel did not survive the death of the founder, Alleaume, in 1152, there is mention of an *ecclesia sancti Nicolai in Charnia* in 1197.[79]

One might expect the community of brothers serving the altars of Étival to reside within a few hundred meters of the nuns' church, as they did at Fontevraud and Saint-Sulpice–Notre-Dame du Nid-au-Merle, but the chapel of Saint-Nicolas lies on the opposite side of the Forêt de la Grande Charnie, distant across it by a little less than six kilometers. Although this distance is exceptional, we think it results from the circumstances of foundation. Alleaume's community

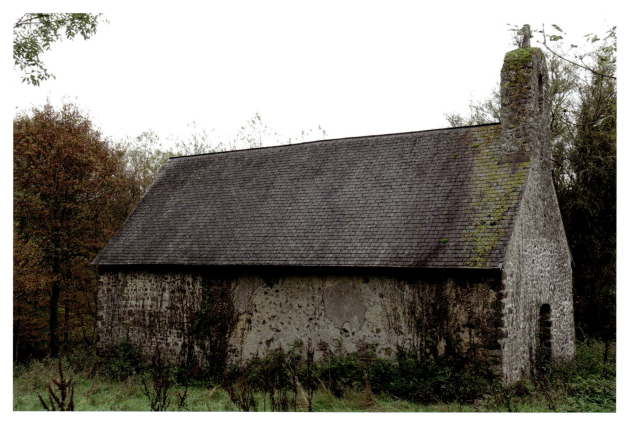

10 View of the Chapel of Saint-Nicolas-en-Charnie (Saint-Alleaume) from the northwest.

of brothers was already in existence before Étival was established. Further, while the distance of six kilometers might seem daunting to us today, the one-hour walk was certainly less so for the priests of Saint-Nicolas who were accustomed to living in and moving through the forest.[80]

The "double monastery" of Saint-Sulpice–Notre-Dame du Nid-au-Merle[81]

Raoul de la Futaie, former monk of Saint-Jouin-des-Marne, hermit, preacher, and companion of Robert d'Arbrissel, established the abbey of Notre-Dame du Nid-au-Merle in the forest of Merle near the village of Saint-Sulpice-la-Forêt, some fifteen to twenty kilometers outside the episcopal town of Rennes (see Map).[82] Founded for Benedictine nuns, the abbey had its own customs.[83] It evidently also had a double dedication, sometimes called Saint-Sulpice in the documents, sometimes Notre-Dame du Nid-au-Merle, and sometimes both.

Foundation

No foundation charter survives that might yield details of the circumstances of the new monastery's foundation, or that might provide a precise date for the formal act it recorded. The authors of *Gallia christiana* thought the formal foundation occurred "around 1112," which, if true, suggests that the process of establishment must have begun earlier in the twelfth century.[84] Further, historians of the Saint-Sulpice—Notre-Dame du Nid-au-Merle have complicated the issue by pointing out that an abbey was founded at Saint-Sulpice-la-Forêt in the late tenth century by Conan I, citing numerous and important gifts made to that abbey and later enumerated by the archbishop of Tours in 1127.[85] What these authors seem to have overlooked is that part of the process of reform in the eleventh and twelfth centuries involved giving older, often failed, houses to a new community in order to extend the reform. Thus, Saint-Sulpice–Notre-Dame du Nid-au-Merle may in fact have been a re-foundation.[86]

At Saint-Sulpice-la-Forêt, the new church seems to have been finished when it was consecrated in 1117.[87] Presumably a set of claustral ranges and other essential structures were complete at that time as well.[88] Nevertheless, it seems reasonable to assume that, early in the twelfth century, Raoul had entered into negotiations with Duke Alan IV of Brittany (r. 1084– abdicated 1112; d. 1119) and his son Conan III (r. 1112–1148) to gain land and support for his new foundation. This seems likely since Duke Conan III of Brittany held a council with his barons there in 1146/47.[89] Moreover, early charters of the monastery attest to Raoul's activities on behalf of his new monastery. A charter issued in 1117 by Fulques V (r. c. 1089/92–d. 1143), count of Anjou, gives lands to the (unnamed) abbess and the nuns of the new abbey, and places them in the hands of Raoul who is called "monk and master of the nuns."[90] According to an episcopal charter, Bishop William I of Poitiers (r. 1117–1124) gave the church of Saint Mary Magdalen in Fougereuse to Raoul for the nuns of his new monastery to have as part of their domain.[91]

There is considerable controversy about the early leadership of the monastery of Saint-Sulpice–Notre-Dame du Nid-au-Merle. The notion that strong early leadership correlates well with the success of a new foundation helps explain the attention given to the chronology of early abbesses. This problem originates with a charter of Henry II Plantagent dated to about 1155–1158, which states that "... the manor of Lillechurch and all its appurtenances are conceded

to Marie [of Blois], daughter of King Stephen, and to her nuns"[92] Marie of Blois entered monastic life at the priory of Lillechurch, which belonged (probably from before this time) to Saint-Sulpice–Notre-Dame du Nid-au-Merle.[93] Henry's charter, however, makes no mention of Saint-Sulpice–Notre-Dame du Nid-au-Merle, and that abbey's charters make no explicit mention of Marie of Blois.

Scholars initially considered Marie of Blois the first abbess of Saint-Sulpice, one who ruled from 1117 to about 1159.[94] Given that Marie of Blois, the last of King Stephen's children, was born only in 1136, such a long career was never possible. A competing proposal has been made, asserting that a Breton princess, called Marie de Bretagne, was the first abbess, to be followed by Marie of Blois. We have identified no noblewoman who could be called "Marie of Brittany" and we do not think that Marie of Blois was ever abbess of Saint-Sulpice–Notre-Dame du Nid-au-Merle.[95]

It is likely that the first abbess was a noblewoman, as was the case at Étival and Fontevraud. The cartulary evidence for Saint-Sulpice allows us to state that an abbess, identified only as "M.," is known from charters of 1127 and 1131.[96] An abbess named Maria is known from a papal pancarte of Eugenius III dated to 1146.[97] Presumably it is this same Maria who is named in another charter of 1146 and four others ranging in date from 1146/47 to 1156.[98] Four charters, one datable to 1156–1166, one to 1161, and two to 1164, name "Nine" as abbess.[99]

Questions regarding the succession of abbesses of Saint-Sulpice do not end with resolving the "Marian problem." Duke Conan IV, who reigned from 1156 to 1166 when he was forced to abdicate, ". . . gave and conceded to Ennoguent, my sister, and to the holy nuns of Saint-Sulpice my land of Merle"[100] As is the case with the charter of Henry II, there is no explicit identification of Ennoguent as abbess, although some scholars have assumed that she was, as the authors of *Gallia christiana* attest.[101] The next abbess of whom we know is Amelina of Scotland, who is identified in the *necrologium* of Saint-Sulpice as ". . . our fourth mother . . ." (*nobis mater quarto*).[102]

The cartulary entries thus provide us with the first names "Marie," "Nine," and "Amelina." Assuming the necrology to be correct in asserting that Amelina was the fourth abbess, we are left with two choices. Either "M." and "Marie" are one and the same and Ennoguent was the third abbess, or "M." and "Marie" were two different women and Ennoguent was never abbess of Saint-Sulpice. At present, there seems to be no way to resolve the issue. If "M." and "Marie" are one and the same person, then her long reign from c. 1117 to c. 1160 (longer even than the thirty-five-year reign of Petronilla of Chemillé as first abbess of Fontevraud) attests to good and strong leadership that helped set the monastery on its course to international success. In that case, Ennoguent as the third abbess may have continued a tradition of leadership originating in the high nobility of Brittany. If, on the other hand, "M." and "Marie" are not the same person, then we can say less about strong leadership as a source of the monastery's early success.

The abbey site
The monastery of Saint-Sulpice–Notre-Dame du Nid-au-Merle sits on rising land just outside the small town of Saint-Sulpice-la-Forêt, only a few hundred meters from the forest and a small lake. Now the site of a charitable institution, nothing remains of the medieval claustral ranges.[103] Substantial ruins of the church do survive, however, and permit its study.

The church of Saint-Sulpice–Notre-Dame du Nid-au-Merle: description and analysis
Remains of the church at Saint-Sulpice–Notre-Dame du Nid-au-Merle are sufficient to permit us to say that the building was a large and impressive structure (Figs. 11–13). Constructed of local stone—granite and two types of *grès* (*roussard* and *alois*)—the walls are built of roughly-coursed rubble and *moyen appareil* with dressed masonry occurring mostly in the exterior buttresses, the crossing piers and wall angles, and window and door embrasures.[104]

In plan, it was an aisleless, cruciform structure terminating in a semi-circular apse (see Fig. 11). Single absidioles project from each of the broad transept arms as they did at Notre-Dame d'Étival. Anger claims that the church was "entirely ruined" in 1342 during the Hundred Years' War, which cannot literally be true.[105] Significant damage to the church and monastery also occurred in 1556 (fire), 1616 (*violente tempête*), and 1651 (fire).[106] The nave was re-roofed and the crossing tower rebuilt in wood following the fire in 1556. The nave, originally five bays long, was shortened to the three that remain and was re-roofed following the violent storm of 1616 (see Fig. 13). It took nearly forty years to repair the church and monastery after the fire of 1651.

The absence of any trace of piers on the inside of the nave walls, together with its width (12 meters), ensure that the building was never vaulted. The western crossing piers are inset from the nave walls, leaving room for lateral passages into the transept arms and their chapels.[107] In plan, the square of the crossing bay is replicated in the bay of each transept arm and in the choir. It has been suggested that the crossing was originally vaulted, on the basis of the columns in the pier angles that rise above the consoles that frame the sides of the crossing bay.[108] We think it more likely that the columns originally rose to the top of the crossing bay—to the point where the roof of a crossing tower began—with the floor borne by consoles built at a lower level, presumably to support a wooden belfry.

The choir was barrel-vaulted; the base and two semi-column drums of an attached pier can still be seen on the north side and almost certainly corresponded to a transverse arch (Fig. 14a). On the exterior of the choir, the presence of two pairs of buttresses—one pair in the middle of the choir, the other at the head of the apse—suggests that the architectural choir was divided into two bays, before giving onto the semi-dome of the apse.

The broad transept arms reveal no evidence of the piers that would have been necessary had the spaces been vaulted (Fig. 14b). It must therefore have had an open trussed roof as there are no traces of consoles to support a flat ceiling. A blocked, round-arched window appears below a wider one in the terminal wall of the south arm, an alteration that makes clear that the transept was raised, probably during the Gothic period as the slightly pointed arch of the higher window suggests. A substantial amount of red false joint wall painting still survives on the terminal wall of the south transept, and the rest of the interior, with the possible exception of the sanctuary, must originally have been so decorated.[109]

Each of the absidioles consists of a barrel-vaulted bay, separated from a semi-dome by a transverse arch borne on rectangular piers. Three round-arched windows originally lighted the chapel spaces, though the axial window in the north absidiole has been widened. The north side differs from the south in that a spiral staircase has been built between the absidiole and the choir. This stair vise gave access to the upper parts of the crossing tower. At the end of the southern terminal wall of the transept, there is a semi-subterranean, barrel-vaulted, rectangular space that is thought to have served as the burial chamber of the monastery's founder.[110]

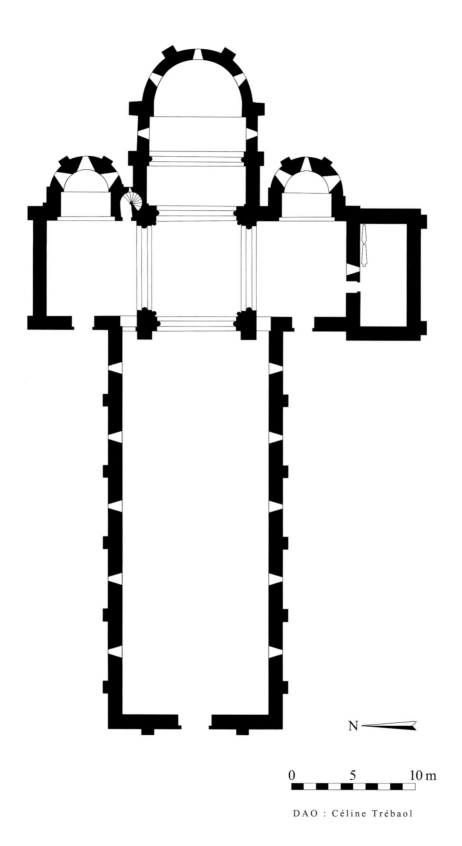

11
Reconstructed plan of Saint-Sulpice-le-Forêt–Notre-Dame du Nid-au-Merle in the 12th century.

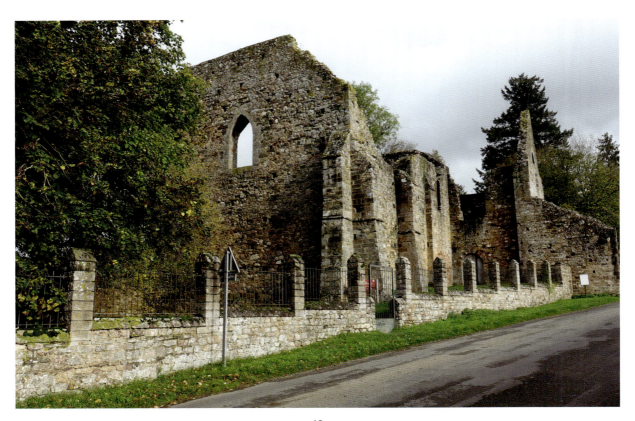

12
View of Saint-Sulpice–Notre-Dame du Nid-au-Merle from the west-southwest.

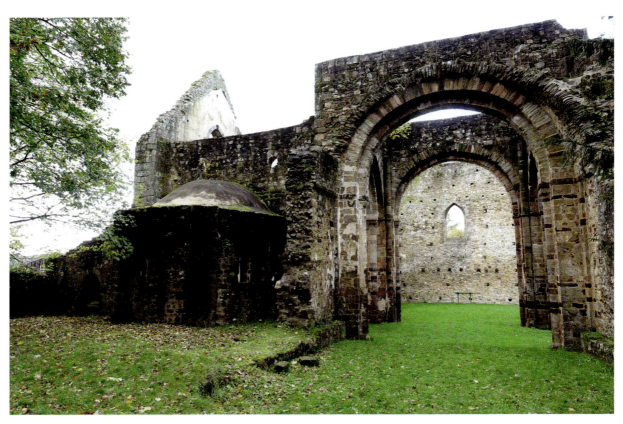

13
View of Saint-Sulpice–Notre-Dame du Nid-au-Merle from the apse foundations to the present western wall.

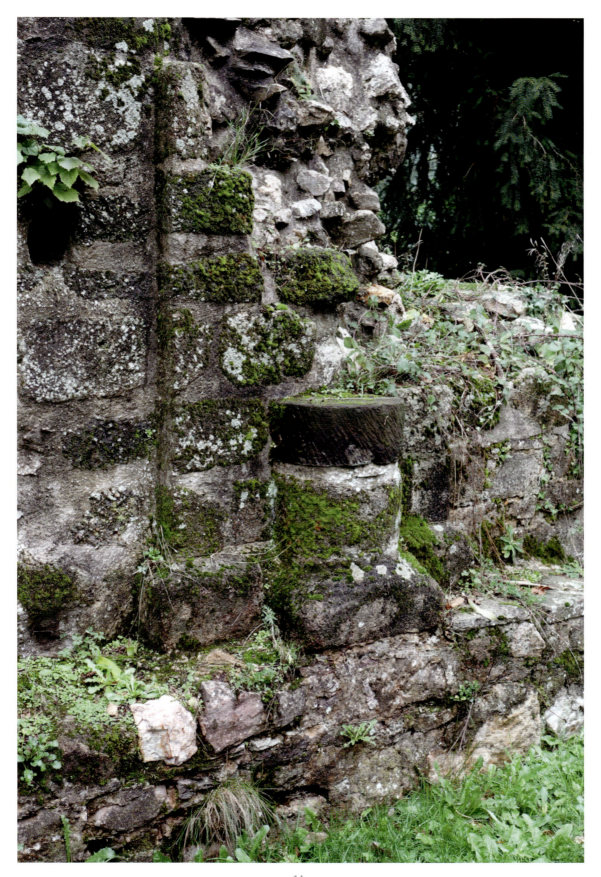

14a
Saint-Sulpice–Notre-Dame du Nid-au-Merle, remains of the attached pier on the north side of the choir corresponding to a transverse arch.

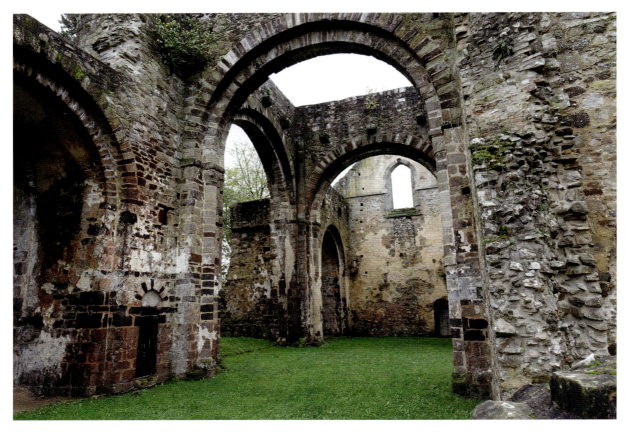

14b View across the transept of Saint-Sulpice—Notre-Dame from the northwest corner to the southeast corner.

Decorated capitals, imposts, and bases (where these survive) exist on the crossing piers. Forms consist of abstract water leaves and geometric patterns in shallow relief, carved from stones that are exceedingly hard to work. One human head occurs on a large, dismounted console. Nothing in any of these forms, limited though they are in number, is inconsistent with a dating in the first quarter of the twelfth century.[111]

The brothers' church of Notre-Dame-sur-l'Eau
We assume that the canons serving the nuns at Saint-Sulpice had a church of their own in proximity to the church of Notre-Dame. Such was the case at Fontevraud, with which Raoul de la Futaie must have been familiar through his friendship with Robert d'Arbrissel.[112] In this section we argue for Notre-Dame-sur-l'Eau as that church.

Located about four hundred meters west of Saint-Sulpice–Notre-Dame du Nid-au-Merle itself, the church of Notre-Dame-sur-l'Eau still survives, though in a ruinous state (Fig. 15a). Anger, citing the canon Amedée Guillotin de Corson (d. 1905), claimed that the chapel was built during the abbacy of Guillemette de Milon who led the nuns from 1427 to 1451(?).[113] Xavier Gilbert and Olivier Guérin date construction to 1435–1440/47, presumably on the basis of style.[114] Finally, Céline Trébaol argues for construction during the years 1426–c. 1437.[115] Guillemette's coat of arms was once visible on the south side of the church. A choir window contained the date 1447 and included an inscription mentioning members of her family.

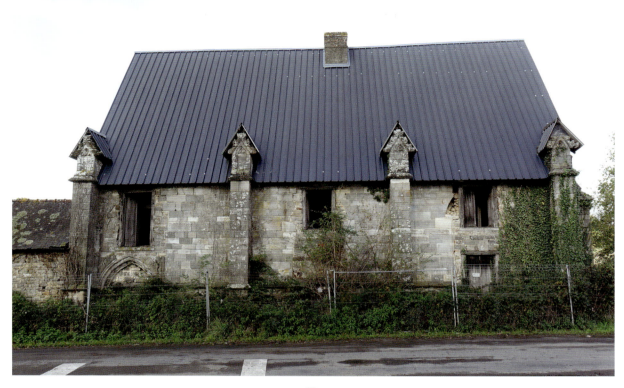

15a
View of the south side of the church of Notre-Dame-sur-l'Eau.

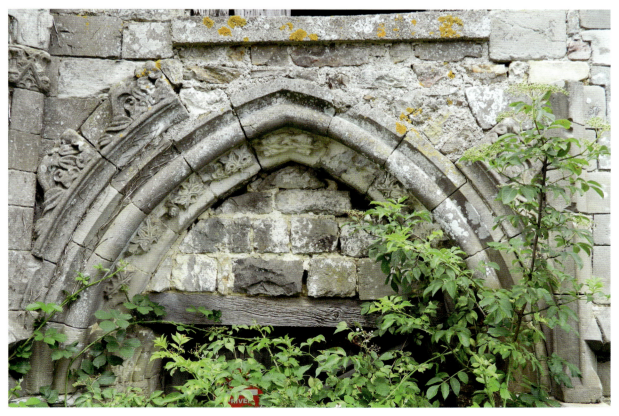

15b
View of the upper parts of the portal in the westernmost bay on the south side of the church of Notre-Dame-sur-l'Eau.

The building, rectangular in plan, consists of three bays, the first of which on the south side contains a sculpted portal (Fig. 15b). While the tympanum is missing, and may have held Guillemette de Milon's coat of arms, its embrasure capitals, foliate archivolt, and spandrel carving provide insight into the quality of the original work and suggest a fifteenth-century date. Traces of a lancet window in each of the remaining two bays on the south side of the church are visible beside the nineteenth-century wood-framed windows that were inserted when the church was converted into a house.[116] On the south side, buttresses crowned by aediculae mark the division of the church into equal bays, but there is no indication on the interior that the building was ever vaulted. The east wall retains a pair of slender colonnettes supporting a single archivolt framing a large lancet window that is now blocked. The terminal wall at the west contains a small oculus, in which enough tracery remains to state that the rosette originally had five lobes. The center of the wall beneath the oculus bears evidence of substantial rebuilding both inside and outside the structure, which in turn suggests that there may have been a large lancet at this end of the chapel as well.

While the south side of the church is marked by four buttresses whose height is augmented by aediculae, only shorter buttresses can be seen at the corners on the north side of the church.[117] In all likelihood this is because canonial structures were attached on the north side of the building and provided lateral support for the building on that side.

It has been suggested that the location of the portal on the south side of the chapel precludes its having been the church of the brothers of the monastery.[118] An 1826 cadaster of Saint-Sulpice-la-Forêt shows what must have been the canonial precinct as a large, roughly square area adjacent to the north side of the chapel.[119] Gilbert and Guérin assert that there is a twentieth-century door on the north side, at the east end of the church.[120] This is, of course, where one would expect the canons' portal to be located. It thus seems possible, perhaps even probable, that the existing door enlarges, or replaces, an original medieval entry that would have given access to the choir from the eastern gallery of the canons' cloister. Only a careful stone-for-stone analysis of the northern wall of the church could determine whether traces of an earlier door remain in the north wall.[121]

The likelihood that the brothers had an entry into their choir on the northern side of the church, presumably from an eastern cloister alley, has implications for the richly sculpted portal on the south side of the building in its westernmost bay. This portal probably served as the portal used by the abbess and nuns for processions from their church to the church of the brothers, as well as for the brothers' processions to Saint-Sulpice—Notre-Dame du Nid-au-Merle, where there may also have been a corresponding "processional portal."[122] Such portals are known from other monastic sites where processions between the churches of the nuns and canons passed in both directions.[123]

The monastery of La Sainte-Trinité de Tiron

Unlike the monasteries of Fontevraud, Notre-Dame d'Étival, and Saint-Sulpice–Notre-Dame du Nid-au-Merle, the new monastery at Tiron became a Benedictine house for men. As we will see, however, women played an essential role in early patronage of the house and at least one of them came to reside in Tiron. Moreover, there is documentary evidence that women were

present at Tiron in a religious capacity.[124] As Kathleen Thompson has pointed out, two charters recording gifts made by a husband and wife include mention of their profession as monks.[125] In the absence of other information, the status of these women is unclear—corrodians, nuns, lay-sisters, full members of the community? Nevertheless, the choice to call these women *monachi* is remarkable and invites further research since it has implications both material and social.

Foundation

Tiron was founded by the monk, hermit, and wandering preacher Bernard of Abbeville/Tiron (d. 1116) in the early years of the twelfth century (see Map).[126] Following a period of wandering and preaching, Bernard seems to have recognized the need to create something more permanent for himself and his followers. He entered into negotiations with the reforming bishop Yves of Chartres and with Rotrou the Great (r. 1099–1144), Count of the Perche, and members of his family for the initial grants of land and resources.[127] Precisely when Bernard and his followers settled at Tiron is the subject of some debate among scholars, with dates as early as 1107/1109 and as late as 1114 being offered.[128] In part, this debate stems from different notions of monastic foundation, specifically whether foundation is about event or process. There is no doubt that the formal event of foundation occurred in 1114, when bishop Yves of Chartres issued a charter granting lands and rights at Tiron to Bernard to establish a permanent monastery there.[129] If one considers foundation as a process, of which the formal event, recognized in a charter, is a necessary part, then one can understand the earlier date of 1109 as the beginning of a process that culminated thirty years later following the development of a domain sufficient to ensure the continued existence of a successful, reformed Benedictine house.[130]

Bernard's early patronage connections led to others: Rotrou was the son-in-law of King Henry I Beauclerc, whose brother-in-law David became king of Scotland in 1124, about a decade after he had become interested in the Tironensian form of monasticism.[131] Tensions between Henry I and Louis VI of France, combined with Tiron's location along the frontier between their realms, presumably led to the French king's support for the new abbey.[132]

Probably following the marriage of her son, Rotrou the Great, Beatrix de Roucy moved to Tiron and lived there until the end of her days, supporting the new house with funds for construction.[133] The count's sister Juliana probably did not follow her mother to Tiron after the death of her husband, William l'Aigle, on the White Ship. She certainly continued, however, to support the abbey after her mother's demise.[134] Where such women resided is unknown. It may have been in one of the medieval houses at the western limit of the abbey precinct or, perhaps more likely, in a building that no longer survives.

Abbot Bernard died in 1116, not long after the new monastery had begun to flourish. Following a two- or three-year period of short abbatial rules, the community selected as abbot William I (r. 1119–c. 1150) whose long and effective rule went far to assure the success of the new congregation.[135]

The new and newly stable community under the leadership of its founder and his early successors consisted of former hermits and attracted new members, particularly among the artisanal classes according to Orderic Vitalis.[136] Though little studied until recently, the new monastery grew, flourished quickly, and became the head of an international order that included more than 150 dependent houses, including pre-existing parish churches, newly

founded priory-granges, and a small number of dependent monasteries.[137] To these churches, all of which were to be occupied by the monks of Tiron, can be added farms, mills, houses, and other landed possessions as well as rights and privileges.[138]

The monastery site

The monastery of Tiron sits in the base of a narrow valley through which runs the small river Tironne from which the monastery takes its name. At some point, presumably early in the site's monastic phase, the brothers dammed the river, both to create a large pond and also to control the flow of water through their site. The land above the valley slopes was presumably forested, and forest remains not far from the limits of the village today. Nearby quarries for the *grès roussard* and limestone used in building the monastery have been identified; these ensured that the monastery's building materials were entirely local.[139]

The site occupies an area near the intersection of the medieval dioceses of Chartres, Le Mans, and Sées as well as the important political territories of the Maine, the Île-de-France, and Normandy. Chartres, within which diocese Tiron actually sat, is the nearest important town at a distance of about 50 kilometers. The comital castle in Nogent-le-Rotrou, located about 15 kilometers to the west of the new monastery, formed the nearest base of secular power. Its isolation and liminality notwithstanding, the first monks of Tiron had ample and easy access to the three resources necessary for creating their new monastery: stone and wood for construction, and water for life. Under the leadership of Abbot Bernard and, shortly after, that of Abbot William I (r. 1119– c. 1150), the new community acquired the support of ecclesiastical and secular lords whose advocacy and support assured the success of what became a congregation with more than one hundred and fifty dependent houses.

The church of La Sainte-Trinité de Tiron

The mother house of the Tironensian congregation still stands, largely intact. Although almost unstudied until recently, the church is a major monument of the twelfth-century monastic movement (Figs. 16–18).[140] The west façade and walls of the nave remain to their full height. The crossing bay and parts of the walls of the north and south transept arms remain in elevation or have been recently revealed by excavation.[141] Portions of the north and south walls of the choir also still stand, and the location of its eastern terminal wall was identified during our excavations in 2018 (Figs. 19a, 19b).[142] Finally, a southern tower that is intact, and the surviving lower portions of two walls of a northern one, allow us to state that towers were "shouldered" into the angles between the transept arms and the choir with which they shared common walls.

The original, twelfth-century sanctuary was eventually replaced by a late Gothic choir terminating in a flat apse surrounded by double aisles, a project evidently necessitated by damage to the church incurred near the end of the Hundred Years' War.[143] In spite of reconstructions and damage, enough remains of the twelfth-century church to describe its plan and aspects of its elevation.

While the surviving parts of La Sainte-Trinité offer the strongest evidence for the plan and elevation of the twelfth-century church, a detailed plan of the building, drawn in 1651 by the Maurist architect dom Hilaire Pinet, offers insight (as we will see) into parts of the church no longer standing today (Fig. 20).[144] A cavalier view of the abbey, showing the church from the

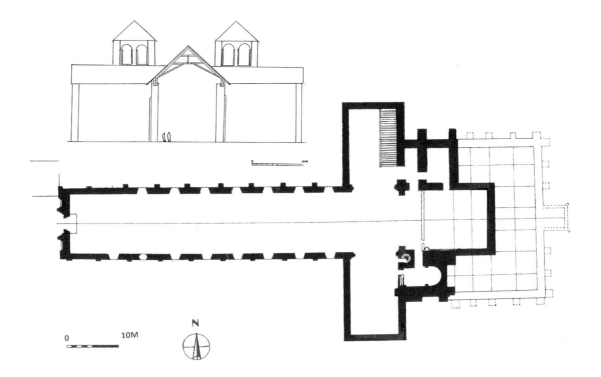

16 La Sainte-Trinité de Tiron, reconstructed plan and elevation of the Romanesque phase of the church, 2018.

north, appears in the *Monasticon Gallicanum*; it is, however, of more use for the lost late Gothic choir than for the twelfth-century church.[145]

Like the other monastic churches with an eremitic origin considered here, Tiron was an aisleless, cruciform building, with strongly projecting transepts, that terminated in a comparatively short, flat-ended choir.[146] Tiron's choir was flanked by, and shared walls with, two integrally built towers set in the angles between it and the transept arms.[147] Measurement and clearing of the interior of the ground floor of the southern tower in 2017 revealed the beginnings of two curving walls that once formed part of a non-projecting absidiole, the rest of which had been cut away during construction of the late Gothic chevet (see Fig. 16).[148]

Today, Tiron's nave interior is lighted by tall, rather wide, round-headed windows, seven on the north side and nine on the south.[149] Most remain open, although several are blocked or partially so. None of the windows has its original glass. Today these openings have straight embrasures with the glazing set near to the wall exterior. These features, together with the width of the windows leads us to think that the original, twelfth-century window openings have been altered.[150] In this regard, it is interesting to observe that on Pinet's 1651 plan of the church, the nave windows are represented as being narrower and as having splayed embrasures toward the interior and exterior, with the glass set near the center of the opening.[151] From the physical and pictorial evidence, we infer that the nave fenestration at Tiron originally consisted of relatively tall, narrow windows with doubly splayed embrasures. The four westernmost windows of the nave of La Roë provide an example of what the original windows at Tiron may have looked like (see Fig. 2). We also assume that the glazing was likely grisaille, in part because only 2% of the

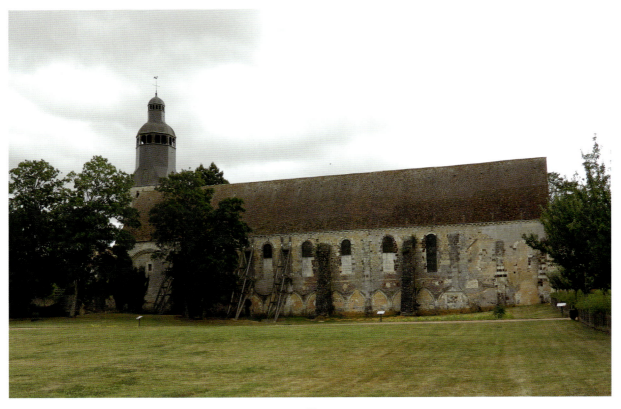

17
View of La Sainte-Trinité de Tiron from the north in 2016.

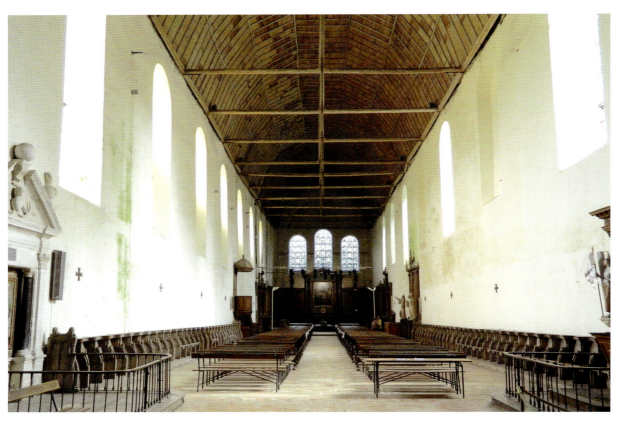

18
View of the interior of La Sainte-Trinité from the west in 2018.

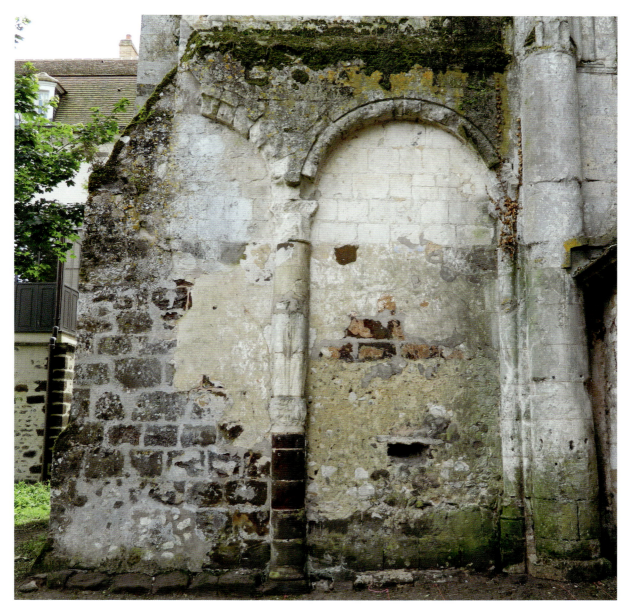

19a La Sainte-Trinité, remains of the Romanesque south choir wall in 2018.

more than three hundred sherds of window glass recovered from our excavations was colored and none of those sherds was painted.[152]

The only fenestration surviving in the transept arms today are small stair vise windows, but it seems reasonable to assume that Pinet's plan (see Fig. 20), which shows the windows similar to those in the nave, is accurate in its representation.[153] His plan shows windows on the east and west sides of the transept arms, which undoubtedly provided considerable light to the interior of that vessel.[154] Surviving evidence suggests that the monastic church at Tiron was well lighted.

Despite the loss of most of the choir and transept arms, enough survives to suggest that sculptural decoration within the church was quite limited. Portions of the lower walls of the choir survive, with the most evidence on the south side. This part of the choir was articulated

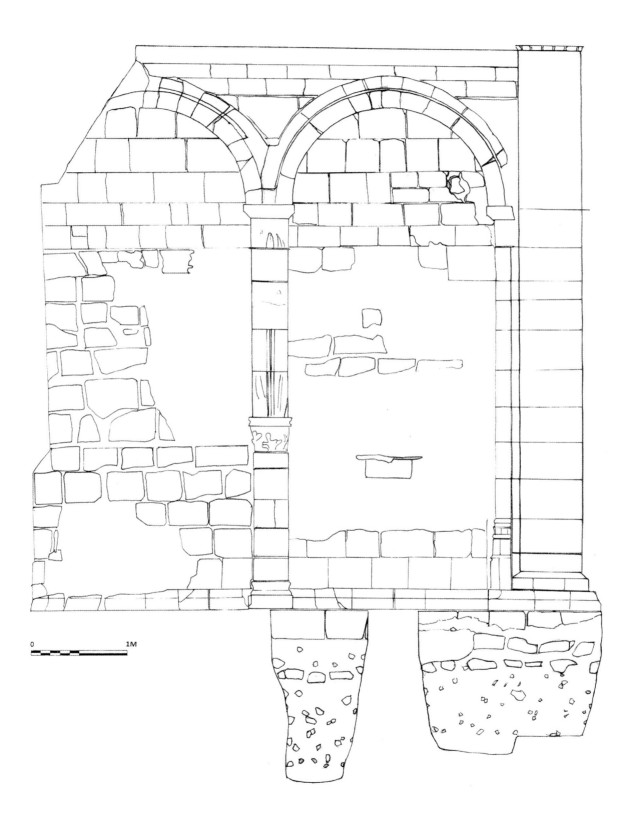

19b
La Sainte-Trinité, drawing of the remains of the south choir wall, 2018.

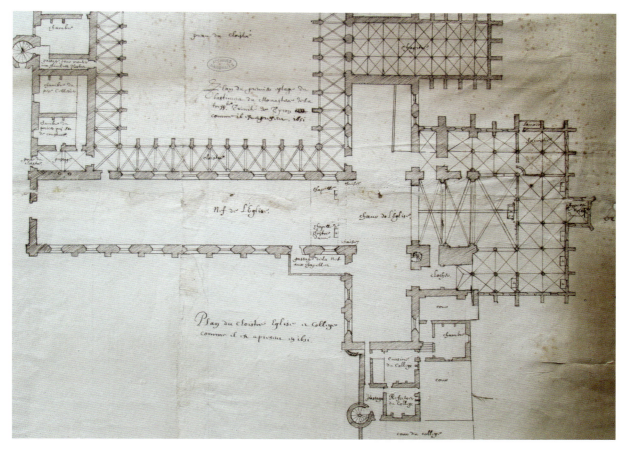

20 Dom Hilaire Pinet, plan of La Sainte-Trinité de Tiron, 1651, Paris, Archives nationales, NIII Eure-et-Loir 4/1 détail 6; photo courtesy Arthur Panier.

by a blind arcade that presumably continued around the three sides of the sanctuary, similar in concept to the blind arcade that runs around the choir and apse in the church of Notre-Dame-sur-l'Eau in Domfront (Orne), dated to shortly after 1100.[155] Two poorly preserved foliate capitals survive in the arcade on the south side that appear to have been acanthus capitals of the type still common c. 1100. The best evidence comes from the northwest crossing pier where one capital *à godrons* remains largely intact.[156] Common in the half century after c. 1090 and widespread in Normandy, this capital at Tiron seems to reflect one direction of the community's patronage connections.

The west façade of La Sainte-Trinité remains the most problematic part of the building. Measurement and on-site analysis make clear that the façade was constructed in two main phases, followed by restorations (Figs. 21–23). In an initial phase, the façade was much more modest, consisting of a thin-walled façade divided by four buttresses—two larger ones at the corners and two shallower ones on either side of the portal (Fig. 24a, b, c). This type of façade design is relatively common in the region, appearing on the west façades of parish churches such as Le Gault du Perche, La Chapelle Guillaume, Berthonvilliers, and La Basoche Gouët. Entry was likely through a simple, round-arched portal, probably with articulated jambs, but without a tympanum. Such doorways are widespread in the region, appearing on Tironensian priory churches such as Notre-Dame d'Yron (Eure-et-Loire) and Saint-Vincent de Reno (Orne).

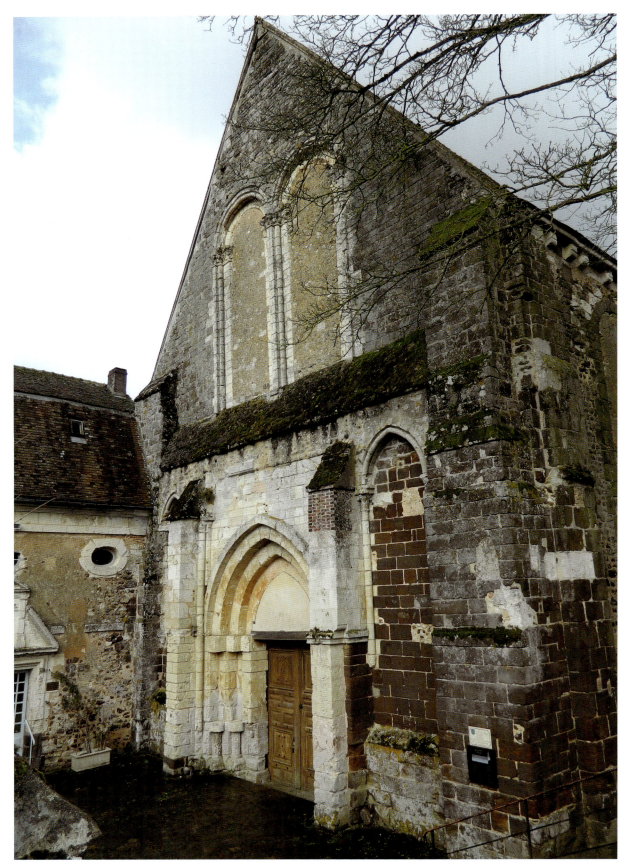

21
La Sainte-Trinité, view of the west façade, winter 2016.

22a
La Sainte-Trinité, view of the lower coursing of the southwest corner buttress showing the irregular coursing at the junction of the buttresses of phase 1 (right) and phase 2 (left).

22b
La Sainte-Trinité, view of the intermediate coursing of the southwest corner buttress showing the arris marking the angle of phase 1 of the west façade.

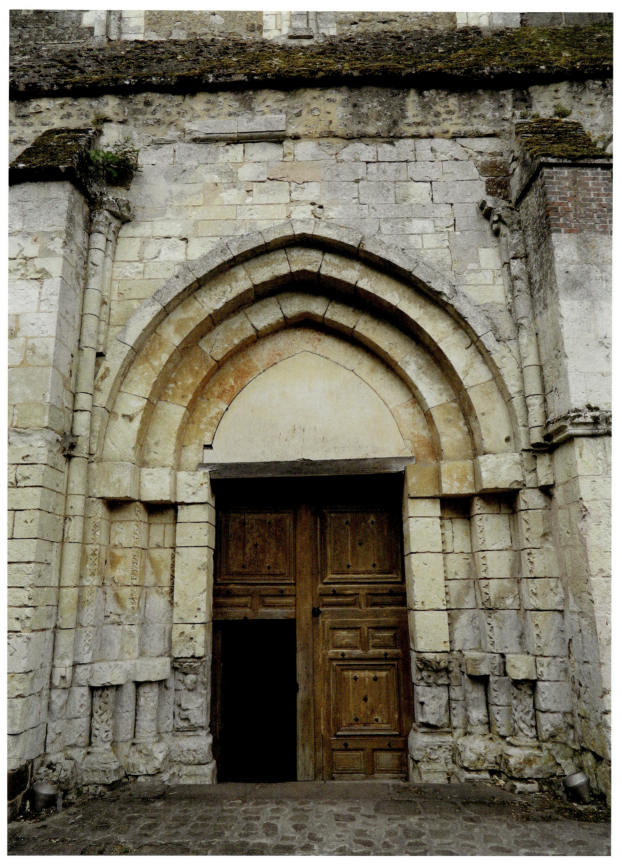

23
La Sainte-Trinité, view of the west portal in 2018.

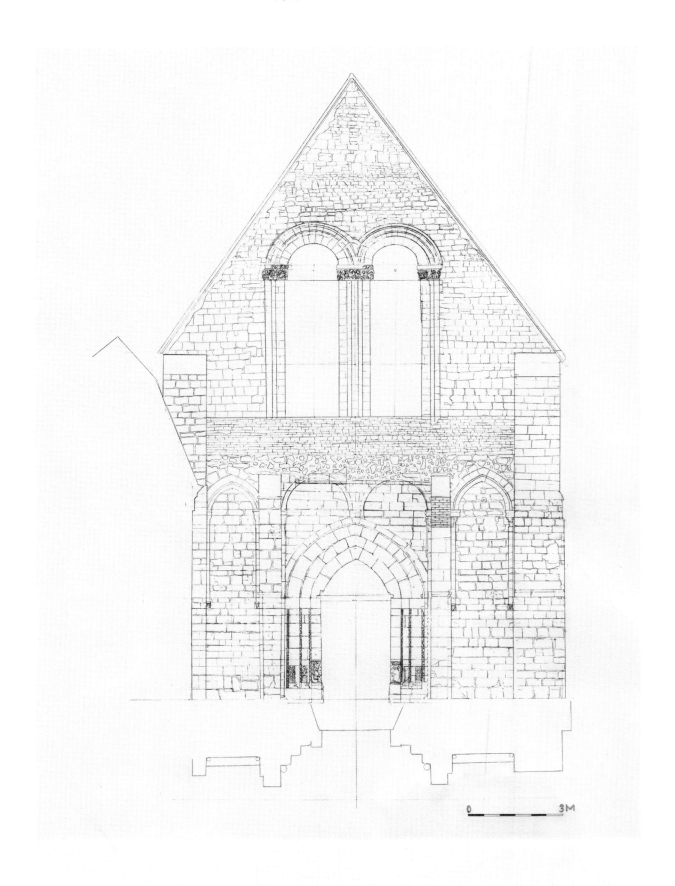

24a
La Sainte-Trinité de Tiron, stone for stone drawing of the west façade, 2018–2021.

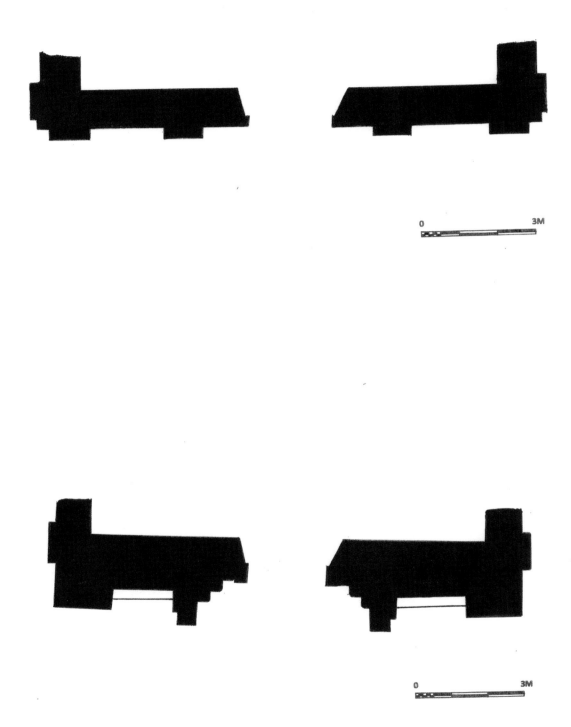

24b–c
La Sainte-Trinité de Tiron: plans of phase 1 (b) and phase 2 (c) of the west façade.

In both of these churches the portal embrasures are stepped back to receive colonnettes that support a single moulded archivolt. Nothing is known about the fenestration of the initial phase of Tiron's west façade. Regional parish churches suggest a single, round-headed lancet, in Tiron's case probably larger than the original nave and transept lancets, but a small rose window cannot be ruled out.[157]

Part of the evidence for the transformation of the first phase of Tiron's façade resides in the thickening of the façade's ground story and in the wrapping of its buttresses, both of which will be discussed below. The best evidence for the existence of the first phase is found in the southwest corner pier.[158] Irregularities in the coursing, between the south buttress and the west one, reveal a reworking of the pier (see Fig. 22a and b). Part way up the pier, a section of a small projecting arris preserves the turning angle of the west wall proper. This projection represents the exterior corner of the original nave wall. Its dimensions and position, taken in relation to the interior of the façade, allow us to assert that the original west wall (phase 1) measures within a few centimeters of the thickness of the lateral walls of the nave.

The second phase transformed the original, simple thin-walled façade, replacing it with the one we see today. The ground story of the western façade was thickened and decorated with more sculpture than appeared on the façade during its first phase (see Figs. 24 a and c). The original portal was replaced with the portal we see today, in which the splayed embrasures step back to receive colonnettes that almost certainly once carried column figures. These, in turn, corresponded to archivolts that frame a tympanum and lintel borne on rectangular jambs that have figurative reliefs at the bottom.

All of the existing portal, both the sculpted parts and the dressed blocks, are limestone. Some are grayish in color while others are yellowish beige. Both types have been confirmed by XRF analysis as coming from the nearby quarry at the Maquis de Plainville.[159] Some of the latter blocks are likely also restorations. The rest of the façade is built of *grès fereugineux*, also called *grès roussard*, save for the lancet windows of the upper zone, which are also limestone.[160]

The two central buttresses that frame the portal were also thickened, allowing them to project further from the façade wall. Blind arcades, carried on consoles carved with sculpted heads (three kings, one queen) supporting thin colonnettes, occupy the spaces between the central and outer buttresses.[161] In the spandrels above the portal, traces of a similar blind arcading terminated on a now-missing central console above the apex of the portal. While nothing survives of the original fenestration in the upper story, that space, which is set back from the vertical plane of the ground story, was opened in the second phase to include a pair of round-arched lancet windows, now blocked, and their historiated capitals.

The capitals are displayed in a frieze that extends across the embrasures of the windows, thus forming three groups (Fig. 25a). Above the capitals proper, on the impost blocks, there were originally a band of heads and wings of angels. Two heads remain above the northern capitals and two more survive above the southern capitals. The central and south groups are carved figures of sirens, some with monastic cowls and some without. All of these moralizing figures look down, rather than out.

The remaining group represents a conflated narrative of the Annunciation (Fig. 25b). In this three-capital composition, the angel Gabriel "arrives," represented diagonally across the left capital with his right hand raised in the conventional gesture of address. The Virgin Mary,

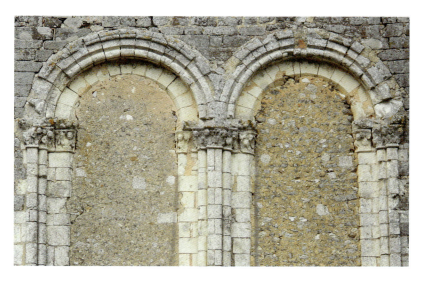
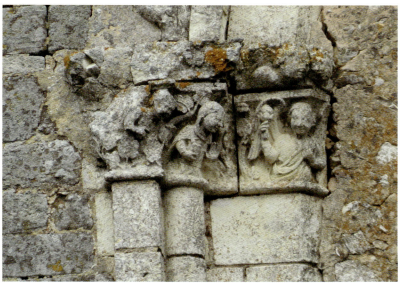
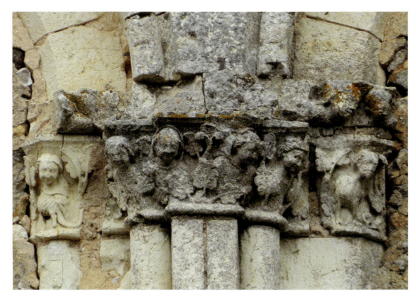

25
La Sainte-Trinité de Tiron, west façade clearstory capital frieze: a) (top) extended Annunciation scene;
b) (center) sirens with monastic hoods; c) (bottom) sirens, some with monastic hoods.

seated on the central capital, holds a book in her right hand and gestures in response to the angel with her left. Her head is turned, however, not to the announcing angel, but to her left, toward a second angel, on the third capital, who holds a short, flowered rod in his upraised right hand. The Annunciation is typically represented as a single event wherein the angel Gabriel announces to the Virgin Mary that she will become pregnant, which she acknowledges simultaneously in her gesture of response. The narrative in the Gospel of Luke 1:26–38 is more extended. In it, Mary is initially troubled and confused by the angel's words. Gabriel then explains the genealogy and Mary questions him about how this will happen. Gabriel explains further and Mary utters the well-known phrase, "Behold the handmaiden of the Lord" (1:38). The narrative extension of the initial annunciation is represented by the second angel, also Gabriel, who holds the flowering rod, widely understood by art historians to represent the Rod of Jesse prophesied in Isaiah 11:1, 10. The Annunciation scene at Tiron thus conflates several elements of the Annunciation story in Luke and Isaiah's prophesy in a three-capital composition that represents not simply the Annunciation to Mary, but also the unity of the Old and New Testaments. The carver also used the impost blocks as a sculptural field, expanding the narrative by creating frieze of bustate angels representing a heavenly host that signals the importance of the scene below (Figs 25c, see also Fig. 25b).

This iconographically central theme within the Christian narrative is eccentrically placed on the façade and is best seen from a southwest angle, rather than from directly in front of the façade. We do not know the medieval topography of Tiron, but today one approaches the façade from above, on a slope to the south-southwest. It may be that one came from that direction in the Middle Ages as well. The sirens on the other capitals look directly down on the small courtyard in front of the church. We do not know what events took place in front of Tiron's façade, but we can be sure that the figures of the capital frieze thus activated the space in front of the façade to engage the vision and thoughts of people gathered there.

Figures of sirens, most with monastic cowls (see Fig. 24c)," have close parallels compositionally and stylistically with capitals in the portal of Saint-Loup-de-Naud, as well as capitals in the collections of the Palais Synodal from the blind arcading of the Cathedral of Sens. These sculptures have all been dated to the decades immediately before and after the middle of the twelfth century.[162]

The final phase of Tiron's west façade was a restoration, executed probably in the nineteenth century. This phase consisted principally of insertions of dressed limestone blocks into the portal embrasures and voussoirs and the use of bricks in places in the buttresses. In considering the present state of the portal, it is useful to refer to the notes of Arsène Vincent, which were cited by Lucien Merlet more than 135 years ago:[163]

The main portal faces west and its style is partly Romanesque and partly Early Gothic. It is composed of two archivolts resting on pilasters without mouldings: the first archivolt is round, the second is ogival The bottoms of the pilasters supporting the archivolts are each carved with a seated figure holding a book on his knee; between the two pilasters is a small colonnette of which the shaft is carved with lierre leaves. Above the doors, there was originally a cornice; but, because it was of soft stone, weathering destroyed it. The tympanum of the portal was painted; it represented the Virgin flanked by angels. The buttress piers on each side of the portal are carved with interlaces and acanthus leaves.[164]

The second phase of the west façade is thus more richly decorated and more charged iconographically than any other part of this relatively sober church. The portal reflects trends in mid-twelfth-century portal designs that are well known in Chartres and the Île-de-France, from the stepped plan of its embrasures with their lost column figures to the embrasures' projecting angles that are richly decorated, carved in continuous foliate and geometric patterns. The door jambs at Tiron may also have borne large figures in relief as do the jambs of the lateral portal of Le Mans Cathedral.[165] These compositional and stylistic comparisons, seen in the light of the long reign of Abbot William, make a compelling case for dating the second phase of Tiron's west façade to the last years of that abbot's tenure, c. 1135–c. 1150.

La Sainte-Trinité de Tiron thus was, and even in its vestigial form still is, a monumental structure of the highest importance to the study of the monastic reform and Romanesque architecture in the north of France. The church was austere in decoration, especially at the eastern end. Its plan and elevation were as simple as they were monumental.

Conclusion: the churches of the hermit monasteries in western France

The churches we have examined in this chapter—La Roë, Fontevraud I, Étival, Saint-Sulpice–Notre-Dame du Nid-au-Merle, and Tiron—formed part of a group of five similar churches, built for communities with a deep commitment to eremitic experience.[166] In a sense, these monastic communities—their patrons and leaders as well as their builders—confronted an issue faced by the Carthusians a generation earlier and by other new orders such as the Chalaisians and the Camaldolese: how to create an architecture for eremitic coenobitism; how to craft spaces that speak both to individual and communal identities.

As we consider the common features within the architecture of eremitic coenobitism in early twelfth-century western France, we will insist that those features are the result of a set of conscious choices made by the four charismatic leaders, their followers and supporters, and builders, about how their churches should look from without and within.[167]

Thus, we see architecture not as a stage within an evolution of forms but as the product of human choices among formal alternatives. Further, we hold that architectural iconography should not be considered as a matter of formal choices alone, but as a selection of forms situated within particular contexts both temporal and spatial. Those contexts include religious aims, the type of community, and, importantly, the nature of the site. Choice of a building type without reference to where the structure is sited ignores a critical factor in the way its meaning might be perceived.[168]

For all five of the churches we have considered, their charismatic founders chose forested "wilderness" sites with easy access to water and essential resources, but which were also reasonably isolated from other settlements.[169] While the new communities were coenobitic and permanent, each retained something of the founders' eremitic ideals in their choice of location.

The five churches we have considered were all established by men who knew one another and who shared a set of religious experiences. They were all well-traveled former monks, wandering preachers, and hermits. All of them founded new monasteries during the early years of the twelfth century, monasteries that became the centers of their reformed religious communities. All four men seem to have negotiated with the local and regional nobility for gifts

of land, supplies, and resources necessary to construct the new houses that shaped the regular lives of their followers. The five churches they built share important characteristics and embody the inevitable tensions that arise between permanence and monumentality and the eremitic ideals of mobility, as well as simplicity, austerity, and humility.

Plan and elevation

Strikingly, all five of the great churches that these men founded were built on an aisleless, cruciform plan.[170] Each church was thus comprised of a *nef unique* giving onto a single vessel transept that opened from the crossing onto a single vessel choir. Four of them had a single absidiole projecting off each transept arm; the fifth, Tiron, had one, non-projecting chapel within a tower opening off one transept arm and different interior spaces in the other, accessed from the opposite arm.[171] In none of the churches were the nave or transept originally vaulted, though the transept of La Roë was vaulted later.[172] All of the churches presumably had very short choirs although we have material evidence for only Fontevraud I, Saint-Sulpice, and Tiron.[173] Bourdan's watercolor of Étival (see Fig. 2) shows a short choir and a semi-circular or polygonal apse with wall buttresses, which suggests that the apse and choir were vaulted, as was probably the case for the other houses. Direct evidence for vaulting in the choir and apse exists only at Fontevraud I and Saint-Sulpice in the form of footings for transverse arches and exterior buttressing.

Similarities in plan and in aspects of the elevation notwithstanding, there is variability among these five churches. Much of the variability is concentrated in the crossing and transept arms. La Roë, Saint-Sulpice-la-Forêt, and probably Fontevraud I (and certainly Fontevraud II) all had crossing towers. Only Tiron had lateral towers shouldered between the choir and transept arms. Étival has left no traces of the crossing bay on the site, and Bourdan's image (see Fig. 2) shows only a later spire at the crossing, suggesting that the church never had a crossing tower.

These differences would have resulted in somewhat different spatial experiences of the interior and exterior. To support their crossing towers, the builders of La Roë and Saint-Sulpice framed the crossing bays with diaphragm arches. Presumably the builders of Fontevraud I would have done the same had the building been completed. The crossing no longer survives at Étival, though the evidence for lateral passages suggests that it, too, may have had diaphragm arches framing the crossing even though it evidently had no tower. Tiron, in contrast, had a broad open transept.

Set off by diaphragm arches, a transept intrudes visually in the experience of the relationship of nave to sanctuary. The effect is that of additively joined spaces. At Tiron, the visual experience looking from nave to sanctuary is more unified, even if the arch opening into the choir and apse was lower than the height of the nave and transept.[174]

Turning to the exteriors, the presence of square crossing towers presumably covered by pyramidal roofs would have been the most striking aspect of the exterior elevation of four of the churches as travelers approached the monastic sites. At Tiron, the presence of two shouldered towers increased the sense of monumentality. Bells in these towers would have been heard at considerable distances in the quiet countryside and would have signaled aurally the presence of these monumental buildings even before they came into view.

Scale and monumentality
The five churches upon which we have focused in this study were not all of the same size. We have excellent information for Tiron, Saint-Sulpice–Notre-Dame du Nid-au-Merle, and Fontevraud II. We also have good, if not complete, information for La Roë and some for Fontevraud I, but we lack measurements for the nave of Étival. As we consider the differences in size of the five churches, we will focus on understanding these buildings in the context of both the region of western France and their rural, forested settings. The typical length of parish churches in the region for the eleventh and twelfth centuries ranges between 25 and 45 meters.[175] The eleventh-century Angers Cathedral measured only 75 meters in length. Abbeys like Saint-Florent de Saumur or Saint-Aubin in Angers were also large buildings, measuring 73 and 90 meters respectively. Other monasteries like Ronceray and Glanfeuil measure 57 and 52 meters respectively. Priories were sometimes also significant buildings. Saint-Jean in Château-Gontier measured 60 meters and Chemillé was 50 meters long.[176]

Fontevraud I was, or would have been, the smallest church of the group founded by the hermit preachers, its estimated length measuring only 42 to 46 meters. Its size would have compared favorably with larger parish churches, but could not have accommodated the rapidly growing community, regardless of whether the church was completed or abandoned in the course of construction. Saint-Sulpice and La Roë were larger than Fontevraud I and were essentially the same size, although the former was somewhat wider, both measuring about 60 to 65 meters long. Each would have been larger than abbeys in the greater region that were founded earlier, like Ronceray (early eleventh century) and Glanfeuil (refounded in the tenth century). Surprisingly, Fontevraud II and Tiron are, in comparison, both giant churches with interiors measuring 81.75 and 79.6 meters respectively, making them longer than the eleventh-century cathedral of Angers and, in fact, comparable, at least in length, to early Gothic cathedrals like Noyon and Laon.

The size of these two monastic churches clearly reflects the greater size of their communities. Their size also changes the experience of their interiors, which are proportionally longer and narrower. More even than Saint-Sulpice and La Roë, these two churches, thought to have been completed before 1150, can only have been enormously impressive in their scale and monumentality, as they remain so in their rural settings today. In fact, part of what emphasizes the monumentality of all of these buildings is that setting. Nearly all of the other large-scale buildings discussed above were built in the larger towns of the region. Finding large-scale churches in the 'wilderness' can only have served to underscore the scale and monumentality of these new, reform monasteries.

Aisleless cruciform monastic churches and meaning
None of the five aisleless, cruciform churches established by their charismatic founders was a particularly modest building, not even the apparently abandoned Fontevraud I. Monastic reformers and their builders were not, however, the only ecclesiastics to build large stone churches with an aisleless cruciform plan. As we have noted, Angers Cathedral in its eleventh-century and later phases, employed the plan, although its eastern end was more elaborate than the hermits' churches considered here. The cathedral is also the only major church in the ancient Anjou to adopt the form. Mallet's study of the region shows clearly, however, that the form was

common. Twenty-six parish churches but only two priories adopted the form over the course of the eleventh and twelfth centuries.[177] For churches of smaller size and lesser importance in western France, the plan type might simply be a regional tradition, rather than a reformist choice.[178]

That the cathedral of Angers was the only major church in the region to adopt this plan type makes it less likely that its choice by the reformers was simply a matter of building tradition. It is also useful to point out that one of the five churches, La Sainte-Trinité de Tiron, lay outside the region of western France, within the diocese of Chartres. In the Île-de-France, the aisleless cruciform plan was an infrequently used form. Tiron's relationship to its own larger region can, however, be seen in the two towers shouldered into the angles between the choir and the transept arms. Churches in the Île-de-France with shouldered towers are well known and include Morienval, Saint-Germain-des-Pres, and Notre-Dame de Melun, all of which date to the eleventh century. Nevertheless, Abbot Bernard and his builders chose the aisleless cruciform plan, linking his church to those of his three fellow hermit preachers. In a sense, Tiron's use of what was for it an extra-regional plan type confirms the interpretation of the aisleless cruciform plan as a building type that represented the idea of eremitic coenobitism.

It is important to note that the choice of an aisleless cruciform plan can, of course, be associated with notions of eleventh- and twelfth-century reform in other parts of Europe.[179] In different parts of France alone, other congregations with an eremitic origin also built churches on an aisleless cruciform plan. In the south, the order of Chalais was committed to churches of this type, as churches of that order at Valbonne and Boscodon reveal.[180] Even Augustinian communities with an eremitic origin sometimes chose the aisleless cruciform plan as the spatial organization appropriate to embody their reformist ideals. In addition to the hermit-canons of La Roë, the Augustinians of the abbey of Sablonceaux (Charente Maritime), whose first abbot was the hermit Geoffroy de Lorroux (later archbishop of Bordeaux), chose this plan type.[181] Still other orders of eremitic origin like the Celestines, the Grandmontains, and the Carthusians, all of which had smaller communities and built even simpler churches, typically constructed single-vessel structures terminating in semi-circular or polygonal apses.[182]

The aisleless cruciform plan thus seems to have been a meaning-laden form. It is important to underscore that the transept was not merely an excrescence on the sides of the church's main vessel. As Barbara Franzé and Nathalie Le Luel have recently pointed out, the Latin term most frequently used to designate the transept during the Middle Ages was *crux*, so that the volume would have easily been associated with the cross and the crucifix, one of which was often located in the crossing bay.[183] Otto von Simson long ago pointed out that the Middle Ages inherited from Vitruvius the notion that the church (*templum*) ought in its proportions to reflect those of the human body, an idea given literal expression by Durandus in the thirteenth century—"*ecclesiae forma humani corporis partionibus responder*"—but certainly in the minds of theologians even earlier.[184] For a group of men interested in returning to the Gospels—that is, to Jesus and the apostles—as *exemplae*, knowledge of the symbolism linking the aisleless cruciform plan to the cross and to human proportions must have seemed self-evident.

Jill Franklin has suggested that Saint Ambrose's Basilica Apostolorum, popularly known as San Nazaro, was important in communicating the idea of the aisleless cruciform building to reformers of the late eleventh century.[185] Whether the Basilica Apostolorum—about 80 meters in

length—was directly associated with the eleventh-century reform in Milan, as Franklin believed, it was certainly associated with the notion of apostolicity by reason of its dedication and by the apostolic relics it contained, including those of Saint Nazarius, a martyr and evangelizer of the first century and thus also regarded as an apostle.[186] Possibly visited by Bernard of Tiron on his trip to Rome, the Basilica Apostolorum was certainly known to popes and other high churchmen in contact with the four western French reformers considered here. It is worth remembering that the Basilica Apostolorum is the only known early Christian aisleless cruciform church to survive into the twelfth century.[187] We can thus infer that if the building was known to late eleventh- and early twelfth-century monastic reformers, the Basilica Apostolorum may have been particularly inspirational not only by virtue of its plan, but also by virtue of its relics and its connection to Saint Ambrose and the era of the apostles.

Decoration: interior and exterior

The aisleless cruciform arrangement of these five churches placed limitations on interior sculptural decoration since the need for piers with capitals and bases existed only at the crossings and the choirs.[188] At La Roë, Saint-Sulpice–Notre-Dame du Nid-au-Merle, Tiron, and Étival interior sculpture consists of simplified bases and capitals or imposts with simple foliate, geometric, or abstract decoration. Surviving sculpture is located on the crossing piers of Saint-Sulpice, on the northwest crossing pier and in the surviving blind arcades of the choir at Tiron, and on piers supporting a wooden crossbeam inside the north transept arm at Étival. Exterior sculpture on the same arm at Étival is stylistically identical to the sculpture on the interior and stylistically comparable to the sculpture at Saint-Sulpice–Notre-Dame du Nid-au-Merle.

Painted decoration hardly differs. As we have seen, there is evidence for red false-joint decoration in the south transept arm at Saint-Sulpice, and similar fragments survive in the lapidary reserve at Tiron, suggesting that such decoration may have been normative in the naves and transepts of all of the churches.[189] In no case—La Roë, Fontevraud I, Étival, Saint-Sulpice–Notre-Dame du Nid-au-Merle, or Tiron—does the sanctuary remain intact and in elevation. Only at Étival and Saint-Sulpice do chapels survive in their entirety, though any painting they may have had does not. There is reason to think that the short choir and apse of each of these four churches was vaulted. A few traces of red painting on a light ochre ground that seem to represent some sort of foliage, survive on the choir side of the northeast crossing pier at Saint-Sulpice. This single surviving fragment may indicate that the sanctuary walls and vaults of Saint-Sulpice and the other churches may have held richly painted surfaces.[190]

In this regard, it is useful to consider the Tironensian priory of Notre-Dame d'Yron near Cloyes-sur-Loir (Fig. 26). This single-vessel church is divided by a pair of columns into a western part covered in false-joint and an eastern part in which walls, window embrasures, and apse vault are covered with figurative painting. Wall painting may thus have been impressively present in the four monastic churches considered in this paper, but we cannot be certain.[191]

Our knowledge of the "public face" of these aisleless cruciform churches is limited to La Roë and Tiron. The west façades of Étival and Saint-Sulpice are destroyed and that of Fontevraud I was evidently never built. The façade of Fontevraud II is devoid of sculptural decoration and strikingly austere, which allows us to suggest that the façade of Fontevraud I probably would

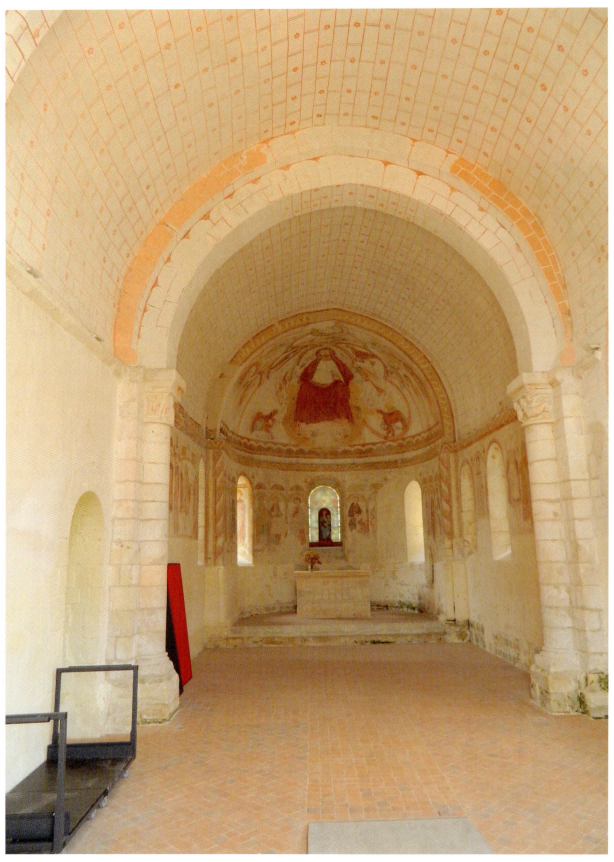

26

Tironensian Priory of Notre-Dame d'Yron, interior view toward the east showing its wall painting.

have been similar. Nevertheless, the surviving façades of La Roë and Tiron provide us with important information.

La Roë's façade is arguably the latest part of the twelfth-century building. Its design is certainly complex with layers of masonry that project forward, and recede behind, the plane of the façade. Sculptural decoration is, however, minimal and essentially non-figural. As we have discussed, the façade of Tiron today contains two principal phases: a first simple phase with very little decoration, and a second phase, datable to c. 1135–c. 1150, that responded to developments in portal decoration that were taking place in the Île-de-France. There is some evidence that the portal combined (painted) sculpture with painting on the tympanum.[192] It has become a commonplace to refer to the decoration of houses of regular canons and reformist monks like the Cistercians and Grandmontains as austere and simple.[193] As far as the evidence allows us to see, the decoration of these five houses, which included two different orders of nuns, one of regular canons and one of Benedictine monks, followed the same pattern of decorative austerity.

Materials and meaning

Consideration of the materials used in the construction of these monastic churches also bears on their meaning. Étival, Tiron, and La Roë were substantial buildings constructed of local stone using *petit appareil* for the walls and *moyen appareil* for buttresses and piers as well as, in the case of La Roë, the façade. Tiron also used limestone, but almost exclusively for limited decorative work and the shouldered towers. Saint-Sulpice–Notre-Dame du Nid-au-Merle is also built of *petit appareil*, save for the buttresses and crossing piers, which are built of large dressed blocks of two types of *grès* and granite. This type of construction, using dressed masonry only at structurally important points, is typical of parish church architecture throughout the larger region. Moreover, of these churches, only Fontevraud II can be said with certainty to have originally been fully vaulted. It seems reasonable to suggest that at least part of the choice to build using a humble technique would have been rooted in the notion of humility that was part of the ideas of monastic reform that the founders espoused. The choice to cover these large churches with an open truss-work roof reflects the same ideas.

There is thus a tension between the simple plan, austere decoration, and humble construction techniques of these five churches and the scale and monumentality of their architecture. That the early churches at four of these sites evidently remained standing until the French Revolution also suggests that the ideas of the founders endured throughout the lives of these houses—indeed, even the more richly decorated "second" church of Fontevraud retained the aisleless cruciform plan.[194]

The aisleless cruciform church, built in a 'wilderness' setting of locally sourced, modest materials with relatively little decoration, can thus be said to represent a particular aspect of the monastic reform phenomenon of the late eleventh and twelfth centuries. This church type enshrines humility, simplicity, and austerity in a monumental scale, which allows the structures to respond to the size of their communities and the scale of their aspirations while employing

forms and materials that belong to smaller, humbler precedents, particularly parish churches. The aisleless, cruciform church was thus the appropriate monumental, architectural form to assert within the landscape the presence of a community of monks or nuns following a regular life whose origins lay in an eremitic experience. Church type alone was not the only signifier. The site characteristics of these churches also embodied for their founders and their communities the notions of austerity, simplicity, and humility that were for them the core values of monastic reform and represented an appropriate expression of eremitic coenobitism.

Just as the four hermit-monastic founders stood with one foot in the forest and the other in the Church, so too did the monastic sites they chose for their new communities. These sites were all located within or at the very edge of forests and were isolated from substantial settlements, as they are even today. As such, these monasteries, like their hermit founders, remained in the wilderness, in settings that were austere, isolated, and humble; and yet, as recognized houses, these new foundations also became permanent, well-established communities that were integrated into the hierarchy of the organized Church.

Abbreviations

AASS	*Acta Sanctorum*, ed. Bollandists, 68 vols. (Brussels and Paris, 1643–1940)
ADIV	Archives départementales de l'Ille-et-Vilaine, Rennes
ADM	Archives départementales de la Mayenne, Laval
ADS	Archives départementales de la Sarthe, Le Mans
AN	Archives nationales, Paris
GC	*Gallia christiana in provincias ecclesiastias distributa*, 16 vols. (Paris: 1715–1865)
PL	*Patrologiae cursus completus, Series latina*, ed. J.-P. Migne, 221 vols. in 223 (Paris, 1800–1875)

Primary and Secondary Works

Amis de l'Abbaye 2003: Amis de l'Abbaye et du Patrimoine Valbonnais, *Histoire de Valbonne, Sophia Antipolis* (La Calade: Edisud, 2003).

Anger 1905: Pierre Anger, "Cartulaire de l'abbaye de Saint-Sulpice-la-Forêt, I," *Bulletin et Mémoires de la Société archéologique d'Ille-et-Vilaine*, 34 (1905): 165–262.

Anger 1906: Pierre Anger, "Cartulaire de l'abbaye de Saint-Sulpice-la-Forêt, II," *Bulletin et Mémoires de la Société archéologique d'Ille-et-Vilaine*, 35 (1906): 325–388.

Anger 1920: Pierre Anger, *Histoire de l'abbaye de Saint-Sulpice-la-Forêt, Ille-et-Vilaine, de ses relations, de la vie religieuse au moyen age et au XVIIIe siècle* (Paris and Rennes: Champion and Plihon et Hommay, 1920).

Angheben 2017: Marcello Angheben, "Le portail royal du Mans et l'évolution de la première gothique, entre les façades de Dijon et Chartres," *Cahiers de civilisation médiévale*, 60 (2017): 27–58.

Angot 1900–1903, 1909: Les abbés Alphonse Angot et Ferdinand Gaugain, *Dictionnaire historique, topographique et biographique de la Mayenne*, 4 vols. (Laval: Goupil, 1900–1903, 1909) [also available at http://angot.lamayenne.fr/].

Anon. Cartulaire, n. d.: Anonymous, "Cartulaire de l'abbaye de Notre-Dame de la Roë," XIIe siècle, Laval, ADM, H 154, (n.d.) [available online at https://chercher-archives.lamayenne.fr/archives-en-ligne/ark:/37963/r314582ww55k/f1?context=ead::FRAD053_2NUM213_RM_de-1].

Anon. 1685: Anonymous, "Constitutions des religieuses bénédictines de l'abbaye de Saint-Sulpice, dans le diocèse de Rennes," unpublished manuscript, ADIV 24 H88, (1685).

Anon. 1901: Anonymous, "Restauration de l'ancienne église abbatiale d'Étival-en-Charnie (Sarthe)," *Bulletin monumental*, 65 (1901): 77–79.

Anon. 1992: Anonymous, "Chronologie fontevriste [and] Les abbesses de Fontevraud (1115–1792), *Fontevraud: Histoire-Archéologie*, 1 (1992): 5–8.

Arnoux 2003: Mathieu Arnoux, "Ermites et ermitages en Normandie (XIe-XIIIe siècles)," in Vauchez 2003, 115–135.

Bandmann (1951) 2005: Günter Bandmann, *Mittelalterliche Architektur als Bedeutungsträger* (Berlin:

Gebrüder Mann Verlag, 1951), trans. as *Early Medieval Architecture as Bearer of Meaning*, trans. and intro. Kendall Wallis, afterword Hans Josef Böker (New York: Columbia University Press, 2005).

Banéat 1927–1929: Paul Banéat, *Le Département d'Ille-et-Vilaine: Histoire, Archéologie, Monuments*, 4 vols. (Rennes: Librairie Moderne J. Larcher, 1927–1929).

Barral i Altet 2005: Xavier Barral i Altet, *Art roman en Bretagne* (Luçon: Éditions Jean-Paul Gisserot, 2005).

Baylé 1985: Maylis Baylé, "La sculpture romane dans la Normandie ducale", in *Les siècles romans en Basse-Normandie*, exhibition catalogue (Caen: J. Pougheol, 1985), 55–63.

Baylé 2001: Maylis Baylé, *L'architecture normande au moyen-âge*, 2 vols. (Caen: Presses Universitaires de Caen – Edition Charles Corlet, 2001).

Beck 1998: Bernard Beck, *Saint Bernard de Tiron, l'ermite, le moine et le monde* (Cormelles-le-Royal: Éditions la Mandragore, 1998).

Beck 2010: Bernard Beck, "Bernard de Tiron: les relations d'un ermite avec les pouvoirs," in *Le pouvoir dans le Perche au temps des Rotrou*, Actes du colloque du 22 octobre 2006 à Nogent-le-Rotrou, ed. Sophie Montagne-Chambolle and Philippe Siguret (Rémalard: Amis du Perche, 2010), 73–83.

Beck 2014: Bernard Beck, "Bernard de Tiron: l'ermite, le moine, le monde," in *Actes du colloque international de Paris—les fondations monastiques dans le Perche et le diocèse de Chartres au Moyen Âge. Cahiers du Percheron*, 199/3: 15–24.

Bercé 2008: Françoise Bercé, "Chemiré-en-Charnie," *La Sauvegarde de l'Art Français*, 21 (2008): 49–50.

Bienvenu (1991) 2008: Jean-Marc Bienvenu, "Notre-Dame de La Roë au tournant des années 1100," *Bulletin de la Société d'Histoire et d'Archéologie de la Mayenne* (2008) [http://mes-recherches-en-histoire-medievale.over-blog.com/]; first published in *La Mayenne: Archéologie, Histoire*, 14 (1991): 9–37.

Bienvenu and Prigent 1992: Jean-Marc Bienvenu and Daniel Prigent, "Installation de la communauté fontevriste," *Fontevraud: Histoire-Archéologie*, 1 (1992): 15–22.

Blin 1873: Jean-Baptiste-Nicolas Blin, *Vie des saints du diocèse de Séez et l'histoire de leur culte*, 2 vols. (Laigle: P. Montauzé, 1873).

Bonde and Maines 2003: Sheila Bonde and Clark Maines, eds., *Saint-Jean-des-Vignes in Soissons. Approaches to its Architecture, Archaeology and History*. Bibliotheca Victorina, XV (Turnhout: Brepols, 2003).

Bonde and Maines 2019: Sheila Bonde and Clark Maines, "Thiron-Gardais (Eure-et-Loir) Abbaye de Tiron," *Archéologie Médiévale*, 49 (2019): 297–298.

Bonde and Maines 2020: Sheila Bonde and Clark Maines, "L'inventaire du dépôt lapidaire de Tiron," *Le Collector. Bulletin du réseau européen de l'Ordre de Tiron*, 8 (2020): 2–3.

Bonde and Maines (in progress): Sheila Bonde and Clark Maines, "Reconstructing a Lost Monument of the Late Gothic: The Fifteenth-Century Choir of the Abbey of Tiron" (in progress).

Bonde and Maines et al. 2018: Sheila Bonde and Clark Maines, with Albane Saintenoy and John Sheffer, "L'église-mère de la Congrégation bénédictine réformée de Tiron, Sondages archéologiques dans le choeur détruit de l'abbatiale et Prospections des zones des bâtiments claustraux," unpublished field report available from the authors and at the Service regional de l'archéologie—Centre-Val de Loire in Orléans, France, 2018.

Bonde, Maines, and Saintenoy 2020: Sheila Bonde, Clark Maines, and Albane Saintenoy, "Thiron-Gardais—Chœur de l'abbaye et ancienne cuisine: Intervention archéologique préalable à une reconstruction du chœur gothique en 3D et prospection radar situant l'ancienne cuisine hexagonale," *Le Collector. Bulletin du réseau européen de l'Ordre de Tiron*, 7 (2020): 2–5.

Bonde, Maines, and Sheffer 2021 (in press): Sheila Bonde and Clark Maines, with John Sheffer, "Tiron on the Edge: Cultural Geography, Regionalism and Liminality," in *The Regional and Transregional in Romanesque*, ed. John Mc Neill and Richard Plant (Leeds: British Archaeological Association and Maney Publishing, 2021 [in press]).

Bonnebas 2014: Georges Bonnebas, "La fondation de l'abbaye de Tiron: sa place dans l'histoire des communautés réguliers du diocèse de Chartres des origines à 1180," *Actes du colloque international de Paris sur le 900ᵉ anniversaire de l'abbaye de Tiron*, 5 avril 2014; *Cahiers Percherons*, 199/3: 34–45.

Bonnet 1978: Charles Bonnet, "L'église Saint-Laurent d'Aoste," in *Atti del IX Congresso internazionale di Archéologia cristiana*, 2vols. (Rome: Vatican), II: 105–15.

Bresson 2013: Gilles Bresson, *Monastères de Grandmont, Guide d'histoire et de visite* (Saint-Sébastien-sur-Loire: Éditions d'Orbestier, 2013).

Bugner 1984: Monique Bugner, *Cadre architectural et vie monastique des bénédictins de la congrégation de Saint-Maur* (Nogent-le-Roi: Jacques Laget—Librairie des Arts et Métiers, 1984).

Carbonnier 1999: Youri Carbonnier, "L'abbaye et le collège de Tiron au XVIIᵉ siècle: état et projets au début de l'époque mauriste," *Cahiers Percherons*, 199/2: 1–16.

Chibnall 1969–1980: Marjorie Chibnall, ed. and trans., *The Ecclesiastical History of Orderic Vitalis*, 5 vols. (Oxford: Oxford University Press, 1969–1980).

Cline 2009: Ruth Harwood Cline, trans., intro., and notes, *Geoffrey Grossus: The Life of Blessed Bernard of Tiron* (Washington, DC: Catholic University Press, 2009).

Cline 2019: Ruth Harwood Cline, *The Congregation of Tiron: Monastic Contributions to Trade and Communication in Twelfth-Century France and Britain* (Leeds: Arc Humanities Press, 2019).

Cross and Livingstone 1990: F. L. Cross and E. A. Livingstone, eds., *The Oxford Dictionary of the Christian Church*, 2nd rev. ed. (Oxford: Oxford University Press, 1990).

Crossley 1988: Paul Crossley, "Medieval Architecture and Meaning, the Limits of Iconography," *Burlington Magazine*, 130 (1988): 116–121.

Crozet 1946: René Crozet, "Étude sur les consécrations pontifiales," *Bulletin monumental*, 104 (1946): 5–46.

Crozet 1964: René Crozet, "Fontevraud," *Congrès archéologique de France tenu dans l'Anjou*, 127 (1964): 427–477.

Dalarun 2004a: Jacques Dalarun, "Fortune institutionnelle, littéraire et historiographique de Robert d'Arbrissel," in Dalarun 2004b, 293–322.

Dalarun 2004b: Jacques Dalarun, ed., *Robert d'Arbrissel et la vie religieuse dans l'ouest de la France*, Actes du colloque de Fontevraud, 13–16 décembre 2001. Disciplina Monastica, I (Turnhout: Brepols, 2004).

Dalarun 2006: Jacques Dalarun, *Robert of Arbrissel: Sex, Sin, and Salvation in the Middle Ages*, trans. with an introduction and note by Bruce Venarde (Washington, DC: Catholic University Press, 2006).

Dalarun et al. 2006: Jacques Dalarun, Geneviève Giordanengo, Armelle Le Huërou, Jean Longère, Dominique Poirel, and Bruce Venarde, *Les Deux Vies de Robert d'Arbrissel Fondateur de Fontevraud, Légendes, écrits et témoignages/ The Two Lives of Robert of Arbrissel Founder of Fontevraud, Legends, Writings, and Testimonies*. Disciplina Monastica, 4 (Turnhout: Brepols, 2006).

Davy (1997–1998) 2000: Christian Davy, "Badigeons, couleurs et peintures murals médiévales dans l'abbaye Notre-Dame de Fontevraud: état des découvertes," *Fontevraud: Histoire-Archéologie*, 5 ([1997–1998] 2000): 57–68.

De Wismes n.d. (c. 1855–1860): Baron de Wismes, *Le Maine et l'Anjou historiques, archéologiques et pittoresques*, 2 vols. [I: le Maine; II: l'Anjou] (Nantes and Paris: Forest and Grimaud-Bry, n.d.).

Durand and Nougaret 1992: Geneviève Durand and Jean Nougaret, *L'ordre de Grandmont, art et histoire, Actes des Journées d'Études de Montpellier, 7 et 8 octobre 1989* (Gap: Études de l'Hérault; Centre d'Archéologie médiévale du Languedoc, 1992).

Feiss, O'Brien, and Pepin 2014: Hugo Feiss O.S.B., Maureen O'Brien, and Ronald Pepin, ed., trans., and intro., *Abbot Vitalis of Savigny, Abbot Godfrey of Savigny, Peter or Avranches, Blessed Hamo*. The Lives of Monastic Reformers, 2; Cistercian Studies Series, 230. (Collegeville, MN: Liturgical Press and Cistercian Publications, 2014).

Foulon 2003: Jean-Hervé Foulon, "Les ermites dans l'ouest de la France: les sources, bilan et perspectives," in Vauchez 2003, 81–113.

Foulon 2008: Jean-Hervé Foulon, *Église et réforme au Moyen Âge, Papauté, milieux réformateurs et ecclésiologie dans les Pays de la Loire au tournant des XIe- XIIe siècles*. Bibliothèque du Moyen Âge, 27 (Brussels: De Boeck Université, 2008).

Franklin 2012: Jill Franklin, "Augustinian and Other Canons' Churches in Romanesque Europe: The Significance of the Aisleless Cruciform Plan," in *Architecture and Interpretation: Essays for Eric Fernie*, ed. J. Franklin, T. A. Heslop, and C. Stevenson (London: Hambledon Press, 2012), 78–98.

Franklin 2013: Jill Franklin, "Iconic Architecture and the Medieval Reformation: Ambrose of Milan, Peter Damian, Stephen Harding and the Aisleless Cruciform Church," in *Romanesque and the Past*, ed. J. McNeil and R. Plant (Leeds: Maney Publishing and British Archaeological Association, 2013), 77–94.

Franzé 2015: Barbara Franzé, ed., *Art et réforme grégorienne en France et dans la péninsule ibérique* (Paris: Picard, 2015).

Franzé and Le Luel 2018: Barbara Franzé and Nathalie Le Luel, eds., *Le transept et ses espaces élevés dans l'église du Moyen Âge (XIe-XVIe siècles). Pour une nouvelle approche fonctionnelle*, Actes du Colloque de Lausanne, 20–21 avril 2015 (Zagreb: Motovun, 2018).

Germain 1675: dom Michel Germain, *Histoire de l'abbaye royale de Notre-Dame de Soissons de l'Ordre de Saint-Benoit* (Paris: J.-B. Coignard, 1675).

Germain (1870) 1967: dom Michel Germain, *Monasticon Gallicanum*, ed. Achille Peigné-Delacourt (Paris: Victor Palmé, 1870; repr. Brussels: Culture et Civilisation, 1967).

Gilbert and Guérin 2001: Xavier Gilbert and Olivier Guérin, "Inventaire préliminaire," *Abbaye Notre-Dame-du-Nid-au-Merle, rue de l'abbaye (Saint-Sulpice-la-Forêt)*: Dossier IA35010813 included in Société archéologique de Notre-Dame-du-Nid-au-Merle, 2001) [available at http://patrimoine.bzh/gertrude-diffusion/dossier/chapelle-notre-dame-sur-l-eau-l-abbaye-rue-de-l-abbaye-saint-sulpice-la-foret

/51a04adb-82ea-4c58-9b64-0884f97d6465 (accessed 15.ix.2021)].

Giostra 2007: Caterina Giostra, "La basilica di S. Simpliciano fra età paleocristiana e altomedioevo: alcuni spunti," *Studia ambrosiana*, 1 (2007): 77–98.

Goodman 1985. Nelson Goodman, "How Buildings Mean," *Critical Inquiry*, 11/1 (1985): 642–653.

Grand 1958: Roger Grand, *L'art roman en Bretagne* (Paris: Picard, 1958).

Griffiths 2008: Fiona Griffiths, "The Cross and the Cura Monialium: Robert of Arbrissel, John the Evangelist and the Pastoral Care of Women in the Age of Reform," *Speculum*, 83 (2008): 303–330.

Grodecki (1953) 1954: Louis Grodecki, "Notre-Dame-sur-l'Eau de Domfront," *Congrès archéologique de France, tenu dans l'Orne*, 111 ([1953] 1954): 221–235.

Grundmann (1935) 1995: Herbert Grundmann, *Religiöse Bewegungen im Mittelalter*. Historische Studien, 267 (Berlin: E. Ebering, 1935); trans. S. Rowan, *Religious Movements in the Middle Ages* (Notre Dame: Notre Dame University Press, 1995).

Guillemin 1999: Denis Guillemin, *Thiron, abbaye médiévale*. Collection: Présence du Perche (Montrouge: Les Amis du Perche, 1999).

Guilloreau 1901: dom Léon Guilloreau, "L'abbaye d'Étival-en-Charnie et ses abbesses (1109–1790)," *Revue historique et archéologique du Maine*, 49 (1901): 113–139.

Guilloreau 1902: dom Léon Guilloreau, "L'abbaye d'Étival-en-Charnie et ses abbesses (1109–1790)," in *Revue historique et archéologique du Maine*, 52 (1902): 121–160.

Guillotin de Corson 1880–1886: Amédée Guillotin de Corson, *Pouillé historique de l'archevêché de Rennes*, 6 vols. (Rennes: Charles Catel, 1880–1886).

Hamon-Jugnet 1971: Marie Hamon-Jugnet, "Cartulaire de l'abbaye Notre-Dame de La Roë, édition critique," unpublished thesis for the diploma "archiviste-paléographe," École des Chartes, Paris, 1971 [available at ADM Mc 26 and 4 Mi 11 (microfilm)].

Héliot 1967: Pierre Héliot, "Sur les tours jumelles au chevet des églises du moyen age," in *Arte in Europa. Scritti dell'arte in onore di Eduardo Arslan* (Milan: n.p., 1967), 149–170.

Hollister 2001: C. W. Hollister, *Henri I*, ed. and completed by Amanda Clark Frost. Yale English Monarchs (New Haven and London: Yale University Press, 2001).

Hutchison 1989: Carole A. Hutchison, *The Hermit Monks of Grandmont* (Kalamazoo, MI: Cistercian Publications, 1989).

James and Prigent 1990: F. C. James and Daniel Prigent, "Fontevraud, neuf siècles de construction," *303 Arts, Recherches et Créations* (*La revue des Pays de la Loire*, 24) (1990): 68–81.

Jasper and Howe 2020: Kathryn Jasper and John Howe, "Hermitism in the Eleventh and Twelfth Centuries," in *The Cambridge History of Medieval Monasticism in the Latin West, I: Origins to the Eleventh Century, and II: The High and Late Middle Ages*, ed. Alison I. Beach and Isabelle Cochelin, 2 vols. (Cambridge: Cambridge University Press, 2020), II: 684–696.

Kimpel and Suckale 1990: Dieter Kimpel and Robert Suckale, *L'architecture gothique en France*, 1130–1270, trans. from the German by Françoise Neu (Paris: Flammarion, 1990).

Konerding 1975: Volker Konerding, *Die Passagenkirche, ein Bautyp der romanischen Baukunst in Frankreich* (Berlin and New York: De Gruyter, 1975).

Krautheimer (1942) 1969a: Richard Krautheimer, "Introduction to an Iconography of Medieval Architecture," *Journal of the Warburg and Courtauld Institutes*, 5 (1942): 1–33; repr. in *Studies in Early Christian, Medieval and Renaissance Art*, ed. James Ackerman et al. (New York: New York University Press, 1969), 115–150.

Krautheimer (1942) 1969b: Richard Krautheimer, "The Carolingian Revival of Early Christian Architecture," *Art Bulletin*, 24 (1942): 1–38; repr. in *Studies in Early Christian, Medieval and Renaissance Art*, ed. James Ackerman et al. (New York: New York University Press, 1969), 203–256.

Labat, Perrichon, and Louis 2015: O. Labat, in collaboration with P. Perrichon and A. Louis, "Vestiges de l'abbaye de Tiron et du Collège militaire royal, Rapport de Diagnostic archéologique—Thiron-Gardais, 10–12 rue de l'abbaye," unpublished excavation report, Chartres, 2015.

Lambert 1957: Élie Lambert, "Notes sur la série des plans de l'ancien fonds de Saint-Germain-des-Prés aujourd'hui conservés aux Archives nationales," *Mémorial du XIVe centenaire de l'abbaye de Saint-Germain-des-Prés. Recueil de travaux sur le monastère et la congrégation de Saint-Maur, Revue d'histoire de l'Église de France*, 43.140 (1957): 313–332.

Lefèvre-Pontalis (1912) 1913: Eugène Lefèvre-Pontalis, "L'église abbatiale de Sablonceaux (Charente-Inférieur)," *Congrès archéologique de France tenue à Angoulême*, 79.2 ([1912] 1913): 287–303.

Le Goff (1985) 1988: Jacques Le Goff, *The Medieval Imagination*, trans. Arthur Goldhammer (Chicago and London: University of Chicago Press, [1985] 1988).

Leroy 1982: Pierre Leroy, « Saint-Sulpice-la-Forêt (Ille-et-Villaine), » *Archéologie médiévale*, 12 (1982): 338.

Leroy, Hardy, and Jacquemar 1983: Pierre Leroy, Bertrand Hardy, and Pierre Jacquemar, *Abbaye de Notre-Dame-du-Nid-au-Merle* (Saint-Sulpice-la-Forêt: Société archéologique de Notre-Dame-du-Nid-au-Merle).

Leyser 1984: Henrietta Leyser, *Hermits and the New Monasticisim: A Study of Religious Communities in Western Europe, 1000–1150* (New York: St. Martin's Press, 1984).

Liégard 2018: Sophie Liégard, "Thiron-Gardais—Cloître de l'abbaye, Intervention archéologique préalable à la reconstruction du cloître d'août à novembre 2016," *Le Collector. Bulletin du réseau européen de l'Ordre de Tiron*, 6 (2018): 5–7.

Lusseau 2000: Patricia Lusseau, "Historique et vue monastique," *303 Arts, Recherches et Créations* (*La revue des Pays de la Loire*, 67) (2000), 8–16.

Mallet 1982: Jacques Mallet, "Le type d'églises à passages en Anjou [Essai d'interprétation]," *Cahiers de Civilisation médiévale*, 25.1 (1982): 49–62.

Mallet 1984: Jacques Mallet, *L'art roman de l'ancien Anjou* (Paris: Picard, 1984).

Mallet 2003: Jacques Mallet, "La nef unique dans l'art religieux angevin," in *Anjou, Medieval Art, Architecture and Archaeology*, ed. John McNeill and Daniel Prigent. British Archaeological Association Conference Transactions, 26 (Leeds: Maney, 2003), 52–65.

McCurrach 2011: Catherine Carver McCurrach, "'Renovatio Reconsidered:' Richard Krautheimer and the Iconography of Architecture," *Gesta*, 50 (2011): 41–70.

McDonnell 1955: Ernest W. McDonnell, "The *Vita Apostolica*: Diversity or Dissent," *Church History*, 24.1 (1955): 15–31.

Melot 1997: Michel Melot, *L'abbaye de Fontevraud*. Petites Monographies des Grands Édifices de France (Paris: Jacques Lanore, 1997).

Mercier et al. 2011: Jérôme Mercier et al., "Thiron-Gardais (Centre—Eure-et-Loir) Abbaye de Thiron, Façade nord de l'église et galerie sud du cloître: Étude du bâti et fouille, Rapport intermédiaire de fouille préventive," unpublished excavation report, Carpiquet, Oxford Archéologie Grand Ouest; Orléans, DRAC de la Région Centre-SRA, 2011.

Merlet 1883: Lucien Merlet, *Cartulaire de l'abbaye de la Sainte-Trinité de Tiron*, 2 vols. (Chartres: Imprimerie Garnier, 1883).

Milis 1979: Ludo Milis, "Ermites et chanoines réguliers au XIIe siècle," *Cahiers de civilisation médiévale*, 22 (1979): 39–80.

Musset 1967–1974: Lucien Musset, *Normandie romane*, 2 vols. (Saint-Léger-Vauban: Zodiaque, 1967–1974).

Niermeyer 1984: J. F. Niermeyer, *Mediae Latinitatis Lexicon Minus* (Leiden: Brill, 1984).

Perinetti and Cortelazzo 2010: Renato Perinetti and Mauro Cortelazzo, "Aoste (Italie), le complexe St. Ours-St. Laurent et le groupe épiscopal," *Bulletin du Centre d'Études médiévales d'Auxerre*, hors sér. n° 3 (2010): 1–17.

Piolin 1851–1863: dom Paul Piolin, *Histoire de l'église du Mans*, 5 vols. (Paris: Julien, Lanier et Cie, 1851–1863).

Planté 1888: Jules Planté, *Cartulaire de l'abbaye royale de chanoines de Saint-Augustin de N.-D. de La Roë* (Mamers: Fleury et Dangin, 1888).

Pressouyre 1990: Léon Pressouyre, *Le rêve cistercien* (Paris: Gallimard, 1990).

Prigent 1988–1991: Daniel Prigent, "Fontevraud (Maine-et-Loire). Abbaye," *Archéologie Médiévale*, 18 (1988): 320–321; 19 (1989): 290–291; 20 (1990): 377–378; 21 (1991): 309.

Prigent 1994: Daniel Prigent, "Les sépultures du sanctuaire de l'abbatiale de Fontevraud," *Fontevraud: Histoire-Archéologie*, 2 (1994): 43–53.

Prigent (1997–1998) 2000: Daniel Prigent, "Le cadre de vie à Fontevraud dans la seconde moitié du XIIe siècle," *Fontevraud: Histoire-Archéologie*, 5 ([1997–1998] 2000): 39–56.

Prigent 2000: Daniel Prigent, "L'eau à Fontevraud," *303 Arts, Recherches et Créations* (*La revue des Pays de la Loire*, 67) (2000), 86–93.

Prigent 2004: Daniel Prigent, "Fontevraud au début du XIIe siècle: les premiers temps d'une communauté monastique," in Dalarun 2004b, 255–79.

Raison and Niderst 1948: abbé L. Raison and R. Niderst, "Le mouvement érémitique dans l'ouest de la France à la fin du XIe siècle et au début du XIIe siècle," *Annales de Bretagne*, 55.1 (1948): 1–46.

Reveyron 2018: Nicolas Reveyron, "Le transept dans l'organisation de l'espace ecclésial," in Franzé and Le Luel 2018, 23–38.

Sandron 2000: Dany Sandron, "La cathédrale de Laon, un monument à l'échelle du diocese (vers 1150–

1350)," *La Sauvegarde de l'art français*, Cahier 13 (2000): 22–39.

Souchet,1866–1873: Jean-Baptiste Souchet (d. 1654), *Histoire du diocèse et de la Ville de Chartres*, 4 vols. (Chartres: Imprimérie de Garnier).

Suteau 1997: Pierre Suteau, *Notre-Dame du Nyoiseau. Une abbaye royale en Haut-Anjou* (Laval: Éditions Siloë, 1997).

Terrel 1980: Marc Terrel, *Abbayes de l'Ordre de Chalais* (La Pierre-qui-Vire: Zodiaque, 1980).

Thompson K. 2009: Kathleen Thompson, "The First Hundred Years of the Abbey of Tiron: Institutionalising the Reform of the Forest Hermits," *Anglo-Norman Studies*, 31 (2009): 104–117.

Thompson K. 2013: Kathleen Thompson, "The Cartulary of the Monastery of Tiron/ Le cartulaire du monastère de Tiron," *Tabularia*, "Études," XIII (2013): 65–123.

Thompson K. 2014a: Kathleen Thompson, *The Monks of Tiron. A Monastic Community and Religious Reform in the Twelfth Century* (Cambridge: Cambridge University Press, 2014).

Thompson K. 2014b: Kathleen Thompson, "Les origines du premier siècle à Thiron, du monastère à l'abbaye," *Actes du colloque international de Paris sur le 900ᵉ anniversaire de l'abbaye de Tiron*, 5 avril 2014; *Cahiers Percherons*, 199 (2014): 25–33.

Thompson S. P. 2004: S. P. Thompson, "Mary (Marie of Blois), *suo jure* countess of Boulogne (d. 1182)," *Oxford Dictionary on National Biography* [accessed at http://doi.org/10.1093/ref:odnb/54455].

Tillet, Castel, and Vié 1982: Louise-Marie Tillet, with the collaboration of abbé Yves-Pascal Castel and Henri Vié, *Bretagne romane*, sér. "La nuit des temps" (La Pierre-qui-Vire: Zodiaque, 1982).

Trébaol 2017a: Céline Trébaol, "L'abbaye de Saint-Sulpice et ses dépendances: l'expérience monastique au féminin dans le diocèse de Rennes, XIIᵉ-XVIIIᵉ siècles," unpublished PhD dissertation, Université de Rennes, 2017.

Trébaol 2017b: Céline Trébaol, "L'abbaye de Saint-Sulpice-la-Forêt et ses dépendances à l'époque moderne: la 'mère' et ses 'filles'," *Chrétiens et sociétés, XVIᵉ-XXIᵉ siècles*, 24 (2017): 73–96.

Trébaol 2018: Céline Trébaol, "L'abbaye de Saint-Sulpice-la-Forêt, architecture et décor (XIIᵉ-XVIIIᵉ siècles)," *Bulletin et Mémoires de la Société archéologique et Historique d'Ille-et-Vilaine*, 122 (2018): 51–82.

Vanderputten 2013: Stephen Vanderputten, *Monastic Reform as Process: Realities and Representations in Medieval Flanders, 900–1100* (Ithaca and London: Cornell University Press, 2013).

Van Houts 1992–1995: Elisabeth M. C. van Houts, ed. and trans., *Gesta Normannorum ducum of William of Jumièges, Orderic Vitalis and Robert of Torigni*, 2 vols. (Oxford: Oxford University Press, 1992–1995).

Vauchez 2003: André Vauchez, dir., *Ermites de France et d'Italie (XIᵉ-XVᵉ siècle). Actes du colloque organisé par l'École française de Rome à la Certosa di Pontignano, 5–7 mai 2000, avec le patronage de l'Université de Sienne*. Collection de l'École française de Rome, 313 (Rome: École française de Rome, 2003).

Venarde 1997: Bruce L. Venarde, *Women's Monasticism and Medieval Society: Nunneries in France and England, 890–1215* (Ithaca and London: Cornell University Press, 1997).

Venarde 2003: Bruce L. Venarde, *Robert of Arbrissel: A Medieval Religious Life,* trans. and annotated by Bruce L. Venarde (Washington, DC: Catholic University of America, 2003).

Von Simson 1988: Otto von Simson, *The Gothic Cathedral: Origins of Gothic Architecture and the Medieval Concept of Order*. Bollingen Series, XLVIII, 3rd ed. (Princeton: Princeton University Press, 1988).

Von Walter 1903–1906: Johannes von Walter, *Die ersten Wanderprediger Frankreichs: Studien zur Geschichte des Mönchtums*, 2 vols. (Leipzig: Dieterich, 1903–1906).

Voragine 1993: Jacobus de Voragine, *The Golden Legend. Readings on the Saints*, trans. William Granger Ryan, 2 vols. (Princeton: Princeton University Press, 1993).

* It is a pleasure to acknowledge the support we received from Victor Provot, Maire de Thiron-Gardais, as well as from other members of the Conseil Municipal, from the office staff and from the SRA du Centre—Val-de-Loire. Without their help our work would not have been possible.

1 For an overview of the eremitic movement, see Jasper and Howe 2020, and Leyser 1984. On eremitism in the west of France, see Raison and Niderst 1948; Foulon 2003; Foulon 2008; and, among the older literature, von Walter 1903–1906 and Guilloreau 1901. For eremitism in Normandy at this time, see Arnoux 2003. For discussion of the female houses established by hermits, see Venarde 1997, 57–66. Milis 1979, while focused on the relationship between hermit communities and those of canons regular, has much to offer on monasteries. See also the thoughtful essay on "the wilderness in the medieval west" in Le Goff (1985) 1988, 47–59.

2 Thompson K. 2009, 104.

3 Grundmann (1935) 1995, 210–213; McDonnell 1955.

4 Grundmann (1935) 1995, 210–213.

5 Sources for the life of Bernard of Tiron include the *Vita B. Bernardi* published with French translation in Beck 1998, 312–471, with related documents. For an English translation with an introduction and notes, see Cline 2009. Important information can also be found in the early charters published by Merlet 1883, I:1–24, which should be used in conjunction with Thompson K. 2013.

6 For the quotation, see Beck 1998, chap. III, §20:336 for the Latin, and 337 for the French; and Cline 2009, chap. III, §20:27. Geoffrey makes this statement in the context of discussing Bernard's life as a hermit. Later in the text, Geoffrey groups Robert, Bernard, Vitalis, and Raoul together as monastic founders. See Beck 1998, chap. IX, §82:398, 400, and 401; Cline 2009, chap. IX, §82:87.

7 The question of how to relate works of art and architecture to the Gregorian reform has been recently reviewed and critiqued. See Franzé 2015.

8 Savigny grew rapidly with some twenty-four abbeys in its congregation by 1138; see Feiss, O'Brien, and Pepin 2014, 18–20. It would be interesting to examine these dependent houses for evidence of Savignac (pre-Cistercian) architecture. The Cistercian abbey of Louroux, founded in the west within the diocese of Angers in 1121, was also an aisleless cruciform church. Enough remains of the building to state that it was, unlike the churches of the hermit preachers, vaulted in the nave and transept arms, making it likely that the choir was also vaulted. No written evidence survives to provide starting or consecration dates for the building. On Louroux, see Mallet 1984, 123–124, who argues for the influence of Fontevraud II in the design of the nave of Louroux.

9 On Nyoiseau, see *GC*, XIV:704–709; Suteau 1997; Mallet 1984, 116–118; and Mallet 1982, 56, 57, fig. 12 and pl. III. At Nyoiseau, only parts of the chapter room façade remain standing. Mallet believed, primarily on the basis of a nineteenth-century pen-and-ink drawing, that the church at Nyoiseau was an aisleless cruciform building with lateral passages between the nave and the transept. While he may have been correct, we find the perspective in the drawing inconsistent and confusing. We thus prefer to withhold judgement until excavations and/or remote sensing can confirm or reject his interpretation. While Suteau 1997 (12, 24–25, and 64) discusses the iconography of the abbey, his images do not provide sufficient evidence to describe the plan of the church convincingly. The most important contribution of his study is the rediscovery of a seventeenth-century, French version of the abbey cartulary and obituary commissioned in the 1660s for the abbess Philippe-Françoise de Bretagne (r. 1645–d. 1684), on which see Suteau 1997, 42–43.

10 The source for this relationship seems to be *GC*, XIV:704. See also Raison and Niderst 1948, 13 and 41; Dalarun 2004a, 309, describes Salomon as an "ancien compagnon" of Robert.

11 Beck 1998, chap. VI, §48:364 and 365; Cline 2009, chap. VI, §48:54–55. Bishop Peter II of Poitiers was instrumental in helping Robert of Arbrissel; see Venarde 1997, 60, 62. It seems possible that Robert and Bernard met through Bishop Peter if they were not already acquainted with one another.

12 Beck 1998, chap. VI, §49:366 and 367; Cline 2009, chap. VI, §49:56. See also the anonymous *Brevis Descriptio in Vita beati Bernardi Tironenisis abbatis* in Beck 1998, 476 and 477; Cline 2009, Appendix C, §4:157.

13 Raison and Niderst 1948, 21–22, address the issue of relations among these charismatic men in a general way, but do not cite specific points of contact between them. See also Dalarun 2006, 129–130, and Andreas of Fontevraud, *Vita Altera Roberti*, in *AASS*, February 3: chaps. 16–18. For an English translation of the *Vita Altera*, see Venarde 2003, 22–67.

14 Andreas of Fontevraud, in *AASS*, February 3: chap. 15, 0611A: *Abbas Bernardus bonorum omnium memoria dignus, cuius laus usque hodie per omnes Gallicae Ecclesias*. For the English, see Venarde 2003, 33. Bernard was also known to Hugh of Amiens, archbishop of Rouen (r. 1130–d. 1164), who mentions Bernard's posthumous intercession that led to the miraculous release of the crusader saint, Adjutor. *AASS*, April 3: 0823F–0825D.

15 On Alleaume, see Angot 1900–1909.

16 Blin first argued that Alleaume is the same as the "Adelinus" who appears in Geoffrey's *Life of the Blessed Bernard*, presumably based on the similarity between Adelinus and Adalhelm, the Germanic version of Alleaume. Beck, in his study of Bernard of Tiron, has called the nominal association of Adelinus and Alleaume into question, at least partly on chronological

grounds, suggesting that the young disciple of the hermit Aubert would have been too young to have founded the abbey of Étival in 1109. See Blin 1873, II:497–499 and 499, n. 1, for the association of Adelinus and Alleaume. See Beck 1998, chap. V, §38:354, 356, and 357; Cline 2009, chap. V, §38:45–46, for the passages in Geoffrey Grossus. See Beck 1998, 246, n. 37, for his criticism of Blin. Adelinus' older companion, Aubert, is thought to have been buried with Raoul de la Futaie in a crypt chapel attached to the south transept arm of the abbey of Saint-Sulpice–Notre-Dame du Nid-au-Merle.

17 Venarde 2003, 13–14, quoting in translation from Baudri of Dol's "First Life of Robert of Arbrissel" (*PL*, 162:1043–1058). See also Dalarun 2006, 37 and n. 57. On the complicated status of itinerant preachers, see Grundmann (1935) 1995, 17–21, and McDonnell 1955.

18 The foundation charter is included in La Roë's cartulary, on fol. 1r. The cartulary dates to the twelfth century and is Laval, ADM, H 154. See Anon. Cartulaire n.d. An uncritical edition was published by Planté 1888. The manuscript was the subject of an unpublished École des Chartes thesis by Hamon-Jugnet 1971, a copy of which is also in the AD de la Mayenne, Mc 26. A shortened version of the foundation charter is *GC*, XIV, Instrumenta: 151, doc. X. The *Gallia chrisitana* text is essentially faithful to the charter through the first list of ecclesiastical signatories. It omits the "Notice" (which is the second half of the document) that includes concession of all that the hermit-canons would purchase or would obtain of the lands of Renaud de Craon and a further list of signatories. On the Notice, see Bienvenu (1991) 2008, sect. I. 9, Catalogue des actes, n° 1.

19 Dalarun et al. 2006, 152–161 for the Latin as well as French and English translations for the parts of Baudri's 'Life' that pertain to La Roë and 152–155 (§12.1) for the crowds coming to the forest to hear Robert. For a more accessible English translation, see Venarde 2003, 12–13.

20 Dalarun et al. 2006, 154 (§12.1, 190): *Aedificarunt itaque commune domicilium*

21 Baudri mentions the common dwelling. We should assume that the group also had a kitchen, whether as part of the common dwelling or as a separate structure, and perhaps other functional structures as well.

22 Bienvenu (1991) 2008.

23 The six, original canon-hermits are known: Robert d'Arbrissel, Quintin, Hervé de la Sainte-Trinité, Gautier le Petit, Hervé, and Humbert. See Bienvenu (1991) 2008, I. 4, sect. I. A.

24 Bienvenu (1991) 2008, I. 4, sect. I. A. and B. 3: Il est difficile dans ce cas de considérer l'acte n° 1 comme la charte de fondation d'une abbaye. Il serait préférable de parler de la fondation d'un groupe canonial à caractère érémitique.

25 Bienvenu (1991) 2008, I. 4, sect. I. B. 2.

26 Bienvenu (1991) 2008, I. 4, sect. II. A.-C. Bienvenu also considers the precarious nature of the early gifts of material support to the group of canon-hermits, suggesting that the uncertain material footing of the group may have helped to push them toward their establishment as a formal monastic community with a solid patrimony.

27 Bienvenu (1991) 2008, I. 6, sect. I. A.

28 Bienvenu (1991) 2008, I. 6, n. 70: *primus pater et pastor nostre congregationis*.

29 Bienvenu (1991) 2008, I. 6, sect. I. B.

30 Bienvenu (1991) 2008, I. 6, sect. I. B. and n. 76.

31 Bienvenu (1991) 2008, I. 6, sect. I. C.

32 Bienvenu (1991) 2008, I. 6, sect. I. D.

33 Bienvenu (1991) 2008, I.4, sect. I. B. 1. Given the relative humidity of forest soils, we imagine a simple wooden church of which the walls were set on one or two courses of dense masonry (like the *grès roussard* or the granite of which the successor church would be built) to block the rise of moisture into the walls.

34 The distance is about 15 kilometers in either direction.

35 *GC*, XIV:716: . . . *ecclesiam ruricolae dixerunt S. Mariam de Bosco, vel de Silva*, and charters.

36 Mallet 1984, 111: Commencée après 1100

37 On lateral passages, also called *passages berrichons*, see Konerding 1975 and Mallet 1982. Like La Roë, Fontevraud II, Étival, and Saint-Sulpice-la-Forêt all have lateral passages. Only Tiron does not. We do not know about Fontevraud I because excavation did not extend that far west.

38 Mallet 1984, 111. The change in stone work moves from roughly coursed rubble construction (*moellons*) to medium sized dressed blocks (*moyen appareil*).

39 Round-headed windows set in the transept terminal walls are more elaborate, being flanked by colonnettes. The south transept arm has been heavily restored, but the north arm still has traces of paired, round-headed windows that are similar to those in the crossing tower. Other, minor, changes include the insertion of rib vaults in the transept arms and crossing.

40 In this respect, the façade of La Roë shares much in common with the façade of the Augustinian abbey of Nieul sur l'Autise (Vendée), which, although a basilica, also has a complex, integrated, and layered west façade design that is devoid of figuration.

41 A lithograph by Baron Olivier de Wismes, dated c. 1860, represents La Roë's central portal of the west façade without a tympanum and with only two archivolts. The tympanum and its archivolt were added when the portal was restored in 1901. On the restorations, see Mallet 1984, 118. In most other respects, the lithograph replicates the façade as we see it today.

42 *GC*, XIV:718: *Perfecit Robertus ecclesiam abbatialem et*

magni nominis praesules ad eam consecrandam convenientes excepit. (Robert completed the abbey church and, welcoming a gathering of bishops of great renown, it received consecration.)

43 Mallet 1984, 118, citing Angot 1900–1903, 1909, III: 432.

44 "They worked for a long time on the construction of the abbey church. Finally, around 1137–1139, the archbishop of Tours, assisted by the bishops of the province: Ulger of Angers, Hamelin of Rennes, Hugues of Le Mans, Danoald of Saint-Malo, [and] the great lords: Guérin of Craon, Guy of Laval, William of La Guerche, his brother Hamon, etc. consecrated the building, probably on August 9th, because the fair instituted on this occasion was held ever since on the same day. Yet they continued to work on the monument, and gifts multiplied in order that it was magnificent." Angot 1900–1903, 1909, http://angot.lamayenne.fr/notice/T3C18_COMM0045 (accessed 15.ix.2021), section "Notes historiques." The online version of Angot is searchable, but is not paginated like the print version. Mallet 1984, 118, in quoting Angot, replaces *aedificari* with *fieri*, presumably in the interest of meaning. He points out that the length of the church was established in the first campaign using *grès roussard* stone which extends as far as the façade at the lower level of the nave, so the use of *magnum* cannot refer to length.

45 *GC*, XIV:716: *Ecclesiam B. Mariae de Rota convenerunt iterum consecraturi, annos inter 1135 et 1141,* (They [the bishops of the region] gathered again for the consecration of the church of Notre-Dame de la Roë, between the years 1135 and 1142,)

46 Angot 1900–1903, 1909, http://angot.lamayenne.fr/notice/T3C18_COMM0045 (accessed 15.ix.2021). The list of sources appears at the end of the notice and includes (as the sources are listed): Arch. de la M., Chart. et cart. de la Roë; B. 2.966, 2.972, 2.975, 3.058. — Reg. par. depuis1617. — Arch. nat., X/1a. 168, f. 53; Q/1. 703; F/19. 448; F/1b, II, Mayenne,1; F/1c, III, Mayenne, 8; G/8. 1.268. — Bibl. nat., lat. 22.450, f. 225, 226; nouv. acq.,1.227, f. 415. — Arch. de la S., E. 283. — Arch. de la Vienne, H/3. 143. — Ménage, Hist. de Sablé, p. 110,135. — Chron. craonn. — Baron de Wismes, Le Maine et l'Anjou. — Gallia Christ., t. XIV, col. 716. — Bibl. D'Angers, mss. 895.

47 Mallet 1984, 118 and nn. 30 and 31.

48 Crozet 1946 remains important to our understanding of the relationship between church construction and consecration.

49 La Roë's growth, as measured by the number of parishes and priories it held, rivals that of Augustinian Saint-Jean-des-Vignes, which held more than forty priories and parishes by 1140. On the domain of Saint-Jean in this period, see Bonde and Maines 2003, 94–114.

50 Mallet 1984, 16–21 *et passim*, and Mallet 2003.

51 An archpriest held supervisory responsibilities over priests within a diocese or district. See Cross and Livingstone 1983, 82. On the life and career of Robert of Arbrissel, see Dalarun 2004a and b, Dalarun 2006, and Venarde 2003.

52 For an overview of the monastic complex, see most recently Prigent (1997–1998) 2000. See also Melot 1997 and Crozet 1964.

53 Bienvenu and Prigent 1992, 17–18.

54 Prigent 1994, 49–52.

55 Bienvenu and Prigent 1992, 15–17; Prigent 2000, 88–91; Prigent 2004, 255–258.

56 *PL*, 162, cols. 1051–1052.

57 Prigent 2000, 88, on the water resources for the house; Bienvenu and Prigent 1992, 17.

58 Prigent (1997–1998) 2000 discusses recent archaeological discoveries that permit an understanding of how the spaces within the church were divided and used.

59 Recent archaeological and restoration work has revealed that the interior of Fontevraud II was also painted, some of which was executed in relation to the church's funerary function. See Davy (1997–1998) 2000.

60 It is thought that Fontevraud's second church was begun not long after its first. See Prigent 2004, 261. We wonder whether it might not be possible that the second church owes something to patronage in the 1140s when a Plantagenet, Mathilde d'Anjou, ascended to the abbacy. For a summary chronology of the abbey and a list of its abbesses, see Anon. 1992.

61 On the excavations, see James and Prigent 1990, 70 and 79; Bienvenu and Prigent 1992, 19–21; and Prigent 2004, 258–260 and 277, fig. 2. Summary descriptions of the stages of the excavation of the area of the choir and transept of the abbey church appear in the resumés of each year's work (*chroniques des fouilles*), published in *Archéologie Medievale*. See Prigent 1988–1991, 18:320–321, 19:290–291, 20:377–378, 21:309.

62 Prigent 2004, 259 and nn. 17–18, and 261 and n. 30.

63 James and Prigent 1990, 70: "La nef était vraisemblement à vaisseau unique." Prigent 2004, 259: "Certes, les seules constructions bien préservées de nos jours sont l'église abbatiale et la cuisine romane, mais l'organisation originelle se lit encore de façon satisfaisante dans le monastère actuel."

64 See Figs. 3 and 6a for the plan of La Roë and a view of the nave of Fontevraud II from the west.

65 On early twelfth-century Chemillé, see Mallet 1984, 189–190 and pl. XXX-1. The north side-aisle seems to have been added to the single nave, although perhaps not much later.

66 Churches with an apse-en-echelon composition often have their absidioles aligned with the nave side-aisles, regardless of whether there was a transept, as at the

67 Prigent 2004, 274, and Prigent (1997–1998) 2000, 50–52.

68 The painting of the church is known from a photograph taken of it, which shows the building from what appears to be the choir looking westward across the walls of two bays of the north side of the nave. Photographed by Henri Gaud, the image is available at https://dictionnaireordremonastiquedefontevraud.wordpress.com/2011/07/16/r-ruines-de-l%E2%80%99eglise-saint-jean-de-l%E2%80%99habit/ (accessed 15.IX.2021).

69 Prigent 2000, 91 and 93 (plan). The plan published by Prigent is apparently drawn after a plan (cadaster?) of the mid-eighteenth century. The church of Saint-Jean de l'Habit also appears in a cavalier view of 1699. See Lusseau 2000, 10.

70 The foundation charter of 1109 is known through an early modern copy of a 1285 *vidimus*, and is published in Piolin 1851–1863, III (1856):677–680, pièce justificative LIII. The document itself remains unstudied.

71 Piolin 1851–1863, III (1856):678–679: *. . . in quo siquidem loco, ad meam petitionem et instanciam monasterium in honore Dei et beate Virginis Marie humiliter fabricavit; quo fabricato, ego predictus vicecomes affectans et desiderans conventum sanctimonialium ibidem agrgari pariter et uniri, que sub habitu regulari, accensis lampadibus, ut sponso se preparant per opera sanctitatis, et Domino de cetero famulantur, me suplicante, constituit et fecit, et eumdem locum per dictum reverendum episcopum at Dominum consecravit;*

72 *GC*, XIV:505–507, esp. col. 505, which is a principal source for the history of the foundation of this house. See also Piolin 1851–1863, III (1856):471–472 and 481–486; Venarde 1997, 65–66 and n. 42; and Guilloreau 1902, 158–160.

73 Piolin 1851–1863, III (1856):678: *. . . Adelermo clara stirpe nato. . . .* See below on the brothers' church.

74 As noted by Venarde 1997, 66 and n. 42, who rightly sees family interests involved in the foundation.

75 The church of Étival is essentially unstudied. See Anon. 1901 and Bercé 2008.

76 The museum is also known as the *Carré Plantagenet*. Images of the tombs are available online at https://monumentum.fr/chapelle-etival-pa00109711.html.

77 On the use of narrow, lateral passages, see Mallet 1984, 187–194, who does not, however, discuss Étival.

78 One window survives, near the east end of the southern wall. In its present form, this opening appears to be a later insertion, though if it replaced an original, that window would have shed southern light on the altar.

79 Le Mans, ADS, fonds d'Étival.

80 The contemporary *Carte Michelin Départemental*, n° 310, shows a forest road running from Saint-Nicolas three-quarters of the distance to Étival. It seems likely that a medieval trackway existed along a similar route between the two churches.

81 Trébaol 2018 appeared after our fieldwork at Saint-Sulpice was complete. Céline Trébaol's study is the first to approach the abbey from an architectural/archaeological perspective, phasing the church and the site across the centuries of its existence. She also considers the nature of materials and the style of the abbey's limited decoration. In large measure, her observations correspond with ours. We have not seen Trébaol 2017a, which we hope will soon be published. We are indebted to her for her plan of the church, which we reproduce as Fig. 11.

82 *GC*, XIV:786–787, briefly describes the career of Raoul.

83 Anon. 1685. The customs are unpublished and it is not known whether they copy earlier, perhaps twelfth-century customs, or belong to a later period.

84 *GC*, XIV:786–787, provides a short summary of the establishment of the house, giving a foundation date of *anno circiter 1112*. See also Raison and Niderst 1948, who ascribe the foundation to Raoul and give a date of 1102, though without explanation (36). Anger 1905 and Anger 1906 provide an edition of the sixteenth-century cartulary (XXXIV) and of individual documents related to the monastery (XXXV). On the cartulary and related documents, see Anger 1905, 172–173. Anger 1920, 1–45, also provides a history of the abbey from its beginnings to the French Revolution. Anger's history is inclined toward what might be called "disaster tropes" (". . . entièrement ruinée, . . .," e.g.) and must be read critically. The strength of Anger's history lies in its citations of early modern documents (see Anger 1920, 7–8). Earlier writers cited by Anger suggested that the site was changed and a new monastery built during the reign of Conan IV (r. 1156–1166), a position that Anger refutes convincingly. Surprisingly, Grand 1958, 542, accepts construction of the monastery during the reign of Conan IV, which he misdates.

85 Anger 1920, 6–7, citing Rennes, ADIV, 2H2/64, although he points out that the silence of documents in the intervening years is difficult to explain. Anger is echoed uncritically by Grand 1958, 452. See also Anger 1906, 356–358, document LVI, dated 1127.

86 If Saint-Sulpice–Notre-Dame du Nid-au-Merle was, in fact, a re-foundation, this might explain the choice of the archbishop of Tours, in 1127, to enumerate the gifts given by Count Conan I of Rennes (r. 970–992) to the earlier house of Saint-Sulpice. Comparison of the 1127 list of properties in relation to the possessions of the new abbey could provide insight into both houses.

87 *GC*, XIV:787: *Consummatum jam videtur opus novi parthenonis et sub invocation S Sulpicii consecratum, anno 1117*. No excavation at the site has been carried out that might confirm the date or indicate an earlier foundation on the same site. There is also no textual evidence that confirms the existence of an earlier church. Accordingly, we assume that the existing remains on site belong to the church consecrated in 1117 and that construction likely began before the formal act of foundation was issued.

88 Nothing is known of any of these buildings before the fifteenth century when the surviving *porterie* and residence of the abbess was built. A mill less than 100 meters from the *porterie* was built or rebuilt by Abbess Jeanne de Milon (1391–1407), whose mutilated coat of arms still appears on the tympanum. Other structures date to the seventeenth century (infirmary, west alley of the cloister, guesthouse, and a hall).

89 www.infobretagne.com/abbaye_de_saint-sulpice.htm (accessed 15.ix.2021), 5 of 19, probably on the basis of a charter of the abbey of Saint-Florent de Saumur to which the duke made a donation at this council.

90 Anger 1906, 353–354: *Idcirco Fulco, Andegavensis, Cenomanensis, et Turonensis comes, mandatis Domini aliquantunum obtemperare cupiens, ecclesiae sanctae Mariae monasteri novi et abbatisssae sancti Sulpicii et sanctimonialibus ejus, tam futuris quam praesentibus, in puram et perpetuam elemonsinam do et concedo locum fontis sancti Martini cum omni terra Ego vero Fulco et Eremburgis, comitissa, uxor mea, posuimus supradictum donum in manu Radulphi, monachi, magistri sanctimonialium et eum de dono investivimus cum anulo aureo*

91 Anger 1906, 351–352, document LII: *Ego Willelmus, Dei gratia, Pictaviensium episcopus, dono et concedo domino Radulpho de Flageio, sanctissimo viro et religiosissimo, ecclesiam Dei et sanctae Mariae Magdalenae quae est sita in parrochia Fulgeriosa et fundata in Plessio Cofredi ad opus Sanctimonialium Sancti Sulpicii . . . (351).*

92 Anger 1906, 371–372, document LX: *. . . concessisse Marie, filie regis Stephani et monialibus suis, manerium de Lillehercha cum omnibus pertinensis suis*

93 Thompson S. P. 2004 asserts the priory at Lillechurch was linked with Saint-Sulpice-la-Forêt and was founded by Marie's parents for their daughter who can be assumed to have been prioress by reason of charters she issued from there. Henry II's charter dates to 1155–1158, and before 1160, by which time Marie had left Lillechurch to become abbess of Romsey. There is no evidence she was ever abbess of Saint-Sulpice-la-Forêt/Notre-Dame du Nid-au-Merle.

94 See Thompson S. P. 2004.

95 We make this assertion on the basis of her tumultuous life (departure from regular life, forced marriage, children, and return to the cloister) and religious affiliations, as these have been traced by S. P. Thompson.

96 Anger 1906, 356–358 and 358–359, documents LVI and LVII respectively: *M. abbatissae*, in both cases.

97 Anger 1906, 325–328, document XLII: *Mariae, abbatissae*

98 Anger 1906, 1146/1147, document LI (350); 1152, document LIX (361–353); 1156, document LX (363–364); and, 1156, document LXII (367–369): all *Mariae abbatissae*, save for 1152, *Mariae ecclesie Sancti Sulpicii abbatisse*.

99 Anger 1906, 1156–1166, document LXIII (369); 1161, document XLIV (329–333); 1164, documents LXVI and LXVII (373 and 374–375, respectively): all identify *Ninae* or *Nine abbatissae*, save for the last wherein the copyist has misread the name as *Hine*.

100 Anger 1906, 369, document LXIII (1156–1171): *. . . dedisse et concessisse Ennoguent, sorori mee, et sanctimonialibus sancti sulpicii terram suam de Merle*

101 *GC*, XIV:787–788: *Enoguen . . . tertia dicitur a quibusdam S. Supicii abbatissa*. Evidently the authors did not consider that Enoguen was the third abbess "even though some" have said so, because they list Amelina (788) incorrectly as the third abbess, in spite of the quote from the obituary that describes her as the fourth abbess. Further, the authors of *Gallia christiana* considered Marie of Blois to have been the first abbess, which we know not to have been the case.

102 *Anno Domini du[odecim]centesimo decimo ab incarnatione Domini, lux pietatis, fons immense caritatis, Amelina d'Escose, abbatissa, mater pia, quam ducat ad coelestia Christi misericordia, nobis mater quarta fuit et feliciter tenuit ideoque sine fine Christi fruatur lumine*. Cited in www.infobretagne.com/abbaye_de_saint-sulpice.htm, 13. See also *GC*, XIV:788, where Amelina's death date is given as 1210, based on the abbey obituary. Amelina is also known from the cartulary. See also Anger 1906, document X, dated 1184–1198, where she appears as *A. Abatissa*.

103 See Trébaol 2017b and Trébaol 2018, 59–61 and 78–81 on the early modern buildings and their phases.

104 See Trébaol 2018, 68 and 70, fig. 17. Trébaol considers the (slightly irregular) alteration of voussoir blocks, of which each type is a different color, to have been deliberate and part of the decorative program of the church. This is an exciting possibility, but it requires knowing that the voussoirs of arches throughout the building were not plastered and painted as the walls were. Of this we cannot yet be certain.

105 Anger 1920, 13: *. . . entièrement ruinée* Regarding a *sondage* in the nave and evidence for damage during the Hundred Years' War, see Leroy 1982, 338.

106 Anger 1920, 25–28, on the 1556 fire and its aftermath; 28–31, on the damage done by the 1616 storm; and 31–35, on the damage done and repairs made after the second fire. Anger cites numerous documents in Rennes, ADIV: 2H2/1, 2H2/3, 2H2/10, 2H2/12, 2H2/16, 2H2/17, 2H2/18, 2H2/25, 2H2/29, and 2H2/49.

107 See the discussion of lateral passages at Notre-Dame d'Étival above.

108 If this is the case, then the vault either collapsed or was removed and a wooden ceiling, supported on the consoles, was inserted, perhaps after the fire in the mid-sixteenth century or after the storm in the early seventeenth.

109 Trébaol 2018, 71, observes that red false joint painting extends into the embrasure of the now blocked round-arched window in the terminal wall of the south transept arm. From this she infers that the red false joint belonged to the pre-Gothic phase of the wall. She further notes that traces of red false joint also appear on the blockage, implying that once the window had been replaced by the one above it, the false joint was "repaired" to disguise the blocked window. Together these observations suggest that an early, if not original, non-figural decoration survived into the thirteenth century.

110 On this "burial *caveau*," see Trébaol 2018, 57, 59, and 65–66, who demonstrates that the structure is contemporary with the church itself. She also describes the recent excavations (1980s) in the interior.

111 Barral i Altet 2005, esp. 22–25; Tillet, Castel, and Vié 1982, 73–120, on churches in the diocese of Rennes; Grand 1958, 121–157, on sculptural form (capitals and bases) and 452–453 at Saint-Sulpice. It is worth recalling that some of the Breton predisposition for abstract and geometric forms stems, at least in part, from the hardness of local stone—grès roussard and granite. Limestone sculptures in Brittany were carved from imported stone.

112 The abbey of Étival also had a church for the brothers serving the nuns' altar. As a comparison, Étival is less compelling because of the distance between the two churches. We wonder, however, whether further exploration at/of the site of Étival might not reveal a chapel for the brothers within the larger precinct.

113 Anger 1920, 17. See also Gilbert and Guérin 2001, who assign dates of 1433–1435 (*sic* 1455) to Abbess Guillemette's rule, as well as Banéat 1927–1929, IV:155, and Guillotin de Corson 1880–1886, II:315. The building was classified as a historical monument in 1992 and stabilized during the years 1999–2005, when the new, metal roof was put on. See Gilbert and Guérin 2001.

114 Gilbert and Guérin 2001.

115 Trébaol 2018, 76 and n. 40.

116 Below each of these windows is another nineteenth-century opening, one of which may have been a window and the other perhaps a door, though neither interpretation is certain. Gilbert and Guérin 2001 state that the chapel also served as a barn for a period of time.

117 Gilbert and Guérin 2001 state that there are three buttresses and no decoration on the north side. Given the present state of vegetation on the north side of the church, it is impossible to state where the third buttress is located and whether there once was a fourth, as on the south.

118 Gilbert and Guérin 2001. Trébaol 2018, 76–77, does not attribute the chapel but discusses only the portal in the westernmost bay on the south side.

119 Gilbert and Guérin 2001.

120 Gilbert and Guérin 2001.

121 A Monuments Historiques photograph taken between 1999 and 2005, during the reroofing and stabilizing of the chapel, reveals that there was no portal in the west façade. See Gilbert and Guérin 2001.

122 There is a portal in the west wall of the south transept arm that Trébaol 2018, 57, has linked to pilgrims' access of the tomb of Raoul de la Futaie. On the side away from the cloister, this entry could also have served the brothers of Notre-Dame-sur-l'Eau, not only for formal processions but also simply for entry to celebrate mass.

123 On processions between the convent church of Notre-Dame de Soissons and the collegiate church of Saint-Pierre-au-Parvis, whose canons served the altars of the convent, see Germain 1675, 455–457.

124 For a recent assessment of the complicated and conflictual relationship between men and women among new communities with an eremitic history, see Griffiths 2008.

125 Thompson K. 2009, 116. See also Cline 2019, 20–22. The phrase *in conversione sua* is formulaic, best translated as "upon his/their profession;" see Niermeyer 1984, 271. It can also appear simply as *in conversione*. In the Cartulary of Tiron, the fullest form of the phrase appears in a charter of 1141 (Merlet 1883, II:27, charter CCLVII), the beginning of which reads: *Notum sit universis sancta ecclesie filiis presentibus et futuris quod Robertus de Bellenvilla, in conversione sua cum factus est Tironii monachus, dedit ejusdem loci monachis, . . .* (Let it be known to all sons of the holy church, in the present and the future, that Robert of Blainville, at his profession when he is made a monk of Tiron, has given in this place to the monks . . .). In an undated charter of c. 1130 (Merlet 1883, I:165–166, charter CXL) that records the gift of half of a house in Mortagne, the husband and wife donors are both made monks: *Notum sit omnibus hominibus quod Guillelmus cementarius de Mauritania et Hersendis uxor venerabilis, in conversion sua, monachi enim Tironensis ecclesie fuerunt, . . .* (Let it be known to all men that William the mason of Mortagne, and Hersendis his venerable (monk-like/chaste) wife, upon their profession, were made monks of the church of Tiron, . . .). In a subsequent charter dated 21 September 1131 (Merlet 1883, I:174–178, charter CLI), *Guillelmus cementarius de Mauritania* is among the witnesses to a gift made in the chapter room of the abbey of Tiron. There is no other mention of Hersendis. In a charter dated c. 1135 (Merlet 1883, I:224–226, charter CXCV), William of Vaupillon and his wife Agnes give numerous

lands, fields, and forests as well as a pond and two mills to the monks of Tiron and go to the abbey to make profession: *Hec omnia dederunt Guillelmus et Agnes uxor ejus monachis de Tyron, pro remedio animarum suarum, libera atque solute ab omnibus secularibus consuetudinibus et justiciis et calumniis, sed diversis temporibus. Et ut hec omnia monachi in pace possiderent, memoratus Guillelmus et Agnes uxor ejus, ad conversionem venientes aput Tyron dereliquerunt dotem ipsius Agnetis, quam jam predictis monachis concesserant, . . .* (All this William and Agnes, his wife, gave to the monks of Tiron, for the remedy of their souls, free and released from all secular custom and justice and slander, but [these things were given] at different times. And that monks shall possess all in peace, the aforesaid William and Agnes his wife coming [for] profession at Tiron, they bequeathed the dowry of that Agnes which now had been conceded to the aforesaid monks, . . .). See also Milis 1979, 59–60, where he discusses briefly the presence and problems of women in communities that were in the process of becoming or had just become monasteries.

126 Bernard is thought to have been born in the area of Abbeville and is sometimes given that name in the scholarship. Sources for the life of Bernard de Tiron are given in n. 5 above.

127 We have discussed, in the context of regions, the early networks for patronage built by Bernard and his early followers in Bonde, Maines, and Sheffer 2021 (in press). See also Beck 2010.

128 Thompson K. 2014a, 103–107, Thompson K. 2014b, 25–26, and Cline 2009, XVIII, prefer an earlier date, presumably working from Souchet 1868, II: 354. Bonnebas 2014, 40–43, prefers 1114, in our view overemphasizing the role of Bishop Yves of Chartres. Beck 2010, 73, 80–81 and Beck 2014, 22, sees Bernard at "Tiron" in 1107, in the parish of Brunelles, and then moving to Gardais, where the abbey is today, in 1114. This change of sites is not uncommon in the history of monasticism, although in this case it is unclear whether the narrative is historical or a rhetorical trope as part of the story of Cluniac persecution of the abbot. It is worth pointing out, as Thompson K. 2014a, 104 has done, that Geoffrey Grossus' assertion that Bernard was offered a site at Arcisses during this period of challenge finds no independent corroboration in the sources, an observation that underscores the caution needed when drawing inferences from a single source.

129 Merlet 1883, I:117–119, doc. XXXII. Merlet dated the charter 3 February 1114, while the charter itself reads *. . . tercio nonas februarii, anno ab incarnacione Domini millesimo centesimo tercio decimo. . . .* See also Merlet's note 4 (117–118) on the false charters dating the foundation to 3 February 1110.

130 For a developed statement of monastic foundation as process, see Bonde and Maines 2003, 55–83, and Vanderputten 2013, 8–13. See also Milis 1979, 62–64, on the process of transforming an eremitic community into a monastic one.

131 According to Hollister 2001, 409 and n. 212, citing Van Houts 1992–1995, II (1995):254–255, "Robert of Torigny also says that the king, who contributed to abbey and cathedral construction in many regions, made great contributions toward the construction of the abbey's [Tiron] domestic buildings and was solely responsible for the dormitory, which he ordered to be built from scratch at his expense and in his memory."

132 Bonde, Maines, and Sheffer 2021 (in press), and Van Houts 1992–1995, II (1995):254–255.

133 Geoffrey Grossus, *Vita B. Bernardi*, caput IX, §81. See Beck 1998, 398, for the Latin, and 401, for the French. See Cline 2009, 87, for the English. Orderic Vitalis confirms Beatrix's support for Tiron. See Chibnall 1969–1980, IV, book VIII, 27, 330–331.

134 On Juliana's support for Tiron, which is mentioned by Geoffrey Grossus, see Beck 1998, 398, for the Latin, and 401, for the French; and Cline 2009, 87, for the English.

135 On long abbatial rules near the beginning of foundation, see Vanderputten 2013, 97–101. On Abbot William of Tiron, See Thompson K. 2009, 110–113, and Thompson K. 2014a, 92 and 132.

136 Chibnall 1969–1980, IV, book VIII, 27, 330–331: *Illuc multitudo fidelium utriusque ordinis abunde confluxit, et predictus pater omnes ad conuersionem properantes caritatiuo amplexu suscepit, et singulis artes quas nouerant legitimas in monasterio exercere precepit. Vnde liberter conuenerunt ad eum fabri tam lignarii quam ferrarii, sculptores et aurifabri, pictores et cementarii, uinitores et agricolae, multorumque officiorum artifices peritissimi.* (A multitude of the faithful of both orders flocked to him there, and Father Bernard received in charity all whom were eager for conversion to monastic life, instructing individuals to practice in the monastery the various crafts in which they were skilled. So among the men who hastened to share his life were joiners and blacksmiths, sculptors and goldsmiths, painters and masons, vine-dressers and husbandmen and skilled artificers of many kinds.)

137 Thompson K. 2014a brought Tiron to the attention of monastic scholars. Her article in this volume continues her research on the monastery into the later Middle Ages. Guillemin 1999, while written for a popular audience, is the only treatment on the history of the abbey from its foundation to the present and contains useful information. Among the older literature, Merlet 1883 remains essential, but should be used in conjunction with Thompson K. 2013. Since this article was written, Ruth Harwood Cline has contributed a second historical study of the abbey (Cline 2019).

138 We are at work on mapping and analyzing Tiron's monumental domain and have completed phased maps for the confirmations provided in the papal pancartes of Calixtus II (1119) and Innocent II (1132) to understand the nature and expansion of Tironensian monasticism.

139 See Bonde, Maines, and Sheffer 2021 (in press), 139–43,

Appendix: "XRF Identification of the quarries used to provide stone for Tiron." The *grès roussard* quarry is near Blainville at a distance of 3.6 kilometers from the abbey. This dense stone is the predominant material of the church's construction. The limestone quarry is known as the Maquis de Plainville, located 8 kilometers from Tiron. Limestone is used predominantly for quoins and decorative members (capitals, voussoirs, west portal, etc.) and, importantly, in the choir and the surviving shouldered tower.

140 The first archaeological and architectural studies of the church appeared in 2019 and 2020. See Bonde and Maines 2019, and Bonde, Maines, and Saintenoy 2020. A third study, Bonde, Maines, and Sheffer 2021, 119–40, is in press. Archaeological work on the cloister was first carried out by Oxford Archéologie Grand Ouest and reported on by Mercier et al. 2011. This work was continued under the direction of Sophie Liégard, summarized in Liégard 2018. Other archaeological excavations have recently been carried out in the area of the south transept arm, of which the unpublished excavation report is cited below.

141 Rescue excavation by Labat, Perrichon, and Louis 2015, 32 and 69–74, brought to light a small section of the western wall of the south transept arm.

142 Bonde and Maines, et al. 2018, 66–79.

143 The late Gothic chevet of Tiron was constructed during the abbacy of Léonet Grimault (r. 1453–1498) and collapsed in 1817. From Pinet's plan of the church (Fig. 20) and the cavalier view in the *Monasticon Gallicanum* (Germain [1870] 1967, pl. 58), the chevet consisted of a flat-ended choir enveloped by a double ambulatory with one projecting chapel on the central axis. Bonde and Maines (in progress) will situate the essentially unstudied chevet in the context of late Gothic architecture in the west of France.

144 Pinet's plans of Tiron were first published (redrawn) by Carbonnier 1999. See Paris, AN, NIII Eure-et-Loir 4—1–11, of which, N/III/Eure-et-Loir/4/2 contains the church plan shown here. On dom H. Pinet, see Bugner 1984, 39, 40, 113, n. 151 and 114, n. 20. According to Bugner, Pinet made his profession in 1630 at La-Trinité-de-Vendôme, and died forty-five years later at Nogent-sous-Coucy. He was one of a number of "religieux architectes" who traveled and worked widely among Maurist houses in a variety of regions, including the Loire valley, Burgundy, the Beauce, Champagne, and the Beauvaisis. Pinet was among the more active of these architects and is known to have drawn plans for at least twenty-one sites in addition to those of Tiron. See Lambert 1957, 313–332. Another plan of Tiron, dated to 1780, was drawn by dom G.-A. Huet but it is too schematic to help understand the church. Huet's plan is reproduced in Merlet 1883, I:XC, and Guillemin 1999, 53.

145 Germain (1870) 1967, pl. 58.

146 The aisleless cruciform plan was certainly used at Notre-Dame d'Étival and at Saint-Sulpice–Notre-Dame du Nid-au-Merle. At Fontevraud I, the evidence, as we have seen, is not clear, though it does seem likely that the church had, or was intended to have, an aisleless cruciform plan.

147 Shouldered towers are common in the Île-de-France around this time. They are not a regular feature in the west of France. See Héliot 1967 and Bonde, Maines, and Sheffer 2021, 131–32 (in press).

148 The equivalent space beneath the former north tower is inaccessible. It is filled with debris, presumably from the collapse of the Gothic chevet in 1817, and now covered with undergrowth. Pinet's 1651 plan (Fig. 20) represents the north tower after it was altered by the addition of the Gothic chevet. The plan appears to represent vestiges of the twelfth century and, if that is the case, the north tower was originally configured differently than the south. It may have served as the sacristy and vestiary, and perhaps the armarium above.

149 The two westernmost nave bays on the north were omitted to accommodate the presence of the western claustral range.

150 Changing window size and form as well as adding or removing tracery has been a common practice from the Middle Ages to the present day. For example, the priory of La Chapelle Monthodon (Aisne) still has the remains of windows belonging to three different phases in its south nave wall.

151 We acknowledge that Pinet's rendering of the window openings could simply be conventional. There is, however, an important element of reportage required in the kind of project with which he was engaged, and if part of the seventeenth-century project was to enlarge the openings, then it would be important to represent the windows as they actually were.

152 Bonde and Maines, with Saintenoy and Sheffer, 2018, 101–105.

153 Pinet worked, in a sense, as a restoration architect for the Maurist congregation. His plans for Tiron are labelled . . . *comme il est à present* . . . and . . . *comme on pretend le faire* . . . , or, in other words, the actual state and a proposed state after restorations and changes. Pinet's task required him to make accurate representations of things as they actually were in order that the Maurists could decide how best to make changes.

154 Pinet's plan provides no information about fenestration in the twelfth-century choir, which had been almost entirely destroyed by the time he drew his plan. The lower portions of the lateral walls of the choir that do survive had no windows. There may have been one or three windows in the terminal wall and one, or perhaps two, in each of the lateral walls, but there is no way to be certain.

155 Domfront has a second level of blind arcading above the first. It is not clear whether there was a second level

at Tiron or not, due to alterations in the Gothic period and the effects of time. On Domfront, see Grodecki (1953) 1954, 221–235; Musset 1967–1974, I (1967):211ff; and Baylé 2001, II:85–88.

156 On the capital type *à godrons*, see Baylé 1985, esp. 61–62 on "Le développement du géométrisme et l'apparition du chapiteau à godrons." Recent research on the Tower of London permits us to state that the earliest capital *à godrons* dates to c. 1090. We are grateful to John McNeill for this information.

157 A more complicated arrangement, such as a lancet surmounted by an oculus, is, of course, also possible. We think, however, that the overall simplicity of the building makes such possibilities less likely.

158 The northwest pier opposite is substantially masked by another building identified as the former presbytery. Only at the very top is it possible to see the north side courses, which appear to be disrupted.

159 Bonde, Maines, and Sheffer 2021, 139–143 (in press).

160 Bonde, Maines, and Sheffer 2021, 139–143 (in press).

161 We have compared one of these heads to the head of a column statue from Saint-Denis, now in the collections of the Walters Art Gallery in Baltimore. See Bonde, Maines, and Sheffer 2021 (in press).

162 Capitals on the inside of the window are damaged and covered with plaster. Only the capital(s) between the two windows, which are comparable in style to those on the exterior, appear to belong to the insertion of the windows into the façade. The other two capitals, which flank the windows, appear to have carried now-missing sculpture above their imposts. These capitals belong stylistically to the late twelfth or the early thirteenth century.

163 Merlet 1883, I:CIII: "La porte principale tournée à l'ouest tient du style roman et de l'ogive primitive. Elle se compose de deux archivoltes reposant sur de pilastres sans moulures: la première archivolte est en plein-cintre, la seconde en ogive Le bas des pilastres qui soutiennent les archivoltes est orné de deux statuettes assises tenant un livre sur leurs genoux; entre les deux pilastres est une petite colonne dont le fût est sculpté de feuilles de lierre. Au-dessus de la porte, il y avait primitivement une corniche ; mais, comme elle était en pierre tendre, le temps l'a détruite. Le tympan de la porte était peint ; il représentait la Vierge entourée d'anges. Les piliers contre-forts de chaque côté de la porte sont sculptés d'entrelacs et de feuilles d'acanthe." This quotation is largely accurate as description, but there are errors (e.g., there are three archivolts rather than two). How much of what Merlet published is Vincent's prose and how much is Merlet's (re)interpretation of it is unknown.

164 Merlet 1883, I:CII, reveals that the foregoing was taken from the notes of a certain A. Vincent: ". . . qui, né et mort dans l'enceinte de l'ancienne abbaye et ne l'ayant jamais quittée, est le guide le plus sûr pour tout ce qui touche aux annales de Thiron depuis le commencement de ce (XIXe) siècle." Whether Merlet ever visited Tiron and saw the portal is unknown. We have thus far been unable to locate Arsène Vincent's journal, which we believe to be in private hands.

165 On the portal at Le Mans, see recently Angheben 2017.

166 In this section, as throughout the paper, we focus on the first monumental church of each community. Where it seems useful to the discussion, however, we will include Fontevraud II, the only site to have rebuilt its first conventual church.

167 In this approach, our thinking has been partially shaped by one of the classic discussions of architectural iconography, specifically Günter Bandmann's notion that forms are actively chosen because they are signifiers of extra-artistic meaning that receivers believed to be embodied in the forms and that they wished to convey to themselves and to their world— in this case, the abbots, monks, and nuns as well as their patrons and builders chose forms that embodied ideas about monasticism and reform with which they wished to surround themselves and through which they wished to communicate to their world. See Bandmann (1951) 2005, 61–67 and 237–239. Other important discussions of architectural iconography include: Krautheimer (1942) 1969a, and Krautheimer (1942) 1969b. Critical responses include Crossley 1988; McCurrach 2011. For a different approach to meaning in architecture, see Gustafson in this volume.

168 See Goodman 1985 on how a building might and might not signify.

169 Pressouyre 1990, 30–36, for an eloquent evocation of the wilderness sought by hermits and the reform orders.

170 In this discussion, we follow current thinking that Fontevraud I (which we consider here) was like its successor, an aisleless, cruciform building with a single absidiole projecting off each arm of its transept. We reserve a note of caution about the nave and the crossing tower, as we discussed above.

171 The surviving evidence in the case of Tiron is insufficient to determine whether there was a chapel opening off the north transept arm. It is possible that the north tower was reworked before 1651, perhaps in the fifteenth century when the Gothic chevet was added.

172 Vaults were added in the transept at La Roë during the Gothic period.

173 The eastern termination of Fontevraud I and Saint-Sulpice was apsidal, whereas the east end of Tiron was flat.

174 For a recent review of the role of the transept that considers both its form and function, see Reveyron 2018, who argues (26–27) that the presence of a transept transforms how a church is perceived from both the interior and the exterior in ways that augment the

monumentality of the building. For a review of the literature on transepts in the West and on the term itself, see Franzé and Le Luel 2018, 7–21.

175 There were a few exceptions, like Brion and Chalonnes, which were 50 meters long, and Notre-Dame de Natilly (Saumur), which was 60.

176 These measurements are all based on the scaled plan in Mallet 1984 and are all exterior rather than interior measurements.

177 Mallet 1984, 309–348; for the collection of phased plans, see 309–348.

178 Another possible interpretation for these smaller churches is that they imitate the form of the cathedral of Angers. See Sandron 2000, who argues for the cathedral as the model for churches within a diocese, using Laon as an example.

179 Franklin 2012, and Franklin 2013. For an opposing view, see Gustafson in this volume.

180 Amis de l'Abbaye 2003, 47–67, and Terrel 1980.

181 On Sablonceaux, see Lefèvre-Pontalis (1912) 1913.

182 On Celestine architecture, see the study by Arthur Panier in this volume. On the Grandmontains, see Hutchison 1989; Durand and Nougaret 1992; and Bresson 2013. On the Camaldolese and the Vallombrosans, see the study by Gustafson in this volume.

183 Franzé and Le Luel 2018, 8–9.

184 Von Simson 1988, 36, n. 38. The notion was given pictorial form by Francesco de Giorgio (1439–d. 1502) on what appears to be an aisleless cruciform church plan with a human body superimposed upon it. Von Simson, pl. 7, from Florence, Biblioteca Laurenziana, MS Ashburnham 361, c.10 b.

185 Franklin 2012; Franklin 2013.

186 Gustafson, in this volume, argues that the Basilica Apostolorum was not itself a focal point for reformers in Milan. On Saint Nazarius, see Voragine 1993, II: 18–21.

187 The fourth-century, Milanese church of San Simpliciano, originally an aisleless cruciform building, was in the late eleventh century in the process of becoming a vaulted basilica. See Giostra 2007; our thanks to Erik Gustafson for the reference. The fifth-century church of Saint-Laurent in Aosta was also an aisleless cruciform church. That building survived into the ninth century when it was damaged by fire and rebuilt. See Bonnet 1978, 105–115, and Perinetti and Cortelazzo 2010. There must have been other such churches, but few are known, making the Basilica Apostolorum the focus for the type.

188 We do not consider here the use of sculpture on the interior of Fontevraud II, which is of another order both in the nature of the carving and the quantity of it throughout the church.

189 While a false-joint fragment from Tiron is known, its provenance—beyond stating that it came from the site—is not, and there is no information available on where it was found. See Bonde and Maines 2020, 2.

190 On this wall painting fragment at Saint-Sulpice–Notre-Dame du Nid-au-Merle, see Trébaol 2018, 71, who attributes the painting to the thirteenth century.

191 There is a poorly preserved painting of an abbess, probably of thirteenth- or fourteenth-century date, on the east wall of the north transept arm interior at Étival. See Bercé 2008, 50.

192 Merlet 1883, CII and CIII and notes 163 and 164 above. It is now generally understood that medieval portal sculpture was painted.

193 For example, Mallet 1984, 111–112, in the region for the twelfth century; Kimpel and Suckale 1990, 442, for the Gothic period. The literature on Cistercian austerity pervades nearly every study of the architecture. Pressouyre 1990, 60–67.

194 All of these houses were wealthy enough to have rebuilt, or to have added to, the original churches if they had wished to do so. This was the case at Tiron and La Roë, where the devastations of war presented the opportunity to replace the Romanesque choir with a Gothic one during the second half of the fifteenth century. The Romanesque transept and nave, however, remained in elevation. That the resources to rebuild existed is clear from early modern images of two of the sites—Tiron and Étival—and from surviving early modern buildings at La Roë, Fontevraud, and Saint-Sulpice–Notre-Dame du Nid-au-Merle.

KATHLEEN THOMPSON

The Abbey of Tiron in the Late Middle Ages: The Development of a New Monastic Order

They left the fellowship of the black monks and, changing their habit to grey, began to live apart, eager to restore the early practice of the black monks from whom they had withdrawn which those monks had for the most part abandoned through neglect and slackness.[1]

Jacques de Vitry is here describing the monks of the Tironensian congregation, whose mother house had been established to the west of Chartres in the early twelfth century under Abbot Bernard.[2] Like other "new monasticisms" of the years around 1100, Bernard's community took as its inspiration the poverty of the early church and the need to escape the world. The earliest sketch of his initiative, which is provided by William of Malmesbury, stresses the immense popularity of the approach and describes Bernard as:

a famous devotee of poverty; leaving a monastery that had great possessions, he retired with a few companions into a deserted place in the woods, and there, when many came flocking to him, for his light could not be hid under a bushel, he erected a monastery more famous for the piety and number of its monks than for the quantity and brilliance of its riches.[3]

As well as recruiting many individuals to their fellowship, the monks of Tiron also attracted the support of the elite, and donations of land and property led to the establishment of Tironensian communities across northern France and the British Isles with outliers south of the Loire and in Burgundy.[4] While the emergence of the Tironensians and others, such as the Camaldolese, Carthusians, and Grandmontains, has in modern times been the subject of historical scrutiny, the subsequent history of these new groups, with the exception of that of the

Cistercians, has not always attracted historians' attention.[5] The abbey of Tiron was placed in commendation (*en commende*) in 1551, the Maurists arrived in 1629, and in the years before its suppression in 1791 it was a military college.[6] A survey of Tironensian history in the fourteenth and fifteenth centuries therefore presents an opportunity to consider the grey monks' experiment as it adapted to changing political, social, and religious circumstances.[7] The Tironensians never regained the high profile that they had enjoyed in the twelfth century, despite bursts of energy as abbots of vision strove to make their mark, and scholarship has generally been content to categorize them among "other monasticisms."

The thirteenth and early fourteenth centuries: the abbey flourishes

By 1225 the Tironensian association of abbeys and priories with a regular assembly of its leaders was well-established, in contrast to the black monks on whom the Lateran Council of 1215 had imposed administrative structures. Despite the founder's devotion to poverty, a series of able and long-serving abbots, Gervais (1232?-1255), Étienne (c. 1255–c. 1275), and Jean II de Chartres (c. 1275–d. 1297), conserved and probably increased the material assets of Tiron. The rate of new endowments had slowed to a near standstill, but the endowment was enhanced through exchange and purchase, and ready cash was available to make those purchases; a sale by Bernard of La Ferté-Bernard and his wife, Johanna, for example, involved a price of £540.[8] In the middle of the thirteenth century a roll was compiled listing the rents to which the monks were entitled and, in response to a notification that rents were not being paid to the monks in the dioceses of Le Mans, Chartres, and Sées, Pope Martin IV issued instructions to pay on pain of ecclesiastical censure for the clergy and excommunication or interdict for the lay offenders.[9] The Tironensians remained true to their founder's desire to escape to solitude. With the exception of the small house dedicated to Saint Cross in Newport on the Isle of Wight, where the new town was established at much the same time as the priory, they founded no urban houses.[10] The strong ties of the twelfth century between the monks and the people of Chartres, when small communities of craftsmen chose to associate themselves with the Tironensians, are no longer apparent in the thirteenth-century records, perhaps because the houses of Friars, established in Chartres in 1231 and 1232, fulfilled that role.[11] This is not to suggest, however, that the monks' property was all in the countryside. There was urban property in Chartres, Châteaudun, Southampton,[12] Winchester,[13] and above all Paris, where they held several properties that they jealously guarded through litigation, going to law in the period 1237–1260 no fewer than four times.[14] Such urban property was lucrative and analysis of the 1250 rent roll suggests that the monks were increasingly relying on money rents.[15] Of the 121 items on the roll that can be deciphered, 54 are money rents, while 28 are renders in various forms of grains, 13 are tithes, 2 are mill tithes, and 8 churches are mentioned with associated tithes. There are hints, too, of an internal budget in the monastery; a regular payment of 20s. from Rivray contributed to the lighting of the church, for example, and the profits of the patronage of the church of Lignerai were directed to the kitchen.[16] Financial resource was moved within the Tironensian congregation too, as indicated by a bond in the sum of nine marks sterling, given by John, abbot of Saint Dogmael's to the abbot of Tiron and repayable to the community in the Isle of Wight a year later.[17]

To all intents and purposes, then, Tiron was a well-organised and well-funded monastic

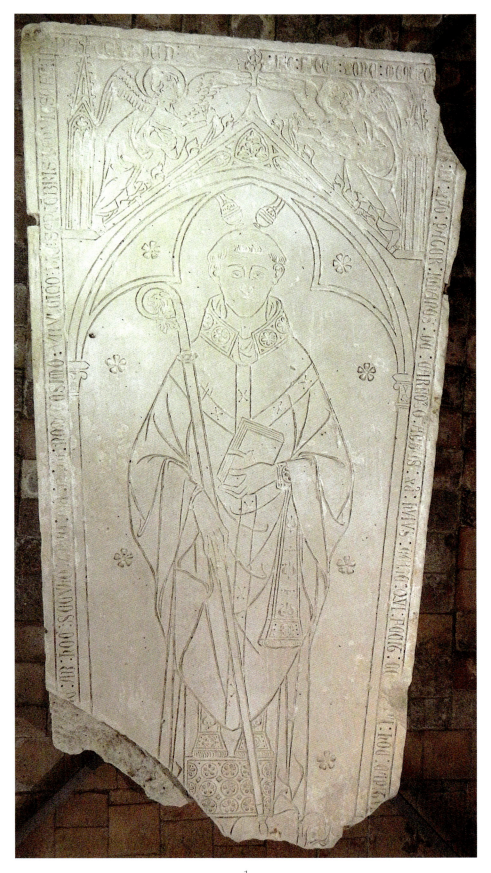

1
Tomb slab of Abbot Jean de Chartres (†1297).

community, similar to other Benedictine ("black monk") houses, and in 1290 Pope Nicholas IV confirmed all the privileges that had been acquired by the monks.[18] A life of Abbot Bernard had been composed that preserved the community's memories of its founder, but there are indications that Bernard's approach of simplicity and austere personal conduct, as described in the life, were not being followed by his successors.[19] Abbot Jean II, a great builder, is known to have kept great state in a lordly style that reflected his noble background and is used by Ursmer Berlière as an example of the growing separation between the abbot and the rest of the community.[20] Jean rebuilt the cloister and chapter house as recounted by his surviving tomb slab that once lay in the chapter house itself and is today displayed in the nave of the abbey church (Fig. 1).[21] The abbot is represented frontally within an architectural niche decorated with star forms, while above the niche angels swing censers. Incised with deep, bold lines, the tonsured figure appears in full ecclesiastical regalia holding his crozier in his right hand and a book in his left. Abbot Jean carries what appears to be an embroidered maniple and his chasuble is decorated with a "Y"-shaped form marked at intervals with crosses, perhaps deliberately resembling a pallium, the garment worn only by archbishops and hinting again at the growing distance between the abbot, as head of the order, and monks.

Six of the seven fourteenth-century heads of the community, who succeeded Abbot Jean, served for more than ten years: Simon (1297–c. 1313), Robert II Coupel (c. 1313–1315), Nicholas (c. 1315–1338), Henri I des Jardins (c. 1338–1354), Jean III (1354–1383), Étienne III Guillier (1384–1387/88), and Pierre Tersal (c. 1388–1414). Little is known of the abbots as individuals, although the epitaph of Abbot Henri indicated that he had ruled the house well, living soberly, justly, and according to monastic standards.[22] The abbot of Tiron stood at the head of the congregation and was probably recruited from within it, although our only evidence is derived from *Gallia Christiana*, which tells us that Robert Coupel had formerly been abbot of the Tironensian community at Ferrières and that Jean III had been abbot of Saint-Florent of Saumur, an abbey with which Tiron enjoyed confraternity.[23] Appointments were made centrally at an assembly and documentation was developed to facilitate the process, which was copied into the cartulary of the mother house.[24] Abbatial visitations were well established and, on occasion, the abbot disciplined the daughter houses, while in 1238 Pope Gregory IX had responded to the abbot's petition about the frivolous use of appeals in disciplinary action.[25] Relations with neighbouring communities such as the canons of the College of Saint-Jean in Nogent-le-Rotrou must have been friendly, for the dean undertook the abbot's obligation to attend the papal court at Avignon.[26]

In the temporal world, the community continued to administer the property committed to it by earlier benefactors; leases survive from this period as does a receipt from Abbot Stephen Guillier for 10s. received from the lord of Brimont in 1384.[27] Some new property was received, albeit not on the scale of the twelfth-century endowments,[28] and the community was still active in asserting its rights; there are, for example, no fewer than six orders under the authority of the counts of Alençon and the lords of Nogent, requiring payments promised to the monks to be honoured.[29] The clustering of these orders in the period 1349–1380 may of course be an accident of survival, but equally it may reflect the effects of the Black Death on the countryside, which are likely to have lasted more than a generation.[30] Abbot Henri's reluctance to travel to the papal court at Avignon, which led to the appointment of the dean of Nogent-le-Rotrou as proctor, may also be related to the pandemic.

The Hundred Years' War: Tiron divided

It was within a countryside devastated by the plague that the conflict between the English and the French crowns would be renewed in the 1350s, and although the abbey of Tiron did not lie in the direct path of the opposing armies, the French king, Jean II le Bon (r. 1350–1364), made Chartres the centre of his operations in 1356 in his confrontation with the Black Prince, bringing an army of fighting men to compete for scarce resources. King Edward III of England's march through Normandy in 1346 had probably already had a serious effect on Tiron's priories in upper Normandy, but it was the English houses where the prolonged conflict had most impact.[31]

As long ago as 1294, when a new period of conflict had broken out between the kings of France and England, Edward I of England had seized the revenues of property belonging to religious establishments that lay outside of England, the so-called "alien priories," and thereafter "hardly a decade passed without the monks feeling the heavy hand of the king on their property."[32] The abbots of Tiron had regularly appointed proctors from the community to act on their behalf in administering the English estates, but the appointment of John Lescriveyn in 1313, an Englishman, who probably had expertise in the law, suggests increasing business complexity.[33] When Edward III began the first phase of the Hundred Years' War in 1337, like his grandfather before him, he seized the property of the alien priories, intending that the monks should farm their property for the benefit of the crown, accounting for it at the exchequer. Thus the priors of Hamble and Andwell appeared at Westminster on 27 July of that year to give a commitment for 12 marks and £4, respectively, with John Scryveyn acting as surety for the prior of Hamble.[34] There was also the fear that French monks based in the English properties of their mother houses would incline to the French interest, suggesting that there was little local recruitment to these French foundations. Geoffrey de Lisle, prior of Titley in 1327 and from 1332 prior of the largest Tironensian settlement in England at Andwell, is, however, known to have been English, for he was given a royal pardon for the farm.[35] When Geoffrey became too old to perform his office, English fear of foreigners came to the fore. During Geoffrey's illness in 1341 the abbot of Tiron initially committed the care of the priory to one of the monks, Robert Renard, but when a formal appointment as prior was made after Geoffrey's death, the nominee, Richard of Beaumont, was arrested at Southampton and accused of spying because he was French.[36]

The property of the Tironensians' English houses would remain under the English king's control for more than two decades with the king presenting to the English livings held by the Tironensians, although he did not, after the misunderstanding about Richard of Beaumont, attempt to interfere with appointments. The treaty of Brétigny-Calais in 1360 brought a respite, and on 28 January 1362 John le Roier, abbot of Arcisses, was appointed proctor general in England with a clear mandate to put matters in order.[37] He commissioned Richard Wynnegod, whose family had been tenants of the prior of Andwell since the 1280s, as custodian of the priories of Hamble, Andwell, and Saint Cross.[38] Less than two years later, however, his arrangements were overturned by Abbot Jean III. Writing from Paris on 30 June 1366, the abbot revoked the three leases to Wynnegod, fearing to overturn the lease that had been given to Thomelyn Driffield, esquire to Edward III.[39]

This confusion in the Tironensians' English affairs attracted the attention of the new bishop of Winchester, William Wykeham, who shortly after his appointment sequestered the properties

of Andwell and Saint Cross on the grounds that they were "dilapidated and ruined through the fault of priors and servants," and he admonished William of Moutiers, the prior of Hamble, for absence without episcopal permission.[40] It is possible that the two English attorneys, Richard Wynnegod and William Froylle, whom the abbot appointed in December 1368, were instructed to improve the frosty relationship, but the challenges resumed with renewed hostilities between the French and English kings in 1369, and the prior of Hamble formally resigned in 1371.[41] A Tironensian monk, William of *Salariis*, was still in residence at that date, and the bishop of Winchester conveyed custody of the priory, but the Act of Parliament expelling aliens in 1378 made the Tironensians' tenure in England almost impossible.[42] It is likely that they had already lost interest; Prior William of Moutiers had apparently taken the valuables of his house away with him and Bishop Wykeham appointed a monk of Chertsey, William Foxele, as prior of Hamble in 1375.[43] Hamble's status as a priory of a French house did not, however, save it from damage in a raid by French galleys in 1380.[44]

The fifteenth century: disruption and recovery

In 1391 the situation was resolved by the sale of Tiron's English houses to Bishop Wykeham, who used them as part of the endowment of his new establishment, Winchester College.[45] Tiron was not the first French community to divest itself of its English properties; Troarn and the canons of Rouen had already done so and Bishop Wykeham was alert to the opportunities.[46] Wykeham's actions have been described as a "good stroke of business" but the sale was no bad thing for Tiron.[47] The challenges of administering such far flung properties were removed and the purchase price of 1300 marks (£866) had its uses, perhaps including the purchase in 1400 of the property called Loron in the parish of La Gaudaine, which bordered Tiron.[48] It must have seemed an excellent arrangement for the abbot, Pierre Tersal, whose ambitions lay in a different direction. In 1393 the abbot was granted the right to wear the mitre by Rome and in 1409, along with other princes of the church, he attended the Council of Pisa. Meanwhile in Normandy he attempted to reconstitute the Tironensian patrimony by re-establishing the priory of La Madeleine-sur-Seine, near Pressagny l'Orgueilleux (Eure).[49] When Tersal died on 12 April 1414 he was buried in the abbey's chapel of Mary Magdalen and his tomb bore a rebus, a form of self-representation that was becoming increasingly common among abbots of English monasteries in the later Middle Ages.[50] The Maurist scholars who compiled *Gallia Christiana* in the seventeenth century were unable to decipher the device completely, but distinguished three ducklings with outspread wings. The ducklings are less significant than their wings, which are a play on Tersal's surname (*tres ala*, or three wings), and they can be clearly seen on the escutcheons on Tersal's abbatial seal (Figs. 2a, 2b).[51] The abbot is shown kneeling within a round-headed, ornamented niche flanked by two shields showing his rebus. The abbot's chasuble falls in deep folds from his arm, and in his hand he holds a crozier. He appears to be wearing a deep collar similar to that shown in Abbot Jean's tomb slab and he may be mitred but, if he is, it would be an astonishing display of ambition for this seal was used in 1391, two years before the grant of the mitre.

Abbot Tersal's seal also reveals how early practice at Tiron had been replaced by contemporary forms. In the late thirteenth century, when Abbot Jean sealed an act he did so

2a
Seal of Abbot Pierre Tersal (†1414) dated from 1391–1392. WCM 2970. Reproduced by kind permission of the Warden and Scholars of Winchester College. Photo: Thompson.

2b
Detail of the Seal of Abbot Pierre Tersal (†1414), dated from 1391–1392, showing the kneeling abbot flanked by his coats of arms. WCM 2970. Reproduced by kind permission of the Warden and Scholars of Winchester College. Photo: Thompson.

with a corporate seal showing the Saviour in the act of benediction with a counterseal image of Abbot Bernard the founder.⁵² The corporate seal in use in Tersal's time is much grander in form, showing a *Gnadenstuhl* (mercy seat, throne of grace) image.⁵³ Against a diapered background containing fleurs de lys a nimbate figure of God the Father sits enthroned, supporting the cross and crucified Christ on his knees, while a dove flies from the Father's mouth with its head pointing to the head of the Saviour. The image reflects Trinitarian theology and Tiron's dedication, which appears in the legend: SIGILLUM CAPITULI SANCTI / SALVATORIS DE TYRON (Seal of the chapter of the Holy Saviour of Tiron).⁵⁴ For his abbatial seal Tersal adapted this image, placing the figures within an architectural setting under a sculptured canopy and adding his own image and rebus below, but refining the title of the monastery in the legend: S PETRI ABBATIS SANCTI / TRINITATIS . . . (seal of Pierre abbot of Holy Trinity . . .).⁵⁵

Tersal's desire to be remembered as an individual and the grant of the right to wear episcopal vestments, specifically the mitre, are indications of the scale of change at Tiron. They mark another stage in the increasing separation of the abbot from the community, for Tersal's mitre had moved him definitively above his brothers and beyond the humble clothing remarked by Jacques de Vitry.⁵⁶ It is worth pointing out that there is a clear difference between an image of an abbot *holding* a crozier, symbolizing his office, and an image of an abbot *wearing* a mitre, symbolizing his status.

As the fifteenth century progresses there is further evidence of the abbots' high profile, and there may have been intervention in their appointment through papal provision. At Tiron it had been the custom to select heads of houses from within the congregation; Hugues, for example, who had been the treasurer of Tiron, became abbot of Gué de l'Aunay in 1375. While it is known that Tersal was a native of Clermont, however, it is not known whether he had been a monk of Tiron before he became abbot.⁵⁷ His successor, Robert Dauphin (abbot 1414–1421), certainly was not. He had begun his career at La Chaise-Dieu, another foundation with eremitic origins, but unlike earlier abbots of Tiron he did not die in office.⁵⁸ Abbot Robert was well connected: his father was Béraud II, dauphin of the Auvergne, and his mother, Margaret, countess of Sancerre. By 1421 he had been nominated as bishop of Chartres, perhaps as a reward for a diplomatic mission to Spain, in opposition to Jean de Fitigny who held the office with the support of the English.⁵⁹

The 1420s in France were difficult years with the English in possession of Paris and much of the north after the treaty of Troyes. Even the death of the English king Henry V in 1422 did little to undermine the English occupation, which continued under the regency of Henry's able brother, John, duke of Bedford. Tiron lay in the conflict zone between the power blocs, and the Tiron archives preserve an account of the damage done to the abbey by the English general, Thomas Montagu, earl of Salisbury (1388–1428).⁶⁰ The church and conventual buildings were set on fire and the whole monastery severely damaged, although the chronology of the episode is far from clear.⁶¹ The account, which is given in a register compiled in the late fifteenth century, assigns events to the period immediately (*statim*) before Salisbury's death at the siege of Orléans (3 November 1428), but this date cannot be supported by contemporary documents. Salisbury's movements after his return from England to France in July 1428 are known with precision because he wrote to the commune of London describing his conquests and his list has been carefully analysed by Auguste Longnon.⁶² Salisbury's itinerary took him through the area that

lies between the modern départements of Eure-et-Loir, Seine-et-Oise, and Loiret. Although there were Tironensian dependencies in those areas, he did not come near to the mother house at Tiron. Salisbury's visit to Tiron must therefore have taken place at a different time; possible dates are in August/September 1424 in the aftermath of the battle of Verneuil or in 1426 when Salisbury was appointed to the military command of upper Normandy during the absence of the duke of Bedford and a contemporary chronicle describes his capture of La Ferté Bernard, Le Mans and Nogent-le-Rotrou.[63] Lucien Merlet also prints an account written by a monk of Arcisses, which places the events on the evening of 12 and morning of 13 June 1450 and, while the year must be mistaken, the month may perhaps be a pointer to an earlier date of June 1421 when Salisbury made a raid south from his base at Alençon towards Angers.[64] In a letter to King Henry V, dated 21 June 1421, Salisbury describes the raid from which he had returned on the previous Saturday (14 June) and the "prey of bestes" that they had taken.[65] The narrative written by the monk of Arcisses describes a similar predatory activity with the extortion of the sum of 4000 ecus (£5000) and the best of the horses from the locality.[66]

Not only did the years of conflict cause disruption and physical damage, but debt and internal dissension followed. In order to raise a sum of money for payment to the papacy resulting from the departure of Robert Dauphin, Ivo de Kerbout (abbot 1421–1426) was obliged to sell property at Meleray and the monks had to borrow 100 ecus (£125) on the security of a silver cross and six silver cups.[67] In June 1426 when Guillaume Grimault was elected abbot, the election was contested by Michel Houssard, probably the prior of the house, who claimed to have a papal reversion to the office. Although Houssard died in 1431, Grimault was not really secure in the post until he was confirmed by the Council of Basel in 1438.[68] *Gallia Christiana* tells us that Grimault spent most of his abbacy in Paris and he is known to have been admitted a member of the king's council in 1440. His response to a contested election at the abbey of Joug-Dieu towards the end of his abbacy, in 1452, was made from that city.[69]

The attraction of Paris for the abbots is made clear, moreover, by the development of the so-called Hôtel de Tiron, which has been reconstructed by Youri Carbonnier using an official eighteenth-century survey of the property.[70] Situated on the rue Tiron between the rue Saint-Antoine (modern rue François-Miron) and the rue Roi de Sicile, a complex of buildings had developed around a tower that had probably been built when these lands lay outside the city walls. A chapel and large kitchen had been added creating a courtyard, and stabling probably lay to the rear. An elaborate Gothic gateway led into the complex from the rue Tiron. Residence in Paris was clearly helpful to the abbots as they conducted business; of the six fifteenth-century abbots of Tiron, five are known to have been university-trained (Pierre Tersal, Ivo de Kerbout, and Guillaume Grimault in canon law; Léonet Grimault in an unknown subject; and Louis I de Crevant in theology). One, Robert Dauphin and possibly two, if the pluralist Louis I de Crevant is included, might reasonably be described as ecclesiastical careerists. All would have been comfortable in the Parisian environment.[71]

The gradual recovery of the French crown in the 1430s and renewed stability would have brought its benefits to Tiron's monks. From 1430 onwards there is a sequence of royal orders to pay the 100s. rent from the revenue of Chartres, given originally by the Countess Isabelle in 1221, and in 1445 the monks were able to lease to a local merchant their house behind the College of Toussaints at Mortagne, which had been in English hands for many years.[72] By 1452 they were

receiving an annual rent of £7 from their house at the corner of the rue Saint-Antoine and the rue Tiron in Paris.[73] Nonetheless, as late as 1472 the monks convinced the lord of Nogent-le-Rotrou, Charles de Guise, of the "abbey's poverty and the complete ruin in which it currently lies."[74] Like the rest of society the Tironensians faced the harsh economic and social conditions of the fifteenth century, and all religious communities were likely to find some of their revenues lost to appointments at papal behest. In 1394, for example, Benedict XIII had ordered that a benefice with a value of £60 should be found from Tiron's resources for one Jean Fresnelle, and the letters of *committimus* granted in 1444 to a student in Paris, William du Chesnay, who was prior of the Tironensian house of Cohardon, may indicate similar practice.[75] Repeated contests for the abbacy, involving appeals to Rome, did not come cheaply either, nor did the display now associated with the abbatial office.

The monks would address that poverty in the courts; in 1466 there was a lawsuit against Estoud of Estouteville, lord of Beaumont-le-Chartif, and another in 1484 with Joanna de la Vove, lady of Blainville, while a series of "procedures" was undertaken against John de Husson, lord of Villeray (1462–1484).[76] Sometimes those who had family connections with the community lent their support; in 1475, for example, Pierre of Montdoucet and his wife, Agasse de Cleraunay, ratified rents in wheat and money in the parish of Coulonges, given by her ancestor, Robert Giffart, but there is little sense of the monks' families supporting the community with gifts as Joanna and Margaret of Tercy had done in 1360 when their brother was received as a monk.[77] Apart from the remission of arrears in wheat renders that the monks gave to Pierre, lord of Vaupillon, in 1451 because of war damage and the plague, Tiron's connections with neighbouring families, which might have provided it with support during this period of reconstruction, are hard to recover.[78] It may be that the monks and the local elite had little to offer each other during this time of economic and social pressure. Evidence is emerging that the monastery may have acted as a place of burial for local patrons, but we do not know who or with what frequency the monks received individuals for burial.[79] In its earliest days Tiron had enjoyed a warm relationship with the Rotrou counts of the Perche, but found no replacement for their patronage when that dynasty died out in 1226, despite successive confirmations from those to whom the county of the Perche was entrusted by the kings of France.[80] While its daughter abbeys of Notre-Dame du Tronchet (Ille-et-Vilaine) and Notre-Dame de Joug-Dieu (Rhône) looked respectively to the dukes of Brittany and the lords of Bourbon, Tiron seems to have considered the rather more remote king of France its protector and it is therefore often described as the "royal abbey of Tiron." The longevity and strength of the royal patronage enjoyed by the abbey was emphasised in an act, produced by the monks in the fifteenth century, asserting that King Louis VI (r. 1108–1137) had extended important privileges to Tiron.[81] In practice, however, royal patronage seems to have amounted to little more than repeated confirmations of Tiron's privileges and might even be a cause of further expense, if the king required accommodation for a lay person, as did Francis I in 1516.[82] It was, in fact, to the newly revitalized communities of the cities that the French kings of the turn of the fifteenth and sixteenth centuries gave their support, rather than to Tiron, which remained rooted in the distant countryside.[83]

In the patient process of rebuilding and consolidating the patrimony, officials were made to respect the monks' rights. The farmer of the forest of Bellême recognised their pasture in

1473, for example, and there were sometimes small donations: Perrin Glatigny gave land in the parish of Frétigny, while Vincent Mondeguerre gave all that he owned at Ceton.[84] Eventually there was sufficient money for purchases to be made. In 1467, at a cost of 50 ecus (£62 10s,), the monks bought rights in the parishes of Saint-Hilaire-des-Noyers (Orne), Gardais, and Saint-Denis d'Authou, and in 1476 they acquired a mill.[85] In 1481 the abbot bought urban property in Chartres, while between 1476 and 1490 the monks extended their interests in Frétigny by buying rents from the d'Estouteville family.[86]

The success of this recovery must in large part have been attributable to the leadership of Léonet Grimault (abbot 1453–1498), whose long abbacy stretched over more than a generation. Abbot Léonet was a man with an eye for detail: during a visitation of the abbey of Gué de l'Aunay he ordered the deeds, accounts, charters, and registers, as well as rules, liberties, privileges, and records to be placed in a closed chest with its treasure and relics, with the two keys kept by separate individuals.[87] He was also punctilious in his instructions for building repair at the dependencies, which must have been long neglected because of war. *Gallia Christiana* tells us that he restored buildings that had been consumed by fire, perhaps an allusion to the Salisbury damage, at his own expense and that of friends.[88] This is our only hint of a friendship network that supported Tiron's recovery. We do not know which buildings were repaired, though all of the monastic estate must have required repair, refurbishment, and even renewal after the Hundred Years' War.[89] Although no documentary confirmation has yet been found, Léonet is also the abbot most likely to have initiated the building of the late Gothic choir at Tiron.[90] The choir, recorded pictorially in the *Monasticon Gallicanum*, collapsed in 1817 and only vestiges of it remain in elevation on the north side of the tower that flanked it.[91]

As a former cellarer of Tiron and prior of Bouche d'Aigre, Léonet was seasoned in Tironensian practice but, like his uncle before him, he experienced a contested election—this time from within the congregation, by Harduin Botterel, abbot of Ferrières, rather than from within Tiron. Standing at the head of an association of communities, the abbot of Tiron might reasonably have expected some tensions. Internal disputes were not unknown in the community's history; in the late 1390s, for example, the monks of Tronchet in Brittany had elected Ralph Tournevache without the consent of Tiron, and litigation that followed occupied the early years of the fifteenth century.[92] In 1437 and 1451 actions were brought against the priors of Bouche d'Aigre to establish the procurations that would be paid when the abbot undertook visitations.[93]

Abbot Léonet seems, however, to have faced a loosening of the ties within the order. He inherited, for example, a difficult situation when the monks of Joug-Dieu requested that Simon le Couvreur, prior of the Celestines at Lyon, should be appointed their abbot.[94] They commended Simon for his "conduct, character, knowledge, wisdom and administrative ability," but it seems chiefly for the latter. The monks asserted that Simon had found his house in a poor and desolate state and had restored it, making it one of the best administered of his order. The monastery and possessions of Joug-Dieu, on the other hand, were in ruins: revenues were falling, meals and clothing for the four remaining monks were hard to find, and divine service was hardly possible. The monks' account describes the effects of years of economic and social crisis, and the abbey's patron, Charles, duke of Bourbon (1401–1456), wrote in support of Simon's candidature in much the same terms. Such was the case made to Abbot Guillaume in 1452, but he was not to be browbeaten; he wrote a lengthy letter by return (the duke had written from Moulins on

1 February; the abbot replied on 8 February), pointing out that it was contrary to the ordinances of the order of Tiron to make such an appointment and it was his intention to place at Joug-Dieu someone who knew how to administer, rule, and govern, who would make repairs and put in place the correct number of monks.[95] The challenge from Joug-Dieu was faced down and early in 1453 a Tironensian was appointed to that house, but Abbot Léonet would continue to preside over a turbulent congregation, with Ferrières' refusal to accept a visitation in 1463 and a disciplinary action against the abbot of Gué de l'Aunay in 1474.[96] It was the troubled relationship with Ferrières, however, that was to dominate Léonet's abbacy. In the late 1470s no fewer than three candidates were contesting the abbacy of Ferrières, and in 1490 the monks sought to deliver themselves from the influence of the abbot of Tiron by electing a powerful outsider, Cardinal Andrew of Espinay, archbishop of both Bordeaux and Lyon.[97]

The administration of the Tironensian congregation then required energy and steadfastness. Within the abbey of Tiron itself, the abbot was supported by a chamberlain, a sacristan, and an infirmarer and these officials' names are known for Léonet's abbacy, since they are recorded in a new register begun in the 1480s.[98] Offices rotated: Alexander de la Barge was infirmarer in 1483, and was succeeded by Pierre Guérin in 1491 and Louis de Cambettes in 1494. Jean Lebas was sacristan in 1483 and succeeded by Philip de Thère in 1488. By 1490 Jean Lebas had become prior of La Roussière, in 1497 he was prior of Sainte-Radegonde, and by 1498 had moved to Saint-Epargne d'Ablis. In the English houses of the first half of the fourteenth century: Richard of Beaumont had been successively prior of Hamble in 1320–1337 and prior of Andwell in 1343–1344, while Geoffrey de Lisle was prior of Titley in 1327 and prior of Andwell in 1332–1340.[99] Such mobility had been the practice since the earliest days of Tiron and was perhaps intended to promote consistency of approach within the order.[100]

While internal mobility may have been the traditional way to prevent slackness in isolated communities, there were other tools at the abbot's disposal to promote appropriate behaviour. Abbatial directives issued in the 1480s suggest an increasing inability on the monks' part to remain separate from the outside world.[101] In 1482 Léonet forbade the presence of women below the age of 50 among the brothers, presumably as servants, and inappropriately warm relations with the laity are suggested by the abbot's order in 1484 that monks should not baptise or name infants. He also ordered them not to wear unseemly clothes or swords especially in public places, and this decree may in part have been influenced by his judgement on John Larcher and John Bretereau of the abbey of La Pélice for a brawl that had drawn blood. There was clearly cause for concern, for in 1486 a further directive was issued on unsuitable clothing, the carrying of weapons, and the frequenting of taverns.[102]

The abbot also had the power of visitation and notes survive of a visitation in 1484 made by the abbot's vicar, Philibert Haizon, prior of Châtaigniers, and of a visitational tour by Abbot Léonet himself in November 1485.[103] The ceremonial of the abbot's reception into the church is described for each visit, the name of the receiving prior and the abbot's instructions after his visitation. At the abbey of Gué de l'Aunay, for example, Léonet instructed the sacristan to provide decent linen covering for the eucharist and he reminded the community that one chapter of the Benedictine rule should be read at least one day every week.[104] At the abbey of La Pélice, Léonet was dissatisfied with the monks' dress; on pain of excommunication, they were to wear "seemly" monastic clothing which was defined as a long tunic or coat, short

stockings, and strapped shoes.[105] At the priory of Saint-Michel du Tertre the visitation revealed woodwork problems and difficulties enforcing contracts for its repair with carpenters and with masons to complete work on repairing walls. After mass had been heard, the prior was instructed to have the chalice cleansed and the chasuble repaired, while he was to secure a missal and a cloth for the altar.[106] The report implies that the prior, Pierre of Montireau, was an absentee, for the farmer (*firmarius*) was John Lesleu, prior of La Roussière, near Courtomer, who declared that he celebrated at least two masses a week at Saint-Michel du Tertre. Two days later Léonet was at La Roussière, where it will have come as no surprise that the prior, John "Leillu" [*sic*], was absent; he was presumably still at Saint-Michel du Tertre, but the estate manager (*mediatarius*) assured the abbot that mass was celebrated twice a month. The abbot found the estate manager's equipment at the back of the church; a missal was needed and there appeared to be no vestments, since the estate manager was instructed to buy a chasuble, stole, and maniple to compensate for his misuse of the building. Major refurbishment was required; the church was to be whitewashed, two new windows created with images of the saints in them, while the farmer was to make major repairs.[107] There was clearly much to be done in Tiron's minor dependencies.

By the early 1490s Léonet had been in post for more than thirty years and he sought to hand over the responsibility to his nephew, Jacques Le Bord, but Le Bord apparently never took up the task, for Léonet's eventual successor was another nephew, Louis de Crevant (abbot 1497–1503).[108] It is tempting to see Léonet in these years of quasi-retirement, when he presided over the general congregation of the order in Louis' name, preparing his own memorialisation. An elegant incised tomb slab, displayed today in the nave of the abbey church, shows Léonet side-by-side with his uncle, Guillaume (Fig. 3). The slab was recovered at the entry to the choir, following the collapse of the chevet in 1817.[109] Although worn and more damaged than the tomb slab of Abbot Jean II de Chartres, its carving is both finer and shallower than that of the earlier slab and enough survives to judge its quality. Both abbots are shown frontally in their vestments, which may be embroidered copes; both are wearing mitres and carrying croziers. The hands of the figure to the left are placed together in prayer. Both heads rest on figured pillows, and scutcheon shapes, presumably bearing armorial devices, can be discerned covering the lower parts of the bodies; below the feet is an arcade. Each figure rests beneath an ogival niche and they are framed by elaborate Gothic architectural motifs. There is a three-gabled canopy above each figure, each containing three figures, some with a nimbus, and the one above the right figure is holding a book. The slab is framed on the exterior by a long inscription, parts of which are now missing.[110]

Other details of abbatial artistic patronage are hard to recover, although Abbot Léonet's instructions concerning the chapels of the dependencies suggest that stained glass windows, statuary, and woodwork were commissioned, while the albs and copes worn by monks during abbatial visitations indicate the commissioning of vestments.[111] The community must also have possessed liturgical vessels and other metalwork for it borrowed against the security of a cross and six silver cups, but such artistic patronage as well as the community's manuscript commissions remain, as yet, a matter of surmise.[112] The most famous example of Tironensian patronage is of course the silver-gilt and enamel crozier found behind the sanctuary at Tiron in 1842, likely to have been buried with a thirteenth-century abbot (Fig. 4).[113]

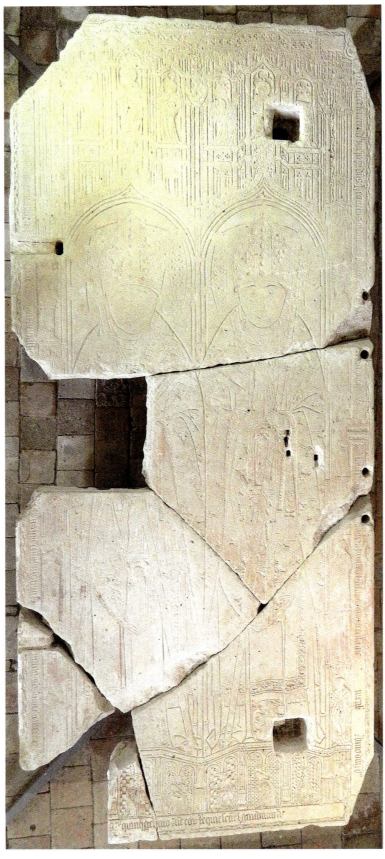

3
The tomb slab of Abbot Guillaume Grimault (r.1426–53) and his nephew Abbot Léonet Grimault (r.1453–98).

4 Head of an abbatial crozier (13th c.) found during excavations behind the present sanctuary in 1842.

The sixteenth century: a monastery slipping behind the times

Abbot Léonet's chosen successor, Abbot Louis, had already held or tried to hold abbatial office at two abbeys: Sainte-Foy of Conques (1482) and La Trinité, Vendôme (1487), and his interests were clearly centred on securing ecclesiastical preferment. Nonetheless, he was an able man; he sought to restore Vendôme and Pope Alexander VI permitted him to take control of the priory of Saint-Georges of Oléron in order to increase resources available to Vendôme.[114] While it is difficult to be sure that the initiatives were those of Abbot Louis, there does seem to have been an energetic new atmosphere at Tiron as the fifteenth century drew to a close.[115] In 1500, presumably in an effort to improve efficiency, a statement of rents due from Mortagne was drawn up and two new enterprises were established: a tannery at the lake edge in 1496, and in

1498 land near the lake of Sainte-Anne was leased to one John Coisneau with the instruction to establish tile-making there.[116]

Louis I's tenure of the abbacy was short-lived, however, for moves were soon being made to hand over the office to his own nephew, Louis II (abbot 1503–1549). In 1501 the younger Louis promised obedience to the bishop of Chartres and obtained papal sanction for his appointment in February 1503, the leisurely quality of the handover probably attributable to Louis' youth, for he had been born only in 1484.[117] The papal involvement and the family connection were perhaps typical of the period, for Louis' brother, Anthony, was to hold the abbacy of Bois-Aubry at papal behest (c. 1502–1514) and Ferrières (c. 1503–1513). Similarly his cousin, also Anthony, was abbot of Bois-Aubry (1514–1531) and succeeded their uncle at Vendôme (1522–1539), while a John de Crevant would be prior of Tironensian Croixval in 1531–1532.[118] The Crevant abbots and the Grimault before them are, then, examples of abbatial dynasties, as identified by Berlière. Family names also recur among the priors of the dependencies, including Larbent (Raoulet and Jacques at La Madeleine-sur-Seine, in 1482 and 1484, respectively), Guerin (Antoine at Saint-Blaise de Luy, 1483, and Écomon, 1484; and Pierre at Monrion, 1483), Bacqueville (Louis, 1522; and Guillaume, 1523), and Renoncet (Charles, Montaillé, 1517; François, infirmarer, 1531).[119]

Abbot Louis II would remain in post until 1549, with only one further abbot, Geoffrey Laubier (1549–1551), freely elected before the abbey was placed in commendation in 1551.[120] Some visitation records for Louis' abbacy survive, including that of his visit to Joug-Dieu from December 1510 to January 1511 during which he presented to the abbey a newly printed breviary.[121] The record of the visit describes the mitred Abbot Louis, clad in a white cope and carrying the pastoral staff that the head of the house had presented to him for the duration of his visit, leading vespers on Christmas eve and celebrating high mass on Christmas day during what must have been a fortnight's hard work, correcting bad practice and poor behaviour. For much of his abbacy, however, he seems to have been preoccupied by relations with the cathedral chapter in Chartres. The precise details of the relationship between the abbey of Tiron and the chapter had often been contested.[122] During Louis II's abbacy, however, despite the bishop's conciliatory gesture in acknowledging the abbot's right to take first place in assemblies of the clergy in Chartres, the quarrel came to a head in a lengthy and ruinous series of lawsuits.[123]

In order to prove that the abbey of Tiron was exempt from the jurisdiction of the Chartres chapter, the monks redrafted their foundation charter and created papal, archiepiscopal, and other confirmations of that charter, which they exhibited in court in Chartres. The litigation dragged on through appeal and counter-appeal until 1556.[124] In his study of the documents, Lucien Merlet saw the forgeries as evidence of self-interest among the monks of Tiron, who had lost the discipline and simplicity of their forbears. While it is clear that the purpose of the redrafted acts and associated documents was to enhance the abbey's material position, they also reveal a skilled and busy scriptorium at the abbey. Early in the fifteenth century when Abbot Pierre Tersal restored monastic observance at La Madeleine-sur-Seine, the community had been furnished with copies of foundation charters, some translated into French, and a life and miracle collection of the warrior saint Adjutor had been provided.[125] During the course of the fifteenth century other documents were produced; the record of the visitation to Cohardon notes, in fact, the abbot's instruction that the prior should appear at Tiron to secure a copy of the foundation charter, and it is likely that other houses looked to the mother house for

similar records.[126] On occasion, documents must have been drafted to support Tiron's position in disputes with its daughter houses. The foundation charter of Joug-Dieu, pronounced by Lucien Merlet as "obviously false," might well fit into this pattern, although its contents may reflect traditions preserved at Joug-Dieu.[127] It is hard, too, not to see the hand of Tironensian monks behind Louis XI's confirmation of their right to receive salt at Mortagne, which was made at the "humble supplication of our dear and well loved monks, the abbot and convent of the abbey of Tiron," and which gives a brief history of the house. It was "founded in praise of God the creator and Saint Bernard, who was the first abbot of the abbey. He chose the place where it was constructed and built, for it was situated in an isolated place in the woods, in deserted and uninhabited country, in a marsh in a valley . . . and established himself there with his disciples who were around 300 in number, leading a religious and contemplative life . . ."; the act goes on to describe (erroneously) how Saint Louis and his army took the cross there.[128] As Merlet comments, considerable expertise was deployed in the production of these documents, and in another house this energy might have been directed to historical enquiries and the writing of histories of the community.[129] Even so, there is some evidence that the expertise was well known, for in 1510, two Tironensian monks, Jean Legrand and Bertrand Legros, joined a party of four canons from the cathedral at Chartres in Paris in organizing the refurbishment of the inscription on the tomb of Bishop Simon of Perruchay (1277–1297).[130]

Conclusion

After more than thirty years of litigation with the chapter of Chartres a compromise was offered to the monks and the documentation associated with this proposal provides a picture of the Tironensian community in 1542.[131] Led by Abbot Louis, Brother Charles Renoncet (prior of Heudreville), Matthew André (the claustral prior), Guillaume des Guetz (the prior of Montallier), and Michel Regnard (the sub-prior), twenty-five other professed monks are named. When Abbot Louis II made his visitation of Joug-Dieu, the community comprised eight monks and an abbot. These numbers are small in comparison to the "multitude" that Orderic described flocking to Tiron in the twelfth century, but it is an impressive number for a rural community that had been in existence for 350 years.[132] Jacques de Vitry's sketch of the Tironensians describes fasts and vigils; unceasing prayer; a regime of praise, reading, and meditation; humble clothing; and the practice of hospitality, however, and there is no sign in Tiron's later charters or other records of a return to eremiticism in response to the *devotio moderna*. Neither is there any indication of the practice of personal mortification, which was becoming a feature of monastic practice.[133] The baton of monastic renewal had long since been passed to others.[134]

Abbreviations

ADEL	Chartres, Archives départementales d'Eure-et-Loir
CCR	Calendar of Close Rolls
CFR	Calendar of Fine Rolls
CPR	Calendar of Patent Rolls preserved in the Public Record Office
GC	*Gallia Christiana*, rev. ed., 16 vols. (Paris, 1715–1865)
Inv. 1897	Inventaire-sommaire des Archives Départementales Antérieurs de 1790, Eure-et-Loir, VIII: Archives Ecclésiastiques, série H, 1, ed. Lucien Merlet (Chartres: Imprimerie Garnier, 1897)
WCM	Winchester College Muniments

Printed Primary Works

Benedict XIII 1983: *Lettres de Benoit XIII (1394–1422), tome I: (1394–1395)*, ed. Jeannine Paye-Bourgeois. Analecta Vaticana Belgica, XXXI (Rome: Institut Historique Belge de Rome, 1983).

CCR: *Edward III*, 14 vols. (London: HMSO, 1896–1913).

CFR: 22 vols. (London: HMSO, 1911–1963).

CPR: *Edward I*, 4 vols. (London: HMSO, 1893–1901), vol. 1: 1272–1281, vol. 2: 1281–1292, vol. 3: 1292–1301, vol. 4: 1301–1307; *Edward II*, 5 vols. (London: HMSO, 1894–1904), vol. 1: 1307–1313; vol. 4: 1321–1324; *Edward III*, 16 vols. (London: HMSO, 1891–1916), vol. 1: 1327–1330; vol. 2: 1330–1334, vol. 3: 1334–1338, vol. 13: 1364–1367; vol. 14: 1367–1370; *Richard II*, 7 vols. (London: HMSO, 1895–1909), vol. 1: 1377–1381.

Geoffrey Grossus 2010: *The Life of Blessed Bernard of Tiron*, trans. Ruth Harwood Cline, with intro. and notes (Washington, DC: Catholic University of America Press, 2010).

Hockey 1981: S. F. Hockey, ed., *The Cartulary of Carisbrooke Priory* (Newport, Isle of Wight: Isle of Wight Record Office, 1981).

Inv. 1897: Série H, I, ed. Lucien Merlet (Chartres: Imprimerie Garnier, 1897).

Jacques de Vitry 1972: *The Historia Occidentalis of Jacques de Vitry: A Critical Edition*, ed. John Frederick Hinnebusch. Spicilegium Friburgense, Texts concerning the history of Christian life, 17 (Fribourg: Fribourg University Press, 1972).

Lépinois and Merlet 1862–1865: E. de Lépinois and Lucien Merlet, eds., *Cartulaire de Notre-Dame de Chartres*, 3 vols. (Chartres: Garnier, 1862–1865).

Merlet 1883: Lucien Merlet, ed., *Cartulaire de l'abbaye de la Sainte-Trinité de Tiron*, 2 vols. (Chartres: Garnier, 1883).

Orderic Vitalis 1969–1980: *Ecclesiastical History*, ed. Marjorie Chibnall, 6 vols. (Oxford: Oxford University Press, 1969–1980).

Walsingham 2018: Thomas Walsingham, *The Deeds of the Abbots of St Albans:* Gesta abbatum, Monasterii Sancti Albani, ed. James G. Clarke, trans. David Preest (Woodbridge: Boydell & Brewer, 2018).

William of Malmesbury 1998–1999: Gesta Regum Anglorum, *The History of the English Kings*, ed. and trans. R. A. B. Mynors, completed by R. M. Thomson and M. Winterbottom, 2 vols. (Oxford: Clarendon Press, 1998–1999).

Secondary Works

Bastard d'Estang 1857: Auguste de Bastard d'Estang, "Rapport fait à la section d'archéologie, le 28 juillet 1856 . . . sur une crosse du XIIe siècle trouvée dans l'église de Tiron, arrondissement de Nogent-le-Rotrou," *Bulletin du Comité de la Langue, de l'Histoire et des Arts de la France* (1857): 400–521.

Beck 1998: Bernard Beck, *Saint Bernard de Tiron: l'ermite, le moine et le monde* (Cormelles-le-Royal: Éditions La Mandragore, 1998).

Benedictow 2004: Ole Benedictow, *The Black Death 1346–1353: The Complete History* (Woodbridge, Suffolk: Boydell Press, 2004).

Berlière 1927: Ursmer Berlière, "Les élections abbatiales au moyen âge," *Academie Royale de Belgique Mémoires*, 2e sér., 200 (1927): 3–101.

Bonde and Maines 2019a: Sheila Bonde and Clark Maines, "Thiron-Gardais (Eure-et-Loir) Abbaye de Tiron," Chronique des fouilles, *Archéologie Médiévale*, 49 (2019): 297–298.

Bonde and Maines 2019b: Sheila Bonde and Clark Maines, "Chœur de l'abbaye et ancienne cuisine: Intervention archéologique préalable à une reconstruction du chœur gothique en 3D et prospection radar situant l'ancienne cuisine hexagonal," *Le Collector. Bulletin du réseau européen de l'Ordre de Tiron*, 7 (2019): 2–5.

Bonde and Maines 2020: Sheila Bonde and Clark Maines, "L'Inventaire du dépôt lapidaire de l'abbaye de Tiron," *Le Collector. Bulletin du réseau européen de l'Ordre de Tiron*, 8 (2020): 2–3.

Bruun 2013: Mette Birkedal Bruun, ed., *The Cambridge Companion to the Cistercian Order* (Cambridge: Cambridge University Press, 2013).

Carbonnier 1999: Youri Carbonnier, "L'abbaye et le collège de Tiron au XVIIe siècle: état et projets au début de l'époque mauriste," *Cahiers Percherons*, 2 (1999): 1–18.

Carbonnier 2004: Youri Carbonnier, "Les biens de l'abbaye de Thiron à Paris: état des lieux aux XVIIe et XVIIIe siècles," *Cahiers Percherons*, 4 (2004): 1–20.

Cazelles 1962: Raymond Cazelles, "La peste de 1348–1349 en langue d'oïl, epidémie prolétarienne et enfantine," *Bulletin Philologique et Historique (jusquà 1610) du Comité des Travaux Historiques et Scientifiques* (1962): 293–305.

Clark 2011: James G. Clark, *The Benedictines in the Middle Ages* (Woodbridge: Boydell Press, 2011).

Cline 2019: Ruth Harwood Cline, *The Congregation of Tiron: Monastic Contributions to Trade and Communication in Twelfth-Century France and Britain* (Leeds: ARC Humanities Press, 2019).

Coppack 2002: Glyn Coppack, "The planning of Cistercian monasteries in the later middle ages: the evidence from Fountains, Rievaulx, Sawley and Rushen," in *The Religious Orders in Pre-Reformation England*, ed. James G. Clark (Woodbridge: Boydell Press, 2002), 197–209.

Davis 2007: Virginia Davis, *William Wykeham* (London: Hambledon Continuum, 2007).

Doubleday and Page 1903: H. Arthur Doubleday and William Page, eds., "Alien houses: Priory of St

Cross, Isle of Wight," in *A History of the County of Hampshire*, 2 vols. (London: Victoria History of the Counties of England, 1903), II: 225 [also available via *British History Online* at http://www.british-history.ac.uk/vch/hants/vol2/p225; accessed 26 August 2019].

Emery 1962: Richard Wilder Emery, *The Friars in Medieval France: A Catalogue of French Mendicant Convents, 1200–1550* (New York: Columbia University Press, 1962).

Fisquet 1864–1873: Honoré Fisquet, *La France Pontificale (Gallia Christiana): Histoire Chronologique et Biographique des Archevêques et Évêques de Tous les Diocèses de France*, 22 vols. (Paris: Repos, 1864–1873).

Gaussin 1962: Pierre-Roger Gaussin, *L'Abbaye de la Chaise-Dieu (1043–1518)* (Paris: Cujas, 1962).

Germain (1870) 1967: dom Michel Germain, *Monasticon Gallicanum*, ed. Achille Peigné-Delacourt (Paris: n.p., 1870; repr. Brussels: Culture et Civilisation, 1967), plate 58.

Gransden 1982: Antonia Gransden, *Historical Writing in England, c. 1307 to the Early Sixteenth Century* (Oxford: Routledge, 1982).

Guillemin 1929: André Guillemin, *Thiron, son abbaye, son collège militaire* (Nogent-le-Rotrou: Fauquet, 1929).

Heale 2009: Martin Heale, "Mitres and arms: aspects of the self-representation of the monastic superior in late medieval England", in *Self-representation of Medieval Religious Communities: The British Isles in Context*, ed. Anne Müller and Karen Stöber (Berlin: Lit Verlag, 2009), 99–122.

Heale 2016: Martin Heale, *The Abbots and Priors of Late Medieval England* (Oxford: Oxford University Press, 2016).

Herlihy 1997: David Herlihy, *The Black Death and the Tranformation of the West*, ed. Samuel K. Cohn (Cambridge, MA: Harvard University Press, 1997).

Hourihane 2013: Colum Hourihane, ed., *Patronage: Power and Agency in Medieval Art* (Princeton, NJ: Pennsylvania State University Press, 2013).

Jamroziak 2013: Emilia Jamroziak, *The Cistercian Order in Medieval Europe, 1090–1500* (London: Routledge, 2013).

Jenkins 2012: John Jenkins, "Monasteries and the defence of the South coast in the Hundred Years War," *Southern History*, 34 (2012): 1–23.

Lawrence 2015: C. H. Lawrence, *Medieval Monasticism: Forms of Religious Life in Western Europe in the Middle Ages*, 4th ed. (London and New York: Routledge, 2015).

Le Gall 2001: Jean-Marie Le Gall, *Les moines au temps des réformes: France (1480–1560)* (Seyssel: Champ Vallon, 2001).

Lekai 1977: Louis J. Lekai, *The Cistercians: Ideals and Reality* (Kent, OH: Kent State University Press, 1977).

Liégard 2018: Sophie Liégard, "Thiron-Gardais – cloître de l'abbaye. Intervention archéologique préalable à la reconstruction du cloître d'aout à novembre 2016," *Le Collector. Bulletin du réseau européen de l'Ordre de Tiron*, 6 (2018): 5–7.

Longnon 1875: Auguste Longnon, "Les limites de la France et l'étendue de la domination anglaise à l'époque de la mission de Jeanne d'Arc," *Revue des Questions Historiques*, 18 (1875): 444–546.

Luxford 2005: Julian M. Luxford, *The Art and Architecture of English Benedictine Monasteries 1300–1540: A Patronage History* (Woodbridge: Boydell Press, 2005).

Martène 1928–1929: Edmond Martène, *Histoire de la Congrégation de Saint-Maur*, ed. Gaston Charvin, 10 vols. (Paris: Picard, 1928–1954).

Matthew 1962: Donald Matthew, *The Norman Monasteries and their English Possessions* (Oxford: Oxford University Press, 1962).

McHardy 1975: A. K. McHardy, "The alien priories and the expulsion of aliens from England in 1378," *Studies in Church History*, 12 (1975): 133–141.

Merlet 1854: Lucien Merlet, "Chartes fausses de l'abbaye de la Trinité de Tiron," *Bibliothèque de l'École de Chartes*, 3$^{\text{ème}}$ sér., 5 (1854): 516–527.

Millet 1981: Hélène Millet, "Les pères du Concile de Pise (1409): édition d'une nouvelle liste," *Mélanges de l'Ecole française de Rome. Moyen-Age, Temps modernes*, 93 (1981): 713–790.

Morgan 1941: M. M. Morgan, "Historical revision, no. 99: The suppression of the alien priories," *History*, 26 (1941): 204–212.

Munns 2016: John Munns, *Cross and Culture in Anglo-Norman England: Theology, Imagery, Devotion*. Bristol Studies in Medieval Culture (Woodbridge: Boydell Press, 2016).

New 1916: Chester William New, "History of the Alien Priories in England to the Confiscation of Henry V," PhD dissertation, University of Chicago, 1916 (private edition distributed by the University of Chicago Libraries).

Newhall 1924: R. A. Newhall, *The English Conquest of Normandy, 1416–1424: A Study in Fifteenth Century Warfare* (New Haven: Yale University Press, 1924).

Oury 1979: Guy-Marie Oury, "Les Bénédictines réformés de Chezal-Benoît," *Revue d'histoire de l'église de France*, 65 (1979): 89–106.

Portal 1895: Charles Portal, "II. Rodrigue de Villandrando et les habitants de Cordes (1436)," *Annales du Midi*, 7 (1895): 212–216.

Ramsay 1892: James Ramsay, *Lancaster and York: A Century of English History (A.D. 1399–1485)*, 2 vols. (Oxford: Clarendon Press, 1892).

Rupin 1890: Ernest Rupin, *L'œuvre de Limoges* (Paris: Picard, 1890).

Rymer 1739–1745: Thomas Rymer, ed., "Rymer's Foedera with Syllabus: June 1421", in *Rymer's Foedera* (London: Apud Joannem Neulme, 1739–1745), 10:125–134 [also available via *British History Online* at http://www.british-history.ac.uk/rymer-foedera/vol10/pp125–134; accessed 31 August 2019].

Stevenson 1861–1864: Joseph Stevenson, *Letters and Papers Illustrative of the Wars of the English in France during the Reign of Henry the Sixth, King of England*, 2 vols. in 3, Rolls series, 22 (London: Longman, Green, 1861–1864).

Stöber 2007: Karen Stöber, *Late Medieval Monasteries and their Patrons: England and Wales, c. 1300–1540*. Studies in the history of medieval religion (Woodbridge: Boydell Press, 2007).

Sullivan 1995: Thomas Sullivan, *Benedictine Monks at the University of Paris, A.D. 1229–1500: A Biographical Register* (Leiden: Brill, 1995).

Sumption 1990–2016: Jonathan Sumption, *The Hundred Years War*, 4 vols. (London: Faber, 1990–2016).

Thompson B. 2002: Benjamin Thompson, "Monasteries, society and reform in late medieval England," in *The Religious Orders in Pre-Reformation England*, ed. James G. Clarke (Woodbridge: Boydell Press, 2002), 165–195.

Thompson K. 2009: Kathleen Thompson, "The First Hundred Years of the Abbey of Tiron: Institutionalizing the Reform of the Forest Hermits," *Anglo-Norman Studies*, 31 (2009): 104–117.

Thompson K. 2014: Kathleen Thompson, *The Monks of Tiron* (Cambridge: Cambridge University Press, 2014).

Thompson K. 2018: Kathleen Thompson, "The miracles of Saint Adjutor: the development of a Norman cult," in *Sur les Pas de Lanfranc, du Bec à Caen: Recueil d'Études en Hommage à Véronique Gazeau*, ed. Pierre Bauduin, Grégory Combalbert, Adrien Dubois, Bernard Garnier, and Christophe Maneuvrier, *Cahier des Annales de Normandie*, 37 (2018): 303–321.

Vallet de Viriville 1859: Auguste Vallet de Viriville, ed., *Chronique de la Pucelle, ou Chronique de Cousinot, suivie de La Chronique Normande de P. Cochon* (Paris: Delahayes, 1859).

Viguerie 1979: Jean de Viguerie, "La réforme de Fontevraud, de la fin du XVe siècle à la fin des guerres de religion," *Revue d'Histoire et de l'Église de France*, 174 (1979): 107–117.

Warner 1998: M. W. Warner, "Chivalry in action: Thomas Montagu and the war in France, 1417–1428," *Nottingham Medieval Studies*, 42 (1998): 146–173.

NOTES TO THE TEXT

1 Jacques de Vitry 1972, 127: *Hii a consortio nigrorum monachorum, mutato habitu nigro in grisio, recedentes, seorsum habitare ceperunt, primas monachorum nigrorum obseruantias, quas per negligentiam et dissolutionem hii, a quibus recesserunt, ex magna parte reliquerant, in se reformare cupientes.*

2 The modern place name is Thiron-Gardais (région Centre—Val de Loire, département Eure-et-Loir, canton Nogent-le-Rotrou), but the old French orthography of "Tiron" is usually adopted for the abbey.

3 William of Malmesbury 1998–1999, I (1998):786–788: *Alter famosus paupertatis amator, in saltuosum et desertum locum, relicto amplissimarum diuitiarum cenobio, cum paucis concessit, ibique, quia lucerna sub modio latere non potuit, undatim multis confluentibus monasterium fecit, magis insigne religione monachorum et numero quam fulgore pecuniarum et cumulo.*

4 For the early history of Tiron, see Thompson K. 2014, and earlier, Thompson K. 2009, as well as Bonde and Maines in this volume.

5 Bruun 2013 and references.

6 *GC*, VIII:1267–1268, for the history of the abbey from the sixteenth to the eighteenth centuries. Originally the revenues of a monastic house might be granted temporarily to an individual in trust (*in commendam*) during an abbatial vacancy, but such commendations later involved grants for life of the title of abbot, as well as revenues, and were used as rewards for prominent figures. The practice was common in France after the 1516 concordat between the papacy and King Francis I. See Lawrence 2015, 259–260. Tiron's first commendatory abbot was Cardinal Jean du Bellay (1498–1560), diplomat, dean of the Sacred College, and patron of Rabelais. For reform by the Congregation of Saint Maur and subsequent plans for the buildings at Tiron, see Martène 1928–1929, II (1929):265–267, and Carbonnier 1999, respectively. For the college, see Merlet 1883, I:LXXVII-CII.

7 See also Cline 2019, 167–179, which appeared after this study was submitted.

8 Merlet 1883, II:181. Merlet published many documents associated with the abbey in this volume, including extensive extracts from, but not all of, the cartulary, ADEL, H 1374.

9 ADEL H 1434, printed as Merlet 1883, II:154 and II:195.

10 Doubleday and Page 1903. In England, dedications to the Holy Cross are usually described as Saint Cross. There are references to the street in which Saint Cross lay, such as: *in vico qui ducit ad Sanctam Crucem, in australi parte strate que ducit de Cutebrigge versus Sancta Crucem* [*sic*], in Hockey 1981, n°s 131, 183.

11 Merlet 1883, I:64, 74, 122. Emery 1962, 55.

12 WCM 10656–58. The author is grateful to the Warden and Scholars of Winchester College for permission to consult and quote from documents in their archives, and to Suzanne Foster, archivist of the college, for her help.

13 WCM 10653.

14 Merlet 1883, II:145, 147, 172, 175.

15 This approach was followed by other monastic groupings such as the Cistercians; Lekai 1977, 307–310; Jamroziak 2013, 186–189.

16 Merlet 1883, II:158, 157.

17 WCM 10664.

18 Merlet 1883, II:198.

19 Geoffrey Grossus 2010 is the most accessible edition of the life. For the Latin and a French translation, see Beck 1998, 312–461. Thompson K. 2014, chapter 2, esp. 57–61, for the writing of the life.

20 *GC*, VIII:1265; Berlière 1927, 79.

21 The tomb slab is now damaged but its original wording is transcribed in *GC*, VIII:1265: . . . *qui fecit construi hoc capitulum ac claustrum ac multa alia alib aedificavit*

22 The epitaph on Henri's tomb was transcribed in *GC*, VIII:1265 and reads: *Hic jacet bonae memoriae venerabilis in Christo pater Henricus de Oris abbas xix hujus ecclesiae qui eam tempore suo bene rexit, sobrie, juste ac religiose vivendo. Orate pro eo. Amen* (followed by his death date). The authors of *GC* also indicated that Henri's tomb was located . . . *in basilica inter altaria sancti Thomae & sanctae Mariae,*

23 *GC*, VIII:1265, for each abbot's earlier service. The Tironensian abbey of Saint-Léonard of Ferrières was situated in the modern département de Deux-Sèvres, canton le Val de Thouet, commune Loretz-d'Argenton (formerly Bouillé-Loretz) and should not be confused with the more well-known abbey of Ferrières-en-Gatinais (Loiret).

24 ADEL H 1374, fol. 11v. Printed as Merlet 1883, I:50, n. 1.

25 Merlet 1883, II:201, 146.

26 ADEL H 1427, published as Merlet 1883, II:203.

27 Leases: ADEL H 1679, H 1722 (agricultural holdings), H 1577 (meadow), H 1869 (vines); receipt: H 1587.

28 ADEL H 1431, H 1527, H 1559, H 1651.

29 ADEL H 1413 (1310), printed as Merlet 1883, II:202, H 1414 (1349), H 1952 (1369), H 1414 (1371), H 1413 (1375), H 1413 (1380).

30 Cazelles 1962; Herlihy 1997; Benedictow 2004.

31 On the war, see Sumption 1990–2016.

32 For an overview, see Morgan 1941; for the quotation, see Matthew 1962, 81. For a full consideration, see Jenkins 2012.

33 CPR, *Edward I*, I:399; II:130, 352; III:22, 97; IV:462; *Edward II*, IVB:25; *Edward III*, I:358; II:543; XIII:42;

XIV:184. For John: *Edward II*, I:598; in a renewal of the letters of appointment in 1334, he is named John Scriptor Anglicus (*Edward III*, II:543).

34 CFR, V:29.

35 CPR, *Edward III*, III:560.

36 CFR, V:214, for Robert Renard's commission at Andwell; CCR, VI:638, for the arrest of Richard of Beaumont. The situation must have been resolved promptly, for Robert Renard appears as prior of Saint Cross in 1343 and Richard of Beaumont as prior of Andwell in 1344 (CFR, V:316, 370).

37 WCM 10682.

38 WCM 17216. For Wynnegod's lands, see WCM 2866–77.

39 WCM 10675.

40 Andwell and Saint Cross: see Kirby 1896–1899, II (1899):63: *Sonus gravis clamoris et fama publica nostrum pulsarunt auditum, quod bona spiritualia et temporalia prioratuum de Enedwelle et S. Crucis in Insula Vecta, nostre diocesis, ad cultum divinum et usus ecclesie antiquis temporibus ex devocione fidelium deputata, per culpas, negligencias, et incurias priorum et aliorum ministrorum eorundem miserabiliter sunt deperdita et collapsa; . . .* Hamble: Kirby 1896–1899, II (1899):14–15 (no. 4a): *Willelmus de Monasteriis . . . quod infra sex mensium spacium a tempore monicionis huiusmodi continuè sequencium numerandum ad prefatam ecclesiam de Hamele, qui sic dereliquit et dimisit taliter desolatam, personaliter redeat et accedat, et faciat in eâ residenciam*

41 CPR, *Edward III*, XIV:84; Kirby 1896–1899, II (1899):17 (no. 59b).

42 McHardy 1975.

43 Kirby 1896–1899, II (1899):15; Kirby 1896–1899, I (1896):62 (no. 63).

44 WCM 2921; CPR, *Richard II*, I:443.

45 WCM 2970.

46 Matthew 1962, 99–103, on the general situation, citing several examples, but not Tiron. On Wykeham's preparations, see Davis 2007, 150–151.

47 New 1916, 80.

48 ADEL H 1612.

49 For a comparison with similar grants of pontificals, see Heale 2009, 100–102; Thompson K. 2018.

50 GC, VIII:1265–1266; Heale 2016, 167–169.

51 WCM 2970 and other examples in the Winchester muniments.

52 WCM 2900.

53 Munns 2016, 46.

54 The abbey church of Tiron was dedicated to the Holy Trinity, yet throughout its history, and especially in the twelfth century, the church was sometimes identified as the church of the Holy Saviour.

55 The capitular seal and Tersal's abbatial seal are appended to WCM 2970, 2971, 2972, each in varying states of preservation.

56 Thompson K. 2014, 186.

57 *GC*, XIV:497.

58 On Abbot Robert III Dauphin, see *GC*, VIII:1266.

59 Fisquet 1864–1873, 3:151–152. Robert Dauphin was later to contest by force of arms the bishopric of Albi, on which see Portal 1895.

60 Warner 1998.

61 Merlet 1883, II, 209, quoting ADEL H 1423.

62 Longnon 1875, 487, n. 1. Ramsay 1892, II:380, for Salisbury's embarkation at Sandwich in July.

63 Newhall 1924, 280; Stevenson 1861–1864, I:LX, n. 3; Vallet de Viriville 1859, 200 (chap. 222).

64 Ramsay 1892, II:295.

65 Rymer 1739–1745, X:131.

66 Merlet 1883, II:209–210, n.1.

67 ADEL H 1957; H 1454.

68 *GC*, VIII:1266; ADEL H 1428. The prior, Michael Houssard, is mentioned in connection with Salisbury's attack on Tiron; Merlet 1883, II:209, n. 1.

69 ADEL H 1428, *GC*, VIII:1275–1276.

70 Carbonnier 2004.

71 On Tersal, see Millet 1981, 740; on de Kerbout, *GC*, VIII:1266; on Guillaume Grimault, Sullivan 1995, 163; on Léonet Grimault, *GC*, VIII:1266 and ADEL H 1428; on Louis I de Crevant, *GC*, VIII:1267.

72 ADEL H 1408; H 1660.

73 ADEL H 1688.

74 ADEL H 1415.

75 Benedict XIII 1983, n° 479; ADEL H 1940.

76 ADEL H 1611; H 1712; H 1548.

77 ADEL H 1559; H 1611.

78 ADEL H 1705. For an English study, see Stöber 2007.

79 Excavations in the south cloister alley, carried out under the direction of Sophie Liégard, revealed a fragmentary engraved tomb slab, which she attributes to the thirteenth century, based on its architectural motifs; Liégard 2018, 5–7. Sondages in the area of the Gothic chevet carried out under the direction of Sheila Bonde and Clark Maines in 2018 recovered 6 human bones and 1 fragmentary one, presumably from tombs disturbed during quarrying activity before and after the collapse of the choir in 1817. On the sondages in the choir, see Bonde and Maines 2019a, and Bonde

and Maines 2019b. I am indebted to the editors for this information. Regrettably, no obituary for Tiron seems to have survived, but compare observations on twelfth-century practice in Thompson K. 2014, 127–128. A papal bull from 1260 granting the monks of Tiron permission to bury servants and household members in their own cemeteries is preserved in an English cartulary, but not in the archives of Tiron; Hockey 1981, no. 228.

80 ADEL H 1414: Joanna of Brittany (1340), and Joanna, countess of Alençon (1371); H 1415: John, duke of Alençon (1467), and Charles de Guise, lord of Nogent-le-Rotrou (1472). For the Rotrou counts as patrons, see Thompson K. 2014, 96.

81 Merlet 1883, I:46–48.

82 ADEL H 1400, for the confirmations of Louis XI (1461), Louis XII (1498), and Francis I (1515); and Merlet, 1883, II:231–234, for the latter two.

83 Le Gall 2001, chapters 1 and 2. Contrast Tiron's "sister" order of Fontevraud where the nuns received assistance from family, king, and papacy; Viguerie 1979. See also Shaw and Panier in this volume for discussion of Celestine presence in urban centres.

84 ADEL H 1456; H 1578; H 1499.

85 ADEL H 1717; H 1486. Saint-Denis d'Authou and Gardais are each only a short distance from Tiron itself.

86 ADEL H 1505: a house at the corner of the rue de Muret and the rue d'Havedant; H 1589.

87 Merlet 1883, II:217.

88 *GC*, VIII:1266: *Subjecta Tironio coenobia, cellasque saepis invisit, criminosus adduxit ad meliorem vitae rationem, quae flammis devorata restabant aedificia propriis amicorumque sumptibus restituit.*

89 The monastic buildings have now almost all disappeared. For reordering and refurbishment in England, see Coppack 2002.

90 For plans of the choir, see Carbonnier 1999. Publication of detailed work on the choir is planned by Sheila Bonde and Clark Maines for an article provisionally titled: "A Lost Monument of the Late Gothic: the Fifteenth-Century Choir of the Abbey of Tiron."

91 Germain (1870) 1967, pl. 58.

92 *GC*, XIV:1076–1077.

93 ADEL H 1784.

94 On the Celestines, see articles by Shaw and Panier in this volume.

95 *GC*, VIII:1274–1276.

96 *GC*, VIII:1270–1271; *GC*, XIV:497.

97 *GC*, VIII:1271.

98 ADEL H 1423, abstracted in Inv. 1897, 163–164.

99 WCM 10704, *CCR*, 6:638; WCM 4280a, WCM 2842, *CFR*, V:214.

100 Thompson K. 2014, 142–143.

101 Similar "permeability" between cloister and society has been detected in England; Thompson B. 2002, 185–187.

102 All material drawn from ADEL H 1423, abstracted in Inv. 1897, 163–164.

103 ADEL H 1423, published in Merlet 1883, II:212–222.

104 Merlet 1883, II:215–217.

105 Merlet 1883, II:218: *gerant habitus religiosos et honestos, videlicet bombicinia longa seu jacquetas, caligas curtas et sotulares corrigaiatos.*

106 Merlet 1883, II:220.

107 Merlet 1883, II:221–222.

108 *GC*, VIII:1267.

109 Information provided in Guillemin 1929, 8 and 11.

110 The inscription in heavily abbreviated Gothic script, which has been neither transcribed nor translated, begins with the usual formula *Hic iacet Reverendus in Christo pater Leonetus . . .* (Here lies the reverend father in Christ, Léonet . . .).

111 Merlet 1883, II:222, 224.

112 ADEL H 1454. For an inventory of the abbey's plate at the time that it was looted in 1562, based on a list that has since been lost, see Merlet 1883, I:LVII-LVIII. For a broad survey of medieval patronage, including monastic patronage, see Hourihane 2013. For study on monastic patronage in England, see Luxford 2005.

113 Bastard d'Estang 1857. Originally in the Musée de Chartres, and now in the Musée du Collège Royal et Militaire de Thiron-Gardais, the crozier was discussed, illustrated with an engraving, and dated to the thirteenth century by Rupin 1890, 558 and pl. XLVI, fig. 622. It likely came from a tomb located in one of the chapels that lined the interior of the outer aisle of the Gothic chevet. I am indebted to the editors for this information.

114 Fisquet 1864–1873, III:420–422.

115 A preliminary investigation of the sculptural fragments from the new choir provides another confirmation of this new atmosphere. See Bonde and Maines 2020.

116 ADEL H 1660; H 1594; H 1593. The hamlet named La Tuilerie on the south side of the lake near the road to La Gaudaine perhaps preserves the memory of Coisneau's enterprise. The "étang Sainte-Anne" lies in close proximity to the abbey.

117 Fisquet 1864–1873, III:422.

118 Anthony de Crevant, b. 1484: *GC*, XVI:308, *GC*, VIII:1271; Anthony de Crevant, b. 1496, *GC*, XVI:308.

119 Berlière 1927, 38; ADEL H 1423, for the Tironensian officials.

120 *GC*, VIII:1267.

121 Merlet 1883, II:222.

122 The abbey had been built on a carrucate of land in the parish of Gardais, given by Bishop Ivo (1092–1115), the dean and chapter, in 1114. There had been skirmishes in 1212 over ecclesiastical jurisdiction in the settlement of Gardais and the monks' bourg and again some forty years later over secular jurisdiction at Tiron; Merlet 1883, II:127, 165. In 1470 the monks secured from Louis XI an exemption from visitation by the bishop's vicar; ADEL H 1403.

123 ADEL H 1395.

124 Since it constitutes important evidence for the developing discipline of diplomatic, the critical study of the protocols and fomulae used in creating historical documents, Merlet examined the dispute in detail, first in Merlet 1854 and later in Merlet 1883, I:XVIII-LVI. The documents were first exhibited during an action heard at Chartres before 1508. The chapter appealed on the grounds that the documents were forgeries; the appeal was rejected in 1525, but accepted on a higher appeal to the Parlement in Paris in 1535. A response by the monks, an attempt at compromise in 1542, and a further round of hearings lasting from 1550 to 1556 followed. Meanwhile, as the 1542 compromise stated clearly, repairs to the church were necessary (Merlet 1883, I:XLVII).

125 Thompson K. 2018.

126 Merlet 1883, II:219.

127 Merlet 1883, I:30.

128 ADEL H 1951.

129 English examples include Walsingham 2018 and Gransden 1982.

130 Lépinois and Merlet 1862–1865, I:25, n. 1.

131 Merlet 1883, I:XLVII.

132 Orderic Vitalis 1969–1980, IV (1973), book viii, 330–331: *Illuc multitudo fidelium utriusque ordinis abunde confluxit, et predictus pater omnes ad conuersionem properantes caritatiuo amplexu suscepit,et singulis artes quas nouerant legitimas in monasterio exercere precepit. Vnde liberter conuenerunt ad eum fabri tam lignarii quam ferrarii, sculptores et aurifabri, pictores et cementarii, uinitores et agricolae, multorumque officiorum artifices peritissimi.* (A multitude of the faithful of both orders flocked to him there, and Father Bernard received in charity all who were eager for conversion to monastic life, instructing individuals to practise in the monastery the various crafts in which they were skilled. So among the men who hastened to share his life were joiners and blacksmiths, sculptors and goldsmiths, painters and masons, vine-dressers and husbandmen and skilled artificers of many kinds.)

133 Clark 2011, 280.

134 Oury 1979.

Figure Credits

Introduction: Figs. 1–3—authors. Panier: Figs. 1a, 1b—Nanterre, Bibliothèque La Contemporaine; Figs. 3, 5, 6, 12–16—author; Fig. 4—Millin 1790–1798 (vol. 1, pl. 2); Figs. 7, 10a, 10b, 11—Guynemer 1912 (pls. XXVII, XXXIV, XXXV, XL); Fig. 8—Paris, BnF; Fig. 9—Beauvais, Archives départementales de l'Oise; Fig. 17—Compiègne, Bibliothèque municipale. Wade: Fig. 1—photo Grentidez, Wikicommons; Fig. 2—after S. Brigode in Génicot 1972 (50); Figs. 3–4—Wikicommons; Fig. 5—photo Zi You Xun Lu, Wikicommons. Killian: Figs. 1–13a, 14, 15 (bottom)—author; Fig. 13b—after J. Trouvelot in Wigny 1972 (fig. 2); Fig. 13c—after Plouvier in Héliot 1970 (pl. XXV); Fig. 13d—after Sardon in Deshoulières 1920 (132); Fig. 15 (top) courtesy Bonde and Maines; Fig. 16a—after P. Glotain in Droguet 1994 (fig. 9); Fig. 16b—after Leman 1977 (fig.1); Fig. 16c—after Defente 1997 (fig. 4). Gustafson: Figs. 1–3, 5–11—author; Fig. 4—from *Annales Camaldulenses* 1755. Kinias: Fig. 1—Paris, Musée Carnavalet; Fig. 2—Musée nationale des Châteaux de Versailles et de Trianon, photo Wikicommons; Fig. 3—Musée du domaine départementale de Sceaux; Fig. 4—Stockholm, Nationalmuseum, public domain; Fig. 5—Paris, BnF; Fig. 6—*Acta Sanctorum*, (August 1743, vol. VI, 791); Fig. 7—Paris, BnF; Fig. 8—author; Fig. 9—Paris, BnF; Fig. 10—courtesy Bonde and Maines; Fig. 11—Monteil, *Histoire des français…*, 1842 (I, 3), photo courtesy Alamy. Chilson-Parks: Fig. 1—Archives de la Ville de Dijon; Fig. 2—Paris, BnF; Figs. 3, 5—Bibliothèque municipale de Dijon; Figs. 4, 6, 8—author; Fig. 7—courtesy Bonde and Maines. Bonde and Maines: Map 1, Figs. 3, 6a, 8–10, 12–19, 21–26—authors; Figs. 1, 2, 5—Wikicommons; Fig. 4—photo Mieusement, Wikicommons; Fig. 6b—courtesy Daniel Prigent; Fig. 7—Paris, BnF; Fig. 11—courtesy Céline Trébaol; Fig. 20—Paris, Archives nationales, photo courtesy Arthur Panier. Thompson: Figs. 1, 3, 4—courtesy Bonde and Maines; Figs. 2a, 2b—author (reproduced by kind permission of the Warden and Scholars of Winchester College).